# PLACE-NAMES OF NORTHE

## Volume Four

## COUNTY ANTRIM I

## THE BARONIES OF TOOME

Published 1995
The Institute of Irish Studies
The Queen's University of Belfast
Belfast

Research and Publication funded by the
Central Community Relations Unit

Copyright 1995

ISBN 0 85389 568 6 (hb)

ISBN 0 85389 569 4 (pb)

British Library Cataloguing-in-Publication Data.
A catalogue record for this book is available from the British Library.

Printed by W. & G. Baird Ltd, Antrim.

# Place-Names of Northern Ireland

## VOLUME FOUR

### County Antrim I
### The Baronies of Toome

Patrick McKay

The Northern Ireland Place-Name Project
Department of Celtic
The Queen's University of Belfast

General Editor: Gerard Stockman

## RESEARCH GROUP

Professor Gerard Stockman

Fiachra Mac Gabhann MA
Dr Patrick McKay
Dr Kay Muhr
Mícheál B. Ó Mainnín MA
Dr Gregory Toner

## LIST OF ILLUSTRATIONS

Cover: A section of John Speed's map entitled *The Province Ulster Described* (1610)

The cover logo is the pattern on one face of a standing stone found at Derrykeighan, Co. Antrim. The art style is a local variant of the widespread "Celtic Art" of the European Iron Age and dates to about the 1st century AD. The opposite side of the stone is similarly decorated. (Drawing by Deirdre Crone, copyright Ulster Museum).

The townland maps have been prepared from OSNI digitized data by Kay Muhr. Based on the Ordnance Survey map with the sanction of the Controller of HM Stationery Office, Crown Copyright reserved (Permit no. 354).

BÉV

# ACKNOWLEDGEMENTS

In a multi-disciplinary field of study such as place-names, consultation with outside experts is of vital importance. We cannot thank by name all those who have given us of their time and knowledge, but among them we count the following:

R.J. Hannan, formerly of the Northern Ireland Place-Name Project.

Eilís McDaniel, formerly of the Northern Ireland Place-Name Project, who initiated the computerization of the project.

Dr Cathair Ó Dochartaigh, Dr Leslie Lucas, W.C. Kerr, J.F. Rankin, R.E. Turner, Mrs Maeve Walker.

Dr Kieran Devine, Dr A. Sheehan, Dr M.T. Flanagan, Mary Kelly, Dr Hiram Morgan, Pamela Robinson, of Queen's University, Belfast.

Professor Séamas Mac Mathúna of the University of Ulster, Coleraine.

Art Ó Maolfabhail, Dónall Mac Giolla Easpaig, Pádraig Ó Cearbhaill, Pádraig Ó Dálaigh of the Place-Names Branch of the Ordnance Survey of Ireland and Dr Nollaig Ó Muraíle, formerly of the Place-Names Branch of the Ordnance Survey of Ireland, now of the Department of Celtic, Queen's University, Belfast.

Angélique Day and Patrick McWilliams, Ordnance Survey Memoir Project, Institute of Irish Studies, QUB.

Pascal McCaffrey of the Classics Department of Our Lady and St Patrick's College, Knock, Belfast.

Members of the Steering Committee: Michael Brand, Professor Ronnie Buchanan, Dr Maurna Crozier, Dr Alan Gailey, Dr Ann Hamlin, Dr Maurice Hayes, Sam Corbett, Dr Brian Walker.

Claire Foley, Ann Given, Dr Chris Lynn of the Archaeological Survey of Northern Ireland.

Leonard Brown, John Buckley, Chris Davidson, Geoff Mahood, Larry Toolan of the Ordnance Survey of Northern Ireland.

Dr Bill Crawford, Clifford Harkness of the Ulster Folk and Transport Museum.

Dr Brian Trainor of the Ulster Historical Foundation.

Richard Warner of the Ulster Museum.

Norman Scott, Jack Hannon, the late George McManus, David Campbell, Frank O'Boyle, the late James McFall, John McKay, John Simpson, James McKeown, William Bailie, the late Brian Griffin, Tom McCudden, Brian Grant, Willie Higgins, James Kenny, Harry Hume, Edmund McCann, Kevin Kelly, Willie Kennedy, Charlie O'Boyle, Eamon Stinson, and all others who assisted with fieldwork and in any other way in the locality.

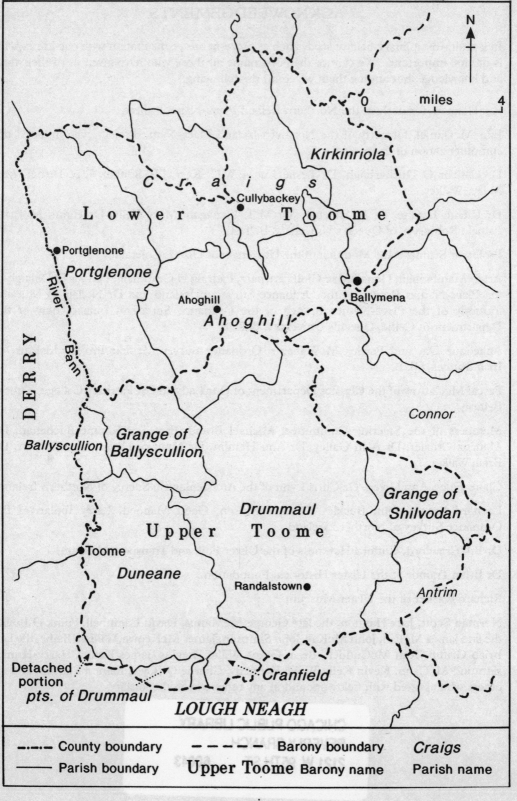

N

0 — miles — 4

*Kirkinriola*

C r a i g s

L o w e r — T o o m e

Cullybackey

Portglenone

*Portglenone*

River

DERRY

Bann

Ahoghill

Ballymena

*Ahoghill*

*Connor*

*Ballyscullion*

*Grange of Ballyscullion*

*Drummaul*

*Grange of Shilvodan*

U p p e r — T o o m e

Toome

*Duneane*

Randalstown

*Antrim*

Detached portion *pts. of Drummaul*

*Cranfield*

**LOUGH NEAGH**

—·—·— County boundary    — — — Barony boundary    *Craigs*

——— Parish boundary    **Upper Toome** Barony name    Parish name

vi

# CONTENTS

# GENERAL INTRODUCTION

## BRIEF HISTORY OF PLACE-NAME STUDY IN IRELAND

Place-name lore or *dindsenchas* was a valued type of knowledge in early Ireland, to be learnt by students of secular learning in their eighth year of study. Stories about the origin of place-names appear regularly in early Irish literature. At the end of the epic "Cattle Raid of Cooley" the triumphal charge of the Brown Bull of Cooley around Ireland is said to have given rise to names such as Athlone (Irish *Áth Luain*), so called from the loin *(luan)* of the White-horned Bull slain by the Brown Bull. In the 10th, 11th and 12th centuries legends about the naming of famous places were gathered together into a number of great collections. Frequently, different explanations of the same name are offered in these legends, usually with no preference being expressed. In an entry on the naming of *Cleitech,* the palace on the Boyne of the early king *Muirchertach mac Erca,* five separate explanations of the name are offered, none of which can be correct in modern scholarly terms. Place-name study was cultivated as a branch of literature.

Knowledge of Irish place-names was of practical importance during the English conquest and exploration of Ireland in the 16th century. Recurring elements in the place-names were noted by surveyors, and a table giving a few English equivalents appears on some maps of this period. There was concern that Irish names were "uncouth and unintelligible". William Petty, the great 17th-century surveyor and map-maker, commented that "it would not be amiss if the significant part of the Irish names were interpreted, where they are not nor cannot be abolished" (Petty 1672, 72–3). However, although the English-speaking settlers created many new names, they did not usually change the names of the lands they were granted, and the names of land units remained as they were, albeit in an anglicized form.

Interest in the meaning of Irish place-names developed further towards the end of the 18th century. The contributors to William Shaw Mason's *Parochial Survey of Ireland* often included a table explaining their local townland names, and this aspect was retained in the Statistical Reports compiled by the officers of the Royal Engineers on the parishes they surveyed for the first six-inch survey of Ireland in the late 1820s and early 1830s. Information on the spelling of place-names for the maps was collected in "name-books", and the Ordnance Survey was concerned to find that a variety of anglicized spellings was in use for many Irish place-names. The assistant director, Thomas Larcom, decided that the maps should use the anglicized spellings that most accurately represented the original Irish (Andrews 1975, 122) and he employed an Irish scholar, John O'Donovan, to comment on the name-books and recommend standard forms of names. O'Donovan was sent to the areas being surveyed to talk to local inhabitants, where possible Irish speakers, to find out the Irish forms. These were entered in the name-books, but were not intended for publication.

In 1855, a reader of *Ulster Journal of Archaeology* calling himself "De Campo" asked "that a list of all the townlands should be given in their Irish and English nomenclature, with an explanation of their Irish names" (*UJA* ser. 1, vol. iii, 25 1b). Meanwhile William Reeves, the Church of Ireland Bishop of Connor, had decided to compile a "monster Index" of all Irish townlands, which would eventually include the etymology of the names, "where attainable" (Reeves 1861, 486) . Reeves' project was cited favourably by William Donnelly, the Registrar General, in his introduction to the first Topographical Index to the Census of Ireland: "It would greatly increase the value of a publication of this nature if it were accompanied by a glossary or explanation of the names, and an account of their origin" *(Census 1851* 1, 11–12).

However, it was left to another scholar, P. W. Joyce, to publish the first major work dealing exclusively with the interpretation of Irish place-names, and in his first chapter he acknowl-

edges his debt to both O'Donovan and Reeves (*Joyce* i 7–8, 10). At this period the progress made by Irish place-name scholarship was envied in England (Taylor 1896, 205). The high standard of Joyce's work has made him an authority to the present day, but it is regrettable that most popular books published since on Irish place-names have drawn almost entirely on the selection and arrangement of names discussed by Joyce, ignoring the advances in place-name scholarship over the last hundred years (Flanagan D. 1979(f); 1981–2(b)).

Seosamh Laoide's *Post-Sheanchas,* published in 1905, provided an Irish-language form for modern post towns, districts and counties, and research on place-names found in early Irish texts resulted in Edmund Hogan's *Onomasticon Goedelicum* (1910). Local studies have been published by Alfred Moore Munn (Co. Derry, 1925), and P. McAleer (*Townland Names of County Tyrone,* 1936). The idea of a comprehensive official survey was taken up again by Risteard Ó Foghludha in the introduction to his *Log-ainmneacha* (1935). A Place-Names Commission was founded in Dublin in 1946 to advise on the correct forms of Irish place-names for official use and this was followed by the Place-Names Branch of the Ordnance Survey. They have published the Irish names for postal towns (*AGBP* 1969), a gazetteer covering many of the more important names in Ireland (*GÉ* 1989), a townland survey for Co. Limerick (1990), and most recently bilingual lists of the place-names of a number of individual Irish counties.

John O'Donovan became the first professor of Celtic in Queen's University, Belfast, and in the 20th century members of the Celtic Department continued research on the place-names of the North of Ireland. The Ulster Place-Name Society was founded by the then head of department, Seán Mac Airt, in 1952 (Arthurs 1955–6, 80–82). Its primary aims were, (a) to undertake a survey of Ulster place-names; and (b) to issue periodically to members a bulletin devoted to aspects of place-name study, and ultimately to publish a series of volumes embodying the results of the survey. Several members undertook to do research on particular areas, much of which remains unpublished (Deirdre Flanagan on Lecale, and Dean Bernard Mooney on the names of the Diocese of Dromore).

The primary objective of the Ulster Place-Name Society was partly realized in 1987, when the Department of Celtic was commissioned by the Department of the Environment for Northern Ireland to do research into, "the origin of all names of settlements and physical features appearing on the 1:50,000 scale map; to indicate their meaning and to note any historical or other relevant information". In 1990, under the Central Community Relations Unit, the brief of the scheme was extended: to include work on all townlands in Northern Ireland, and to bring the work to publication. Although individual articles have already been published by various scholars, the *Place-Names of Northern Ireland* series is the first attempt in the North at a complete survey based on original research into the historical sources.

## METHOD OF PLACE-NAME RESEARCH

The method employed by the Project has been to gather early spellings of each name from a variety of historical records written mainly in Irish, Latin and English, and arrange them in chronological order. These, then, with due weight being given to those which are demonstrably the oldest and most accurate, provide the evidence necessary for deducing the etymology. The same name may be applied to different places, sometimes only a few miles apart, and all forms are checked to ensure that they are entered under the correct modern name. For example, there are a number of references to a place called *Crosgare* in 17th-century sources, none of which refer to the well-known town of Crossgar in Co. Down, but to a townland also called Crossgar a few miles away near Dromara. Identification of forms is most readily facilitated by those sources which list adjoining lands together or give the name

of the landholder. Indeed, one of the greatest difficulties in using Irish sources and some early Latin or English documents is the lack of context which would enable firm location of the place-names which occur in them.

Fieldwork is an essential complement of research on earlier written sources and maps. Sometimes unrecorded features in local topography or land use are well-known to local inhabitants. More frequently the pronunciation represented by the early written forms is obscure, and, especially in areas where there has been little movement of people, the tradi-tional local pronunciation provides valuable evidence. The members of the research team visited their respective areas of study, to interview and tape-record informants recom-mended by local historical societies etc., but many others met in the course of fieldwork kindly offered their assistance and we record here our gratitude. The local pronunciations have been transcribed in phonetic script and these are given at the end of each list of histor-ical forms. The tapes themselves will become archive material for the future. The transcrip-tion used is based on the principles of the International Phonetic Alphabet, modified in accordance with the general practice in descriptions of Irish and Scottish Gaelic dialects. The following diagram illustrates the relative position of each of the vowels used:

| Front | Central | Back | |
|---|---|---|---|
| i | | ʌ u | High |
| ı | | | |
| e | ï ö | o | High-mid |
| | ə | o̧ | |
| ɛ | | ɔ | Low-mid |
| a | | ɑ | Low |

Although this research was originally based on the names appearing on the 1:50,000 scale map, it soon became clear that many townland names, important in the past and still known to people today, were not given on the published version. Townlands form the smallest unit in the historical territorial administrative system of provinces, counties, baronies, parishes, and townlands. This system, which is that followed by the first Ordnance Survey of Ireland in its name-books, has been used in the organization of the books in this series. The names of all the relevant units are explained in Appendix B. Maps of the relevant barony and parish divisions within the county are supplied for the area covered in each book, to complement the published 1:50,000 series, and to make the historical context more accessible.

In the process of collecting and interpreting early forms for the *Place-Names of Northern Ireland* each researcher normally works on a group of 4 or 5 parishes. Since some books will contain 10 or more parishes, joint authorship will be the norm, and there may be differences of style and emphasis in the discussions within and between books. It seemed better to retain individuality rather than edit everything into committee prose. The suggested original Irish forms of the place-names were decided after group discussion with the general editor. The members of the group responsible for the text of each book will be distinguished by name on the contents page.

All the information in this book is also preserved in a computer database in Queen's University Belfast. It is hoped that this database will eventually become a permanent resource for scholars searching for examples of a particular type of name or name element. Modern map information, lists of the townlands making up historical parishes and baronies, historical sources and modern Irish forms are all available on separate files which can be searched and interrelated. The database was designed by Eilís McDaniel, and the Project gratefully acknowledges her continuing interest and assistance.

## LANGUAGE

Since Ulster was almost wholly Irish-speaking until the 17th century, most names of townlands are of Irish-language origin. Some early names were also given Latin equivalents for use in ecclesiastical and secular documents but few probably ever gained wide currency. Norse influence on northern place-names is surprisingly slight and is largely confined to coastal features such as **Strangford Lough** and **Carlingford Lough.** The arrival of the Anglo-Normans in the 12th century brought with it a new phase of naming and its influence is particularly strong in east Ulster, most notably in the Barony of Ards. Here, the names of many of their settlements were formed from a compound of the owner's name plus the English word *tūn* "settlement" which gives us Modern English "town". Names such as **Hogstown** and **Audleystown** have retained their original form, but a considerable number, such as **Ballyphilip and Ballyrolly,** derive from forms that were later gaelicized.

By the time of the Plantation of Ulster in the 17th century the system of townland units and their names already existed and this was adopted more or less wholesale by the English and Scots-speaking settlers. These settlers have, nevertheless, left their mark on a sizeable body of names, particularly those of market towns, country houses, villages and farms which did not exist before the 17th century. What made the 17th-century Plantation different from the earlier ones was its extent and intensity, and it was the first time that the Irish language itself, rather than the Irish aristocracy, came under threat. The change from Irish to English speaking was a gradual one, and Irish survived into the 20th century in parts of Antrim and Tyrone. However, the language shift, assisted by an official policy that discriminated against Irish, eventually led to the anglicization of all names to the exclusion of Irish versions.

## SPELLING AND PRONUNCIATION

Most of the historical sources used in this series were originally handwritten and this inevitably led to a considerable number of errors, both by contemporary copyists and by modern editors. Many of the documents, particularly grants, were copied time and again, while other sources sometimes only survive in late copies or published calendars. Mistakes could occur in any transcription but were particularly likely when the language or names being copied were unfamiliar. There is a long history of confusion in the Roman alphabet between letters of the type *i, u, n, m, w. U* and *n* are frequently confused, as are *m* and *w*. Where two or more of these letters occur together, the minims (vertical strokes) may be read in different combinations: the simple pair *ui* may be read as *iu, ni, in, m,* or *w*. Another common error is the confusion of long *s* (ʃ) and *f*. The name **Ballyhaft** (par. Newtownards, Dn) is frequently spelt in 17th-century sources with *s* instead of *f* and the modern form of the name may result from confusion of the written forms. In early sources, horizontal strokes (suspension strokes) could be written over a vowel as shorthand for a following *n* or *m*, but they were easily overlooked by scribes or editors. Spellings such as *Ballemulle* for **Ballymullan** (par. Bangor, Dn) may be explained in this way.

As well as taking account of spelling mistakes, there is sometimes difficulty in interpreting just what the spellings were intended to represent. For example, *gh,* which is usually silent in modern English dialects (e.g. night, fought) often retained its original value in the 17th century and was pronounced like the *ch* in Scots *loch* and *nicht.* Thus, *gh* was the obvious way to represent the Irish sound in words like *mullach* "summit", although both the English and Irish sounds were being weakened to [h] in certain positions at the time.

In Irish the spelling *th* was originally pronounced as in modern English *thick,* but in the 13th century it came to be pronounced [h]. The original Irish sound was anglicized as *th* or as *gh* at different periods, but where the older form of the spelling has survived the sound *th*

has often been restored by English speakers. In names such as **Rathmullen** and **Rathfriland,** where the initial element represents *ráth* "a ringfort", the *th* has almost invariably been re-established.

It is clear that some spellings used in place-names no longer signify what they did when first anglicized. The *-y* in the common elements "bally-" and "derry-" was selected to represent the final vowel in the corresponding Irish words *baile* and *doire* (the same sound as the *a* in "above") but this vowel is now usually pronounced as a short *ee* as in English words such as *happy, sorry*. In modern Ulster English, the vowel in words ending in *-ane*, such as *mane*, *crane*, is a diphthong, but in the 17th century it was pronounced as a long *a*. Thus, Irish *bán* "white" was usually represented in anglicized forms of names as *bane* as, for example, in the names **Kinbane** (Ant.) and **Carnbane** (Arm.) and this is frequently how the names are still pronounced locally.

## SOURCES

The earliest representations of Irish place-names are found in a broad range of native material, written mostly in Irish although occasionally in Latin, beginning in the 7th or 8th centuries. The Irish annals, probably begun about 550 AD (Byrne 1973, 2) but preserved in manuscripts of much later date, contain a large number of place-names, particularly those of tribes, settlements, and topographical features. Tribal names and those of the areas they inhabited frequently appear among genealogical material, a substantial proportion of which is preserved in a 12th-century manuscript, Rawlinson B 502, but is probably much older. Ecclesiastical records include martyrologies or calendars giving saints' names, often with the names and locations of their churches. The Latin and Irish accounts of the life of St Patrick, which depict him travelling around Ireland founding a series of churches, contain the first lists of place-names which refer to places owned by a particular institution. Later Irish saints' lives also may list lands dedicated to the founder of a church. Medieval Irish narrative shows a great interest in places, often giving, for example, long lists of place-names passed through on journeys. Although many of these sources may date back to the 7th or 8th centuries, the copies we have often survive only in manuscripts of the 12th century and later, in which the spelling may have been modernized or later forms of names substituted.

The administrative records of the reformed Church of the 12th century are among the first to provide detailed grants of land. There are also records from the international Church, such as the papal taxation of 1302–06 (*Eccles. Tax.*). These records are more productive for place-name study, since the names are usually of the same type (either parishes or other land units owned by the church) and are usually geographically related, making them easier to identify with their modern counterparts. However, the place-names in these documents are not usually spelled as they would be in Irish.

Paradoxically, perhaps, the 17th-century Plantation provides a massive amount of evidence for the place-names of Ulster. Grants to and holdings by individuals were written down by government officials in fiants, patents and inquisitions (in the latter case, the lands held by an individual at death). A series of detailed surveys, such as the *Escheated Counties* maps of 1609, the *Civil Survey* of 1654–6, and Sir William Petty's Down Survey (*DS (Par. Maps), Hib. Del.* and *Hib. Reg.*), together with the records of the confiscation and redistribution of land found in the *Books of Survey and Distribution* (*BSD*) and the *Act of Settlement* (*ASE*), meant that, for the first time, almost all the names of smaller land units such as townlands were recorded. Unfortunately the richness of these resources has been depleted by two serious fires among the Irish public records, one in 1711 and the other in the Four Courts in Dublin in 1922. As a result, some of the original maps, and the Civil Survey covering the north-eastern counties, are lost, and the fiants, patents, inquisitions and Act of Settlement

now only exist in abridged form in calendars made by the Irish Record Commission in the early 19th century. These calendars were criticized even at the time of publication for their degree of précis and for inaccurate transcription of names.

After the 17th century, little surveying of an official nature was carried out in Ireland, despite the clearance of woods and bogs and reclamation of waste land. The best sources for the 18th century, therefore, are family papers, leases, wills and sometimes estate maps, most of which remain unpublished. It became clear in the early 19th century that much of the taxation system was based on records that were out of date. The Ordnance Survey came to Ireland in 1824 and began in 1825 to do the first large-scale (six inches to the mile) survey of the country. Most of the variant spellings which they collected in their name-books were of the 18th or early 19th centuries, though in some cases local landowners or churchmen allowed access to earlier records, and these again provide a convenient and invaluable source of place-names. Minor names were also recorded in the descriptive remarks of the namebooks, in the fuller treatment of local names (water features, ancient monuments, church sites and other landmarks) in the associated Ordnance Survey Memoirs (*OSM*) and in the Ordnance Survey Revision Name-Books (OSRNB), dating from the second half of the 19th century.

Early maps are an extremely valuable source, since they show the geographical relationship between names that is often crucial for identification purposes, and in many cases they are precise enough to locate lost townlands or to identify the older name of a townland. In parts of Ulster, maps by 16th-century surveyors may antedate texts recording place-names, thus providing the earliest attestation of the names in those areas.

However, maps have their own problems. Like other written texts they often copy from each other, borrowing names or outline or both. Inaccuracies are frequent, especially in the plotting of inland water features, whether due to seasonal flooding, or the lack of a vantage point for viewing the course of a river. Frequently the surveyor of the ground was not the person who drew or published the surviving map. The great continental and English map and atlas publishers, such as Ortelius, Mercator and Speed, all drew on earlier maps, and this custom undoubtedly led to the initiation and prolongation of errors of form and orthography. Sixteenth-century maps of Lough Neagh, for example, regularly show rivers entering the lake on the south between the Blackwater and the Bann where there are known to be none (Andrews 1978, plate 22). Unsurveyed territory was not always drawn to scale. Modern Co. Donegal, for example, is usually drawn too large on 16th-century maps, while Co. Derry is frequently shown too small. The *Escheated County* maps appear to have been partly drawn from verbal information and, in the map for the barony of Armagh, the draughtsman has produced a mirror image reversing east and west (Andrews 1974, 152).

William Petty's Down Survey provided the standard map of Ireland for the 17th century. In the 18th and early 19th centuries various individuals produced local county maps: Roque (1760) Co. Armagh; Lendrick (1780) Co. Antrim; Sampson (1814) Co. Derry; Sloane, Harris, Kennedy and Williamson (1739–1810) Co. Down; Knox and McCrea (1813) Co. Tyrone. These were consulted for the place-names on their own maps by the Ordnance Survey in the 1830s. Apart from published maps, a number of manuscript maps, some anonymous, others the original work of the 16th-century surveyors Lythe and Jobson, still exist. Richard Bartlett and Thomas Raven left important manuscript maps of Ulster from the early 17th century.

## HOW TO USE THIS SERIES

Throughout the series, the editors have tried to adhere to the traditional territorial and administrative divisions used in Ireland, but this has not always proved possible. The con-

venient unit on which to base both research and publication has been the civil parish and all townland names and minor names are discussed under the relevant parish, regardless of whether they are in the same barony or county. Each book normally deals with the parishes in one or more barony, but where the barony is too large they are split into different books, some of which may contain material from geographically adjacent baronies. Every effort has been made to accommodate the historical system in a series of volumes of regular size. Each parish, barony and county is prefaced by an introduction which sets forth its location and history, and discusses some of the sources from which the older spellings of names have been extracted.

Within each parish, townland and other names are arranged in alphabetical order in sep-arate sections following a discussion of the parish name. The first section deals with town-land names. The second section deals with names of towns, villages, hills and water features which appear on the OS 1:50,000 map, but which are not classified as townlands. This sec-tion may also include a few names of historical importance which do not appear on the map but which may be of interest to the reader. Lesser names on the 1:50,000 are only treated if relevant material has been forthcoming. An index of all the names discussed in each book is given at the back of the relevant volume.

Each name to be discussed is given in bold print on the left-hand side of the page. Bold print is also used elsewhere in the text to cross-refer the reader to another name discussed in the series. The four-figure grid-reference given under each place-name should enable it to be located on modern Ordnance Survey maps.

Beneath the map name[1] and its grid reference, all the pre-1700 spellings that have been found are listed, together with their source and date, followed by a selection of post-1700 forms. Early Irish-language forms are placed above anglicized or latinized spellings because of their importance in establishing the origin of the name. Irish forms suggested by 19th- and 20th-century scholars are listed below the historical spellings. Irish-language forms collected by O'Donovan in the last century, when Irish was still spoken in many parts of the North, require careful assessment. Some may be traditional, but there are many cases where the suggestion made by the local informant is contradicted by the earlier spellings, and it is clear that sometimes informants merely analysed the current form of the name. The current local pronunciation as collected by the editors appears below these Irish forms in phonetic script.

Spellings of names are cited exactly as they occur in the sources. Manuscript contractions have been expanded within square brackets, e.g. [ar]. Square brackets are also used to indi-cate other editorial readings: [...] indicates three letters in the name which could not be read, while a question mark in front of one or more letters enclosed in square brackets, e.g. [?agh], denotes obscure letters. A question mark in round brackets before a spelling indicates a form which cannot be safely identified as the name under discussion.

The dates of all historical spellings collected are given in the right-hand column, followed, where necessary, by *c* when the date is approximate. Here, we have departed from the nor-mal practice, employed elsewhere in the books, because the database would otherwise have been unable to sort these dates in numeric order. In Latin and English sources a *circa* date usually indicates an uncertainty of a year or two. Irish language sources, however, rarely have exact dates and *circa* here represents a much longer time-span, perhaps of one or two cen-turies where the dating is based purely on the language of a text. Where no date has been established for a text, forms from that text are given the date of the earliest MS in which they appear. Following normal practice, dates in the Irish annals are given as in the source, although this may give certain spellings an appearance of antiquity which they do not deserve. The Annals of the Four Masters, for example, were compiled in the early 17th cen-

tury using earlier material, and many of the names in the text were modernized by the compilers. Moreover, annals were written later for dates before the mid-6th-century, and the names, let alone the spellings, may not be that old. Another difficulty with dates concerns English administrative sources. The civil year in England and Ireland began on March 25th (Lady Day) until the year 1752, when the calendar was brought into line with changes made in the rest of Europe in 1582. Thus, the date of any document written between 1st of January and 24th of March inclusive has had to be adjusted to reconcile it with the current system by adding a year.

The original or most likely original Irish form of a name, where one is known to have existed, is given in italics on the top line to the right of the current spelling, with an English translation below. This includes Norse, Anglo-Norman and English names for which a Gaelic form once existed, as well as those of purely Irish origin. *Loch Cairlinn*, for example, was used by Irish-speakers for *Carlingford Lough* and this, rather than the original Norse, is printed on the top line. Although the name may have originally been coined at an early period of the language, standard modern Irish orthography is employed throughout, except in rare cases where this may obscure the meaning or origin of the name. The rules of modern Irish grammar are usually followed when not contradicted by the historical evidence. Where some doubt concerning the origin or form of a name may exist, or where alternatives may seem equally likely, plausible suggestions made by previous authorities, particularly the *OSNB* informants, are given preference and are printed at the top of the relevant entry. Nevertheless, where there is firm evidence of an origin other than that proposed by earlier scholars, the form suggested by our own research is given prominence.

Names for which no Irish original is proposed are described according to their appearance, that is, English, Scots etc. The form and meaning is usually obvious, and there is no evidence that they replace or translate an original Irish name. Names which are composed of two elements, one originally Irish and the other English or Scots, are described as hybrid forms. An important exception to this rule is names of townlands which are compounded from a name derived from Irish and an English word such as "upper", "east" etc. In these cases, the original Irish elements are given on the right-hand side but the later English appendage is not translated.

In the discussion of each name, difficulties have not been ignored but the basic consideration has been to give a clear and readable explanation of the probable origin of the name, and its relationship to the place. Other relevant information, on the language of the name, on other similar names, on historical events, on past owners or inhabitants, on physical changes or local place-name legends, may also be included, to set the name more fully in context.

The townland maps which appear at the beginning of each parish show the layout of all the townlands in that parish. They are based on printouts from the Ordnance Survey's digitized version of the 1:50,000 map.

The rules of Irish grammar as they relate to place-names are discussed in Appendix A, and the historical system of land divisions in Ulster is described in Appendix B. The bibliography separates primary sources and secondary works (the latter being referred to by author and date of publication). This is followed by a glossary of technical terms used in this series. The place-name index, as well as providing page references, gives the 1:50,000 sheet numbers for all names on the published map, and sheet numbers for the 1:10,000 series and the earlier 6-inch county series for townland names. The index of Irish forms gives a semi-phonetic pronunciation for all names for which an Irish form has been postulated.

## SUGGESTIONS FOR FURTHER INVESTIGATION

A work like this on individual names cannot give a clear picture of any area at a particular time in the past. Any source in the bibliography could be used, in conjunction with townland or other maps, to plot the references to a particular locality at that date, or to lands with a particular owner. Also the Public Record Office of Northern Ireland holds a considerable amount of unpublished material from the eighteenth century and later, which awaits investigation for information on place-names arising at that period.

Although fieldwork forms an integral part of place-name research, it is difficult for a library researcher to acquire the familiarity with an area that the local inhabitants have. Local people can walk the bounds of their townlands, or compare boundary features with those of the early 6-inch maps. Written or tape-recorded collections of local names (especially those of smaller features such as fields, rocks, streams, houses, bridges, etc.), where exactly they are to be found, how written and pronounced, and any stories about them or the people who lived there, would be a valuable resource for the future. The Place-Name Project will be happy to talk to anyone engaged on a venture of this kind.

### Footnote

(1) On the OS maps apostrophes are sometimes omitted, e.g. Mahulas Well, Deers Meadow. In this series they have been inserted when there is evidence to indicate whether the possessive is singular or plural, e.g. Mahula's Well, Deers' Meadow.

Kay Muhr
*Senior Research Fellow*

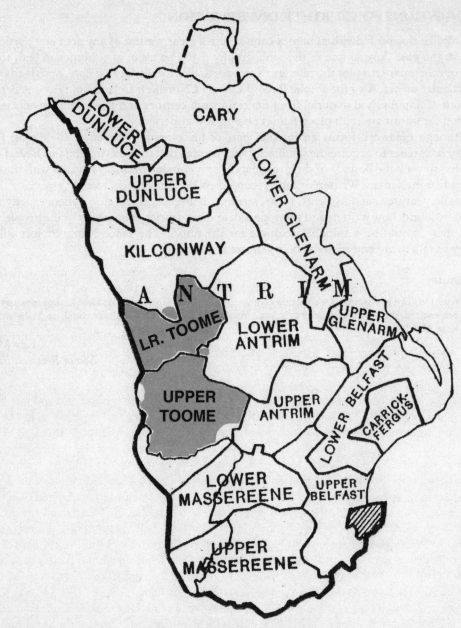

**Map of Baronies in Co. Antrim**

The area described in this volume, roughly coterminous with the baronies of Toome Lower and Toome Upper, has been shaded to highlight its position.

# INTRODUCTION TO COUNTY ANTRIM

The counties of Ulster as they now stand were established under English rule in the early 17th century. They were built up out of pre-existing smaller districts, some of which were preserved as baronies within the county. County Antrim is bounded by the sea to the north and east and on the south-west by Lough Neagh. On the west the boundary follows the course of the Upper Bann from Toomebridge northwards, but a short distance south of Coleraine it runs eastwards from the Bann to the sea, leaving a small district to the east of the river (i.e. the barony of North-East Liberties of Coleraine) in Co. Derry. On the south it is bounded by the Lagan canal and the river Lagan to the sea.

The county town is named from an early monastery which in Old Irish was known as *Oentreb* "single dwelling". The site is marked by a round tower which stands a little to the north of the centre of the modern town of Antrim. At a later stage, the name *Aontreibh* (<O. Ir. *Oentreb*) was reinterpreted as *Aontroim* "single ridge" which is the accepted modern form of the name.

There are nine barony names, including Carrickfergus, which was formerly known as "the county of the town of Carrickfergus" (*O'Laverty* iii 44). The baronies of Antrim, Belfast, Dunluce, Glenarm, Massereene and Toome are each divided into upper (southern) and lower (northern) halves, while Carrickfergus, Cary and Kilconway are undivided. The native administrative unit of the *tuath* or tribal kingdom (anglicized "tuogh") was well preserved in Antrim and most of the baronies are made up of an amalgamation of these native divisions. For example, the barony of Toome Lower represents a combination of the tuoghs of *Muntercallie* and *Clanagherty* (EA 344–5) while Dunluce Upper is coterminous with the tuoghs of Ballymoney and Loughguile.

The *Ulaid* were once the most powerful tribal group in the north of Ireland and it is from them that the province of Ulster derives its name (Flanagan 1978(d)). However, in the 4th and 5th centuries they were driven eastwards into the modern counties of Antrim and Down under pressure from the *Uí Néill* (who originated in Connaught) and the related *Airgialla*. *Dál Fiatach*, the "true Ulaid", settled in mid-Down, in Lecale and in the vicinity of Strangford Lough. Among the other groups which made up the wider federation of the Ulaid or Ulstermen were several whose ethnic origin was *Cruthin*, a name closely related to *Briton*. The main Cruthin tribe, *Dál nAraide*, was situated east of Lough Neagh and the Lower Bann. Their chief seat appears to have been at *Ráith Mór Maige Line* "Rathmore of Moylinny". Both Rathmore and Moylinny are now mere townlands lying to the east of the town of Antrim, but Moylinny was formerly a tuogh (coextensive with the barony of Antrim Upper) (*EA* 345) and also a medieval deanery (*ibid*. 62). Lying to the north west of this, along the Lower Bann to the sea, was the subkingdom of *Eilne*.

South of Lough Neagh, along the Upper Bann, was a tribe related to *Dál nAraide*, i.e. *Uí Echach Coba* (Iveagh barony in Co. Down). Other more northern kingdoms within the reduced Ulster included *Lathairne* and *Semne* around Larne and Island Magee, *Dál mBuain* and *Uí Earca Céin* near Lough Neagh and the Lagan (all Cruthin) and in the Glens of Antrim the unrelated tribe of *Dál Riata*. Their boundary with *Dál nAraide* was the rivers *Fregabhail* (Glenravel Water) (*AFM* i 32–3) and *Buas* (Bush) (*Céitinn* i 164–6).

From the 6th to 10th centuries the kingship of the Ulaid was shared by Dál Fiatach, Dál nAraide and Uí Echach Coba, but in the 8th century Dál Fiatach extended their influence northward over the area east of Lough Neagh. Benmadigan (*Beann Mhadagáin* "*Madagán*'s cliff", now Cave Hill at Belfast), Glengormley (*Clann Ghormlaithe* "descendants of *Gormlaith*") and Clandermot (*Clann Diarmada* "descendants of Dermot"), a now-obsolete district name west of Belfast, are named from chieftains of Dál Fiatach (*Descendants Ir* 82, 85).

The 8th and 9th centuries saw a great advance southwards and eastwards on the part of the *Cenél nEógain*, a branch of the Uí Néill who originated in the Donegal peninsula of Inishowen (Byrne 1973, 114). This had the effect of forcing some of the Airgialla tribes eastwards, further weakening Dál nAraide. One of the most powerful of these tribes was the *Uí Thuirtre* who began to move east across the north shore of Lough Neagh. In the 10th century they took over Eilne, since their lands in Tyrone and Derry had come under the lordship of Cenél nEógain whose dynastic centre was now at *Tulach Óc* (**Tullyhogue**) near Dungannon (*ibid.* 125). Another tribe, the *Fir Lí*, moved east of the Bann into Eilne when their lands in Derry were taken over by the Cenél nEógain sub-king Ó Catháin (O'Kane) of *Ciannachta Glinne Geimin* (Dungiven). By the 12th century we find Uí Thuirtre calling themselves kings of Dál nAraide (*ibid* 126) and their name had come to be applied to a district coterminous with the baronies of Toome Upper and Lower (*EA* 294).

After the Anglo-Norman invasion the whole area east of the Upper and Lower Bann became the feudal Earldom of Ulster, and English shire government was established in the territory of the Ulaid. It was divided into various native and other areas: the "bailiwicks of Antrim, Carrickfergus, Art, Blathewyc, Ladcathel" in 1226, the "counties of Cragfergus, Antrim, Blathewyc, Dun and Coulrath" in 1333 (*Inq. Earldom Ulster* i 31; ii 136, 141; iii 60,63; iv 127). Uí Thuirtre survived as a largely independent Irish district within the Norman Earldom and it gave name to the medieval rural deanery of *Turtrye* which, as well as the baronies of Toome Upper and Lower, also comprised the baronies of Antrim Lower, Glenarm Lower and part of Kilconway (*EA* 83).

In 1549 we find a reference to "the county of Ulster, that is to say the baronies of Grenecastle, Dondalk, Lacayll, Arde, Differens, Gallagh, Bentry, Kroghfergous, Maulyn, Twscard and Glyns" (*Cal. Carew MSS* 1515–74, 223–4). The Antrim districts represented here are *Kroghfergous* (Carrickfergus), *Maulyn, Twscard* and *Glyns* (the Glens). The name *Maulyn* has been met with above in the form Moylinny and in this case it refers to the valley of the Six-Mile Water, while *Twscard* is derived from Irish *Tuaisceart* "north" and, as its name suggests, lay to the north and had its capital at Coleraine (*Coulrath* in the aforementioned inquisition of 1333). In 1571 a commission was set up "to survey the countries of Lecale, the Duffrens, M'Carton's country, Slaight M'Oneiles country, Kilvarlyn, Evaghe, M'Ghenes's country, Morne, the lands of the Nury, and O'Handlone's country, and to form them into one county, or to join them to any neighbouring counties or baronies" (*Fiants Eliz.* §1736). This led to the separation from Antrim of the modern county of Down.

A description of Ulster written in 1586 informs us that Antrim "stretching from the haven of Knockfergus to the going out of the Bann" contained the "countreis" of "*North Clandeboy, Iland Magye* (Island Magee), *Brian Caraghe's countrey, Glynnes* (the Glens) and the *Rowte* (the Route)" (*Bagenal's Desc. Ulst.* 154). The name Clandeboy is derived from Irish *Clann Aodha Buí* (earlier *Clann Aodha Buidhe*) "family of *Aodh Buí* or yellow-haired Hugh" and refers to a branch of the O'Neills of Tyrone who after the decline of the Anglo-Norman Earldom of Ulster from the mid-14th century onwards gained control of the area to the north and east of Lough Neagh. In 1584, the territory was divided into Upper and Lower (i.e. North) Clandeboy, the former being represented by the modern baronies of Castlereagh Upper and Lower in Co. Down and the latter by the baronies of Toome, Antrim, Belfast, Massereene Lower and Carrickfergus in Co. Antrim. An alternative name for Clandeboy from Irish literature was *Trian Conghail* "*Conghal's* third or portion". It was named from *Conghal Cláiringhneach* who is said to have ruled Ireland shortly before the coming of Christ and is the central character in the early Modern Irish tale *Caithréim Conghail Cláiringhnigh* "the martial career of *Conghal Cláiringhneach*" (*C. Conghail Cláir.*). *Brian Caraghe's countrey* was named from Brian O'Neill, a member of the Clandeboy O'Neills, who died in 1586 and

was grandson of *Domhnall Donn* O'Neill, the founder of a sept named *Clann Domhnaill Doinn na Banna* "the Clann of Donnell Donn, of the Bann" who were located west of the Bann, to the north of Maghera (*GUH* 32). However, *Brian Caraghe's countrey* also comprised territory on the Antrim side of the Bann and, according to Reeves (*EA* 388), it included the parish of Ahoghill in Co. Antrim and the barony of Loughinsholin in Co. Derry. The *Rowte* (Route) refers to the area between the Glens of Antrim and the river Bann, extending as far south as the Glenravel Water to the north of Ballymena. According to MacNeill (1932, 27) its name is derived from Norman French *route* "road" and was originally applied to the northern section of the *Slige Midluachra*, an ancient roadway which ran from Tara to Dunseverick on the north Antrim coast.

The county boundaries were not settled all at once. Jobson's set of Ulster maps (c. 1590) and Norden's map of Ireland (1610) show the names and bounds of the three counties of Antrim, Down and Armagh. According to Jobson, Down included Killultagh on the east bank of Lough Neagh (later the barony of Massereene Upper in Co. Antrim). A document in the state papers of 1603 gives *Kilulto* as a separate "country" (*Cal. Carew MSS* 1601–3, 451). In 1605 Killultagh was annexed to Co. Antrim (*CSP Ire.* 1603–6, 321). In the same year an inquisition on Clandeboy states that the most noted boundary between the parts of it called Killultagh and Upper Clandeboy (later Castlereagh) was the river Lagan (*Inq. Ult.* §2 Jac. I), and the Lagan remains the boundary between Cos Antrim and Down to this day.

# THE BARONIES OF TOOME UPPER AND LOWER

**Toome**                                       *Tuaim*
                                                "a pagan burial place(?)"

| | | |
|---|---|---|
| 1. per Doim | Tírechán's Collect. (Bieler) 162 | 670c |
| 2. per doim | L. Ardm. 30a l.29 | 807c |
| 3. for Fertais Tuamma | Trip. Life (Stokes) i 168 | 900c |
| 4. for Fertais Tuama | Trip. Life (Mulchrone) 168 1944–5 | 900c |
| 5. tar Tuaim i nUlltoibh | AFM ii 960–962 | 1099 |
| 6. tar tuaim | AFM iii 58 | 1181 |
| 7. tar Tuaim a tír Eogain | ALC i 200 | 1196 |
| 8. tar tuaim hi ttír eógain | AFM iii 110 | 1197 |
| 9. tar tuaim | AFM iii 118 | 1199 |
| 10. ar fersaid Bona Tuama | AU iii 232 | 1470 |
| 11. tar Túaim | LCABuidhe 158 §21 l.135 | 1617c |
| 12. per Fersait-Tuama | Trias Thaum. 148 col.1 | 1647 |
| 13. Fersait tuama, hodie vulgo vocatur Tuaim | Trias Thaum. 183 n.231 | 1647 |
| 14. Codhnach Túama | LCABuidhe 148 §19 l.61 | 1680c |
| 15. a thriath Tuama | LCABuidhe 188 §26 l.43 | 1680c |
| 16. éignibh Tuama | LCABuidhe 224 §35 l.121 | 1680c |
| 17. Gasradh Tuama | LCABuidhe 224 §35 l.137 | 1680c |
| 18. a healtoin Tuama | LCABuidhe 237 §38 l.3 | 1680c |
| 19. fian Tuama | LCABuidhe 241 §38 l.134 | 1680c |
| 20. beithir Thuama | LCABuidhe 250 §40 l.26 | 1680c |
| 21. cath Tuama | LCABuidhe 88 §7 l.32 | 1680c |
| 22. Fersait Tuama | Dobbs' Descr. Ant. 419 | 1683 |
| 23. Fersat tuama | O'Flaherty's Ogygia 361 | 1685 |
| 24. Twomey | Mercator's Ire. | 1564 |
| 25. C:Toome | Ulster Map | 1570c |
| 26. Tomey | Nowel's Ire. (1) | 1570c |
| 27. Castle Tomey | CSP Ire. 507 | 1573 |
| 28. the castle of Foane at the end of Lough Eaugh | Cal. Carew MSS 483 | 1579 |
| 29. Castle Toome, a ruin called | CSP Ire. 118 | 1588 |
| 30. Tuom | Dartmouth Map 5 | 1590 |
| 31. Tome fort | Jobson's Ulster (TCD) | 1590c |
| 32. C.Tome | Jobson's Ulster (TCD) | 1590c |
| 33. the barony of Toome | CSP Ire. 423 | 1591 |
| 34. the Castle Toome upon the Bann | CSP Ire. 62 | 1592 |
| 35. the Barony of Toome | CSP Ire. 256 | 1594 |
| 36. C.Thome | Mercator's Ulst. | 1595 |
| 37. Ca. Tome | Boazio's Map (BM) | 1599 |
| 38. Forte of Toome | Bartlett Map (PRO) | 1601 |
| 39. Toom | CSP Ire. 397 | 1601 |
| 40. Fort of Toame | Bartlett Map (Greenwich) | 1602 |
| 41. Ca:Tuame | Bartlett Map (Greenwich) | 1602 |
| 42. Fort Tuom | Bartlett Maps (Esch. Co. Maps) 1 | 1603 |
| 43. C:Tuom | Bartlett Maps (Esch. Co. Maps) 1 | 1603 |

| | | |
|---|---|---|
| 44. Castletoome | Inq. Ant. (DK) 45 | 1605 |
| 45. (?)Ballykinaghan | Inq. Ant. (DK) 45 | 1605 |
| 46. CastleToome | Inq. Ant. (DK) 50 | 1605 |
| 47. Castle-Toome orw. Ballikillaghan | CPR Jas I 78a | 1605 |
| 48. Towm or Toome | CPR Jas I 83a | 1605 |
| 49. Toome or Castletuom | CPR Jas I 83a | 1605 |
| 50. Castletuom | CPR Jas I 83a | 1605 |
| 51. Twom | CPR Jas I 83a | 1605 |
| 52. Castletome orw. Ballickinaghan | CPR Jas I 93b | 1606 |
| 53. Castletome or Castletowne | CPR Jas I 93b | 1606 |
| 54. Toune cast | Speed's Ulster | 1610 |
| 55. ye fort of Tome | Speed's Ulster | 1610 |
| 56. Tome | Mercator's/Hole's Ire. | 1610 |
| 57. Forte Tuom | Norden's Map | 1610c |
| 58. C. Tuom | Norden's Map | 1610c |
| 59. Tuome al. Castletoome or Ballykinaghan | CPR Jas I 199a | 1611 |
| 60. Castletoome | Lodge Fairs & Markets 2 | 1611 |
| 61. Toome | CPR Jas I 204b | 1611 |
| 62. barron' de Tombe | Ex. Inq. (Ant.) §16 Jac. I | 1618 |
| 63. Toome | CPR Jas I 432b | 1619 |
| 64. Toome | CPR Jas I 433a | 1619 |
| 65. Toome | CPR Jas I 484b | 1620 |
| 66. Castletoum | Lodge RR Chas I i 305 | 1634 |
| 67. the Forte of Toome | Warr Ire. Hist. (O'Laverty) iii 346 | 1650 |
| 68. the barony of Toome | Civ. Surv. x 64ab, 65 | 1655c |
| 69. Toome | DS (Par. Map) Duneane | 1657c |
| 70. The Barony of Toome | DS (Reg.) | 1657c |
| 71. Tome | Hib. Reg. Toome | 1657c |
| 72. The Old Fort of Toome | Hib. Reg. Toome | 1657c |
| 73. Toome | ASE 49 b 11 | 1665 |
| 74. Toome | ASE 106 a 1 | 1666 |
| 75. Barrony of Tuam | HMR Ant. 139 | 1669 |
| 76. Tombe | HMR Ant. 151 | 1669 |
| 77. Tome | Hib. Del. Antrim | 1672c |
| 78. Barony of Toome | Census 7 | 1669c |
| 79. The Toombe | Dobbs' Descr. Ant. 377 | 1683 |
| 80. Toomb | Dobbs' Descr. Ant. 386 | 1683 |
| 81. the castle, towns and lands of Toome | Lodge RR Chas II ii 292 | 1684 |
| 82. Toome | Reg. Deeds 90-171-62470 | 1739 |
| 83. Toome Ferry | Lendrick Map | 1780 |
| 84. Toome Bridge | Duff's Lough Neagh | 1785 |
| 85. Toome | OSNB A 40 | 1828 |
| 86. Tuaim "mound, tumulus" | J O'D (OSNB) A 40 | 1828 |
| 87. Droichead Thuama | GÉ 92 | 1989 |
| 88. tu:m | Local pronunciation | 1987 |

Because of its strategic importance at the head of the great natural boundary which is the Lower Bann, the name of Toome is fortunately well-documented in Irish language sources from an early date. The earliest reference occurs in an account of St Patrick's journey through Ireland by the 7th-century monk *Tírechán*. The writer informs us that, having been to *Sliab Scirte* (i.e. the hill of Skerry, near Slemish mountain), the saint journeyed onwards: "through *Doim* to the territory of the *Uí Thuirtre*, to *Collunt Patricii*, and baptized the *Uí Thuirtre*" (*Tírechán's Collect. (Bieler)* 162). Bieler is undoubtedly correct in his suggestion that *Doim* (reproduced in form (2)) is a mistake for *Tóim*, the archaic spelling of *Túaim* (angl. Toome) (*op. cit.* 232), while Gwynn's identification of *doim* with Toomebridge in Co. Antrim (*L. Ardm.* lviii) is beyond question: Uí Thuirtre was the name of a people who in St Patrick's time occupied a territory west of Lough Neagh (see county introduction), and as the saint had just visited a place in modern Co. Antrim, Toome would be the natural place to cross the Bann. Moreover, *Collunt Patricii* has been tentatively identified with **Slieve Gallion**, a mountain which lies to the west of Lough Neagh (*Tírechán's Collect. (Bieler)* 255n.). The *Dictionary of the Irish Language* is clearly mistaken in interpreting *Doim* in the early texts as the name of a river (*DIL* sv. *Doim*).

While the name Toome is obviously derived from the Irish word *tuaim*, it is difficult to be sure of its exact significance. The original meaning of *tuaim* was "mound" or "hill" but a wide range of other meanings is attested, including, "a flank, ridge or side; a moat, mound or bank; a knap, tump or hillock; a tomb, grave or sepulchre; a town or fortress" (*DIL* sv. *túaim*). According to Joyce, the word *tuaim* was applied "primarily to a hillock or dyke, and in a secondary sense to a monumental mound or tomb" and as an element in place-names it is found in every part of Ireland. Of the place under consideration he remarks:

> There must have been formerly at this place both a sandbank ford across the river and a sepulchral mound near it, for in the Tripartite Life it is called Fearsat Tuama, the farset or ford of the tumulus; but in the annals it is generally called Tuaim (*Joyce* i 334).

Mac Giolla Easpaig (1984, 51) agrees that the primary meaning of *tuaim* is "hill" or "hillside", but he suggests that as an element in place-names it is likely to refer to "a pagan site of some kind, a burial place, or a graveyard, perhaps" and this must be considered the most satisfactory interpretation of our place-name. However, whether it consisted of a raised mound or not remains unclear. Certainly, there is now no trace or record of a burial mound, though when we consider that the place-name is first documented as early as c. 670 AD it would not be surprising if any such mound had been long since destroyed.

In c. 900 the word *fertas* (Mod. Ir. *fearsaid* "sand-bank ford") appears for the first time in conjunction with the element *tuaim* (3, 4). This is the reference from the *Tripartite Life of Saint Patrick* which is interpreted by Joyce as "the farset or ford of the tumulus" (see above). The word *fearsaid* is found in five other forms (10, 12, 13, 22, 23) and it clearly refers to a former ford across the mouth of the Bann at this point. However, it appears unlikely that it ever formed a genuine element of the place-name. As noted by Joyce (*loc. cit.*), in the annals Toome is generally referred to simply as *Tuaim*, and it is notable that in the one annalistic reference in which *fearsaid* does appear it is written with a small letter rather than with a capital (10). Colgan's 1647 versions of the place-name (12, 13) are based on those of the *Tripartite Life of Saint Patrick* and he notes that the place "is now commonly called *Tuaim*". Similarly, in form 10 it is clear that *Bona*, the genitive form of *bon* (Mod. Ir. *bun* "base, bottom"), is not to be read as part of the place-name, even though it is given a capital letter in the text: the entry *fersaid Bona Tuama* appears to signify simply "the ford at the foot of Toome".

Hogan (*Onom. Goed.* 414) identifies Toome with the site of a battle referred to as *Cath*

*Feirtsi* in 666 AD *etir Ulta 7 Cruithne*, i.e. "between the Ulidians and the Cruithni" (*AFM* i 278). However, O'Donovan identifies this place with *Béal Feirste* (Belfast) (*ibid.*), and in this he is supported by Byrne (1959, 129), who argues that it is unlikely that a place as far north and west as Toome would have been the site of a battle between the *Cruthin* and the Ulidians in 666 AD, since at that time the Ulidians (i.e. the *Dál Fiatach*) were still settled in what is modern Co. Down and had not yet begun their northwards expansion into what is now the southern part of Co. Antrim. Byrne's argument is certainly a convincing one, and it is difficult to understand on what grounds Hogan decided that Toome was a more likely site for *Cath Feirtsi* than Belfast. As suggested above, it is unlikely that the word *fearsaid* "sand-bank ford" ever formed a true element of the place-name, which strengthens the argument for rejecting Hogan's identification. It is also worth pointing out that Stokes, in his edition of the 11th-century *Annals of Tigernach*, also translates *Cath Feirtsi* as "the battle of *Belfast*" (*A. Tigern.* xvii 200).

In several early 17th-century documents the name of the townland of Toome is given as *Castletoome et. var.* The first part of this name obviously refers to the castle which formerly stood on the shore of Lough Neagh, a little to the south of the present bridge of Toome, and which, during the 16th century, was a stronghold of the O'Neills of **Feevagh**, a branch of the O'Neills of Clandeboy (Marshall 1934, 54). The name *Ballikillaghan/Ballickinaghan* appears as an alias name for *Castletoome* in a number of early 17th-century documents while *Ballykinaghan* is documented as a separate townland in 1605 (45). This name is now obsolete and in the absence of further evidence it is impossible to suggest a reliable derivation.

The modern barony of Toome was formally constituted in 1584 (*Lewis'Top. Dict.* i 31) and its bounds are described in detail in the Civil Survey of c. 1655 (*Civ. Surv.* x §65). Its division into the baronies of Toome Upper and Lower took place during the course of the 18th century. The barony of Toome Upper consists of the civil parishes of Cranfield, Drummaul, Duneane, Grange of Ballyscullion and Grange of Shilvodan. It also includes six townlands and one portion of a townland which belong to the parish of Ahoghill as well as the townland of Ballyscullion East which belongs to the parish of Ballyscullion in Co. Derry and a small number of townlands which are in the parish of Antrim (see map on page vi). The barony of Toome Lower comprises the parishes of Ahoghill (except the townlands which lie in the barony of Toome Upper and the portion of the townland of Tullaghgarley which is in the barony of Lower Antrim), Craigs (except the townland of Craigs which is in the barony of Kilconway), Kirkinriola (Ballymena) and Portglenone. In order to enable the parishes to be dealt with as single units in this series, the small portion of Antrim parish which is in the barony of Toome Upper is not included in this volume nor is the townland of Ballyscullion East which belongs to the parish of Ballyscullion in Co. Derry. The townland of Craigs which is in the barony of Kilconway is, however, included as is the townland of Tullaghgarley which is in the barony of Antrim Lower.

When the barony of Toome was set up in 1584 it was formed out of four pre-existing Irish petty kingdoms or tuoghs, namely:

1. The tuogh of **Feevagh** which formed the western portion of the modern barony of Toome Upper. It comprised roughly the parishes of Duneane and Cranfield, and possibly the parish of Grange of Ballyscullion. Its name derives from Irish *Fiobha* "wood/wooded place" and is discussed in detail below.

2. **Munterividy**, which formed roughly the eastern portion of the barony of Toome Upper. It consisted of the parishes of Drummaul and Grange of Shilvodan, along with the por-

tions of the parishes of Ahoghill and Antrim which are in the barony of Toome Upper and the portion of the parish of Connor which is south of the Kells Water and is, in fact, in the barony of Antrim Lower. The name Munterividy appears to be derived from Irish *Muintir Dhuibhéidigh* "the descendants of *Duibhéidigh*". Several individuals named *Duib Eitigh* (Mod. Ir. *Duibhéidigh*) are listed in the early East Ulster genealogical tract *The History of the Descendants of Ir.* Among them is a *Duib Eitig mac Mail Mena m. Leathlobair,* i.e. "*Duibhéidigh*, son of *Maol Meana*, son of *Leathlobhair*" whose name appears in a genealogy of *Clann Leathlobhair* "Lawlor" (*Descendants Ir* 110). The family of Lawlor were anciently rulers of *Dál nAraide*, apparently with their headquarters at Rathmore near Antrim (*O'Laverty* iii 224) and it is possible that this *Duibhéidigh* was the individual who gave name to the sept and the territory of Munterividy.

3. **Muntercallie**, which formed the western portion of the barony of Toome Lower and was made up roughly of the parish of Portglenone along with the sections of the parishes of Ahoghill and Craigs which lie to the west of the river Main and are in the barony of Toome Lower. Its name derives from Irish *Muintir Cheallaigh* "the descendants of *Ceallach*". The personal name *Ceallach* is well attested in early East Ulster genealogies (*Descendants Ir* 108, 110, 116 etc.) and is also the basis of the surname *Ó Ceallaigh* "Kelly" which is fairly common in this area.

4. **Clanagherty**, which formed the eastern portion of the barony of Toome Lower and consisted roughly of the parish of Kirkinriola (Ballymena), along with the portions of the parishes of Ahoghill and Craigs which lie east of the river Main. According to Reeves, its name is likely to derive from the *Clann Fhogarta* (*recte Clann Fhócarta*) who are mentioned in the *Annals of Inisfallen* under the year 1177 AD and also (in the variant form *Clann Fhuacarta*) in the *Book of Lecan* (*EA* 345). However, as the sept referred to by Reeves belonged to the *Dál Fiatach* of Co. Down (*Descendants Ir* 86) this identification appears unlikely. Moreover, it is unlikely that the medial -c- of *Fócarta* (pronounced [g]) would give rise to the medial -gh- of *Clanagherty*. Nevertheless, Reeves's interpretation of Clanagherty as *Clann Fhócarta* or *Clann Fhuacarta* (Mod. Ir. *Clann Fógarta*) "descendants of *Fógarta*" cannot be ruled out, since the Old Irish personal name *Fócarta/ Fuacarta* has often been confused with *Fogartach*, Modern Irish *Foghartach*, (Ó Corráin & Maguire 1981, 106), a name which in the genitive and with lenition of the initial *f* could conceivably have been anglicized as -*agherty*. A number of individuals named *Fuacarta* are recorded in early pedigrees of Dál nAraide (*Descendants Ir* 107, 108, 111 etc.) and it is possible that it was one of these who gave name to Clanagherty.

## Parish of Cranfield
### Barony of Toome Upper

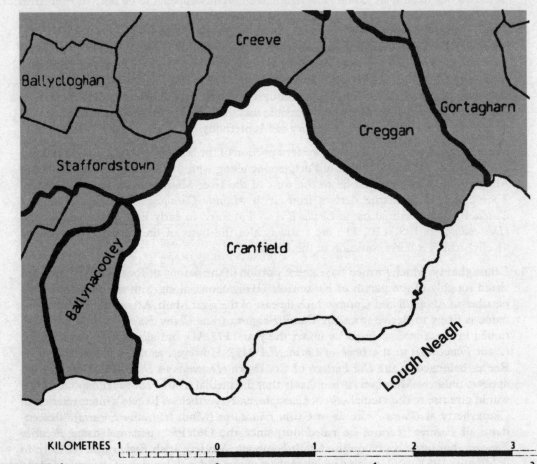

*Townlands*
Cranfield

Based upon Ordnance Survey 1:50,000 mapping, with permission of the Director of the Ordnance Survey of Northern Ireland, Crown copyright.

# THE BARONY OF TOOME UPPER

## PARISH OF CRANFIELD

The parish of Cranfield lies on the north shore of Lough Neagh and covers an area of roughly 3,526 acres, of which 2,691 acres are comprised of the waters of the lough itself (*Census 1851*). It is bounded on the north, east and west by the civil parish of Duneane. Although shown on the *Ordnance Survey 1:10,000* map as consisting of only one townland, it was previously divided into four townlands, the names of which are discussed below.

The parish contains the ruins of an ancient church, which has been dated to the 13th century. However, it is likely that there was a church here at a much earlier period, as Cranfield appears to be referred to in the 9th-century *Martyrology of Tallaght* (*Mart. Tal.* May 31 p47).

We find no mention of the church of Cranfield until 1306 when, in the *Ecclesiastical Taxation*, it is referred to as *the church of Crewill*, and valued at half a mark per annum (roughly 35p) (*Eccles. Tax.* 87). In c.1542, the name of the church of Cranfield appears in a list of churches in the rural deanery of Turtrye (see county introduction).

According to the *Ecclesiastical Register* under the year 1584 the rectory of Cranfield was formerly appropriate to the priory of St John of Jerusalem (*Eccles. Reg.* 35). St John of Jerusalem was a monastic order (now known as the Knights of Malta) whose chief house in the diocese of Connor was the priory of Templepatrick, which, in turn, was under the control of the Preceptory of St John the Baptist of the Ards, or Castleboy (see *PNI* ii 75–8). The *Ulster Visitation* of 1622 states that half of the tithes of the parish belonged to *St Jerusalem* (*Ulster Visit. (Reeves)* 261).

In 1605, the "advowsons, presentations and right of patronage" of *Chramechill in Tuoghnifuigh* were granted by King James I to James Hamilton (*CPR Jas I* 78a). In 1608, the same rights were conferred on Arthur Bassett of Dublin (*CPR Jas I* 121b), and in 1620 they were granted to the Lord Deputy, Sir Arthur Chichester, (*CPR Jas* I 524b). *Tuoghnifuigh* represents Ir. *Tuath na Fíobha* "the tuogh of the wood" and was a petty Irish kingdom whose name has been anglicized as **Feevagh** and which was roughly co-extensive with the parishes of Duneane, Cranfield and Grange of Ballyscullion (see barony introduction).

The *Terrier or Ledger Book of Down and Connor* (1615) informs us that, in addition to "the four towns of Cranfield" which were the property of the diocese of Down and Connor, there was one other townland in the parish of Cranfield (*Terrier (Reeves)* 67). Reeves suggests that the fifth townland was Creeve which is now in the neighbouring parish of Duneane (*EA* 87).

In 1622, according to the *Ulster Visitation*, the "church of *Cramchill*" was in a ruinous state (*Ulster Visit. (Reeves)* 261). In 1657, the parish of Cranfield is referred to as *Grange of Crabekill* and is linked with the parish of Drummaul as forming one rectory (*Inq. Par. Ant.* 59). Cranfield is also linked with Drummaul in Bramhall's *Triennial Visitation* of 1661 (*Trien. Visit. (Bramhall)* 5). However, on the Down Survey Parish Map of c.1657 it is included with the map of Duneane parish (though the four Church townlands of Cranfield are shown). O'Laverty informs us that in 1704 the civil parish of Cranfield was united to Duneane (*O'Laverty* iii 326), but it is clear that even before that date Cranfield had ceased to be regarded as a parish in its own right. Although it is listed as a separate parish in the *Census of Ireland* of 1851, it is dealt with in the *Ordnance Survey Name Book* for Duneane (*OSNB* A40).

A short distance along the shore to the east of the ancient church is a holy well which is still frequented by pilgrims on the feast of SS Peter and Paul (June 29th). About a mile to the north of the ruins of the church, on the boundary between the townlands of Cranfield and Creeve, there formerly stood an ancient black oak cross (now replaced by a modern

marble cross), which in all likelihood was a *termon* cross, erected to mark the boundary of the Church lands of Cranfield.

PARISH NAME

**Cranfield**                                         *Creamhchoill*
J 0586                                                "wild-garlic wood"

| | | |
|---|---|---|
| 1. (?)Eogan episcopus et sapiens Maigi Cremc[h]aill | Mart. Tal. May 31 p47 | 830c |
| 2. (?)Colman Crimchailli | CSH 707.260 | 1125c |
| 3. (?)Moernoc Crimchailli | CSH 707.782 | 1125c |
| 4. (?)Ernin Cremh-caille | Mart. Gorm. May 31 p106 | 1170c |
| 5. (?)Ernin Cremhchoille | Mart. Don. May 31 p141 | 1630 |
| 6. Creamchoill, Ecclesia de | Acta SS Colgan 378 col.1 n16 | 1645 |
| 7. Creamchoill, Parrochia de | Trias Thaum. 183 col.1 n210 | 1647 |
| 8. Crewill, Ecclesia de | Eccles. Tax. 86 | 1306 |
| 9. Crannchyll, Rect. Eccl. de | Reg. Dowdall §129 268 | 1542c |
| 10. Cramerhill | Eccles. Reg. 35 | 1584 |
| 11. Cramechill, the parish church of | Inq. Ant. (DK) 45 | 1605 |
| 12. Chramechill | CPR Jas I 78a | 1605 |
| 13. Cramechill | CPR Jas I 121b | 1608 |
| 14. Crawinkill, Ecclesia de | Terrier (Reeves) 67 | 1615 |
| 15. Crehamkill | Terrier (Reeves) 105 | 1615 |
| 16. Cromwell, quatuor villae de | First Fruits Roll (Reeves) | 1616 |
| 17. Cranichill | CPR Jas I 483b | 1620 |
| 18. Cramerhill | Inq. Ult. (Antrim) §7 Jac.I | 1621 |
| 19. Cramechill | CPR Jas I 524ab | 1621 |
| 20. Lands of Crankhill | Ulster Visit. (Reeves) 241 | 1622 |
| 21. Cramchill, Ecclesia de | Ulster Visit. (Reeves) 261 | 1622 |
| 22. Crankell | Ulster Visit. (Reeves) 263 | 1622 |
| 23. Cramchill | Regal Visit. (PROI) 125 | 1634 |
| 24. Grange of Crabekill | Inq. Par. Ant. 59 | 1657 |
| 25. Cramekill Grange | Inq. Par. Ant. 59 | 1657 |
| 26. Grange of Cramkill | Inq. Par. Ant. 88 | 1657 |
| 27. The Foure Townes of Cranfeild | DS (Reg.) | 1657c |
| 28. Dromaula cu Cramchill | Trien. Visit. (Bramhall) 5 | 1661 |
| 29. Cramechill | Lodge RR Chas II i 217 | 1666 |
| 30. ye 4 towns of Cramhill | ASE 106 a 1 | 1666 |
| 31. Cranfield Well | Dobbs' Descr. Ant. 384 | 1683 |
| 32. the Parish of Cranfield | Dobbs' Descr. Ant. 384 | 1683 |
| 33. Croghill al. Cranfield | EA 87 | 1683 |
| 34. Cranfield | Williamite Forf. | 1690s |
| 35. The Parish of Cranfield and Duneane | Grand Jury Pres. 27 | 1713 |
| 36. Cranfield | EA 88 | 1729 |
| 37. Cranfield | Lendrick Map | 1780 |
| 38. Cranfield | Duff's Lough Neagh | 1785 |
| 39. Cranfield Bay or Pebble Bay | Duff's Lough Neagh | 1785 |
| 40. Crawfield | Comm. Inq. Irish Educ. 205 | 1826c |

| | | |
|---|---|---|
| 41. Cranfield | OSNB A 40 | 1828 |
| 42. "The four towns of Cranfield" – Ballykeel, Ballyharvine, Ballynarny and Tamnaderry | EA 87 | 1847 |
| 43. Creamhchoill "wild garlic wood" | J O'D (OSNB) A 40 | 1828 |
| 44. Creamhchoill "wild garlic wood" | Joyce ii 348 | 1875 |
| 45. Creamh-Choill "a wild-garlic wood" | O'Laverty iii 317 | 1884 |
| 46. 'kranfild | Local pronunciation | 1987 |
| 47. 'kranfi:l | Local pronunciation | 1987 |

In a section of Colgan's *Acta Sanctorum Hiberniae* (1645) entitled "The Life of Saint Olcan or Bolcan", the author quotes from earlier writers (among them the 12th-century monk Jocelin) who tell how St Patrick founded a church at Muckamore in the modern county of Antrim, and then caused to flow forth a marvellous spring, known in Irish as *Slán*, i.e. "health", a spring which had the power to cure many bodily infirmities (*Acta SS Colgan* 376 col. 1). In a footnote to this text, Colgan (378 col.1n) informs us that the well was called *Tipra Phadruic* "the well of St Patrick", and that it seemed to be either beside the church of *Creamchoill* (obviously Cranfield), or beside the church of *Schire* (i.e. Skerry, in the Braid valley, east of Ballymena). In a similar account in his other great work, *Triadis Thaumaturgae* (1647), under the heading *Septima Vita* (which is his own Latin version of the Irish 9th-century *Tripartite Life of St Patrick*) Colgan tells how St Patrick went to the place named *Lettirphadruic* in *Dál nAraide*, (now Glenavy, Co. Antrim) where he produced a well from the earth, capable of curing many illnesses, a well commonly known as *Slán* (*Trias Thaum.* 147 col. 1). In a footnote, Colgan remarks:

> In Dál nAraide, in the district of the diocese of Connor, there are three miraculous wells which are visited by many pilgrims – one is in the parish of *Schire Phadruic* (i.e. modern **Skerry**, east of Ballymena), another in the parish of *Creamchoill* (Mod. Ir. *Creamhchoill*) and the third in the city of Connor (*ibid.* 183 col. 1n).

Even though the holy well at Cranfield appears to be too far away from both Muckamore and Glenavy to be the well referred to as *Slán* in the early texts, the "parish of Creamchoill" referred to by Colgan is obviously to be identified with Cranfield and there is no reason to doubt Colgan's Irish form of the name, i.e. *Cream[h]choill* "wild-garlic wood".

O'Laverty points out that in the *Martyrology of Donegal* there is a reference, at May 31, to "Ernin of Cremchoill – the old name of Cranfield" (*O'Laverty* iii 319). In the *Martyrology of Tallaght* which dates from approximately 830 AD the place-name is recorded as *Mag cremc[h]aill* "plain of the garlic-wood", and the name of the associated saint as *Eógan* (Mod. Ir. *Eoghan*) rather than *Ernin* (Mod. Ir. *Eirnín*) (1). However, Best and Lawlor, the editors of the 1931 edition of the work, have pointed out that, on account of "the interlineation in the lost original", the first element of the place-name *Mag Bile* "Moville", has been accidentally prefixed to *Cremc[h]aill*, and *Eoghan*, rather than *Eirnín*, has been mistakenly associated with *Cremc[h]aill* (*Mart. Tal.* May 31 p47). The intended reading is, therefore, *Ernin Cremchaille* (Mod. Ir. *Eirnín Creamhchoille*), i.e. "*Eirnín* of Cranfield". In a list of Irish saints dating from c.1125 AD we find a reference to *Moernoc Crimchailli* i.e. "*Moernoc* of *Crimchaill*" (*CSH* 707.782). *Moernoc* signifies "my *Ernoc*" and it is possible that *Ernoc* (Mod. Ir. *Earnóg*) represents a variant form of *Ernin* and that *Crimchaill* (Mod. Ir. *Creamhchoill*) may be identified with the parish of Cranfield. O'Laverty suggests that St Ernin of Cranfield

9

may be one and the same saint as St Ernach of Duneane whose festival was held on 30th October (*O'Laverty* iii 334).

O'Laverty notes a tradition (recorded in 1727) that the holy well at Cranfield was consecrated by St Colman and remarks that the *Martyrology of Donegal* refers to a saint named *Colman Proinntighe* or "Colman of the refectory" whose feast day was 26th June, on which day stations used to be made at Cranfield (*O'Laverty* iii 318–9). While it is striking that the feast day of this saint coincides with the former "pattern day" at Cranfield, it should be noted that in the much earlier *Martyrology of Tallaght*, the name of this saint is written as *Colman Partraighi* (*Mart. Tal.* 52). The Catholic parish of Partry in Co. Mayo is named from the early population group the *Partraige* (Ó Muraíle 1985, 39) and it is possible that this is the place referred to. However, a saint named *Colman Crimcailli* i.e. "Colman of (?)Cranfield" appears in the aforementioned list of Irish saints in c. 1125 (*CSH* 707.260) and the association of a saint Colman with Cranfield cannot therefore be ruled out.

Locally, the saint associated with Cranfield is St Olcan, and the day of pilgrimage to the holy well is 29th June. Lewis' *Topographical Dictionary of Ireland* of 1837 informs us that the holy well was "endued with healing properties by St Olcan, who is traditionally recorded to have been buried here in earth brought from Rome" (*Lewis' Top. Dict.* i 432).

The development of the place-name from the original Irish form of *Creamhchoill* to the modern Cranfield is well illustrated by the English historical forms. The earlier versions universally represent the final element as -*chill et var.*, and not until c. 1657 do we find this element rendered as "feild" (for "field") (27). Joyce cites the anglicization of Irish *choill* as "field" as an example of a "systematic change" i.e. "the conversion of *ch* into *f*, the addition of *d* after *l* and . . . the alteration of the Irish into an English word" (*Joyce* i 39–40). In the earlier language, the medial -*mh*- of *creamhchoill* would have been pronounced as a nasalized [v]. In the north of Ireland, -*mh*- was later vocalized (the sound suggested by form 8). However, the residual nasal quality of the original Irish sound has resulted in its being anglicized in many cases as *m* or (as in this case) *n*. The anglicization of Irish *creamh* as *cran*- is well attested, as in Cranford (<*Creamhghort* "wild-garlic field") in Donegal (*GÉ* 78), and in **Cranfield**, the name of a townland in Co. Down, which is also derived from Irish *Creamhchoill* "wild-garlic wood" (*PNI* iii, 34). There is also a townland named **Crankill** in the parish of Craigs in the barony of Toome Lower, the name of which also goes back to Irish *Creamhchoill*, but the final element of which has undergone the more usual anglicization as *kill* rather than as *field*.

<div align="center">TOWNLAND NAMES</div>

| | |
|---|---|
| **Cranfield** | *Creamhchoill* |
| J 0586 | "wild-garlic wood" |

See parish name

The modern townland of Cranfield was formerly made up of four townlands, the names of which were recorded by Reeves c. 1847 as *Ballykeel, Ballyharvine, Ballynarny* and *Tamnaderry* (*EA* 87). The name of each of these townlands is dealt with below, under "Other Names".

<div align="center">OTHER NAMES</div>

| | |
|---|---|
| **Ballyharvine** | *Baile Uí Fharannáin*(?) |
| J 0485 | "Farnon's townland" |

Obsolete townland name

| | | |
|---|---|---|
| 1. Farranstowne | DS (Par. Map) Duneane | 1657c |
| 2. Ferranstowne | DS (Reg.) | 1657c |
| 3. Forrenstowne | Hib. Reg. Toome | 1657c |
| 4. ffaranstowne | BSD 134 | 1661 |
| 5. Forenstowne | Hib. Del. Antrim | 1672c |
| 6. Ballyharnon | Grand Jury Pres. April 14 | 1791 |
| 7. Ballyharvey | Grand Jury Pres. April 14 | 1791 |
| 8. Ballyharuan | Grand Jury Pres. (Summer) | 1791 |
| 9. Ballyharvine | EA 87 | 1847 |

Ballyharvine appears to have occupied the western-most portion of the modern townland of Cranfield. It is difficult to see a clear connection between this form of the name and the earlier spellings (1–5). The -v- of forms 7 and 9 and the -u- of form 8 may be a mistake for -n- as may be the second -r- of forms 1–3 (which are all related). A tentative interpretation of the place-name is, therefore, *Baile Uí Fharannáin* "Farnon's townland". According to Woulfe (1923, 522), *Ó Farannáin* was the name of an Ulster ecclesiastical family who were erenaghs of Ardstraw. However, in the absence of further evidence it is impossible to establish a reliable derivation for the place-name.

**Ballynarny**        Of uncertain origin
J 0684

Obsolete townland name

| | | |
|---|---|---|
| 1. Urinstowne | DS (Par. Map) Duneane | 1657c |
| 2. Uriestowne | Hib. Reg. Toome | 1657c |
| 3. Urinstowne | BSD 134 | 1661 |
| 4. (?)Ballynereny | HMR Ant. 145 | 1669 |
| 5. Ureistowne | Hib. Del. Antrim | 1672c |
| 6. Ballynarny | EA 87 | 1847 |

As in the case of the previous townland, it is difficult to see a clear connection between the earlier forms and that recorded by Reeves in 1847 (6), even though all appear to refer to the eastern-most portion of the modern townland of Cranfield. One is tempted to suggest that the first element of *Urinstowne* could represent a corrupt form of *Eirnín*, the name of a saint who appears to have been associated with Cranfield (see above) and that Reeves's *Ballynarny* could represent an anglicization of *Baile Eirnín* "*Eirnín*'s townland". However, since names of early saints are rarely found in combination with the element *baile* "townland", this suggestion must be regarded as unlikely. One might also consider the Irish form *Baile an Airchinnigh* "townland of the erenagh" (see Glossary). It is also possible that we are dealing with the element *urnaí* which literally means "a prayer" but which is used in a secondary sense to signify a prayer house or oratory and is found in place-names in the anglicized form Urney (*Joyce* i 321). One might therefore consider the derivation *Baile Urnaí* "townland of the oratory". However, there is insufficient evidence to enable one to establish a reliable Irish form of the place-name. Form 4 may represent a corruption of Ballynaleney, the name of a townland a little to the west. However, since the form *Ballynelaine* occurs later in the same source (*HMR Ant.* 146), it is possible that *Ballynereny* is a version of Reeves's *Ballynarny*.

**Churchtown**        *Baile na Cille*
J 0585        "townland of the church"

| | | |
|---|---|---|
| 1. Kellstowne | DS (Par. Map) Duneane | 1657c |

11

| | | |
|---|---|---|
| 2. Killstowne | Hib. Reg. Toome | 1657c |
| 3. Kellstowne | BSD 134 | 1661 |
| 4. Ballykeele | HMR Ant. 145 | 1669 |
| 5. Kellstowne | Hib. Del. Antrim | 1672c |
| 6. Ballykeele | Grand Jury Pres. (Summer) | 1791 |
| 7. Ballykeel | EA 87 | 1847 |

Churchtown is the portion of the modern townland of Cranfield which contains the ruins of the ancient church. It is clearly to be identified with *Ballykeel*, the name of one of "the four towns of Cranfield" recorded by Reeves c. 1847 (*EA* 87). *Ballykeel* is obviously derived from Irish *Baile na Cille*, of which Churchtown is an exact equivalent. In forms 1–3 and 5 (which are all based on form 1), the medial -*s*- may have been added by analogy with the names of the neighbouring townland of *Farranstowne* and the nearby *Urinstowne*. While *Ballykeel* may seem a strange anglicization of Irish *Baile na Cille*, Reeves (*EA* 282) notes that in the parish of Culfeightrin in Co. Antrim the word "keel" (<Irish *cill* "church") was used by the country people to refer to a small burying ground, often for the burial of unbaptized children.

**Claremont**                                    An English form
J 0685

The *OSRNB* of c. 1858 (sheet 49) describes Claremont as a "handsome thatched cottage on north shore of Lough Neagh, the residence of C. Magee Esq." There is a place named Claremont in Surrey which was named from the Earl of Clare (Ekwall 1936, 104) and there are various places so named in a number of different countries including the United States, New Zealand and Australia. In America the name became popular because it was understood to signify "clear mountain" (Stewart 1970, 100). In the case of this Claremont the name may have been adopted simply because it appealed to the man who resided there. In latter times, the house was known as Hutton's Cottage, but it has been recently removed.

**Rabbit Point**                                    An English form
J 0685

This is a well-known point of land which juts into Lough Neagh, in the south east of the townland of Cranfield. The name is recorded in the *OSRNB* of c. 1858 (sheet 49) which remarks that the point is noted as a rabbit burrow, from which it derives the name Rabbit Point.

**Rockhead**                                    An English form
J 0586

The *OSRNB* of c.1858 (sheet 49) describes Rockhead as "a small village of three dwelling houses, built on a small rocky hill which gives rise to the name Rockhead". It is situated in the north of the townland of Cranfield.

**Tamnaderry**                                    *Tamhnach an Doire*(?)
J 0586                                    "field/clearing of the oak-wood"

Obsolete townland name

| | | |
|---|---|---|
| 1. Tanvilla | DS (Par. Map) Duneane | 1657c |
| 2. Tanvillagh | Hib. Reg. Toome | 1657c |
| 3. Tanvilla | BSD 134 | 1661 |

| 4. (?)Ballyilt | HMR Ant. 145 | 1669 |
| 5. Tanvillagh | Hib. Del. Antrim | 1672c |
| 6. Tamnaderry | EA 87 | 1847 |

It is surprising that *Tamnaderry* is recorded as one of the "four towns of Cranfield" in 1847, since there is another townland of this name only a short distance to the north-west, in the neighbouring parish of Duneane. *Tamnaderry* appears to represent Irish *Tamhnach an Doire* "field/clearing of the oak-wood". However, one wonders if Reeves's informant has mistakenly given this as the name of one of the "four towns of Cranfield" and if the true name of the townland was something like that suggested by the earlier recorded spellings. However, in the absence of further evidence it is impossible to suggest a reliable Irish form. The form *Ballyilt* (4) appears to refer to this townland, but it shows no obvious resemblance to the other recorded spellings. One might suggest that it represents Irish *Baile Aillt* "townland of the glen" or, possibly, *Baile Ailt* "townland of the hillock" but it is dangerous to base an etymology on one historical form and this suggestion must be regarded as speculative.

## Parish of Drummaul
### Barony of Toome Upper

*Townlands*
Aghaboy
Aghaloughan
Andraid
Artresnahan
Aughalish
Ballealy, Nth
Ballealy, Sth
Ballybollen
(shared with
Ahoghill)
Ballydunmaul
Ballygrooby
Ballylurgan
Ballymacilroy
Ballytresna
Barnish
Caddy

Clare
Cloghogue
Clonboy
Clonkeen
Coolsythe
Craigmore
Creagh
Downkillybegs
Drumanaway
Drummaul
Drumsough
Farlough
Feehogue
Gortagharn
Groggan
Kilknock
Leitrim
Lenagh

Lisnagreggan
Lurgan West
Magherabeg
Magheralane
Maghereagh
(shared with Antrim)
Mount Shalgus
Muckleramer
Procklis
Randalstown
Shane's Castle Park
Sharvogues
Tamlaght
Tannaghmore
Terrygowan

*Town*
Randalstown

The following detached townlands are too far away to be shown on the map and are included in the map of the parish of Duneane:

Ballynacraigy
Ballynaleney (+ detached portion)
Killyfad
Portlee (+ detached portion)

Based upon Ordnance Survey 1:50,000 mapping, with permission of the Ordnance Survey of Northern Ireland, Crown copyright reserved.

13

# PARISH OF DRUMMAUL

The civil parish of Drummaul (Randalstown) is situated in the barony of Toome Upper and covers an area of 32,394 acres, of which 11,472 are in Lough Neagh and 171 in the river Main (*Census 1851*). It is bounded on the east by the parishes of Antrim, Grange of Shilvodan and Connor, on the north by the parish of Ahoghill, on the west by the parishes of Grange of Ballyscullion and Duneane and on the south by Lough Neagh. It is made up of 49 full townlands and the greater part of two other townlands – Maghereagh and Ballybollen – each of which has a small portion in the neighbouring parishes of Antrim and Ahoghill respectively. The parish has a "detached portion", consisting of the four townlands of Ballynacraigy, Killyfad, Portlee and Ballynaleney, which lie along the north-west shore of Lough Neagh, approximately two miles from the main section of the parish; two of them, Portlee and Ballynaleney, are themselves divided into two parts, the "detached portion" in each case lying a short distance to the west of the main townland.

The earliest recorded reference to the church of Drummaul occurs in the *Ecclesiastical Taxation* of 1306, where it is referred to as *The Church of Drummaule* and valued at 40 shillings per annum(*Eccles. Tax.* 87). At this time the parish church was situated in the townland of Drummaul, which lies roughly two miles north of the town of Randalstown. The site is marked by an old graveyard, surrounded by a circular wall of stone. In the centre of the graveyard there is a fragment of a wall, which is said to be a portion of the gable of the former parish church.

Several references to the church of Drummaul are found in the course of the 15th and 16th centuries. In 1415, a petition was presented to the pope on behalf of a priest named *Patrick Oquenan* requesting that the latter be granted possession of "the perpetual vicarage of *Demymaula*", a request which was granted on condition that the appointment was approved by the abbot of the nearby monastery of Kells (*Annates Ulst.* 135 app.). This illustrates the fact that the right to appoint the vicar of the parish of Drummaul belonged to the abbot of Kells. In 1458, according to the Registry of Archbishop John Prene, Patrick Mcerewyn was vicar of the parish church of *Drumaule* (*Reg. Prene* (*EA*) 86n). In 1488, Michael Mcgremayn was vicar of the church of *Sanctae Brigidae de Druimaula* i.e. "St Brigid's of Drummaul" (*Reg. Octavian* (*EA*) 86n).

In c. 1542, the parish of Drummaul is referred to as *Vic. Ec. de Druman le*, i.e. "the vicarage and church of Drummaul" in a list of churches in the rural deanery of *Turtrye* in the diocese of Connor (*Reg. Dowdall* §129 268) (see county introduction).

An inquisition taken in 1603 finds that at the time of the dissolution of the monasteries under King Henry VIII in 1542, *Murtagh O Nullowe* (*recte* McAnully or McNally), the last abbot of the nearby monastery of Kells, was in possession of *the impropriate rectories of Dunyen* (Duneane) and *Drommalde* (Drummaul) in *le Fuaghe* (*Ex. Inq.* (*Ant.*) §1 Jac.I). This means that the rectorial tithes of Drummaul and of the neighbouring parish of Duneane, and as remarked above, the right to appoint the vicar, belonged to the abbot of Kells. The name *le Fuaghe* refers to the tuogh or Irish petty kingdom of **Feevagh**. According to Reeves, it contained the parishes of Duneane, Cranfield and Ballyscullion Grange (*EA* 345). It appears, therefore, that the inquisition of 1603 is mistaken in placing the church of Drummaul in Feevagh, though it is also possible that the latter was formerly more extensive than suggested by Reeves.

The *Terrier* of Down and Connor of 1615 remarks: "The church of *Drummaulla* hath 4 towns Erinoth lands" (*Terrier* (*Reeves*) 65), meaning that the rents of four townlands were the property of the bishop of the diocese of Down and Connor, but that they were held by an *erenagh* or lay tenant to the bishop. The four townlands in question were Drummaul itself,

along with three others immediately adjoining it, namely Tamlaght, Coolsythe and Caddy. The *Terrier* also remarks: "O'Hara hath it for my Lord Deputy", meaning that the tithes of the parish were in the control of the Lord Deputy Sir Arthur Chichester (who had been granted all the possessions of the dissolved monastery of Kells) but that they were held for him by a local landlord named O'Hara.

By 1622, the church of Drummaul was already in a state of decay (*Ulster Visit* (*Reeves*) 259) and the church lands of the parish, together with those of the neighbouring parishes of Cranfield and Duneane, had been set to Sir Thomas Phillips for a period of sixty years at a rent of £10 per annum (*ibid*. 241).

An inquisition of 1657 remarks: "the church of *Drumall* is out of repayre and is situated near the west of the parish and not convenient for resort" (*Inq. Par. Ant.* 59). This inquisition also tells us that in that year Drummaul parish consisted of "fifty-one quarters and a halfe". The term *quarter* in this case appears to be the equivalent of *townland*, as the number of *quarters* mentioned is very close to the total number of townlands in the parish today. In 1709 a new parish church was completed in the townland of Dunmore (now Randalstown townland) (*Lewis' Top. Dict.* 518). In 1831, this church was pulled down (*OSM* xix 62), and in 1832 the present Church of Ireland church was erected on the same site (*ibid*. 42). Historically, the parish church of Drummaul was dedicated to Saint Brigid as is the modern Church of Ireland church.

Although the name of the parish of Drummaul is not documented until 1306, it is quite likely that there was a church at this site from a much earlier period. The townland of Drummaul borders on the townland of **Tamlaght**, the Irish form of which is *Tamhlacht* signifying a burial-place, usually a place of pagan burial. Hamlin (1976, 3) remarks on the frequency with which early Christian churches were established on sites of previous pagan worship and it seems more than coincidence that the church of Drummaul was sited in the immediate vicinity of a place of previous pagan burial. However, the church whose remnants can still be seen in the graveyard is clearly of much later construction, and was in all likelihood a medieval church, built on the same site as the earlier ecclesiastical structure.

The earliest source which provides names of townlands in the parish is the *Antrim Inquisition* of 1605, a summary of which appears in the Appendix to the *26th Report of the Deputy Keeper of the Public Records of Ireland* (*Inq. Ant.* (*DK*) 43–51). This important document gives a very detailed description of the native Irish divisions which made up the territory of Lower Clandeboy (consisting of the baronies of Toome, Antrim, Belfast, Massereene Lower and the county of Carrickfergus) and, as such, is a valuable source of earlier forms of place-names for a large area of Co. Antrim. The inquisition describes the boundaries of the native Irish territories, and gives a list of the townlands which make up each territory. The parish church of Drummaul is stated to lie in the territory of *Munter Rinidy* (*recte Munter Rividy*), a territory which, according to Reeves (*EA* 345), comprised the parishes of Drummaul, Grange of Shilvodan, that part of Connor parish which lies south of the Kells Water and those parts of the parishes of Ahoghill and Antrim which are in the barony of Toome Upper (see barony introduction). Reeves's information is not entirely accurate, as the townlands of Clonkeen, Ballydunmaul and Aghaloughan, which lie at the western extremity of the parish of Drummaul, were in fact in the tuogh of Feevagh, while the "detached townlands" of Drummaul were also in that tuogh.

According to the inquisition, the territory of Munterividy was made up of eleven townlands "with others unknown". Of the eleven, seven are in the parish of Drummaul and can be identified with the modern townlands of Shane's Castle Park, Magherabeg, Ballylurgan, Magheralane, Ballygrooby, Maghereagh and Lenagh. The remaining four can be identified with townlands in the parish of **Grange of Shilvodan**.

All the land in the baronies of Toome, with the exception of the townlands of Toome, Moneyglass, Gallagh and Ballydugennan in the parish of Duneane, the parishes of Cranfield and Grange of Ballyscullion and the territory of *Clanagherty* (roughly coterminous with the parish of Ballymena, plus part of Ahoghill and Craigs) was granted by King James I to Shane O'Neill of Shane's Castle in 1606 (*CPR Jas I* 93a-b; *Lodge RR* Jas I i 351–3). In this grant, the lists of townlands making up each tuogh are very similar to those in the aforementioned *Antrim Inquisition* of 1605.

In 1617, the same lands which had been granted to Shane O'Neill in 1606 were granted by King James I to his son, Henry (*CPR Jas I* 324b) and each of the Irish tuoghs or territories was constituted a manor and given a new name. Thus, the territory of *Munter-Revedie* was re-named the manor of *Edenduffcarricke*, the latter being the old name of Shane's Castle. In 1637, the lands were re-granted by King Charles I to the aforementioned Henry who converted to Protestantism and received a knighthood (*Lodge RR* Chas I i 407). The 1637 grant begins by repeating almost *verbatim*, and in the same order, the names of the townlands which appear in the 1606 grant, but many more names are added, bringing the total number of townlands in each territory or manor up to a figure which is similar to that of today. This shows that a thorough investigation into the names of the townlands had been carried out some time between 1605 (when only eleven townland names are recorded in the tuogh of Munterividy) and 1637 when the total runs to 64 townlands. In the territory of Munterividy, most of the names listed can be identified with modern townlands, but five names are now obsolete[1].

The 1637 lists of townlands are repeated, with minor variations, in a grant to Cormack O'Neill of Broughshane in 1663 (*Lodge RR* Chas II i 106) and in a grant of 1684 to Rose O'Neill, Marchioness of Antrim and daughter of the aforementioned Sir Henry (*Lodge RR* Chas II ii 292), which is reproduced, with minor variations, in a document of 1684–8 entitled *Abstract of Grants of Lands and other Hereditaments under the Commission of Grace* (*Comm. Grace* 10). It also appears likely that the 1637 lists form the basis of at least some of the lists of townland names found in the *Registry of Deeds* (*Reg. Deeds*) which contains a record of land transactions from 1708 onwards, since in many cases the names of the townlands listed in this source follow the same order as that of the original 1637 grant to Sir Henry O'Neill.

Although all the land in the parish had been granted to Shane O'Neill of Shane's Castle in 1606, a small number of townlands were regranted to Catholic tenants. The townlands of Aghaloughan in the parish of Drummaul and Creeve in the parish of Duneane were granted by Shane O'Neill to *Daniel McEverr Boy O'Neile* of Creeve and his heirs, and were forfeited on account of the said Daniel's rebellion in 1641. Likewise, the townlands of Creggan in Duneane and Leitrim in Drummaul (which had been granted to *Phelemy McRory O'Neile* of Creggan and his heirs) were forfeited due to the rebellion of Phelemy's son Edmund in 1641. The townlands of Ballydunmaul (in Drummaul) and Killyfast (in Duneane) which were granted to *Bryan Mac Toole Unagh O'Neile* and *Thirlagh Groome O'Neile* and which were in the possession of the latter's younger brother *Connor Boy O'Neile* in 1641 were forfeited by him because of his part in the rebellion. The townland of Clonkeen which was granted to *Phelemy Duffe O'Neile* and his heirs was forfeited by the rebellion of his son *Toole McPhelemy Duffe O'Neile* in 1641. The townland of Sharvogues, which was granted by Sir Henry O'Neill of Shane's Castle to *Cahell McManus* in 1631 was also forfeited on account of the rebellion of the latter in 1641 (*Lodge RR* Chas II i 106).

Surprisingly, none of the aforementioned forfeited townlands appear on Petty's Down Survey maps of c. 1657 (*DS (Par. Map)*; *Hib. Reg.*), which show Church townlands and lands forfeited by Catholics for their part in the 1641 Rebellion. Apart from the four Church

17

townlands of Drummaul, the only townland in the parish which is shown on the maps is Ballybollen, which is attributed to one "Henry O'Neale, Irish papist" (*DS* (*Reg.*)). This Henry O'Neill (not to be confused with the Henry O'Neill who turned Protestant and received a knighthood) was a grandson of the Shane O'Neill of Shane's Castle to whom most of the land in the baronies of Toome had been granted in 1606 (see above). An inquisition of 1635 finds that, in addition to *Ballynenarny* (Ballybollen), Henry was also in possession of the townland of Kilknock in the parish of Drummaul, and of Aughterclooney and Drumramer in the parish of Ahoghill (*Inq. Ult. §106 Car. I*), and again it is surprising that none of these townlands are shown on the Down Survey maps. In the *Books of Survey and Distribution*, which tell us to whom the forfeited lands were allocated, the forms of the town-land names are obviously taken from the Down Survey. As well as listing forfeited lands, the Quit Rent Office version of the *Book of Survey and Distribution* (*BSD*) includes a full list of the townlands of the area and, while the forms of the names are quite similar to those of *Lodge RR* of 1637, they do not follow the same order, and do appear to provide independent evidence for the origin of the place-names.

Since most of the land in the baronies of Toome was owned by the O'Neills of Shane's Castle, one would expect the estate papers of the latter to be a rich source of earlier forms of the place-names. Unfortunately, however, almost all the papers were destroyed in a fire at the "new" Shane's Castle in 1922, having survived an earlier fire which left the old castle in ruins in 1816. Only two relevant documents survive. These are an 1814 copy of a 1666 grant to Rose O'Neill, Marchioness of Antrim, which refers back to a 1637 grant to Sir Henry O'Neill of Shane's Castle (*EP Edenduffcarrick*) and the names of the townlands are quite similar to those recorded in the aforementioned *Lodge RR* (Chas I i 407). The second document is one entitled "Instrument Relating to Edenduffcarrick Estate 1660–c.1685" (*Inst. Edenduffcarrick*) and the names of the townlands bear a strong resemblance to those in the earlier document.

A small number of the townlands of the parish are referred to in documentation of the Williamite Wars of 1688–91. Captain Peter Dobbin of Drumsough forfeited that townland as well as the townlands of Farlough and Lenagh, for being in the service of King James. Others who lost their lands at this period included Captain Bryan O'Neill who forfeited the townland of Aghaloughan, Hugh O'Neill of Leitrim who forfeited that townland, William Dobbin of *Coolnagooghan* who forfeited the townland of that name (now Culnageehan, a sub-division of the townland of Maghereagh), Captain Cormick O'Hara who forfeited the town-land of Sharvogues and Hugh and Thomas McLorinan who forfeited the townland of Magheralane, the latter also losing the townland of *Ballytresnachon* (Ballytresna) (*Williamite Forf.*).

Only a few of the place-names of the parish are found in Irish language sources. The River Main is referred to as early as c. 830 AD in the *Martyrology of Oengus* (*Fél. Óeng.* Sep 16 p. 209) and a number of times in the late 17th-century collection of bardic poetry *Leabhar Cloinne Aodha Buidhe* (*LCABuidhe*), while the name of the Mainwater Foot at the mouth of the Main is recorded in the *Annals of the Four Masters* in the year 928 AD (*AFM* ii 624), in the *Annals of Ulster* in 930 AD (*AU* (*Mac Airt*) 380) and in the *Martyrology of Donegal* in c. 1630 (*Mart. Don.* 251). *Leabhar Cloinne Aodha Buidhe* also records the name *Éadan Dúcharraige* "brow of black rock", the old name for Shane's Castle townland, a name which is also found in the *Annals of the Four Masters* (*AFM* iv 1178) and in the *Annals of Ulster* (*AU* iii 232, 348). Colgan's *Triadis Thaumaturgae*, a 17th-century Latin work containing lives of three Irish saints, provides us with the original Irish form of the name of the townland of Downkillybegs, i.e. *Dun-chille Bige* "fort of the little church", as well as a handful of other place-names for which a tentative identification with modern townlands appears to be justified (*Trias Thaum.* 184 col.1n).

18

The *Grand Jury Presentement Books* (*Grand Jury Pres.*), which date from 1711, deal mainly with construction of roads, bridges and other public works and contain earlier versions of names of places referred to in the course of the transactions. Other 18th-century sources of the place-names of the parish are the *Belfast News Letter*, which was founded in 1737, *Lendrick's Map of Co. Antrim* (*Lendrick Map*) of 1780, which is the first map to show all the townlands of the area, and *Duff's Map of Lough Neagh* (*Duff's Lough Neagh*) of 1785.

The most important 19th-century source is the *Ordnance Survey Name Books* of c. 1830 (*OSNB*) which contain a number of contemporary variant spellings of the place-names, as well as the official versions which were chosen to be engraved on the *OS 6-inch* maps. They also include the Irish forms of the place-names which were recommended by the eminent scholar John O'Donovan. Unlike many other counties, Antrim was not visited by O'Donovan himself and he had to rely on correspondence with army officers on the ground for local information. Moreover, the failure to find any native speakers of Irish in the baronies of Toome meant that no traditional Irish language interpretation of the place-names was available, as was the case, for example, in some parishes of Co. Down. For this reason, O'Donovan's Irish forms of the place-names must be treated with caution, and they are always critically evaluated in the text.

**Footnote**

(1) These are: *Bunamanie* or *Bunmany* which appears to have formed part of the eastern portion of the modern townland of **Shane's Castle Park**; *Gilnedin*, which seems to have been part of the same townland but to have lain west of the river Main; *Ballekeenachan* which lay to the north west of Randalstown, near the townland of **Clonboy**; and two other townlands, *Ballyfoaghnegoun* and *Tawerknepagh* whose location is uncertain, but which appear to have lain in the north of the parish, near the townland of **Ballybollen**.

PARISH NAME

**Drummaul**                                  Of uncertain origin

| | | |
|---|---|---|
| 1. Drommaule | Eccles. Tax. 86 | 1306 |
| 2. Demymaula, perpetual vicarage of | Annates Ulst. 135 app. | 1415 |
| 3. Drumaule | Reg. Prene (EA) 86n | 1458 |
| 4. Druimaula, "Sanctae Brigidae" de | Reg. Octavian (EA) 86n | 1488 |
| 5. Drumarde in Lefraghe, impropriate rectory of | Mon. Hib. 13 | 1542 |
| 6. Druman le, Vic. Ecc. de | Reg. Dowdall §129 268 | 1542c |
| 7. Dromaulde | Eccles. Reg. 35 | 1584 |
| 8. Drommalde in le Fuaghe, rect. impropriat. de | Ex. Inq. (Ant.) §1 Jac. I | 1603 |
| 9. Drommelde in the Fews | Mon. Hib. 14 | 1603 |
| 10. Dromuulde | Lodge RR Jas I i 65 | 1603 |
| 11. Drommelde | Lodge RR Jas I i 127 | 1603 |
| 12. Dromuulde | CPR Jas I 39a | 1604 |
| 13. Dromowlagh, the parish church of | Inq. Ant. (DK) 45 | 1605 |
| 14. Dromowlaght | Inq. Ant. (DK) 50 | 1605 |
| 15. Drommalde | CPR Jas I 72b | 1605 |
| 16. Drommald | CPR Jas I 122a | 1608 |
| 17. Drummalle, Ecclesia de | Terrier (O'Laverty) 331 | 1615 |
| 18. Drumaulla, Ecclesia de | Terrier (Reeves) 65 | 1615 |
| 19. Drummale, Quatuor villae de | First Fruits Roll (Reeves) | 1616 |
| 20. Dromaulde | Inq. Ult. (Antrim) §7 Jac.I | 1621 |

| | | |
|---|---|---|
| 21. Dromarde | CPR Jas I 524a | 1621 |
| 22. Dromowlagh | CPR Jas I 524b | 1621 |
| 23. Dromald | CPR Jas I 524b | 1621 |
| 24. Dromaula, lands of | Ulster Visit. (Reeves) 241 | 1622 |
| 25. Dromawley, Ecclia de | Ulster Visit. (Reeves) 259 | 1622 |
| 26. Dromaula | Regal Visit. (PROI) 11 | 1634 |
| 27. Drumalla | Exch. Deeds & Wills 653 | 1644 |
| 28. Drumall | Inq. Par. Ant. 59 | 1657 |
| 29. Drumaulla | Inq. Par. Ant. 61 | 1657 |
| 30. Drumaule, the Parish of | DS (Par. Map) Drummaul | 1657c |
| 31. Drumale, the Parish of | Hib. Reg. Toome | 1657c |
| 32. Dromald or Dromard al. | | |
| Dromawlagh | Lodge RR Chas II i 269 | 1665 |
| 33. Drumall | HMR Ant. 157 | 1669 |
| 34. Drumale | Hib. Del. Antrim | 1672c |
| 35. Dromaule vicaria | Trien. Visit. (Boyle) 38 | 1679 |
| 36. Drumaul | Eccles. Reg. 73 | 1703 |
| 37. Old Drumall | O'Laverty iii 305 | 1735 |
| 38. Drumaule or Randalstown | State Connor | 1765 |
| 39. Drummaul | Lendrick Map | 1780 |
| 40. Drummaul | Duff's Lough Neagh | 1785 |
| 41. Drumaul | Beaufort's Mem. Map | 1792 |
| 42. Four Towns of Drumall | Grand Jury Pres. (Summer) | 1795 |
| 43. Drummaul | OSNB A 41 162 | 1830 |
| | | |
| 44. Druim Máil "Mal's Ridge" - | | |
| called from Maul King of Uladh | J O'D (OSNB) A 41 162 | 1830 |
| 45. "the bald or bare ridge" | O'Laverty iii 313 | 1884 |
| | | |
| 46. dro̯'mɔːl | Local pronunciation | 1987 |

The first element of the place-name is clearly *droim* "ridge", and is likely to refer to the conspicuous little rounded hill in the south of the townland of Drummaul, on the lower slopes of which are situated the ruins of the former parish church. The origin of the second element is problematic. In form 6, *le* appears to have been accidentally detached from the end of the name, and the *n* seems to be a scribal error for *u*, the intended orthography being, apparently, *Drumaule*. It is difficult to tell if the final *-e* of this and a number of other early forms is to be read as silent or if it indicates an extra syllable which has fallen out of use in the modern version of the place-name. However, the presence of a significant number of forms ending in *-a*, *-agh*, *-aght* or *-ley* points to a disyllabic final element and therefore argues against O'Donovan's interpretation of the place-name as *Druim Máil* "Mal's Ridge" (44). On the same grounds, O'Laverty's suggestion (45) that the name of the parish signifies "the bald or bare ridge" (presumably from Irish *Droim Maol*) must also be regarded as unlikely.

A number of possible interpretations of the place-name suggest themselves. One might propose the Irish form *Droim Málla*. Both Dinneen and Ó Dónaill cite *málla* as a variant form of the adjective *mánla* "sedate, stately, pleasant, affable, gentle" (*Dinneen* sv.); "gentle, gracious, pleasant" (*Ó Dónaill* sv.). According to Dinneen, it goes back to the earlier form *málda*, from the noun *mál* "a prince or noble, a champion, a poet". However, *DIL* gives *málla* as "an adj. of uncertain meaning, used of persons in complimentary sense; sometimes identified with *mánla*, but seems an earlier word; perhaps <*mall-da*? cf. *malla* 'modest,

shamefaced, delicate', O'R." (*DIL* sv.). The form *Droim Málla* appears to be reconcilable with the documentary evidence and one could argue that the numerous late 16th- and early 17th-century forms ending in *-lde* represent a backward formation, the second *l* of *Málla* being reinterpreted as *d*. Moreover, in the north of Ireland, final unstressed vowels tend to disappear in place-names which would explain the absence of the final *a* in the modern version of the place-name. However, the use of an adjective such as "modest" or "delicate" to refer to a ridge appears unlikely. Moreover, this element does not appear to be otherwise attested in place-names and this interpretation cannot be regarded as entirely satisfactory.

One might also consider the derivation *Droim Abhla* "ridge of the apple-tree". However, in the earlier language the medial *-bh-* of *abhla* would have been pronounced as [v] and one might expect to find some evidence of this sound among the earliest recorded spellings. Moreover, it is difficult to see how Irish *Droim Abhla* would have come to be written *Dromaulde*, *Drommalde*, *Drommelde* etc. in the late 16th and early 17th centuries. One is also inclined to reject the derivation *Droim Amhalghadha* "*Amhalghaidh*'s ridge" on the grounds that the pronunciation of medial *-mh-* as [v] in the earlier language is not reflected in any of the earlier spellings.

All in all, the evidence for the derivation of Drummaul is too inconsistent to enable one to establish a reliable Irish form.

In a number of sources the churches of Drummaul and Duneane are both stated to be in the tuogh or Irish petty kingdom of Feevagh, variously written *Lefraghe* (5), *le Fuaghe* (8) and *the Fews* (9). It appears that these sources are mistaken in placing the church of Drummaul in Feevagh, since the latter was roughly co-extensive with the parishes of Duneane, Cranfield and Grange of Ballyscullion, though it is also possible that Feevagh was formerly more extensive and included the site of the church of Drummaul (see parish introduction).

TOWNLAND NAMES

**Aghaboy**                                       *Achadh Buí*
J 0793                                           "yellow field"

| | | | |
|---|---|---|---|
| 1. | Ballyeaghboy or Balleaghevoy | Lodge RR Chas I i 407 | 1637 |
| 2. | Ballyaghoboy | BSD 135b | 1661 |
| 3. | Balleaghboy | Lodge RR Chas II i 106 | 1663 |
| 4. | Aghyboy | HMR Ant. 145 | 1669 |
| 5. | Ballaghboy | Comm. Grace 10 | 1684 |
| 6. | Ballyagheboy | Lodge RR Chas II ii 292 | 1684 |
| 7. | Ballyaghiboy | Reg. Deeds 10-133-3227 | 1712 |
| 8. | Ballyaghoboy | Reg. Deeds 90-171-62470 | 1739 |
| 9. | Aghaboy | Lendrick Map | 1780 |
| 10. | Aughaboy | Reg. Deeds 598-371-410286 | 1808 |
| 11. | Aughaboy | Bnd. Sur. | 1825 |
| 12. | Aughaboy | OSNB A 41 162 | 1830 |
| 13. | Achadh Buidhe "Yellow Field" | J O'D (OSNB) A 41 162 | 1830 |
| 14. | ˌaxəˈbɔi | Local pronunciation | 1987 |

The name of this townland is clearly derived from Irish *Achadh Buí* "yellow field", as suggested by O'Donovan (13). Any minor variations in orthography in the documented versions are clearly attributable to scribal error. Most of the earlier forms of the place-name display the prefix *Bally-*, but its presence is likely to be due to the practice in English documentation

of the period of using *Bally-* to mark a land division as a townland, and is not to be taken as an indication that *baile* "townland" was an element of the original Irish version of the place-name. The adjective *buí* "yellow", is most frequently anglicized *-boy* (*Joyce* ii 279). It is commonly found, as in this case, in combination with *achadh* "field", and with other elements which refer to expanses of land, including *machaire* "plain" and *lorgain* "long ridge/long strip of land". This suggests that it most likely refers to either the colour of the vegetation or the colour of the soil. The presence in this townland of a farm named "Sandfield Farm" may provide a hint that in this case the qualifying adjective "yellow" is more likely to refer to the colour of the soil.

## Aghaloughan
J 0588

*Achadh an Locháin*
"field of the little lake"

| | | |
|---|---|---|
| 1. Ballyaghineloghan | Inq. Ult. (Antrim) §127 Car. I | 1637 |
| 2. Ballyagheloghan | Lodge RR Chas II i 407 | 1637 |
| 3. Agheloghan | Inq. Ult. (Antrim) §4 Car. II | 1661 |
| 4. Ballyagheloghan al. Ballaghecan | BSD 135b | 1661 |
| 5. Ballyogheloghan | Inq. Ult. (Antrim) §8 Car. II | 1662 |
| 6. Ballyagheloghan | Lodge RR Chas II i 106 | 1663 |
| 7. Aghilogan | HMR Ant. 147 | 1669 |
| 8. Ballyaghloghane al. Ballyaghethan | Comm. Grace 10 | 1684 |
| 9. Ballyagheloghane al. Ballyaghethan | Lodge RR Chas II ii 292 | 1684 |
| 10. Aghaloghan | Williamite Forf. | 1690s |
| 11. Ballyagheloghane al. Ballyaghechan | Reg. Deeds 90-171-62470 | 1739 |
| 12. Aghalogh | Lendrick Map | 1780 |
| 13. Aghaloughan | Duff's Lough Neagh | 1785 |
| 14. Aughaloghan | Bnd. Sur. | 1825 |
| 15. Aughaloughan | OSNB A 41 162 | 1830 |
| 16. Aughaloughan | OS Name Sheets | 1830 |
| 17. Aghaloughan | OS Name Sheets (J O'D) | 1830 |
| 18. Achadh an Locháin "field of the little lough or pool" | J O'D (OSNB) A 41 162 | 1830 |
| 19. ˌaxəˈlɔːxən | Local pronunciation | 1987 |

There is no reason to disagree with O'Donovan's interpretation of this place-name as *Achadh an Locháin* "field of the little lough or pool" (18). Of the recorded spellings, only form 1 shows evidence of the Irish definite article *an*, and one might suggest the Irish form *Achadh Locháin*. However, in the form *Achadh an Locháin* the *-n* of the article *an* is likely to be assimilated to the initial *l-* of the final element and therefore to disappear, and for this reason O'Donovan's Irish form is accepted as the most satisfactory. Forms 4b, 8b, 9b and 11b appear to suggest an alias name for the townland, but it is more likely that these forms are merely corrupt versions of *Ballyagheloghan*. As in the case of the preceding townland of **Aghaboy**, the *Bally-* prefix in most of the earlier spellings is clearly unhistorical, serving merely to mark the land-unit in question as a townland.

Although there is now no sign of a lake in the townland, the site of the former "little lake" is marked by a large tract of moorland, which runs into the neighbouring townlands of

Derryhollagh and Greenan (both in the neighbouring parish of Duneane), and which was drained around 1830 (*OSM* xix 98). The *Antrim Inquisition* informs us that in 1605 the lake was known as *Loughdireare* and that it contained a "fortified island" or crannog (*Inq. Ant. (DK)* 45). According to the *Ordnance Survey Memoir* of 1836, this crannog was said to have been the abode of "Arthur Oge O'Neill, a celebrated marauder" (*OSM loc. cit., see* **Artogues Dam** below). Commenting on the text of the *Antrim Inquisition*, Reeves remarks that the former lake in Aghaloughan was "called in modern times *Loughravel*, a corruption of the ancient *Loughdireare*" (*UJA* ix, 170). No linguistic connection between the two names for the lake suggests itself and in the absence of any other evidence, it is pointless to speculate about the original Irish form of either name.

Both *Lendrick's Map of Co. Antrim* of 1780 (*Lendrick Map*) and *Duff's Map of Lough Neagh* of 1785 (*Duff's Lough Neagh*) show Aghaloughan in the parish of Duneane, while the *OSNB* of 1830 places it in the parish of Drummaul (*OSNB* A 41 162), indicating that in the intervening period it had been transferred from one parish to the other.

There are three other townlands named Aghaloughan in Ireland, one in each of the counties of Monaghan, Cavan and Longford.

| **Andraid** | *Béal Átha an Droichid* | |
| J 0896 | "the ford of the bridge" | |

| | | |
|---|---|---|
| 1. Ballynered (Ballendred), ye ford of | Bnd. Connor Par. | 1604 |
| 2. Ballenderry (Ballendred) | Bnd. Connor Par. | 1604 |
| 3. Bealadrete | Lodge Fairs & Markets 2 | 1617 |
| 4. Bealadrete | CPR Jas I 324b | 1617 |
| 5. Ballydreate | Lodge RR Chas I i 407 | 1637 |
| 6. Ballondreed, the foote called | Civ. Surv. x §64ab | 1655c |
| 7. Ballandrehitt | Civ. Surv. x §65b | 1655c |
| 8. the three quarters of Ballydread al. Bealacudread | BSD 135b | 1661 |
| 9. Ballendreatt 3 Qtrs. | Lodge RR Chas II i 106 | 1663 |
| 10. Ballindreate | EP Edenduffcarrick | 1666 |
| 11. Andread | HMR Ant. 157 | 1669 |
| 12. ½ of Ballydread al. Beallaendreade | Comm. Grace 10 | 1684 |
| 13. Ballydread al. Beallaendreade | Lodge RR Chas II ii 292 | 1684 |
| 14. Ballindrade Ford | O'Laverty iii 398 | 1704 |
| 15. Adraid | Grand Jury Pres. 12 | 1712 |
| 16. Ballindred | Grand Jury Pres. 12 | 1712 |
| 17. Ballondrade foarde | Grand Jury Pres. 44 | 1713 |
| 18. Ballyedreid | Grand Jury Pres. 202 | 1718 |
| 19. Ballydread al. Bealeandreadd | Reg. Deeds 90-171-62470 | 1739 |
| 20. Andread | Lendrick Map | 1780 |
| 21. Andread ford | Grand Jury Pres. (Summer) | 1791 |
| 22. Andread | Bnd. Sur. | 1825 |
| 23. Ballyandraid or Andraid | OSNB A 41 162 | 1830 |
| 24. Baile an Droichid "townland of the bridge" | J O'D (OSNB) A 41 162 | 1830 |
| 25. Ballyandraid "the town of the bridge" | O'Laverty iii 310 | 1884 |
| 26. an'dre:d | Local pronunciation | 1987 |

It is clear that the modern version of this place-name represents only the final portion of the original Irish form of the name: form 23 shows that when the Ordnance Survey came to fix the official spelling of the name early in the last century both *Ballyandraid* and *Andraid* were in use. It is possible that the townland name may go back to Irish *Baile an Droichid* "townland of the bridge", as proposed by O'Donovan (24) and O'Laverty (25). However, a number of the earlier forms represent the first element of the place-name as *Beal-* suggesting the Irish word *béal*, which literally means "mouth" or "opening". In place-names it can signify "entrance to/approach to" and it is sometimes used as a shortened form of *béal átha*, a combination which literally signifies "ford mouth" or "ford entrance" but is often used to denote simply "ford" (*Joyce* i 357). One might therefore consider the Irish form *Béal an Droichid* "the ford of the bridge". However, in that case, the *-n* of the definite article would be likely to disappear in speech, and it is most improbable that it would be retained in the modern version of the place-name. The form *Béal Átha an Droichid* is, however, compatible with the modern form Andraid, since the Irish article *an* would not disappear when preceded by the final *-a* of *Átha*. *Béal Átha an Droichid* "the ford of the bridge" is therefore the suggested interpretation of the place-name.

None of the recorded spellings show any trace of the medial *-ch-* of *droichead* "bridge", which reflects the tendency for palatal *-ch-* between two vowels to weaken or disappear altogether in East Ulster Irish (O'Rahilly 1932, 209). The medial *-h-* of form 7 may show an intermediate stage between the earlier pronunciation of the *-ch-* and its total disappearance. The devoicing of the final *-d* of *droichid*, which is suggested by the final *-t(e)* of many of the earlier recorded spellings, is not unusual in two-syllable words.

The townland lies along the west bank of the river Main. There is now no sign of a bridge in the townland, but as late as 1933 the *OS 6-inch* map marks a ford across the river, beside the little hamlet of Andraid. The *OSNB* of 1830 comments that at that time the ford was passable to foot-passengers in summer but not in winter (*OSNB* A 41 162). It was common practice in Ireland to construct a bridge at the site of a ford (*Joyce* i 368) and it is clear that at some time in the past the river was crossed at this point by a bridge, all trace of which has now disappeared.

That the former village of Andraid was in earlier times a place of some importance (no doubt on account of its ford) is shown by the fact that in 1617 it was licensed to hold a Monday market (*Lodge Fairs & Markets* 2). Also, there are numerous references to the upkeep of the road to the ford in the *Grand Jury Presentement Books* from 1711 onwards.

**Artresnahan**            *Ard Treasacháin*(?)
J 0689                     "*Treasachán*'s height"

| | | |
|---|---|---|
| 1. Balleotresseken | Lodge RR Chas I i 497 | 1637 |
| 2. Ballytressikane | BSD 135a | 1661 |
| 3. Balleo'treschan | Lodge RR Chas II i 106 | 1663 |
| 4. Balleatressekan | EP Edenduffcarrick | 1666 |
| 5. Artrasnan | HMR Ant. 144 | 1669 |
| 6. Ballyotresikane | Comm. Grace 10 | 1684 |
| 7. Ballyotressikane | Lodge RR Chas II ii 292 | 1684 |
| 8. Otrossichane | Reg. Deeds 10-133-3227 | 1712 |
| 9. Ballyotresikane | Reg. Deeds 90-171-62470 | 1739 |
| 10. Ardtresna | Belfast News Letter Feb. 3 | 1758 |
| 11. Artrashnanan | Lendrick Map | 1780 |
| 12. Artrasnaghan | Duff's Lough Neagh | 1785 |

| | | |
|---|---|---|
| 13. Artresnaghan | Bnd. Sur. | 1825 |
| 14. Artresnahan | OSNB A 41 162 | 1830 |
| 15. Ard Treasnachain "Trasnachan's height or hill" | J O'D (OSNB) A 41 162 | 1830 |
| 16. ˌarˈtrɛːsnəhən | Local pronunciation | 1987 |

A number of the earlier forms (1, 3, 6, 7, 9) suggest that this place-name belongs to a large group of townland names which displays the structure *Baile* "townland" followed by a surname. However, it seems likely that *Bally-* is prefixed to the earlier forms simply to mark the land unit as a townland and cannot be regarded as evidence of the presence of the element *baile* "townland" in the original Irish form of the place-name. Moreover, it has to be borne in mind that the forms which contain a medial *-o-* are all related and a mistake in the earliest form would be duplicated in the others. English scribes of this period had a tendency to prefix *o* to an element which appeared to be a surname and the medial *o* of forms 1, 3, 6, 7 and 9 seems best understood as a corruption of *ard* "height".

There is a conspicuous ridge 300 feet high running across the townland, and one is tempted to suggest that the final element of the place-name may represent a form of the word *trasna* "transverse", possibly *trasna* plus the diminutive ending *-achán* (see *Joyce* ii 32–33), perhaps with the significance of something like "little cross ridge". Against this interpretation is the fact that the form *trasnachán* does not appear to be otherwise attested and that the modern medial *-n-* is absent from all the earliest recorded forms. It is more likely, therefore, that the final element represents the personal name *Treasachán*, a name which is attested in several early East Ulster genealogies (*Descendants Ir* 92, 99, 105). The modern *-n-* in the place-name may perhaps have developed by analogy with the name of the nearby townland of **Ballytresna**. The typical East Ulster pronunciation of short *ea* as [ɛ] before *d, s* and *g* (Holmer 1940, 76) is reflected in the modern pronunciation of the place-name and also in the vast majority of the recorded spellings.

| | | |
|---|---|---|
| **Aughalish** | *Eochaillidh* | |
| J 1093 | "yew-wood" | |
| 1. Ballynclurgan al. Ferelagh al. Oglully | McSkim. Carrick. 422 | 1703 |
| 2. Ballynelurgan al. Fforelagh al. Oghilly | Reg. Deeds 10-212-3459 | 1712 |
| 3. Achilley | Belfast News Letter Aug. 1 | 1766 |
| 4. Aughellish | Lendrick Map | 1780 |
| 5. Aughelly | Grand Jury Pres. (Summer) | 1792 |
| 6. Aughelly | Bnd. Sur. | 1825 |
| 7. Aughalish | OSNB A 41 162 | 1830 |
| 8. Achadh Lis "field of the fort" | J O'D (OSNB) A 41 162 | 1830 |
| 9. ˈɔːxəlïʃ | Local pronunciation | 1987 |

O'Donovan's suggested Irish form (8) is unlikely on two accounts. First, the local pronunciation throws the stress on the first syllable of the name, whereas *Achadh Lis* "field of the fort" would be stressed on the final syllable. Second, the interpretation of the place-name as *Achadh Lis* is not supported by the vast majority of the recorded spellings, which show the

name of the townland as ending in -y. The modern final -sh, which is first documented in 1780, most likely reflects an anglicized plural form of the place-name; it is easy to see how a plural form of *Aughilly* would have come to be rendered Aughalish, perhaps by analogy with the name of the nearby townland of Barnish. The reason for the plural form is in this case not apparent. Normally, a plural anglicized form is attributable either to a plural form in the original Irish version of the place-name or to a townland's having been formerly divided into two or more sections (*Joyce* i 32–3). In this case, there is no evidence of either.

It is interesting that forms 1 and 2 give Aughalish and Farlough as alias names for the large neighbouring townland of **Ballylurgan**. This may suggest that both were originally sub-divisions of Ballylurgan, and would explain the fact that Aughalish is absent from documentation of the 17th century and that the name of **Farlough** is not recorded until 1661.

| | | |
|---|---|---|
| **Ballealy** North | *Baile Aili*(?) | |
| Ballealy South | "townland of the stony place" | |
| J 0788, J 0887 | | |

| | | |
|---|---|---|
| 1. Balleo-Illis | Lodge RR Chas I i 407 | 1637 |
| 2. Ballyvillis | BSD 135a | 1661 |
| 3. Balleoelly | Lodge RR Chas II i 106 | 1663 |
| 4. Balleo Illis | EP Edenduffcarrick | 1666 |
| 5. Bally Illis | EP Edenduffcarrick | 1666 |
| 6. Ballyally | HMR Ant. 144 | 1669 |
| 7. Ballyollis | Comm. Grace 10 | 1684 |
| 8. Ballyoillis | Lodge RR Chas II ii 292 | 1684 |
| 9. Ballyollis | Reg. Deeds 10-133-3227 | 1712 |
| 10. Ballyoilis | Reg. Deeds 90-171-62470 | 1739 |
| 11. Balleley | Belfast News Letter Oct. 23 | 1761 |
| 12. Hugh (Blelagh) McCann's farm | Belfast News Letter Aug. 24 | 1764 |
| 13. B:naleney | Lendrick Map | 1780 |
| 14. Belley | Duff's Lough Neagh | 1785 |
| 15. Balleley | Reg. Deeds 660-290-457358 | 1813 |
| 16. Ballyolis orw. Ballyvillis | Reg. Deeds 756-26-513561 | 1820 |
| 17. Ballely | Bnd. Sur. | 1825 |
| 18. Ballealy N. Ballealy S. | OSNB A 41 162 | 1830 |
| 19. Baile Uí Eilidhe "O'Healy's Town" | J O'D (OSNB) A 41 162 | 1830 |
| 20. ˌbaˈleːli | Local pronunciation | 1987 |

The final -s of many of the earlier spellings of Ballealy appears to be an English plural ending, such as is found in the name of the townland of **Aughalish**. In this case, the plural ending may be explained by the townland's having been formerly divided into two portions, though the modern division into Ballealy North and Ballealy South is clearly of fairly recent origin, caused by the dissection of the townland on the enlargement of the neighbouring townland of **Shane's Castle Park**. Form 13 has obviously arisen as the result of confusion with the name of the nearby townland of Ballynaleney, while the medial *v* of forms 2 and 16b seems to be a mistranscription of *o*.

The earliest spellings of the place-name suggest that it displays the common formation *baile*-plus-surname. However, O'Donovan's suggestion that it is derived from *Baile Uí Eilidhe* (>*Baile Uí Éili*) "O'Healy's Town" appears unlikely, since the earliest historical forms do not

suggest the long [e]-sound of *Ó hÉilí*. Moreover, *Ó hÉilí* "Healy" is a North Connaught surname (MacLysaght 1985, 151) and there is no evidence that it was to be found in this area. A possible suggestion is that the final element of the place-name is the surname *Ó hAilche*. Even though this surname, which is anglicized "(O)Hall(e)y", is said by MacLysaght (*op. cit.* 142) to be either of Clare or Waterford/Tipperary origin, the personal name *Ailche* from which it is derived appears in an early East Ulster genealogy (*Descendants Ir* 105) and one might suggest that the final element of the place-name could represent a local occurrence of the surname. However, I can find no evidence of the presence of the surname in this area and the suggestion that the place-name represents *Baile Uí Ailche* "Halley's townland" is perhaps an improbable one. Nor does the form *Baile Ailche* "*Ailche*'s townland" appear likely, since *baile* "townland" is a latish element and is only occasionally found in combination with early Irish personal names.

It is possible that the medial *-o-* of a number of the earlier recorded spellings is not historical, since it was fairly common for English scribes to insert *o* in place-names which they believed to contain a surname (see **Artresnahan** above). The word *aileach* is well attested in place-names in the sense of "a circular stone fortress" (*Joyce* i 293), while the same word is cited by Ó Dónaill, signifying "rocky place, rock" (*Ó Dónaill* sv.). There is no record of a stone fortress in the townland but in Ballealy North there is a large heap of stones, locally known as "The Pound" which constitutes evidence of stony ground in the past. *Baile Ailí* "townland of the stony place" is therefore put forward as a possible, if somewhat tentative, interpretation of the place-name.

| **Ballybollen** | *Baile na bPollán* | |
|---|---|---|
| J 0497 | "townland of the marshy hollows" | |

| | | | |
|---|---|---|---|
| 1. | Ballynenarny | Inq. Ult. (Antrim) §106 Car. I | 1635 |
| 2. | Ballynebolan | Lodge RR Chas I i 407 | 1637 |
| 3. | Ballenebollan | DS (Par. Map) Drummaul | 1657c |
| 4. | Ballinebolland | Hib. Reg. Toome | 1657c |
| 5. | Ballenebollan | BSD 135 | 1661 |
| 6. | Ballebollan | Lodge RR Chas II i 106 | 1663 |
| 7. | Ballybollan | ASE 106 a 1 | 1666 |
| 8. | Ballybollan, and the half of Ballybollan al. Uterclony | ASE 96 a 48 | 1666 |
| 9. | Ballinebolen | Hib. Del. Antrim | 1672c |
| 10. | Ballynebollan | Comm. Grace 10 | 1684 |
| 11. | Ballynebollan | Lodge RR Chas II ii 292 | 1684 |
| 12. | Ballybollan | Williamite Forf. | 1690s |
| 13. | Ballynebollan | Reg. Deeds 10-133-3227 | 1712 |
| 14. | Ballybollan | Reg. Deeds 90-171-62470 | 1739 |
| 15. | Ballybollen | Lendrick Map | 1780 |
| 16. | Ballybollan | Duff's Lough Neagh | 1785 |
| 17. | Ballybolan | Bnd. Sur. | 1825 |
| 18. | Ballybollen | OSNB A 41 162 | 1830 |
| 19. | Baile Balláin "townland of the spring-well" | J O'D (OSNB) A 41 162 | 1830 |
| 20. | ˌbaliˈbɔːlən | Local pronunciation | 1987 |

One might propose that the final element of this place-name represents Irish *ballán,* a word which originally meant "vessel" but which came to be applied to a range of things distinguished by their roundness (including O'Donovan's "spring-well" (19)). According to Ó Máille (1959, 56–7) its normal meaning in place-names is "a round hill". There is a conspicuous round hill known as "Henry's Hill" in the east of the townland and *Baile Balláin* "townland of the round hill" might be suggested as the original Irish form of the place-name. However, this interpretation is not supported by the great majority of the earlier historic forms, all of which display medial *-ne-*. A more satisfactory explanation of the name is therefore *Baile na bPollán* "townland of the marshy hollows". The word *pollán* can signify, "(small) pool, hollow place" (*Ó Dónaill* sv.); "a small hole, an area of wet ground riddled with puddles" (O'Kane 1970, 143). In Scottish Gaelic, the word is attested in the sense of "bog; wet, miry meadow" (*Dwelly* sv.). In this case the most appropriate interpretation appears to be "marshy hollow", referring to the area of bog in the north-west of the townland.

Approximately two-thirds of this townland is in the parish of Drummaul, while the remainder is in the parish of Ahoghill. The reference in form 8 to *the half of Ballybollan al. Uterclony* seems to be to the portion of Ballybollen which lies in the parish of Ahoghill and borders on the townland of **Aughterclooney**.

Form 1, i.e. *Ballynenarny* has been identified by O'Laverty with Ballybollen (*O'Laverty* iii, 388). There is no reason to doubt O'Laverty's identification, though it is clear that there is no linguistic connection between the two names. *Ballynenarny* may represent Irish *Baile na nAirni* "townland of the sloes" but in the absence of further evidence it is impossible to make a definite judgement.

## Ballydunmaul
J 0491

*Dún Máil*
"*Mál's* fort"

| | | | |
|---|---|---|---|
| 1. (?)úarán Dhúine Máil | Buile Suibhne §40 l.1207 | 1200c |
| 2. Dumaile | Inq. Ult. (Antrim) §111 Car. I | 1636 |
| 3. Donmaile | Inq. Ult. (Antrim) §111 Car. I | 1636 |
| 4. Ballydonmaly | BSD 135b | 1661 |
| 5. Doonmale | Inq. Ult. (Antrim) §8 Car. II | 1662 |
| 6. Doonmale | Lodge RR Chas II i 106 | 1663 |
| 7. Dunmall | HMR Ant. 149 | 1669 |
| 8. Ballydunmalla | Comm. Grace 10 | 1684 |
| 9. Ballydunmalle | Lodge RR Chas II ii 292 | 1684 |
| 10. Donemale | Reg. Deeds 10-133-3227 | 1712 |
| 11. Ballydumnall | Reg. Deeds 90-171-62470 | 1739 |
| 12. Dunmaul | Lendrick Map | 1780 |
| 13. Dunmaul | Duff's Lough Neagh | 1785 |
| 14. Dunmaul or Ballydunmaul | OSNB A 41 162 | 1830 |
| 15. Dún Máil "Mal's Fort", *baile* "a townland" | J O'D (OSNB) A 41 162 | 1830 |
| 16. ˌbalidǫn'mɔ:l | Local pronunciation | 1987 |

The element *Bally* is missing from the earliest recorded versions of this townland name, which suggests that Irish *baile* "townland" may not have been an original element in the place-name. In 1830, the forms Dunmaul and Ballydunmaul were both in use (14) but the latter was decided on as the official name of the townland. The most satisfactory interpre-

tation of the place-name is *Dún Máil* "*Mál*'s fort", as suggested by O'Donovan (15). The identification of the earliest recorded form, i.e. (*úarán*) *Dhúine Máil* (1), with the name of this townland is extremely tentative: the fact that the place-name is preceded by the word *úarán* (Mod. Ir. *uarán*) "spring/fountain", may suggest that it is more likely to refer to the hillfort of **Dunmull** in the townland of Toberdornan near Bushmills in Co. Antrim, on the top of which is an ancient well. Nonetheless, it does appear likely that the name of this townland may be derived from the same Irish form as (*úarán*) *Dhúine Máil*, in which *Dúine Máil* is clearly a genitive form of *Dún Máil* "*Mál*'s fort". The anglicization of Irish *Máil* as [mɔ:l] appears to be by analogy with the name of the parish of **Drummaul** in which it is situated.

The name *Mál* is an early and fairly rare personal name, the most famous bearer of the name being *Mál*, son of *Rochraidhe*, king of Ulster, who in 107 AD became king of Ireland, having slain the previous king, *Tuathal Teachtmhar*, near Larne in the modern Co. Antrim (*AFM* i 98–100).

There is now no trace or record of a fort in this townland. There is a large rocky outcrop near its centre, which is marked "The Rock" on the *OS 1:10,000* map and this may be a likely site for a former fort.

**Ballygrooby**  Of uncertain origin
J 0989

| | | |
|---|---|---|
| 1. Ballygroobeh | Inq. Ant. (DK) 45 | 1605 |
| 2. Ballygroobeth | CPR Jas I 93a | 1606 |
| 3. Ballygroobeth | Lodge RR Jas I i 251 | 1606 |
| 4. Ballygroveth | Lodge RR Chas I i 407 | 1637 |
| 5. Ballygrube or Ballygroobie | Lodge RR Chas I i 407 | 1637 |
| 6. Ballygrobeth | BSD 135a | 1661 |
| 7. Ballygrooby | BSD 135a | 1661 |
| 8. Ballygrobeth | Lodge RR Chas II i 106 | 1663 |
| 9. Ballygrooby | Lodge RR Chas II i 106 | 1663 |
| 10. Ballygrobeth | EP Edenduffcarrick | 1666 |
| 11. Ballygrube | EP Edenduffcarrick | 1666 |
| 12. Ballygraby | HMR Ant. 142 | 1669 |
| 13. Ballygrobeth | Lodge RR Chas II ii 292 | 1684 |
| 14. Ballygrooby or gruvy | Lodge RR Chas II ii 292 | 1684 |
| 15. Ballygrobeth | Reg. Deeds 90-171-62470 | 1739 |
| 16. Ballygrooby | Reg. Deeds 90-171-62470 | 1739 |
| 17. Ballygrooby | Belfast News Letter Aug. 1 | 1766 |
| 18. B:groby | Lendrick Map | 1780 |
| 19. Ballygrooby | Duff's Lough Neagh | 1785 |
| 20. Ballygrooby | Grand Jury Pres. (Spring) | 1788 |
| 21. Ballygrooby | OSNB A 41 162 | 1830 |
| 22. Baile Crúibe "town of the hoof" | J O'D (OSNB) A 41 162 | 1830 |
| 23. ˌbaliˈgrubi | Local pronunciation | 1987 |

O'Donovan's interpretation of Ballygrooby as *Baile Crúibe* "town of the hoof" (22) must be regarded as unlikely since none of the recorded spellings show any evidence of the initial *c* of *crúibe*. Moreover, it is difficult to see why the townland would have been named "the town-land of the hoof". No entirely satisfactory explanation of the place-name suggests itself. The

recorded spellings fall into two distinct groups, those ending in -*eth* and those ending in -*y*. To complicate matters, in a number of cases both spellings occur in the same source. The final -*eth* of a number of the earlier spellings may suggest the Irish adjectival ending -*(e)ach* but no suitable Irish form comes to mind. There is a place named **Grouba** overlooking the river Main, in the parish of Craigs, whose name appears to correspond with a denomination referred to as *Groogagh* in 1847 (*EA* 89). One could argue that the medial -*g*- has developed to -*b*- by dissimilation from the initial *g* and that a similar development has taken place in the name Ballygrooby. One might therefore suggest that the name could go back to an Irish form *Baile Gruagaí* "townland of the sedgy place", which could perhaps be understood as a development from an earlier form *Baile Gruagach* in which *gruagach* is an adjectival form signifying "sedgy". According to Joyce, the word *gruagach*, which is derived from *gruaig* "hair of the head", is used by extension to signify "a place producing long sedgy grass" (*Joyce* ii 339). A variant form of *gruagach*, i.e. *grógán<gruagán*, appears to be the basis of the name of the nearby townland of **Groggan** which lies to the north of Randalstown. Against the derivation *Baile Gruagaí* is the fact that none of the recorded spellings show any evidence of a medial -*g*- in the final element, and to this extent this interpretation can hardly be regarded as satisfactory.

Dinneen lists the adjective *grabach* "rough of land; interspersed with stones or boulders" (*Dinneen* sv.) and while one might consider that a form of this word is represented, it is difficult to reconcile this derivation with the [u]-vowel in Ballygrooby. Again, it is worth noting the word *griobach* "bustle, confusion" which, according to O'Kane (1970, 97) may form the final element of the name of the townland of Meenagrubby in the parish of Inniskeel in Co. Donegal and which, according to Joyce, may have the significance of "miry" (*Joyce* iii 502). However, as in the case of *grabach* it is difficult to see how this derivation would give rise to the medial [u] in the final element.

Dwelly gives the Scottish Gaelic adjective *gróbach* signifying "serrated 2. indented 3. wrinkled 4. joined by serration 5. digging, grubbing" (*Dwelly* sv.). Holmer (1942, 27) notes that in Rathlin the sound [o:] often borders on [u:] and one might suggest that it is a form of this word which is represented in the place-name. One might therefore argue for an Irish form such as *Baile Gróbaí* "townland of the wrinkled (i.e. rough/rugged(?)) place". However, the word *gróbach* does not appear to be otherwise attested in place-names and this suggestion can only be regarded as speculative.

All in all, it is impossible to establish a satisfactory derivation for the name of this townland.

**Ballylurgan**
J 1093

*Baile na Lorgan*
"townland of the long low ridge"

| | | |
|---|---|---|
| 1. Ballinalurgan | Inq. Ant. (DK) 45 | 1605 |
| 2. Ballinalurgan | CPR Jas I 93a | 1606 |
| 3. Ballinlurgan | Lodge RR Jas I i 251 | 1606 |
| 4. Ballynelurgan | Lodge RR Chas I ii 407 | 1637 |
| 5. Ballynalurgan | BSD 135a | 1661 |
| 6. Ballenelingin | Lodge RR Chas II i 106 | 1663 |
| 7. Ballylurgan ½ Town | HMR Ant. 141 | 1669 |
| 8. Ballynalurgane E. | Comm. Grace 10 | 1684 |
| 9. Ballynalurgane | Lodge RR Chas II ii 292 | 1684 |
| 10. Ballynclurgan al. Ferelagh al. Oglully | McSkim. Carrick 422 | 1703 |

| | | |
|---|---|---|
| 11. Ballynalurgan East | Reg. Deeds 10-133-3227 | 1712 |
| 12. Ballynelurgan al. Fforelagh al. Oghilly | Reg. Deeds 10-212-3259 | 1712 |
| 13. B:lurgan East | Lendrick Map | 1780 |
| 14. Ballylurgan | Duff's Lough Neagh | 1785 |
| 15. Ballylurgan | OSNB A 41 162 | 1830 |
| 16. Baile Lurgain "town of the long hill" | J O'D (OSNB) A 41 162 | 1830 |
| 17. Baile-Lurgan "townland of the long hill" | Joyce iii 102 | 1913 |
| 18. ˌbali'lǫrgən | Local pronunciation | 1987 |

The final element of the place-name is clearly derived from *lorga*, which literally signifies "shin" but in place-names is figuratively applied to "a long low ridge" or "a long stripe of land" (*Joyce* i 527; Ó Maolfabhail 1987–8, 20). There is a large area of bog in this townland, but there is also a long cultivated ridge running along its eastern boundary. Forms 10 and 12 give the names of the adjoining townlands of Farlough and Aughalish as alias names for Ballylurgan. As pointed out above in the discussion of the townland of **Aughalish**, this may indicate that Aughalish and Farlough were formerly subdivisions of Ballylurgan.

**Ballymacilroy**      *Baile Mhic Giolla Rua*
J 0697      "McIlroy's townland"

| | | |
|---|---|---|
| 1. the half-town of Ballymc. Itroye or Ilroye | Lodge RR Chas I i 407 | 1637 |
| 2. Ballymcillroy | BSD 135b | 1661 |
| 3. Ballymc.Ilroy | Lodge RR Chas II i 106 | 1663 |
| 4. Ballymackilroy | HMR Ant. 158 | 1669 |
| 5. Ballymakillroye | Comm. Grace 10 | 1684 |
| 6. Ballymuckillroy | Reg. Deeds 10-133-3227 | 1712 |
| 7. Ballymackillroy | Reg. Deeds 54-76-34930 | 1722 |
| 8. Ballymackleroy | Belfast News Letter Oct. 14 | 1763 |
| 9. Ballymacelcroy | Belfast News Letter Aug. 24 | 1764 |
| 10. B:Muckilroy | Lendrick Map | 1780 |
| 11. Ballymuckleroy | Reg. Deeds 660-290-457358 | 1813 |
| 12. Ballymuckleroy | Bnd. Sur. | 1825 |
| 13. Ballymackelroy | OSNB A 41 162 | 1830 |
| 14. Baile Mic Giolla Ruaidh "Mac Gilroy's town" | J O'D (OSNB) A 41 162 | 1830 |
| 15. Baile-Mic-Giollaruaidh "Mackleroy's or Gilleroy's town" | Joyce iii 103 | 1913 |
| 16. ˌbalimakəl'rɔi | Local pronunciation | 1987 |

Woulfe (1923, 379) informs us that the surname *Mac Giolla Rua*, which signifies "son of *Giolla ruadh* (red youth)" can also be anglicized as MacElroy, Gilroy and Kilroy, that it is "the name of a Fermanagh family, the head of which resided at Ballymackilroy, in the parish of Aghalurcher", and that in the 16th century it was common in Down, Roscommon, Cavan

and Offaly. However, the presence of the surname in the name of this townland as well as in the name of the townland of **Ballymakilroy** in the parish of Errigal Keerogue in Co. Tyrone provides evidence of early settlement of branches of the family in these areas also. Bell (1988, 166) informs us that in mid 19th-century Antrim the name was most common to the west of Ballymena, in the barony of Toome Lower. The surname MacIlroy is also found in Scotland, where it takes the forms "Macilroy/Macelroy". According to Black (1946, 515), this was "an old surname in the parish of Ballantrae, Ayrshire". Bell (*loc. cit.*) points out that this was the area from which hailed so many of the Plantation settlers. However, it is unlikely that a "planter" surname would be found as an element in an Irish townland-name as early as 1637 when this place-name is first documented. It is, of course, possible that the townland could have been named from a Scottish family who settled in Ireland in pre-Plantation times, but it appears much more likely that it is to an Irish, rather than to a Scottish, family that our place-name owes its origin.

| **Ballynacraigy** | *Baile na Creige* | |
|---|---|---|
| J 0385 | "townland of the rock/rocky ground" | |
| 1. Mortluen orw. Ballynecregge | CPR Jas I 356a | 1617 |
| 2. Mortluen or Nortluen al. Ballynecregge | Lodge RR Jas I ii 560 | 1617 |
| 3. Ballingrreay | Exch. Deeds & Wills 653 | 1644 |
| 4. Ballycreg | Inq. Ult. (Antrim) §6 Car. II | 1662 |
| 5. Ballinacragy | HMR Ant. 148 | 1669 |
| 6. Ballynacroggie | Comm. Grace 10 | 1684 |
| 7. Ballynecrey | Indent. (Staff.) | 1692 |
| 8. Ballynacrig | Marriage Indent. (Staff.) | 1692 |
| 9. Ballynacreg | Marriage Indent. (Staff.) | 1692 |
| 10. Ballynecregg | Reg. Deeds 10-133-3227 | 1712 |
| 11. Ballurvereagh | Reg. Deeds abstracts i §621 | 1736 |
| 12. Ballynacreggy | Reg. Deeds 90-171-62470 | 1739 |
| 13. B:nacregy | Lendrick Map | 1780 |
| 14. Ballynacregy | Duff's Lough Neagh | 1785 |
| 15. Ballymargey | Grand Jury Pres. April 14 | 1791 |
| 16. Ballinacraigy | Bnd. Sur. | 1825 |
| 17. Ballynacreecy | OSNB A 41 162 | 1830 |
| 18. Baile na Craoisighe "town of the lance" | J O'D (OSNB) A 41 162 | 1830 |
| 19. ˌbalənəˈkreːgi | Local pronunciation | 1987 |

This is one of the four "detached townlands" of the parish of Drummaul, lying roughly two miles from the main portion of the parish, on the north-west shore of Lough Neagh. O'Donovan was obviously misled by the incorrect spelling *Ballynacreecy* in the *OSNB* (17) to suggest the Irish form *Baile na Craoisighe* "town of the lance" (18), rather than *Baile na Creige* "townland of the rock, rocky ground". The physical feature to which the final element of the place-name refers is not apparent; there is no conspicuous rock in the townland, nor does the terrain seem to suit the interpretation of the place-name as "townland of the rocky ground", though the *OS 6-inch* map of 1833 does mark "rocks" in the middle of the neighbouring townland of Ballynacooley. Both *Lendrick's Map of Co. Antrim* (1780) and *Duff's*

*Map of Lough Neagh* (1785) show Ballynacraigy to the east of its present position, inside the boundary of the modern townland of Cranfield, but it seems likely that this is due to cartographers' errors and cannot be taken as a true indication of the situation of the townland at that time. The forms *Mortluen/Nortluen* (1, 2) which are given as alias names for this townland in fact refer to the nearby townland of **Artlone** in the parish of Duneane.

| **Ballynaleney** | *Baile na Léana* | |
|---|---|---|
| J 0285 | "townland of the wet meadow" | |
| | | |
| 1. Ballanaleun | Lodge RR Jas I i 560 | 1617 |
| 2. Ballinlany | Inq. Ult. (Antrim) §20 Car. I | 1633 |
| 3. Ballyleany | Lodge RR Chas I i 407 | 1637 |
| 4. Balleany | Lodge RR Chas I i 407 | 1637 |
| 5. Ballylenny | BSD 135b | 1661 |
| 6. Ballyleny | Lodge RR Chas II i 106 | 1663 |
| 7. Balleany | EP Edenduffcarrick | 1666 |
| 8. Ballynelaine | HMR Ant. 146 | 1669 |
| 9. Ballylinny | Comm. Grace 10 | 1684 |
| 10. Ballylenny | Lodge RR Chas II ii 292 | 1684 |
| 11. Ballylenny | Reg. Deeds 10-133-3227 | 1712 |
| 12. Ballylenny | Reg. Deeds 90-171-62470 | 1739 |
| 13. Ballynaleny | Belfast News Letter July 4 | 1739 |
| 14. Ballynaleaney | Belfast News Letter Oct. 22 | 1765 |
| 15. B:leny | Lendrick Map | 1780 |
| 16. Ballynaleany | Duff's Lough Neagh | 1785 |
| 17. Ballinalainy | Bnd. Sur. | 1825 |
| 18. Ballynaleany | OSNB A 41 162 | 1830 |
| 19. Ballynaleany also called Knockafurt | OS Name Sheets | 1830 |
| 20. Ballynaleney | OS Name Sheets (J O'D) | 1830 |
| 21. Baile na Léana "town of the meadow" | J O'D (OSNB) A 41 162 | 1830 |
| 22. Baile-na-léana "town of the wet meadows" | Joyce iii 113 | 1913 |
| 23. ˌbalənəˈleːni | Local pronunciation | 1987 |

This is another of the four "detached townlands" of Drummaul parish. Moreover, the townland itself is divided into two portions, the "detached portion" lying approximately a quarter of a mile to the west of the main portion. The element *léana* in place-names, which is commoner in Ulster than elsewhere, can signify either "a wet swampy meadow" or "any green field, meadow or pasture-land" (*Joyce* ii 401). Given that this townland consists entirely of low-lying, grassy land along the shore of Lough Neagh, and is quite likely to have been swampy in the past, the former interpretation appears the more appropriate. The place-name may represent a "contrast-name" with the name of the neighbouring townland of **Ballynamullan** in the parish of Duneane, which is derived from *Baile na Mullán* "townland of the little summits". In form 19, *Knockafurt* is given as an alias name for Ballynaleney. *Knockafurt* is now spelt **Knockaphort** and is a small settlement in the "detached portion" of Ballynaleney.

**Ballytresna**
J 0792

*An Baile Trasna*
"the transverse townland"

| | | |
|---|---|---|
| 1. Ballytrasngeighragh | Exch. Deeds & Wills 383 | 1619 |
| 2. Ballytrasnaeytragh | Exch. Deeds & Wills 383 | 1619 |
| 3. Ballytrassnaeytragh | Inq. Ult. (Antrim) §116 Car. I | 1637 |
| 4. Ballytrasna-Itragh | Lodge RR Chas I i 407 | 1637 |
| 5. Ballytrasna-Oughtragh | Lodge RR Chas I i 407 | 1637 |
| 6. Ballytrasnaetragh | BSD 135b | 1661 |
| 7. Ballytrasna-otragh | BSD 135b | 1661 |
| 8. Balletrasna-Itragh | Lodge RR Chas II i 106 | 1663 |
| 9. Balletrasna-Uttragh | Lodge RR Chas II i 106 | 1663 |
| 10. Ballytrasney | HMR Ant. 143 | 1669 |
| 11. Upper Ballytrasney | HMR Ant. 143 | 1669 |
| 12. Ballytrasnaghoughtragh | BSD (Head.) | 1680c |
| 13. Ballytrasna-Iteragh | Comm. Grace 10 | 1684 |
| 14. Ballytrasnaoughtragh | Comm. Grace 10 | 1684 |
| 15. Ballytrasniteragh | Lodge RR Chas II ii 292 | 1684 |
| 16. Ballytrasnaoughtragh | Lodge RR Chas II ii 292 | 1684 |
| 17. Ballytresnachon | Williamite Forf. | 1690s |
| 18. Ballytrasnaitragh, | Reg. Deeds 10-133-3227 | 1712 |
| 19. Ballytrasnaotragh | Reg. Deeds 10-133-3227 | 1712 |
| 20. Ballytrasna Oughtra al. Up. Ballytrasnagh | Reg. Deeds 89-414-63860 | 1738 |
| 21. Ballytrasna Iteragh, | Reg. Deeds 90-171-62470 | 1739 |
| 22. Ballytrasna oughtragh | Reg. Deeds 90-171-62470 | 1739 |
| 23. Ballytrasna | Belfast News Letter Aug. 1 | 1766 |
| 24. B:trasney | Lendrick Map | 1780 |
| 25. Lower B:trasney | Lendrick Map | 1780 |
| 26. Lower Ballytrasna | Grand Jury Pres. (Spring) | 1787 |
| 27. Lower Ballytrasnachan | Grand Jury Pres. April 14 | 1791 |
| 28. Upper Ballytrasnachan | Grand Jury Pres. April 14 | 1791 |
| 29. Ballytresnaghan | Comm. Inq. Irish Educ. 205 | 1826 |
| 30. Ballytresna | Bnd. Sur. | 1825 |
| 31. Ballytresna | OSNB A 41 162 | 1830 |
| 32. Baile Trasna "Cross Town" | J O'D (OSNB) A 41 162 | 1830 |
| 33. ˌbaliˈtrɛːsnə | Local pronunciation | 1987 |

The name of the townland is clearly derived from Irish *Baile Trasna* "transverse townland", as suggested by O'Donovan (32). The documentary evidence shows that the townland was formerly divided into two portions, *Baile Trasna Uachtarach* "Upper Ballytresna" and *Baile Trasna Íochtarach* "Lower Ballytresna". The addition of the termination *-chon* in form 17 and *-chan, -ghan* in forms 27–9 seems to be the result of confusion with the name of the nearby townland of **Artresnahan**. The element *trasna* in place-names "is applied to anything having a transverse position with respect to anything else" (*Joyce* ii 446). In the case of this townland, the significance of the element is not readily apparent. The townland is a noticeably "wide" one by comparison with the townlands around it, and one might suggest that it was therefore regarded as lying in a "transverse" position. According to Mooney (1954, 24(a)) the townland of **Derrytrasna** (<*Doire Trasna* "transverse oak-wood") in the parish of

Seagoe in Co. Armagh was so-named because it stretches across from the Bann to Lough Neagh. Since Ballytresna lies on the west bank of the river Main, one is tempted to suggest that it has been named as stretching across to the river from some point whose significance is not now apparent, or perhaps it was named as being across the river from somewhere else, but these explanations must be regarded as speculative.

**Barnish**  *Bearnais*
J 1189  "a gap or pass"

| | | |
|---|---|---|
| 1. Bernish | Lodge RR Chas I i 407 | 1637 |
| 2. HalfTown of Burnish | BSD 135a | 1661 |
| 3. Birnish ½ townland | Lodge RR Chas II i 106 | 1663 |
| 4. the ½ of the town of Bernish | EP Edenduffcarrick | 1666 |
| 5. Barnish | HMR Ant. 141 | 1669 |
| 6. Half of Barnish | Comm. Grace 10 | 1684 |
| 7. Half of Birnish | Lodge RR Chas II ii 292 | 1684 |
| 8. Birnish | Reg. Deeds 90-171-62470 | 1739 |
| 9. Barnish | Lendrick Map | 1780 |
| 10. Barnish | Duff's Lough Neagh | 1785 |
| 11. Barnish | Bnd. Sur. | 1825 |
| 12. Barnish | OSNB A 41 162 | 1830 |
| 13. Bearnas "gap or chasm" | J O'D (OSNB) A 41 162 | 1830 |
| 14. 'bɑrnïʃ | Local pronunciation | 1987 |

The name of this townland is clearly derived from Irish *bearnais*, an oblique form of *bearnas* "a gap" (*Joyce* i 434). Although *bearnas* is masculine in Donegal Irish, it was feminine in some dialects of East Ulster Irish (see *PNI* ii 219). The term is often applied to conspicuous natural gaps through mountainous land, as in the case of Barnesmore Gap in Donegal, the Irish form of which is *An Bearnas Mór* "the great gap" (*GÉ* 35). However, in the case of this townland, there is no such natural gap. It is likely, therefore, that in this case *bearnais* may signify a man-made gap or pass through what may have been previously heavily wooded or boggy country.

**Caddy**  *Cadaigh*
J 0894  "bog moss/land exchanged by treaty(?)"

| | | |
|---|---|---|
| 1. Cady | DS (Par. Map) Drummaul | 1657c |
| 2. Cady | Hib. Reg. Toome | 1657c |
| 3. Cady | BSD 135 | 1661 |
| 4. Caddey | HMR Ant. 157 | 1669 |
| 5. C:cady | Hib. Del. Antrim | 1672c |
| 6. Caddy | Lendrick Map | 1780 |
| 7. Caddy | Grand Jury Pres. (Spring) | 1786 |
| 8. Caddy | OSNB A 41 162 | 1830 |
| 9. Céide "a round hill, level on top" | J O'D (OSNB) A 41 162 | 1830 |
| 10. Ceadach "a flat-topped hill" | Joyce iii 155 | 1913 |
| 11. Cadaigh | GÉ 41 | 1989 |
| 12. 'ka:di | Local pronunciation | 1987 |

This was one of the four townlands in the parish of Drummaul which were the property of the diocese of Down and Connor. Since Church townlands are not included in the land documents which provide most of the historical forms of the townland names from the early 17th century onwards, earlier spellings of the name are scarcer than normal.

O'Donovan's interpretation of the place-name as *Céide* "a round hill, level on top" appears to fit the local conditions; there is a conspicuous little round hill here, on the west bank of the river Main. However, it is difficult to see how Irish *-éi-* would have developed into the [a:]-sound of the modern pronunciation, a sound which is also suggested by all the historical forms. Joyce does give *ceadach* as an alternative form of *céide* (*Joyce* iii 155). However, since short *-ea-* before *d* in East Ulster Irish is likely to have been sounded as [ɛ] (Holmer 1940, 76), this form must also be regarded as unlikely.

The evidence is in favour of the Irish form *Cadaigh* as suggested in *GÉ* (11), but it is difficult to determine its meaning. McCann (1982, 41) suggests that the name of the townland of **Cady** in the parish of Desertcreat Co. Tyrone may be derived from *cadach* "bog-moss", a word which is cited by Dinneen as occurring in the Irish dialect of Omeath. He supports his derivation by pointing out that there was formerly a large area of marsh or flow-bog in the townland. It is possible that the name of our townland may represent an oblique form of *cadach* "bog moss", though in this case there is no evidence of any bog in the townland. However, there was formerly a bog in the neighbouring townland of **Tamlaght**.

Ó Muraíle (1989, 34) suggests that the name of the townland of **Cadian** in the parish of Clonfeacle in Co. Tyrone is derived from a diminutive form of *cadaigh*, an oblique form of *cadach/codach* (earlier *cotach*), which originally meant "treaty" but later came to mean "land exchanged by treaty" and this is another possible interpretation of our place-name.

| **Clare** | *Clár* | |
|---|---|---|
| J 0797 | "a plain" | |
| 1 (?)an Chláruigh, go himlibh cinn | LCABuidhe 127 §14 l.16 | 1680c |
| 2. Ballyclare | Lodge RR Chas I i 407 | 1637 |
| 3. Ballyclare | BSD 135b | 1661 |
| 4. Balleclare | Lodge RR Chas II i 106 | 1663 |
| 5. Sare | HMR Ant. 157 | 1669 |
| 6. Balleclare | Comm. Grace 10 | 1684 |
| 7. Balleclare | Lodge RR Chas II ii 292 | 1684 |
| 8. Ballyclare | Reg. Deeds 10-133-3227 | 1712 |
| 9. Clare | Belfast News Letter Oct. 14 | 1763 |
| 10. Clare | Lendrick Map | 1780 |
| 11. Clare | OSNB A 41 162 | 1830 |
| 12. Clár "a plain" | J O'D (OSNB) A 41 162 | 1830 |
| 13. kle:r | Local pronunciation | 1987 |

The word *clár* in Irish literally means "a board or plank", but in place-names it normally refers to "a flat piece of land" (*Joyce* i 427). In the east of the townland there is a large flat area which forms part of an extensive plain lying along the west bank of the river Main. Even though most of the earlier historical forms show the prefix *Bally-*, suggesting an Irish form such as *Baile Cláir* "townland of the plain", it appears likely that *Bally-* in these sources is merely a "townland marker". The most likely Irish form, therefore, is simply *Clár* "a plain". In form 5 the initial *S-* is clearly a scribal error for *Cl-*.

Lloyd (*Meyer Miscellany* 55) has made a tentative identification of this townland with a place referred to as *An Clárach* in a late 17th-century poem (*LCABuidhe* 127). The poem is entitled *Racha Mé Shúr Mo Shealbha*, i.e. "I will go in search of my inheritance" and in it the poet Séamas Ó hUid (James Hood) is appealing to Cormack O'Neill of Broughshane to restore him to the lands which he claims were the hereditary "bardic lands" of his family as official poets to the O'Neills of Clandeboy for eight hundred years. The poet informs us that the territory consisted of ten townlands in the *Braghuid*. The latter is most likely to be identified with the valley of the river Braid, which lies north-east of Ballymena, and this would appear to immediately rule out the identification of *An Clárach* with Clare. However, the poet goes on to mention places which suggest that in fact the bardic estate was originally of much greater extent. Among the places mentioned are *Peiridh*, which Lloyd identifies with "Toome Ferry on the Bann" and *bun Banna*, which literally means "the mouth of the Bann", but which is identified by Lloyd (*loc. cit.*) with the north opening of Lough Beg. However, while the townland of Clare could conceivably be in the area referred to by Ó hUid, its identification with *An Clárach* must be regarded as extremely dubious, on the grounds that there is no evidence of the *-ach* termination among the historical forms of the place-name.

| **Cloghogue** | *Clochóg* | |
|---|---|---|
| J 0798 | "stony path/stepping stones(?)" | |
| 1. Half-town of Ballyclaghoge | Lodge RR Chas I i 407 | 1637 |
| 2. Ballycloghoge | BSD 135a | 1661 |
| 3. Ballecloghoge | Lodge RR Chas II i 106 | 1663 |
| 4. Ballyclaghoge | EP Edenduffcarrick | 1666 |
| 5. Clooagh | HMR Ant. 158 | 1669 |
| 6. Ballyclaghoge | Comm. Grace 10 | 1684 |
| 7. Ballyclaghoge | Lodge RR Chas II ii 292 | 1684 |
| 8. Ballycloghoge | Reg. Deeds 10-133-3227 | 1712 |
| 9. Ballyclaghoge | Reg. Deeds 90-171-62470 | 1739 |
| 10. Cloghouge | Lendrick Map | 1780 |
| 11. Cloghogue | OSNB A 41 162 | 1830 |
| 12. Clochóg "stony land" | J O'D (OSNB) A 41 162 | 1830 |
| 13. 'klɔːxog | Local pronunciation | 1987 |

According to Joyce, the element *clochóg* in place-names "is generally applied to rocky land or to a place full of round stones" (*Joyce* i 413). It is defined by Ó Dónaill as a "stony patch" (*Ó Dónaill* sv.) and by Dinneen as "a tract of land full of boulder-stones" (*Dinneen* sv.). There is now no sign of any stony land in this townland, the north-eastern and eastern portions of which consist entirely of moorland, while the remainder is well cultivated. It is possible that the townland was named from a small rocky area which has now been cleared. It is also worth remarking that O'Kane (1970, 139) defines *clochóg* as "stony land (applied to a path or causeway)" and he refers to a place named *An Chlochóig* in the parish of Kilteevogue, Co. Donegal, which he describes as "a path" (*ibid.* 88). It is possible that this place-name may also owe its origin to a former rocky path or causeway through the boggy area of the townland. It may also be of interest that the *OS 6-inch* map of 1933 marks "stepping-stones" over the Parish Burn, on the boundary between this townland and the townland of **Straid** in the parish of Ahoghill, which raises the possibility that in this case *clochóg* may have the significance of "stepping-stones".

| | | |
|---|---|---|
| **Clonboy** | *Cluain Baoith*(?) | |
| J 0690 | "*Baoth*'s meadow" | |
| | | |
| 1. (?)Cluain Buith | Trias Thaum. 184 col.1n | 1647 |
| 2. (?)Cluain-Baoith | Onom. Goed. 255 | 1910 |
| | | |
| 3. Balleclanboy | Lodge RR Chas I i 407 | 1637 |
| 4. Ballyclonboy | BSD 135a | 1661 |
| 5. Clanbolly | Inq. Ult. (Antrim) §8 Car. II | 1662 |
| 6. Balleeclanboy | Lodge RR Ch II i 106 | 1663 |
| 7. Clonboy | HMR Ant. 144 | 1669 |
| 8. Ballyclonboy | Comm. Grace 10 | 1684 |
| 9. Ballyclonboy | Lodge RR Chas II ii 292 | 1684 |
| 10. Clonboy | Reg. Deeds 10-133-3227 | 1712 |
| 11. Clanboy | Grand Jury Pres. 269 | 1720 |
| 12. Ballyclonboy | Reg. Deeds 90-171-62470 | 1739 |
| 13. Clanbury | Lendrick Map | 1780 |
| 14. Clanbury | Duff's Lough Neagh | 1785 |
| 15. Clanboy | OSNB A 41 162 | 1830 |
| 16. Clonboy | OS Name Sheets | 1830 |
| | | |
| 17. Cluain Buidhe "yellow lawn, meadow or bog island" | J O'D (OSNB) A 41 162 | 1830 |
| | | |
| 18. ˈklɔːnˈbɔi | Local pronunciation | 1987 |

The 17th-century scholar Colgan refers to a place named *Cluain-Buith* (1) as one of nine places in the territory of Uí Thuirtre, some of which were in his day regarded as "holy places" and all of which, he suggests, may mark the sites of earlier, Patrician, churches (*Trias Thaum*. 184 col. 1n). Colgan's reference to the territory of Uí Thuirtre is clearly to the rural deanery of Turtrye which at his time of writing was co-extensive with the baronies of Toome Upper and Lower, Antrim Lower, Glenarm Lower and part of Kilconway (see county introduction). One of the places listed by Colgan, i.e. *Dun-chille Bige* can be identified with the nearby townland of **Downkillybegs** and since there does not appear to be any other place named Clonboy in Uí Thuirtre, a tentative identification of this townland with *Cluain-Buith* appears reasonable. Colgan's *Cluain-Buith* is interpreted by Hogan as *Cluain-Baoith* (2) and the final element appears to represent the personal name *Baoth* which is fairly common in the early genealogies (Ó Corráin & Maguire 1981, 27). An earlier form of this name was *Báeth*, and the genitive form *Buith* is attested (*CGH* 228 151b45) which may be the form intended by Colgan. Since the element *cluain* is particularly common in ecclesiastical place-names (*Joyce* i 233) and since Colgan informs us that *Cluain-Buith* was formerly regarded as a "holy place", it is reasonable to suggest that *Baoth* may in this case represent the name of a saint. However, there is no evidence or tradition to connect any saint of this name with the area and the townland has no known ecclesiastical associations.

In view of the tentative nature of the above identification, O'Donovan's suggestion that the place-name derives from Irish *Cluain Buidhe* (>*Bui*) "yellow meadow" (17) cannot be ruled out.

There are in all over 1800 places in Ireland whose names begin with *cluain* "meadow" (*Joyce* i 235), and there are other townlands named Clonboy in Monaghan, Clare and Westmeath, and two townlands named Cloonboy in Co. Mayo.

**Clonkeen**                           *Cluain Caoin*
J 0392                                 "pleasant/smooth meadow"

| | | |
|---|---|---|
| 1. Ballyclonekeine | Inq. Ant. (DK) 45 | 1605 |
| 2. Balleclonekeine | CPR Jas I 93b | 1606 |
| 3. Balleclonekeine | Lodge RR Jas I i 252 | 1606 |
| 4. Clonkeene | Inq. Ult. (Antrim) §112,114 Car. I | 1636 |
| 5. Ballyclonkeene | Lodge RR Chas I i 407 | 1637 |
| 6. Ballyclonkeen | BSD 135 | 1661 |
| 7. Clonkeen | Inq. Ult. (Antrim) §8 Car. II | 1662 |
| 8. Ballycloonkeen | Lodge RR Chas II i 106 | 1663 |
| 9. ½ townland of Clonkeene | Lodge RR Chas II i 106 | 1663 |
| 10. The half townland of Clonkeene | Lodge RR Chas II i 108 | 1668 |
| 11. Clonkean | HMR Ant. 149 | 1669 |
| 12. Ballyclonkeene | ASE 194 b 10 | 1669 |
| 13. Ballyclonkeene | Comm. Grace 10 | 1684 |
| 14. Ballyclonkeene | Lodge RR Chas II ii 292 | 1684 |
| 15. Clonkeene | Reg. Deeds 10-133-3227 | 1712 |
| 16. Ballyclonkeen | Reg. Deeds 90-171-72470 | 1739 |
| 17. Upper Clonheen | Belfast News Letter Oct. 22 | 1765 |
| 18. Clonkeen | Lendrick Map | 1780 |
| 19. Clankeen | Duff's Lough Neagh | 1785 |
| 20. Clonkeen | OSNB A 41 162 | 1830 |
| 21. Cluain Caoin "beautiful lawn or meadow" | J O'D (OSNB) A 41 162 | 1830 |
| 22. ˌklɔːnˈkiːn | Local pronunciation | 1987 |

While the element *caoin* may have the significance of "beautiful" as suggested by O'Donovan (21) (cf. *Joyce* ii 63), it is also possible that it could have practical significance, referring to the quality of the soil, i.e. "smooth, easily worked". The entire townland is at a considerable elevation, rising to 485 feet, and there is a small marshy area to the west, as well as an area of bog in the north, which forms part of the extensive bog known as Groggan Moss. The meadow in question may have been designated "smooth" by comparison with the boggy land around it.

There are parishes named Clonkeen in Galway, Limerick and Louth, as well as 14 townlands of the same name, which are well scattered in Ireland, and some 20 townlands named Cloonkeen.

**Coolsythe**                          *Cúil Saighead*
J 0694                                 "the corner of the arrows"

| | | |
|---|---|---|
| 1. Cullsidgh | DS (Par. Map) Drummaul | 1657c |
| 2. Culsid | Hib. Reg. Toome | 1657c |
| 3. Cullsidgh | BSD 135 | 1661 |
| 4. Culsicle | HMR Ant. 157 | 1669 |
| 5. Culside | Hib. Del. Antrim | 1672c |
| 6. Colsythe | Lendrick Map | 1780 |
| 7. Coolsythe | Bnd. Sur. | 1825 |
| 8. Coolsythe | OSNB A 41 162 | 1830 |

| | | |
|---|---|---|
| 9. Cúil Saighead "corner or angle of the darts or javelins" | J O'D (OSNB) A 41 162 | 1830 |
| 10. "the corner of the arrows" | Joyce ii 179 | 1875 |
| 11. kul'saið | Local pronunciation | 1987 |

This was one of the four Church townlands of Drummaul parish, and, as such, it is less well documented than usual. The name of the townland appears to derive from Irish *Cúil Saighead* "the corner of the arrows", as suggested by O'Donovan (9). The townland may be so named as marking a place where a great number of arrowheads were found in the soil, suggesting the site of a former battle, or perhaps there was a local memory of a battle in which arrows were used. The amusing representation of the final element of the place-name as *sicle* in form 4 is obviously the result of the mistranscription of *d* as *cl*.

Evidence of the English voiced dental fricative *th* does not appear in the recorded spellings until 1780 (6). Its presence appears to be due to the phenomenon known as "folk etymology", i.e. the tendency to convert an element of a place-name in a language that is not understood into an intelligible word with a similar sound in the language which is understood (*Joyce* i 38–42). Thus, Irish *saighead* has in this case been converted into *sythe*, a close approximation to the English word *scythe*.

According to Joyce, the name of the townland of Gortnasythe in Co. Roscommon is derived from Irish *Gort na Saighead* "field of the arrows", while Moneenascythe, which is the name of a lake in Co. Tipperary, goes back to Irish *Móinín na Saighead* "little bog of the arrows" (*Joyce* ii 179).

**Craigmore**
J 0590

*An Chreag Mhór*
"the great rock/rocky hill"

| | | |
|---|---|---|
| 1. Craigmore | HMR Ant. 143 | 1669 |
| 2. Craigmore | Reg. Deeds 52-507-35506 | 1722 |
| 3. Creagmore | Reg. Deeds 89-414-63860 | 1738 |
| 4. Creagemore | Belfast News Letter Aug. 1 | 1766 |
| 5. Cregmore | Lendrick Map | 1780 |
| 6. Cregmore | Duff's Lough Neagh | 1785 |
| 7. Craigmore | Grand Jury Pres. (Lent) | 1796 |
| 8. Craigmore | OSNB A 41 162 | 1830 |
| 9. Creag Mór "Great Rock" | J O'D (OSNB) A 41 162 | 1830 |
| 10. 'kre:g'mo:r | Local pronunciation | 1987 |

Craigmore is obviously named from the conspicuous rocky hill of 496 feet which is the site of a large and well-known quarry known as Craigmore Quarry and the highest point in the parish of Drummaul. The townland is documented in only one 17th-century source, which may suggest that it did not achieve townland status until a fairly late date. The anglicization of Irish *creag* as *craig* reflects the typical East Ulster pronunciation of *ea* before *d*, *s* and *g* as [ɛ] rather than as [a] as in most Modern Irish dialects.

**Creagh**
J 0697

*Maigh Choille Criathair*
"plain of the wood of the quagmire"

| | | |
|---|---|---|
| 1. half-town of Meghilliekrier | Lodge RR Chas I i 407 | 1637 |

| | | |
|---|---|---|
| 2. Half-town of Meagkillycrier | BSD 135b | 1661 |
| 3. Meghkillcreare ½ townland | Lodge RR Chas II i 106 | 1663 |
| 4. Meghillicrer | Inst. Edenduffcarrick | 1672c |
| 5. ½ of Meaghkillicrier | Comm. Grace 10 | 1684 |
| 6. Half of Meaghkillcrier | Lodge RR Chas II ii 292 | 1684 |
| 7. Meaghkillcrier | Reg. Deeds 10-133-3227 | 1712 |
| 8. Creagh al. Machilcree | Reg. Deeds 54-76-34930 | 1722 |
| 9. Crea | Belfast News Letter Oct. 14 | 1763 |
| 10. Crea | Lendrick Map | 1780 |
| 11. Crea | Reg. Deeds 660-290-457358 | 1813 |
| 12. Crea | Bnd. Sur. | 1825 |
| 13. Creagh | OSNB A 41 162 | 1830 |
| 14. Críoch "a boundary" | O'D (OSNB) A 41 162 | 1830 |
| 15. ðə 'krɛ: | Local pronunciation | 1987 |

O'Donovan's suggestion that the name of this townland is derived from Irish *Críoch* "a boundary" (14) is not supported by the documentary evidence which suggests that the most likely derivation is *Maigh Choille Criathair* "plain of the wood of the quagmire". Alternatively, one might suggest the form *Maghchoillidh Chriathair* "plain-wood of the quagmire." However, the compound *maghchoillidh* "plain-wood", is not otherwise attested, and this derivation must therefore be regarded as a less likely one. The word *criathar* in Irish literally means "sieve" but is used, mainly in the north and west of Ireland, to refer to "boggy or swampy places, or to broken land intermixed with quagmires and brushwood" (*Joyce* ii 391). The representation of Irish *criathar* as *krier/crier* in the earliest sources reflects the tendency for medial intervocalic *-th-* to disappear in East Ulster Irish (O'Rahilly 1932, 175). It is difficult to account for the loss of the final *-r* which is illustrated by the form *Creagh al. Machilcree* in 1722 (8). It is possible that after the first two elements were lost, the place-name was reinterpreted and a form ending in *-each* developed, possibly *Critheach* which could be understood as consisting of *crith* "tremble" plus the termination *-each* and having the significance of "shaking bog". In Ulster Irish, final *-ch* tends to be weakened (*op. cit.* 210), which would explain its absence in the modern pronunciation of the place-name. The townland consists entirely of a level plain, and the *OSNB* of 1830 records "a small tract of bog on its eastern border" (*OSNB* A 41 162).

## Downkillybegs
J 0899

*Dún Cille Bige*
"fort of the little church"

| | | |
|---|---|---|
| 1. Dun-chille Bige | Trias Thaum. 184 col.1n | 1647 |
| 2. the half-town of Downkilbegg | Lodge RR Chas I i 407 | 1637 |
| 3. the Half-Town of Downekilbegg | BSD 135b | 1661 |
| 4. Donkilbeg ½ townland | Lodge RR Chas II i 106 | 1663 |
| 5. Downekilbegg | EP Edenduffcarrick | 1666 |
| 6. ½ of Downekillbeg | Comm. Grace 10 | 1684 |
| 7. Half of Downekillbegg | Lodge RR Chas II ii 292 | 1684 |
| 8. Downkillbegg | Reg. Deeds 10-133-3227 | 1712 |
| 9. the half towne land of Doonekillybeggs | Reg. Deeds 53-424-36229 | 1718 |
| 10. Down Killbeggs | Reg. Deeds 90-171-62470 | 1739 |

| | | |
|---|---|---|
| 11. Down Kilbegs | Lendrick Map | 1780 |
| 12. Downkelbeggs | Reg. Deeds 660-290-457359 | 1813 |
| 13. Down-Killybegs | Bnd. Sur. | 1825 |
| 14. Downkillibegs | OSNB A 41 162 | 1830 |
| 15. Dún Cille Bige "fort of the little church" | J O'D (OSNB) A 41 162 | 1830 |
| 16. Dun-chille-bice "the fortress of the little church" | Joyce ii 414 | 1875 |
| 17. ˌdəunˈkïliˈbɛːgz | Local pronunciaton | 1987 |

O'Donovan (*AFM* iii 25n.; *OSNB* A 41 162) is obviously correct in his identification of Downkillybegs with *Dun-chille Bige* "fort of the little church", the name of one of nine places listed by Colgan as "holy places" in Uí Thuirtre in 1647 (see **Clonboy** above).

There is now no trace or evidence of a church in the townland. There is a conspicuous motte which is situated near its eastern boundary, on the bank of the river Main, and this may be the feature referred to in the place-name. Flanagan (1980-1(a), 19) has pointed out that there are about twenty *dún*-named mottes in Cos Antrim and Down, within the former Norman Earldom of Ulster, and she tentatively suggests that in most of these cases the name may have been originally applied to an Irish fort and later transferred to a Norman fort constructed on the same site. There is also evidence that in this area of Co. Antrim mottes were constructed by the Irish themselves during the Anglo-Norman period (McNeill 1980, 102-3). The element *cill* in place-names most commonly refers to an early Irish church (Flanagan 1981-2(b), 72) and it seems likely that in this case the fort may have been named "fort of the little church" by association with a little church which already stood in the vicinity, though it is impossible to tell whether the fort was originally of Irish or Norman construction.

The modern plural ending of the townland-name is not documented until 1718 (9). It may have its origin in the division of the townland into two portions, which is suggested by the fact that it is marked as "Killybegs Upper" and "Killybegs Lower" on the *OS 1:10,000* and *OS 1:50,000* maps. Or possibly the plural ending has grown up by analogy with the name of the townland of Kilbegs in the parish of Antrim, or the well-known town of Killybegs in Co. Donegal.

**Drumanaway**
J 0693

*Droim Fhionnmhai*
"ridge of the white/fair plain"

| | | |
|---|---|---|
| 1. Ballydromenvye | Lodge RR Chas I i 407 | 1637 |
| 2. Ballydromoneny | BSD 135b | 1661 |
| 3. Balledrumenoy | Lodge RR Chas II i 106 | 1663 |
| 4. Drummiry | HMR Ant. 145 | 1669 |
| 5. Ballydromenery | Comm. Grace 10 | 1684 |
| 6. Ballydrominevy | Lodge RR Chas II ii 292 | 1684 |
| 7. Ballydrominevy | Reg. Deeds 10-133-3227 | 1712 |
| 8. Ballydromenevy | Reg. Deeds 90-171-62470 | 1739 |
| 9. Driminevey | Belfast News Letter Dec. 17 | 1762 |
| 10. Drimineway | Belfast News Letter Aug. 24 | 1764 |
| 11. Drumminaway | Lendrick Map | 1780 |
| 12. Druminaway | Grand Jury Pres. (Summer) | 1785 |

| | | |
|---|---|---|
| 13. Drumaway | Reg. Deeds 660-290-457358 | 1813 |
| 14. Ballydrominery | Reg. Deeds 756-26-613561 | 1820 |
| 15. Drumanawy | Bnd. Sur. | 1825 |
| 16. Druminaway | OSNB A 41 162 | 1830 |
| 17. Druim Míne Buidhe "ridge of the yellow surface" | J O'D (OSNB) A 41 162 | 1830 |
| 18. ˌdrọ'mïnəwɛ | Local pronunciation | 1987 |

In O'Donovan's suggested Irish form, *Druim Míne Buidhe* "ridge of the yellow surface" (17) the stress would fall on the final syllable and is thus at variance with the local pronunciation as is the long [i]-sound of *míne* and the unlenited *b* of *Buidhe* "yellow". While many of the recorded spellings have been corrupted as a result of the common scribal confusion of the letters *n*, *r* and *v*, the evidence points to *Droim Fhionnmhai* "ridge of the white or fair plain", as the original Irish form of the place-name. The compound *fionnmhaigh* "white, fair plain" is of common occurrence in Irish place-names (*Onom. Goed.* 422). A similar anglicization of Irish *Fionnmhaigh* is found in the name of the townland of Finaway in Co. Cavan (*Joyce* ii 272). The townland appears to have been named from the prominent ridge of 300 feet in the west, at the foot of which there is a level stretch of land. The qualifying epithet *fionn* "white, fair" was no doubt originally applied to the colour of the soil or vegetation, though this is not apparent from the modern landscape.

**Drummaul**
J 0795

Of uncertain origin

See parish name

**Drumsough**
J 1190

*Droim Sú*
"ridge of berries"

| | | |
|---|---|---|
| 1. Ballydromsagh | Lodge RR Chas I i 407 | 1637 |
| 2. Ballydrumsagh al. Ballydrumtah | BSD 135a | 1661 |
| 3. Drumsagh | Lodge RR Chas II i 106 | 1663 |
| 4. Drumsoe | HMR Ant. 142 | 1669 |
| 5. Ballydromsagh al. Ballydrumsagh | Comm. Grace 10 | 1684 |
| 6. Ballydromsagh al. Ballydrumsugh | Lodge RR Chas II ii 292 | 1684 |
| 7. Drumsough | Williamite Forf. | 1690s |
| 8. Drumsough | McSkim. Carrick. 422 | 1703 |
| 9. Drumsoogh | Forfeit. Estates 376a §1 | 1703 |
| 10. Dromsoogh | Reg. Deeds 10-212-3459 | 1712 |
| 11. Ballydromsagh al. Ballydrumsugh | Reg. Deeds 90-171-62470 | 1739 |
| 12. Drumsough | Belfast News Letter Oct. 14 | 1763 |
| 13. Drumsoo | Lendrick Map | 1780 |
| 14. Drimsoo | Grand Jury Pres. Aug. 8 | 1793 |
| 15. Drumsoogh | Grand Jury Pres. (Summer) | 1795 |
| 16. Drumsough | OSNB A 41 162 | 1830 |
| 17. Druim Subh "ridge of the strawberries" | J O'D (OSNB) A 41 162 | 1830 |
| 18. Druim samhach "ridge of sorrel" | Joyce iii 338 | 1913 |
| 19. drọm'su: | Local pronunciation | 1987 |

Most of the earlier spellings represent the final element of the place-name as *sagh*, which may suggest some form of Irish *samhadh* "sorrel", as suggested by Joyce (18). Dwelly gives *samh* as the usual word for "sorrel" in Scottish Gaelic, with an adjectival form *samhach* "abounding in sorrel" (*Dwelly* sv.). While *Droim Samhach* "sorrel-abounding ridge" may appear an acceptable interpretation of our place-name, it appears more likely that the medial *-a-* of *sagh* in the earlier spellings is in fact a scribal error for *-u-*, and that the sound intended is [su:], with silent final *-gh*, as in the modern pronunciation of the place-name. The most satisfactory interpretation of the place-name, therefore, is that suggested by O'Donovan, i.e. *Druim Subh* "ridge of berries" (17), which in standard Irish would be written *Droim Sú*. While *sú* "berry" in Mod. Ir. has a genitive plural *sútha*, in the earlier language it was an *ā*-stem which would have remained unchanged in the genitive plural (*DIL* sv. *sub*). According to Joyce, the names of the townlands of **Drumsoo** in Fermanagh and **Drumnasoo** in Armagh are both derived from Irish *Droim na Sú* "ridge of the berries" (*Joyce* iii 335, 338) while **Tullynasoo** in the parish of Kilcoo in Co. Down derives from *Tulaigh na Sú* "mound/hill of the berries" (*PNI* iii 115). There is also a place named **Inishnasoo** in Armagh which is written as *Inis na subh* "island of the berries" in the *Annals of the Four Masters* (*AFM* ii 1130). There are several hills in the townland and it is impossible to tell which has given rise to the place-name.

| Farlough | *Forloch* | |
|---|---|---|
| J 0994 | "outlying lake" | |
| 1. Half Town of Forologh | BSD 135b | 1661 |
| 2. Fforlack | HMR Ant. 141 | 1669 |
| 3. ½ of Forlagh | Comm. Grace 10 | 1684 |
| 4. the half town of Forlagh | Lodge RR Chas II ii 292 | 1684 |
| 5. ffarlagh | Williamite Forf. | 1690s |
| 6. Ballynclurgan al. Ferelagh al. Oglully | MacSkim. Carrick. 422 | 1703 |
| 7. Forelagh | Reg. Deeds 10-133-3227 | 1712 |
| 8. Ballynelurgan al. Forelagh al. Oghilly | Reg. Deeds 10-212-3459 | 1712 |
| 9. Farlogh | Lendrick Map | 1780 |
| 10. Varlagh | Grand Jury Pres. (Sep.) | 1786 |
| 11. Farlogh | Grand Jury Pres. (Summer) | 1790 |
| 12. Farlagh | Reg. Deeds 660-290-457358 | 1813 |
| 13. Farlogh | OSNB A 41 162 | 1830 |
| 14. Farloch or Fuarloch "cold lough" | J O'D (OSNB) A 41 162 | 1830 |
| 15. For-loch "outlying lake" | Joyce iii 349 | 1913 |
| 16. 'fɑrləx | Local pronunciation | 1987 |

O'Donovan (14) suggests that the origin of this place-name is *Farloch*, a variant form of *Fuarloch*, and goes on to interpret the name as "cold lough". However, in the Irish language *Farloch* is not an acceptable variant of *Fuarloch*. The word *fuarlach* is testified in the sense of "the weedy, marshy edge of a lake or river; a place liable to floods; a flood plain" (*Dinneen* sv.); "low-lying marginal land, subject to flooding" (*Ó Dónaill* sv.). According to Mooney (1954(a), 38), *Fuarlach* is the Irish form which lies behind the place-name **Farlagh** in the

parish of Seagoe in Co. Armagh. Given the situation of Farlough on the east bank of the river Main, it is tempting to suggest a similar derivation. However, the weight of the documentary evidence is against it and it must be regarded as unlikely.

Ó Máille (1987, 33) gives *far* and *for* as alternative forms of *or*, which he interprets as "border, edge". In the earlier language, the word *or* is attested in the sense of "a limit, boundary, extreme", and also "bank (of a river)" (*DIL* sv.). One might suggest that the place-name is derived from the Irish form *Farlach*, consisting of the element *far*, plus the termination *lach*, signifying "place of". The name would then signify something like "place of borders, river banks", or, more likely, simply "border, river bank", since *-lach* is sometimes added to the end of a word without in any way adding to its meaning (*Joyce* ii 5). While this form is certainly reconcilable with the documentary evidence, it does not appear to be otherwise attested and it can hardly be regarded as entirely convincing.

All things considered, Joyce's interpretation of the name as *For-loch* "outlying lake" (15) appears as likely as any. In Ulster Irish, [ɔ] is often lowered to [ɑ] before *r*, which would explain the modern rendition of the first syllable of the place-name as [fɑr] rather than as [fɔr]. The prefix *for-* which signifies "outer, upper" is well attested in place-names. According to Joyce, the names of the townlands of Fargrim in Fermanagh and Leitrim are derived from Irish *Fardhroim* or *Fordhroim* "outer ridge or hill" (*Joyce* i 47). There is now no lake in the townland, but there is an area of bog in its south east, which forms part of an extensive bog known as **Sluggan Moss**, the centre of which is said to have been formerly the site of a lake (*OSM* xix 38). In the parish of Tullyniskin in Co. Tyrone there is another townland named **Farlough** in which there is a small lake, and there is evidence that the name is also derived from Irish *Forloch* "outlying lake". There are rivers named **Farlough River Lower** and **Farlough River Upper** in Co. Armagh and a river named **Furlough River** in the parish of Clonoe in Co. Tyrone.

As referred to above in connection with the townland of **Aughalish**, both this townland and Aughalish are given in several sources as alias names for Ballylurgan, and it is possible that Aughalish and Farlough were formerly subdivisions of Ballylurgan.

| **Feehogue** | *Fiodhóg* | |
|---|---|---|
| J 0891 | "rushy place/little wood/place of woods" | |

| | | | |
|---|---|---|---|
| 1. town of Ballyfeoghoge al. the Iron Works upon the Mayne Water | Lodge Fairs & Markets 2 | 1637 |
| 2. Ballynfighogie | Lodge RR Chas I i 407 | 1637 |
| 3. Ballynafighogy | BSD 135b | 1661 |
| 4. Ballenefeeghoge | Lodge RR Chas II i 106 | 1663 |
| 5. ffighog | HMR Ant. 145 | 1669 |
| 6. Ballynafighogie | Comm. Grace 10 | 1684 |
| 7. Ballynafighogie or Ballinafroghra | Lodge RR Chas II ii 292 | 1684 |
| 8. Ballynesehoge | Reg. Deeds 10-133-3227 | 1712 |
| 9. Ballynafighogie | Reg. Deeds 90-171-62470 | 1739 |
| 10. Feevouge | Lendrick Map | 1780 |
| 11. Feehog | Grand Jury Pres. (Summer) | 1782 |
| 12. Feeheough | Grand Jury Pres. (Summer) | 1801 |
| 13. Feehogue | OSNB A 41 162 | 1830 |
| 14. Fitheog "little wood" | J O'D (OSNB) A 41 162 | 1830 |
| 15. 'fiːhoːg | Local pronunciation | 1987 |

O'Donovan's suggested Irish form, i.e. *Fitheog* "little wood" (14) is not attested but it is probably to be understood as representing *fiodh* "wood" plus the diminutive termination *-óg* which sometimes has the significance of "place of" (*Joyce* ii 29). The form *fiodhóg* "little wood, place of woods" appears to be of rare occurrence, but it is reconcilable with the documentary evidence.

The medial *-dh-* of *fiodhóg* would have been originally pronounced as a dental fricative [ð], but from the 12th century onwards it came to be sounded as a gutteral fricative [ɣ] (O'Rahilly 1932, 56) and this appears to be the sound represented by the medial *-gh-* of all the earlier historical forms. Even though medial non-palatal *-dh-* is now generally silent in the Irish language, it is still heard in a few words in Ulster Irish (*op. cit.* 212). The modern rendition of this sound as [h] (first recorded in 1712) is most likely to avoid hiatus between the two vowel sounds of the place-name, after the disappearance of the medial fricative when the name would have come to be pronounced ['fiːɔg] (cf. the development of medial [h] in words such as *draíocht* (<*draoidheacht*) "magic" and *ríocht* (<*righeacht*) "kingdom" in modern Donegal Irish).

The word *fiodh* is also attested as an alternative form of *feag* "a rush" (*Ó Dónaill* sv.) and the name *Fiodhóg* could therefore have the significance of "rushy place". There is a low-lying plain on the west bank of the river Main and this might lead one to suggest the latter as the more likely interpretation, but it is impossible to reach a firm decision.

Many of the earlier forms suggest that the place may formerly have had an alias name incorporating the element *baile* "townland", followed by the article *na* i.e. *Baile na Fiodhóige* "townland of the little wood/wooded place" or "townland of the rushy place".

Form 1 refers to Feehogue as the town of *Ballyfeoghoge al. the Iron Works upon the Mayne Water. The Iron Works* was a former name for the town of Randalstown, and this entry shows that the original iron works, around which the town no doubt grew up, were on the banks of the river Main, in the townland of Feehogue and a little to the north of the present centre of Randalstown.

| **Gortagharn** | *Gort an Chairn* | |
|---|---|---|
| J 0787 | "field of the cairn" | |
| | | |
| 1. (?)a nGort an Chairn(n) | LCABuidhe 186n | 1680 |
| 2. (?)Ballygartacarney | Inq. Ant. (DK) 45 | 1605 |
| 3. (?)Balligartacarney | CPR Jas I 93b | 1606 |
| 4. (?)Ballygartacarney or | | |
| Ballygortocarney | Lodge RR Jas I i 252 | 1606 |
| 5. Ballegortcarne | Lodge RR Chas I i 407 | 1637 |
| 6. (?)Ballygortcarnie | Lodge RR Chas I i 407 | 1637 |
| 7. Ballygortkarne | BSD 135a | 1661 |
| 8. (?)Ballygortgarny | BSD 135b | 1661 |
| 9. Ballygort-carne | Lodge RR Chas II i 106 | 1663 |
| 10. Gortcarne | HMR Ant. 144 | 1669 |
| 11. Ballygortkarne | Comm. Grace 10 | 1684 |
| 12. Ballygortkarne | Lodge RR Chas II ii 292 | 1684 |
| 13. Ballygortcarne | Reg. Deeds 10-133-3227 | 1712 |
| 14. Ballygortkarne | Reg. Deeds 90-171-62470 | 1739 |
| 15. Gartaharn | Belfast News Letter Aug. 24 | 1764 |
| 16. Gortaharn | Lendrick Map | 1780 |
| 17. Gortaharn | Duff's Lough Neagh | 1785 |

| | | |
|---|---|---|
| 18. Gortagharn | Grand Jury Pres. (Summer) | 1791 |
| 19. Gortagharn | Bnd. Sur. | 1825 |
| 20. Gortagharn | OSNB A 41 162 | 1830 |
| 21. Gort an Chairn "field of the cairn or heap" | J O'D (OSNB) A 41 162 | 1830 |
| 22. ˌgɔrtə 'haːrn | Local pronunciation | 1987 |

In a note in *Leabhar Cloinne Aodha Buidhe* (*LCABuidhe* 186n) the scribe Ruaidhrí Ó hUiginn writes that he is resting after what he wrote that day (June 17, 1680) at *Gort an Chairn*(n) (1). Lloyd (*Meyer Miscellany* 53) has identified *Gort an Chairn*(n) with a townland named **Gortaheran** in the parish of Portglenone and barony of Toome Lower, Co. Antrim. However, this identification is unsupported by the documented versions of that townland name, which suggest the Irish form *Gort an Chaorthainn* "field of the rowan-tree" (see below). The historical forms of Gortagharn, however, are reconcilable with the Irish form *Gort an Chairn* "field of the cairn", even though the forms with a question mark cannot with certainty be identified with this place-name.

Nevertheless, it is impossible to make a positive identification of Gortagharn with Ó hUiginn's *Gort an Chairn*(n) since there are other places in Ireland whose names clearly share this derivation: there are townlands named **Gortacharn** and **Gortaharn** in Fermanagh; Hogan (*Onom. Goed.* 447) cites a place named *Gort an Chairn* which he identifies with "Gortacharn tl. in p.Clontuskert, c.Galw." (apparently the townland whose official orthography is now Gortnahorna); there is also a place named Gortacarna, in the parish of Kilcommon and barony of Erris, Co. Mayo, the Irish form of which is *Gort a' Chairn* (Ó Donnchadha 1950, 312), and whose claim must be taken seriously, in view of the fact that it is situated in the same barony as that from which the scribe Ruaidhrí Ó hUiginn appears to have hailed (*LCABuidhe* xxxiii). Nonetheless, the claim of our Gortagharn to be identified with Ó hUiginn's *Gort an Chairn*(n) cannot be ignored, in view of the fact that it is in the same general area as Broughshane, the residence of Colonel Cormack O'Neill, the patron who commissioned Ruaidhrí Ó hUiginn to write down the poems in *Leabhar Cloinne Aodha Buidhe*. It is also only a few miles from Shane's Castle, the main stronghold of the O'Neills of North Clandeboy. There is now no trace or tradition of a cairn in the townland.

| **Groggan** | *An Grógán* | |
|---|---|---|
| J 0693 | "the place of sedge(?)" | |
| 1. Ballygrogane | Lodge RR Chas I i 407 | 1637 |
| 2. Ballygrogane | BSD 135b | 1661 |
| 3. Ballegrogan | Lodge RR Chas II i 106 | 1663 |
| 4. Grogan | HMR Ant. 145 | 1669 |
| 5. Ballygrogane | Lodge RR Chas II ii 292 | 1684 |
| 6. Grega | O'Laverty iii 354 | 1704 |
| 7. Grogan | Reg. Deeds 10-133-3227 | 1712 |
| 8. Grogan | Reg. Deeds 36-491-23759 | 1718 |
| 9. Ballygrogan | Reg. Deeds 36-491-23759 | 1718 |
| 10. Groggan Isles | Lendrick Map | 1780 |
| 11. Groggan Isles | Duff's Lough Neagh | 1785 |
| 12. Groggan | OSNB A 41 162 | 1830 |

| | | |
|---|---|---|
| 13. Gruagán "land of sedge or long grass" | J O'D (OSNB) A 41 162 | 1830 |
| 14. sedge – a place producing long, sedgy grass | Joyce ii 339 | 1875 |
| 15. 'grɔːgən | Local pronunciation | 1987 |

There is a large bog, known as Groggan Moss, in the west of the townland. In the middle of the bog there is an area of dry, cultivated land, known as Groggan Island. The remainder of the townland is cultivated, and there is a conspicuous hill of 400 feet in the middle of it. The documentary evidence is quite uniform and the name of the townland is clearly derived from Irish *An Grógán*, a variant form of O'Donovan's *Gruagán* (13). Ó Dónaill gives the word *grugán* "a hump or ridge" and one might argue that this could apply to the conspicuous hill. However, the vowel of the first syllable is not written as *u* in any of the recorded spellings and this interpretation must be regarded as unlikely. While the Irish form of the place-name is not in doubt, its exact significance is less obvious. The presence of the large bog in the townland would appear to favour O'Donovan's interpretation of the place-name as "land of sedge or long grass" (13), since sedge is known to grow in marshy places. Joyce suggests that the word *gruaig*, meaning "the hair of the head", is applied by extension, to "long hair-like grass, growing in a marshy or sedgy place", and he lists Grogagh, Grogey, Grogan, Grogeen and Gruig as well as the name of this townland as examples of place-names which are derived from it (*Joyce* ii 339). None of the standard dictionaries gives the word *gruaig* in the sense of "long hair-like grass", but Ó Dónaill does give *gruagach an tobair*, meaning "moorgrass" (*Ó Dónaill* sv.). Dinneen cites *gruagán*, signifying "a small pyramidal heap of turf-sods set on end to dry al. a hard patch of land; al. *grógán, gruaigín*" (*Dinneen* sv.). The interpretation of the place-name as "a small heap of turf" is clearly improbable, though one might suggest that the second meaning, "a hard patch of land", could refer to the area of cultivated land in the middle of the bog, known as Groggan Island. However, in view of the extensiveness of the bog in the townland, the interpretation of the place-name as "place of sedge" appears the more acceptable of the two suggestions.

| **Kilknock** | *Cluain Chnoic* | |
|---|---|---|
| J 0595 | "the meadow of the hill" | |

| | | |
|---|---|---|
| 1. (?)Cluainchnuc | Trias Thaum. 184 col.1n | 1647 |
| 2. (?)Cluain chnoc; in Hi tuirtre; leg. C.Cnuic | Onom. Goed. 258 | 1910 |
| 3. Ballyclonknocke | Inq. Ult. (Antrim) §106 Car. I | 1636 |
| 4. Ballyclanknocke | Lodge RR Chas I i 407 | 1637 |
| 5. Ballyclanknock | BSD 135b | 1661 |
| 6. Balleclancocke | Lodge RR Chas II i 106 | 1663 |
| 7. Ballyclanknock | Comm. Grace 10 | 1684 |
| 8. Ballyclanknock | Lodge RR Chas II ii 292 | 1684 |
| 9. Ballylanknocke | Reg. Deeds 10-133-3227 | 1712 |
| 10. Ballyclanknock | Reg. Deeds 90-171-62470 | 1739 |
| 11. Kilnock | Lendrick Map | 1780 |
| 12. Kilnock | Duff's Lough Neagh | 1785 |
| 13. Kellnock | Reg. Deeds 660-290-457358 | 1813 |

| | | |
|---|---|---|
| 14. Killknock | Bnd. Sur. | 1825 |
| 15. Kilnock | OSNB A 41 162 | 1830 |
| 16. Coill an Chnoic "wood of the Hill" | J O'D (OSNB) A 41 162 | 1830 |
| 17. Coill-a'-chnuic "wood of the hill" | Joyce iii 405 | 1913 |
| 18. kïl'nɔːk | Local pronunciation | 1987 |

All the earlier recorded spellings point to the Irish form *Cluain Chnoic* "meadow of the hill", rather than *Coill an Chnoic* "wood of the hill" as suggested by O'Donovan (16), or *Cill Chnoic* "church of the hill", which is the form suggested by the modern version of the place-name. The substitution of *Kil-* for *Clon-* is not documented until 1780 (11) and the change appears likely to have taken place in the English, rather than in the Irish, version of the place-name. It is most likely due to the process known as metathesis, the earlier [klï'nɔk] coming to be sounded [kïl'nɔk].

The entire townland is situated at a considerable elevation (c. 400 feet) and there is a conspicuous hill of 486 feet in its centre. The *OS 6-inch* map of 1833 shows the western section of the townland as consisting of bog. The place-name appears best interpreted as a hill-meadow, on the edge of boggy land. The consistent representation of the final element as *knock(e)* in the historical forms suggests that the place-name was coined before the letter *n* in the combination *cn* came to be sounded as [r] in the Irish of the north of Ireland, a change which appears to have taken place during the course of the 17th century (O'Rahilly 1932, 22–3).

Writing in 1647, Colgan cites a place named *Cluainchnuc* (1) as one of a number of "holy places" in the district of Uí Thuirtre (see **Clonboy** and **Downkillybegs** above). Since the earlier forms of Kilknock appear to be reconcilable with Colgan's *Cluainchnuc* and since there does not appear to be any other place identifiable with *Cluainchnuc,* a tentative identification appears justified, even though there is no trace or record of any ecclesiastical structure in the townland. Colgan's form appears to be a compound, signifying "meadow hill". However, as this compound is not otherwise attested, it is more likely that the intended form is *Cluain Cnuic* (>*Cluain Chnoic*) as suggested by Hogan (2).

| **Killyfad** | *An Choillidh Fhada* | |
|---|---|---|
| J 0386 | "the long wood" | |
| 1. Ballykillifed | Inq. Ant. (DK) 45 | 1605 |
| 2. Ballikillifed | CPR Jas I 93b | 1606 |
| 3. Ballykillifed | Lodge RR Jas I i 252 | 1606 |
| 4. Killtofell otherwise Killtoffeed | CPR Jas I 356a | 1617 |
| 5. Killtofell orw. Killtoffeed | Lodge RR Jas I ii 560 | 1617 |
| 6. Ballekillefede | Lodge RR Chas I i 407 | 1637 |
| 7. Bally Cilltefed | Exch. Deeds & Wills 653 | 1644 |
| 8. Ballykillfefed | Inq. Ult. (Antrim) §6 Car. II | 1663 |
| 9. Ballekillefede | ASE 106 a 1 | 1666 |
| 10. Kilfade | HMR Ant. 147 | 1669 |
| 11. Ballykillfad | Comm. Grace 10 | 1684 |
| 12. Ballykillfadd | Lodge RR Chas II ii 292 | 1684 |
| 13. Killefad | Indent. (Staff.) | 1692 |
| 14. Ballykillfad | Reg. Deeds 10-133-3227 | 1712 |

| | | |
|---|---|---|
| 15. Killyfadd | Reg. Deeds 30-26-16158 | 1720 |
| 16. Killifad als. Killyfadd | Reg. Deeds 66-434-47346 | 1731 |
| 17. Killyfad | Lendrick Map | 1780 |
| 18. Killyfad | Duff's Lough Neagh | 1785 |
| 19. Killyfadd | OSNB A 41 162 | 1830 |
| 20. Coille Fada "long wood" | J O'D (OSNB) A 41 162 | 1830 |
| 21. ˌkĭli'faːd | Local pronunciation | 1987 |

The first element of the place-name is *coillidh*, an oblique form of *coill* "wood" which is found in most dialects of Ulster Irish (Ó Baoill 1978, 56). Forms 4b, 5b, 7 and 8 may suggest a plural form of the first element, i.e. *coillte* "woods" but it is possible that the addition of the *t* is the result of scribal error. The representation of the vowel of the final element of the place-name as *-e-* in many of the earlier spellings is clearly a scribal mistranscription of *-a-*, while the absence of any trace of the final *-a* of *fada* "long" reflects the tendency in the north of Ireland for unstressed final vowels to disappear. The form *coillidh* is found in a number of other Ulster place-names including **Killylea**, Co. Armagh (<*Coillidh Léith* "grey wood") and Killybrone, Co. Monaghan (<*Coillidh Brón* "wood of the quern") (*GÉ* 238).

This is another of the four "detached townlands" of the parish of Drummaul. There is now no trace or record of native woodland in the townland, but the district in which it is situated is still known to older people as **Feevagh** (<*Fíobha* "wood"), proving that the area was extensively wooded in the past.

## Leitrim
J 0688

*Liatroim*
"grey ridge"

| | | |
|---|---|---|
| 1. Leytrim | Inq. Ult. (Antrim) §113 Car. I | 1636 |
| 2. Balleletroom | Lodge RR Chas I i 407 | 1637 |
| 3. Leytrym | Inq. Ult. (Antrim) §129 Car. I | 1639 |
| 4. Letrym | Inq. Ult. (Antrim) §130 Car. I | 1639 |
| 5. Ballyletroom al. Leitrim | BSD 135a | 1661 |
| 6. Bally-Leadrim | Inq. Ult. (Antrim) §8 Car. II | 1662 |
| 7. Ballyleatrim | Lodge RR Chas II i 106 | 1663 |
| 8. Letrum | HMR Ant. 145 | 1669 |
| 9. Ballyletroome al. Leitrim | Comm. Grace 10 | 1684 |
| 10. Ballyketroome al. Leitrim | Lodge RR Chas II ii 292 | 1684 |
| 11. Leterim | Williamite Forf. | 1690s |
| 12. Letrim | Williamite Forf. | 1690s |
| 13. Letrim | Reg. Deeds 10-133-3227 | 1712 |
| 14. Ballylettrome al. Leitrim | Reg. Deeds 90-171-62470 | 1739 |
| 15. Leitrim | Lendrick Map | 1780 |
| 16. Leitrim | Duff's Lough Neagh | 1785 |
| 17. Leitrim | OSNB A 41 162 | 1830 |
| 18. Liathdhruim "grey ridge" | J O'D (OSNB) A 41 162 | 1830 |
| 19. Liath-dhruim "grey ridge" | Joyce i 525 | 1869 |
| 20. 'liːtrĭm | Local pronunciation | 1987 |

The name of this townland has been correctly interpreted by both O'Donovan (18) and Joyce (19) as *Liathdhruim* "grey ridge", a form which in standard Irish would be written

*Liatroim.* There is a little hill in the east of the townland, beside which the hamlet of Leitrim is marked on the *OS 6-inch* map of 1933, and this may be the feature which has given rise to the place-name. This is a very common townland name, there being forty townlands named Leitrim scattered throughout Ireland. It is also the name of a county, of two baronies and of two parishes.

## Lenagh
J 1191

*Léanach*
"place of wet meadows"

| | | |
|---|---|---|
| 1. Ballylany | Inq. Ant. (DK) 45 | 1605 |
| 2. Ballilany | CPR Jas I 93a | 1606 |
| 3. Ballilany | Lodge RR Jas I i 251 | 1606 |
| 4. Ballyleany | Lodge RR Chas II i 407 | 1637 |
| 5. Ballyleank al. Ballylonagh | BSD 135a | 1661 |
| 6. Ballilany | Lodge RR Chas II i 106 | 1663 |
| 7. Lanagh | HMR Ant. 141 | 1669 |
| 8. Ballylenagh | Comm. Grace 10 | 1684 |
| 9. Ballyleany | Lodge RR Chas II ii 292 | 1684 |
| 10. Lenox | Williamite Forf. | 1690s |
| 11. Lenagh | McSkim. Carrick. 422 | 1703 |
| 12. Lenagh | Forfeit. Estates 376a §1 | 1703 |
| 13. Lenagh | Reg. Deeds 10-212-3459 | 1712 |
| 14. Ballyleany als. Ballylenagh | Reg. Deeds 90-171-62470 | 1739 |
| 15. ½ townland of Lenogh | Belfast News Letter Aug. 1 | 1766 |
| 16. Lenagh | Lendrick Map | 1780 |
| 17. Lenogh | Grand Jury Pres. (Spring) | 1788 |
| 18. Lenagh | OSNB A 41 162 | 1830 |
| 19. Léanach "wet meadowland" | J O'D (OSNB) A 41 162 | 1830 |
| 20. "wet meadowy land" | Joyce iii 468 | 1913 |
| 21. 'leːnəx | Local pronunciation | 1987 |

The name of this townland appears to be made up of the noun *léana* "wet meadow", plus the collective ending *-ach*, which in place-names often carries the significance of "place of . . . " (*Joyce* ii 3–4). The final *-y* of many of the earlier recorded spellings suggests that an alternative form of the place-name incorporating the element *baile*, i.e. *Baile Léanaí* "townland of the place of wet meadows" may also have been for a time in use. A number of the earlier spellings represent the first vowel of the place-name as *a*, but it is possible that in these forms *e* is omitted as a result of scribal error. The *OSNB* of 1830 remarks that "much of the townland is bog and poor land" (*OSNB* A 41 162). There are still scattered areas of marshy land in the townland.

## Lisnagreggan
J 0990

*Lios na gCreagán*
"fort of the little rocks"

| | | |
|---|---|---|
| 1. Ballylisgraggan | Lodge RR Chas I i 407 | 1637 |
| 2. Ballisgragane | BSD 135b | 1661 |
| 3. Ballelisnegragan | Lodge RR Chas II i 106 | 1663 |
| 4. Lisnegragan | HMR Ant. 143 | 1669 |

| | | |
|---|---|---|
| 5. Ballylisgragane | Comm. Grace 10 | 1684 |
| 6. Ballylisgragan or Ballysgragan | Lodge RR Chas II ii 292 | 1684 |
| 7. Ballylisgragan | Reg. Deeds 10-133-3227 | 1712 |
| 8. Lisnegregan | Reg. Deeds 89-414-63860 | 1738 |
| 9. Lisnagreggan | Reg. Deeds 242-379-107072 | 1765 |
| 10. Lisnagregan | Belfast News Letter Aug. 1 | 1766 |
| 11. Lisnagregan | Lendrick Map | 1780 |
| 12. Lisnagreggan | OSNB A 41 162 | 1830 |
| 13. Lios na gCreagán "fort of the little rocks" | J O'D (OSNB) A 41 162 | 1830 |
| 14. Lios-na-gcreagán "fort of the little rocks" | Joyce iii 478 | 1913 |
| 15. ˌlïsnəˈgrɛːgən | Local pronunciation | 1987 |

There is no reason to disagree with the previous interpretation of the place-name as *Lios na gCreagán* "fort of the little rocks" (13, 14). While none of the 17th-century forms provide any evidence of the typical East Ulster pronunciation of *ea* as [ɛ] before *d, s* and *g* (Holmer 1940, 76) the representation of this sound as *-a-* in these forms is likely to be merely a mistranscription of *-e-*. *NISMR* marks two "enclosures" in the townland, no trace of either of which now remains.

**Lurgan West**
J 0789

*An Lorgain*
"the long low ridge"

| | | |
|---|---|---|
| 1. Ballelurgine | Lodge RR Chas I i 407 | 1637 |
| 2. Ballylurgin | BSD 135a | 1661 |
| 3. Ballylurgan-Gilnedin | Lodge RR Chas II i 106 | 1663 |
| 4. Lurgan | HMR Ant. 144 | 1669 |
| 5. Ballylurgin | Comm. Grace 10 | 1684 |
| 6. Ballylurgin or Ballylurgine | Lodge RR Chas II ii 292 | 1684 |
| 7. Ballylurgan | Reg. Deeds 90-171-62470 | 1739 |
| 8. B'lurgan W. | Lendrick Map | 1780 |
| 9. B. Lurgan | Duff's Lough Neagh | 1785 |
| 10. Lurgan West | Grand Jury Pres. (Summer) | 1801 |
| 11. Lurgan west | Reg. Deeds 660-290-457358 | 1813 |
| 12. Lurgan West | Bnd. Sur. | 1825 |
| 13. Lurgan West | OSNB A 41 162 | 1830 |
| 14. Lurgan "a long hill" | J O'D (OSNB) A 41 162 | 1830 |
| 15. ˌlɔrgən ˈwɛːst | Local pronunciation | 1987 |

Many of the earlier documented forms suggest that the name of this townland was originally prefixed by the element *baile* "townland", though it is perhaps more likely that *Bally-* in these forms is merely a "townland marker". In any case, the presence of the element *Bally-* has led to the use of the qualifying element *West* (first recorded in 1780), to distinguish this townland from the townland of **Ballylurgan** which is also in the parish of Drummaul and the element *West* has stuck to this townland name, even after the element *Bally-* has disappeared. There is a long ridge of 200 feet in Lurgan West, which runs almost the entire width of the townland, and it is possible that this is the naming feature of the townland.

In form 3, the name of this townland is hyphenated with *Gilnedin*. The latter name is found documented as a townland in its own right in several other sources. The name is now obsolete, but it no doubt represents a land unit in the vicinity of Lurgan West, and is quite probably included in the territory now incorporated in the neighbouring townland of **Shane's Castle Park**. However, there is insufficient evidence to enable one to establish the original Irish form of *Gilnedin*.

**Magherabeg**
J 1094

*An Mhachaire Bheag*
"the small plain"

| | | |
|---|---|---|
| 1. Ballinamagheribegg | Inq. Ant. (DK) 45 | 1605 |
| 2. Ballinamagheribeg | CPR Jas I 93a | 1606 |
| 3. Ballina:magheribeg | Lodge RR Jas I i 251 | 1606 |
| 4. Ballynemagherybegg or | | |
| Ballynamayherrybegg | Lodge RR Chas I i 292 | 1637 |
| 5. Ballynemagherebegg | BSD 135a | 1661 |
| 6. Ballemaghebegg | Lodge RR Chas II i 106 | 1663 |
| 7. Ballynamagherebegg | Comm. Grace 10 | 1684 |
| 8. Ballynamagherybegg | Lodge RR Chas II ii 292 | 1684 |
| 9. Magherebegg | Reg. Deeds 10-133-3227 | 1712 |
| 10. Ballynamagherbegg | Reg. Deeds 90-171-62470 | 1739 |
| 11. Magherabeg | Lendrick Map | 1780 |
| 12. Magherabeg | OSNB A 41 162 | 1830 |
| 13. Machaire Beag "small plain" | J O'D (OSNB) A 41 162 | 1830 |
| 14. ˌmaxərəˈbɛːg | Local pronunciation | 1987 |

The noun *machaire* "plain" may be either masculine or feminine in Mod. Ir. (*Ó Dónaill* sv.). The earlier spellings of this place-name, if reliable, suggest that in this case *machaire* was a feminine noun and that a form incorporating the element *baile*, i.e. *Baile na Machaire Bige* "townland of the small plain" was at one time in use. O'Donovan's Irish form, i.e. *Machaire Beag* "small plain" (13) is acceptable, except that the final element would be lenited after the feminine noun *machaire* and that the earlier spellings provide evidence of the presence of the definite article *an*. There is a small, grassy plain near the western boundary of this townland, and this may be the feature which has given rise to the place-name. There is also a considerable stretch of level bogland in the east of the townland.

**Magheralane**
J 0992

*Maigh Dhoire Leathain*
"plain of the broad oak-wood"

| | | |
|---|---|---|
| 1. Ballinmuck-dirrelchan | Inq. Ant. (DK) 45 | 1605 |
| 2. Dirreleghan | CPR Jas I 93a | 1606 |
| 3. [Ballimuck] Dirreleghan | Lodge RR Jas I i 251 | 1606 |
| 4. Megerteyan | Exch. Deeds & Wills 383 | 1619 |
| 5. Megerleyan | Inq. Ult. (Antrim) §122 Car. I | 1637 |
| 6. Ballymucke/Derrylaghan or | | |
| Ballymacderrylaghane | Lodge RR Chas II i 407 | 1637 |
| 7. Mergerlian | Lodge RR Chas II i 407 | 1637 |
| 8. Ballymegerlian al. Magherelean | BSD 135a | 1661 |

| | | |
|---|---|---|
| 9. East Ballymuck Derrelaghan | BSD 135a | 1661 |
| 10. Ballymcderrylaghan | Lodge RR Chas II i 106 | 1663 |
| 11. Ballymergerlyan | Lodge RR Chas II i 106 | 1663 |
| 12. Ballymucke Derrylaghan | EP Edenduffcarrick | 1666 |
| 13. Ballymaghderrylaghane | EP Edenduffcarrick | 1666 |
| 14. Ballymergerlian | EP Edenduffcarrick | 1666 |
| 15. Magherlean | HMR Ant. 141 | 1669 |
| 16. Ballymergerly al. Maghalean | Comm. Grace 10 | 1684 |
| 17. Ballymuck Derrylaghan | Lodge RR Chas II ii 292 | 1684 |
| 18. Ballymergerlyan | Lodge RR Chas II ii 292 | 1684 |
| 19. Magherlean | Lodge RR Chas II ii 292 | 1684 |
| 20. Maghralane | Williamite Forf. | 1690s |
| 21. Ballymucke Dirreloghan | Reg. Deeds 10-133-3227 | 1712 |
| 22. Maghereleane | Reg. Deeds 56-44-36910 | 1718 |
| 23. Ballymergerlyan al. Magherlean | Reg. Deeds 90-171-62470 | 1739 |
| 24. Ballymuck Derryloghane | Reg. Deeds 90-171-62470 | 1739 |
| 25. Magherlane | Belfast News Letter Oct. 14 | 1763 |
| 26. Magheralane | Lendrick Map | 1780 |
| 27. Magheralane | OSNB A 41 162 | 1830 |
| 28. Machaire Leathan "broad plain" | J O'D (OSNB) A 41 162 | 1830 |
| 29. ˌmaxərˈleːn | Local pronunciation | 1987 |

A number of the earlier forms appear to suggest that the name of this townland is made up of a combination of two place-names, perhaps *Baile Maí* "townland of the plain" and *Doire Leathan* "broad oak-wood". However, it must be borne in mind that these forms are all related and that an error in the earliest would be reproduced in the later sources. The *Bally-* prefix is likely to be merely a "townland marker", and it is quite probable that form 1, i.e. *Ballimuck-dirrelchan* has been understood by a number of later scribes as representing two distinct place-names, while in form 2 the first element of the place-name has been accidentally omitted altogether. A more plausible interpretation of the place-name is, therefore, *Maigh Dhoire Leathain* "plain of the broad oak-wood". O'Donovan's suggestion that the place-name derives from *Machaire Leathan* "broad plain" (28) is not supported by the weight of the documentary evidence, which suggests that the first element of the name is made up of a combination of *maigh* "plain" and doire "oak-wood".

In the earlier language, the *-th-* of leathan "broad" would have been pronounced as a dental fricative, but in most Irish dialects *-th-* between two vowels has come to be sounded as [h], a sound which tends to be dropped altogether in East Ulster Irish (O'Rahilly 1932, 207–8). This would explain the anglicization of *leathan* "broad" as *lane*, a form which is found in several other East Ulster place-names (*Joyce* ii 418).

There is a very large level area of bog (known as **Sluggan Moss**) which covers the entire eastern portion of the townland, and this may be the feature referred to by the first element of the place-name. There is now no significant area of natural woodland in the townland.

| | |
|---|---|
| **Maghereagh** | *An Mhachaire Riabhach* |
| J 1189 | "the streaked/grey plain" |

| | | |
|---|---|---|
| 1. Ballymaghereevagh | Inq. Ant. (DK) 45 | 1605 |
| 2. Ballimagherevagh | CPR Jas I 93a | 1606 |

| | | |
|---|---|---|
| 3. Ballimagherevagh | Lodge RR Jas I i 251 | 1606 |
| 4. Ballymaghereigh | Exch. Deeds & Wills 702 | 1637 |
| 5. Ballymagherivagh | Lodge RR Chas I i 407 | 1637 |
| 6. Ballynemackeragh | BSD 135a | 1661 |
| 7. Ballymaghreveigh | Lodge RR Chas II i 106 | 1663 |
| 8. Magheragh | HMR Ant. 142 | 1669 |
| 9. Ballynemacheragh | Comm. Grace 10 | 1684 |
| 10. Ballynemachereagh or | | |
|     Ballymagheryvagh | Lodge RR Chas II ii 292 | 1684 |
| 11. Ballynemuckredgh | Reg. Deeds 90-171-62470 | 1739 |
| 12. Magheragh | Belfast News Letter Aug. 1 | 1766 |
| 13. Maghereagh | Lendrick Map | 1780 |
| 14. Maghereagh | Duff's Lough Neagh | 1785 |
| 15. Maghereagh | OSNB A 41 162 | 1830 |
| 16. Machaire Riabhach "grey plain" | J O'D (OSNB) A 41 162 | 1830 |
| 17. "grey plain" | Joyce ii 520 | 1875 |
| 18. ˌmaxəˈrɛː | Local pronunciation | 1987 |

As pointed out above in connection with the townland of **Magherabeg**, the word *machaire* can be either masculine or feminine in Mod. Ir. In the case of Maghereagh, only a small number of forms (6,9,10a,11) show definite evidence of a feminine gender. However, since *machaire* appears to be feminine in the name of the townland of **Magherabeg** (see above), it is also taken to be a feminine noun in this place-name.

In the earlier language, the medial *-bh-* of *riabhach* "streaked/grey" would have been pronounced as [v] but in northern Irish this sound would normally have developed to [w] (O'Rahilly 1932, 211). However, in East Ulster place-names there is some evidence of the pronunciation of non-palatal *-bh-* as [v]. For example, the name of the townland of **Portavogie** is from Irish *Port an Bhogaigh* "place of the bog" (*PNI* ii 108), and, according to Joyce, **Derrygortrevy** in Tyrone is from *Doire Ghoirt Riabhaigh* "the oak-wood of the grey field" (*Joyce* ii 283). The earlier spellings of Maghereagh suggest that the medial *-bh-* of *riabhach* was also pronounced [v]. The modern spelling, i.e. *-reagh*, (first recorded in 1780) may reflect a standardized anglicization and may not be a good indication of the Irish pronunciation.

The original meaning of the adjective *riabhach* appears to have been "streaked, striped" (*DIL* sv. *riabach*). In Mod. Ir. it has a variety of meanings, including "streaked, striped, brindled, (speckled) grey" (*Ó Dónaill* sv.). A boundary description in 1607 refers to "a parcel of unprofitable pasture ground called *Lurganreogh*" in the tuogh of Ballylinny, Co. Antrim (*Lodge RR* Jas I ii 322) suggesting that *riabhach* may carry connotations of unproductiveness. The townland is predominantly flat and low-lying, and is now well cultivated, but the *OS 6-inch* map of 1833 shows a small area of bog in the western portion. Most of the townland is in the parish of Drummaul, but a small portion in the east lies in the parish of Antrim.

| **Mount Shalgus** | *Móin Sealgluis*(?) | |
|---|---|---|
| J 0788 | "bog of stonewort" | |
| 1. Ballymonsalgis or Ballymonsilgis | Lodge RR Chas I i 407 | 1637 |
| 2. Ballamonasalgis | BSD 135a | 1661 |
| 3. Ballemonshallgis | Lodge RR Chas II i 106 | 1663 |

| 4. Munnsalgus | HMR Ant. 144 | 1669 |
|---|---|---|
| 5. Ballymonasalgis | Comm. Grace 10 | 1684 |
| 6. Ballymonasalgis | Lodge RR Chas II ii 292 | 1684 |
| 7. Ballymunsalgis | Reg. Deeds 10-133-3227 | 1712 |
| 8. Ballymonasalgis | Reg. Deeds 90-171-62470 | 1739 |
| 9. Montshalgus | Reg. Deeds Index | 1770c |
| 10. Mount Shalgus | Lendrick Map | 1780 |
| 11. Mountshalgus | Duff's Lough Neagh | 1785 |
| 12. Mountshalgus | Bnd. Sur. | 1825 |
| 13. Mountshalgus | OSNB A 41 162 | 1830 |
| 14. Mount Shalgus | OS Name Sheets (J O'D) | 1830 |
| 15. "An English Name" | J O'D (OSNB) A 41 162 | 1830 |
| 16. ˌməunt ˈʃaːlgəs | Local pronunciation | 1987 |

Even though it has been suggested by O'Donovan (15) and Mac Aodha (1979, 41) that this place-name has its origin in the English language, there is no doubt that it is, in fact, derived from Irish. Commenting on Mac Aodha's article, Flanagan (1979(g), 55) declines to suggest an Irish form for the place-name, merely quoting forms 1, 3 and 6 as evidence that the initial element is a corruption of an Irish element. The evidence appears to favour the interpretation of the first element of the place-name as *móin* "bog". The long -*o*- of *móin* would have been shortened before the main stress in Ulster Irish, which would explain the representation of the sound as -*u*- in forms 4 and 7. Moreover, spellings such as *Ballymonasalgis* (2) suggest *móna*, the genitive form of *móin* "bog", preceded by *baile* "townland".

The origin of the final element of the place-name is problematic. A tentative suggestion is that it could represent *sealgluis*, the genitive form of *sealglus* "the herb stonewort" (*Dinneen* sv.), a word which appears to be related to *sealgán* "an edible herb/meadow sorrel" (*Dinneen* sv.). The second -*l*- of sealglus, being in a consonant cluster, would be liable to disappear in speech, which would explain its total absence from the recorded forms of the place-name. Stonewort is a type of fresh-water green algae which is found in marshy ground, and this would tie in well with the interpretation of the first element of the place-name as *móin* "bog".

A number of the earlier forms appear to suggest an alternative form of the place-name incorporating the element *baile* "townland", i.e. *Baile Móna Sealgluis*(?) "townland of the bog of stonewort".

The townland is now largely under cultivation, but there is a small area of boggy land in the south. It is highly likely that Mount Shalgus has been reduced in size due to the enlargement of the townland of **Shane's Castle Park**, which borders it on the east.

**Muckleramer**
J 0694

*Mucail Ramhar*(?)
"broad pig-backed hill(?)"

| 1. (?)Cornemologh Mountain | CPR Jas I 93a | 1606 |
|---|---|---|
| 2. Ballymeagh, Killravane | Lodge RR Chas I i 407 | 1637 |
| 3. Ballymeagh Killravane | BSD 135b | 1661 |
| 4. Ballmegkillravan | Lodge RR Chas II i 106 | 1663 |
| 5. Makelramer | HMR Ant. 145 | 1669 |
| 6. Ballymeaghkilravane | Comm. Grace 10 | 1684 |
| 7. Ballymeaghkillravane | Lodge RR Chas II ii 292 | 1684 |
| 8. Ballymeaghkillravane | Reg. Deeds 10-133-3227 | 1712 |
| 9. Muckleraver | Reg. Deeds 43-144-647985 | 1732 |

| | | |
|---|---|---|
| 10. Meaghkillravan | Belfast News Letter Dec. 28 | 1750 |
| 11. Muckleramer | Belfast News Letter Aug. 1 | 1766 |
| 12. Muckilraver | Lendrick Map | 1780 |
| 13. Muckelraver | Grand Jury Pres. (Summer) | 1807 |
| 14. Muckelrammer | Bnd. Sur. | 1825 |
| 15. Mucklerammer | OSNB A 41 162 | 1830 |
| 16. Muclach Ramhar "Fat Piggery". "Mucklagh" is where pigs fed on acorns | J O'D (OSNB) A 41 162 | 1830 |
| 17. ˌmọkəl'raːmər | Local pronunciation | 1987 |

The earliest spellings suggest that we are in fact dealing with two distinct place-names which have become compounded into one, i.e. *Baile Maí* "townland of the plain" and *Coill Ramhar* "broad wood". While this possibility cannot be ruled out, it is perhaps more likely that the division of the place-name into two names is due to scribal error, as in the case of the name of the townland of **Magheralane**. A possible interpretation of the name is *Maigh Coille Raimhre* "plain of the broad wood", but the difficulty with this suggestion is that we would expect the genitive form of *coill*, i.e. *coille*, to be anglicized as *killy*. This raises the possibility that the first element of the place-name is a noun-plus-noun compound, i.e. *maghchoill* "plain-wood". However, this compound does not appear to be otherwise attested (see **Creagh** above). Perhaps the most satisfactory solution to the problem, therefore, is that the first element of the place-name is *mucail*, an earlier form of *muclach* "piggery" (Binchy 1941, 54b), and that it has been corruptly written as *meagh*, *Kill* by the scribe of form 1 (perhaps due to the influence of the earlier forms of **Creagh** townland), a mistake which has been copied (with variations) in later, related, sources.

Ó Máille (1955, 90) has pointed out that in certain phrases such as *muc shneachta* "snow drift" and *muc ghainmhe* "sand hill" the word *muc* (literally "pig") can signify "a pile or a ridge which is unusually steep". He also suggests that the element *muiceanach* in place-names signifies "a pig-back ridge". In the middle of the townland there is a conspicuous hill of 400 feet, now known as Fair View, and one is tempted to suggest that, like *muiceanach*, the element *mucail* (usually interpreted as "piggery, pig-enclosure") may have topographical reference to a pig-back ridge, though more investigation of the element (and of its later and more common form *muclach*), is required. It is worth remarking that the situation of the townland seems to fit in with a place referred to as *Cornemoklogh Mountain* in a description of the boundary between the tuoghs of Munterividy and Feevagh in 1606 (*CPR Jas I* 93a). The name *Cornemoklogh* may go back to Irish *Corr na Muclach* "hill of the pig-back ridge" and it is possible therefore that the initial element of Muckleramer and the final element of *Cornemoklogh* may refer to one and the same feature.

The final element of the place-name is *ramhar* "fat, broad", the final -r of which is mis-transcribed as *n(e)* in many of the earlier recorded spellings. The tendency for *ramhar* to be anglicized as *ramer* in the north of Ireland has been noted by Joyce, who cites **Killyramer** in Antrim, and **Cullyramer** in Derry as well as Kinramer on Rathlin Island as examples (*Joyce* ii 419–20). Holmer (1942, 31) gives the Irish form of the latter as *An Cinn Reamhar* "the broad headland", and notes that it is sometimes spelt "Kinramer" and sometimes "Kinraver" in English. He describes the medial -*mh*- of *reamhar* (>*ramhar*) as "the voiced labiodental nasal", and suggests that "its acoustic effect is almost *mv*", but that, more recently "usually a plain (broad) *v* is substituted, but occasionally also *m*". The recorded forms of Muckleramer suggest that the medial -*mh*- of *ramhar* was at an earlier period pronounced as [v], which later developed into the [m]-sound which is heard today, and it

is possible that its original effect was the [mv]-sound which was recorded by Holmer on Rathlin at a much later date.

| **Portlee** | *Port Loinge* | |
|---|---|---|
| H 9886, J 0285 | "harbour of the large boat" | |
| 1. Ballygarnery otherwise | | |
| Ballyportlong | CPR Jas I 356a | 1617 |
| 2. Ballygarnery als Ballyportlong | Lodge RR Jas I ii 560 | 1617 |
| 3. Ballypurly | Inq. Ult. (Antrim) §20 Car. I | 1633 |
| 4. Ballypurtleagh | Lodge RR Chas I i 407 | 1637 |
| 5. Ballypurtliagh | Lodge RR Chas I i 407 | 1637 |
| 6. Balyportleagh | BSD 135b | 1661 |
| 7. Ballyportileagh | Lodge RR Chas II i 106 | 1663 |
| 8. Ballypurleagh | EP Edenduffcarrick | 1666 |
| 9. Portlie | HMR Ant. 146 | 1669 |
| 10. Ballyportleagh | Comm. Grace 10 | 1684 |
| 11. Ballyportleagh or Ballypurtleogh | Lodge RR Chas II ii 292 | 1684 |
| 12. Ballyportleagh | Reg. Deeds 90-171-62470 | 1739 |
| 13. Portlie | Lendrick Map | 1780 |
| 14. Portlee | Duff's Lough Neagh | 1785 |
| 15. Portlee | OSNB A 41 162 | 1830 |
| 16. Port Liath "Grey Bank" | J O'D (OSNB) A 41 162 | 1830 |
| 17. Port-laoigh "port of the calf" | Joyce iii 532 | 1913 |
| 18. ˌportˈliː | Local pronunciation | 1987 |

Forms 1a and 2a obviously refer to the nearby townland of **Garriffgeery** and are not to be regarded as a true alias name for Portlee. The previously suggested Irish forms *Port Liath* "grey bank" (16) and *Port-laoigh* "port of the calf" (17) are both worthy of consideration. However, forms 1b and 2b must be taken as reliable evidence that the final element of the place-name is a form of *long* "ship", since it is difficult to see how the representation of the final element as -*long* in these sources could be attributable to scribal mistranscription. The most likely Irish form of the place-name is therefore *Port Loinge* "harbour of the ship/large boat". The vocalization of -*ng* after a stressed vowel is well attested in East Ulster Irish (O'Rahilly 1932, 183). Thus, the pronunciation of *long* has been recorded as [lʌː] in Derry and Tyrone (Ó Ceallaigh 1950(b), 127), and (in the dat. sing. form *luing*) as [liː] in central Tyrone (*LASID* iv 290), while the place-name **Portnaluinge** in Rathlin Island (<*Port na Loinge* "the port of the ship"), was pronounced [port nə ˈleij.] or [pʌrt nɑ ˈlEiə] (Mac Giolla Easpaig 1989–90, 18), and *Purt na Luinge* "port of the ship", in the Glens of Antrim, was pronounced [pʌrt nə ˈLeiə] (Holmer 1940, 42). The recorded forms of Portlee suggest a similar realization of the final element, apparently developing from an earlier pronunciation which still retained the [ŋ]-sound of *loinge*, as suggested by forms 1b and 2b.

Portlee is another of the four "detached townlands" of the parish of Drummaul, and the townland is itself divided into two portions, with the detached portion lying roughly two miles west of the main portion. There are small fishing harbours in both portions of the townland, the better known of which is in the detached portion, in a small district known as **Doss**. The word *long* is normally interpreted as "ship", but since it is clear that no harbour in the townland could have catered for a full-size ship, the final element of the place-name is probably best understood as signifying "large boat, large vessel".

## Procklis
J 0596

*An Phrochlais*
"the badger sett/den/cave/hollow(?)"

| | | |
|---|---|---|
| 1. Ballybraghliske | Lodge RR Chas II i 407 | 1637 |
| 2. Ballybracklisk al. Proghliske | BSD 135b | 1661 |
| 3. Ballebrughliske | Lodge RR Chas II i 106 | 1663 |
| 4. Prickless | HMR Ant. 157 | 1669 |
| 5. Ballybracklisk al. Proughlisk | Comm. Grace 10 | 1684 |
| 6. Ballybrackliske al. Proughliske | Lodge RR Chas II ii 292 | 1684 |
| 7. Proughliske | Reg. Deeds 10-133-3227 | 1712 |
| 8. Ballyprocklus al. Procklish | Reg. Deeds 54-76-34930 | 1722 |
| 9. Prockless | Belfast News Letter Oct. 14 | 1763 |
| 10. Procklis | Lendrick Map | 1780 |
| 11. Prockless | Reg. Deeds 660-290-457358 | 1813 |
| 12. Procklus | Bnd. Sur. | 1825 |
| 13. Prockless | OSNB A 41 162 | 1830 |
| 14. Broc-lios "badger warren" | J O'D (OSNB) A 41 162 | 1830 |
| 15. Broc-lusc "badger-den" | Joyce iii 533 | 1913 |
| 16. An Phrochlais | GÉ 147 | 1989 |
| 17. 'prɔ:klïs | Local pronunciation | 1987 |

O'Rahilly notes a tendency for initial *b* to be replaced by *p* in a number of Irish words, e.g. *blaosc/plaosc* "egg shell"; *boc/poc* "he-goat"; *bronn/pronn* "bestow" (O'Rahilly 1932, 149). The historical forms of this place-name suggest a similar development, in this case from *brochlais* to *prochlais*. The representation of the first vowel of the place-name as *a* in the related forms 1, 2a, 5a and 6a is likely to be a scribal error for *o*. Dinneen gives both *broclais* and *prochlais* as variant forms of *broclach* "a badger warren; al. a heap of stones (Antr.)" (*Dinneen* sv.) while Ó Dónaill cites *prochlais* as one of the variant forms of *prochóg* "hole, den, cave, hollow; hovel" and *broclais* as a variant form of *brocais* "den; dirty, smelly place" (*Ó Dónaill* svv.). *DIL* gives both *pruchlais* "a den or cave" and *prochlais* "a cave, den or vault" and draws attention to the word *pruch* "a hole in the ground". The name of the townland, therefore, is likely to signify either "a badger's sett" or simply "a hole, den, cave or hollow". Ó Dónaill gives *broclach* as a variant form of *breaclach* "patch of stony ground" and this may be the basis of Dinneen's *broclach* "a heap of stones (Antr.)".

Joyce (15) suggests that this place-name is a compound of *broc* "badger" and *lusc* "cave", hence *Broc-lusc* "badger-den", a derivation which he also suggests for the names of the townlands of **Procklis** in Donegal and Fermanagh (*Joyce* iii 533). However, while it could be argued that the final *-k(e)* of many of the earlier spellings could represent the final *-c* of *broc-lusc* "badger den", *k* in these forms is more likely to be a scribal error for *h*. O'Donovan's Irish form, i.e. *Broc-lios* "badger-warren" (14) is unacceptable since it is not reconcilable with the earlier recorded spellings. Moreover, the combination of *broc* "badger" and *lios* "warren(?<fort)" is not attested.

## Randalstown
J 0890

*An Dún Mór*
"the great fort"

| | | |
|---|---|---|
| 1. (?)Ballyndownemore | Inq. Ant. (DK) 45 | 1605 |
| 2. (?)Balli[n]downemer | CPR Jas I 93a | 1606 |
| 3. (?)Ballindownemore | Lodge RR Jas I i 252 | 1606 |

| | | |
|---|---|---|
| 4. town of Ballyfeoghoge al. the Iron-Works upon the Mayne Water | Lodge Fairs & Markets 2 | 1637 |
| 5. Balledownemore | Lodge RR Chas I i 407 | 1637 |
| 6. (?)Ballidownemore | Lodge RR Chas I i 407 | 1637 |
| 7. the Iron Works which is in the Parish of Drumaule | DS (Reg.) | 1657c |
| 8. Iron Mills | Hib. Reg. Toome | 1657c |
| 9. (?)Ballydownmore | BSD 135a | 1661 |
| 10. (?)Ballydowanmore | BSD 135b | 1661 |
| 11. Balledoonemore | Lodge RR Chas II i 106 | 1663 |
| 12. (?)Ballydonmore | Lodge RR Chas II i 106 | 1663 |
| 13. (?)Balledownemore | EP Edenduffcarrick | 1666 |
| 14. Towne of Ironworkes al. Mainewater – created a free borough named Randalstowne | ASE 106 a 1 | 1666 |
| 15. Randles Towne | HMR Ant. 143 | 1669 |
| 16. The Iron Mills | Hib. Del. Antrim | 1672c |
| 17. Randalstown | Dobbs' Descr. Ant. 386 | 1683 |
| 18. (?)Ballydownmore | Comm. Grace 10 | 1684 |
| 19. (?)Ballydownmore | Lodge RR Chas II ii 292 | 1684 |
| 20. Dunmore | Eccles. Reg. 73 | 1703 |
| 21. Randleston | Grand Jury Pres. 8 | 1711 |
| 22. Dunmore | Reg. Deeds 10-133-3227 | 1712 |
| 23. (?)Ballydonmore | Reg. Deeds 10-133-3227 | 1712 |
| 24. (?)Ballydownmore | Reg. Deeds 90-172-62470 | 1739 |
| 25. Dunmore | Lendrick Map | 1780 |
| 26. Dunmore | Duff's Lough Neagh | 1785 |
| 27. Randalstown | Reg. Deeds 660-290-45758 | 1813 |
| 28. Randalstown al. Dunmore | Bnd. Sur. | 1825 |
| 29. Randlestown (i.e. "town of Randal") or Dunmore townland | OSNB A 41 162 | 1830 |
| 30. Dunmore | O'Laverty iii 305 | 1884 |
| 31. Randalstown . . . formerly called Main-Water | O'Laverty iii 311 | 1884 |
| 32. Dún Mór "the great dún or earthen fort" | J O'D (OSNB) A 41 162 | 1830 |
| 33. Randalstown, formerly called Mullynierin or "the iron mills" | OSM xix 40 | 1838 |
| 34. Muileann-iarainn "the mill of iron" | O'Laverty iii 311 | 1884 |
| 35. Baile Raghnaill | GÉ 26 | 1989 |
| 36. 'ra:ndəlz,təun | Local pronunciation | 1987 |

While the identification of the historical forms marked with a question mark with Randalstown is not absolutely certain, there is no doubt that the earliest name for the townland of Randalstown was *An Dún Mór* "the great fort". There is a prominent motte-and-bailey, sometimes referred to as "The Mount", which stands on the west bank of the river

Main a little to the south of Randalstown and in the townland of **Shane's Castle Park**. The area adjoining this fort is known locally as Dunmore and it is clear that the former townland of Dunmore comprised this area and also all of the modern townland of Randalstown. Because of its Irish origin, one would naturally suspect that the name *An Dún Mór* "the great fort" may have been originally applied to a native Irish fort which stood on the same site as the present motte-and-bailey, and that the name was later transferred to the Norman fort. However, there is evidence that in this area of Co. Antrim the Irish themselves built mottes on the Norman model (see **Downkillybegs** above), and it is quite possible that they would have used the term *dún* to refer to them, in which case it is not necessary to speculate that the name has been transferred from an Irish to a Norman fort. In the absence of documentary or archaeological evidence, it is impossible to draw firm conclusions on the matter.

The first documented reference to the town of Randalstown occurs in 1637, when it is referred to as the *town of Ballyfeoghoge al. the Iron-Works upon the Mayne Water* (4). The *town of Ballyfeoghoge* is obviously the townland of **Feehogue** and it is clear that the iron works were situated in that townland, along the river Main, and a little to the north of the present centre of Randalstown. It was no doubt around the iron works that the town of Randalstown grew up. The name of the town is also shown as *Iron Mills* in c. 1657 (8) and as *The Iron Mills* in c. 1672 (16). An anglicized version of the Irish form of this name, i.e. *Mullynieren* (<*Muilinn Iarainn* "iron mills") is found in the *Ordnance Survey Memoir* of 1838 (33).

In 1666, the town was created a free borough and its name was changed to Randalstown (14). The change of the name of the town was occasioned by the marriage of Rose O'Neill of Shane's Castle to Randal MacDonnell, second Earl and first Marquis of Antrim, in whose honour the town was re-named Randalstown. Up until that time the town was also known as *Mainewater* (14).

The change of the name of the townland of Dunmore to Randalstown is a much more recent occurrence, being first documented in 1813 (27). The old name of the townland is recorded in the *OSNB* of 1830, which gives the name as *Randlestown or Dunmore townland* (29).

The name of the town of Randalstown has been gaelicized as *Baile Raghnaill* i.e. "town of Randal" in *GÉ* (35).

| **Shane's Castle Park** J 1088 | *Éadan Dúcharraige* "brow of black rock" | |
|---|---|---|
| 1. co hEden-Dubchairrgi, idon, co baile Cuinn, mic Aedha buidhe | AU iii 232 | 1470 |
| 2. Castel Edain-daubchairrgi, idon, castel Neill, mic Cuinn, mic Oeda buidhe | AU iii 348 | 1490 |
| 3. Caislén édain dubhcairrcce i. caislén neill mic cuinn mec aodha buidhe | AFM iv 1178 | 1490 |
| 4. caisdel Edain-dubhcharge | AU iii 596 | 1535 |
| 5. a Éduin aird Dubhchairge | LCABuidhe 145 §18 l.178 | 1680c |
| 6. Euduin Dubhchairrge | LCABuidhe 185 §25 l.145 | 1680c |
| 7. cúirt Dhubhchairrge | LCABuidhe 201 §29 l.150 | 1680c |
| 8. Edindukarig | Flem. Letter (MacDonnells Ant.) | 1565 |
| 9. Castle Mowbray al. Eden Doucarg | CSP Ire. 507 | 1573 |
| 10. Moubray | Ortelius Map | 1573 |

| | | |
|---|---|---|
| 11. Edendonchase | Ireland E. Coast | 1580c |
| 12. Edenduchar | Bagenal's Desc. Ulst. 157 | 1586 |
| 13. the castle of Edenduffcarrick | CSP Ire. 116 | 1588 |
| 14. Edendufcarick | Jobson's Ulster (TCD) | 1590c |
| 15. the castle of Edendocarge, Edenduffcarrick or Shane's Castle | CSP Ire. 423 | 1591 |
| 16. the Castle of Edendoughkery | CSP Ire. 428 | 1591 |
| 17. the Castle of Edendowkerry i.e. Shane's Castle | CSP Ire. 444 | 1591 |
| 18. (?)C. Moubray | Mercator's Ire. | 1595 |
| 19. Edendonchow | Mercator's Ire. | 1595 |
| 20. Edendonc. hau | Mercator's Ulst. | 1595 |
| 21. the castle of Edeirdocarrig | CSP Ire. 357 | 1597 |
| 22. the castle of Edenduscarrick | CSP Ire. 397 | 1597 |
| 23. Edendoucarick | Boazio's Map (BM) | 1599 |
| 24. Castle of Eden-dufcarrick | Ulster & Other Irish Maps xix | 1600c |
| 25. Castle Edendough-carricke | Bartlett Map (PRO) | 1601 |
| 26. Edenduff Carrick | Bartlett Map (Greenwich) | 1602 |
| 27. Edendufcarick | Bartlett Maps (Esch. Co. Maps) | 1603 |
| 28. Edendoughcarrick | Inq. Ant. (DK) 44,45 | 1605 |
| 29. (?)CastleMoubray | Inq. Ant. (DK) 50 | 1605 |
| 30. Edendough-carricke | CPR Jas I 77a | 1605 |
| 31. Edendoughcarrick | CPR Jas I 93a | 1606 |
| 32. Edendoughcarrick or Edenduffcarrick | Lodge RR Jas I i 251 | 1606 |
| 33. Edenduffe-Carricke | CPR Jas I 110b | 1607 |
| 34. Dendough Carrick cast. | Speed's Ulster | 1610 |
| 35. Ca Edend or Edenduff Carick | Norden's Map | 1610c |
| 36. Edenduffcarricke | CPR Jas I 324b | 1617 |
| 37. Edenduffcarrick | Lodge Fairs & Markets 2 | 1617 |
| 38. Edenduffcarrigg | Inq. Ult. (Antrim) §7 Jac. I | 1621 |
| 39. (?)Castlemowbrey | Inq. Ult. (Antrim) §7 Jac. I | 1621 |
| 40. Edenduffcarricke | Inq. Ult. (Antrim) §19,§20 Car. I | 1633 |
| 41. Edenduffcarricke | Inq. Ult. (Antrim) §32 Car. I | 1635 |
| 42. Edenduffecarricke | Inq. Ult. (Antrim) §34 Car. I | 1635 |
| 43. Edenduffcarricke | Inq. Ult. (Antrim) §106,107 Car. I | 1636 |
| 44. Edenduffcarricke | Inq. Ult. (Antrim) §113–116 Car. I | 1636 |
| 45. Edenduffcarricke | Inq. Ult. (Antrim) §121,122 Car. I | 1637 |
| 46. Edenduffcarricke | Inq. Ult. (Antrim) §124–127 Car. I | 1637 |
| 47. Edenduffcarrick | Exch. Deeds & Wills 702 | 1637 |
| 48. Edenduffcarrige | Lodge RR Chas I i 106 | 1637 |
| 49. Edenduffcarricke | Inq. Ult. (Antrim) §137 Car. I | 1640 |
| 50. Edenduffcarricke | Inq. Ult. (Antrim) §142 Car. I | 1641 |
| 51. Shanes Castle | Civ. Surv. x §64a | 1655c |
| 52. Edenduffcarrick, Manor of | BSD 135a | 1661 |
| 53. Edenduffe Carrick | BSD 135a | 1661 |
| 54. half town and lands of Edenduffecarricke | Lodge RR Chas II i 106 | 1663 |

| | | |
|---|---|---|
| 55. Edenduffcarrigge | EP Edenduffcarrick | 1666 |
| 56. Edenduffcarricke | ASE 106 a 1 | 1667 |
| 57. Edenduffecarricke | ASE 106 a 1 | 1667 |
| 58. Edenduffcarrick | HMR Ant. 139 | 1669 |
| 59. Shanscastle . . . or Edenduff Carrick | Dobbs' Descr. Ant. 385-6 | 1683 |
| 60. Edenduffcarrick | Comm. Grace 10 | 1684 |
| 61. Edenduffcarrick | Lodge RR Chas II ii 292 | 1684 |
| 62. Edenduffecarrick | Forfeit. Estates 365b §58 | 1703 |
| 63. Ed[en] Duffcaricke | Grand Jury Pres. 8 | 1711 |
| 64. Shane's Castle | Grand Jury Pres. 31 | 1713 |
| 65. viledge of Edenduffcarrick | Grand Jury Pres. 38 | 1713 |
| 66. village of Eddenduff | Grand Jury Pres. 172 | 1717 |
| 67. town of Shane's Castle | Belfast News Letter Oct. 21 | 1766 |
| 68. Deer Park | Lendrick Map | 1780 |
| 69. Edenduffcarick | Lendrick Map | 1780 |
| 70. Demesne | Duff's Lough Neagh | 1785 |
| 71. Deer Park | Duff's Lough Neagh | 1785 |
| 72. Edenduffcarrick | Duff's Lough Neagh | 1785 |
| 73. Shanescastle | Reg. Deeds 392-313-259014 | 1787 |
| 74. demesne of Shane's Castle | Statist. Sur. Ant. 229 | 1812 |
| 75. Shanescastle | Reg. Deeds 660-290-457358 | 1813 |
| 76. Edenduffcarrick | Reg. Deeds 756-26-523561 | 1820 |
| 77. Demesne | Bnd. Sur. | 1825 |
| 78. Shane's Castle tl. i.e. John O'Neill's Castle | J O'D (OSNB) A 4 | 1830 |
| 79. Shane's Castle Park – "Edenduffcarrick is the old name" | OSNB A 41 162 | 1830 |
| 80. Éadan Dubh-chairrge "Brow of black rock" | J O'D (OSNB) A 41 162 | 1830 |
| 81. "the black face of stone" | OSM xix 67b | 1838 |
| 82. "the dark face of the rock" | EA 86 | 1847 |
| 83. Edan-dubh-Cairrge "the black front, or brow of the rock" | O'Laverty iii 297 | 1884 |
| 84. Edan Dubh Cairrge "The Black Slope Rock" | PSAMNI 41 | 1940 |
| 85. 'ʃeːnz 'kasəl 'pɑrk | Local pronunciation | 1987 |

The historical townland of Edenduffcarrick appears to be represented by the south-east corner of Shane's Castle Park townland which includes the ruins of the famous O'Neill castle known as Shane's Castle (formerly Edenduffcarrick), along with the small townland of **Shane's Castle** in the parish of Antrim. The very large modern townland of Shane's Castle Park (c. 2000 acres) clearly owes its origin to the creation of a castle demesne in the late 18th century, and it has absorbed portions of the neighbouring townlands on both sides of the river Main. In addition, it appears to comprise two townlands whose names are now obsolete, i.e. *Gilnedin* on the west bank of the Main and *Bunmany* on the east (see parish introduction). In the absence of sufficient evidence, it is impossible to establish the derivation of

these obsolete names, but one might tentatively suggest that *Bunmany* may be derived from Irish *Bun Meana* "foot of the Main".

*Edenduffcarrick* is now obsolete as a townland name, but part of it is preserved in the shortened form **Edenduff**, which is now applied to a row of houses in the neighbouring townland of Shane's Castle, just outside the demesne of Lord O'Neill. There was formerly a village named Edenduffcarrick, immediately adjoining the old castle, but the houses were knocked down in 1803–4 and the land on which they stood was added to the demesne (*OSM* xix 64a). The villagers were subsequently re-housed in the row of houses now known as Edenduff.

In form 1, *Edenduffcarrick* is described as *baile Cuinn, mic Aedha buidhe*, i.e. "the castle(?) of Conn, son of yellow Hugh". While *baile* in place-names is often interpreted as "townland", there is evidence that in the medieval period it could be used to signify a stronghold or castle, possibly with accompanying houses (Price 1963, 121) and this may be the sense in which it is used in this entry. The Conn referred to was ruler of the O'Neill sub-kingdom of Clandeboy from 1468 until his death in 1482 (*NHI* ix 143). By 1490, the castle had passed into the hands of Niall, son of Conn (2). This was Niall Mór, who ruled from 1482 to 1512, and was the last lord of united Clandeboy before it was divided into Upper and Lower sections (*ibid.*).

Both Reeves and O'Laverty have understood the adjective *dubh* "black" in the name of the townland to refer to the element *éadan* "brow, face", and interpreted the place-name as "the dark face of the rock" (82) and "the black front, or brow of the rock" (83) respectively. A similar interpretation is suggested in the *Ordnance Survey Memoir*, i.e. "the black face of stone" (81) and in the *Preliminary Survey of the Ancient Monuments of Northern Ireland*, i.e. "The Black Slope Rock" (84). However, it is clear from the Irish language versions of the place-name (1–7) that the adjective *dubh* "black" is a prefix, qualifying the word *carraig* "rock", and that the correct interpretation of the name is "brow of black rock", as suggested by O'Donovan (80). In a late 17th-century bardic poem which is entirely devoted to the castle it is referred to as: *a Éduin aird Dubhchairge*, i.e. "O high Brow of Black Rock" (5) and *cúirt Dhubhchairrge*, i.e. "court/mansion of Black Rock" (7). In standard Irish the final *-bh* of *dubh* "black" is dropped, with compensatory lengthening of the *u*, resulting in the form *Éadan Dúcharraige* "brow of black rock".

While the original Irish form of the place-name is not in doubt it is difficult to identify with certainty the feature to which it refers. The element *éadan*, which literally means "front/face", is often used figuratively in place-names to refer to the brow of a hill (*Joyce* i 523). However, since there is no such natural feature in the immediate vicinity one is led to suggest that the place-name may have been coined to refer to the castle itself. The element *éadan* would therefore refer to the front or face of the castle and symbolically to the whole building. The final element, i.e. *dúcharraig* "black rock", could refer either to the material from which the castle was constructed or, as suggested by Dobbs, to "the Black Rock it stands on" (*Dobbs' Descr. Ant.* 386). It could also refer to "the black crags or little cliffs extending westwards from the castle along the shore" (*OSM* xix 68a). It is also possible that the place-name may owe its origin to the ancient carved head of black rock (known as "the black head of the O'Neills") which is mounted on the wall of the oldest surviving portion of the castle and concerning which there is a tradition that if the head falls so also will the family of O'Neill. The name *Éadan Dúcharraige* "face of black rock" could have originally applied to this head and thence come to be applied to the castle and later to the townland. The suggestion in the *Preliminary Survey of the Ancient Monuments of Northern Ireland* that the name Edenduffcarrick originally applied to a steep rocky cliff on the bank of the river Main beside the motte-and-bailey at Dunmore or Randalstown (*PSAMNI* 41) is also

worthy of consideration. While it is unlikely that the townland of Edenduffcarrick ever extended as far as this point (which is about two miles north west of the site of Shane's Castle) it is conceivable that Edenduffcarrick could have been used as an alternative name for the motte-and-bailey at Dunmore (with reference to its location) and that the name could have been transferred to Shane's Castle, perhaps after the O'Neills gained control of the area in the middle of the 14th century.

In form 9 *Castle Mowbray* is given as an alias name for the castle and this name also appears in a number of later sources (10, 18, 29, 39). According to the *Preliminary Survey of the Ancient Monuments of Northern Ireland* this area was reputed to have been allotted to an early Anglo-Norman settler named De Mowbray and the castle referred to in English records as Castle Mowbray and in the Irish Annals as *Éadan Dúcharraige* was in fact the motte-and-bailey of Dunmore or Randalstown (*PSAMNI loc. cit.*). However, while it is conceivable that the name *Éadan Dúcharraige* could have been transferred from Dunmore to Shane's Castle, the *bona fide* of *Castle Mowbray* as an alias name for Edenduffcarrick is open to question. It is perhaps more likely that *Castle Mowbray* is in fact to be identified with the *ruinous castle of Moubray alias Cloghanmabree* (*Inq. Ant. (DK)* 44) which lay to the south of Shane's Castle near Muckamore Abbey and that the name has been mistakenly applied to Shane's Castle in 1573 and the error duplicated in a number of later forms. O'Laverty (iii 249) interprets *Cloghanmabree* of the Antrim Inquisition as "*Cloch na mbrathar* – the castle of the friars". In the absence of further evidence, it is impossible to judge the accuracy of this interpretation.

The modern name Shane's Castle, which is documented as early as 1591 (15), undoubtedly derives from Shane mac Brian mac Phelim O'Neill, ruler of Lower Clandeboy from 1595 to 1617, who was the first of the Clandeboy O'Neills to bear this forename. However, since the oldest portion of the castle still standing is a square tower-house which has been dated to the late 15th or early 16th century (Lawlor 1928, 153), it could not have been built by this Shane. The castle was probably named "Shane's Castle" in the late 16th century because it was Shane mac Brian mac Phelim who was in residence there when the area was first surveyed by the English at this period.

| **Sharvogues** | *Na Searbhóga* | |
|---|---|---|
| J 1095 | "the bitter/acidic lands(?)" | |
| 1. Servoge or Servage | Bnd. Connor Par. | 1604 |
| 2. Ballineservoge | Lodge RR Chas I i 407 | 1637 |
| 3. Ballynasharvog | Civ. Surv. x §65b | 1655c |
| 4. Ballyneservoge | BSD 135a | 1661 |
| 5. Ballynesarragg | Inq. Ult. (Antrim) §8 Car. II | 1663 |
| 6. Ballenescrougy | Lodge RR Chas II i 106 | 1663 |
| 7. Ballynesarrnagg or | | |
|    Ballynefarrnagg | Lodge RR Chas II i 106 | 1663 |
| 8. Ballyneservage | EP Edenduffcarrick | 1666 |
| 9. Servages | HMR Ant. 140 | 1669 |
| 10. Ballyneseroge | Comm. Grace 10 | 1684 |
| 11. Ballyneserroge or Ballyneservoge | Lodge RR Chas II ii 292 | 1684 |
| 12. Sharvagh | Williamite Forf. | 1690s |
| 13. Sharvogs | Reg. Deeds 89-414-63860 | 1738 |
| 14. Ballyneservoges | Reg. Deeds 90-171-61470 | 1739 |
| 15. Sharvogs | Belfast News Letter July 4 | 1739 |

| | | |
|---|---|---|
| 16. Sharvoge | Grand Jury Pres. (Summer) | 1777 |
| 17. Sharvogs | Lendrick Map | 1780 |
| 18. Sharvogs | Grand Jury Pres. (Lent) | 1799 |
| 19. Sharvogues | OSNB A 41 162 | 1830 |
| 20. Searbhóga "land abounding in dandelions" | J O'D (OSNB) A 41 162 | 1830 |
| 21. "dandelion or land producing dandelion" | Joyce ii 29 | 1875 |
| 22. 'ʃɑːrvoːgz | Local pronunciation | 1987 |

A large part of this townland consists of bog, but there are several portions of cultivated land. The most satisfactory Irish form of the place-name is *Na Searbhóga* but it is questionable if the most appropriate interpretation is "dandelion/land abounding in dandelion" as previously suggested (20, 21). The word *searbhóg* is not attested in the sense of "dandelion". Ó Dónaill gives *searbhóg mhilis* "bittersweet" while Dwelly cites the Scottish Gaelic word *searbhàg* "small pale-green, sorrel-tasting trefoil, growing in cool, shady places" (*Dwelly* sv.). The latter may indicate the presence of an Irish word *searbhóg* with a similar meaning, or perhaps as a variant form of *searbhán* which is attested in the sense of "bitter herb" (*Ó Dónaill* sv.) and "a wild variety of oats, oat-corn, dandelion" (*Dinneen* sv.). *Na Searbhóga*, therefore, could represent a simple plural form of *searbhóg*, signifying, perhaps, "bitter herbs/wild oats/dandelions".

It is also possible that the place-name derives from the word *searbh* plus the diminutive ending *-óg* which often has the significance of "place of" (*Joyce* ii 19). *Searbh* is cited by Ó Dónaill as a variant form of *searbhán*, which, as referred to above, has a range of meanings. *Na Searbhóga*, then, could have the significance of, for example, "the places of bitter herbs/wild oats/ dandelions". However, given the fact that most of the townland is bog, it is perhaps more likely that the name is derived from the adjective *searbh* "bitter, sour, acid" plus the diminutive termination *-óg* and that the most appropriate interpretation is "bitter, acidic lands".

Many of the earlier recorded spellings contain the prefix *Ballyna-/Ballyne-*, and it appears likely that the Irish form *Baile na Searbhóg* "townland of the bitter, acidic lands" was also for a time in use.

**Tamlaght**
J 0796

*Tamhlacht*
"(pagan) burial-place"

| | | |
|---|---|---|
| 1. Tamleagh | DS (Par. Map) Drummaul | 1657c |
| 2. Tamleagh | Hib. Reg. Toome | 1657c |
| 3. Tumleagh | BSD 135 | 1661 |
| 4. Tomlogh | HMR Ant. 157 | 1669 |
| 5. Tomleagh | Hib. Del. Antrim | 1672c |
| 6. Tamlagh | Lendrick Map | 1780 |
| 7. Tamlogh | Grand Jury Pres. (Spring) | 1787 |
| 8. Tamlagh | Grand Jury Pres. (Summer) | 1787 |
| 9. Tamlough | Bnd. Sur. | 1825 |
| 10. Tamlaght | OSNB A 41 162 | 1830 |
| 11. Tamlaght | Tithe Applot. | 1834 |
| 12. Tamhlaght "burial-ground" | J O'D (OSNB) A 41 162 | 1830 |
| 13. 'tamlə | Local pronunciation | 1987 |

As this was one of the four Church townlands of the parish of Drummaul, documentation of the place-name is scarcer than normal. In spite of the absence of the final -*t* from all the recorded spellings prior to 1830, the name of the townland is clearly derived from Irish *Tamhlacht* "(pagan) burial-place". The place-name *Tamhlacht* is a fairly common one, there being in all twenty-five townlands (mainly in the north of Ireland) whose names appear to derive from this Irish form, and in almost all of these the element stands alone without a qualifier, suggesting that the place referred to was a unique feature of the locality, requiring no distinguishing qualifying element. In the earlier language, the medial -*mh*- of *tamhlacht* would have been pronounced as a nasalized [v], but by the 17th century it would have been weakened to a nasalized [w]. In the process of anglicization, medial -*mh*- is often represented as either *m* (as in this case) or *n* (as in the case of **Cranfield** < *Creamhchoill* "wild-garlic wood"), which is a reflection of the residual nasal quality of the original Irish sound. The absence of the final -*t* from all the earlier spellings suggests that it had disappeared in speech before the name was first documented c. 1657 and that its presence in the modern form of the place-name is due to the imposition of a standardized spelling by the Ordnance Survey in 1830 (10).

The element *tamhlacht* originally denoted a pagan burial place, but it is of fairly common occurrence in the names of early ecclesiastical sites, as Christian churches were often constructed on sites of pagan burial (Flanagan 1981–2(c), 74). It is surely no mere coincidence that this townland is bordered by the townland of Drummaul, which contains the site of the former parish church of the same name. There is now neither trace nor record of a burial-place in the townland.

| **Tannaghmore** | *An Tamhnach Mhór* | |
|---|---|---|
| J 0592 | "the large field/clearing" | |
| 1. Ballytawvenaghmore or | | |
|    Ballytawnaghmore | Lodge RR Chas I i 407 | 1637 |
| 2. Ballytawnaghmore | BSD 135b | 1661 |
| 3. Tavnaghmore | Lodge RR Chas II i 106 | 1663 |
| 4. Townamore | HMR Ant. 143 | 1669 |
| 5. Ballytawnaghmore | Inst. Edenduffcarrick | 1672c |
| 6. Ballytownaghmore | Comm. Grace 10 | 1684 |
| 7. Ballytownaghmore or | | |
|    Ballytawnaghmore | Lodge RR Chas II ii 292 | 1684 |
| 8. Ballytownaghmore West | Reg. Deeds 90-172-62470 | 1739 |
| 9. Taunaghmore West | Lendrick Map | 1780 |
| 10. Tavnaghmore West | Duff's Lough Neagh | 1785 |
| 11. Tannaghmore | Reg. Deeds 487-435-311111 | 1792 |
| 12. Tannagmore West | Reg. Deeds 660-290-457358 | 1813 |
| 13. Ballytownagmore West | Reg. Deeds 756-26-513561 | 1820 |
| 14. Tannaghmore | OSNB A 41 162 | 1830 |
| 15. Tamhnach Mór "great field" | J O'D (OSNB) A 41 162 | 1830 |
| 16. 'ta:nəx'mo:r | Local pronunciation | 1987 |

The word *tamhnach* is variously defined as "a cultivated or arable spot in a waste; a green field" (*Dinneen*); "a grassy upland; arable place in mountain" (*Ó Dónaill*); "a green field which produces fresh sweet grass" (*Joyce* i 231); "a clearing, a patch of good land surrounded by bog" (de hÓir 1980–1, 6). In the case of this townland, the local conditions clearly ren-

der the interpretation "grassy upland, arable place in mountain" inappropriate and "green field" or "clearing" seems the most suitable explanation. The *OS 6-inch* map of 1834 shows a large area of bog in the north-west of the townland, and there is also a large bog in the neighbouring townland of Groggan, which would support the interpretation of *tamhnach* as a piece of grassy or fertile land on the edge of infertile terrain. *Tamhnach* is very common in the place-names of Ulster and Connaught, and it can be anglicized as *Tawnagh*, *Tawny*, *Tavanagh*, *Tavnagh*, *Tauna*, *Tannagh*, *Tamna(gh)*, *Tamny* etc. The recorded spellings of this place-name suggest that by the 17th century the medial *-mh-* of *tamhnach* (originally a nasal [v]) had been vocalized, hence forms such as *Ballytawnaghmore* (2) and *Townamore* (4). As pointed out above in the discussion of **Tamlaght**, medial *-mh-* is often anglicized as *m* or (as in this case) *n* due to the residual nasal quality of the original Irish sound.

In some of the later versions, the name of the townland is followed by the qualifying element "West". This is obviously to distinguish it from the townland named **Tavnaghmore** which lies a few miles to the east, in the Grange of Shilvodan, and whose name is pronounced "Tannaghmore", in spite of the difference in spelling.

| | | | |
|---|---|---|---|
| **Terrygowan** | *Tuar Gabhann* | | |
| J 0595 | "the cattle-field/pasture of the smith" | | |
| 1. Towergoan | Lodge RR Chas I i 407 | 1637 | |
| 2. Half town of Towergoan | BSD 135b | 1661 | |
| 3. Bowergowan + townland | Lodge RR Chas II i 106 | 1663 | |
| 4. Towergan | EP Edenduffcarrick | 1666 | |
| 5. ½ of Towergoan | Comm. Grace 10 | 1684 | |
| 6. Half of Towergoan | Lodge RR Chas II ii 292 | 1684 | |
| 7. Towergoan | Reg. Deeds 10-133-3227 | 1712 | |
| 8. Ballyturrygowan | Reg. Deeds 54-76-34930 | 1722 | |
| 9. Towergouan | Reg. Deeds 90-171-62470 | 1739 | |
| 10. Turrygowan | Belfast News Letter Oct. 14 | 1763 | |
| 11. Terrygowan | Lendrick Map | 1780 | |
| 12. Terrygowan | Duff's Lough Neagh | 1785 | |
| 13. Terrygowan | Reg. Deeds 660-290-457358 | 1813 | |
| 14. Terrygowan | OSNB A 41 162 | 1830 | |
| 15. Tír Uí Ghabhann "O'Gowan's land" | J O'D (OSNB) A 41 162 | 1830 | |
| 16. ˌtɛriˈgəuən | Local pronunciation | 1987 | |

*Ow* in 17th-century English spellings often represents the sound [u:] (*GUH* 33), and the first element of the place-name is likely to be *tuar* "cattle-field, pasture", rather than *tír* "land, district", as suggested by O'Donovan (15). The element *tuar* has a wide range of meanings including "land, a field, paddock or pasture . . . a night-field for cattle, a bleach-green or -yard; dung, ordure, etc." (*Dinneen* sv.); "dung, manure; manuring of land, manured land, cattle-field, sheep-run, pasture, lea, bleaching-green (*Ó Dónaill* sv.). According to Joyce, *tuar* in place-names signifies "primarily a bleach-green, or where things are spread out to dry, secondarily a home-field where cows graze and are fed or milked" (*Joyce* i 236). In the absence of any evidence of a bleach-green in the townland, *tuar* in this case seems best interpreted as "cattle-field" or "pasture." It is difficult to account for the presence of the medial *-y-* in the modern version of the place-name, which is first recorded in 1763 (10). It is perhaps best

understood as an epenthetic vowel, or perhaps a form of the place-name incorporating the Irish definite article, i.e. *Tuar an Ghabhann*, later developed. Again, it is possible that the anglicized form of the place-name has been influenced by the name of the nearby townland of Tullygowan in the parish of Ahoghill.

A number of 17th-century documents refer to a now-obsolete townland named *Towerknapagh* (*Lodge RR* Chas II ii 292 *et. al.*) which was clearly situated in this area and whose name may be derived from Irish *Tuar Cnapach* "lumpy/knolly cattle-field/pasture" but in the absence of further information this suggestion is a tentative one.

<div align="center">OTHER NAMES</div>

| | | |
|---|---|---|
| **Call Hill** | Of uncertain origin | |
| J 1191 | | |
| | | |
| 1. 'kɔl 'hïl | Local pronunciation | 1987 |

This name is applied to a small hill with a farmhouse on its summit, in the townland of Lenagh. Call Hill could represent an anglicization of Irish *Collchaill* "hazel-wood", the final element of the name i.e. *coill* "wood" being corrupted by English speakers to English "hill", a corruption which is well-attested in Irish place-names (*Joyce* i 40). Thus, a name which was originally coined to refer to a wood (which may have been either on the hill or in the near vicinity) could have come to be applied to the little hill. Another possibility is that the first element of the name is the surname Coll which, according to Bell (1988, 37), is of Donegal origin, from Gaelic *Mac Colla*, "the name of a galloglass family introduced there from Argyllshire in the sixteenth century". If this be the case, one might expect the hill to be named Coll's Hill rather than Coll Hill, though the possessive *s* is sometimes omitted in names of this type (for example, **Corrigan Hill** in the parish of Magheralin in Co. Armagh). The forename Col is also attested as a shortened form of Colin. All in all, the lack of documentary evidence prevents one from drawing a firm conclusion as to the origin of the place-name. An improbable account of the origin of the name is given in the *OSRNB* of c.1858 (sheet 43) which states that the name of the hill originated with one Arthur Heart who at one time lived on it and whose voice was so powerful that it was heard by people two or three miles away!

| | | |
|---|---|---|
| **Carney Hill** | A hybrid form | |
| J 0697 | | |
| | | |
| 1. 'kɑrni 'hïl | Local pronunciation | 1987 |

This is a low, flat-topped hill, situated in the east of the townland of Ballymacilroy. The name appears likely to be an Irish-English hybrid, but it is difficult to determine its original form with any certainty. Several possible derivations for the first element suggest themselves, including the adjectives *carnach* "full of cairns" and *cearnach* "angular-shaped" as well as the surname *Mac Cearnaigh* "Kearney", a name which is fairly common in this area. However, in view of the fact that the *OSRNB* (sheet 37) remarks that "large quantities of coarse gravel were taken from the hill to repair roads", the most satisfactory interpretation of the first element of the name appears to be *carnaigh*, an oblique form of *carnach* which is made up of the noun *carn* "cairn" plus the collective ending *-ach* "place of" and may have the significance of "place of cairns" or, more probably in this case, "place of rocks". It is worth noting the Scottish Gaelic noun *càrnach* which is defined as "stony ground, quarry – used as

<div align="center">69</div>

the names of several places having a stony or rocky situation" *Dwelly* sv. (see **Carneyhill** in the parish of Donaghadee, Co. Down (*PNI* ii 188–9)).

| **Connell Hill** | Of uncertain origin | |
|---|---|---|
| J 1191 | | |
| 1. ˌkɔnəl 'hïl | Local pronunciation | 1987 |

The *OSRNB* of c.1858 (sheet 43) describes Connell Hill in the townland of Drumsough as a "village of three farm houses without offices on a small hill" and suggests that it was named from a man named Connell who occupied the place at that time. While one would therefore expect the hill to be named Connell's Hill, rather than Connell Hill, the possessive *s* appears to be sometimes omitted in names of this kind (see **Call Hill** above), and this explanation of the origin of the place-name is worthy of consideration. It is also possible that the name of the hill was originally "Colin Hill" and that it has developed to Connell Hill as a result of metathesis. The first element could therefore be derived from Irish *Collann* "place of hazel", *Cuileann* "holly" or *Cuilleann* "a steep slope", but it is impossible to say which of these (if any) is the most likely. The origin of the place-name therefore remains obscure.

| **Crock** | *An Cnoc* | |
|---|---|---|
| J 0991 | "the hill" | |
| 1. krɔk | Local pronunciation | 1987 |

This is the name of a small hill with several houses on its summit, in the townland of Magheralane and near the southern boundary of the large flow-bog known as Sluggan Moss. It is not a conspicuous height, but given the flat nature of the surrounding terrain it is easy to see why it would have been referred to as a hill. Historically, the Irish word *cnoc* would have been pronounced as [knɔk], but in Northern Irish the [n] came to be sounded as [r], a change which may have occurred during the course of the 17th century (O'Rahilly 1932, 22–3). The fact that the *n* of *cnoc* is here sounded as [r] proves that it was after that period that this name was anglicized.

| **Doss** | *Dos* | |
|---|---|---|
| H 9986 | "bushy tree/thicket" | |
| 1. Doss | Lendrick Map | 1780 |
| 2. Doss | Duff's Lough Neagh | 1785 |
| 3. dɔːs | Local pronunciation | 1987 |

This name is well-known in the locality, and refers to a small area which borders on the north-west corner of Lough Neagh, in the "detached portion" of the townland of Portlee. It is chiefly known for its small fishing-port, beside which there stands a very old and badly decayed ash-tree, locally known as "Doss Tree". The name is derived from Irish *dos* which in the earlier language signified "bushy tree, a tall tree with a thick branching head . . . a bush, bramble or thicket" (*DIL* sv.), and in Mod. Ir. means "bush, tuft; copse, thicket" (*Ó Dónaill* sv.). It is likely that it was originally applied to the aforementioned tree, or to a thicket of which Doss Tree is the last remnant. On *Lendrick's Map of Co. Antrim* (1780), and on *Duff's Lough Neagh* (1785), Doss is shown as a townland, corresponding to the "detached portion" of Portlee. However, it is not documented as a townland in any other source.

| **Farranflough** | *Fearann Fliuch* | |
|---|---|---|
| J 1290 | "wet district" | |
| 1. ˌfɑrən'flox | Local pronunciation | 1987 |

Although this place-name is omitted from the *OS 1:50,000* map (see *OS 1:10,000* sheet 95), it is a well-known one in the area. It is a small hamlet in the east of the townland of Drumsough. The name is clearly derived from Irish *Fearann Fliuch* "wet district", and refers to the wet nature of the land in the little hollow in which it is situated. An alternative local name for Farranflough is Flughey, which appears to derive from Irish *Fliuchaigh*, an oblique form of *fliuchach* "wet place". There was formerly a school here, named "Farinflough National School". It was opened in 1834 and was closed approximately 25 years ago.

| **Knockaphort** | *Cnoc an Phoirt* | |
|---|---|---|
| H 9986 | "hill of the port/harbour" | |
| 1. Nockafort | Lendrick Map | 1780 |
| 2. Knockafurt Point | Duff's Lough Neagh | 1785 |
| 3. Ballynaleany also called | | |
|    Knockafurt | OS Name Sheets | 1830 |
| 4. ˌnɔkə'fort | Local pronunciation | 1987 |

The fact that Irish *cnoc* "hill" is here pronounced as English "knock" suggests that the place-name was coined before the -*n*- of *cnoc* came to be pronounced as [r] in northern Irish (see **Crock** above). Knockaphort is a tiny settlement adjacent to Lough Neagh in the "detached portion" of the townland of Ballynaleney. There is only a slight rise in the terrain here, but given the flatness of the land in the vicinity it is easy to see how it would have been designated a hill. The final element of the place-name i.e. "port, harbour" may refer to the little harbour of **Doss** which lies a short distance to the west. *Lendrick's Map of Co. Antrim* (1780) marks *Nockafort* as a townland, corresponding to the "detached portion" of Ballynaleney. However, as in the case of Doss, it is not documented as a townland in any other source.

| **Lisconaye** | *Lios Cinn Eich* | |
|---|---|---|
| J 0896 | "fort of the horse's head" | |
| 1. Liskerry | Bnd. Connor Par. | 1604 |
| 2. Ballyliskeneagh or | | |
|    Ballylickuneagh | Lodge RR Chas I i 407 | 1637 |
| 3. Ballyliskenagh | BSD 135b | 1661 |
| 4. Ballyliskeny | Lodge RR Chas II i 106 | 1663 |
| 5. Ballylickeneagh | EP Edenduffcarrick | 1666 |
| 6. Ballylickenagh | Comm. Grace 10 | 1684 |
| 7. Ballylickineagh | Lodge RR Chas II ii 292 | 1684 |
| 8. Liskenenagh | Reg. Deeds 10-133-3227 | 1712 |
| 9. Ballylickemeagh | Reg. Deeds 90-171-62470 | 1739 |
| 10. Lisconnick | Grand Jury Pres. (Summer) | 1788 |
| 11. Lisconey | Grand Jury Pres. (Summer) | 1788 |
| 12. ˌlisko'nai | Local pronunciation | 1987 |

This name is applied to a dwelling house and small farm of land situated on a hill on the west bank of the river Main. It was formerly a townland in its own right, and is so documented from 1604 onwards. However, it has long been incorporated in the townland of Andraid. The *OSRNB* of c.1858 (sheet 37) suggests that the place-name may signify "the fort above the ford", no doubt from Ir. *Lios Os Cionn Átha*, the final element referring to the former ford at the village of Andraid. While this interpretation of the place-name cannot be ruled out, it is perhaps more likely that the name is from Ir. *Lios Cinn Eich* "fort of the horse's head". *Ceann Eich* "horse's head" is the Irish form of the name of the parish of Kinneigh in Co. Cork and the townland of Kinnyagh in Co. Wexford (*Onom. Goed.* 203). There is also a place named *Áth Cinn Con* "ford of the dog's head" in Co. Westmeath (*ibid.* 55), a place named *Leacht Cinn Con* "cairn of the dog's head" near the Mourne Mountains in Co. Down (*ibid.* 480) and a stone fort named *Cathair Chinn Con* "fort of the dog's head" in Co. Limerick (*ibid.* 168). There is now no trace or record of a fort at Lisconaye.

**Main, River**  *An Mhin*
J 0893  "the river/water(?)"

| | | | |
|---|---|---|---|
| 1. | Min abhann mor | Fél. Óeng. Sep. 16 p 209 | 830c |
| 2. | occ Rubha Mena | AFM ii 624 | 928 |
| 3. | oc Rubu Mena | AU (Mac Airt) 380 | 930 |
| 4. | Rubha-Mena "the point of the river Men" | Mart. Don. 251n | 1630c |
| 5. | triath Meana | LCABuidhe 143 §28 l.144 | 1680c |
| 6. | gég Mheana | LCABuidhe 183 §25 l.79 | 1680c |
| 7. | meighre Mena | LCABuidhe 219 §34 l.31 | 1680c |
| 8. | meighre Meana | LCABuidhe 224 §35 l.123 | 1680c |
| 9. | eó Meana | LCABuidhe 229 §36 l.89 | 1680c |
| 10. | Owen Myn | Inq. Ant. (DK) 43 | 1605 |
| 11. | Myn Water | Inq. Ant. (DK) 45 | 1605 |
| 12. | Mynewater | Inq. Ant. (DK) 45 | 1605 |
| 13. | Mynwater | Inq. Ant. (DK) 45 | 1605 |
| 14. | Owenmyn | Inq. Ant. (DK) 45 | 1605 |
| 15. | Owen-Myn | CPR Jas I 93a | 1606 |
| 16. | Mynwater | CPR Jas I 93b, 94a | 1606 |
| 17. | Minewater | CPR Jas I 114a | 1607 |
| 18. | the Mayne Water | Lodge Fairs & Markets 2 | 1637 |
| 19. | the Mayne Water | Civ. Surv. x §54b | 1655c |
| 20. | Mayne water | Civ. Surv. x §64b | 1655c |
| 21. | Mayne Water | Civ. Surv. x §65ab, §66b | 1655c |
| 22. | the Mayne Water | Civ. Surv. x §66ab, §67a | 1655c |
| 23. | An Mhean | GÉ 136 | 1989 |
| 24. | ðə 'miən 'rïvər | Local pronunciation | 1987 |

The name of the river Main is recorded as *Min* in the 9th-century *Félire Óengusso* (1). No suitable interpretation of the word *min* is found in *DIL* and it is difficult to be sure of its exact meaning. However, Wagner (1979, 32) has suggested that the name of the river is related to O. Ir. *Mana*, Welsh *Manaw*, the name of the Isle of Man. He suggests that it is also connected with Welsh *Menai*, the name of the stretch of water between Anglesey and the Welsh main-

land, and with *Môn*, the Welsh name for Anglesey itself. According to Wagner, all these names appear to contain a common element meaning "river", "sea", or "water" in general. In the absence of any other feasible explanation of the place-name, Wagner's interpretation must be regarded as the most satisfactory.

In the earliest reference to the river in c. 830 AD it is described as *abhann mor atá etir Dalaraide 7 Cenel n-Eogain* i.e. "a great river which is between Dál nAraide and Tyrone" (*Fél. Óeng.* Sep. 16 p 209). The description of the location of the river is not entirely accurate, since at that time the kingdom of Dál nAraide would have stretched as far west as the Bann. However, there is no doubt that the river referred to as *Min* is to be identified with the River Main.

In *GÉ* the Irish form of the name of the river is *An Mhean* (23). However, the weight of the documentary evidence is in favour of the form *An Mhin*, with a genitive form *Na Meana*. The name may have been anglicized "Main" by analogy with the English word "main".

| **Mainwater Foot** | *Rubha Meana* | |
|---|---|---|
| J 0986 | "point or promontory of the Main" | |
| 1. occ Rubha Mena | AFM ii 624 | 928 |
| 2. oc Rubu Mena | AU (Mac Airt) 380 | 930 |
| 3. Rubha-Mena "the point of the river Men" | Mart. Don. 251n | 1630c |
| 4. ˌmiənwater 'fǫt | Local pronunciation | 1987 |

There is a prominent point of land here, where the river Main flows into Lough Neagh. It is noteworthy as being the place where the Vikings, under the command of Torolbh, set up their camp, on taking up their station on Lough Neagh in 928 AD (*AFM* ii 624). *DIL* cites *rub(h)a* as a "word of doubtful meaning frequent in place-names" (*DIL sv. 2 ruba*). However, Stokes (*Rev. Celt.* xiv 447) has identified *rub(h)a* with the Scottish Gaelic word *rudha* "a point of land, promontory" (*Dwelly* sv.) and this is undoubtedly its meaning in this place-name. This element is of fairly common occurrence in Scottish place-names and is also quite common on Rathlin Island where there is a very prominent headland known as **Rue Point** (<*An Rubha* "the point") (Mac Giolla Easpaig 1989–90, 88). *Rubha* also forms the first element of the names of the townlands named **Rowreagh** and **Rowbane** in the Ards Peninsula in Co. Down, but in both these cases it appears to mean "clearing", the names signifying "variegated clearing" and "white clearing" respectively (*PNI* ii 93, 110).

| **Muddyderg** | *Maide Dearg* | |
|---|---|---|
| J 1087 | "red stick-bridge" | |
| 1. ˌmǫdʒi'gɛ:rǐk | Local pronunciation | 1987 |
| 2. ˌmǫdʒi'dɛrg | Local pronunciation | 1987 |

The *OSRNB* of c. 1858 (sheet 49) records the place-name as *Mudgy derg* (a spelling amended by O'Donovan to *Muddyderg*) and remarks that it is said to mean "red twigs". The Irish form suggested by O'Donovan is *Maididhe Dearga* (Mod. Ir. *Maidí Dearga*) "red sticks". However, the modern form of the name would support the singular form *Maide Dearg*, since a final unstressed -*e* is often anglicized as *y* (cf. the anglicization of Irish *baile* as "bally"), and this appears a more plausible interpretation. A local pronunciation which I recorded from an elderly informant is [ˌmǫdʒi'gɛ:rǐk]. The pronunciation of the initial letter

of the final element as [g] rather than as [d] is most likely due to the process of dissimilation from the *d* of *maide*, while the pronunciation of the final letter of the place-name as [k] may be due to the tendency of English speakers to devoice stops in final unstressed position (O'Rahilly 1932, 147n), though it is also possible that it could be the result of further dissimilation from the (unhistorical) initial [g] of the final element. The pronunciation of the medial vowel-sound of *maide* as [o̞] may have developed from the realization of short *-ai-* as [ɔ] after a labial consonant in East Ulster Irish (Holmer 1940, 75).

The word *maide*, literally "stick", is sometimes used for "a strong stick placed across a little stream, by which you might cross" (*Joyce* iii 494). The name Blackstaff is not uncommon as a river-name, the element *-staff* referring to beams of oak that were formerly stretched from stone to stone making it possible to walk across the river (Flanagan 1978(c), 25). The Irish form for the Blackstaff River in the Ards Peninsula is *Maide Dubh na hArda* "the black staff of the Ards", and appears to have been named from black staffs or beams placed across it to form a primitive bridge (*PNI* ii 96), while the name of the river Blackstick in Louth is derived from Irish *An Maide Dubh* (*L. Log. Lú* 29).

The *OSRNB* describes Muddyderg as a "small sandy bay, with a little rocky island in its centre". A small (un-named) stream flows into Lough Neagh at this point, over which there is a small foot-bridge, named Muddyderg Bridge. It is probable that the place-name was originally applied to a primitive foot-bridge over the stream, possibly at the same point (perhaps later applied to the stream itself?) and subsequently transferred to the bay. The final element of the place-name represents the colour *dearg* "red", possibly referring to the colour of the wood of which the bridge was composed, or to the colour of the water, if we take *maide* to refer to the stream.

| **Pollan Bay** | A hybrid form | |
| H 9886 | | |
| | | |
| 1. 'pɔlən 'bɛː | Local pronunciation | 1987 |

This is the name of the small bay in which is situated the harbour of Doss in the "detached portion" of the townland of Portlee. While the place-name appears to have been coined in the English language, the first element appears to be derived from Irish *pollán*, a type of fresh-water herring which is plentiful in Lough Neagh, and which is still known by this name in the English dialect of the area. It is also possible that the bay may be named from an Irish word which is also spelt *pollán* but which signifies "(small) pool, hollow place" (*Ó Dónaill sv.*) (see Ballybollen above). However, since the name appears to have been coined in the English language, and since *pollán* "fresh-water herring" is a well-attested loan-word in the English of the area whereas *pollán* "(small) pool, hollow place" is not, the former explanation must be accepted as the more likely of the two.

| **Skady** | *Sceadaigh* | |
| H 9984 | "bare/patchy place" | |
| | | |
| 1. Scawdy Shoal | Duff's Lough Neagh | 1785 |
| | | |
| 2. 'skadi 'tauər | Local pronunciation | 1987 |

Although written "Scady Tower" on the *OS* maps, this small island which lies off the shore of the "detached portion" of the townland of Ballynaleney is always known simply as

"Scady". The element *Tower* on the map appears to refer to a former tower-house on the island, built by the O'Neills of Clandeboy around 1804, and used as a shooting-lodge by the then Lord O'Neill (*OSM* xix 89). The noun *scead* in Irish can signify "blaze (on animal), light, bare, bald patch", and the adjective *sceadach* "blazed, starred, patchy, blotchy, spotted" (*Ó Dónaill* sv.). The place-name appears to derive from *sceadaigh*, an oblique form of *sceadach*, which is made up of the noun *scead* plus the collective termination -*ach*, which would give it the significance of "place of bare patches/bare, patchy place". This interpretation would agree with the nature of the island, which is flat and rocky and measures only about three roods in area. There is another **Scaddy Island** in the south-west corner of Lough Neagh, off the shore of Tyrone and a place named **Scaddy** on the shore of Strangford Lough in Co. Down, the Irish form of which is also *Sceadaigh* (*GÉ* 154).

| | |
|---|---|
| **Skeiganeagh** | *Sciachóg an Éin*(?) |
| J 1190 | "thorn-bush of the bird" |

| | | |
|---|---|---|
| 1. ˌskigəˈniːn | Local pronunciation | 1987 |

This is a tiny hamlet which is situated on the summit of a small abrupt hill, in the north of the townland of Drumsough. Although the name is written *Skeigeneagh* on the map, it is locally pronounced "Skeeganeen". The first element is clearly derived from Irish *sciachóg* "a whitethorn", a form derived from earlier Irish *scé* "thorn-bush, whitethorn", and which has a variety of other forms in Mod. Ir. including *sceach, sceachóg*, and *sceitheog* (*Dinneen* sv.) (cf. Scottish Gaelic *sgitheag* "stalk or prickle of hawthorn; diminutive hawthorn tree", and *sgitheach* "whitethorn, hawthorn; thicket of hawthorn" (*Dwelly* sv.). With regard to the realization of Irish *sciachóg* as "skeeg", medial non-palatal -*ch*- tended to be sounded as [h] in Ulster Irish (O'Rahilly 1932, 210). However, Holmer (1940, 25) points out that in the Irish of the Glens of Antrim there was an aversion for *h* after a vowel, as shown by the pronunciation of *sciachóg* as [skiːg]. It is likely that the same process would have led to the dropping of the medial [h]-sound in the first element of this place-name, and the two vowel-sounds would easily have coalesced as [iː].

The derivation of the final element of the place-name is uncertain: the written form "Skeiganeagh" would suggest an Irish form such as *Sciachóg an Fhéich* "thorn-bush of the raven". However, the written version is at odds with the local pronunciation, "Skeeganeen", which points to an Irish form such as *Sciachóg an Éin* "thorn-bush of the bird", or, possibly, *Sciachóg an Eidhinn* "thorn-bush of the ivy". In the absence of further evidence, it is impossible to make a definite judgement on the matter. The place-name was clearly originally applied to a thorn-bush and later transferred to the little hill or settlement.

| | |
|---|---|
| **Sluggan Moss** | A hybrid form |
| J 0992 | |

| | | |
|---|---|---|
| 1. ˈslogən ˈmɔːs | Local pronunciation | 1987 |

This is a large flow-bog of roughly 850 acres, which covers portions of the townlands of Magheralane, Ballylurgan, Drumsough and Farlough. The first element of the name is clearly derived from Irish *slogán* which is cited by Ó Dónaill as a variant form of *slogaide* "swallow hole" (*Ó Dónaill* sv. *slogaide*) and defined by Dinneen as "a vortex or quagmire" (*Dinneen* sv.). Given the nature of the feature referred to, in this case the latter is clearly the most appropriate interpretation. The word *slug* is used in this area as a dialect word in the

sense of "a gulp or swallow", and it is clear that it is derived from the Irish verb *slog* "to swallow", which is obviously the basis of the first element of the place-name. The second element is the Scots dialect word "moss" which in this area is used in the sense of a peat bog. According to the *Ordnance Survey Memoir* of 1838, the centre of Sluggan Moss was said to have been formerly the site of a lake (*OSM* xix 38). There is a townland named **Sluggan** in the parish of Termonmaguirk, Co. Tyrone in which there is also a large bog.

**The Three Islands**                              An English form
J 0085

1. ðə ˈθri ˈailənz                              Local pronunciation                              1987

Repeated lowerings of the level of the water of Lough Neagh to prevent flooding around the shore have meant that two of the islands are now joined to the mainland; only the easternmost is now a true island. The middle island was formerly the site of an ancient church, no trace of which remains, though, according to O'Laverty, the site of the graveyard of the church was still locally known towards the end of the last century (*O'Laverty* iii 340). The *Ordnance Survey Memoir* of 1838 supplies two drawings of a holy water font of hard greenstone which was said to have been found on one of the islands, and which would constitute evidence of a former religious site. A local tradition persists in the area of a "holy man" who formerly lived on the middle island. According to O'Laverty, the four townlands which now make up the "detached portion" of the parish of Drummaul (all of which lie along the lough shore, close to The Three Islands) formerly made up the parish of the ancient church which was situated on the middle island (*op. cit.* 337–40). On *Duff's Lough Neagh* (1785), the two eastern-most islands are marked as "Fir Tree Island" and "Ash Tree Island" but these names are locally unknown and are clearly not historical.

**Tullynatrush**                              Of uncertain origin
J 1290

1. ˌtolinaˈtroʃ                              Local pronunciation                              1987
2. ˌtolnaˈtroʃ                              Local pronunciation                              1987

The name of this little hill in the townland of Drumsough is not recorded on the *OS 1:50,000* map (see *OS 1:10,000* sheet 95). O'Laverty refers to it as *Tornarush* and informs us that it was a place where Mass was celebrated before the erection of the church at Randalstown (*O'Laverty* iii 294). This form of the name is unknown to local people, who always refer to the place as "Tullynatrush" or "Tulnatrush", and this appears to be the more reliable form of the name. The first element is likely to be *tulaigh*, an oblique form of *tulach* "hillock". However, the derivation of the final element of the place-name is obscure. It could be argued that it is a corruption of the anglicized element *trusk* which is described by Joyce as "a component of names, generally of mountains, of frequent occurrence" (*Joyce* iii 586) but whose origin is, however, uncertain. Joyce's suggestion that it represents the Irish word *trosc* "a cod" is clearly unacceptable. It has also been suggested that it is made up of a compound of *tur* "dry" plus *easc(a)* "water/marsh", that it refers to a dried up bog or simply to an area of poor (formerly boggy) land, and that it has been rendered *trosc* and *trosca* by analogy with the word *trosc* "a cod" (Ó Concheanainn 1966, 16–17). However, this explanation is hardly convincing in the context of Ulster place-names, where the stress in a compound such as *tureasc* "dry marsh" would always fall on the first syllable and could not therefore

result in the form *trosc*. One might suggest that the final element of the place-name is a corruption of *turas* which literally means "journey" but can signify "pilgrimage", and that this could be in some way connected with the former use of the hill as a Mass station but the origin of the place-name remains uncertain.

| **Whitehill** | An English Form | |
|---|---|---|
| J 1189 | | |

| 1. 'hwait 'hil | Local pronunciation | 1987 |
|---|---|---|

This is the name of a small settlement situated on the side of a small hill in the townland of Maghereagh. The name is well-known in the area as it is attached to a local football and hurling club. The *OSRNB* of c. 1858 (sheet 43) informs us that the hill in question was at one time part of a grazing-farm, and was named as having a whitish appearance by comparison with the rest of the land.

## Parish of Duneane
### Barony of Toome Upper

| *Townlands* | Carlane | Killyfast |
|---|---|---|
| Aghacarnaghan (+ detached portion) | Carmorn | Lismacloskey |
| Annaghmore | Cloghogue | Moneyglass |
| Artlone | Creeve | Moneynick |
| Ballycloghan | Creggan | Moneyrod |
| Ballydonnelly | Derrygowan | Muckrim |
| Ballydugennan | Derryhollagh | Mullaghgaun |
| Ballylenully | Drumboe | Ranaghan |
| Ballylurgan | Drumcullen | Staffordstown |
| Ballymatoskerty | Drumderg | Tamnaderry |
| Ballynacooley | Drumraymond | Tamnaghmore |
| Ballynafey | Gallagh | Toome |
| Ballynamullan (+ detached portion) | Garriffgeery | Tullaghbeg |
| Brecart (+ detached portion) | Gortgarn | |
| Brockish, part of Cargin | Gortgill | *Town* |
| Cargin | Greenan | Toome |

The townlands of Ballynacraigy, Killyfad, Portlee and Ballynaleney form the detached portion of the parish of Drummaul but are too far away to be included in the map of that parish.

Based upon Ordnance Survey 1:50,000 mapping, with permission of the Ordnance Survey of Northern Ireland, Crown copyright reserved.

77

Muckleramer

Coolsythe

Drumanaway

Groggan

Muckrim

Killyfast

Drumraymond

Clonkeen

Tannaghmore

Bali

Moneyglass

Ballymatoskerty

Gortgill

Ballydonnelly

Ballydunmaul

Brecart
(Detached Portion)

Brecart
(Main Portion)

Cloghogue

Tamnaghmore

Craigmore

Lisnagreggan

Moneyrod

Ballylenully

Toome

Lismacloskey

Clonboy

Drumderg

Artlone

Derryhollagh

Artresnahan

Brockish
Part of
Cargin

Drumcullen

Moneynick

Gortgarn

Aghaloughan

Leitrim

Ballydugennan

Ballynafey

Aghacarnaghan
(Detached Portion)

Greenan

Annaghmore

Gallagh

Cargin

Mullaghgaun

Garriffgeery

Drumboe

Derrygowan

Creeve

Aghacarnaghan
(Main Portion)

Carmorn

Ballylurgan

Ballycloghan

Creggan

Ge

Ballynamullan
(Detached Portion)

Tullaghbeg

Tamnaderry

Portlee
(Detached
Portion)

Carlane

Staffordstown

Cranfield

Ballynaleney
(Detached Portion)

Ballynamullan
(Main Portion)

Ballynaleney
(Main Portion)

Killyfad

Ballymacraigy

Ballynacooley

Portlee
(Main Portion)

KILOMETRES 1          0          1          2          3

STATUTE MILES 1          0          1          2

78

# PARISH OF DUNEANE

The parish of Duneane consists of 44 townlands and covers an area of some 13,128 acres, of which roughly 415 acres are in Lough Beg and 29 acres are in the river Bann (*Census 1851*). It is bounded on the west by Lough Neagh, the river Bann and Lough Beg, on the north by the parishes of Ballyscullion and Grange of Ballyscullion, on the east by the parish of Drummaul and on the south by Lough Neagh, the parish of Cranfield and the "detached portion" of the parish of Drummaul. Three of the townlands (Ballynamullan, Aghacarnaghan, Brecart) have detached portions which lie to the west of their main portions, while the townland of Brockish is officially designated "part of Cargin", the latter lying roughly a mile to the east.

The civil parish of Duneane is roughly co-extensive with the Catholic parish of the same name, except that in the Catholic arrangement the four "detached townlands" of Drummaul have been transferred to Duneane in exchange for the townland of Creggan and the townland (formerly parish) of Cranfield. A portion of the townland of Derryhollagh is in the Catholic parish of Drummaul, whereas in the civil parish system the whole townland belongs to Duneane. The Catholic parish of Duneane also includes all of the civil parish of Grange of Ballyscullion.

The name of the parish is recorded as early as c. 830 AD in the *Martyrology of Óengus* where we find a reference to a saint named *Ercnait* from *Dún da en isin Fidbaid i nDail Araide*, i.e. "Duneane in the Feevagh in Dál nAraide" (*Fél. Óeng.* Jan 8 p 42), and also to a saint named *Ernach virgo . . . [in Dún] da én a nDáil Araide*, i.e. "Ernach, a virgin . . . in Duneane in Dál nAraide" (*ibid.* Oct 30 p 230). The same two saints are associated with Duneane in the 12th-century *Martyrology of Gorman* (*Mart. Gorm.* pp 12, 206) and in the 17th-century *Martyrology of Donegal* (*Mart. Don.* pp 10, 288).

O'Laverty, however, suggests that in fact only one saint was truly associated with Duneane (the male saint *Ernach*, whose feast day was celebrated on October 30) and that the name of this saint has been accidentally confused with that of the similar-sounding female saint *Ercnait* (whose feast day was January 8). He bases this conclusion on the fact that in an older transcript of the *Martyrology of Óengus* the St *Ernach* whose feast day is October 30 is described as *oc* "a youth", rather than as *uag* "a virgin" and also that a note in yet another version of the *Martyrology* (i.e. the *Leabhar Breac* version) states that Ernach was: "son of Tairnd . . . but it fitted not the quatrain; and in Dun-da-en, in Fidbaid of Dalaraidhe, is he"(*O'Laverty* iii 333–4). O'Laverty is undoubtedly correct to conclude that the saint associated with Duneane was a male named *Ernach*, rather than a female named *Ercnait*, even though both he and Reeves have failed to realize that the note on the name Ernach is a gloss explaining the meaning of the name as "son of iron", hence O'Laverty's interpretation of *mac iairnd* as "son of Tairnd" and Reeves's "son of *Jairnn*" (EA 300).

O'Laverty suggests that the St *Ernach* associated with Duneane may be one and the same as the St *Ernin* who is associated in the Martyrologies with the small neighbouring parish of **Cranfield** (*O'Laverty* iii 334).

Writing in 1645, Colgan draws attention to the reference to St Ercnait in the earlier Martyrologies, and remarks that: "today *Cluainda-en* is a parish church in the diocese and county of Down beside the shore of Lough Neagh in Ulster" (*Acta SS Colgan* 42 n9). *Cluainda-en* is obviously to be identified with Duneane, and Reeves has pointed out Colgan's mistake in placing it in "the diocese and county of Down" (*EA* 300) (see below).

In an early genealogy of the *Cenél nEógain* sept *Cenél nEchach in Chodaigh*, i.e. "the sept of *Eochaidh* of *an Codach*" we find a reference to three septs named *Síl Ciaran* (Mod. Ir. *Síol Chiaráin* "descendants of Ciarán"), among them *sil ciaran duine da en a ndail araidhe* (*L. Lec.*

54b; *BB* 69a), i.e. "the descendants of Ciarán of Duneane in Dál nAraide". The other two septs named *Síol Chiaráin* were settled around Ardstraw and east of Armagh city respectively (see *Onom. Goed.* 671, 26) and all three are said to be descended from one Ciarán who was son of *Eochaidh*, son of *Eogan* who in turn was son of of the famous *Niall Naoighiallach* or "Niall of the Nine Hostages". According to Ó Ceallaigh (*GUH* 6), *Cenél nEchach in Chodaigh* were settled around Omagh in Co. Tyrone, and the implication is clearly that various branches spread out from there to other areas of Ulster, including the parish of Duneane. However, the sept named *Síol Chiaráin* of Duneane does not appear to be referred to in any other context and the name appears to have become obsolete at an early date.

The present Church of Ireland parish church of Duneane occupies the same site as the ancient church and is situated in the townland of **Lismacloskey**. According to tradition, a portion of the eastern gable and the side walls belonged to a monastic building which was formerly four times the length of the present church. After the siege of Derry in 1689, Major Dobbin, the landlord, pulled down three quarters of the building, leaving it a more appropriate size to cater for the small number of Protestants in the parish (*OSM* xix 106–7). The present graveyard immediately adjoins the church. However, the ancient graveyard of the monastery is said to have been at the foot of the hill on which the present parish church is situated (*ibid.*). According to O'Laverty, in the vicinity of the ancient graveyard there was a holy well, known as the Nun's Well, but by his day it had already been filled up (*O'Laverty* iii 333).

In the *Ecclesiastical Taxation* of 1306 the church of Duneane is valued at 20 shillings per annum (*Eccles. Tax.* 86) which is only half the value of the neighbouring parish of Drummaul. In c.1542, Duneane is referred to as *Vic. Ec. de Dewnan* "vicarage church of Duneane" in the list of churches in the rural deanery of Turtrye (*Reg. Dowd.* §129 268), the extent of which is discussed in the county introduction. At the time of the dissolution of the monasteries in 1542, *the impropriate rectories of Dunyen* (Duneane) and *Drommalde* (Drummaul) were in the possession of the nearby monastery of Kells (*Ex. Inq. (Ant.)* §1 Jac. I).

In 1615, the *Terrier* of Down and Connor states that the church of *Dumben* "hath four towns – erinothe lands" (*Terrier (Reeves)* 67), meaning that four townlands in the parish were the property of the bishop, but that they were held by an *erenagh* or lay tenant to the bishop. The four townlands in question were Lismacloskey, Tamnaghmore, Cloghogue and Gortgill, and are commonly referred to in historical sources as "The Four Towns of Duneane". The *Terrier* also informs us that the parson was the Lord Deputy (meaning that the Lord Deputy, i.e. Sir Arthur Chichester, was in possession of the tithes of the parish) and that the vicar was *Hugh McClerenane* (*ibid.*).

In 1622, the church of Duneane was ruinous (*Ulster Visit (Reeves)* 259). An inquisition of 1657 remarks: "The church is ruinous and was conveniently seated near the midst of the parish . . . Mr Hugh Graffan, preaching minister and now in salary, is the present incumbent . . .". This inquisition also states that the parish was at that time made up of: "38 small quarters (i.e. townlands) and a halfe" (*Inq. Par. Ant.* 60), which is quite close to today's total of 44 townlands. As referred to above, after the Williamite Wars of 1688–91 the church was restored, though on a much smaller scale than before. In 1765, the *vicarage of Duneane* is reported as being united with that of Cranfield, and the church is described as being "in pretty good repair" (*State Connor*).

Since almost all of the parish of Duneane was the property of the O'Neills of Shane's Castle, the names of the townlands of the parish are documented in roughly the same sources as those described in connection with the parish of **Drummaul**, which also formed part of the lands of the O'Neills. The parish of Duneane lay in the tuogh or petty Irish king-

dom of **Feevagh**, almost all of which was included in a large territory granted by King James I to Shane O'Neill of Shane's Castle in 1606 (*CPR Jas I* 93b; *Lodge RR* Jas I i 352). The name of the tuogh of Feevagh, which is commonly written as *Tuoghnefuigh*, i.e. *Tuath na Fíobha* "the district of the wood" in early 17th-century documents, is recorded in the earliest references to Duneane and is still known in the area. According to Reeves (*EA* 345), Feevagh was coterminous with the parishes of Duneane, Cranfield and Grange of Ballyscullion. As pointed out above in connection with the parish of Drummaul, the names of the townlands in the 1606 grant to Shane O'Neill appear to be based on the *Antrim Inquisition* of 1605 (*Inq. Ant.* (*DK*) 45), which is the earliest source of townland names in the area. The portion of the territory of Feevagh which was not included in the grant to Shane O'Neill comprised the townlands of Toome, Gallagh, Moneyglass and Ballydugennan which were the property of the Earl of Antrim and the first three of which are listed in the *Irish Patent Rolls of James I* as being excluded from the 1606 grant to the aforesaid Shane (*CPR Jas I* 93b).

Only 21 townlands are listed in the *Antrim Inquisition* as making up the entire territory of Feevagh, though it is pointed out that the list of townlands is incomplete, as some of the names could not be learned "on account of the devastation of the country and the mortality of the inhabitants" (*Inq. Ant.* (*DK*) 45), an obvious reference to the terrible carnage which took place in the course of the Nine Years' War (1594–1603). Of the 21 names listed, 13 can be identified with certainty with modern townlands, and, of these, 11 are in the parish of Duneane, namely Toome, Gallagh, Tamnaderry, Creeve, Derryhollagh, Moneyglass, Moneynick, Drumcullen, Ballinafey, Mullaghgaun and Ballylurgan, while two others, i.e. Killyfad and Clonkeen are in the parish of Drummaul. The task of identifying the remainder of the townlands is complicated by the fact that the description of the boundary between the territories of Feevagh and Munterividy (*CPR Jas I* 93a–b) is problematic. Thus the townland listed as *Ballygartacarney* could represent either Gortgarn in the parish of Duneane or Gortagharn in the parish of Drummaul, while *Ballyndownemore* appears to represent an earlier form of the name of the townland of *Dunmore* or Randalstown in the parish of Drummaul, suggesting that the territory of Feevagh included part of the parish of Drummaul. However, the obscurity of the boundary description prevents one from arriving at a definite conclusion. Of the remaining six townlands, *Ballykinaghan* appears to be identifiable with the townland of Toome, though listed as a separate townland (see barony introduction). *Ballintollought* may be tentatively identified with the modern Staffordstown and possibly *Ballygortcross* with Gortgarn. However, I can offer no modern equivalent for the townlands of *Ballyvullinane*, *Ballinhone* and *Lessoferren*.

On the death of the aforementioned Shane O'Neill in 1617, the same lands were granted to his son, Henry O'Neill of Shane's Castle (*CPR Jas I* 324b). The latter turned Protestant and was knighted. In a re-grant of the lands from King Charles I to *Sir Henry (O) Neale, Knight* in 1637, the names of the townlands bear a strong resemblance to those of the original 1606 lists (*Lodge RR* Chas I i 407). However, Tamnaderry is omitted from the 21 townland names which appear in the 1606 list, and to the list is added the townlands of Tullaghbeg, Carlane, Garriffgeery, Moneyrod, Ballydonnelly, Ballynemullan, Killyfast, Aghaloughan, Creggan, Greenan, Ballymatoskerty, Ballynaleney, Portlee, Ballynacooley, Aghacarnaghan, Ballylenulla and a townland named *Drumelly* (unidentified). The grant also refers to "the rent of £5 English a year out of 10 townlands in the Territory of Fuagh (i.e. Feevagh) in the tenure of Edmund Stafford". This Edmund Stafford, who died in 1644, was the brother of Martha Stafford who married the aforementioned Sir Henry O'Neill early in the 17th century, and it was no doubt at that time that the ten townlands referred to came into the possession of the Stafford family who continued to pay a small rent to the O'Neills.

81

An inquisition of 1662 finds that the late Edmund Stafford of *Mountstafford* (i.e. Mount Stafford near Portglenone) was in possession of 20 townlands in the Portglenone area, as well as nine townlands and two half townlands adjoining the hamlet of Staffordstown in the parish of Duneane. The nine townlands in question are Ballycloghan, Derrygowan, Drumboe, Ballynacraigy, Ballylurgan, Staffordstown, Tamnaderry, Ranaghan and Killyfad, while the two half townlands are Artlone and Carmorn (*Inq. Ult.* §6 Car. II).

While almost all the lands of the parish had been granted to the Protestant Henry O'Neill, a good number of townlands were sub-let to Catholic land-holders: this is proven by the fact that the townlands of Mullaghgaun, Ballynafey, Gortgarn, Ballydonnelly Lower, Moneyrod, Derryhollagh, Moneynick, Gariffgeery, Tullaghbeg, Carlane, Annaghmore and Drumcullen all appear on the Down Survey Parish Map of c.1657, which shows lands forfeited by Catholics in the Cromwellian period for their part in the rebellion of 1641 (*DS (Par. Map)*). Ballydonnelly Lower, Ballynafey and Drumcullen were in the hands of Hugh Oge O'Neill, while Moneyrod, Derryhollagh, Moneynick, Gariffgeery, Mullaghgaun, Gortgarn, Carlane, Tullaghbeg as well as Drumderg (which does not appear on the map) which had been granted by Sir Henry O'Neill to the aforementioned *Hugh Oge O'Neile* had come into the possession of his brother Art Oge O'Neill, who forfeited them by his rebellion in 1641 (*Lodge RR* Chas II i 106). This Art Oge O'Neill is referred to in the discussion of of **Artoge's Dam** below. The townland of Ballydonnelly Upper, which does not appear on the Down Survey Parish Map, was forfeited by *Bryan Duffe Mac Murtagh O'Neile* (*ibid.*).

The Down Survey also shows as forfeited the townlands of Toome, Moneyglass, Gallagh and Ballydugennan which, as stated above, were the property of Randal MacDonnell, Earl of Antrim. The *Book of Survey and Distribution* (*BSD* 133) of 1661 shows that after the Cromwellian period these four townlands were re-granted to Randal McDonnell, while all the other townlands which had been sub-let to Catholics prior to 1641 were re-distributed to his wife, Rose O'Neill of Shane's Castle.

Only three place-names in the parish of Duneane can be identified in Irish language sources. These are the name of the parish itself and the name of the district of Feevagh in which it was situated, as well as the name of the townland and barony of Toome which is referred to by *Tírechán* as early as c. 670 AD (*Tírechán's Collect. (Bieler)*) and occurs in a number of later sources, including the *Book of Armagh* (*L. Ardm.*), the *Tripartite Life of St Patrick* (*Trip. Life (Stokes)*), the *Annals of the Four Masters* (*AFM*), the *Annals of Ulster* (*AU*) and *Leabhar Cloinne Aodha Buidhe* (*LCABuidhe*).

PARISH NAME

**Duneane**                         *Dún Dá Éan*
                                    "fort of the two birds"

| | | |
|---|---|---|
| 1. o Dún da en isin Fidbaid i nDail Araide | Fél. Óeng. Jan 8 p 42 | 830c |
| 2. in Dún da én a nDáil Araide | Fél. Óeng. Oct 30 p 230 | 830c |
| 3. ó Dún dá én i fiodhbaid Dáil Araidhe | Mart. Gorm. Jan 8 p 12 | 1170c |
| 4. ó Dún dá én i ffiodhbhaidh Dhál Araidhe | Mart. Gorm. Oct 30 p 206 | 1170c |
| 5. sil ciaran duine da en a ndail araidhe | BB 69a l.48 | 1390c |
| 6. sil ciaran dúin da en a ndail araidi | L. Lec. 54b | 1397c |

| | | |
|---|---|---|
| 7. i ndún da en hi fidbaid dail araide | LB 98n | 1400c |
| 8. Dún dá én i nDál Araidhe | Mart. Don. Jan 8 p10 | 1630c |
| 9. Dún dá én, i bhFiodhbhaidh Dalaraidhe | Mart. Don. Oct 30 p288 | 1630c |
| 10. Cluanida en, in Ecclesia de | Acta SS Colgan 42 col. 2 | 1645 |
| 11. Cluainda-en, in Ecclesia de | Acta SS Colgan 42 n. 9 | 1645 |
| 12. Dun da en in Sylva Dalaradiae d. Connor | Acta SS Bolland lxii 348 | 1883 |
| | | |
| 13. Dovan | Eccles. Tax. 86 | 1306 |
| 14. Dunnyen, the impropriate rectory of | Mon. Hib. 13 | 1542 |
| 15. Vicaria Ecclesia de Dewnan | Reg. Dowdall §129 268 | 1542c |
| 16. Dunean | Eccles. Reg. 35 | 1584 |
| 17. Dunyen . . . in Le Fuaghe, rect. impropriate de | Ex. Inq. (Ant.) §1 Jac. I | 1603 |
| 18. Dunyon . . . in the Fews | Mon. Hib. 14 | 1603 |
| 19. Dumen | CPR Jas I 39a | 1604 |
| 20. Duneane | Inq. Ant. (DK) 45 | 1605 |
| 21. Duneyn | Inq. Ant. (DK) 50 | 1605 |
| 22. Durien | CPR Jas I 72b | 1605 |
| 23. Duryen | CPR Jas I 122a | 1608 |
| 24. Dunneyne | CPR Jas I 122a | 1608 |
| 25. Duneane | Terrier (Reeves) 105 | 1615 |
| 26. Dumben, Ecclesia de, | Terrier (Reeves) 67 | 1615 |
| 27. Duneene, Quatuor villae de | First Fruits Roll (Reeves) | 1616 |
| 28. Duryen | Inq. Ult. (Antrim) §7 Jac. I | 1621 |
| 29. Durien al. Dunine | CPR Jas I 524ab | 1621 |
| 30. Dunine | CPR Jas I 524ab | 1621 |
| 31. Dunien | CPR Jas I 524ab | 1621 |
| 32. Lands of Dunean | Ulster Visit. (Reeves) 241 | 1622 |
| 33. Duneene, ecclesia de | Ulster Visit. (Reeves) 259 | 1622 |
| 34. the parish of Duneane | Exch. Deeds & Wills 653 | 1644 |
| 35. Dunean Parish | Inq. Par. Ant. 60 | 1657 |
| 36. Parish of Dunean | DS (Par. Map) Duneane | 1657c |
| 37. Dunean | Hib. Reg. Toome | 1657c |
| 38. Duneane | BSD 133 | 1661 |
| 39. Duneene | Trien. Visit. (Bramhall) 5 | 1661 |
| 40. Duryen . . . in ye Fuigh al. The Fyvagh al. Tuogh-fuigh | Lodge RR Chas II i 217 | 1665 |
| 41. ye 4 towns of Gunean | ASE 106 a 1 | 1666 |
| 42. Dunean | HMR Ant. 149 | 1669 |
| 43. The Parish of Duneane | Hib. Del. Antrim | 1672c |
| 44. Dunean Vicaria | Trien. Visit. (Boyle) 38 | 1679 |
| 45. Duneen | Eccles. Reg. 73 | 1703 |
| 46. Dunean – vic. united to Cranfield | State Connor | 1765 |
| 47. Duneane | Lendrick Map | 1780 |

| | | |
|---|---|---|
| 48. Dunnain Church | Taylor & Skinner (Rev.) | 1783 |
| 49. Duneane | Duff's Lough Neagh | 1785 |
| 50. Duneane | OSNB A 40 | 1828 |
| 51. Dún Éan "fort of the birds" | J O'D (OSNB) A 40 | 1828 |
| 52. Dughen or Deahen or '2 birds perched on a deer's horns' | OSM xix 10 | 1837 |
| 53. Dun-da-en "the fort of the two birds" | EA 300 | 1847 |
| 54. Dun-dá-én "the fortress of the two birds" | Joyce i 256 | 1869 |
| 55. Dun-da-en, the old form of the name Duneane, signifies "the fort of the two birds" | O'Laverty iii 334 | 1884 |
| 56. dọ'ni:n | Local pronunciation | 1987 |

The Irish version of the name of the parish, i.e. *Dún Dá Éan* 'fort of the two birds', is fortunately well documented in Irish language sources from an early date. In form 13, the medial *-n-* appears to have been mistranscribed as *-v-*, while the *-a-* may well be a mistake for *-e-*, hence O'Laverty's remark that the name has been written *Dovan* "by some mistake" (*O'Laverty* iii 333). The development from the Irish form *Dún Dá Éan* to the modern form Duneane is most likely due to the assimilation of the initial *D-* of *Dá* to the final *-n* of *Dún*. The final *-á* of *Dá* would then naturally suffer elision before the initial vowel sound of *Éan*.

The element *dún* "fort", although a non-ecclesiastical one, is of common occurrence in the names of parishes, there being, in all, 45 parishes in Ireland which have *dún* as the first element in their names. The fact that the early Irish monastic unit was basically a ring-fort raises the possibility that, in cases (such as this one) where the site is demonstrably an early ecclesiastical one, the element *dún* may refer to the actual church or monastic site itself. Flanagan (1980–1(a), 18–19) however, points out that in many cases churches have been named *dún* by association with or transfer from a nearby fort, and that, unlike the element *ráth*, which also signifies "fort", there is no clear evidence of the use of *dún* to apply directly to ecclesiastical sites. It is more likely, therefore, that in this case the church was named by association with a nearby fort, in the vicinity of which it was sited. There is now no trace or record of a fort either at the site of the church of Duneane or in the near vicinity. There is a place named **The Doon** about two miles away, which may mark the site of a former fort, but it appears to be too far away to have given name to the church of Duneane.

Colgan is unique in giving *cluain* "meadow", rather than *dún* "fort" as the first element of the name of the parish (10, 11). In the course of a short Latin account entitled *De S. Ergnata Virgine* i.e. "of St Ergnat, Virgin", which is compiled from earlier sources, he remarks that a saint of this name was commemorated in the church of *Cluanida en* "in a district of Dál nAraide which is called Feevagh" on January 8 and October 31 (*recte* October 30) (*Acta SS Colgan* 42 col. 2). In a footnote he remarks: "today *Cluainda-en* is a parochial church in the diocese and county of Down near the bank of Lough Neagh" (*ibid.* n. 9). There is no doubt that the parochial church referred to is that of Duneane, even though, as pointed out above, Colgan has mistakenly placed it "in the diocese and county of Down". For the form *Cluainda-en* Colgan cites earlier authorities, including the Martyrology of *óengus* and the *Martyrology of Gorman* (*ibid.*). However, none of these gives *cluain* as an alternative first element to *dún* and it appears that Colgan's *cluain* is simply a mistake for *dún*.

The dual element *dhá* "two", is of fairly common occurrence in Irish place-names, and

names referring to two natural features of the landscape as well as two animals or (as in this case) two birds are quite numerous. There are places named *Snámh Dá Éan* "ford of the two birds" on the river Shannon, *Sliabh Dá Éan* "mountain of the two birds" in Sligo and *Bealach an Dá Éan* "pass of the two birds" in Monaghan (*Joyce* i 256–7). As suggested by Joyce, it is likely that most place-names which contain references to two animals or birds have their origin in legends or superstitions (*Joyce* i 256). The *Ordnance Survey Memoir* for the neighbouring parish of Grange of Ballyscullion contains a legend which explains the origin of the name Duneane. It tells how St Brigid intended building a church in the townland of Kilvillis in that parish but, as the workmen were drunk on beer brewed from heather, they could not raise it higher than the foundation. In order to put a head on the beer, St Brigid ordered them to take some froth from the mouth of a wild boar which passed that way. When St Patrick heard that St Brigid had allowed the workmen to get drunk, he ordered her to wander until she came to the place where she would see two blackbirds perched on a deer's horns i.e. at *Dún Dá Éan* "fort of the two birds", and there she was to build the church (*OSM* xix 10). The unfinished church which St Brigid originally began to build in the **Grange of Ballyscullion** was known as Temple Moyle, from Irish *Teampall Maol* "the bald or unfinished church" (*O'Laverty* iii 353).

TOWNLAND NAMES

| **Aghacarnaghan** | *Achadh na gCarnánach* |
| J 0187 | "field of the places of cairns(?)" |

| | | |
|---|---|---|
| 1. Balliagnacarnanagh | Inq. Ult. (Antrim) §20 Car. I | 1633 |
| 2. Ballyagnecarnanagh | Lodge RR Chas I i 407 | 1637 |
| 3. Ballyurghleycarnanagh | BSD 135b | 1661 |
| 4. Ballyaghnecarnenagh | Lodge RR Chas II i 106 | 1663 |
| 5. Aghacarnagh | HMR Ant. 148 | 1669 |
| 6. Ballyaghnecarnanagh | Lodge RR Chas II ii 292 | 1684 |
| 7. Aghnecarnanagh | Reg. Deeds 10-133-3227 | 1712 |
| 8. Ballyaghnecarnanagh | Reg. Deeds 90-171-62470 | 1739 |
| 9. Quarterland of Aghocarnaghan | Belfast News Letter Oct. 14 | 1763 |
| 10. Aghacarnon | Lendrick Map | 1780 |
| 11. Aghcanagher | Bnd. Sur. | 1826 |
| 12. Aughacarnaghan | OSNB A 40 | 1828 |
| 13. Achadh Cearnachin "Kernaghan's field" | J O'D (OSNB) A 40 | 1828 |
| 14. ˌaxəˈkɑrnəxən | Local pronunciation | 1987 |

O'Donovan's explanation of Aghacarnaghan as *Achadh Cearnacháin* "Kernaghan's field" (13) is not supported by the the earlier recorded spellings, most of which represent the final element of the place-name as *-carnanagh* rather than the modern *-carnaghan*. The adjective *carnánach* is attested in the earlier language in the sense of "full of cairns, stony" (*DIL* sv.) and one might argue for the Irish form *Achadh Carnánach* "cairny/stony field" on the grounds that the first *-n-* of forms 1 and 2 may be a mistranscription of *-h-*, the intended form being *Aghacarnanagh*. However, the weight of the evidence points to the presence of the Irish definite article in the place-name. It is difficult to suggest an entirely satisfactory Irish form but the evidence would appear to favour *Achadh na gCarnánach* with loss of the

eclipsing *g* before the name was first recorded in 1633. The final element of the place-name may consist of *carn* plus the diminutive suffix *-án* plus the collective ending *-ach* and the entire place-name may have the significance of "field of the places of little cairns". Alternatively, since the termination *-án* does not always express a diminutive idea (*Joyce* ii 18), the name may signify simply "field of the places of cairns".

The development of the final element of the place-name from *carnánach* to the modern *-carnaghan* is due to metathesis (see Glossary).

This townland is divided into two separate portions, the "detached portion" lying approximately one mile north-west of the main portion.

| **Annaghmore** | *Eanach Mór* | |
| J 9988 | "great marsh or bog" | |
| 1. Annamoore ¼ of Tullaghbegg | DS (Par. Map) Duneane | 1657c |
| 2. Annaghmoore, part of Tullabegg | DS (Reg.) | 1657c |
| 3. Annughmore | Hib. Reg. Toome | 1657c |
| 4. Enaghmore | Inq. Ult. (Antrim) §5 Car. II | 1661 |
| 5. Annaghmore, part of Tullaghbog | BSD 133 | 1661 |
| 6. Annaghmore | BSD 135b | 1661 |
| 7. Enaghmore | HMR Ant. 151 | 1669 |
| 8. Annaghmore | Lodge RR Chas II ii 292 | 1684 |
| 9. Anaghmore | Reg. Deeds 10-133-3227 | 1712 |
| 10. Anaghmore | Belfast News Letter Aug. 1 | 1766 |
| 11. Anaghmore | Lendrick Map | 1780 |
| 12. Anaghmore | Duff's Lough Neagh | 1785 |
| 13. Annaghmore | OSNB A 40 | 1828 |
| 14. Eanach Mór "great morass" | J O'D (OSNB) A 40 | 1828 |
| 15. 'anəx'mo:r | Local pronunciation | 1987 |

The name of this townland clearly goes back to Irish *Eanach Mór* "great marsh or bog" as suggested by O'Donovan (14). Annaghmore is a flat, low-lying townland, on the shore of Lough Neagh, and, although most of it has now been drained, the *OSNB* of 1828 remarks: "portion of the townland is bog. The whole is low, flat ground, very subject to inundation". The Down Survey Parish Map of c.1657 describes Annaghmore as being, *¼ of Tullaghbegg* (1). This seems to reflect the arrangement in the area whereby a number of townlands have "detached portions" lying a short distance to the west of their main portions. In this case Annaghmore appears to have previously formed the "detached portion" of Tullaghbeg, which lies roughly two miles to the east of it.

| **Artlone** | *Ardchluain* | |
| J 0390 | "high meadow" | |
| 1. Mortluen | CPR Jas I 356a | 1617 |
| 2. Mortluen or Nortluen | Lodge RR Jas I ii 560 | 1617 |
| 3. Ardcloane | Inq. Ult. (Antrim) §6 Car. II | 1663 |
| 4. Artclon | HMR Ant. 150 | 1669 |
| 5. Ardclone | Lodge RR Chas II ii 292 | 1684 |
| 6. Ardcloan | Indent. (Staff.) | 1692 |
| 7. Ardclone | Reg. Deeds 10-133-3227 | 1712 |

| | | |
|---|---|---|
| 8. Ard Cloan. | Reg. Deeds 30-39-16255 | 1720 |
| 9. Athlone | Reg. Deeds 30-39-16255 | 1720 |
| 10. Artlon | Reg. Deeds 37-104-21527 | 1722 |
| 11. Ardcloan al. Artloan | Reg. Deeds 66-434-47346 | 1731 |
| 12. Ardclone | Reg. Deeds 90-171-62470 | 1739 |
| 13. ½ town of Arklone | Belfast News Letter Oct. 14 | 1763 |
| 14. Artlone | Lendrick Map | 1780 |
| 15. Artlone | OSNB A 40 | 1828 |
| 16. Ard Uan "hill or height of the fat lambs" | J O'D (OSNB) A 40 | 1828 |
| 17. art'lo:n | Local pronunciation | 1987 |

O'Donovan's suggestion that the name of this townland is derived from Irish *Ard Uan* "hill or height of the fat lambs" (16) is at odds with the documentary evidence. The medial *-c-* of many of the recorded spellings provides evidence that the final element of the place-name is in fact *cluain* "meadow". While the initial element is indeed *ard*, it is obviously employed as a prefix rather than as a substantive and the place-name is best interpreted as *Ardchluain* "high meadow". Forms 1 and 2 may provide evidence of the Irish definite article *an*, but if this is the case it is liable to be a fairly late innovation and is unlikely to have formed part of the original place-name.

The devoicing of the final *-d* of *ard*, together with the anglicization of the final element of the place-name as "-clon" has led to the juxtaposition of the two voiceless plosives *t* and *k*, as in the form *Artclon* (4). In the consonant cluster *tcl*, it is no surprise that the velar consonant *c* has disappeared between the two alveolar consonants *t* and *k*. The place-name has obviously undergone a change of stress, since in the Irish language the main stress in a compound such as this would normally fall on the first syllable. The pronunciation of the final syllable of the place-name as [lo:n] reflects the tendency for Irish *ua(i)* to develop to [o:]. There is a prominent hill, named Artlone Hill (354 feet) in the east of the townland, and this seems most likely to be the feature which has given rise to the townland name.

**Ballycloghan**
J 0487

*Baile an Chlocháin*
"townland of the causeway/stony ground/stone structure(?)"

| | | |
|---|---|---|
| 1. Ballycloghan | CPR Jas I 356a | 1617 |
| 2. Ballycloghan | Lodge RR Jas I ii 560 | 1617 |
| 3. Ballycloghin | Exch. Deeds & Wills 653 | 1644 |
| 4. Ballyclogher | Inq. Ult. (Antrim) §6 Car. II | 1663 |
| 5. Ballycloghan | HMR Ant. 147 | 1669 |
| 6. Ballycloghane | Lodge RR Chas II ii 292 | 1684 |
| 7. Ballycloghan | Indent. (Staff.) | 1692 |
| 8. Ballyclogan | Reg. Deeds 30-26-16158 | 1720 |
| 9. B:cloghen | Lendrick Map | 1780 |
| 10. Ballyloughan | Duff's Lough Neagh | 1785 |
| 11. Ballycloghan | OSNB A 40 | 1828 |
| 12. Baile Clocháin "town of the stony fort" | J O'D (OSNB) A 40 | 1828 |

| | | |
|---|---|---|
| 13. "the town of the *cloghan*" | Joyce i 364 | 1869 |
| 14. ˌbaliˈklɔːxən | Local pronunciation | 1987 |

The final element of the townland has been correctly identified as Irish *clochán* (12, 13). The word *clochán* is derived from *cloch* "a stone", and its original meaning appears to have been "paved road or causeway" (*DIL* sv.). In Mod. Ir. it has a wide range of applications, including "stepping-stones, (old) stone structure, stony ground" (*Ó Dónaill* sv.); "ruin, remnants of an old fort, heap of stones, stone circle, causeway, burying-ground" (*Dinneen* sv.). According to Joyce, in place-names it is most commonly applied to stepping stones across a river or to a stone castle (*Joyce* i 364). Out of all these possible meanings, it is impossible to say which is in this case the most appropriate. A small stream does form the western boundary of the townland, but it does not appear significant enough to require stepping stones to cross it. There is no trace of a stone castle in the townland and, while the *Ordnance Survey Memoir* of 1836 refers to "an ancient castle" in the neighbouring townland of Staffordstown, the ruins of which had long been destroyed (*OSM* xix 120b), it is unlikely that it would have been built early enough to give name to this townland. There is a rocky outcrop in the northeast of the townland, on top of which are the remains of an old fort, but it is impossible to identify with certainty the naming feature of the townland.

| **Ballydonnelly** | *Baile Uí Dhónalláin* | |
|---|---|---|
| J 0391 | "O'Donnellan's townland" | |
| 1. Ballydonellmeytra | CPR Jas I 356a | 1617 |
| 2. Ballydonellineytra or | | |
| Ballydonellaneytra | Lodge RR Jas I ii 560 | 1617 |
| 3. Ballydonellan | Inq. Ult. (Antrim) §116 Car. I | 1636 |
| 4. Ballyodonellan | Lodge RR Chas I i 407 | 1637 |
| 5. Ballydonnellane | Inq. Ult. (Antrim) §136 Car. I | 1639 |
| 6. Ballydonnellaneetragh | DS (Par. Map) Duneane | 1657c |
| 7. Ballidonellanetra | Hib. Reg. Toome | 1657c |
| 8. Ballydonnellane + tragh | BSD 133 | 1661 |
| 9. Ballydonclaneitragh, | | |
| Ballydonelloughtragh | BSD 135b | 1661 |
| 10. Balle-Donelan-Doragh | Inq. Ult. (Antrim) §8 Car. II | 1662 |
| 11. Ballydonellan | Lodge RR Chas II i 106 | 1663 |
| 12. Balledonellanuttragh, | | |
| Ballydonellanittragh | Lodge RR Chas II i 106 | 1663 |
| 13. Ballydonelan | HMR Ant. 150 | 1669 |
| 14. Ballidonellanetra | Hib. Del. Antrim | 1672c |
| 15. Ballyodonnellane Itragh, | | |
| Ballydonellaneoughtragh | Comm. Grace 10 | 1684 |
| 16. Ballyodonnellane: ightra, | | |
| Ballydonellane-oughtragh | Lodge RR Chas II ii 292 | 1684 |
| 17. Ballydonelanytragh | Reg. Deeds 10-133-3227 | 1712 |
| 18. Ballyodonnellane Ightreagh, | | |
| Ballydonnellan Oughtreagh | Reg. Deeds 90-171-62470 | 1739 |
| 19. Ballydonnollon | Belfast News Letter Oct. 14 | 1763 |
| 20. Ballydonnolly | Belfast News Letter Aug. 24 | 1764 |
| 21. Bːdonelly | Lendrick Map | 1780 |

| | | |
|---|---|---|
| 22. B:donnelly | Duff's Lough Neagh | 1785 |
| 23. Ballydonelly | OSNB A 40 | 1828 |
| 24. Baile Uí Dhonnghaile "Donnelly's town" | J O'D (OSNB) A 40 | 1828 |
| 25. ˌbaliˈdɔnəli | Local pronunciation | 1987 |

The documentary evidence shows that the place-name is derived from *Baile Uí Dhónalláin* "O'Donnellan's townland", rather than *Baile Uí Dhonnaile* "O'Donnelly's townland", which is suggested by the modern version of the place-name, and accepted by O'Donovan (24). The historical forms show that the form with final *y* appears for the first time in 1764 and also that the townland was formerly divided into two portions, *Baile Uí Dhónalláin Uachtarach* "Upper Ballydonnelly" and *Baile Uí Dhónalláin Íochtarach* "Lower Ballydonnelly". The final element of the place-name has probably been anglicized as "Donnelly" by analogy with the surname Donnelly, which is well known in this area.

The origin of the Co. Derry surname *Ó Dónalláin* "O'Donnellan", has been traced to one *Domnallan*, (Mod. Ir. *Dónallán*), son of *Maelcraibe mac Duibsinaigh* (+919), the last *Uí Thuirtre* overking of Airgialla (Fee 1950, 169). The extent of the Gaelic kingdom of Uí Thuirtre at various stages in history is discussed in the county introduction. According to Byrne (1959, 143n) the two ruling families of Uí Thuirtre were *Ó Fhloinn* (later *Ó Loinn* or Lynn) and *Ó Dónalláin* "Donnellan". The surname O'Donnellan is now unknown in this area.

## Ballydugennan
J 0189

*Baile Uí Dhuígeannáin*
"O'Duigenan's townland"

| | | |
|---|---|---|
| 1. Ballyduginan | DS (Par. Map) Duneane | 1657c |
| 2. Ballidugrinan | Hib. Reg. Toome | 1657c |
| 3. Ballyduginan | BSD 133 | 1661 |
| 4. Ballydongemon | ASE 49 b 11 | 1665 |
| 5. Ballynewgenan | ASE 106 a 1 | 1666 |
| 6. Ballydugenan | EP Earl Ant. | 1667 |
| 7. Ballydugnan | HMR Ant. 150 | 1669 |
| 8. Ballydugenan | Lodge RR Chas II ii 292 | 1684 |
| 9. Ballydugina | Hib. Del. Antrim | 1685 |
| 10. Ballydugenan | Reg. Deeds 10-133-3227 | 1712 |
| 11. Ballydugenan | Belfast News Letter Oct. 14 | 1763 |
| 12. B:doogannan | Lendrick Map | 1780 |
| 13. B.dugonan | Duff's Lough Neagh | 1785 |
| 14. Ballydugennan | OSNB A 40 | 1828 |
| 15. Ballydoogan | OS Name Sheets | 1830 |
| 16. Baile Duibhgeanáin "Duigenan's town" | J O'D (OSNB) A 40 | 1828 |
| 17. Baile-Ui-Duibhgeannain [Duigenan], "O'Duigenan's or O'Duignan's town" | Joyce iii 83 | 1913 |
| 18. ˌbaliˈduːgən | Local pronunciation | 1987 |
| 19. ˌbaliˈduːgənən | Local pronunciation | 1987 |

Locally, this townland is generally known as "Ballydougan", and it is clear from form 15 that this form of the name dates back to the first half of the last century. However, the earlier spellings shows that the place-name is derived from Irish *Baile Uí Dhuígeannáin* "O'Duigenan's townland", as previously suggested (16, 17), rather than *Baile Uí Dhúgáin* "O'Dougan's townland". The surname Dougan is fairly common in the area, and *Ó Duígeannáin* may have been anglicized as "Doogennan" (and later as "Dougan") by analogy.

The family of *Ó Duígeannáin* were one of the principal learned families of Gaelic Ireland and originated in East Connaught (MacLysaght 1985, 92). At first sight it appears unlikely that a Connaught surname would be found as an element of a place-name in this area. However, it was common for members of bardic families to travel widely and to be granted lands far from home in return for their professional services. Thus, an inquisition of 1636 finds that *Cnoghor O'Dugenan* of *Tobberdroman* in Co. Antrim had been granted the latter townland by Randal MacDonnell (*Inq. Ult.* §92 Car. I). *Tobberdroman* appears to correspond with the townland of **Toberdornan** in the barony of Lower Dunluce. A *Farfesse O Duygenan* is recorded as lessee of the same townland in 1637 (*O'Duygenan Grant*)), while a *Cú Choigcríche Ó Duibhgeannáin* is recorded at Dunluce in 1613 (Ó Cuív 1984, 140). It is surely more than coincidence that our Ballydugennan was also one of the townlands held by Randal MacDonnell in the parish of Duneane and it seems highly likely that it was named from a member of the Ó Duígeannáin family, to whom it was granted by MacDonnell in return for professional services. The fact that the name is not recorded until c. 1657 would support this opinion. It is likely that up until this time the townland was known by another name which may be one of the obsolete names referred to in the parish introduction.

**Ballylenully**     *Baile Lann Ula*
J 0290     "townland of the church of the penitential station"

| 1. | Lamilly orw. Ballelamy | CPR Jas I 356a | 1617 |
|---|---|---|---|
| 2. | Ballylanally | CPR Jas I 356a | 1617 |
| 3. | Lanully (Lamilly) al. Ballelamy | Lodge RR Jas I ii 560 | 1617 |
| 4. | Ballylanully | Lodge RR Jas I ii 560 | 1617 |
| 5. | Lannully | Inq. Ult. (Antrim) §20 Car. I | 1633 |
| 6. | Ballylevally | Lodge RR Chas I i 407 | 1637 |
| 7. | Ballyhenally | BSD 135b | 1661 |
| 8. | Ballylenaly | Lodge RR Chas II i 106 | 1663 |
| 9. | Lennloe | HMR Ant. 150 | 1669 |
| 10. | Ballylenally | Comm. Grace 10 | 1684 |
| 11. | Ballylevally | Reg. Deeds 10-133-3227 | 1712 |
| 12. | Ballylenulla | Reg. Deeds 36-491-23759 | 1718 |
| 13. | B:lenulla | Lendrick Map | 1780 |
| 14. | Ballyglenulla | Bnd. Sur. | 1826 |
| 15. | Ballylenully | OSNB A 40 | 1828 |
| 16. | Baile Léan-Ulaidh "town of the wet meadow" | J O'D (OSNB) A 40 | 1828 |
| 17. | ˌbalilə'nǫli | Local pronunciation | 1987 |
| 18. | ˌbaliglɛ'nǫla | Local pronunciation | 1987 |

Many of the recorded spellings of Ballylenully show the common scribal confusion of *n* with *v* and *u* with *a*. In form 9, the second *n* is obviously a scribal mistranscription of *u*. The name of the townland appears to go back to Irish *Baile Lann Ula* "townland of the church of the penitential station", though the absence of the "Bally-" prefix in a number of early forms suggests that a form without the element *baile* "townland" may have been for a time in use. The original meaning of Irish *lann* was "land" or "open space", but it developed a secondary meaning of "building" or "church", and it is in this secondary meaning that it most commonly occurs in non-compound place-names (Mac Giolla Easpaig 1981, 155). According to Flanagan, it is a fairly rare element which appears to be confined to the east of Ireland. Athough it belongs to the early Christian period, it does not appear to predate the monastic age which began in the sixth century (Uí Fhlannagáin 1969(b)).

The element *ula* (O. Ir. *ailad*) originally signified "tomb, cairn", but later came to denote "a penitential station, or a stone altar erected as a place of devotion" (*Joyce* i 338). In many of the recorded spellings, the medial vowel of the initial element of the place-name is represented as *-e-* rather than as *-a-*, perhaps suggesting *léana* "wet meadow" (as proposed by O'Donovan). However, in combination with the final element i.e. *ula* "penitential station, stone altar", *lann* "church, monastery", must be regarded as the more likely derivation.

There now remains no trace or record of a church or penitential station in the townland. However, Ballylenulla lies close to the site of the early Christian church of Duneane, and it is possible that it may have been connected with this site.

A common local pronunciation of the name is *Ballyglenulla* which is reflected in form 14 from 1826. While this form of the place-name suggests that the second element is Irish *gleann* "glen", the earlier spellings clearly show that the latter is a corruption of *lann* "church". A similar anglicization of Irish *lann* "church" as *glen* is found in the name of the parish of **Glenavy** in Co. Antrim, which goes back to Irish *Lann Abhaigh* "church of the dwarf"(*GÉ* 120). Other well-known place-names which display the element *lann* are *Lann Bheag* "little church" (**Lambeg**) in Co. Antrim and *Machaire Lainne* "plain of the church" (**Magheralin**) in Co. Down (*ibid.*).

| **Ballylurgan** | *Baile na Lorgan* | |
|---|---|---|
| J 0287 | "townland of the long low ridge" | |
| | | |
| 1. Ballinlorgan | Inq. Ant. (DK) 45 | 1605 |
| 2. Ballinlorgan | CPR Jas I 93b | 1606 |
| 3. Ballinlorgan or Ballinlurgan | Lodge RR Jas I i 252 | 1606 |
| 4. Ballinlurgane | Lodge RR Chas I i 407 | 1637 |
| 5. Ballylurgen | Lodge RR Chas II i 106 | 1663 |
| 6. Ballylongan | HMR Ant. 148 | 1669 |
| 7. Ballylurgan | Lodge RR Chas II ii 292 | 1684 |
| 8. Ballylurgan | Indent. (Staff.) | 1692 |
| 9. Ballylurgan | Reg. Deeds 10-133-3227 | 1712 |
| 10. Ballylurgan | Lendrick Map | 1780 |
| 11. Ballylurgan | Duff's Lough Neagh | 1785 |
| 12. Ballylurgan | Bnd. Sur. | 1826 |
| 13. Ballylurgan | OSNB A 40 | 1828 |
| | | |
| 14. Baile Lurgain "town of the long hill" | J O'D (OSNB) A 40 | 1828 |

| | | |
|---|---|---|
| 15. Baile-Lurgan "townland of the long hill" | Joyce iii 102 | 1913 |
| 16. ‚bali'lọrgən | Local pronunciation | 1987 |

The element *lorgain*, which is an oblique form of *lorga* "shin" is in place-names figuratively applied to "a long low ridge" or "a long stripe of land" (*Joyce* i 527; Ó Maolfabhail 1987–8, 20). The earlier historical forms appear to suggest that in this case *lorga* is a masculine noun. However, it is more likely that in the earliest of these forms the final *a* of the genitive feminine article *na* has been accidentally omitted and the error duplicated in the later (related) forms. The suggested Irish form of the place-name is therefore *Baile na Lorgan*, the same as **Ballylurgan** in the neighbouring parish of Drummaul. There is a long ridge of 200 feet in this townland, and this appears likely to be the naming feature.

**Ballymatoskerty**
J 0292

*Baile Mhac an Tuasceartaigh*
"townland of the son of the northerner/native of *Tuaisceart*"

| | | |
|---|---|---|
| 1. Ballymc. twoskertie, or Ballymc. thoskertie | Lodge RR Chas I i 407 | 1637 |
| 2. Ballymcloskerty | BSD 135b | 1661 |
| 3. Ballymc. tockerty | Lodge RR Chas II i 406 | 1663 |
| 4. BallyMcCoskerty | HMR Ant. 149 | 1669 |
| 5. Ballymactoskerty | Comm. Grace 10 | 1684 |
| 6. Ballymactwoskerty | Lodge RR Chas II ii 292 | 1684 |
| 7. Ballymacktoskerty | Reg. Deeds 10-133-3227 | 1712 |
| 8. Ballymatoskerty | Reg. Deeds 36-491-23759 | 1718 |
| 9. Ballymatuskerty | Lendrick Map | 1780 |
| 10. B:matoskerty | Duff's Lough Neagh | 1785 |
| 11. Ballymuck Cosherty | Reg. Deeds 756-26-513561 | 1820 |
| 12. Ballymatoskerty | OSNB A 40 | 1828 |
| 13. Baile Máighe Tuaisceartaigh "town of the northern plain" | J O'D (OSNB) A 40 | 1828 |
| 14. Baile-muighe-tuaiscertaighe "the town on the north plain" | Joyce iii 106 | 1913 |
| 15. ‚balimə'tọskərti | Local pronunciation | 1987 |

At first sight one would assume that this place-name is one of a very large category which exhibits the pattern *baile* "townland" plus surname. However, there is no attested surname which is reconcilable with the documentary evidence. Nor is there any personal name which would justify the conclusion that the final element of the place-name is either a local (otherwise unattested) surname derived from a personal name, or a patronymic, preceded by the word *mac* "son of". The most satisfactory solution to the problem appears to be that the final element of the place-name is derived from the Irish word *Tuaisceartach* "northerner". The original Irish form of the place-name may have been *Baile Mic an Tuaisceartaigh* (Mod. Ir. *Baile Mhac an Tuaisceartaigh*) "townland of the son of the northerner", but in the process of anglicization the article may have been lost as happened in the case of MacTaggart from MacEntaggart or Mateer from MacAteer. There was a medieval rural deanery named

*Tuaisceart* "north" which extended from Rathlin Island on the north to the river Ravel on the south (see county introduction) and the element *Tuaisceartach* in this place-name could conceivably refer to a native of this district. It may also be worth pointing out that, as well as meaning "northern" the adjective *tuaisceartach* can signify "sinister, awkward, rude, uncivilised" (*Dinneen* sv.) and it is conceivable that the final element of the place-name could represent "rude, uncouth fellow" though this seems a less likely interpretation.

The previous interpretation of the name of the townland as *Baile Máighe Tuaisceartaigh* "town of the northern plain" is not convincing. While there is an area of level land in the townland, it is hardly significant enough to merit the title "the northern plain".

| **Ballynacooley** | *Baile na Cúile* | |
|---|---|---|
| J 0485 | "townland of the corner or angle" | |
| | | |
| 1. Ballecolle | CPR Jas I 356a | 1617 |
| 2. Ballanacooley | CPR Jas I 356a | 1617 |
| 3. Ballanacooley | Lodge RR Jas I ii 560 | 1617 |
| 4. Ballecolle(y) | Lodge RR Jas I ii 560 | 1617 |
| 5. (?)Ballinelly | Inq. Ult. (Antrim) §20 Car. I | 1633 |
| 6. Ballynecooley | Lodge RR Chas I i 407 | 1637 |
| 7. Ballynecooly | BSD 135b | 1661 |
| 8. Ballynecooly | Lodge RR Chas II i 106 | 1663 |
| 9. (?)Ballycoole | Lodge RR Chas II ii 217 | 1665 |
| 10. Ballyucully | HMR Ant. 146 | 1669 |
| 11. Ballynecooly | Lodge RR Chas II ii 292 | 1684 |
| 12. Ballynecooley | Reg. Deeds 90-133-3227 | 1712 |
| 13. Ballynacoly | Belfast News Letter Oct. 14 | 1763 |
| 14. B:nacoola | Lendrick Map | 1780 |
| 15. B.nacully | Duff's Lough Neagh | 1785 |
| 16. Ballynacooly | Bnd. Sur. | 1826 |
| 17. Ballynacooly | OSNB A 40 | 1828 |
| 18. Baile na Cúile "town of the angle" | J O'D (OSNB) | 1828 |
| 19. ˌbalənəˈkuli | Local pronunciation | 1987 |

The name of the townland is derived from *Baile na Cúile* "townland of the corner or angle", as suggested by O'Donovan (18). However, it is difficult to identify the feature referred to by the final element. There is a narrow corner or angle in the townland boundary in the extreme north-east. It is also possible that the townland may have been named from the nearby peninsula now known as Churchtown Point, or perhaps it was named as forming the south-east corner of the parish of Duneane.

| **Ballynafey** | *Baile na Faiche* | |
|---|---|---|
| J 0288 | "townland of the green/lawn" | |
| | | |
| 1. Ballinafaie | Inq. Ant. (DK) 45 | 1605 |
| 2. Ballinafey | CPR Jas I 93b | 1606 |
| 3. Ballinafay or Ballinafoy | Lodge RR Jas I i 252 | 1606 |
| 4. Ballymaney | CPR Jas I 356a | 1617 |

| | | |
|---|---|---|
| 5. Ballymaney | Lodge RR Jas I ii 560 | 1617 |
| 6. Ballynefie al. Dromderrigge | Lodge RR Chas I i 407 | 1637 |
| 7. Ballynafey | DS (Par. Map) Duneane | 1657c |
| 8. Ballynafey | Hib. Reg. Toome | 1657c |
| 9. Drumfey al. Ballinderrick | Inq. Ult. (Antrim) §5 Car. II | 1661 |
| 10. Ballynasey | BSD 133 | 1661 |
| 11. Ballynafeigh | BSD 135b | 1661 |
| 12. Ballenefly als. Drumderg | Lodge RR Chas II i 106 | 1663 |
| 13. (?)Ballinefeagh al. Ballynefey | Lodge RR Chas II i 207 | 1665 |
| 14. Ballynassi | Hib. Del. Antrim | 1672c |
| 15. Ballnafeagh | Comm. Grace 10 | 1684 |
| 16. Ballynafeigh/Dromderige or Ballynafeigh al. Dromderrig | Lodge RR Chas II ii 292 | 1684 |
| 17. Ballynefeigh | Reg. Deeds 10-133-3227 | 1712 |
| 18. Ballynafey | Lendrick Map | 1780 |
| 19. Ballynafey | Duff's Lough Neagh | 1785 |
| 20. Ballynafy | Bnd. Sur. | 1826 |
| 21. Ballynafie | OSNB A 40 | 1828 |
| 22. Baile na Faithche "town of the (fair) green" | J O'D (OSNB) A 40 | 1828 |
| 23. Baile na faithche "the town of the green" | Joyce i 297 | 1869 |
| 24. ˌbalənəˈfai | Local pronunciation | 1987 |
| 25. ˌbalənəˈfɛː | Local pronunciation | 1987 |

The Irish form of the place-name has been correctly identified as *Baile na Faiche* by both O'Donovan (22) and Joyce (23). The word *faiche* means "a lawn, green, field, exercise ground, esp. the lawn or esplanade in front of a fort or residence" (*Dinneen* sv.). In place-names it is of widespread occurrence, and is variously anglicized as *Fahy, Faha, Faia, Foy, Feigh, Fey* and *Fie* (*Joyce* i 296–7). According to Joyce, the original meaning of *faiche* was "a level green plot in front of ancient Irish residences", but it later developed wider connotations including "a hurling field, or fair green, or any level green field in which meetings were held, or games celebrated, whether in connection with a fort or not . . . In Connaught, at the present time, it is universally understood to mean simply a level green field" (*ibid.*). There is no trace or record of any fort in this townland, and *faiche* in this place-name may be best understood as simply "a green" or "a lawn". In forms 6, 12 and 16(b, d) the name of the nearby townland of **Drumderg** is mistakenly given as an alias name for Ballynafey, while in form 9 the elements of the two townland names have been accidentally confused. Ballynafey is the smallest townland in the baronies of Toome, comprising only 37 acres. However, it was significant enough to appear in the earliest list of townlands in the area in 1605 (*Inq. Ant.* (*DK*) 45), and it was obviously formerly of greater extent for it is shown on the Down Survey Parish Map of c. 1657 (*DS (Par. Map)*) as roughly equal in size to the neighbouring townland of **Mullaghgaun**, which to-day measures approximately 180 acres.

**Ballynamullan**
J 0286

*Baile na Mullán*
"townland of the hillocks"

| | | |
|---|---|---|
| 1. Ballynemullan | Lodge RR Chas I i 407 | 1637 |

| | | |
|---|---|---|
| 2. Ballynemullan | Lodge RR Chas II i 106 | 1663 |
| 3. Ballynemullan | HMR Ant. 146 | 1669 |
| 4. Ballynemullane | Lodge RR Chas II ii 292 | 1684 |
| 5. Ballynemullan | Reg. Deeds 10-133-3227 | 1712 |
| 6. Ballynamullon | Belfast News Letter Oct. 14 | 1763 |
| 7. B:namullen | Lendrick Map | 1780 |
| 8. Ballynamullan | OSNB A 40 | 1828 |
| 9. Baile na Mullán "town of the little summit" | J O'D (OSNB) A 40 | 1828 |
| 10. ˌbalənəˈmọlən | Local pronunciation | 1987 |

O'Donovan's suggested Irish form i.e. *Baile na Mullán* "town of the little summit" (9) is probably intended to translate as "town of the little summits". The townland has a "detached portion" lying some two miles west of the main portion and there is a conspicuous knoll of 135 feet in the north of the main portion (marked "The Hill" on the *OS 1:10,000* map). There is also a slight eminence named **Knockmore** on the boundary between the main portion of Ballynamullan and the townland of Ballynaleney. *Baile na Mullán* "townland of the hillocks" may perhaps be regarded as a "contrast-name" with the name of the neighbouring townland of **Ballynaleney** which is derived from Irish *Baile na Léana* "townland of the wet meadow".

| **Brecart** | *Breacghort* | |
|---|---|---|
| H 9991 | "speckled field" | |
| 1. Blackhart | BSD 135b | 1661 |
| 2. Brackhart | HMR Ant. 151 | 1669 |
| 3. Brackhart | Lodge RR Chas II ii 292 | 1684 |
| 4. Brockart | Williamite Forf. | 1690s |
| 5. Brackart | Reg. Deeds 90-171-62470 | 1739 |
| 6. Brickart | Belfast News Letter Feb. 3 | 1758 |
| 7. Blackhart | Reg. Deeds 241-110-157187 | 1765 |
| 8. Breckart | Lendrick Map | 1780 |
| 9. Brockart | Duff's Lough Neagh | 1785 |
| 10. Brackhart | Bnd. Sur. | 1826 |
| 11. Brecart | OSNB A 40 | 1828 |
| 12. Breac-Art "speckled stone" | J O'D (OSNB) A 40 | 1828 |
| 13. brəˈkɑrt | Local pronunciation | 1987 |

The most satisfactory interpretation of this place-name appears to be *Breacghort* "speckled field". In Irish, compound forms such as *breacghort* are normally stressed on the first syllable, which in this case is at odds with the local pronunciation. However, none of the earlier recorded spellings show any sign of the modern centralization of the medial vowel of the first element, suggesting that previously the place-name was stressed on the first syllable. The presence of the medial *h* in all the earlier spellings suggests the lenited initial *g* of *ghort*, and argues against O'Donovan's interpretation of the place-name as *Breac-Art* "speckled stone" (12). One might also consider the Irish forms *Breacaird* "speckled peninsula", or *Breacard* "speckled height", but the latter interpretation is at odds with the local conditions, and neither suggestion is supported by the medial *h* of the earlier recorded forms.

This townland was cut in two by an alteration in the course of the river Bann in a drainage scheme about 1738 which has left it with a "detached portion" on the Co. Derry side of the modern course of the river (*OSM* xix 97).

| **Brockish, part of Cargin** | *Brocais* | |
| H 9989 | "badger's sett/fox's earth" | |
| 1. Brokestown | DS (Par. Map) Duneane | 1657c |
| 2. Brokestown | Hib. Reg. Toome | 1657c |
| 3. Brookestown | BSD 134 | 1661 |
| 4. the quarterland of Cargin called Brockesh | Belfast News Letter Oct. 22 | 1765 |
| 5. Brockish Bay | Lendrick Map | 1780 |
| 6. Brockish | Duff's Lough Neagh | 1785 |
| 7. Brockish, part of Cargin | Bnd. Sur. | 1826 |
| 8. Brackish | OSNB A 40 | 1828 |
| 9. Breac-ais "speckled land" | J O'D (OSNB) A 40 | 1828 |
| 10. "Brockish . . . another form of Brockagh . . . a place of badgers" | Joyce iii 150 | 1913 |
| 11. 'brɔkiʃ | Local pronunciation | 1987 |

O'Donovan's interpretation of this place-name as *Breac-ais* "speckled land" (9), is based on the spelling *Brackish* which is recorded in the OSNB (8). However, this spelling does not appear to be reliable as it is at odds with the local pronunciation and is not supported by the other historical forms. The form *Brokestown* which is recorded on the Down Survey Parish Map of c. 1657 (*DS (Par. Map)*) and duplicated in forms 2 and 3, appears to represent a peculiar anglicization of the place-name (incorporating the English suffix "-town"), even though it is placed a little to the south of the present position of the townland.

The word *brocais* is derived from *broc* "a badger", and is defined as "1.den. 2.dirty, smelly place" (*Ó Dónaill* sv.); "a badger warren; a den, a haunt of robbers etc., a dirty place, thing or person" (*Dinneen* sv.). Joyce informs us that *brocais* is a variant form of *brocach* "a place of badgers, a badger-warren" (*Joyce* iii 150). According to Ó Dónaill, *brocach*, as well as signifying "a badger's sett", may also denote "a fox's earth" (*Ó Dónaill* sv.). The secondary meaning of *brocais*, i.e. "dirty, smelly place" is apparently derived from its primary meaning of "place of badgers, a badger-warren". Given the low-lying situation of the townland, on the shore of Lough Neagh, one is tempted to interpret its name as "dirty, smelly place" but since this interpretation does not appear to be otherwise attested in place-names, "badger's sett" or, perhaps, "fox's earth" must be regarded as the more likely explanation.

The official title of the townland is "Brockish, part of Cargin", the latter being a townland approximately two miles to the east of it. It is striking that the six land divisions which lie along or near to this part of the shore of Lough Neagh are all regarded as detached portions of townlands which lie a short distance to the east.

| **Cargin** | *An Carraigín* | |
| J 0288 | "the little rock/cairn/rocky place" | |
| 1. Cargin | Inq. Ult. (Antrim) §5 Car. II | 1661 |
| 2. Cargin | BSD 135b | 1661 |
| 3. Ballycargine | Lodge RR Chas II i 106 | 1663 |

| | | |
|---|---|---|
| 4. Curgin | HMR Ant. 148 | 1669 |
| 5. Cargon | Comm. Grace 10 | 1684 |
| 6. Cargin | Lodge RR Chas II ii 292 | 1684 |
| 7. Cargin | Reg. Deeds 90-171-62470 | 1739 |
| 8. Cargin | Lendrick Map | 1780 |
| 9. Cargin | Duff's Lough Neagh | 1785 |
| 10. Cargan | Bnd. Sur. | 1826 |
| 11. Cargin | OSNB A 40 | 1828 |
| 12. Cairgín "little rock" | J O'D (OSNB) A 40 | 1828 |
| 13. 'kɑːrgən | Local pronunciation | 1987 |

The form *carraigín* is a diminutive of *carraig* "rock". It is generally understood to mean "little rock" or "land with a rocky surface", and in the north of Ireland it is usually anglicized as Carrigan, Cargan or Cargin (*Joyce* i 411). The anglicized versions Cargan and Cargin clearly represent a syncopated form of *carraigín*, with loss of the medial vowel, while the shortening of the vowel sound in the final syllable of Cargin is a reflection of the tendency for long [i] in unstressed position to be shortened in most dialects of Ulster Irish (O'Rahilly 1932, 102).

It is difficult to identify the feature which is the origin of the place-name. There is a townland named **Cargan** in the parish of Dunaghy and barony of Kilconway, Co. Antrim, in which there is both a standing-stone and a cairn on top of a rocky hill (*NISMR*), either of which (or perhaps the hill itself, which is marked **Cargan Rock** on the *OS 1:50,000* map) could have given name to the townland. In this townland there is no record of a standing-stone or cairn, nor is there any area of noticeably rocky land.

In the south-east of the townland there is however a conspicuous hill, known as Cargin Hill (253 feet). One might tentatively suggest that the townland may have been named from a former cairn, perhaps on the summit of Cargin Hill, or from an area of rocky land which has now been removed, but the feature referred to in the place-name remains unclear.

**Carlane**  *Carn Liáin*(?)
J 0086  "*Lián*'s cairn"

| | | |
|---|---|---|
| 1. Corlean | Ex. Inq. (Ant.) §3 Jac. I | 1618 |
| 2. Ballecarnelian | Lodge RR Chas I i 407 | 1637 |
| 3. Ballycarnelyan | Lodge RR Chas I i 407 | 1637 |
| 4. Ballycanullen | DS (Par. Map) Duneane | 1657c |
| 5. Ballycanullen | Hib. Reg. Toome | 1657c |
| 6. Carnetran | Inq. Ult. (Antrim) §5 Car. II | 1661 |
| 7. Ballycanullen | BSD 133 | 1661 |
| 8. Ballycarnylyan | BSD 135b | 1661 |
| 9. Ballycarnylyan | Lodge RR Chas II i 106 | 1663 |
| 10. Carliene | HMR Ant. 148 | 1669 |
| 11. B:ranullen | Hib. Del. Antrim | 1672c |
| 12. Ballycarlyane | Comm. Grace 10 | 1684 |
| 13. Ballycarnalyan | Lodge RR Chas II ii 292 | 1684 |
| 14. Ballycarnelyan | Reg. Deeds 10-133-3227 | 1712 |
| 15. Carleane | Belfast News Letter Dec. 30 | 1766 |
| 16. Carlean | Lendrick Map | 1780 |

| | | |
|---|---|---|
| 17. Carleane | Duff's Lough Neagh | 1785 |
| 18. Carlean | Bnd. Sur. | 1826 |
| 19. Carlean | OSNB A 40 | 1828 |
| 20. Car Léan – "meaning uncertain" | J O'D (OSNB) A 40 | 1828 |
| 21. ˌkɑr'leːn | Local pronunciation | 1987 |

Even though the earliest recorded spelling, i.e *Corlean*, suggests that the first element of the place-name is *corr* "a round hill" or, possibly, "hollow/pit", it is not supported by any of the other historical spellings, and it is safe to conclude that the *-o-* in this form is a scribal mistranscription of *-a-*. One might propose that forms 10, 12 and 15–19 suggest the element *carr* which is cited by Joyce as signifying "a rock/rocky land" (*Joyce* i 419) and defined by Ó Dónaill as "rough surface or rocky patch" (*Ó Dónaill* sv.), while in the form *Ballycanullen* (4) (which has been duplicated in forms 5, 7 and 11) the first *-n-* appears to be a mistranscription of *-r-*, which might suggest the element *ceathrú* "quarter (of land)". However, judging by forms 2 and 3, the medial *-u-* appears likely to be a mistranscription of *-n-* and the first *-l-* a mistake for *-e-*, the intended spelling being *Ballycarnelen*. The weight of evidence of the earlier spellings therefore favours the interpretation of the first element of the place-name as *carn* "cairn". It is easy to see how the final *-n* of *carn* could have disappeared due to assimilation to the initial *l* of the final element of the place-name.

The most satisfactory interpretation of the final element is that it represents the personal name *Lighean* (Mod. Ir. *Lián*), which forms the final element of the names of the townlands of Drumleene in Donegal and of two townlands named Drumlion in Co. Cavan (*Onom. Goed.* 366). One might also consider the interpretation of the place-name as *Carn Leathan* "broad cairn". In the Irish dialects of East Ulster Irish, *-th-* between two vowels was normally silent (O'Rahilly 1932, 208), which would explain the anglicization of *leathan* "broad" as *lane*. However, this explanation must be considered a less likely one, since *-th-* at an earlier period would have been sounded as [h] and one might expect to see some evidence of this sound in the earlier historical forms. On the same grounds the personal name *Liathán*, which is a fairly common element in place-names (see *Onom. Goed.*), must be considered unlikely. There is no trace or record of any cairn in the townland.

## Carmorn
J 0287

Of uncertain origin

| | | |
|---|---|---|
| 1. half Towne of Camorne al. Drumisse | Exch. Deeds & Wills 653 | 1644 |
| 2. Carnorne | Inq. Ult. (Antrim) Car. II §6 | 1662 |
| 3. ye half towne of Cammorne | ASE 106 a 1 | 1666 |
| 4. Camrane | HMR Ant. 148 | 1669 |
| 5. ½ of Cancarn | Comm. Grace 10 | 1684 |
| 6. half town of Cancarne | Lodge RR Chas II ii 292 | 1684 |
| 7. Camorne | Indent. (Staff.) | 1692 |
| 8. Cancarne | Reg. Deeds 10-133-3227 | 1712 |
| 9. Camorne als Camorn | Reg. Deeds 66-434-47347 | 1731 |
| 10. Carnorn | Reg. Deeds abstracts i §621 | 1736 |
| 11. Carnecarne | Reg. Deeds 90-171-62470 | 1739 |
| 12. Camone | Lendrick Map | 1780 |
| 13. Cormorne | Duff's Lough Neagh | 1785 |

14. Camorne orw. Carnorne orw.
    Carmorne                Reg. Deeds 528-215-346334      1800
15. Camorn als Cormorne       Reg. Deeds 761-596-517131      1820
16. Carmorn                  OSNB A 40                 1828

17. Ceathrú Móráin "Moran's
    Quarter"                  J O'D (OSNB) A 40          1828

18. kαr'mo:rn             Local pronunciation        1987

The name of this townland is problematic. There is no evidence to show that the first element of the name is *ceathrú* "quarter" as suggested by O'Donovan (17). Many of the earlier spellings suggest that this element is *cam* which often signifies "a bend" but can also denote a vessel-shaped hollow in the ground (Ó Máille 1968, 69). However, in English documents of the period the letter *r* is sometimes lost in combination with a following *n* or *m*. It is therefore possible that the first element of the place-name is *carr* "a rock, rocky patch". Moreover, the final *-n* of *carn* "cairn" would tend to be lost in the combination *rnm* and this too must be considered as a possible development. In the south of the townland there is a small rocky hill known as "Rock Mount" which would support the interpretation of the first element of the name as *carr* "rock" or, possibly, *carn* "cairn" (from a former cairn on its summit) but it is impossible to reach a firm decision on the matter.

The origin of the final element of the place-name is also uncertain. In O'Donovan's suggested Irish form (17) the final element is presumably understood as the personal name *Mórán* (earlier *Moghrán*), from which is derived the surnames *Ó Móráin* and *Ó Moghráin* "Moran", the name of four septs of Connaught and one of Offaly (MacLysaght 1985, 221). The surname Moran is well attested in the Draperstown area of Co. Derry, while the *Irish Patent Rolls of James I* contains a general pardon to a "Shane O'Morrane" of the **Feevagh** in 1607 (*CPR Jas I* 110b). However, since none of the recorded spellings shows any evidence of the surname prefix *Ó*, it is perhaps more likely that we are dealing with a personal name rather than a surname. Nonetheless, O'Donovan's suggestion that this is likely to be the personal name *Mórán* must be regarded as unlikely on the grounds that it is not attested in northern genealogies. One might consider the personal name *Morna* which occurs twice in an early East Ulster genealogical tract (*Descendants Ir* 104, 108). Final unstressed vowels in place-names are often lost, which would explain the absence of the final *-a* in the modern version of the name. However, there is insufficient evidence to enable one to draw a firm decision on the matter.

In form 1, *Drumisse* is given as an alias name for the townland. One is tempted to suggest that it could in fact refer to a prominent hill now known as **Drumaslough** which lies a little to the north. However, it appears more likely that the resemblance between the two names is merely coincidental, and the origin of the name *Drumisse* remains obscure.

**Cloghogue**                    *Clochóg*
J 0091                        "stony place/stony path"

1. Cleog                  DS (Par. Map) Duneane      1657c
2. Cleogtowne            DS (Reg.)                 1657c
3. Clogtowne             Hib. Reg. Toome         1657c
4. Cleogtowne            BSD 134                  1661
5. Cloghtowne            Hib. Del. Antrim        1672c
6. Cloghouse             Lendrick Map           1780

| | | |
|---|---|---|
| 7. Cloghouse | Duff's Lough Neagh | 1785 |
| 8. Cloughogue | Bnd. Sur. | 1826 |
| 9. Cloghogue | OSNB A 40 | 1828 |
| 10. Clochóg "stony land" | J O'D (OSNB) A 40 | 1828 |
| 11. 'klɔ:xog | Local pronunciation | 1987 |

This was one of the four Church townlands of the parish of Duneane and, as such, historical documentation of the name is slighter than usual. All but one of the 17th-century versions display the suffix -*towne*, a peculiarity already remarked on above in connection with the version of the townland name **Brockish** in the same sources. In forms 6 and 7 it is obvious that the penultimate *s* is a scribal mistranscription of *g*, resulting in the unusual form *Cloghouse* (the mistake of one cartographer being duplicated by the other). As suggested by O'Donovan (10), the name of the townland is derived from Irish *clochóg*, an element which is generally understood as applying to rocky land (*Joyce* i 413), but in this case it is difficult to identify with certainty the feature to which the name refers. There is now no noticeably rocky area in the townland, but the *OS 6-inch* map of 1833 marks "rocks" in its south-west corner. There was also formerly a Mass Station in the townland, at a place named "Rigbey's Rocks" (*O'Laverty* iii 353). The latter appear to have been named from Rigby Dobbin who died in 1765 (*McSkim. Carrick.* 422) and was no doubt a descendant of Major Dobbin, the landlord who adapted the parish church of Duneane c. 1688 (see parish introduction). However, the location of Rigbey's Rocks is now unknown. As pointed out above in the discussion of the name of the townland of **Cloghogue** in the parish of Drummaul, it appears that *clochóg* may sometimes have the significance of a stony path or perhaps stepping stones over a stream. A small stream does form the western and part of the southern boundary of the townland, but it is impossible to be sure of the exact significance of the place-name.

**Creeve**
J 0587

*An Chraobh*
"the large tree"

| | | |
|---|---|---|
| 1. Ballynecreive | Inq. Ant. (DK) 45 | 1605 |
| 2. Ballinecreive | CPR Jas I 93b | 1606 |
| 3. Ballinecreive | Lodge RR Jas I i 252 | 1606 |
| 4. Ballynecreeny | Inq. Ult. (Antrim) §127 Car. I | 1637 |
| 5. Ballenecreny | Lodge RR Chas I i 407 . | 1637 |
| 6. Crevy | Inq. Ult. (Antrim) §4 Car. II | 1661 |
| 7. Ballynecrovy | BSD 135b | 1661 |
| 8. Creeve | Inq. Ult. (Antrim) §8 Car. II | 1662 |
| 9. Ballenecreevy | Lodge RR Chas II i 106 | 1663 |
| 10. Creeve | Lodge RR Chas II i 106 | 1663 |
| 11. Crine | HMR Ant. 146 | 1669 |
| 12. Ballenecrevy | Lodge RR Chas II ii 292 | 1684 |
| 13. Ballinecrevy | Reg. Deeds 220-158-146376 | 1762 |
| 14. Creve | Lendrick Map | 1780 |
| 15. Creeve | Duff's Lough Neagh | 1785 |
| 16. Creeve | Reg. Deeds 660-290-457358 | 1813 |
| 17. Crieve | Bnd. Sur. | 1826 |
| 18. Crieve | OSNB A 40 | 1828 |

| | | |
|---|---|---|
| 19. Craobh "wide-spreading or branchy tree" | J O'D (OSNB) A 40 | 1828 |
| 20. Craobh "a branch, a branchy tree" | Joyce iii 272 | 1913 |
| 21. 'kri:v | Local pronunciation | 1987 |

The name of this townland is derived from Irish *An Chraobh* "the large tree", as suggested by O'Donovan (19). In forms 4, 5, 7, 9, 12 and 13 the final *-y* points to *craoibhe*, the genitive form of *craobh*, suggesting that for a time the townland was also known as *Baile na Craoibhe* "townland of the large tree". The medial *-n-* of form 11 is obviously a scribal error for *-v-*. *Craobh* is the normal word for a branch in Mod. Ir., but both Ó Dónaill and Dinneen also cite "tree" as one of its meanings, while Dinneen gives *craobh* as the usual word for a tree in Antrim Irish. *Craobh* is also the common word for a tree in Scottish Gaelic. According to Joyce, the name *Craobh* "was given to large trees, under whose shadows games or religious rites were celebrated, or chiefs inaugurated" (*Joyce* i 501). While it seems unlikely that every *craobh* in townland names necessarily had this ceremonial significance, it is clear that the tree referred to would have to have been of some prominence to be selected as the naming feature of the townland.

Holmer (1940, 108) records the pronunciation of *craobh* as both [krʌ:v] and [kri:v] in the Glens of Antrim; the latter may, like this townland name, reflect a dat. sing. form. It is also possible that the pronunciation has been influenced by the alternative form of the place-name, *Baile na Craoibhe*, in which the medial vowel of *craoibhe* would have been pronounced as [i:].

There is now no particularly prominent tree in the townland. There is a conspicuous hill of 305 feet, which is well-known in the area as *Creeve Hill*, on the summit of which *NISMR* marks a "possible rath" (now destroyed), and this seems a fairly likely location for the tree which gave name to the townland. The element *craobh* in place-names most often stands alone without a qualifying element, suggesting that it referred to a unique feature of the locality in which it was situated.

| **Creggan** | *An Creagán* | |
|---|---|---|
| J 0687 | "the rocky place" | |
| 1. Ballinecreggie orw. Ballycregan | CPR Jas I 356a | 1617 |
| 2. Ballinecreggie al. Ballycregan | Lodge RR Jas I ii 560 | 1617 |
| 3. Creaggan | Inq. Ult. (Antrim) §113 Car. I | 1636 |
| 4. Ballycreggan | Lodge RR Chas I i 407 | 1637 |
| 5. Creggan | Inq. Ult. (Antrim) §129,130 Car. I | 1639 |
| 6. Ballycregan | BSD 135b | 1661 |
| 7. Ballecreggan | Inq. Ult. (Antrim) §8 Car. II | 1662 |
| 8. Ballycreggan | Inq. Ult. (Antrim) §8 Car. II | 1662 |
| 9. Ballycreggan | Lodge RR Chas II i 106 | 1663 |
| 10. (?)Cargin | HMR Ant. 145 | 1669 |
| 11. Ballycregin | Comm. Grace 10 | 1684 |
| 12. Ballycregin or Ballycreggan | Lodge RR Chas II ii 292 | 1684 |
| 13. Cregan | Lendrick Map | 1780 |
| 14. Cregan | Duff's Lough Neagh | 1785 |
| 15. Cregan | Bnd. Sur. | 1826 |
| 16. Creggan | OSNB A 40 | 1828 |

| | | |
|---|---|---|
| 17. Creagán "rocky land" | J O'D (OSNB) A 40 | 1828 |
| 18. 'krɛːgən | Local pronunciation | 1987 |

The word *creagán* is a diminutive of *creag* "rock" and signifies "a little rock; a rocky or stony place" (*Dinneen* sv.). As an element in place-names it is common in every part of Ireland except the south-east, and it is generally applied to rocky land (*Joyce* i 411). In East Ulster Irish, *ea* before *d*, *s* and *g* was pronounced as [ɛ] (Holmer 1940, 76), a sound which is reflected in the local pronunciation of the place-name, as well as the vast majority of the historical forms. There are several small areas of rocky land in the townland.

| **Derrygowan** | *Doire Gabhann* | |
|---|---|---|
| J 0488 | "oak-wood of the smith" | |
| 1. Dirregowan | CPR Jas I 356a | 1617 |
| 2. Dirregowan | Lodge RR Jas I ii 560 | 1617 |
| 3. Ballyderedulen al. Ballydeughan | Inq. Ult. (Antrim) §6 Car. II | 1663 |
| 4. Dirrigoan | HMR Ant. 147 | 1669 |
| 5. Balliderrignan | Lodge RR Chas II ii 292 | 1684 |
| 6. Dorrygowan | Indent. (Staff.) | 1692 |
| 7. Derrygoan | Marriage Indent. (Staff.) | 1692 |
| 8. Ballyderygoan | Reg. Deeds 10-133-3227 | 1712 |
| 9. Derrygowan | Reg. Deeds 30-39-16255 | 1720 |
| 10. Derrygowan | Lendrick Map | 1780 |
| 11. Derrygowan | OSNB A 40 | 1828 |
| 12. Doire Uí Ghabhann "O'Gowan's Derry or Oak-Wood" | J O'D (OSNB) A 40 | 1828 |
| 13. "wood of the *gow* or smith" | Joyce iii 297 | 1913 |
| 14. ˌdɛri'gəuən | Local pronunciation | 1987 |

Non-final stressed *abh* is normally pronounced as [oː] in Ulster Irish (O'Rahilly 1932, 177–8), the sound suggested by forms 4, 7 and 8. O'Donovan's suggested Irish form, i.e. *Doire Uí Ghabhann* "O'Gowan's Derry or Oak-Wood" (12) is worthy of consideration, since the genitive form of the surname particle *Ó* (i.e. *Uí*) would easily be absorbed in the final *e* of *Doire*. However, the absence of the *y* in the two earliest forms argues against this interpretation, and *Doire Gabhann* "oak-wood of the smith" appears more likely. It may be worthy of remark that in the neighbouring townland of **Ballycloghan** there was formerly a fort (now destroyed) which appears to have been occupied by a smith (or possibly a cooper) as late as the reign of George I (1714–27) (*OSM* xix 108b). Derrygowan borders on the townland of **Tamnaderry**, whose name is derived from Irish *Tamhnaigh an Doire* "field/clearing of the oak-wood", which raises the possibility that the element *doire* "oak-wood" in both names may have referred to the same oak-wood, of which there is now no trace or record.

| **Derryhollagh** | *Doire Shalach* | |
|---|---|---|
| J 0589 | "sallow wood" | |
| 1. Ballidalloughan | Inq. Ant. (DK) 45 | 1605 |
| 2. (?)the mountain of Dirresallagh | Inq. Ant. (DK) 45 | 1605 |

| | | |
|---|---|---|
| 3. Ballidanoghan | CPR Jas I 93b | 1606 |
| 4. (?)Dirresallagh Mountain | CPR Jas I 93b | 1606 |
| 5. (?)Mount Dirresallagh | CPR Jas I 93b | 1606 |
| 6. Ballidalloghan | Lodge RR Jas I i 252 | 1606 |
| 7. Direholagh | CPR Jas I 356a | 1617 |
| 8. (?)Ballyderrytoolegg orw. Dirrytooleghe | CPR Jas I 356a | 1617 |
| 9. Direholagh | Lodge RR Jas I ii 560 | 1617 |
| 10. (?)Ballyderrytoolegg al. Dirrytooleghe | Lodge RR Jas I ii 560 | 1617 |
| 11. Ballydullaghane al. Derryollagh | Lodge RR Chas I i 407 | 1637 |
| 12. Ballyderihollagh | DS (Par. Map) Duneane | 1657c |
| 13. Balliderryhollogh | Hib. Reg. Toome | 1657c |
| 14. Derrihollogh | Inq. Ult. (Antrim) §5 Car. II | 1661 |
| 15. Ballyderyhollagh | BSD 133 | 1661 |
| 16. Ballydullaghan al. Derryolagh | BSD 135b | 1661 |
| 17. Ballydulichan al. Derryhullagh | Lodge RR Chas II i 106 | 1663 |
| 18. Ballyderrihullagh | Lodge RR Chas II i 106 | 1663 |
| 19. Derryhullagh | HMR Ant. 148 | 1669 |
| 20. Ballideriholla | Hib. Del. Antrim | 1672c |
| 21. Ballydullaghane al. Derryollagh | Comm. Grace 10 | 1684 |
| 22. Ballydullachane or Ballydallachane al. Derryollagh or Derryultagh | Lodge RR Chas II ii 292 | 1684 |
| 23. Derryullagh | O'Laverty iii 354 | 1704 |
| 24. Derryhullagh | Reg. Deeds 36-491-23758 | 1718 |
| 25. Derryhullogh | Belfast News Letter Aug. 1 | 1766 |
| 26. Derryhullagh | Lendrick Map | 1780 |
| 27. Derryhullagh | Duff's Lough Neagh | 1785 |
| 28. Derryholough | Bnd. Sur. | 1826 |
| 29. Derryhollough | OSNB A 40 | 1828 |
| 30. Doire Shalach "dirty oak-wood" | J O'D (OSNB) A 40 | 1828 |
| 31. ˌdɛriˈhɔləx | Local pronunciation | 1987 |

It is possible that the modern name Derryhollagh represents a development from the earlier form *Ballidalloughan* (1) which is duplicated in a number of later forms (3, 6, 11a, 16a, 17a, 21a and 22). One might suggest that in these forms (which are all related) the medial *-d-* is a mistake for *-h-*. The normal word for "sallow tree" is *sail* or *saileach*, but the form *saileachán* is cited by Dinneen (*Dinneen* sv.). One could argue that the earlier spellings suggest a form such as *Baile Shaileachán* "townland of sallows", which could be understood as a dative form, thus explaining the otherwise irregular lenition of the initial s of the final element after the masculine noun *baile*. Otherwise, it might be suggested that the medial *-d-* of these spellings is historical and that the forms represent a corruption of Irish *Doire Shaileachán* "wood of sallows", the *Bally-* prefix being nothing more than a townland marker. However, it is probably unwise to base too much on what amounts to a single historical form and these suggestions must be regarded as tentative.

The identification of forms 2, 4 and 5 with the name of this townland is uncertain. The forms occur in descriptions of the boundary between the territories of Munterividy and

Feevagh, and Derryhollagh appears to be too far south to fit in with the boundary described. It is however possible that the name Derryhollagh has been mistakenly applied to a hill lying some distance to the north of the townland.

The most satisfactory Irish form of the place-name is *Doire Shalach* as suggested by O'Donovan (30). While O'Donovan's interpretation of this form as "dirty oak-wood" may be correct, it is perhaps more likely that the final element may represent an adjectival use of the genitive singular of *sail* "sallow/willow" and that the place-name may have the significance of "wood of sallow", i.e. "sallow wood". While the word *doire* is generally interpreted as "oak-wood" it is also attested in the simple sense of "wood" (*Ó Dónaill* sv.). According to Dinneen, the meaning of *doire* in Antrim Irish is "a thicket on a steep incline" (*Dinneen* sv.). There is, indeed, a conspicuous hill in the townland but it is impossible to say if this is its significance in this place-name. The Down Survey Parish Map of c. 1657 describes the townland as "pasture with spots of arable and wood" (*DS (Par. Map)*) and also marks a large bog in the east.

## Drumboe
J 0388

*Droim Bó*
"ridge of cows"

| | | |
|---|---|---|
| 1. Dromboe | CPR Jas I 356a | 1617 |
| 2. Drumboe | Lodge RR Jas I ii 560 | 1617 |
| 3. Ballydrumbe | Inq. Ult. (Antrim) §6 Car.II | 1663 |
| 4. Drumboe | HMR Ant. 147 | 1669 |
| 5. Ballydrumboe | Lodge RR Chas II ii 292 | 1684 |
| 6. Drumbo | Indent. (Staff.) | 1692 |
| 7. Ballydrumbo | Reg. Deeds 10-133-3227 | 1712 |
| 8. Drumbo | Lendrick Map | 1780 |
| 9. Drumbo | Bnd. Sur. | 1826 |
| 10. Drumbo | OSNB A 40 | 1828 |
| 11. Drumbow | OS Name Sheets | 1830 |
| 12. Drumboe | OS Name Sheets (J O'D) | 1830 |
| 13. Druim Bó "ridge of the cows" | J O'D (OSNB) A 40 | 1828 |
| 14. drọm'bo: | Local pronunciation | 1987 |

The name of this townland is clearly derived from Irish *Droim Bó* "ridge of cows", as suggested by O'Donovan (13). There is a prominent hill of 300 feet in the middle of the townland, on the summit of which are the remains of an old fort, and this appears likely to be the feature which has given rise to the place-name.

## Drumcullen
J 0289

*Droim Cuilinn*
"ridge of holly"

| | | |
|---|---|---|
| 1. Drumcullin | Inq. Ant. (DK) 45 | 1605 |
| 2. Drumculline | CPR Jas I 93b | 1606 |
| 3. Drumculline | Lodge RR Jas I i 252 | 1606 |
| 4. Ballydrumcullin | DS (Par. Map) Duneane | 1657c |
| 5. Ballidrumoullen | Hib. Reg. Toome | 1657c |
| 6. Ballydrumcullyn | BSD 134 | 1661 |
| 7. Ballydrumcullin | BSD 135b | 1661 |
| 8. Ballydrumkallen | BSD 135b | 1661 |

| | | |
|---|---|---|
| 9. Drumkillen | Inq. Ult. (Antrim) §8 Car. II | 1662 |
| 10. Drumcullyne | Lodge RR Chas II i 106 | 1663 |
| 11. Drumcollen | HMR Ant. 150 | 1669 |
| 12. Ballidrumcullen | Hib. Del. Antrim | 1672c |
| 13. Ballydrumculline | Comm. Grace | 1684 |
| 14. Ballydrumculline or kallen | Lodge RR Chas II ii 292 | 1684 |
| 15. Drumculline | Reg. Deeds 10-133-3227 | 1712 |
| 16. Drumcullen | Lendrick Map | 1780 |
| 17. Drumcullin | Duff's Lough Neagh | 1785 |
| 18. Drumcullen | OSNB A 40 | 1828 |
| 19. Druim Cuilinn "ridge of the holly" | J O'D (OSNB) A 40 | 1828 |
| 20. ˌdrọm'kọlən | Local pronunciation | 1987 |

There is no reason to disagree with O'Donovan's interpretation of this place-name as *Druim Cuilinn* (>*Droim Cuilinn*) "ridge of holly" (19). The townland appears to have been named from a hill of 200 feet, on the summit of which the *OS 6-inch* map of 1833 marks a fort and a small settlement. This hill is now well-cultivated, and no sign of any holly-trees now remains.

**Drumderg**          *Droim Dearg*
J 0090               "red ridge"

| | | |
|---|---|---|
| 1. Ballynfie al. Dromderrigge | Lodge RR Chas I i 407 | 1637 |
| 2. Drumfey al. Ballinderrick | Inq. Ult. (Antrim) §5 Car. II | 1661 |
| 3. Drumderrig | BSD 135b | 1661 |
| 4. Ballenefly als. Drumderg | Lodge RR Chas II i 106 | 1663 |
| 5. town of Ballydrumdergg | Lodge RR Chas II i 106 | 1663 |
| 6. Drumdirry | HMR Ant. 150 | 1669 |
| 7. Dromderige | Comm. Grace 10 | 1684 |
| 8. Ballynafeigh, Dromerige, or Ballynafie al. Dromderrig | Lodge RR Chas II ii 292 | 1684 |
| 9. Drumderick | Reg. Deeds 10-133-3227 | 1712 |
| 10. Drumderrig | Lendrick Map | 1780 |
| 11. Drumderrig | Duff's Lough Neagh | 1785 |
| 12. Drumderig | Grand Jury Pres. (Summer) | 1790 |
| 13. Drimdarg | Grand Jury Pres. (Lent) | 1797 |
| 14. Drumderrig | OSNB A 40 | 1828 |
| 15. Druim Dearg "red ridge" | J O'D (OSNB) A 40 | 1828 |
| 16. drọm'dɛrg | Local pronunciation | 1987 |
| 17. ˌdrọm'dɛrəg | Local pronunciation | 1987 |

The most satisfactory interpretation of this place-name is *Droim Dearg* "red ridge" as suggested by O'Donovan (15). Old Irish *e* followed by a non-palatal consonant became [a], spelt *ea* in most dialects of Modern Irish and there is evidence that *ea* in *dearg* came to be sounded as [a] in East Ulster Irish (Holmer 1940, 110; Sommerfelt 1929, 134, 158). However, the recorded spellings of this place-name almost unanimously suggest the pronunciation of *ea*

as [ɛ], which appears to reflect the earlier realization of the sound. The final *-y* of form 6 is unique to this source and is clearly a scribal error for *g*. The spelling *-derrig(g)e* in many of the forms appears to reflect the original Irish disyllabic pronunciation of *dearg* "red" which is reflected in the pronunciation of the name by older people today. The linking of Drumderg with the nearby townland of **Ballynafey** in forms 1, 4 and 8 and the accidental confusion of the elements of the two townland names in form 2 has been referred to above under the townland of **Ballynafey**.

| **Drumraymond** | *Droim Réamainn* | |
|---|---|---|
| H 9993 | "Raymond's Ridge" | |
| 1. (?)Kilfert | DS (Par. Map) Duneane | 1657c |
| 2. (?)Kilfert | Hib. Reg. Toome | 1657c |
| 3. (?)Kilfert | BSD 134 | 1661 |
| 4. Drumremoune | BSD 135b | 1661 |
| 5. Drumremond | Lodge RR Chas II i 106 | 1663 |
| 6. Drumrimon | HMR Ant. 151 | 1669 |
| 7. (?)Kilfert | Hib. Del. Antrim | 1672c |
| 8. Dronnemon | Comm. Grace 10 | 1684 |
| 9. Dromremon | Lodge RR Chas II ii 292 | 1684 |
| 10. Drumreman | Reg. Deeds 10-133-3227 | 1712 |
| 11. Drumremond | Belfast News Letter Aug. 1 | 1766 |
| 12. Drumreman | Lendrick Map | 1780 |
| 13. Drumremond | Duff's Lough Neagh | 1785 |
| 14. Drumraymond | OSNB A 40 | 1828 |
| 15. Druim Réamoinn "Redmond's Ridge" | J O'D (OSNB) A 40 | 1828 |
| 16. ˌdrọmˈreːmənd | Local pronunciation | 1987 |

The personal name *Réamann* "Raymond", was introduced into England by the Normans and brought from there to Ireland by the Anglo-Norman settlers (Ó Corráin & Maguire 1981, 155). However, this is not necessarily evidence of Norman ownership of the townland, as the name became quite popular among the native Irish in late medieval Ireland and remained popular up until the 19th century among the O'Hanlons, MacCanns, MacArdles, Mackens and other northern families (*ibid.*). The surname Redmond (in the simple form *Réamonn*) is associated almost entirely with South Wexford, while Mac Redmond (*Mac Réamoinn*) is the name of a branch of the Burkes in Connaught, now found in Offaly (MacLysaght 1985, 256). It is most unlikely that either surname would be found as an element in the name of a townland in this area, and it is much more probable that we are dealing with the personal name *Réamann* "Raymond". Although the townland consists mainly of flat and low-lying land on the east shore of Lough Beg, there are two hills of 100 feet in the south of the townland, either of which could be the feature which has given rise to the place-name.

The name of this townland is not documented in the usual sources of the first half of the 17th century. The Down Survey Parish Map of c. 1657 shows a townland named *Kilfert* in the position occupied by the modern townland of Drumraymond (*DS (Par. Map)*), suggesting that this was an older name for the townland. It is also possible that Drumraymond was formerly a sub-division of *Kilfert* and that its name later came to be applied to the entire

townland. A possible interpretation of *Kilfert* is *Cill Fearta* "church of the mound or grave", but in the absence of further evidence, this interpretation must be regarded as extremely tentative.

| **Gallagh**<br>J 0088 | *Gallach*<br>"place of (standing) stones" | |
|---|---|---|
| 1. Ballygallagh | Inq. Ant. (DK) 45 | 1605 |
| 2. Balligallogh | CPR Jas I 78a | 1605 |
| 3. Balligallagh | CPR Jas I 93b | 1606 |
| 4. Ballyallagh | DS (Par. Map) Duneane | 1657c |
| 5. Ballialla | Hib. Reg. Toome | 1657c |
| 6. Ballyallagh | BSD 133 | 1661 |
| 7. Ballygellagh | ASE 49 b 11 | 1665 |
| 8. Ballygally | ASE 106 a 1 | 1666 |
| 9. Gallagh | EP Earl Ant. | 1667 |
| 10. Gallagh | HMR Ant. 148 | 1669 |
| 11. Balliallagh | Hib. Del. Antrim | 1672c |
| 12. Gallagh al. Gallanagh al.<br>Ballyallagh | Lodge RR Chas II ii 292 | 1684 |
| 13. Gallagh al. Gallanagh al.<br>Ballyallagh | Reg. Deeds 90-172-62470 | 1739 |
| 14. Gallagh | Lendrick Map | 1780 |
| 15. Gallagh | Duff's Lough Neagh | 1785 |
| 16. Gallagh | OSNB A 40 | 1828 |
| 17. Gallach "stony, rocky" | J O'D (OSNB) A 40 | 1828 |
| 18. Gallach "a place abounding in<br>standing-stones, or large stones<br>or rocks" | Joyce i 344 | 1869 |
| 19. 'ga:ləx | Local pronunciation | 1987 |

The Irish form of this place-name is most likely to be *Gallach* as proposed by O'Donovan (17). However, it is improbable that *Gallach* in this case represents an adjectival form as suggested; it is much more likely that it is made up of the noun *gall* "stone/standing-stone", plus the collective termination *-ach* and that the place-name has the significance of "place of stones" or "place of standing stones", as suggested by Joyce (18). Forms 12b and 13b give *Gallanagh* as an alias name for the townland, suggesting the Irish form *Gallánach* "place of standing stones", but as this form is not supported by the earliest recorded spellings its reliability must be questioned. In form 4, the initial *g* has disappeared, most likely as a result of scribal error, the final *-y* of *Bally* being accidentally merged with the initial *g* of *Gallagh*, and the scribal error has been duplicated in forms 5, 6, 11, 12c, and 13c. The prefix *Bally-* in the earlier forms is clearly merely a scribal addition, to mark the place referred to as a townland. There is now no trace or record of standing stones in the townland, or of an area of stony land, and we are led to conclude that the feature which gave rise to the place-name has long disappeared. The word *gall* in the sense of "pillar stone/standing stone" has long been obsolete in the Irish language, being found only in place-names and in Early Law tracts and glossaries (Mac Giolla Easpaig 1981, 160). This suggests that this place-name is one of some antiquity, which would explain why it is now impossible to identify the feature which gave rise to the name.

| **Garriffgeery** | *Garbhdhoire* | |
| J 0388 | "rough oak-wood" | |

| | | |
|---|---|---|
| 1. Ballygarnery | CPR Jas I 356a | 1617 |
| 2. Ballygarnery | Lodge RR Jas I ii 560 | 1617 |
| 3. Ballygarnegerry | Lodge RR Chas I i 407 | 1637 |
| 4. Ballygarvegery | Lodge RR Chas I i 407 | 1637 |
| 5. Ballygarugirr | DS (Par. Map) Duneane | 1657c |
| 6. B:garugar | Hib. Reg. Toome | 1657c |
| 7. Gornegarr | Inq. Ult. (Antrim) §5 Car. II | 1661 |
| 8. Ballygarngirr | BSD 133 | 1661 |
| 9. Ballygarnigory | BSD 135b | 1661 |
| 10. Ballygarrugeery | Lodge RR Chas II i 106 | 1663 |
| 11. Garregery | HMR Ant. 148 | 1669 |
| 12. Balligarugar | Hib. Del. Antrim | 1672c |
| 13. Ballygarregerie | Comm. Grace 10 | 1684 |
| 14. Ballygarngerie | Lodge RR Chas II ii 292 | 1684 |
| 15. Garvegery | Reg. Deeds 10-133-3227 | 1712 |
| 16. Garriffgeery | Belfast News Letter Oct. 14 | 1764 |
| 17. Ganygeery | Lendrick Map | 1780 |
| 18. Gariffgeery | Duff's Lough Neagh | 1785 |
| 19. Garrifgeery | Bnd. Sur. | 1826 |
| 20. Garriffgeery | OSNB A 40 | 1828 |
| 21. Garbh na gCaorach "rough land of the sheep" | J O'D (OSNB) A 40 | 1828 |
| 22. ˌɡɑrifˈɡiːri | Local pronunciation | 1987 |
| 23. ˌɡɑriˈɡiːri | Local pronunciation | 1987 |

Many of the historical forms have obviously been corrupted as a result of scribal mistranscriptions. The medial *-n-* of forms 1–3, 7–9 and 14 is likely to be an error for *-v-* as is also the medial *-u-* of forms 5, 6, 10 and 12. Historically, the final *-bh* of *garbh* "rough", would have been pronounced as [v], a sound which in Ulster Irish normally developed into [w]. However, the pronunciation of *garbh* is recorded as [gɑrv] in both the Glens of Antrim (Holmer 1940, 115) and in Rathlin (Holmer 1942, 199). The historical forms of this place-name suggest that *garbh* also preserved the original [v]-sound, which was later devoiced, resulting in the modern [f]-sound, first recorded in 1764 (16).

Although the first element of the place-name is most likely to be *garbh* "rough", O'Donovan's interpretation of the place-name as *Garbh na gCaorach* "rough land of the sheep" (21), appears unlikely. None of the recorded spellings show any evidence of the article *na*, or of the *-ach* termination of *caorach*. A more plausible interpretation of the place-name is *Garbhdhoire* "rough oak-wood". Irish *dh* is commonly anglicized as *g* in place-names (*Joyce* iii, 6–7), while the *oi* of *doire* in East Ulster Irish is likely to have been sounded as [ɛ] (Holmer 1940, 75), a sound which appears to be represented by *ger(r)y* in many of the earlier forms. The modern rendition of this sound as [iː] appears to have developed later in the English dialect of the area.

A common local pronunciation of this place-name is [ˌɡɑriˈɡiːri], which suggests that the first element may be *garraí* "garden/small field", rather than *garbh* "rough". However, this interpretation is not supported by the historical forms, only one of which (17), displays a medial *-y-*.

The interpretation of the place-name as *Garbhdhoire* "rough oak-wood" involves the acceptance of a change in the stress pattern, since compounds are normally stressed on the first syllable in the Irish language. However, one can point to a parallel in the common place-name *Garbhachadh* "rough field" which is regularly anglicized *Garvaghy* and stressed on the second syllable (see **Garvaghy**, parish of Portglenone below).

There is now no sign of a wood or thicket in the townland, but the Down Survey Parish Map of c. 1657 describes the townland as "coarse pasture and wood" (*DS (Par. Map)*).

| **Gortgarn** | *Gort Carnaigh*(?) | |
|---|---|---|
| J 0189 | "field of the cairn/mound(?)" | |
| 1. (?)Ballygartacarney | Inq. Ant. (DK) 45 | 1605 |
| 2. (?)Ballygortcross | Inq. Ant. (DK) 45 | 1605 |
| 3. (?)Balligartacarney | CPR Jas I 93b | 1606 |
| 4. (?)Balligortcrosse | CPR Jas I 93b | 1606 |
| 5. (?)Balligartacarney or Balligartocarney | Lodge RR Jas I i 252 | 1606 |
| 6. (?)Balligortcrossey | Lodge RR Jas I i 252 | 1606 |
| 7. (?)Ballygortcrosty | Lodge RR Chas I i 407 | 1637 |
| 8. (?)Ballygortcarnie | Lodge RR Chas I i 407 | 1637 |
| 9. Ballygorcan | DS (Par. Map) Duneane | 1657c |
| 10. Ballegorcan | Hib. Reg. Toome | 1657c |
| 11. Garnegorm | Inq. Ult. (Antrim) §5 Car. II | 1661 |
| 12. Ballygorcan | BSD 133 | 1661 |
| 13. Ballygortgarny | BSD 135b | 1661 |
| 14. (?)Ballygortcressy | BSD 135b | 1661 |
| 15. (?)Ballegortcrossy | Lodge RR Chas II i 106 | 1663 |
| 16. (?)Gortcarne | Lodge RR Chas II i 106 | 1663 |
| 17. Gorcarne | HMR Ant. 150 | 1669 |
| 18. (?)Ballygartcarny | Inst. Edenduffcarrick | 1672c |
| 19. Balligora | Hib. Del. Antrim | 1672c |
| 20. (?)Ballygortcrossy | Lodge RR Chas II ii 292 | 1684 |
| 21. (?)Ballygortgarvy or Ballygortgarny | Lodge RR Chas II ii 292 | 1684 |
| 22. Ballygortgarny | Reg. Deeds 10-133-3227 | 1712 |
| 23. Gortgarn | Lendrick Map | 1780 |
| 24. Gortgarn | Duff's Lough Neagh | 1785 |
| 25. Gortgarn | OSNB A 40 | 1828 |
| 26. Gort Garrain "field of the copse" | J O'D (OSNB) A 40 | 1828 |
| 27. Gort-gcarn or Gort-na-gcarn "field of the carns or grave-monuments" | Joyce iii 378 | 1913 |
| 28. 'gɔrt'gɑːrn | Local pronunciation | 1987 |

The task of establishing a reliable Irish form for this place-name is rendered more difficult by the fact that it is impossible to be sure whether forms 1, 3, 5, 8, 18 and 21 refer to this townland or to **Gortagharn** in the parish of Drummaul. If the latter, then the possibility

arises that **Gortgarn** may be identified with a townland named *Ballygortcross* which occurs in a number of the earlier sources. The forms *Ballygortcross*, *Ballygortcrossey* etc. suggest an Irish form such as *Gort (na) Croise* "field of the cross or crossroads" (assuming that the *Bally*-element in these forms is not historical). However, it is difficult to see any etymological connection between the final element of this name and Gortgarn, and, if *Ballygortcross* does in fact represent an earlier version of Gortgarn, the two final elements appear to be unrelated in meaning.

The absence of the medial *-g-* in the earlier recorded forms rules out O'Donovan's suggestion that the final element of the place-name is *garrán* "a grove, a copse" (26), and Joyce's suggested Irish forms *Gort gCarn* or *Gort na gCarn* "field of the carns or grave monuments" (27), the second of which he describes as "unlikely though possible" (*Joyce* iii 378). I would tentatively suggest that the most likely Irish form of the place-name is *Gort Carnaigh* "field of the cairn/mound". The normal Irish word for "cairn" is *carn*, but, as the termination *-ach* is added to some words without any resultant change in meaning (*Joyce* ii 5), *carnach* (gen. *carnaigh*) would represent an acceptable variant form. Forms 1, 3 and 5 suggest a form of the place-name incorporating the definite article, i.e. *Gort an Charnaigh*, but, as pointed out above, the identification of these forms with Gortgarn is uncertain. One might also interpret *carnach* as "place of cairns" or as an Irish form of the Scottish Gaelic noun *càrnach* "stony ground, quarry (used as names of several places having stony or rocky situation)" (*Dwelly* sv.). However, the fact that the townland of Gortgarn borders on a conspicuous hill known as **Drumaslough**, which appears a possible site for a cairn, suggests that "cairn" may be the most plausible interpretation of the final element. It is also possible that *carnach* could have the significance of "mound/hillock", as this is listed as an alternative meaning of *carn* in the *Dictionary of the Irish Language* (*DIL* sv.).

I can offer no entirely satisfactory explanation for the presence of the medial *-g-* in the place-name. However, a parallel development from *c* to *g* appears to have occurred in the name of the townland of **Gloonan** in the parish of Ahoghill, which goes back to Irish *Cluanán* "little meadow". In the case of Gortgarn, the anglicization process may have been as follows: Irish *Gort (an) C(h)arnaigh* – anglicized (*Bally*)*gartacarney* (1605) – (*Bally*)*gort-carnie* (1637) – (*Bally*)*gortgarny* (1661) – *Gortgarn* (1780).

| **Gortgill** | *Baile an Ghoirt Ghil* | |
|---|---|---|
| H 9992 | "townland of the white/fallow field" | |

| | | | |
|---|---|---|---|
| 1. Ballygortgill | DS (Par. Map) Duneane | 1657c |
| 2. Balligertgill | Hib. Reg. Toome | 1657c |
| 3. Ballygortgill | BSD 134 | 1661 |
| 4. Balligortgill | Hib. Del. Antrim | 1672c |
| 5. Gortgill | Lendrick Map | 1780 |
| 6. Gortgill | OSNB A 40 | 1828 |
| | | |
| 7. Gort Geal "white field" | J O'D (OSNB) A 40 | 1828 |
| 8. Gort-gile "white field" | Joyce iii 378 | 1913 |
| | | |
| 9. gɔrt'gïl | Local pronunciation | 1987 |

This was one of the four Church townlands of the parish of Duneane, and, as such, documentation of the name is scarcer than usual. O'Donovan's Irish form, i.e. *Gort Geal* "white field" (7) is broadly acceptable, except that it is unlikely that the radical form of the adjective *geal* "white/bright" would be anglicized as "-gill". One could therefore argue in favour

of Joyce's Irish form *Gort Gile* (8) which literally means "field of brightness". However, a more plausible explanation appears to be that the name of the townland goes back to the Irish form *Baile an Ghoirt Ghil* "townland of the white field", as suggested by forms 1–4 and that, even though the element *baile* was later lost, the form of the adjective was left fossilized in the genitive. Ó Dónaill lists the literary term *gort geal*, meaning "fallow field", while *DIL* gives the phrase: *gort geal nach bí fa barr* "a field lying fallow(?)" (*DIL* sv. *gel*), suggesting that when applied to the landscape the adjective *geal* may have connotations of "fallow, untilled".

| **Greenan** | *An Grianán* | |
|---|---|---|
| J 0587 | "the hill/place with a view" | |
| 1. Grenan | Lodge RR Chas I i 407 | 1637 |
| 2. Half ye town of Grenan | BSD 135b | 1661 |
| 3. Greanan ½ townland | Lodge RR Chas II i 106 | 1663 |
| 4. Grenan | HMR Ant. 146 | 1669 |
| 5. Half of Grenane | Lodge RR Chas II ii 292 | 1684 |
| 6. Grennanan | Lendrick Map | 1780 |
| 7. Grenan | Duff's Lough Neagh | 1785 |
| 8. Greening | OSNB A 40 | 1828 |
| 9. Greenan | OS Name Sheets (J O'D) | 1830 |
| 10. Grianán "sunny land, solarium" | J O'D (OSNB) A 40 | 1828 |
| 11. 'gri:nən | Local pronunciation | 1987 |

The word *grianán* is derived from Irish *grian* "sun". According to Joyce, its literal meaning is "a sunny spot", but its normal meaning in place-names is "a royal seat" (*Joyce* i 291–2). Ó Maolfabhail (1974, 69) suggests that *grianán* in townland names was applied to elevated places commanding a good view or to places of some importance, regularly used by the public, a meaning which is a metaphorical extension of the early literary meaning of "upper room in a house". In the case of this townland, there is no evidence to suggest that it was formerly an important place. However, there is a conspicuous hill here, known as "Greenan Hill", which commands an extensive view over Lough Neagh and the surrounding countryside, and this is clearly the feature to which the name *An Grianán* refers. It appears likely, therefore, that in this case the element *grianán* may signify simply "hill, place with a view", an interpretation which is similar to that suggested for the name of the townland of **Greenan** in the parish of Newry, Co. Down (*PNI* i 28). As remarked by Ó Maolfabhail (*ibid.*), the element *grianán* in place-names normally stands alone, without a qualifying element, indicating that the feature referred to was a unique feature of the district in which it was situated. This criterion would apply to the hill referred to in this place-name, as it is certainly a distinctive feature of the landscape.

| **Killyfast** | *Coillidh Feirste* | |
|---|---|---|
| J 0293 | "wood of the hill-ridge" | |
| 1. a wood called Ballykillfart | Inq. Ant. (DK) 45 | 1605 |
| 2. Ballikillsart wood | CPR Jas I 93b | 1606 |
| 3. Ballickilfirst | Lodge RR Chas I i 407 | 1637 |
| 4. Ballykillfirst | Lodge RR Chas I i 407 | 1637 |
| 5. Ballykilfirst als. Muckrom | BSD 135b | 1661 |

| | | | |
|---|---|---|---|
| 6. | the ½ town of Killefae-[ ] | Inq. Ult. (Antrim) §8 Car. II | 1662 |
| 7. | Ballekilferst | Lodge RR Chas II i 106 | 1663 |
| 8. | ½ townland of Killeferst | Lodge RR Chas II i 106 | 1663 |
| 9. | Killifart | HMR Ant. 149 | 1669 |
| 10. | Ballykillfirste al. Muckrum | Lodge RR Chas II ii 292 | 1684 |
| 11. | Killofast | Williamite Forf. | 1690s |
| 12. | Ballykillfast al. Muckrum | Reg. Deeds 90-171-62470 | 1739 |
| 13. | Killfast | Belfast News Letter Aug. 17 | 1763 |
| 14. | quarterland of Killyfast | Belfast News Letter Oct. 27 | 1765 |
| 15. | Killyfast | Lendrick Map | 1780 |
| 16. | Killyfast | Duff's Lough Neagh | 1785 |
| 17. | Killyfast | OSNB A 40 | 1828 |
| 18. | Coill an Fhastaigh "wood of the staying, waiting or delaying" | J O'D (OSNB) A 40 | 1828 |
| 19. | ˌkĭliˈfast | Local pronunciation | 1987 |

Forms 1 and 2 provide definite proof that the derivation of the first element of the place-name is a form of *coill* "wood". In forms 1, 2 and 9 the penultimate *r* is clearly a scribal mis-transcription of *s*, and in form 2 the medial *s* an error for *f*. The final element of the place-name is *feirste*, the genitive form of *fearsaid*, which signifies: "ridge of sand in tidal waters; tidal ford" (*Ó Dónaill* sv.); "a bar or bank of sand as at low water *al.* a deep narrow channel on a strand at low tide" (*Dinneen* sv.); "a sandbank formed near the mouth of a river" (*Joyce* i 361). However, in the case of this inland townland this interpretation is clearly inappropriate. *DIL* defines *fearsaid* as: "a raised bank or ridge of earth or sand . . . generally of a bar or shallow near the sea-shore or a ford in a river", but gives an example of its use to apply to "the ridge (crest) of the plain" (*DIL* sv. *fertas*). In the name of this townland, there-fore, *fearsaid* is likely to apply to a hill ridge or crest. There are several hills in the townland, any one of which could be the feature referred to in the place-name. Unfortunately there is now no trace of the wood referred to in forms 1 and 2, which would help us to identify the naming feature more precisely. A similar anglicization of the element *feirste* as "fast" is found in the name of the city of Belfast, which is derived from *Béal Feirste* (*GÉ* 34), i.e. "approach to the sand-bank ford".

Forms 5, 10 and 12 give the name of the neighbouring townland of **Muckrim** as an alias name for Killyfast. Since Muckrim itself is not documented until 1669, when it is referred to as a "quarter town", it is possible that it previously formed a part of Killyfast. In any case, it is clear that Muckrim is not to be regarded as a true alias name for Killyfast.

**Lismacloskey**  *Lios Mhic Bhloscaidh*
J 0190  "MacCluskey's fort"

| | | | |
|---|---|---|---|
| 1. | Ballymacklesse | DS (Reg.) | 1657c |
| 2. | Ballymackless | BSD 134 | 1661 |
| 3. | Ballimclesse | Hib. Del. Antrim | 1672c |
| 4. | Lismactisky | Lendrick Map | 1780 |
| 5. | Lismaclisky | Reg. Deeds Index | 1780c |
| 6. | Lismactisky | Duff's Lough Neagh | 1785 |
| 7. | Lisnalisky | Bnd. Sur. | 1826 |
| 8. | Lisnalisky | OSNB A 40 | 1828 |

| | | |
|---|---|---|
| 9. Lismaclosky | OS Name Sheets | 1830 |
| 10. Lismacloskey | OS Name Sheets (J O'D) | 1830 |
| 11. Meaning Uncertain | J O'D (OSNB) A 40 | 1828 |
| 12. ˌlïsməˈklọski | Local pronunciation | 1987 |
| 13. ˌlïsnəˈklọski | Local pronunciation | 1987 |

This is one of the four "church" townlands of Duneane and, as such, it is more sparsely documented than usual. The most satisfactory interpretation of the place-name appears to be *Lios Mhic Bhloscaidh* "MacCluskey's fort", though the earlier spellings suggest that the form *Baile Mhic Bhloscaidh* "MacCluskey's townland" may have also been for a time in use. *Mac Bhloscaidh* was the name of a branch of the O'Cahan's (O'Kane's) of Co. Derry, and the family descended from one *Bloscadh Ó Catháin* (Bell 1988, 143), whose son *Donnchadh* is recorded in *Annála Ríoghachta Éireann* as the slayer of Murtagh O'Loughlin, heir to the throne of Ireland in 1196 (*AFM* iii 102).

I have also considered the surname *Mac Giolla Íosa*, a prominent Derry sept, whose name could be anglicized as MacAleese, MacIleese, MacLeese, MacLice, MacLise, etc. (MacLysaght 1985, 3) and could arguably be the name suggested by the 17th-century forms of this place-name. However, the medial *-e-* of these forms appears more likely to be a mistranscription of *-o-*. The second *s* seems to be a mistake for *k* and the intended spelling appears to be *Ballymackloske*, representing a corrupt form of *MacLoskey*, a variant-form of MacCloskey (*op. cit.* 198). The surname MacCloskey is of fairly frequent occurrence in the *Hearth Money Rolls* for Co. Antrim in 1669. MacCloskey is among the ten most common surnames in Co. Derry, and it is also common in Co. Antrim where it is normally spelt MacCluskey (Bell *loc. cit.*).

A common local pronunciation is "Lis*ne*closkey", rather than "Lis*me*closkey" and a number of historical forms also display medial *-na-* rather than medial *-ma-* (7, 8). While this may be interpreted as evidence of the Irish definite article, rather than a surname, the corruption of *Mac* and *Ó* in Irish place-names into English *-na-* is well enough attested. For example, the name of the townland of **Lisnamulligan** in the parish of Clonduff in Co. Down is derived from Irish *Lios Uí Mhaolagáin* "Mulligan's fort" (*PNI* iii 92–93). It seems likely that it is by the same linguistic process that *mac* in this place-name is sometimes rendered *na*.

*NISMR* marks one "enclosure" in the townland, on top of a prominent hill which is known as **Drumaslough** (238 feet) but it is impossible to tell if this is the *lios* or fort which gave name to the townland.

**Moneyglass**
J 0293

*An Muine Glas*
"the green thicket/hill"

| | | |
|---|---|---|
| 1. Ballimeyneglass | Inq. Ant. (DK) 45 | 1605 |
| 2. Ballymoyneglasse | CPR Jas I 78a | 1605 |
| 3. Moyneglasse | CPR Jas I 93b | 1606 |
| 4. Munnyglash | DS (Par. Map) Duneane | 1657c |
| 5. Annglasse | Hib. Reg. Toome | 1657c |
| 6. Munnyglash | BSD 133 | 1661 |
| 7. Ballymonyglasse | ASE 49 b 11 | 1665 |
| 8. Ballymewmeglasse | ASE 106 a 1 | 1666 |
| 9. Muneglass | EP Earl Ant. | 1667 |

| | | |
|---|---|---|
| 10. Muniglass | HMR Ant. 149 | 1669 |
| 11. Annaglass | Hib. Del. Antrim | 1672c |
| 12. Munyglasse | Lodge RR Chas II ii 292 | 1684 |
| 13. Monyglasse | Reg. Deeds 10-133-3227 | 1712 |
| 14. Moneyglass | Lendrick Map | 1780 |
| 15. Monyglass | Duff's Lough Neagh | 1785 |
| 16. Moneyglass | OSNB A 40 | 1828 |
| 17. Muine Glas "Green Brake" | J O'D (OSNB) A 40 | 1828 |
| 18. An Muine Glas | GÉ 140 | 1989 |
| 19. ˌmǫniˈglas | Local pronunciation | 1987 |

The element *muine* is frequently anglicized as *money*, and is generally interpreted as "brake or shrubbery", though it was sometimes applied to a hill (*Joyce* i 496). Ó Ceallaigh (*GUH* 46n) was of the opinion that, in the case of Moneyglass, *muine* should be interpreted as "hill", pointing out that this was its usual meaning in the north-east of Ireland. There are, indeed, several low hills of approximately 100 feet in the townland, the most conspicuous being Grove Hill in the extreme south-east. However, there is also evidence of former woodland in the townland; the Down Survey Parish Map of c. 1657 describes Moneyglass as "pasture and timber wood" (*DS (Par. Map)*). Ó Ceallaigh's statement about the meaning of *muine* is based on the observations of the scholar John O'Donovan in the last century, and, as such, may reflect a fairly late, dialectal, use of the word *muine*. It seems safe to conclude, therefore, that *muine* in this place-name is more likely to signify "thicket" than "hill".

As well as signifying "green", the adjective *glas* may also signify "grey", and I have considered the derivation *Mónaidh Ghlas* "grey bog/moor", the first element representing an oblique form of *móin* "bog/moor". There is a large stretch of bog in the north-west of the townland, referred to as "mossy bog" in c. 1657 (*DS (Reg.)*. However, the representation of the initial element of the name as *moyne* in forms 2, and 3 and as *meyne* in form 1 suggests a palatal *n* in the original Irish form, and *muine* "thicket or hill", must therefore be regarded as more likely than *mónaidh* "bog/moor". On the same grounds, the Scottish Gaelic element *monadh* "hilly ground" can be ruled out.

Forms 5 and 11 are exceptional in that they represent the first element of the place-name as *Ann-* and *Anna-* respectively. One might suggest that they point to the element *eanach* "marsh". However, the sources of these forms are related and it is more likely that the name of the townland has been curiously corrupted in form 5 and the error duplicated in form 11.

**Moneynick**
J 0388

*Muine Chnoic*
"thicket of the hill"

| | | |
|---|---|---|
| 1. Ballyvonaugkie | Inq. Ant. (DK) 45 | 1605 |
| 2. Ballivonanykie | CPR Jas I 93b | 1606 |
| 3. Ballivonanykie or Ballimonankie | Lodge RR Jas I i 252 | 1606 |
| 4. Ballymounckie | Lodge RR Chas I i 407 | 1637 |
| 5. Ballymonukie | Lodge RR Chas I i 407 | 1637 |
| 6. Ballymoninke | DS (Par. Map) Duneane | 1657c |
| 7. Ballimonick | DS (Reg.) | 1657c |
| 8. Ballimonick | Hib. Reg. Toome | 1657c |
| 9. Mumkie | Inq. Ult. (Antrim) §5 Car. II | 1661 |
| 10. Ballymonick | BSD 133 | 1661 |

| | | |
|---|---|---|
| 11. Ballymonucky | BSD 135b | 1661 |
| 12. Ballymonky | Lodge RR Chas II i 106 | 1663 |
| 13. Mumicke | Lodge RR Chas II i 106 | 1663 |
| 14. Murnick | HMR Ant. 149 | 1669 |
| 15. Ballimonick | Hib. Del. Antrim | 1672c |
| 16. Ballymonmucky | Comm. Grace | 1684 |
| 17. Ballemonmucky or Ballymonikie | Lodge RR Chas II ii 292 | 1684 |
| 18. Mununicky | Reg. Deeds 10-133-3227 | 1712 |
| 19. Munynick | Belfast News Letter Oct. 14 | 1763 |
| 20. Moneynick | Lendrick Map | 1780 |
| 21. Moneynick | Duff's Lough Neagh | 1785 |
| 22. Moneynick | OSNB A 40 | 1828 |
| 23. Muine an Chnuic "brake of the hill" | J O'D (OSNB) A 40 | 1828 |
| 24. Móin-a'-chnuic "bog of the knock or hill" | Joyce iii 511 | 1913 |
| 25. Muine Chnoic | GÉ 139 | 1989 |
| 26. ˌmọniˈnïk | Local pronunciation | 1987 |

Many of the earlier spellings show evidence of the common confusion of the letters *m, n* and *u* in English documents of the period. The final *-ie/y* of a number of the earlier forms does not appear to be significant as these forms are all related; it is likely that this termination is the product of a scribal whim, copied from one scribe to the other.

It seems safe therefore to accept that the final element of the place-name consists of one syllable rather than two and that the name of the townland is likely to go back to Irish *Muine Chnoic* "thicket of the hill", as suggested in *GÉ* (25). It is clear that in this case *muine* cannot carry the alternative significance of "hill" (see **Moneyglass** above) since the elements of the place-name would then be tautologous. On the same grounds, the Scottish Gaelic element *monadh* "hilly-ground" can be ruled out.

There is now no natural woodland in the townland, but the Down Survey Parish Map of c. 1657 describes the townland as "pasture and wood" (*DS (Par. Map)*). There are several hills in the townland, the most conspicuous being Morris Hill (357 feet) in the south-east corner. Joyce's interpretation of the place-name i.e. *Móin-a-chnuic* "bog of the knock or hill" (24), is also worthy of consideration, even though his statement that, "there is just one small hill with a bog all round it" is not accurate (*Joyce* iii 511). In fact, there is an area of moorland (formerly bog), bordering a small hill in the east of the townland, and another small area of boggy land in the south-east corner, bordering on Morris Hill. However, neither of these features seems significant enough to have given name to the townland, and *Muine Chnoic* "thicket of the hill", would appear to be the more likely interpretation.

In northern Irish, *n* in the combinations *cn, gn, mn, tn* came to be sounded as [r], possibly during the course of the 17th century (O'Rahilly 1932, 22). The pronunciation of the *n* of *chnoic* as [n] in this place-name clearly reflects the earlier pronunciation, before *n* in the above positions came to be rendered [r] in the Irish dialect of the area.

**Moneyrod**          *Mónaidh Roide*
J 0490               "bog of the reddish mud"

| | | |
|---|---|---|
| 1. Monoroddye | Ex. Inq. (Ant.) §3 Jac. I | 1618 |
| 2. Ballymonyruddey | Lodge RR Chas I i 407 | 1637 |

| | | |
|---|---|---|
| 3. Ballymnyrod | DS (Par. Map) Duneane | 1657c |
| 4. Ballyinnyrod | BSD 133 | 1661 |
| 5. Ballynimrod | BSD 135b | 1661 |
| 6. Ballymonerodoe | Lodge RR Chas II i 106 | 1663 |
| 7. Moneyroad | HMR Ant. 150 | 1669 |
| 8. Ballinyrod | Hib. Del. Antrim | 1672c |
| 9. Ballymoneruddy | Lodge RR Chas II ii 292 | 1684 |
| 10. Moneyrod | Williamite Forf. | 1690s |
| 11. Munyruddy | Reg. Deeds 10-133-3227 | 1712 |
| 12. Moneyroade hill | Grand Jury Pres. 13 | 1712 |
| 13. Moneyrod | Reg. Deeds 36-491-23757 | 1718 |
| 14. Moneyrodd | Belfast News Letter Oct. 14 | 1763 |
| 15. Moneyrodd | Lendrick Map | 1780 |
| 16. Monyrodd | Duff's Lough Neagh | 1785 |
| 17. Moneyrod | OSNB A 40 | 1828 |
| 18. Muine Roda "brake of the ferruginous water or scum" | J O'D (OSNB) A 40 | 1828 |
| 19. "the shrubbery (or perhaps the bog) of the iron scum" | Joyce ii 371 | 1875 |
| 20. ˌmǫni'rɔːd | Local pronunciation | 1987 |

While *Mónaidh Roide* "bog of the reddish mud" is the most likely Irish form of the place-name, there is now no trace or record of a bog in the townland. There is, however, a small lake, known as **Artogue's Dam**, and it is likely that this is an artificial creation. The low-lying area flooded by the damming of the stream which now flows out of the lake may well have been formerly a bog. The Down Survey Parish Map also marks a large bog on the southern boundary of Moneyrod (*DS (Par. Map)*). The word *roide* is attested in the sense of "reddish mud, bog-mire" (*Ó Dónaill* sv.) and is fairly common in place-names where it refers to "a thin, shining, metalliferous-looking scum", formed when soil is impregnated with iron (*Joyce* ii 370–1). Another possible interpretation of the place-name is *Muine Roide* "brake (i.e. thicket) of the ferruginous water or scum", as suggested by O'Donovan (18). Although there is now no native woodland in the townland, the Down Survey Parish Map of c. 1657 describes the townland as "pasture and wood" (*DS (Par. Map)*). However, as a bog is more likely than a thicket to be associated with reddish mud, the first suggestion appears the more plausible. *Muine* might possibly be understood in the sense of "hill". There is a conspicuous hill of 366 feet, known as Moneyrod Hill, which rises steeply from the side of **Artogue's Dam**, and it is possible that it could have been named "hill of the reddish mud" from the former marsh at its foot, but this appears less likely, since the interpretation of *muine* in townland names as "hill" is a tentative one (see **Moneyglass** above). The first element of the place-name could conceivably be interpreted as the Scottish Gaelic element *monadh* "hilly land". However, as this element seems to be of fairly rare occurrence in Irish place-names (*PNI* i 105), it, too, must be regarded as unlikely.

**Muckrim**
J 0093

*Mucroim*
"ridge of the pigs"

| | | |
|---|---|---|
| 1. Ballykilfirst al. Muckrom | BSD 135b | 1661 |
| 2. Mushroin Qr.Towne | HMR Ant. 149 | 1669 |
| 3. Ballykilfirst al. Muckrom | Lodge RR Chas II ii 292 | 1684 |

| | | |
|---|---|---|
| 4. Muckrum | Reg. Deeds 10-133-3227 | 1712 |
| 5. Ballykillfart al. Muckrum | Reg. Deeds 90-171-62470 | 1739 |
| 6. (?)Quarterland of Killyfast | Belfast News Letter Oct. 22 | 1765 |
| 7. Muckrim | Lendrick Map | 1780 |
| 8. Muckrim | Duff's Lough Neagh | 1785 |
| 9. Muckrim | OSNB A 40 | 1828 |
| 10. Mucdhruim "ridge of the pigs" | J O'D (OSNB) A 40 | 1828 |
| 11. 'mo̩krïm | Local pronunciation | 1987 |

The historical forms of the place-name are quite uniform (with the exception of form 2, which is obviously corrupt), and the derivation is clearly *Mucroim*, a compound of the two nouns *muc* "pig" and *droim* "back, ridge", as suggested by O'Donovan (10). *Mucroim* could be interpreted either as "ridge shaped like a pig's back" or "ridge of the pigs". There are several low hills of 100 feet in the townland but, as none of these bear any particular resemblance to a pig's back, it is perhaps more likely that the significance of the place-name is "ridge of the pigs", referring to a ridge where pigs were kept or fed. The name of this townland is conspicuously absent from the documentation of the first half of the 17th century. Form 2 (recorded in 1669) refers to it as a "quarter-town", while a number of references from the end of the 17th century onwards give the name of this townland as an alias for the larger and neighbouring townland of **Killyfast**. This seems to suggest, not that Muckrim was a true alias for Killyfast, but that Muckrim was formerly regarded as a sub-division of Killyfast townland. The 1765 reference to the *Quarterland of Killyfast* (6) may therefore be in fact to Muckrim.

| **Mullaghgaun** | *Mullach Gann*(?) | |
|---|---|---|
| J 0288 | "sparse/poor summit" | |
| 1. Ballymulgay | Inq. Ant. (DK) 45 | 1605 |
| 2. Ballimullgaye | CPR Jas I 93b | 1606 |
| 3. Ballimullgaye | Lodge RR Jas I i 252 | 1606 |
| 4. the manor of Mullagoane | CPR Jas I 324b | 1617 |
| 5. Ballemullegan al. Ballemoyllegall | CPR Jas I 356a | 1617 |
| 6. Ballemullegan al. Ballemoyllegall or Ballemoyllegan | Lodge RR Jas I ii 560 | 1617 |
| 7. Ballymulgay al. Mullaghganie | Lodge RR Chas I i 407 | 1637 |
| 8. Ballymulgay al. Mullaghgane | Lodge RR Chas I i 407 | 1637 |
| 9. The Manor of Mullaghgane | Lodge RR Chas I i 407 | 1637 |
| 10. Mullegan | DS (Par. Map) Duneane | 1657c |
| 11. Mullegan | Hib. Reg. Toome | 1657c |
| 12. Mullaghgain | Inq. Ult. (Antrim) §5 Car. II | 1661 |
| 13. Mullygan | BSD 133 | 1661 |
| 14. Ballymulgay al. Mullaghgaine | BSD 133 | 1661 |
| 15. Mullaghgane (Manor of) | BSD 135b | 1661 |
| 16. Ballymulgay al. Mullaghganie | BSD 135b | 1661 |
| 17. Ballymullaghane | Lodge RR Chas II i 106 | 1663 |
| 18. Ballymulgay al. Malaghane | Lodge RR Chas II i 106 | 1663 |
| 19. the Manor of Mallaghane | Lodge RR Chas II i 106 | 1663 |

| 20. | Mulloghan | HMR Ant. 147 | 1669 |
| 21. | Mullegan | Hib. Del. Antrim | 1672c |
| 22. | Manor of Mullaghgane | Lodge RR Chas II ii 292 | 1684 |
| 23. | Ballemullgay al. Mullaghgane | Lodge RR Chas II ii 292 | 1684 |
| 24. | Mullaghgane | Reg. Deeds 10-133-3227 | 1712 |
| 25. | Ballemulgay orw. Mullaghgane | Reg. Deeds 220-158-146376 | 1762 |
| 26. | Mullaghgaron | Lendrick Map | 1780 |
| 27. | Mullaghgane | Duff's Lough Neagh | 1785 |
| 28. | Mullaghaun | OSNB A 40 | 1828 |
| 29. | Mullaghgaun | OS Name Sheets | 1830 |
| 30. | Mullachán "small summit" | J O'D (OSNB) A 40 | 1828 |
| 31. | ˌmɒləˈgaːn | Local pronunciation | 1987 |
| 32. | ˌmɒləxˈgɔːn | Local pronunciation | 1987 |

O'Donovan's suggestion that the Irish form of this place-name is *Mullachán* "small summit" (30) can be ruled out, since in Ulster Irish the main stress in this form would not fall on the final syllable. Several possible interpretations of the place-name come to mind. Forms 1, 2, 3, 7a, 8a, 14a, 16a, 18a, 23a and 25a may suggest the Irish form *Mullach Gaoithe* "windy summit" or perhaps *Maoil Ghaoithe* "windy hillock". However, it must be remembered that these forms are all related and the final *-y/-ye* is just as likely to be a scribal mistranscription of *-n/-ne* which has been copied from one form to the other. This derivation must therefore be regarded as unsatisfactory.

One might suggest the Irish form *Mullach Gathán* "summit of the little spears/darts". *Gathán* is a diminutive form of *ga* "spear/dart" and the medial *-th-* would have come to be silent in East Ulster Irish (O'Rahilly 1932, 207–8). However, at an earlier stage this sound would have been realized as [h] and, as none of the earlier spellings contain evidence of this sound, this interpretation must also be regarded as unlikely.

I would tentatively suggest that the most satisfactory interpretation of the place-name is *Mullach Gann* "sparse/poor summit". The element *gann* is not a common one in place-names, but it is attested in the topographical sense "thin, poor, as a district" (*Dinneen* sv.). The name of the *Ghann River* in the Mournes in Co. Down is derived from Irish *An Abhainn Ghann* "the scanty river", with reference to its often poor flow of water (*PNI* iii 180). In the middle of Mullaghgaun there is a conspicuous little rounded hillock which is now well cultivated but which could well have been barren in the past and this appears likely to be the naming feature of the townland.

The name of this townland was selected as the name of one of the landed estates of the O'Neills of Shane's Castle which in 1617 was entitled *The manor of Mullagoane* (4), a name which was intended to replace the name of the old Irish territory of Feevagh. The modern pronunciation of the final element of the name as [gɔːn] is not suggested by any of the historical forms before 1830 (29) and it is clearly the result of corruption of the name in the English language.

**Ranaghan**  *Raithneachán*
J 0289  "place of ferns"

| 1. | Ballyhanigan al. Ballyrankan | Inq. Ult. (Antrim) §6 Car. II | 1662 |
| 2. | Ranaghan | HMR Ant. 147 | 1669 |
| 3. | Ballyranaghan | Comm. Grace 10 | 1684 |

| | | |
|---|---|---|
| 4. Ballyrnahan | Lodge RR Chas II ii 292 | 1684 |
| 5. Ranaghan | Indent. (Staff.) | 1692 |
| 6. Ballycrannaghan | Reg. Deeds 10-133-3227 | 1712 |
| 7. Ranahan | Reg. Deeds 30-26-16158 | 1720 |
| 8. Ballyranahan | Reg. Deeds 90-171-62470 | 1739 |
| 9. Rannaghan | Lendrick Map | 1780 |
| 10. Ranaghan | Duff's Lough Neagh | 1785 |
| 11. Ranaghan | OSNB A 40 | 1828 |
| 12. Raithneachan "ferny land, filecetum" | J O'D (OSNB) A 40 | 1828 |
| 13. Raithneachán "a fern-growing spot" | Joyce ii 331 | 1875 |
| 14. 'ra:nəxən | Local pronunciation | 1987 |

The name of this townland has been correctly interpreted as *Raithneachán* (12,13), a diminutive form of *raithneach* "ferns, bracken", with the significance of "place of ferns or bracken". There are six other townlands named Ranaghan, well scattered throughout Ireland, as well as a townland named Ranahan in Co. Limerick which is also derived from the Irish form *Raithneachán* and interpreted as "place of bracken" (Ó Maolfabhail 1990, 235).

**Staffordstown**       An English form
J 0487

| | | |
|---|---|---|
| 1. (?)Ballintollought | Inq. Ant. (DK) 45 | 1605 |
| 2. (?)Ballintollought | CPR Jas I 93b | 1606 |
| 3. (?)Ballintollought or Ballintullought | Lodge RR Jas I i 252 | 1606 |
| 4. Ballymcveagh | CPR Jas I 356a | 1617 |
| 5. Ballymcveagh | Lodge RR Jas I ii 560 | 1617 |
| 6. Ballymcvaagh | Lodge Fairs & Markets 2 | 1635 |
| 7. (?)Ballintullaght | Lodge RR Chas I i 407 | 1637 |
| 8. (?)Ballintalbagh | BSD 135b | 1661 |
| 9. (?)Ballyntragh | Inq. Ult. (Antrim) §6 Car. II | 1662 |
| 10. (?)Ballytullaght | Lodge RR Chas II i 106 | 1663 |
| 11. Mounstafford | HMR Ant. 147 | 1669 |
| 12. Staffordstown | Dobbs' Descr. Ant. 386 | 1683 |
| 13. Ballymackveigh al. Staffordstown | Lodge RR Chas II ii 292 | 1684 |
| 14. (?)Ballintalbagh or tullagh | Lodge RR Chas II ii 292 | 1684 |
| 15. Ballymcveagh | Indent. (Staff.) | 1692 |
| 16. Ballymackveigh al. Staffordstowne | Reg. Deeds 10-133-3227 | 1712 |
| 17. Ballymcmeagh als Ballyneveagh als Staffordstowne | Reg. Deeds 66-434-57456 | 1731 |
| 18. Ballyneveagh orw. Staffordstowne | Reg. Deeds abstracts i §621 | 1736 |
| 19. (?)Ballintaugh orw. Ballinittry | Reg. Deeds abstracts i §621 | 1736 |
| 20. Staffordstown | Lendrick Map | 1780 |
| 21. Staffordstown | Duff's Lough Neagh | 1785 |

| | | |
|---|---|---|
| 22. Ballyutulagh orw. BallyMcEveagh | | |
|     orw. Ballintneagh orw. | | |
|     Ballintueagh orw. Ballynitveagh | | |
|     orw. BallyMcNeagh orw. | | |
|     Staffordstown | Reg. Deeds 528-215-346334 | 1800 |
| 23. Staffordstown | OSNB A 40 | 1828 |
| 24. Ballymackveigh . . . another, | | |
|     perhaps the old name for | | |
|     Staffordstown | O'Laverty iii 336 | 1884 |
| 25. An English name | J O'D (OSNB) A 40 | 1828 |
| 26. Baile Stafard | GÉ 26 | 1989 |
| 27. 'stafərdz,təun | Local pronunciation | 1987 |

This townland seems to correspond with *Ballintollought* of 1605 (1), the final element being corrupted in later sources to *-talbach* (8, 14a), and *taugh* (19a), as well as an amazing variety of (obviously corrupt) forms in 1800 (22). In view of the inconsistent nature of the evidence, it is impossible to suggest a satisfactory Irish form for this version of the place-name.

Another obsolete name for the townland is *Baile Mhic an Bheatha* "MacVeigh's town-land", a form which is documented for the first time in 1617 (4, 5). The surname *Mac an Bheatha*, which is anglicized as Mac Veagh, Mac Veigh and Mac Vey, is common in East Ulster, where it has to some extent been changed to MacEvoy (MacLysaght 1985, 294). The same surname appears to be represented in the name of the townland of **Ballymuckvea** in the nearby parish of Connor, Co. Antrim. The surname is currently not particularly common in this area, but in 1607 the *Irish Patent Rolls of James I* contains "A general pardon to *Donall McVagh* of Edenduffe-Carricke" (i.e. **Shane's Castle** townland) (*CPR Jas I* 110b). The same surname, in the forms "McVagh, McVaigh, McWagh", is well attested in this area in the *Hearth Money Rolls* of 1669 (*HMR Ant.*). In 1766, we find a reference to: "the farms in Cargin, now possessed by the widow Keelin and the McVeaghs" (*Belfast News Letter* Dec. 30 1766).

The name of the townland is first documented in its modern form in 1683 (12). However, it is certain that it had been known as Staffordstown for some time previous to this, as it was so-called on account of the marriage of Henry O'Neill of Shane's Castle (+1638) to Martha Stafford, daughter of Francis Stafford, former Governor of Ulster, early in the 17th century. The Stafford family were at that time granted ten townlands immediately adjoining the pre-sent village of Staffordstown, and it was no doubt then that the name of the townland was changed to Staffordstown. The name has been written *Mounstafford* in 1669 (11) as the result of confusion with **Mount Stafford** just outside Portglenone, the chief seat of the Stafford family in Co. Antrim in the 17th century.

| **Tamnaderry** | *Tamhnaigh an Doire* | |
|---|---|---|
| J 0386 | "field/clearing of the oak-wood" | |
| | | |
| 1. Ballytawinderry | Inq. Ant. (DK) 45 | 1605 |
| 2. Ballytawnydirrie | CPR Jas I 93b | 1606 |
| 3. Ballytawnydirrie | Lodge RR Jas I i 252 | 1606 |
| 4. Ballytannyderry | Exch. Deeds & Wills 653 | 1644 |
| 5. Ballytamnedery | Inq. Ult. (Antrim) §6 Car. II | 1663 |
| 6. Tanenedear | HMR Ant. 147 | 1669 |

| | | |
|---|---|---|
| 7. Ballytaunederry | Comm. Grace 10 | 1684 |
| 8. Ballytawnyderry | Lodge RR Chas II ii 292 | 1684 |
| 9. Ballytamnederry | Indent. (Staff.) | 1692 |
| 10. Ballytounyderry | Reg. Deeds 10-133-3227 | 1712 |
| 11. Tamnaderry | Reg. Deeds 30-26-16158 | 1720 |
| 12. Tamnaderry | Lendrick Map | 1780 |
| 13. Tamnadery | OSNB A 40 | 1828 |
| 14. Tamhnach an Doire "field of the oak-wood" | J O'D (OSNB) A 40 | 1828 |
| 15. ˌtamnəˈdɛri | Local pronunciation | 1987 |

*Tamhnaigh* is an oblique form of *tamhnach* "field/clearing", an element which is very common in the place-names of Ulster and Connaught, and which in East Ulster is often anglicized as *Tamna(gh)* or *Tamny*. Historically the medial *-mh-* of *tamhnaigh* would have been pronounced as a nasalized [v], but in Ulster Irish this was later vocalized, a sound suggested by most of the earlier recorded spellings. In place-names *-mh-* is often anglicized as [m] (as in this case) or [n], due to the strong residual nasal quality of the original Irish sound (see **Tamlaght** above). This townland borders on the townland of **Derrygowan**, which is derived from Irish *Doire Gabhann* "oak-wood of the smith", and this raises the possibility that the element *doire* "oak-wood" in both place-names may have referred to the same feature, all trace of which has now disappeared.

**Tamnaghmore**
J 0291

*An Tamhnach Mhór*
"the large field/clearing"

| | | |
|---|---|---|
| 1. Ballycanaghmore | DS (Par. Map) Duneane | 1657c |
| 2. Ballicanaghmore | Hib. Reg. Toome | 1657c |
| 3. Killcanaghmore | BSD 134 | 1661 |
| 4. Ballicanaghmore | Hib. Del. Antrim | 1672c |
| 5. Tanaughmore | Lendrick Map | 1780 |
| 6. Tanaughmore | Duff's Lough Neagh | 1785 |
| 7. Tannaghmore | OSNB A 40 | 1828 |
| 8. Tamnaghmore | OS Name Sheets | 1830 |
| 9. Tamhnach Mór "big field" | J O'D (OSNB) A 40 | 1828 |
| 10. ˌtamnəˈmoːr | Local pronunciation | 1987 |

This was one of the four "church" townlands of Duneane, and earlier spellings of the place-name are accordingly scarcer than usual. In form 1, *c* is obviously a scribal error for *t* and this error has been reproduced in the other, related, 17th-century sources. The representation of the first element as *Kill-* is peculiar to form 3 and is clearly not original to the place-name; perhaps it was added by the scribe who was aware that it could represent *cill* "church", and wanted to show that Tamnaghmore was a "church" townland.

The various anglicized forms of the element *tamhnach* "field/clearing" have been referred to above (see **Tannaghmore**, parish of **Drummaul**). In the case of Tamnamore, the evidence suggests that *tamhnach* was originally anglicized as *tannagh* and that the modern *tamnagh* owes its origin to the official spelling imposed by the Ordnance Survey early in the last century (8).

| **Toome** | *Tuaim* | |
|---|---|---|
| H 9990 | "a pagan burial place(?)" | |

See barony name

| **Tullaghbeg** | *An Tulach Bheag* | |
|---|---|---|
| J 0287 | "the little hillock" | |

| 1. Tollaghebegge | Ex. Inq. (Ant.) §3 Jac. I | 1618 |
|---|---|---|
| 2. Ballytullybegg | Lodge RR Chas I i 407 | 1637 |
| 3. Tullaghbegg | DS (Par. Map) Duneane | 1657c |
| 4. Tullaghbeg | Hib. Reg. Toome | 1657c |
| 5. Fullaghbegg | Inq. Ult. (Antrim) §5 Car. II | 1661 |
| 6. Tullaghbog | BSD 133 | 1661 |
| 7. Ballytullaghbegg | BSD 135b | 1661 |
| 8. Ballitullibegg | Lodge RR Chas II i 106 | 1663 |
| 9. Tulloghbeg | HMR Ant. 146 | 1669 |
| 10. Tullaghbeg | Hib. Del. Antrim | 1672c |
| 11. Ballytullybegg | Comm. Grace | 1684 |
| 12. Ballytullybegg or | | |
| Ballytullaghbegg | Lodge RR Chas II ii 292 | 1684 |
| 13. Tullaghbeg | Duff's Lough Neagh | 1785 |
| 14. Tullabeg | OSNB A 40 | 1828 |
| 15. Tullaigh Beag "little hill" | J O'D (OSNB) A 40 | 1828 |
| 16. 'tʊləx'bɛːg | Local pronunciation | 1987 |

Forms 2, 8, 11 and 12 appear to support O'Donovan's suggestion that the first element of the place-name is *tulaigh*, the oblique form of *tulach* "hillock". However, the weight of the documentary evidence, as well as the local pronunciation, suggests that we are dealing with the radical form *tulach*. The presence of the *-y-* in the aforementioned forms might be understood as indicating a genitive form after the element *baile* but, since forms ending in *-agh* are also found after *Bally-* (7, 12b), this suggestion must be regarded as unlikely. There is a conspicuous little hill in the middle of this townland, and this appears to be the feature which has given rise to the place-name.

<div align="center">OTHER NAMES</div>

| **Artoges Dam** | A hybrid form | |
|---|---|---|
| J 0490 | | |

| 1. ɑr'toːgz'daːm | Local pronunciation | 1987 |
|---|---|---|

This is a small lake in the townland of **Moneyrod**. It appears to have been artificially created by the damming of a stream to power the water wheel of Artoges Mill. The first element of the place-name is clearly an anglicization of Irish *Art Óg* "young Art". The *OSRNB* of c. 1858 (sheet 43) informs us that Artoges Mill was "said to be of very ancient date and to have been created by one Artogue O'Neill from whom the name is derived". In the neighbouring townland of Derryhollagh there is the site of a crannog which, according to the *Ordnance Survey Memoir* of 1836, was formerly inhabited by "Arthur Oge O'Neill, a cele-

<div align="center">122</div>

brated marauder" (*OSM* xix 98). The *Memoir* goes on to tell how the "robber called Art Ogue" preyed on the surrounding countryside until the local people (rather improbably!) succeeded in dislodging him from the island by letting the water out of the lake, but not without great loss of life to themselves. It also suggests that the modern character of many of the remains found on the crannog prove that this Art Ogue did not live at an earlier period than that of Queen Anne (*OSM* xix 109). Nonetheless, it is striking that an inquisition of 1661 refers to an *Arthur O'Neile of Feevagh* who died in that year and whose lands were forfeited on account of his rebellion against the king in 1641 (*Inq. Ult.* §5 Car. II). The lands of this Arthur O'Neill are listed as consisting of twelve townlands, including Moneyrod and the neighbouring townland of Derryhollagh. In a later inquisition, this same Arthur O'Neill is referred to as *Art Oge O'Neill of the Feevagh* (*Inq. Ult.* §8 Car. II) and, according to Reeves, he "distinguished himself in the scenes of 1641" (*EA* 301). All this is enough to suggest that there is at least a reasonable chance that it was this Art Oge O'Neill who gave name to both Artoges Dam and Artoges Mill.

The crannog in the townland of Derryhollagh is likely to have been formerly a place of some significance, possibly the defensive headquarters of the native Irish tuogh or petty kingdom of **Feevagh** (Reeves 1903, 174).

| | | |
|---|---|---|
| **Ballina Burn** | A hybrid form | |
| H 9988 | | |
| | | |
| 1. balən,a 'bɔrn | Local pronunciation | 1987 |

This is the name of the lower portion of a stream which flows into Lough Neagh at Brockish Bay, and which forms the boundary between a number of townlands. Although there are no historical forms, it appears likely that the first element of the name is derived from Irish *Béal an Átha* "mouth of the ford", or, simply, "the ford". On the boundary between the townlands of Annaghmore and Gallagh there is a bridge named Ballina Bridge, which carries a by-road across the stream. It is quite likely that the bridge marks the site of a former ford, and that it was from this ford that both the bridge and the lower portion of the stream were named.

| | |
|---|---|
| **Bann, River** | *An Bhanna* |
| H 9991 | "the goddess" |

See *PNI* (iii 175–7).

| | | |
|---|---|---|
| **Cam** | *Cam* | |
| H 9992 | "a bend in the river" | |
| 1. Cam | DS (Par. Map) Duneane | 1657c |
| 2. Cam | DS (Reg.) | 1657c |
| 3. Cam | Hib. Reg. Toome | 1657c |
| 4. Cam | BSD 134 | 1661 |

Although this place-name does not appear on the *OS 1:50,000* or *1:10,000* map, it is well-known in the area. It refers to the western portion of the townland of **Gortgill**, and was formerly a townland in its own right, as shown by the fact that on the Down Survey Parish Map of c. 1657 it is marked as one of the Church townlands of Duneane (*DS (Par. Map)*). The element *cam* in place-names can have the significance of a vessel-shaped hollow in the ground (see **Carmorn** above). However, given the situation of Cam at the point where

the river Bann enters Lough Beg, in this case it appears more likely to have the meaning of "a bend in a river" (Ó Máille 1989–90, 129). The course of the river Bann was altered here about 1738 (OSM xix 97) which makes it difficult now to identify the bend referred to. However, the Down Survey Parish Map shows a conspicuous bend in the river at this point and this is likely to be the feature which has given rise to the place-name.

| **Cratty** | *Crataigh* | |
|---|---|---|
| J 0186 | "shaking ground/marshy place" | |
| 1. 'krati | Local pronunciation | 1987 |

This name is given to a former cluster of farm houses in the east of the townland of Carlane. It might be suggested that it could represent *crotaigh*, an oblique form of *crotach*, made up of *crot* "small eminence", plus the termination *-ach*. The sound [o] is commonly lowered to [a] in Ulster Irish, which would account for the *a* in the present form of the name. Against this explanation is the fact that there is no noticeable hill here, unless the name has been transferred from a nearby hill to the settlement. It is perhaps more likely that the name goes back to the Irish form *Crataigh*, an oblique form of *Cratach* (*<Crathtach*), the latter being comprised of the verb *crath* "to shake" plus the termination *-tach* "place of" and having the significance of "shaking ground/marshy place". Near Glenties in Donegal there is a townland named Craghy the name of which is derived from Irish *Crathaigh*, i.e. *crath* "shake" plus the suffix *-ach* (Mac Giolla Easpaig 1984, 52). The suffix *-t(e)ach* is fairly common as an alternative to *-(e)ach* (*Joyce* ii 3) and is found in such elements as *coillteach* "wooded place" and *móinteach* "moorland". The place-name might therefore be understood as referring to an area of marshy land of which there is now no trace but which could well have been a feature of the landscape in the past.

| **Doon Point** | A hybrid form | |
|---|---|---|
| H 9893 | | |
| 1. Dooan Id. | Duff's Lough Neagh | 1785 |
| 2. ðə 'dun | Local pronunciation | 1987 |

This is a flat point of land which juts into Lough Beg, in the townland of Drumraymond. A short distance to the south east is a slight hill and a farmhouse which is marked "Doon" on the *OS 1:10,000* map. The first element of the place-name appears to be derived from the Irish word *dún* which in place-names is most commonly interpreted as "fort". There is no trace or record of a fort in the vicinity, the only recorded archaeological feature being a former "mound" in the south of the townland of Drumraymond (*NISMR*). On Rathlin Island, there is a point of land named **Doon Point** which is interpreted as *Pointe an Dúin* "the point of the fort" and said to be named from a former fort, no trace of which now remains (Mac Giolla Easpaig 1989–90, 81–2). Also on Rathlin, there is a place named **Doonmore**, the name of which is interpreted as *Dún Mór* "great fort" but which is said to refer, not to a man-made feature, but to a large off-shore rock (*op. cit.* 14). There is also a **Doonbeg** which is interpreted as *Dún Beag* "the small fort" but said to refer to "a small smooth detached hill of easy ascent" (*op. cit.* 33). In the case of our Doon Point, it is impossible to tell whether the place-name refers to a former fort or to a natural feature, perhaps to the aforementioned hill, or to a large rock or rocky feature. A rock named "Harvey's Rock" is marked in the south west corner of the townland of Drumraymond on the *OS 1:10,000* map. *Duff's Lough Neagh*

also marks a small island named *Dooan Id.* (marked *Duck Island* on the *OS 1:10,000* map) just to the north of Doon Point. The spelling *Dooan* might lead one to consider that the name may represent the Irish word *duán* "hook; kidney", and that it may be used figuratively to refer to a hook-shaped area of land. However, the local pronunciation does not suggest that the place-name originally contained a diphthong, and this interpretation must therefore be regarded as unlikely.

| **Doorish Point** | A hybrid form | |
|---|---|---|
| H 9993 | | |
| 1. Doorishbeg Id. | Duff's Lough Neagh | 1785 |
| 2. 'durïʃ ˌpɔint | Local pronunciation | 1987 |

This is the name of a small peninsula a little to the south of Doon Point, also in the townland of Drumraymond. The first element of the place-name appears to represent Irish *Dúros* "black peninsula". The word *ros* in Irish can signify "a wood or copse; a point, promontory" (*Dinneen* sv.). According to Joyce, its usual meaning in the south of Ireland is "a wood", while in the north of Ireland it normally signifies "a peninsula" (*Joyce* i 443). In this case, the local conditions appear to favour its interpretation as "peninsula". It is difficult to explain why the final broad -*s* of *Dúros* should be anglicized as -*sh*, rather than as simply *s*, but it should be noted that the anglicization of Irish *s* is not always regular (see Adams 1954, 30). A parallel anglicization of Irish non-palatal *s* as *sh* is found in the name of the town of Rush in Co. Dublin, which is derived from Irish *An Ros* (*GÉ* 152).

| **Drumaslough** | *Droim Os Loch*(?) | |
|---|---|---|
| J 0189 | "the ridge above the lake" | |
| 1. 'drïməs'lɔ:χ | Local pronunciation | 1987 |

This is the name of a prominent hill in the south-east corner of the townland of Lismacloskey. There is now no lake in the immediate vicinity, but the Down Survey Parish Map of c. 1657 marks eight acres of bog at the southern foot of the hill, in the townland of Gortgarn (*DS (Par. Map)*), and it is quite possible that this marks the site of a former lake. Alternatively, one might suggest that the final element of the place-name could refer to Lough Neagh, though the fact that the latter is roughly two miles distant at its nearest point appears to make this less likely.

| **Feevagh** | *Fíobha* | |
|---|---|---|
| | "wood/wooded place" | |
| 1. isin Fidbaid i nDail Araide | Fél. Óeng. Jan 8 p 42 | 830c |
| 2. i fiodhbaid Dáil Araidhe | Mart. Gorm. Jan 8 p 12 | 1170c |
| 3. i ffiodhbhaidh Dhál Araidhe | Mart. Gorm. Oct 30 p 206 | 1170c |
| 4. Cland Chinaetha isin Fhidbaid | Descendants Ir 110 | 1200c |
| 5. hi fidbaid dail araide | LB 98 | 1400c |
| 6. trid in Fidbad | AU iii 232 | 1470 |
| 7. (?)Fiodhbhuidhe, Conchubhar na | LCABuidhe 28 | 1578c |
| 8. (?)Fiodhbhuidhe, mac | | |
| Conchubhair na | LCABuidhe 28 | 1578c |
| 9. ón Fhiodhbhaidh | LCABuidhe 158 §21 l.140 | 1617c |

| | | |
|---|---|---|
| 10. i bhFiodhbhaidh Dalaraidhe | Mart. Don. Oct 30 p 288 | 1630c |
| 11. in regione Dalaradiae Fiodhbhaidh dicta | Acta SS Colgan 42 col. 2 | 1645 |
| 12. Fiodhbhadh | Map Antrim | 1807 |
| 13. in Sylva Dalradiae | Acta SS Bolland. lxii 348 | 1883 |
| 14. the Fews | Mon. Hib. 14 | 1540 |
| 15. Lefraghe | Mon. Hib. 13 | 1542 |
| 16. the Fuaghe | Eccles. Reg. 35 | 1584 |
| 17. The Fewogh | Boazio's Map (BM) | 1599 |
| 18. the Fivagh | Fiants Eliz. §6710 | 1602 |
| 19. le Fuaghe | Ex. Inq. (Ant.) §1 Jac. I | 1603 |
| 20. the Fuaghe | CPR Jas I 39a | 1603 |
| 21. Tuoghnefuigh | Inq. Ant. (DK) 45 | 1605 |
| 22. Tuoghnifuigh | CPR Jas I 78a | 1605 |
| 23. Tuoghnefuigh | CPR Jas I 93b | 1606 |
| 24. Tuoghnefuigh | Lodge RR Jas I i 252 | 1606 |
| 25. the Fynagh | CPR Jas I 110b | 1607 |
| 26. the Finnagh | CPR Jas I 110b | 1607 |
| 27. the Fuigh | CPR Jas I 122a | 1608 |
| 28. Tuoghnefuagh created the manor of Mullagoane | CPR Jas I 324b | 1617 |
| 29. Fivagh Territory | CPR Jas I 356a | 1617 |
| 30. ffeaugh | Ex. Inq. (Ant.) §3 Jac. I | 1618 |
| 31. Tuoghfuigh | CPR Jas I 524a | 1621 |
| 32. the Fuigh | CPR Jas I 534a | 1621 |
| 33. le Fuagh | Inq. Ult. (Antrim) §7 Jac. I | 1621 |
| 34. Tuoghnifeugh | Inq. Ult. (Antrim) §7 Jac. I | 1621 |
| 35. Graungia de Feevagh | Ulster Visit. (TCD) 261 | 1622 |
| 36. le Fewagh | Inq. Ult. (Antrim) §116 Car. I | 1635 |
| 37. the ffeevagh | Exch. Deeds & Wills 702 | 1638 |
| 38. Fuagh | Inq. Ult. (Antrim) §5 Car. II | 1661 |
| 39. the Feeoragh | Inq. Ult. (Antrim) §8 Car. II | 1662 |
| 40. ye Fuigh al. the Fyvagh al. Tuoghfuigh | Lodge RR Chas II i 269 | 1665 |
| 41. Feavagh | ASE 106 a 1 | 1666 |
| 42. Feevogh | Grand Jury Pres. Oct. 8 | 1719 |
| 43. 'fi:və | Local pronunciation | 1987 |

The place-name Feevagh has been referred to above, as the name of one of the Irish petty kingdoms or tuoghs which went to make up the barony of Toome in 1584 (see barony introduction). It was also adopted as the name of one of the Shane's Castle estates granted by King James I to Shane O'Neill in 1606 (*CPR* Jas I 93b). Feevagh is a name of some antiquity, being first documented as early as c. 830 AD (1). Reeves's statement that at the beginning of the 17th century it was co-extensive with the parishes of Duneane, Cranfield and Ballyscullion Grange (*EA* 345) is not entirely accurate: the townlands of Clonkeen, Ballydunmaul and Aghaloughan which are in the parish of Drummaul, along with the four "detached townlands" of Drummaul, were in fact in the tuogh of Feevagh, while there is some doubt as to whether Feevagh included the **Grange of Ballyscullion**. A description of

the boundaries between the tuoghs of Feevagh and Munterividy in 1606 (*CPR Jas I* 93b) gives the impression that the south-west corner of the main portion of the parish of Drummaul was included in Feevagh rather than Munterividy.

An inquisition of 1603 states that Feevagh contained the site of the church of Drummaul as well as Duneane (*Exch. Inq.* §1 Jac. I). This would imply that it included almost all of the portion of the parish of Drummaul which lies west of the Main. However, it is possible that the aforementioned inquisition errs in placing the church of Drummaul in Feevagh, since in the reliable *Antrim Inquisition* of 1605 it is placed in the neighbouring tuogh of Munterividy (*Inq. Ant. (DK)* 45).

At the beginning of the 17th century, the native Irish tuoghs were used in English documents as a convenient unit for the allocation of lands. In these documents, the territory of Feevagh is commonly written *Tuoghnefuigh*, representing Irish *Tuath na Fíobha* "the tuogh of the wood".

The name Feevagh is still known locally but is generally understood to apply to only a small area along the north-west shore of Lough Neagh, rather than the much more extensive territory described in 17th-century documents. The territory is shown as heavily wooded on historical maps, including Boazio's *General discription or chart of Ireland, A.D. 1599* (17), Bartlett's *Map of East Ulster* of 1602c and Speed's *The Province of Ulster Described* of 1610. This district is not now heavily wooded, but in 1836 the *Ordnance Survey Memoir* comments on the great amount of brushwood in the parish, and refers to a tradition that at one time: "a man could walk on the trees from one side of the parish to the other" (*OSM* xix 98b). In 1617, the name of the landed estate was officially changed from Feevagh to *the manor of Mullagoane* (*CPR Jas I* 324b), the latter representing the name of the modern townland of **Mullaghgaun**. However, this name never gained acceptance as a name for the estate.

In the *Leabhar Eoghanach*, which contains a list of all the O'Neill kings of Ulster from the time of Niall of the Nine Hostages (+ 405 AD) up until the time of the famous Hugh O'Neill of Tyrone, there appears a *Conchubhar na Fiodhbhuidhe, mac Flaithbhertaigh Locha Feadha* "Connor of Feevagh, son of Flathartach of Lough Fea", who is stated to have reigned for ten years (apparently during the 12th century), and also his son *Tadhg Glinne mac Conchubhair na Fiodhbhuidhe* "Teague of Glen, son of Connor of Feevagh", who is said to have reigned for seven years (*LCABuidhe* 28). In the first entry, *Loch Feadha* may refer to **Lough Fea**, a small lake near Cookstown on the border between counties Derry and Tyrone, but in the case of the second entry it is impossible to determine the whereabouts of the place called Glen. Ó Ceallaigh (*GUH* 87) was of the opinion that the place referred to as *Fiodhbhadh* (Mod. Ir. *Fíobha*) was in fact our Feevagh, but he produced no evidence in support of this conclusion. The place-name *Fíobha* is a fairly common one, and, in the absence of further evidence, it is impossible to say with certainty whether Ó Ceallaigh's identification is justified.

The name Feevagh also occurs in a reference to *Cland Chinaetha isin Fhidbaid* i.e. "the family of *Cinaeth* in the Feevagh" in an early Irish genealogy of the family of *Ó Leathlobhair*, i.e. (O') Lawlor (4). The latter were a leading ruling family of Dál nAraide who apparently had their stronghold at *Ráith Mór Maige Line* "Rathmore of Moylinny", east of the modern town of Antrim (see county introduction). The pedigree of the *Cinaeth* in question runs: *Cinaeth* son of *Tomaltach* (king of Dál nAraide), son of *Indrechtach*, son of *Lethlobar* (Byrne 1959, xxv) and *Cland Chinaetha* obviously refers to a branch of the ruling family of Moylinny who were settled in the Feevagh. However, the name *Clann Chinaetha* is now totally unknown in this area.

| | | |
|---|---|---|
| **Fourtowns Hill**<br>J 0291 | An English form | |
| 1. ˌfortəunz 'hïl | Local pronunciation | 1987 |

This is a prominent hill, just inside the eastern boundary of the townland of Tamnaghmore. It obviously derives its name from being the highest point in "The Four Towns of Duneane". The latter consisted of the townlands of Tamnaghmore, Lismacloskey, Cloghogue and Gortgill and in earlier times formed the church lands of the parish of Duneane.

| | | |
|---|---|---|
| **Killaslavan**<br>J 0093 | *Coillidh Sleamháin*<br>"elm-wood" | |
| 1. ˌkïli'slavən | Local pronunciation | 1987 |

This name is omitted from the *OS 1:50,000* map (see *OS 1:10,000* sheet 79), but it is well known in the area. It is a sub-division of the townland of Moneyglass. The standard Irish word for "elm-tree" is *leamhán*, but in the north a variant form with prefixed s-, i.e. *sleamhán* is found, and this is often anglicized *slavan* (*Joyce* i 507). While it is possible that the final element of the place-name is the genitive plural form *sleamhán* "of elms", the genitive singular form *sleamháin* "of elm" appears more appropriate.

| | | |
|---|---|---|
| **Knockmore**<br>J 0185 | *An Cnoc Mór*<br>"the great hill" | |
| 1. 'nɔk'mo:r | Local pronunciation | 1987 |

This is in fact not a very significant hill, but given the low-lying nature of the surrounding countryside, it is easy to see how it would have been named *Cnoc Mór* "great hill". It lies on the border between the townlands of Ballynamullan and Ballynaleney. The fact that the first element of the place-name is represented as "Knock" suggests that the name was coined in the period before *n* in the combination *cn* came to be sounded as [r] in northern Irish, a change which may have taken place during the course of the 17th century (O'Rahilly 1932, 22).

| | | |
|---|---|---|
| **Ley Hill**<br>J 0090 | Of uncertain origin | |
| 1. 'jeχïl | Local pronunciation | 1987 |

This is a conspicuous little hill in the east of the townland of **Drumderg**. The origin of the name is obscure. The suggestion in the *OSRNB* of c. 1858 (sheet 42) that the name is a corruption of Lake Hill and that the hill was so named as being the nearest hill to the northern shore of Lough Neagh is clearly improbable. One might suggest that the first element of the place-name is the Scottish dialect word *ley* signifying "fallow/uncultivated". However, the local pronunciation of the place-name argues against this interpretation. It might be proposed that the name could represent Irish *Eochoill* "yew wood", a place-name which is of wide distribution in Ireland, and is anglicized as *Youghall* in the name of the well-known town in Co. Cork (*Joyce* i 511). However, it is difficult to see how this Irish form could have given rise to the medial [e]-sound of the first syllable. A tentative suggestion is that the name could be derived from Irish *Leathchoill* "half-wood". The pronunciation of palatal *l* as *y* has been

128

noted in a number of Tyrone place-names. For example, the name of the townland of **Leaghan** in the parish of Bodoney Lower is sometimes pronounced ['jaxən] and the minor place-name **Lenagarria** as [janə'gariə]. The name "half-wood" could refer to the surviving portion of a larger wood, the other portion having been removed, or, perhaps to one of two woods in the vicinity (cf. the use of the prefix *leath* in Irish to refer to one of a pair, for example *leathchos* "one leg" or *leathchluas* "one ear") .

| | | |
|---|---|---|
| **St. Helena** | An English form | |
| J 0093 | | |
| 1. ˌsent hə'li:nə | Local pronunciation | 1987 |

This is the name of a large house in the portion of the townland of Moneyglass which is known as **Killaslavan**. According to the *Ordnance Survey Memoir* of 1836 it was at that time the residence of the Church of Ireland curate, the Reverend William Boyes, and was built about the year 1801, being the property of Mrs Jones of Moneyglass House (*OSM* xix 114). The house has clearly been named from the mid-Atlantic island of Saint Helena, famous as the place where the French emperor Napoleon Bonaparte was exiled after his defeat at the Battle of Waterloo in 1815, and where he died in 1821.

## Parish of Grange of Ballyscullion

Barony of Toome Upper

*Townlands*
Aghavary
Ardnaglass
Culnafay

Gillistown
Grange Park
Killylaes
Kilvillis

Mill Quarter
Taylorstown

*Village*
Grange Corner

Based upon Ordnance Survey 1:50,000 mapping, with permission of the Director of the Ordnance Survey of Northern Ireland, Crown copyright reserved.

130

# PARISH OF GRANGE OF BALLYSCULLION

The parish of Grange of Ballyscullion lies in the barony of Toome Upper. It is divided into nine townlands and covers an area of roughly 4,279 acres (*Census 1851*). It is bounded on the west by the parish of Ballyscullion and the river Bann, on the north by the parish of Portglenone, on the east by the parishes of Ahoghill and Drummaul and on the south by the parish of Duneane. The Grange was formerly a possession of the Augustinian Abbey of SS Peter and Paul of Armagh (*EA 303*).

On Bartlett's maps of c. 1602/1603, the church is shown as *T:Grang*, the initial *T:* standing for the Irish word *teampall* "church" (*Bartlett Map (Greenwich); Bartlett Maps (Esch. Co. Maps* 1)).

An inquisition of 1657 remarks: "noe church, and cure is served by minister of the next adjoining parish" (*Inq. Par. Ant.* 61). Surprisingly, this inquisition states that the Grange was formerly linked to the Abbey of St John of Jerusalem, rather than to the Abbey of SS Peter and Paul in Armagh, as stated in the normally reliable *Antrim Inquisition* of 1605.

In a number of 17th- and 18th-century documents the Grange is referred to as *Moneybrack, Mannybrooks, Mannor of Mannybrooke*, etc. This name is now obsolete and there is insufficient evidence to enable one to establish its origin.

The earliest list of the townlands of the Grange occurs in the *Antrim Inquisition* of 1605, which lists seven townlands, namely:

> the two Maggs, Ballydirrinagarhie, Ballintemple or Templeagliss, Ballinweigh, Ballycullevegh, Ballyknoacke and Ballygarewhy (*Inq. Ant. (DK)* 51).

Of these, only four can be certainly identified with modern townlands. *Ballintemple* or *Templeagliss* represents the modern **Killylaes**, *Ballinweigh* is **Gillistown**, *Ballycullevegh* is **Culnafay** and *Ballyknoacke* is **Mill Quarter**.

The seven townlands of the Grange were not included in the 1605 grant to Shane O'Neill of Shane's Castle which incorporated almost all the land in the baronies of Toome (see **Drummaul** above). The Grange was granted by King James I to James Hamilton in 1605 (*CPR Jas I* 77b). However, it soon came into the possession of the Clotworthy family of Massereene, for the *Ulster Visitation* of 1622 finds it to be in the possession of Sir Hugh Clotworthy (*Ulster Visit. (Reeves)* 261). An inquisition of 1631 finds that on his death in 1630 Sir Hugh was in possession of six of the seven townlands listed in the 1605 grant (*Inq. Ult.* §12 Car. I). The forms of the names of the townlands in this inquisition are almost identical to those in the 1605 grant which, in turn, are clearly based on the list given above from the *Antrim Inquisition* of 1605. An almost identical list of townlands appears in *Lodge's Records of the Rolls (Lodge RR)* at 1639 and in the *Skeffington Marriage Settlement* at 1654 (*Marriage Sett. Skeffington*), suggesting that the forms of the names in all these sources have their origin in the 1605 list.

The names of *The Seven Townes of Greance* as they appear in the *Hearth Money Rolls* of 1669 are: *Ballinmoy, Mr Taylor's Towne, Carnaglass, Hamerslys Land, Courtney's Land, Killelesh and Balliscullin* (*HMR Ant.* 152). *Ballimoy* represents *Ballinweigh* of the *Antrim Inquisition* of 1605 (the modern **Gillistown**), while *Killelesh* represents *Ballintemple* or *Templeagliss* (the modern **Killylaes**). However, the original Irish names of the townlands have in some cases been replaced by the name of their English owners, and these are discussed in detail below. *Balliscullin* in this list is clearly the townland of **Ballyscullion East**, which is in fact in the neighbouring parish of **Ballyscullion**, the remainder of which lies west of the Bann, in Co. Derry.

131

The *Registry of Deeds (Reg. Deeds)* at 1713 and 1738 provides a list of the townlands which differs substantially from both the 1605 and the 1669 lists and is obviously of independent origin. The *Rent Roll of the Massereene Estate (Rent Roll Mass. Est.)* of 1711–12 and the related *Duty Book for Grange (Duty Bk. Grange)* of 1733 also contain independent spellings of a number of the townland names.

There is some doubt about the tuogh or petty Irish kingdom to which the Grange belonged. The *Ecclesiastical Register* under the year 1584 refers to the Grange of Ballyscullion as "a grange named *Muntercallie*" *(Eccles. Reg.* 36). It appears to be so titled because it was regarded as forming a part of the Irish tuogh of Muntercallie which, according to Reeves, was roughly co-extensive with the modern parish of Portglenone, along with the portions of Ahoghill and Craigs which lie west of the river Main and are in the barony of Lower Toome (see barony introduction). In the aforementioned 1605 grant to James Hamilton (*CPR Jas I* 77b), the parish is referred to as "the small territory called the Graunge . . . lying *in* or *near* the tuogh of Munterkally", while in 1606 the Grange is itself referred to as a tuogh and again said to lie "*in or near* Muntercallie" (*CPR Jas. I* 93b). However, the *Ulster Visitation* of 1622 refers to the parish as *Graungia de Feevagh*, i.e. "Grange of **Feevagh**", the latter being the name of the neighbouring tuogh (*Ulster Visit. (Reeves)* 261).

*Lodge's Records of the Rolls* informs us that from 1639 onwards the territory of the Grange was to be created the *Manor of Deerpark (Lodge RR* Chas I ii 337). The latter name seems to have its origin in the creation of a deer park which can now be identified with the townland of **Grange Park**. The name *Deerpark* is now totally unknown in the area.

In c. 1659, *Graunge* is listed as one of the six divisions of the barony of Toome, with the marginal note: "Query if this be a parish". Its population is given as 116, of which 41 are said to be English and 75 are said to be Irish (*Census* 7).

The site of the former church of the Grange is marked by a graveyard in the townland of **Killylaes**. According to O'Laverty, the walls of the former church were pulled down for material to build the present graveyard wall (*O'Laverty* iii 353). Immediately adjoining the graveyard, but just inside the neighbouring townland of Grange Park, stands the present Church of Ireland church, which, however, is not an ancient building, having been constructed in 1846. According to a local legend, the site of the ancient church was to have been the original site of the church which was eventually built in the townland of Lismacloskey in the parish of **Duneane**.

PARISH NAME

| **Grange of Ballyscullion** | A hybrid form | |
|---|---|---|
| 1. (Grange of . . .) Munterkally | Eccles. Reg. 36 | 1584 |
| 2. T:Grange | Bartlett Map (Greenwich) | 1602c |
| 3. T:Grange | Bartlett Maps (Exch. Co. Maps 1) | 1603 |
| 4. land or territory called the Grange | Inq. Ant. (DK) 51 | 1605 |
| 5. the small territory called the Graunge | CPR Jas I 77b | 1605 |
| 6. tuogh of the Graunge in or near Muntercallie | CPR Jas I 93b | 1606 |
| 7. the Graunge lying in or near the tuogh of Munterkelly | CPR Jas I 121b | 1608 |
| 8. Grange | Speed's Ulster | 1610 |
| 9. Graungia de Feevagh | Ulster Visit. (Reeves) 261 | 1622 |

| | | |
|---|---|---|
| 10. parva territor' de Grange, contin' 7 vil. | Inq. Ult. (Antrim) §12 Car. I | 1631 |
| 11. the Grange, in or near the Tuogh of Monterkally, created the Manor of Deerpark | Lodge RR Chas I ii 337 | 1639 |
| 12. Grange Parish | Inq. Par. Ant. 61 | 1657 |
| 13. Grange of Moneybrack | Inq. Par. Ant. 88 | 1657 |
| 14. The Grange Parish | Hib. Reg. Toome | 1657c |
| 15. Graunge | Census 7 | 1659c |
| 16. The Seven Towns of Greance | HMR Ant. 151 | 1669 |
| 17. Grange | Hib. Del. Antrim | 1672c |
| 18. the territory or Tuogh of the Grange now called by the name of the manor of Deerpark | Reg. Deeds 12-120-4602 | 1713 |
| 19. Mannor of Mannybrooke, al. Grange | Reg. Deeds 65-121-44676 | 1728 |
| 20. Manybrooks Parish | Protest. Householders 247 (115) | 1740 |
| 21. Grange | Belfast News Letter Mar. 16 | 1771 |
| 22. Ballyscullen Grange | Lendrick Map | 1780 |
| 23. Ballyscullen Grange | Duff's Lough Neagh | 1785 |
| 24. Ballyscullion Grange | Bnd. Sur. | 1827 |
| 25. Ballyscullen Grange | OSNB A 39 | 1828 |
| 26. Ballyscullen Grange | OS Name Sheets | 1830 |
| 27. Ballyscullion Grange | OS Name Sheets (J O'D) | 1830 |
| 28. Baile Uí Scuillín "O'Scullion's town" | J O'D (OSNB) A 39 | 1828 |
| 29. ðə 'grianʒ | Local pronunciation | 1987 |

Locally, this parish is known as simply "the Grange". The qualifying element "Ballyscullion" has obviously been added on account of its proximity to the parish of Ballyscullion, west of the Bann in Co. Derry, one townland of which, i.e. **Ballyscullion East**, is on the Antrim side of the river. However, there is no record of any administrative link between the two units. In fact, the element "Ballyscullion" is obviously a late addition, as it does not appear in the documented versions of the place-name until 1780 (22).

The element *grange* is derived from Norman-French *grange* "a barn/granary", and is a common element in Irish place-names, signifying a unit of land held as farm-land by a monastic house of the 12th- or post-12th-century period, frequently of Anglo-Norman foundation. It is sometimes used as the equivalent of "parish", in cases where a "block-unit" of adjoining lands was held by a monastic house (Flanagan 1981–2(c), 75). The Grange of Ballyscullion was formerly a possession of the distant Augustinian monastery of SS Peter and Paul in Armagh (*Inq. Ant. (DK)* 51), and, as such, provides a good example of the use of the element *grange* to refer to a territory lying some distance from the monastery to which it belonged. The element *grange* is gaelicized *gráinseach*, which may in turn be anglicized *Gransha*, the name of townlands in the parishes of Bangor, Comber, Dromara, Inishargy and Newry. In the case of the Grange of Ballyscullion, none of the recorded spellings suggests a gaelicized form of *grange* and the only evidence for an Irish form of the parish name is the fact that the name of the church is marked *T:Grange* on two early 17th-century maps (2,3), the prefix *T:* standing for *teampall* "church".

133

The place-name formation *Grange of* . . . is peculiar to Co. Antrim, there being in all ten parishes and a further three townlands so designated.

The final element of the place-name is obviously the surname Scullion. MacLysaght (1985, 266) takes this surname to represent Irish *Ó Scolláin*, but both the modern pronunciation and the early spellings of the name of the parish of **Ballyscullion** in Co. Derry favour something like an otherwise unattested *Ó Scoillín*. The recommended Irish form of Ballyscullion is therefore *Baile Uí Scoillín*. According to MacLysaght (*ibid.*), the Scullions were erenaghs or hereditary custodians of the church lands of the parish of Ballyscullion, to which parish they have clearly given name. The *Hearth Money Rolls* of 1669 list five people named "O'Scullin" who were householders in the townland of *Ballescullin* (i.e. Ballyscullion East) at that date (*HMR Ant.* 152), and the surname Scullion is still a common one in this area, on both sides of the river Bann.

TOWNLAND NAMES

| **Aghavary** | *Achadh Fhearaigh*(?) | |
|---|---|---|
| J 0297 | "Farry's field" | |
| 1. (?)the grange called | | |
| Balligarewhie | Inq. Ant. (DK) 45 | 1605 |
| 2. (?)Ballygarewhy | Inq. Ant. (DK) 51 | 1605 |
| 3. (?)Balligarwhie | CPR Jas I 77b | 1605 |
| 4. (?)Balligarrewhie | CPR Jas I 93b | 1606 |
| 5. (?)Ballicullygarvohie | Inq. Ult. (Antrim) §12 Car. I | 1631 |
| 6. (?)Ballygarrowhie | Lodge RR Chas I ii 337 | 1639 |
| 7. (?)Hamerslys Land | HMR Ant. 152 | 1669 |
| 8. Agheary | Rent Roll Mass. Est. | 1711c |
| 9. Agheary | Reg. Deeds 12-120-4604 | 1713 |
| 10. Part of Aghrey | Duty Bk. Grange | 1733 |
| 11. Agheary | Reg. Deeds 94-186-65857 | 1738 |
| 12. Aghavary | Reg. Deeds 108-71-74628 | 1742 |
| 13. Agheary | Reg. Deeds 146-334-97835 | 1750 |
| 14. Aghavary | Lendrick Map | 1780 |
| 15. Aghavery | Duff's Lough Neagh | 1785 |
| 16. Agheary | Reg. Deeds 749-498-509833 | 1820 |
| 17. Aghavary | OSNB A 39 | 1828 |
| 18. Achadh Bhearaigh "Bearach's field" | J O'D (OSNB) A 39 | 1828 |
| 19. ˌaxəˈvɑːri | Local pronunciation | 1987 |

The absence of definite pre-18th-century documentation of this place-name renders it difficult to arrive at a satisfactory derivation. In form (5), the initial element of the neighbouring townland of Culnafay has accidentally been prefixed. The 17th-century forms appear to suggest that the final element of the place-name is a form of *garbh* "rough", perhaps *garbhai*, the genitive of the substantive form *garbhach* "rough land" (see *Joyce* iii 358), but these forms cannot certainly be identified with Aghavary, and so cannot be regarded as reliable evidence. Even if we accept the identification of the earlier forms with Aghavary, it appears unlikely that they represent older forms of the modern name for the townland; it seems more likely that we are dealing with two distinct and unconnected names.

The first element of the modern name of the townland appears to be *achadh* "field". The second element is problematic. In forms 8, 9, 11, 13 and 16 (which are related) the medial *-v-* has clearly been omitted as a result of scribal error. A tentative Irish form is *Achadh Fhearaigh*, the final element being the personal name *Fearaíoch*, a name which, in the earlier form *Fearadach*, is of common occurrence in early East Ulster pedigrees (*Descendants Ir* 93, 105, 116, 117, 330, 352) and was sometimes anglicized Ferdinand and Farry (Ó Corráin & Maguire 1981, 143). O'Donovan's Irish form, *Achadh Bhearaigh* "Bearach's field" (18), is also worthy of consideration. However, as the name *Bearach* does not appear to be much attested in northern genealogies, I am inclined to regard it as the less likely of the two suggested derivations. The personal name *Fearaíoch* also appears to form the final element of the name of the nearby townland of **Carnearney** in the parish of Ahoghill.

*Hamersly's Land*, which is listed in the *Hearth Money Rolls* of 1669 as one of "The Seven Townes of Greance" (*HMR Ant.* 151), seems to roughly correspond with Aghavary, though a straightforward identification between the two land-units appears unlikely, as both the *Rent Roll of the Massereene Estate* in c. 1711 and the *Duty Book for Grange* in 1733 refer to a John Hamersly as proprietor of part of the neighbouring townland of Culnafay.

| **Ardnaglass** | *Ard na nGlas* | |
|---|---|---|
| J 0196 | "height of the streams" | |
| 1. Carnaglass | HMR Ant. 152 | 1669 |
| 2. Upper part of Ardneglass –<br>Thos. Courtney | Rent Roll Mass. Est. | 1711c |
| 3. Ardnaglass | Reg. Deeds 12-120-4602 | 1713 |
| 4. Carneglass | Reg. Deeds Index | 1723c |
| 5. Ardnglasse | Reg. Deeds 94-186-54857 | 1738 |
| 6. Ardeglass | Belfast News Letter Mar. 16 | 1771 |
| 7. Arnaglass | Lendrick Map | 1780 |
| 8. Arnaglass | Duff's Lough Neagh | 1785 |
| 9. tl. of Ardenglasse sometimes<br>called Ardneglass orw.<br>Kerneglass | Reg. Deeds 389-309-256490 | 1787 |
| 10. Ardnaglass | OSNB A 39 | 1828 |
| 11. Ard na Glaise "height or hill<br>of the stream" | J O'D (OSNB) A 39 | 1828 |
| 12. "the height of the stream" | Joyce iii 45 | 1913 |
| 13. ˌardnəˈglas | Local pronunciation | 1987 |

The noun *glas* in place-names is commonly interpreted as "stream" (*Joyce* i 455). There are several small hills as well as two streams in the vicinity and the place-name may have the significance of "height of the streams". The word *glas* is also testified in the sense of "a grey cow" (*Ó Dónaill* sv.), as in the well-known legend of *An Ghlas Ghaibhleann*, which tells of a cow which gave an inexhaustible supply of milk and "height of the grey cows" may be another possible interpretation of the place-name.

O'Donovan's explanation of the place-name as *Ard na Glaise* "the height or hill of the stream" (11) is not supported by the historical forms, none of which show any trace of a palatal *s* in the final element. While none of the recorded spellings display any trace of the

eclipsing *n* of *Ard na nGla*s, the letter *n* in the combination *ng* is seldom retained in angli-
cized forms of place-names (*Joyce* i 22).

Forms 1, 4 and 9c suggest that the form *Carn na nGlas* "cairn of the streams", or,
possibly, *Corr na nGlas* "round hill of the streams" may have been for a time in use as an
alternative name for the townland.

| **Culnafay** | *Cúil an Bheithe* | |
|---|---|---|
| H 9997 | "corner/angle of the birch" | |
| 1. Ballycullevegh | Inq. Ant. (DK) 51 | 1605 |
| 2. Balliculleveigh | CPR Jas I 77b | 1605 |
| 3. Ballicullevegh | CPR Jas I 121b | 1608 |
| 4. Ballycullyveogh | Inq. Ult. (Antrim) §12 Car. I | 1631 |
| 5. Ballycullyveigh | Lodge RR Chas I ii 337 | 1637 |
| 6. Ballycullyveigh | Marriage Sett. Skeffington | 1654 |
| 7. (?)Courtnay's Land | HMR Ant. 152 | 1669 |
| 8. Part of Ballycunevea – | | |
| John Hamersly | Rent Roll Mass. Est. | 1711c |
| 9. Ballyconeveigh | Reg. Deeds 12-120-4602 | 1713 |
| 10. Part of Ballyconevy (was | | |
| John Hamersly's) | Duty Bk. Grange | 1733 |
| 11. Ballyconvea orw. Ballyconyvea | Reg. Deeds 94-186-65857 | 1738 |
| 12. Coolanevey River | Grand Jury Pres. (Summer) | 1778 |
| 13. Culnaveagh | Lendrick Map | 1780 |
| 14. Cullnaveagh – Mr. J. Courtney | Duff's Lough Neagh | 1785 |
| 15. (?)the quarterland of Killyfade | Reg. Deeds 389-309-256490 | 1787 |
| 16. Culnaveagh | Bnd. Sur. | 1827 |
| 17. Culnafae | OSNB A 39 | 1828 |
| 18. Cúil na bhFiach "corner of | | |
| the ravens" | J O'D (OSNB) A 39 | 1828 |
| 19. ˌkɒlnəˈfɛ ː | Local pronunciation | 1987 |

O'Donovan's suggested Irish form, *Cúil na bhFiach* "corner of the ravens" (18), is not sup-
ported by the earliest recorded spellings, which show no trace of the genitive plural form of
the Irish definitive article *na*. One might argue for the Irish form *Coillidh Bheithe* "birch
wood", the element *coillidh* being an oblique form of *coill* "wood" which, according to Joyce
(i 493) is frequently anglicized as *Cully*. However, it is surprising that none of the recorded
spellings show any evidence of *Killy*, the usual anglicized form of *coillidh*. A more plausible
interpretation of the place-name, therefore, is *Cúil an Bheithe* "corner of the birch". The
long [u] of *cúil* "corner/angle" is liable to be shortened in unstressed position, which would
explain its anglicization as [kɒl] rather than as [ku:l], and the medial -*na*- of the modern ver-
sion of the place-name (which is not recorded until 1780) is likely to represent a corruption
of the genitive singular form of the article *an*.

The townland of Culnafay seems to correspond with *Courtnay's Land* of the *Hearth Money
Rolls* of 1669 (*HMR Ant* 152), though this is not a simple one-to-one correspondence, as
part of the denomination referred to as *Hamersleys Land* in the same source appears to have
been in Culnafay, and a Thomas Courtney is recorded as proprietor of the *Upper part of
Ardneglass* c. 1711 (*Rent Roll Mass. Est.*).

**Gillistown**                          *Baile an Mhaí*
J 0296                                   "townland of the plain"

| | | |
|---|---|---|
| 1. Ballinweigh | Inq. Ant. (DK) 51 | 1605 |
| 2. Ballinweigh | CPR Jas I 77b | 1605 |
| 3. Ballinweigh | CPR Jas I 121b | 1608 |
| 4. Ballnmoighe | Deed Clotworthy | 1627 |
| 5. Ballyneveigh | Lodge RR Chas I ii 337 | 1639 |
| 6. Ballyneviegh | Marriage Sett. Skeffington | 1654 |
| 7. Ballinmoy | HMR Ant. 151 | 1669 |
| 8. Gillistown | Rent Roll Mass. Est. | 1711c |
| 9. Gillistowne als. Ballynamoy | Reg. Deeds 12-120-46602 | 1713 |
| 10. Gillstown orw. Ballynamay | Reg. Deeds 12-120-46602 | 1713 |
| 11. Gillistown | Duty Bk. Grange | 1733 |
| 12. Gillistown orw. Ballynamoy | Reg. Deeds 94-186-65857 | 1738 |
| 13. Gillistown | Lendrick Map | 1780 |
| 14. Gillistown | Duff's Lough Neagh | 1785 |
| 15. Ballneveagh orw. Gillistown | Reg. Deeds 378-398-253562 | 1786 |
| 16. Mosses of Gillestown and . . . | Reg. Deeds 749-35-509370 | 1820 |
| 17. Gillistown | OSNB A 39 | 1828 |
| 18 "Gillistown – Gill was the ferryman in 1653" | J O'D (OSNB) A 39 | 1828 |
| 19. 'gïləs,təun | Local pronunciation | 1987 |

The earlier historical forms show that the townland was formerly known by the Irish name *Baile an Mhaí* "townland of the plain". The word *magh* (Standard Ir. *má*) "plain" is feminine in Mod. Ir. but in O. Ir. it was a neuter noun and it later throws up both masc. and fem. forms (*DIL sv. mag*). In this case, the earliest spellings suggest that *magh* is a masculine noun. There is a large, flat area of bogland in the east of the townland, and this appears most likely to be the feature which has given rise to the place-name. The modern English form of the place-name is not documented until c. 1711 (8). The first element of this name is obviously the Scottish surname Gillis, a variant-form of "Gillies", which is derived from Gaelic *Giolla Íosa* "servant of Jesus" (Black 1946, 306). An individual named Robert Gillis is recorded in the *Hearth Money Rolls* as residing in the Grange of Ballyscullion in 1666 (Carleton 1991, 164). It is quite likely that this Mr Gillis was a recent settler from Scotland, and that it was he who changed the name of the townland to Gillistown. The tradition recorded in 1828 (18) that the townland was named from an individual named Gill who was the ferryman in 1653 is still alive in the area, and it is possible that Gill is a corruption of the surname *Gillis*.

**Grange Park**                          An English form
J 0195

| | | |
|---|---|---|
| 1. Part of Grange Park | Duty Bk. Grange | 1733 |
| 2. Grange + Park + Tythes | Reg. Deeds Index | 1774c |
| 3. Grange Park + Fifty Acres + Tythes of . . . | Reg. Deeds Index | 1815c |
| 4. the Grange Park + 30a | Reg. Deeds 749-35-509370 | 1820 |
| 5. Grange Park | OSNB A 39 | 1828 |
| 6. 'gre:nӡ 'park | Local pronunciation | 1987 |

It is possible that the modern English name of the townland has replaced an Irish one, as in the case of **Gillistown**. However, it is perhaps more likely that Grange Park was formerly part of another townland, possibly the neighbouring **Killylaes**. The site of the present parish church of the Grange is in Grange Park townland, while the site of the ancient parish church is in the graveyard, immediately adjoining this, but just inside the border of the townland of Killylaes. The latter is now a very small townland, measuring only 85 acres, but its name is documented as early as 1605. Grange Park was a deer park in 1711 (Carleton 1991, 165). This deer park clearly gave rise to the title *The Manor of Deerpark*, which was the name by which the territory of Grange was officially designated from 1639 onwards (*Lodge RR* Chas I ii 337), though the name is now totally unknown in the area.

| **Killylaes** | *Cill Eaglaise(?)* | |
| J 0196 | "graveyard of the church(?)" | |

| | | | |
|---|---|---|---|
| 1. | Ballintemple or Templeagliss | Inq. Ant. (DK) 51 | 1605 |
| 2. | Ballitemple orw. Templeaglisse | CPR Jas I 77b | 1605 |
| 3. | Ballitemple orw. Templeaglisse | CPR Jas I 121b | 1608 |
| 4. | Ballynetemple al. Templeaglishe | Inq. Ult. (Antrim) §12 Car. I | 1631 |
| 5. | Ballytemple al. Templeagusse | Lodge RR Chas 1 ii 337 | 1639 |
| 6. | Bally-temple orw. called Templeaglisse | Marriage Sett. Skeffington | 1654 |
| 7. | Killylesh | HMR Ant. 152 | 1669 |
| 8. | Killyliss | Rent Roll Mass. Est. | 1711c |
| 9. | Killiliss | Reg. Deeds 12-120-4602 | 1713 |
| 10. | Killyliss | Duty Bk. Grange | 1733 |
| 11. | Killyless | Reg. Deeds 378-398-253562 | 1786 |
| 12. | Killalies | Bnd. Sur. | 1827 |
| 13. | Killilaes | OSNB A 39 | 1828 |
| | | | |
| 14. | Coill a Liasa "wood of the shed/hut" | J O'D (OSNB) A 39 | 1828 |
| | | | |
| 15. | ˌkiliˈlɛːz | Local pronunciation | 1987 |

This is the townland which contains the site of the former parish church of Grange. According to the *Ordnance Survey Memoir*, it was originally to have been the site of the church which came to be founded at **Duneane** (*OSM* xix 10–11). The modern parish church (built in 1846) stands just inside the western boundary of Grange Park townland, while its burial ground, which was also the site of the former parish church, is just inside the townland of Killylaes. O'Laverty informs us that the burial ground, and also the former parish church, were in his day known as "Temple Moyle" i.e. "the bald or unfinished church", referring to the fact that, according to the legend recounted under the parish of **Duneane** above, the church which was to be built here was never completed (*O'Laverty* iii 353). The place-name "Templemoyle" is a fairly common one in the north of Ireland and derives from Irish *Teampall Maol*, the first element signifying "church" and the final element *maol* (which literally means "bald") "conveying the idea of flatness, dilapidation or incompletion" (*EA* 82).

   The earliest recorded spellings of the place-name suggest the Irish form *Baile an Teampaill* "townland of the church", with *Teampall Eaglaise* as an alias name. The elements *teampall* and *eaglais* appear to have the same meaning, i.e. a church, frequently a parish church, of the post-12th-century Reform period (Flanagan 1981–2(c), 73) and the form *Teampall Eaglaise*

is apparently tautologous, signifying "church of the church". The unqualified element *Eaglais* "church" (anglicized *Aglish* or *Eglish*) forms the name of a number of parishes and townlands throughout Ireland, and it is possible that the original name of this townland was also simply *Eaglais* and that the element *teampall* was prefixed at a later date. The word *teampall* can also signify "churchyard" (*Ó Dónaill* sv.) and one might suggest that this is its significance in this place-name, and that it was coined to refer to the ancient graveyard after the church had become derelict. If this be the case, *Teampall Eaglaise* may have the significance of "graveyard of the church", but this suggestion can only be regarded as tentative.

The modern form of the place-name (first documented in 1669) bears little apparent resemblance to the earlier forms, and it is difficult to say with certainty whether it constitutes a totally distinct and unrelated name, or a development from the earlier version of the name. One might argue for the form *Coillidh Leasa* "wood of the fort", or *Coillidh Léith* "grey wood". In the case of the latter, the final -*s* of the modern form of the name could be explained as an anglicized plural form. However, in view of the fact that there was formerly a church in the townland, it is more likely that the first element of the place-name represents *cill* "church" and that the final element is an unusual corruption of *eaglaise*, the gen. sing. of *eaglais* "church", which is also represented in the final element of the earlier form *Templeagliss*. If *cill* is understood to signify "church", its usual meaning in townland and parish names (Flanagan *op. cit.* 72), then the form *Cill Eaglaise* is clearly tautologous. However, *cill*, like *teampall*, is also attested in the sense of "churchyard" (*Ó Dónaill* sv.) and it is possible that it is in this sense that it is to be understood in our place-name. *Cill Eaglaise* "graveyard of the church" is therefore put forward as the most satisfactory interpretation of the place-name.

| **Kilvillis** | Of uncertain origin | |
|---|---|---|
| J 0096 | | |
| 1. Kilvalies | Bnd. Sur. | 1827 |
| 2. Kilvillis | OSNB A 39 | 1828 |
| 3. Kilvillis | OS Name Sheets (J O'D) | 1830 |
| 4. Coill Mhilis "Myle's Wood, not 'sweet wood' " | J O'D (OSNB) A 39 | 1828 |
| 5. ˌkilˈvīləs | Local pronunciation | 1987 |

The name of this small townland is not documented until 1827, which suggests that up to that time it was known by another name which is now obsolete or, perhaps more likely, that it was a sub-division of another townland, quite possibly the neighbouring townland of **Killylaes**. Ó Máille (1989–90, 128) suggests that the final element of Kilvillis is a form of *bile* "tree, lip/edge", presumably consisting of *bile* plus the meaningless suffix -*eas*, which in the genitive case would become *bilis*. The name of the townland might therefore be interpreted as *Coill Bhilis* "wood of the (sacred) tree" or *Cill Bhilis* "church of the (sacred) tree", but there is insufficient evidence to allow a definite judgement to be made.

| **Mill Quarter** | An English form | |
|---|---|---|
| J 0097 | | |
| 1. Ballyknoacke | Inq. Ant. (DK) 51 | 1605 |
| 2. Balliknoake | CPR Jas I 77b | 1605 |

| | | |
|---|---|---|
| 3. Balliknoake | CPR Jas I 121b | 1608 |
| 4. Ballyknoake | Lodge RR Chas I ii 337 | 1639 |
| 5. Ballyknoake | Marriage Sett. Skeffington | 1654 |
| 6. The Mill and Mill Qtr. | Rent Roll Mass. Est. | 1711c |
| 7. Mill Quarter als. Ballyknock | Reg. Deeds 12-120-4602 | 1713 |
| 8. Pt. of Mill Quarter + Mill | Duty Bk. Grange | 1733 |
| 9. ye Mill Quarter | Reg. Deeds 83-9-57373 | 1735 |
| 10. Millquarter als. Ballyknock | Reg. Deeds 146-334-97835 | 1750 |
| 11. Milltown | Lendrick Map | 1780 |
| 12. Miltown | Duff's Lough Neagh | 1785 |
| 13. mosses of . . . and Millquarter | Reg. Deeds 749-35-509370 | 1820 |
| 14. Mill Quarter | OSNB A 39 | 1828 |
| 15. 'mil 'kwɑrtər | Local pronunciation | 1987 |

This is another example of a townland whose original Irish name has been replaced by an English one, presumably in the late 17th century or early 18th century (cf. **Gillistown** above). Forms 7b and 10b suggest that the original Irish name was *Baile an Chnoic* "townland of the hill". However, this derivation does not appear reconcilable with forms 1–5. These forms are all related, and while the second *a* of forms 2, 3, 4 and 5 could conceivably be a mistranscription of *c*, the presence of both *a* and *c* in form 1 renders this improbable and the original Irish form of the place-name remains obscure.

The modern name of the townland obviously has its origin in the corn-mill around which there grew up a small village, known as Milltown (11, 12). The *Ordnance Survey Memoir* informs us that, even as early as 1837, the mill was "only in middling repair" (*OSM* xix 8), while the *OSRNB* of c. 1858 (sheet 42) informs us that by that time it had fallen totally out of use. Form 6 indicates that the English name of the townland, and the mill itself, dates back to at least c. 1711. The final element of the place-name, i.e. *Quarter*, in this case does not appear to refer to any fixed measure of land and may signify simply "townland".

**Taylorstown**                              An English form
J 0294

| | | |
|---|---|---|
| 1. Mr Taylor's Towne | HMR Ant. 151 | 1669 |
| 2. (?)Townland of Gortree | Rent Roll Mass. Est. | 1711c |
| 3. (?)Gartre | Reg. Deeds 12-120-4602 | 1713 |
| 4. (?)Lanalolagh | Reg. Deeds 12-120-4602 | 1713 |
| 5. (?)Lana Colagh | Reg. Deeds Index | 1723c |
| 6. (?)Lanallowily | Reg. Deeds Index | 1723c |
| 7. (?)Townland of Gortee and lands of Lanalolly, formerly Mr. Taylor | Duty Bk. Grange | 1733 |
| 8. (?)town and lands of Gorlye and lands of Lanallowly | Reg. Deeds 84-12-76681 | 1735 |
| 9. (?)Gartree and Lanalalagh orw. Lanaolagh | Reg. Deeds 94-186-65857 | 1738 |
| 10. (?)Gartee | Reg. Deeds 146-334-97835 | 1750 |
| 11. (?)Lanalolagh | Reg. Deeds 146-334-97835 | 1750 |
| 12. Taylorstown | Lendrick Map | 1780 |
| 13. Taylorstown | Duff's Lough Neagh | 1785 |
| 14. (?)Garter and Lanalalogh als. Lanalolagh | Reg. Deeds 749-498-509833 | 1820 |

| | | |
|---|---|---|
| 15. (?)Garter and Lisnalslogh | | |
|     orw. Lunalologh | Reg. Deeds 749-498-509833 | 1820 |
| 16. Taylorstown | OSNB A 39 | 1828 |
| 17. 'te:lərz,təun | Local pronunciation | 1987 |

The *Hearth Money Rolls* of 1669 give the name of this townland as *Mr. Taylor's Towne* and lists a Mr Thomas Taylor (with six hearths) and a Samuel Taylor among the householders in the townland (*HMR Ant.* 151). No doubt Mr Thomas Taylor was the originator of the modern name of the townland, and his family were undoubtedly recent settlers in Ireland. Bell (1988, 239) informs us that the name Taylor (which can be of English or Scottish origin) is common in Ireland only in Dublin and Ulster, where its greatest concentration is in counties Antrim, Down and Derry. Although the name was found in Dublin from medieval times onwards, the Taylors of Ulster are "of Plantation or post-Plantation origin". Bell (*ibid.*) also informs us that many members of the "riding clans" of the Scottish borders (of which the "Tailers" were one) sought refuge in Ulster after James VI's "pacification" of the Borders in the decade after 1603. It is quite possible that it was at this time that the Taylors of Taylorstown arrived in Ireland.

The townland of Taylorstown is unusually large, and no doubt it is made up of an amalgamation of smaller land units. The *Duty Book for Grange* in 1733 refers to the "townland of *Gortee* and lands of *Lanalolly*, formerly Mr. Taylor" (7), which suggests that the two denominations named as formerly belonging to Mr Taylor correspond with the townland referred to as *Mr. Taylors Towne* in the *Hearth Money Rolls* of 1669 (*HMR Ant.* 151). The names of both of these land-units, which are found in a number of other 18th-century sources, are now obsolete, and the absence of knowledge of their local pronunciation as well as the inconsistent nature of the documentary evidence, renders it impossible to suggest satisfactory Irish forms.

<div align="center">OTHER NAMES</div>

| | | |
|---|---|---|
| **Battery Hill** | An English form | |
| J 0393 | | |
|   1. ,batəri 'hĭl | Local pronunciation | 1987 |

This is the name of a prominent hill of roughly 450 feet in the south-eastern corner of the townland of **Taylorstown**. It commands an outstanding view over the whole of the surrounding countryside. The *OSRNB* of c. 1858 (sheet 43) remarks: "Small cultivated hill upon which a battery is said to have been erected during some one of the wars of Ireland". The word *battery* in this context obviously signifies an armed military position, but I was unable to obtain any local information about circumstances in which it was used. In Ireland, the word battery can also have the significance of "a sloping wall, an embankment" *(Eng. Dial. Dict.)* but it seems unlikely that it is to be so understood in this place-name.

| | | |
|---|---|---|
| **Crosskeys** | An English form | |
| J 0196 | | |
|   1. 'krɔs'ki:z | Local pronunciation | 1987 |

This is the name of a well-known thatched public house in the townland of **Ardnaglass**. The *OSRNB* of c. 1858 (sheet 36) informs us that at that time it was the property of Dr H. Purden, Wellington Park, Belfast and that the postmaster was George Neeson, Crosskeys. It goes on to remark:

Name given to a comfortable dwelling house in Ardnaglass townland, in which is kept a public groceries and Post Office, and over the door of which is painted the likeness of two keys crossing each other, hence the name Crosskeys. The present occupier (George Neeson) says the place had the name before there was a Public House or sign-board there, but cannot tell the origin of it.

The earliest recorded reference to the Crosskeys appears to be in 1771 in an advertisement in the *Belfast News Letter* which contains a list of "Houses and Lands" to be "set for a Term of Years to be agreed on" in "the Townland of *Ardeglass*, in Grange, and County of Antrim" and which refers to "the noted publick House where the Misses Boyds live, with English Measure". At the bottom of the list it is remarked: "All the above Houses are Good Stone and Lime Farm Houses" (*Belfast News Letter* Mar. 16, 1771).

At the beginning of the 19th century, the Crosskeys was a changing post for horses on a coaching route which ran from Belfast to Kilrea, via Portglenone.

In Wales there is a village named Crosskeys of which Adrian Room (1983, 29) remarks: "The name is almost certainly that of an inn here, with the crossed keys on the inn sign representing the insignia of the papacy". There is also a small hamlet called **Crosskeys** at a crossroads near Upperlands in Co. Derry at which there was also formerly a public house and a place named **The Cross Keys** near Keady in Co. Armagh.

| | | |
|---|---|---|
| **Grange House** | An English form | |
| J 0097 | | |
| 1. ˌgriə:nʒ 'həus | Local pronunciation | 1987 |

This is the name of a large house in the townland of Culnafay. It has obviously taken its name from the name of the parish. The *Ordnance Survery Memoir* of 1837 remarks:

> Grange House was built by Thomas Courtney Esquire upwards of 100 years ago. It is 2-storey high, slated and situated on the road leading from the Cross Keys to Portglenone, in the townland of Culnafoy. Joseph Courtney Esquire was the last proprietor, but has let it to a farmer named Patt Devlin . . . House in bad repair (*OSM* xix 9).

| | | |
|---|---|---|
| **Highland Hill** | An English form | |
| H 9997 | | |
| 1. 'hailənd 'hïl | Local pronunciation | 1987 |

This is a hill of 425 feet in the townland of Aghavary. The *OSRNB* of c. 1858 (sheet 36) refers to it as a "high, flat hill, named from being the highest in the neighbourhood".

| | | |
|---|---|---|
| **Roguery Brae** | A hybrid name(?) | |
| J 0393 | | |
| 1. 'rogəri 'brɛ: | Local pronunciation | 1987 |

Although it is not marked on the *OS 1:50,000* map, this name is well-known in the area (see *OS 1:10,000* sheet 80). It is a steep hill in the south-east corner of the townland of **Taylorstown**. The *OSRNB* of c. 1858 (sheet 43) refers to **Roguery House** as: "a large thatched building, formerly a public house, now the residence of Francis E. Hall Esq.

Surgeon" and goes on to relate the following (rather unlikely!) story of how it got its name:

> "About thirty years ago the house was built by one John Black in opposition to the wishes of his mother, a very old woman who is said to have been fonder of money than of costly building, who when she saw the house exclaimed, 'New found out Roguery!'".

This story is still found in the area, except that it concerns an old man named Black rather than an old woman of that name.

It is perhaps more likely that the name has its origin in the Irish language and that it is derived from *Ruagharraí* "red garden" or *Ruadhoire* "red oak wood", though in the absence of documentary evidence it is impossible to make a firm judgement about its origin.

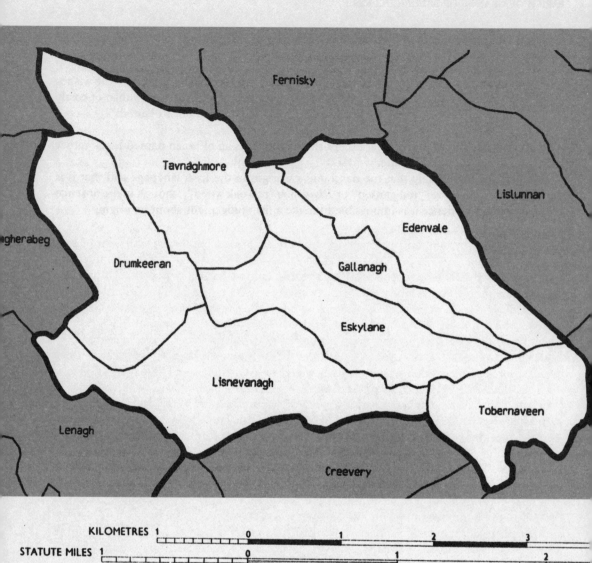

**Parish of Grange of Shilvodan**

Barony of Toome Upper

*Townlands*
Drumkeeran
Edenvale

Eskylane
Gallanagh
Lisnevanagh

Tavnaghmore
Tobernaveen

Based upon Ordnance Survey 1:50,000 mapping, with permission of the Director of the Ordnance Survey of Northern Ireland, Crown copyright reserved.

# PARISH OF GRANGE OF SHILVODAN

The parish of Grange of Shilvodan consists of seven townlands and comprises an area of approximately 3,546 acres (*Census 1851*). It lies in the barony of Toome Upper and is bounded on the west by the parish of Drummaul, on the north and east by the parish of Connor and on the south by the parish of Antrim.

No trace now remains of the former church of Shilvodan. According to Reeves, the site of the old graveyard of the church was believed to be in the townland of **Tavnaghmore** (*EA* 303). O'Laverty informs us that in his time the site of the ancient church was well known and the enclosure of the burying ground remained intact, except on the north side where the road from Randalstown to Kells was driven through it (*O'Laverty* iii 291). This appears to be the site which is marked "Graveyard" by *NISMR* and "Shilvodan Grave Yard" on the *OS 1:50,000* map and is, in fact, in the townland of Drumkeeran. According to the *OSRNB* of c.1858 (sheet 43) it was by that time no longer used as a graveyard, except for the interment of children, and stations used to be performed at a former well which stood in the adjoining field. O'Laverty also refers to a "circular fort" in the townland of Tavnaghmore where unbaptized children and homeless persons were formerly interred *(O'Laverty loc. cit.)*, a feature of which there is now no trace or record. The present owner of the site in Drumkeeran has shown me a stone which appears to be one of the grave stones from the ancient graveyard.

In 1584, Shilvodan is listed among a number of rectories which were "appendant to Muckamore Abbey" (*Eccles. Reg.* 35). A fuller list of the possessions of the monastery of Muckamore occurs in 1603, and includes a reference to "all the tithes in the town and lands of . . . *Salgodan* . . ." (*Mon. Hib.* 19). According to the *Antrim Inquisition* of 1605, the prior of "the late house of regular canons of *Muckmaire*" was, at the time of the dissolution of that monastery in 1542, seised of the chapel of *Sillwoodan*, (where he was bound to maintain a curate), together with the tithes of the townlands of Lisnevanagh, Tavnaghmore, Gallanagh and Eskylane (*Inq. Ant. (DK)* 49). In 1615 Shilvodan is referred to as "the church of *Schilowodan* of Muckamore" (*Terrier (Reeves)* 85)), and in 1616 as the "vicarage of *Silivodden*" (*First Fruits Roll (Reeves)*).

The *Ulster Visitation* of 1622 refers to the parish as *Grangia de Silvoddan (Ulster Visit. (Reeves)* 260) but makes no mention of any church, which suggests that by this date all trace of the ancient church had disappeared. In 1657 the *Inquisition into the Parishes of Co. Antrim* lists *Sylvodan* as one of "5 small granges or Chappellryes . . . anciently belonging to the Abbey of Muckamore" and goes on to remark:

> The Impropriations are now received by Sir John Clotworthy knt. whoe is to maintain Curats . . . they (i.e. the Granges) are distinctly situated in several parts of the county and have no Chappells upon them, but the Cure is supplyed by the Ministers respectively next adjoining (*Inq. Par. Ant.* 46).

In the case of the Grange of Shilvodan this appears to have been the minister of the neighbouring parish of Connor, for an entry in the *Registry of Deeds* in 1716 refers to "the Grange of Silvodan, lying and being in the Parish of Connor" (*Reg. Deeds* 18-214-18870). The other "small granges or Chappellryes" were the Granges of **Nilteen**, **Doagh** and **Ballyrobert** and the chapelry of **Carngranny**.

The Grange of Shilvodan was situated in the tuogh of Munterividy, which was one of three estates in the baronies of Toome granted by King James I to Shane O'Neill of Shane's Castle in 1606 (*CPR Jas I* 93a; *Lodge RR* Jas I i 251). For this reason, the sources of earlier forms of the names of the townlands are roughly the same as those for the parish of **Drummaul**. Of the eleven townlands which are listed in the 1606 grant as making up Munterividy, four are in

the Grange of Shilvodan and can be identified with the modern townlands of Gallanagh, Tavnaghmore, Lisnevenagh and Eskylane. The other seven are in the parish of Drummaul. The forms of the names of the townlands in this grant are similar to those in the *Antrim Inquisition* of 1605 (*Inq. Ant. (DK)* 45) and have apparently been copied from it.

In 1637, the same lands which had been granted to Shane O'Neill in 1606 were re-granted to his son Henry (*Lodge RR* Chas I i 407). The 1637 grant gives a much fuller list of the townlands making up the tuogh of Munterividy and includes the names of the three townlands in the Grange of Shilvodan which are missing from the earlier grant, i.e. Drumkeeran, Edenvale and Tobernaveen. A very similar list of townlands appears in a grant to Cormack O'Neill of Broughshane in 1663 (*Lodge RR* Chas. II i 106), in a grant in 1684 to Rose O'Neill of Shane's Castle (*Lodge RR* Chas II ii 292) and in the *Registry of Deeds* in 1712, 1737 and 1813, suggesting that the forms of the names of the townlands in all these sources have a common origin.

An inquisition of 1620 states that the church of *Silvodan* in Co. Antrim is a parish church and "contains seven towns" (*Inq. Ult.* §4 Jac. I). Four of the names of the "towns" can be identified with Tavnaghmore, Eskylane, Gallanagh, Lisnevenagh, and two "half-towns" are listed which can be identified with Edenvale and Drumkeeran. O'Laverty suggests that the other two "towns" i.e. *Ballecreamy* and *Ballekillganey* are represened by the modern town-land of Tavnaghmore (*O'Laverty* iii 291). However, it appears more likely that *Ballecreamy* and *Ballykillganey* represent the townlands of Creavery and Kilgavanagh in the parish of Antrim. The absence of Tobernaveen from the list may indicate that it had not yet achieved the status of a townland, being composed mainly of coarse upland pasture.

In the aforementioned *Inquisition into the Parishes of Co. Antrim* of 1657 the Grange of Shilvodan is said to consist of "five towns and three quarters", but the names of these denominations are not given (*Inq. Par. Ant.* 46). The three "quarters" may represent the modern townlands of Drumkeeran, Edenvale and Tobernaveen which are generally referred to as "half-towns" in other documentary sources. The five full "towns" appear to be the other four townlands which make up the present parish plus a now obsolete townland whose name is written *Dromkeny* in the 1637 and 1663 grants and which appears to have formed a part of the modern townland of **Drumkeeran**.

While all of the parish had been granted by King James I to Shane O'Neill in 1606, most of the townlands were subsequently sublet to Catholic tenants. The townlands of Gallanagh, Eskylane and Edenvale were granted by Sir Henry O'Neill to *Toole McCann* and his wife *Rosney Neile* (Ir. *Róis Ní Néill* "Rose O'Neill") and forfeited by them for their part in the rebellion in 1641 (*Lodge RR* Chas II i 106). Similarly, the townlands of Tavnaghmore, Drumkeeran and a denomination referred to as *The Quarter of Urballyshunny*, which had been granted by Shane O'Neill to *Edmund Mc Toole O'Neill*, were forfeited by the rebellion of Edmund's son Owen in 1641 (*ibid.*). The name *Urballyshunny* is now obsolete, but a reference in 1738 in the *Registry of Deeds* to *Drumkenny als. Urbleshenny* enables us to identify it with the denomination referred to above as *Dromkeny* (*Reg. Deeds* 90-358-64832). The name appears to represent Irish *Earball Sionnaigh* "fox's tale", a name which is attested in several other places and can refer to a long strip of land which people imagined to resemble a fox's tail (*Joyce* i 426).

| | PARISH NAME | |
|---|---|---|
| **Grange of Shilvodan** | A hybrid form | |
| 1. (?)sil mBaedain | Descendants Ir 115 | 1200c |
| 2. (?)Kill-Boedain | Acta SS Colgan 728 col. 2; | |
| | 753 col. 2 | 1645 |

| | | |
|---|---|---|
| 3. (?)Ecclesiam prius Kill-Boedain apellatam, postea Kill-Oscoba appellari curantes | Acta SS Colgan 728 col. 2 | 1645 |
| 4. (?)Ecclesiam prius Kill Beodain appellatam, postea Kill-oscoba apellari curantes | Acta SS Colgan 753 col. 2 | 1645 |
| 5. (?)Kilboedain | Mon. Hib. 14 | 1786 |
| 6. Sylvodan, rectory of | Eccles. Reg. 35 | 1584 |
| 7. Salgodan | Mon. Hib. 19 | 1603 |
| 8. Sillwoodan | Inq. Ant. (DK) 49 | 1605 |
| 9. Selvodan | CPR Jas I 72b | 1605 |
| 10. Shilvodan of Muckamore, Ecclesia de | Terrier (O'Laverty) 332 | 1615 |
| 11. Schilowodan of Muckamore, Ecclesia de | Terrier (Reeves) 85 | 1615 |
| 12. Silivodan, Vicaria de | Terrier (Reeves) 93 | 1615 |
| 13. Silivodden | First Fruits Roll (Reeves) | 1616 |
| 14. Silvodan | Inq. Ult. (Antrim) §4 Jac. I | 1620 |
| 15. Grangia de Silvoddan | Ulster Visit. (Reeves) 260 | 1622 |
| 16. Silvodan | Regal Vis. (PROI) 11 | 1634 |
| 17. Sylvodan | Inq. Par. Ant. 46 | 1657 |
| 18. The Parish of Silvoden | Hib. Reg. Toome | 1657c |
| 19. Silvodan | Trien. Visit. (Bramhall) 6 | 1661 |
| 20. Silvoden | Hib. Del. Antrim | 1672c |
| 21. Sylvodan | Trien. Visit. (Boyle) 38 | 1679 |
| 22. the Grange of Silvodan, lying and being in the Parish of Connor | Reg. Deeds 18-214-18870 | 1716 |
| 23. Silvodan | Reg. Deeds 145-334-97825 | 1750 |
| 24. Shilvoden | Lendrick Map | 1780 |
| 25. Shilvoden Grange | OSNB A 42 A 10 | 1828 |
| 26. Shilvodan - "it is necessary to add Grange" | OS Name Sheets (J O'D) | 1830 |
| 27. Síol Bhaodáin "Boden's sept" | J O'D (OSNB) A 42 A 10 | 1828 |
| 28. Siol Bhaodain "progenies Boydonia" | EA 302 | 1847 |
| 29. "Shilvodan is obviously the race of Boden" | O'Laverty iii 292 | 1884 |
| 30. Síol Bhaodáin "Boden's posterity" | Joyce iii 554 | 1913 |
| 31. 'griənʒ ǫv ʃil'vo:dən | Local pronunciation | 1987 |

The element *grange* has been discussed above in connection with the **Grange of Ballyscullion**. The Grange of Shilvodan was a former appendage of the monastery of Muckamore (*Eccles. Reg.* 35). Among the other extensive possessions of that monastery were the Granges of **Doagh, Nilteen, Ballyrobert** and **Carngranny** as well as the chapel of **Kirkinriola** (Ballymena) and a share of the tithes of the parish of **Rasharkin** (*Inq. Ant.*

*(DK)* 49). The element *grange* is normally associated with the Anglo-Norman period in Ireland. However, in the case of Muckamore, the monastery was not an Anglo-Norman foundation, having originally been founded by St Colmanellus in the 7th century but, according to O'Laverty, it was affiliated to the Order of Canons Regular of St Augustine around 1183 (*O'Laverty* iii 243). It was doubtless at this time that the abbey of Muckamore gained possession of the chapel of Shilvodan along with the tithes of four townlands in the Grange, which it held until the dissolution of the monastery in 1542 *(Inq. Ant. (DK) loc. cit.)*.

The Irish word for *grange* is *gráinseach*, commonly anglicized in place-names as *Gransha*. In the case of this place-name, none of the documented versions contain any evidence to suggest that the element *gráinseach* ever formed a part of the original Irish form of the place-name. Only one 17th-century source (15) refers to Shilvodan as a "grange" *(grangia)* and it is quite likely that the element *grange* was appended to the place-name at a fairly late date, possibly with the significance of "small parish" rather than in recognition of its former links with Muckamore Abbey.

There is no absolutely certain reference to the name of the parish in Irish language sources. However, a sept named *sil mBaedain* (Mod. Ir. *Síol Bhaodáin* "descendants of *Baodán*") is referred to in an early East Ulster genealogy as a sub-sept of *Clann Leathlobhair* "the family of Lawlor" (1). *Clann Leathlobhair* was a leading ruling family of Dál nAraide who apparently had their headquarters at *Ráith Mór Maige Line* "Rathmore of Moylinny" a little to the east of the modern town of Antrim (see county introduction). It is quite likely, therefore, that the parish of Shilvodan has taken its name from the *sil mBaedain*, the name of the sept being transferred to the territory which is represented by the modern civil parish. The *Baedan* (Mod. Ir. *Baodán*) who gave name to *sil mBaedain* was one of four sons of *Eochu mac Conla* and died c. 590 A.D. (*Descendants Ir*, 115). According to Byrne (1959, 139), his progeny became dominant over all the Cruthin of Co. Antrim.

A possible objection to the interpretation of the final element of the place-name as *Baodán* is that the digraph *ao* is more likely to be anglicized as *oy*, rather than as *o*, and it could be argued that the personal name represented in the place-name is more likely to be *Buadán* from which is derived the rare Irish surname *Ó Buadáin* "Boden" (MacLysaght 185, 20). However, this does not appear to be a problem, as the personal name *Baodán* is anglicized "boden" in the name of the town of Ballyboden in Co. Dublin (<*Baile Bhaodáin, GÉ* 16) and also in the name of the townland of Dunboden Demesne in Co. Westmeath which is derived from Irish *Dún Baodáin* "Baodán's fort" (Walsh 1957, 194).

Writing in 1647, Colgan quotes from a much earlier *Life of St Boedan* which tells how the Munster saint *Boedan* (Mod. Ir. *Baodán*) founded a church named *Kill-Boedain* "the church of *Baodán*" in Dál nAraide (*Acta SS Colgan* 728 col. 2). Reeves (*EA* 302) clearly believed that *Kill-Boedan* might be identified with the former church of Shilvodan, as he includes the relevant passage from Colgan in his discussion of the Grange of Shilvodan. However, O'Laverty points out that: "Shilvodan is obviously the race of Bodan, not the church of Boedan", and goes on to suggest that it is more likely that *Kill-Boedain* was situated somewhere in the Ards in Co. Down, and perhaps in Ballywodan (now officially **Ballywaddan**) in the parish of Ardquin "which is called in an ancient document Kiel Bodan for Kill Bodan" (*O'Laverty* iii 292). The identification of *Kiel Bodan* in the "ancient document" (a grant by John de Courcy to Ralph, Bishop of Down in c. 1203) with *Ballywaddan* has been examined and found improbable as has also its identification with the nearby townland of **Ballywoodan** in the parish of Kilclief (formerly Saul) (*PNI* ii 33–34). The identification of Colgan's *Kill-Boedan* with *Kiel Bodan* of the de Courcy grant can also be ruled out since the *Life of St Boedan* states that *Kill-Boedan* was in Dál nAraide rather than in the district of the Ards.

One is therefore led to consider Reeves's suggestion that the church named *Kill-Boedain* could have been situated in the Grange of Shilvodan. However, the reliability of the *Life of St Boedan* as historical material must be questioned. For example, one of the tribes who are said to have endowed the church of *Kill Boedan*, i.e. the *Kinel-Decill*, appears to have been settled not far from Shilvodan (*O'Laverty* iii 421–2). However, later in the *Life* it is stated that "the descendants of Tomultach" (apparently the *Kinel-Decill*) changed the name of the church from *Kill-Boedan* to *Kill-Oscoba*, i.e. "the church of the descendants of Scoba". The latter is obviously to be identified with the townland and parish named *Cell o scopa* (now Killoscobe) in the barony of Tiaquin in Co. Galway (*Onom. Goed.* 208). Clearly there has been confusion on the part of the author and the general impression which one gets from this passage from the *Life of St Boedan* is of a rather muddled attempt to associate the Munster saint *Baodán* with a place in the north of Ireland the name of which was known to include the personal name *Baodán*.

It seems safe to conclude, therefore, that Shilvodan is likely to have been named from the 6th-century secular ruler Baodán mac Eachach and that any connection between Shilvodan and the Munster saint Baodán is purely by a contrived association of name.

<div align="center">TOWNLAND NAMES</div>

**Drumkeeran**          *Droim Caorthainn*
J 1294                  "ridge of the rowan tree"

|   |   |   |
|---|---|---|
| 1. Drumkerrin | Inq. Ult. (Antrim) §4 Jac. I | 1620 |
| 2. Half town of Drumkerin | Lodge RR Chas I ii 40 | 1637 |
| 3. Half Towne of Dromkerin | BSD 135a | 1661 |
| 4. Drumkirran ½ tl. | Lodge RR Chas II i 106 | 1663 |
| 5. Ballykeerin | Lodge RR Chas II i 106 | 1663 |
| 6. Drumkeram ½ Towne | HMR Ant. 140 | 1669 |
| 7. ½ of Dromkerin or Dromkernie | Lodge RR Chas II ii 292 | 1684 |
| 8. Quarter land of Drumkeerin | Reg. Deeds 88-156-62041 | 1737 |
| 9. Dromkerin | Reg. Deeds 90-171-62470 | 1739 |
| 10. Drumkeerin | Lendrick Map | 1780 |
| 11. Drumkeeran | OSNB A 42 A 10 | 1828 |
| 12. Drumkeerin | OS Name Sheets | 1830 |
| 13. Drumkeeran | OS Name Sheets (J O'D) | 1830 |
| 14. Drumkierin Hill | O'Laverty iii 295 | 1884 |
| 15. Druim Caorthainn "ridge of the rowan-trees" | J O'D (OSNB) A 42 A 10 | 1828 |
| 16. "the ridge of the quicken tree" | Joyce i 513 | 1869 |
| 17. ˌdrọm'kiːrən | Local pronunciation | 1987 |

O'Donovan's interpretation of the place-name (15) is obviously meant to read "ridge of the rowan tree" rather than "ridge of the rowan trees", since *caorthainn* is obviously a genitive singular form.

As there are several hills in the townland, it is difficult to identify the naming-feature. Perhaps the most likely feature is "Breckeney Hill", a conspicuous hill which lies in the east of the townland and which appears to be referred to by O'Laverty as "Drumkierin Hill, a little above the site of the ancient church" (*O'Laverty* iii 292). There are five other

townlands named Drumkeeran, as well as a town in Co. Leitrim named Drumkeeran the name of which is also derived from Irish *Droim Caorthainn* "ridge of the rowan-tree" (*GÉ* 93).

There is a large area of bog in this townland, which may suggest that the final element could be derived from *caorán* "moor". According to O'Rahilly (1932, 185), this is the Donegal version of the Scottish Gaelic word *cáir/cáthar* "a moor" which is, in turn, a borrowing from English. However, *caorán* appears to be little attested as an element in townland names. The indications are that it is a fairly late dialect word and it can be safely ruled out as an explanation of the final element of the place-name.

| **Edenvale** | *Éadan an Bhile* | |
|---|---|---|
| J 1594 | "hill-brow of the (sacred) tree" | |
| 1. Eariville (Edenvilla) | Bnd. Connor Par. | 1604 |
| 2. Edenmille | Inq. Ult. (Antrim) §4 Jac. I | 1620 |
| 3. Edenveele | Inq. Ult. (Antrim) §126 Car. I | 1637 |
| 4. Edenvealer or Edenkeale or Edenveale | Lodge RR Chas I i 407 | 1637 |
| 5. Edennnevill, the halfe towne of | Civ. Surv. x §64b | 1655c |
| 6. Half Towne of Edenveal | BSD 135a | 1661 |
| 7. Edenveal | Lodge RR Chas II i 106 | 1663 |
| 8. ½ tl. Edenveele | Lodge RR Chas II i 106 | 1663 |
| 9. Edenevell | HMR Ant. 140 | 1669 |
| 10. ½ of Edenvale | Comm. Grace 10 | 1684 |
| 11. ½ of Edenveale | Lodge RR Chas II ii 292 | 1684 |
| 12. Edeneveale | Reg. Deeds 10-133-3227 | 1715 |
| 13. Edenveall | Reg. Deeds 90-171-62470 | 1739 |
| 14. Edinveal | Lendrick Map | 1780 |
| 15. Edenveal | Bnd. Sur. | 1826 |
| 16. Edenvale | OSNB A 42 A 10 | 1828 |
| 17. "A fancy name" | J O'D (OSNB) A 42 A 10 | 1828 |
| 18. 'iːdən'veːl | Local pronunciation | 1987 |

The first element of this place-name is obviously *éadan* "hill-brow". While the medial vowel of the final element is difficult to establish with any certainty, the weight of the evidence of the earliest forms appears to favour *-i-* and the most satisfactory interpretation of the place-name is *Éadan an Bhile* "hill-brow of the (sacred) tree". In the north of Ireland, unstressed final vowels (such as the final *e* of *bile* "sacred tree") are inclined to be lost and the development from Irish *bhile* to English *vale* may be explained by the tendency among English speakers to convert unintelligible Irish place-name elements into intelligible English words (*Joyce* i 38–42). There are two natural features in the townland which could qualify for the description *éadan* "hill-brow", Bruce's Hill (407 feet), in the extreme north-west, and another (un-named) ridge of 500 feet in the north-east, but it is impossible to tell which of these is the feature referred to in the place-name. The element *bile* normally refers to a large tree which had ceremonial importance in the life of the people, and often marked the site where chieftains were inaugurated (*Joyce* i 499–501). There is now no local memory of the tree which appears to have given name to the townland.

**Eskylane**
J 1493

*Easca Leathan*
"broad bog/marsh(?)"

| | | |
|---|---|---|
| 1. Ballyskelein | Inq. Ant. (DK) 45 | 1605 |
| 2. Ballyskellenie | Inq. Ant. (DK) 49 | 1605 |
| 3. Balliskelin | CPR Jas I 93a | 1606 |
| 4. Balliskelin or Balliskilin | Lodge RR Jas I i 252 | 1606 |
| 5. Balliskillen | Inq. Ult. (Antrim) §4 Jac. I | 1620 |
| 6. Skilleene | Inq. Ult. (Antrim) §126 Car. I | 1637 |
| 7. Ballyskillene or Ballyskillane | Lodge RR Chas I ii 407 | 1637 |
| 8. Ballykillane | BSD 135a | 1661 |
| 9. Balleskillequin | Lodge RR Chas II i 106 | 1663 |
| 10. Ballyskillyine | Lodge RR Chas II i 106 | 1663 |
| 11. Skeallean Town | HMR Ant. 140 | 1669 |
| 12. Ballyskillane | Comm. Grace 10 | 1684 |
| 13. Ballyskillane or Ballyskillenevinery | Lodge RR Chas II ii 292 | 1684 |
| 14. Ballyskillane | Reg. Deeds 10-133-3227 | 1712 |
| 15. Eskilean | Lendrick Map | 1780 |
| 16. Eskeylane | Bnd. Sur. | 1826 |
| 17. Eskyleane | OSNB A 42 A 10 | 1828 |
| 18. Uisce Léana "water of the meadow" | J O'D (OSNB) A 42 A 10 | 1828 |
| 19. 'ɛ:skə'le:n | Local pronunciation | 1987 |

It seems likely that the prefix *Bally*- in most of the earlier spellings can be attributed to the practice in 17th-century documentation of attaching *Bally*- to the names of all full town-lands. As a result of this, the initial vowel of the first element of the place-name has been sub-merged in the final *y* of *Bally*- which would explain why the scribes of forms 6 and 11 (which lack the element *Bally*-) have failed to recognize that the place-name originally began with a vowel and written the initial letter as *s*. The most satisfactory Irish form of the place-name is *Easca Leathan* "broad bog or marsh". The rendition of the first vowel of *easca* as [ɛ:] in the local pronunciation is in keeping with the tendency for *ea* before *d, s* and *g* to be raised to a mid-front vowel in East Ulster Irish (Holmer 1940, 76). In form 13b, the name of this town-land has been accidentally compounded with that of the nearby townland of **Half Umry** in the parish of Antrim. There is now no bog in Eskylane, but the *OS 6-inch* map of 1933 marks a small bog on its eastern boundary. As well as signifying "wet, sedgy bog", *easca* can also denote "depression, hollow" (*Ó Dónaill* sv.) but since there is no conspicuous hollow in the townland this must be regarded as a less likely explanation. The anglicization of Irish *leathan* "broad" as "lane" has been discussed above under the townland of **Magheralane** in the parish of Drummaul.

**Gallanagh**
J 1493

*An Ghallánach*
"the place of standing-stones"

| | | |
|---|---|---|
| 1. Ballinagallany | Inq. Ant. (DK) 45 | 1605 |
| 2. Ballinegallany | Inq. Ant. (DK) 49 | 1605 |
| 3. Ballinagallany | CPR Jas I 93a | 1606 |
| 4. Ballinagallany | Lodge RR Jas I i 252 | 1606 |

| | | |
|---|---|---|
| 5. Ballegallenaghe | Inq. Ult. (Antrim) §4 Jac. I | 1620 |
| 6. Glanagh | Inq. Ult. (Antrim) §126 Car. I | 1637 |
| 7. Ballynegallanie | Lodge RR Chas I ii 407 | 1637 |
| 8. Ballynegallanagh | BSD 135a | 1661 |
| 9. Ballygallanagh | Lodge RR Chas II i 106 | 1663 |
| 10. Ballinagallon | Lodge RR Chas II i 106 | 1663 |
| 11. Gallanagh | HMR Ant. 140 | 1669 |
| 12. Ballynegallanagh | Comm. Grace 10 | 1684 |
| 13. Ballynegallian al. Ballynegallanagh al. Ballinegallane | Lodge RR Chas II ii 292 | 1684 |
| 14. Ballynegallinagh al. Ballynegallan | Reg. Deeds 10-133-3227 | 1712 |
| 15. Galanagh | Lendrick Map | 1780 |
| 16. Galanagh | Bnd. Sur. | 1826 |
| 17. Galnagh | OSNB A 42 A 10 | 1828 |
| 18. Geal Eanach "white bog" | J O'D (OSNB) A 42 A 10 | 1828 |
| 19. Geal-eanach "white marsh" | Joyce iii 356 | 1913 |
| 20. 'ga:lənəx | Local pronunciation | 1987 |

Although there is an area of bog in the west of the townland, the Irish form which is suggested by both O'Donovan (18) and Joyce (19) i.e. *Geal-eanach* "white bog/marsh" seems unlikely, since the word *eanach* is masc. in Irish, whereas the earliest forms of this place-name suggest a fem. noun. The word *gallán* is found in Scottish Gaelic in the sense of "branch, stalk", as also is the adjectival form *gallánach* "full of boughs or branches" (*Dwelly* sv.), while *gallán mór* in Irish signifies "butterbur" (a daisy-like plant which grows especially in damp places) and *gallán greanchair* signifies "coltsfoot" (*Ó Dónaill* sv.). The name of this townland is clearly derived from the Irish form *An Ghallánach* and one might interpret this as "the place of branches" or, perhaps, "the place of butterburs or coltsfoot". However, in place-names the most commonly attested meaning of *gallán* is "standing-stone/pillar stone", and it seems safer to interpret the name of the townland as "the place of standing stones". A number of the earlier spellings, which display a final *y/ie*, suggest that a form including the element *baile* "townland", i.e. *Baile na Gallánaí* "townland of the place of standing stones" was for a time in use. There is now no trace or record of standing-stones in the townland.

Hill (*MacDonnells Antrim* 136) has identified this townland with *Ballygallantry*, which is mentioned in 1565 as a place where Shane O'Neill of Tyrone rested on his way from Tyrone to the Glens of Antrim, where he later met his fate at the hands of the MacDonnells. However, *Ballygallantry* clearly refers not to Gallanagh but to *Balligalantrim* (*Inq. Ant. (DK)* 44) the name by which the part of the town of Antrim inhabited by the English was formerly known to the native Irish and which is derived from Irish *Gall-Aontroim* i.e. "Foreigners' Antrim".

| **Lisnevanagh** | *Lios Neamhnach(?)* | |
|---|---|---|
| J 1392 | *"Neamhain's fort"* | |
| 1. Ballilissenevenagh | Inq. Ant. (DK) 45 | 1605 |
| 2. Lissnemiagh | Inq. Ant. (DK) 49 | 1605 |
| 3. Ballilylissenuvenagh | CPR Jas I 93a | 1606 |
| 4. Ballilisse:nuvenagh | Lodge RR Jas I i 251 | 1606 |

| | | |
|---|---|---|
| 5. Ballilylisse:nownagh | Lodge RR Jas I i 251 | 1606 |
| 6. Ballelissnawnaghe | Inq. Ult. (Antrim) §4 Jac.I | 1620 |
| 7. Ballylisnenownagh | Lodge RR Chas I i 407 | 1637 |
| 8. Ballylisnenewnagh | BSD 135a | 1661 |
| 9. Ballylisnemounagh | Lodge RR Chas II i 106 | 1663 |
| 10. Lisseninduagh | HMR Ant. 139 | 1669 |
| 11. Ballylislenewnagh | Comm. Grace 10 | 1684 |
| 12. Ballylisnevewnagh | Lodge RR Chas II ii 292 | 1684 |
| 13. Lisnenevena | Forfeit. Estates 365b §58 | 1703 |
| 14. Ballylisnenewnagh | Reg. Deeds 90-171-62470 | 1739 |
| 15. Lisnanevenagh | Belfast News Letter Aug. 24 | 1764 |
| 16. Lisnenevenagh | Lendrick Map | 1780 |
| 17. Lisnevanagh | OSNB A 42 A 10 | 1828 |
| 18. Lios na bhFeathanach "fort of the rushes or reeds" | J O'D (OSNB) A 42 A 10 | 1828 |
| 19. ˌlïs'nɛ:vənə | Local pronunciation | 1987 |

O'Donovan's Irish version i.e. *Lios na bhFeathanach* "fort of the rushes or reeds" (18) is at variance with the local pronunciation which places the stress on the second, rather than on the third, syllable. Moreover, *feathanach* as a word for rushes is not attested in the standard dictionaries. The medial *d* is peculiar to form 10 and is clearly due to a mistranscription. While the first element of the place-name is obviously *lios* "fort", the derivation of the second element is less obvious. A number of the (mainly later) forms show evidence of an extra medial syllable, perhaps suggesting an Irish derivation such as *Lios na nGéibheannach* "fort of the hostages". However, since this form is not suggested by the earliest spellings, the reliability of the later forms is open to question.

Dinneen gives the word *néamhann* signifying "a pearl, a diamond, mother of pearl" (*Dinneen* sv.), and one might consider the Irish form *Lios Néamhainne* "fort of the pearl" or, possibly, *Lios Néamhannach* "pearly (i.e. pebbly?) fort" (see *DIL sv. némannach*). However, the medial *-ow-/-aw-* of forms 5 and 6 and 7 (reproduced as *-ew-* in a number of later forms) suggests that we are in fact dealing with a vocalized form of *eamh* (cf. the earlier forms of **Crankill** <*Creamhchoill* "wild-garlic wood" in the parish of Craigs). The word *neamhain* is attested in the sense of "tormentil" (a common yellow-flowered plant) (*Dinneen* sv.). Dinneen also gives *neamha(i)n* "a royston crow, a raven" and (as a proper noun), the name of a war-goddess (*Dinneen* sv.). The personal name *Neman* (Mod. Ir. *Neamhain*) also appears as a (presumably male) name in an early East Ulster genealogy (*Descendants Ir,* 56). All things considered, the most satisfactory interpretation of the place-name appears to be *Lios Neamhnach* "Neamhain's fort", the final element representing a genitive form of *Neamhain*.

*NISMR* marks four "enclosures" and one "rath" in the townland, the most prominent of these being the latter which is situated on high ground on the border between this townland and the townland of Creevery and is marked **Mount Hilly Rath** on the *OS 1:50,000* map.

| | | |
|---|---|---|
| **Tavnaghmore** | *An Tamhnach Mhór* | |
| J 1296 | "the large field/clearing" | |
| 1. Ballintawnymore | Inq. Ant. (DK) 45 | 1605 |
| 2. Ballymtawnymore | Inq. Ant. (DK) 49 | 1605 |
| 3. Ballintownymore | Lodge RR Jas I i 252 | 1606 |

| | | |
|---|---|---|
| 4. Ballintownymore | CPR Jas I 93a | 1606 |
| 5. Ballitawnihaner | Inq. Ult. (Antrim) §4 Jac. I | 1620 |
| 6. Taughnaghmore | Inq. Ult. (Antrim) §123 Car. I | 1637 |
| 7. Ballytawnymore | Lodge RR Chas I i 407 | 1637 |
| 8. Ballytownemore East | BSD 135a | 1661 |
| 9. Bally-Taunaghmore | Inq. Ult. (Antrim) §8 Car. II | 1662 |
| 10. Bally-Taunaghmore | Lodge RR Chas II i 106 | 1663 |
| 11. Tannaghmore | HMR Ant. 140 | 1669 |
| 12. Ballytawnymore E. | Comm. Grace 10 | 1684 |
| 13. Ballytowmnymore East | Lodge RR Chas II ii 292 | 1684 |
| 14. East Tannaghmore | Reg. Deeds 10-133-3227 | 1712 |
| 15. Tavenaghmore E. al. Ballytaunaghmore E. | Reg. Deeds 88-156-6204 | 1737 |
| 16. Tavanaghmore | Lendrick Map | 1780 |
| 17. Tannaghmore East | Reg. Deeds 660-290-458258 | 1813 |
| 18. Tavanaghmore | Bnd. Sur. | 1826 |
| 19. Tannaghmore | OSNB A 42 A 10 | 1828 |
| 20. Tannaghmore East, or as it is called by the people Tamlaghtmore | O'Laverty iii 295 | 1884 |
| 21. Tamhnach Mór "great field" | J O'D (OSNB) A 42 A 10 | 1828 |
| 22. 'tanəχ'moːr | Local pronunciation | 1987 |

The element *tamhnach* "field/clearing", which is commonly anglicized as *Tawnagh, Tawny, Tavanagh, Tavnagh, Tannagh, Tauna* etc., has been discussed above in connection with the townland of **Tannaghmore** in the parish of Drummaul. All the 17th-century spellings of this place-name suggest that the medial vowel of *tamhnach* was at this time pronounced as [au] and the modern orthography with medial *-v-* is not attested until 1737 (15). In spite of the official spelling, the name of the townland is always pronounced ['tanəχ'moːr], and it is difficult to tell if the form with medial *-v-* reflects an older pronunciation of the place-name or if it has been adopted in order to distinguish this townland from the nearby townland of **Tannaghmore** in the parish of Drummaul. The current local pronunciation does not agree with O'Laverty's statement that the townland is "called by the people *Tamlaghtmore*" (*O'Laverty* iii 295), which would suggest the Irish form *Tamhlacht Mhór* "great (pagan) burial place". Nor do any of the documented versions support this derivation and it is safe to conclude that the true Irish form of the place-name is *An Tamhnach Mhór* "the large field/clearing".

## Tobernaveen
J 1692

*Tobar na bhFiann*
"well of the *Fianna*"

| | | |
|---|---|---|
| 1. Aghetobber | Lodge RR Chas II i 407 | 1637 |
| 2. a fountaine or well called Tobbernaume | Civ. Surv. x §64b | 1655c |
| 3. the great spring well called Tobbernavein | Civ. Surv. x §65b | 1655c |
| 4. half-town of Aghatobber al. Tobbernevine | BSD 135a | 1661 |

| | | |
|---|---|---|
| 5. Aghetobber ½ tl. | Lodge RR Chas II i 106 | 1663 |
| 6. (?)Tobbernevaran | HMR Ant. 117 | 1669 |
| 7. half of Aghtober al. Tobernevine | RR Chas II ii 292 | 1684 |
| 8. Tobernevyne | Reg. Deeds 10-133-3227 | 1712 |
| 9. Tobernameene | Lodge RR Geo. I & II 35 | 1715 |
| 10. Tobernameene | Reg. Deeds 18-214-18870 | 1716 |
| 11. Aghtober al. Tobernevine | Reg. Deeds 90-171-62470 | 1739 |
| 12. Tobernanean | Belfast News Letter Feb. 3 | 1758 |
| 13. Tobernaveen | Lendrick Map | 1780 |
| 14. Tobernaveen | Reg. Deeds 392-313-259014 | 1787 |
| 15. Tobernameen | Bnd. Sur. | 1826 |
| 16. Tobernameen | OSNB A 42 A 10 | 1828 |
| 17. Tobernaveen | OS Name Sheets (J O'D) | 1830 |
| 18. Tobar na Míne "well of smoothness" | J O'D (OSNB) A 42 A 10 | 1828 |
| 19. ˌtoːbərnəˈviːn | Local pronunciation | 1987 |

In form 9 -*m*- is obviously a mistranscription of -*v*-, an error which is duplicated in a number of later spellings and has led O'Donovan to suggest the mistaken derivation *Tobar na Míne* "well of smoothness" (17). The spelling of the final element in form 6 is at variance with all the other documented versions and is obviously corrupt; the placing of Tobernaveen in the neighbouring barony of Antrim in this source appears to be the result of an error, rather than an indication that Tobernaveen was at that time in the barony of Antrim. The well which has given rise to the place-name is a large and well-known spring which rises in the south of the townland and is powerful enough to supply the water reservoir in the townland of **Potterswalls,** north of the town of Antrim. In c. 1655 it is referred as "a fontaine or well called *Tobbernaume*" (2) and "the great spring well called *Tobbernavein*" (3).

Many of the earlier documented versions record the name of the townland as *Aghetobber*, suggesting the Irish form *Achadh an Tobair* "field of the well". This version of the place-name clearly refers to the townland rather than to the well itself, though the element *achadh* "field" has not survived to the present day.

The *Fianna* were the warrior band led by Finn McCool. No doubt the final element of the place-name has its origin in a story or legend connecting the legendary 3rd-century hero and his soldiers with the well. There is now no local folklore to explain the origin of the place-name. However, the *Ordnance Survey Memoir* of 1838 refers to a tradition that the Fenian character Ossian was associated with the nearby valley of the Six Mile Water (*OSM* xxix 30), while Colgan, writing in 1647, remarks that the Braid Valley, east of Ballymena, was in ancient times known by the name of *Gleann-fada-na-feine* i.e. "the long valley of the *Fianna*" (*Trias Thaum.* 183 col. 1n). The name of the townland of **Drumfane** in the parish of Kirkinriola is derived from Irish *Dún Fiann* "fort of the *Fianna*".

### OTHER NAMES

**Bruce's Hill**
J 1494

An English form

| | | |
|---|---|---|
| 1. ˌbrusəz ˈhil | Local pronunciation | 1987 |

This is a hill of approximately 400 feet in the north-east corner of the townland of Edenvale. According to O'Laverty, it was named as being the vantage point from which Edward Bruce,

brother of the Scottish king Robert Bruce, attacked and gained possession of the monastic city of Connor in 1315 after his invasion of Ireland. O'Laverty also informs us that in his day it was more generally known as "Ingram's Hill", from a blacksmith of that name who lived on it (*O'Laverty* iii 282).

| **Mount Hilly (Rath)** | Of uncertain origin |
|---|---|
| J 1492 | |

This is the name of a circular fort on top of a conspicuous little hill on the boundary between the townlands of Lisnevanagh and Creevery. The origin of the name is obscure. One might suggest a form such as *Muine an Choiligh* "hill (or thicket) of the cock (i.e. woodcock)", but in the absence of further evidence this proposal has to be regarded as speculative.

| **Scroggystown** | An English form | |
|---|---|---|
| J 1494 | | |
| | | |
| 1. 'skrɔːgiz ˌtəun | Local pronunciation | 1987 |

This is a small hamlet in the townland of **Edenvale**. The *OSRNB* of c. 1858 (sheet 44) remarks that it was named from a former occupier called John Scroggy. According to Black (1946, 716), the Scottish surname Scroggie has its origin in the name of the village of Scroggie in Perthshire.

## Parish of Ahoghill
Barony of Toome Lower (some townlands in Toome Upper and one in Antrim Lower)

| *Townlands* | Brocklamont | Killane | *Towns* |
|---|---|---|---|
| Aughterclooney | Cardonaghy | Leymore | Ahoghill |
| (Toome Upper) | Carmacmoin | Limnaharry | Galgorm |
| Ballybeg | Carnearney | Lismurnaghan | |
| Ballybollen (Toome | Carniny | Lisnafillon | *Village* |
| Upper, shared with | Corbally | Moneydollog | Gracehill |
| Drummaul) | Craignageeragh | Moyasset | |
| Ballykennedy | Drumramer (Toome | Straid (Toome Upper) | |
| Ballyloughan | Upper) | Tullaghgarley (Antrim | |
| Ballylummin | Galgorm | Lower, shared with | |
| Ballyminstra (Toome | Galgorm Parks | Connor) | |
| Upper) | Glebe (Toome Upper) | Tullygowan | |
| Ballymontenagh | Glenhugh | | |
| (Toome Upper) | Gloonan | | |

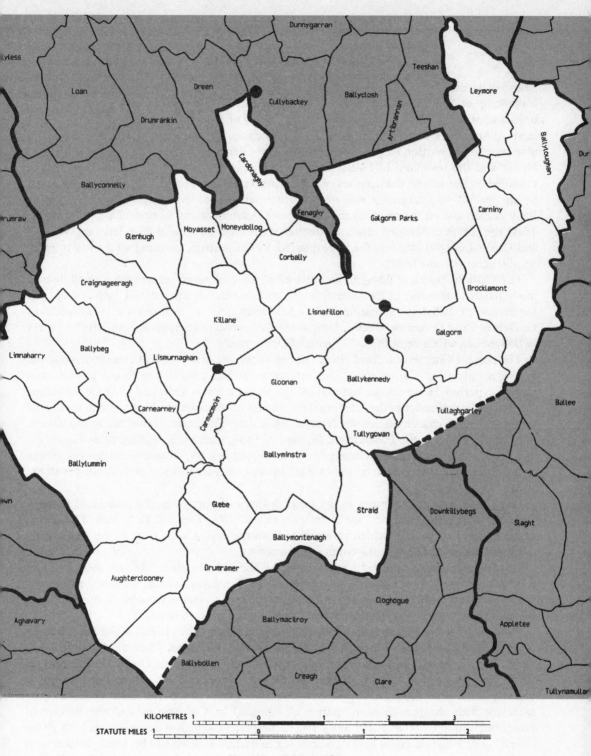

**Parish of Ahoghill**

# BARONY OF TOOME LOWER

## PARISH OF AHOGHILL

The civil parish of Ahoghill covers an area of approximately 12,186 acres (*Census 1871*) and is made up of 29 townlands plus half of the townland of Tullaghgarley and a portion of the townland of Ballybollen. It lies entirely in the barony of Toome Lower, except for the townlands of Aughterclooney, Ballyminstra, Ballymontenagh, Drumramer, Glebe, Straid and the aforementioned portion of the townland of Ballybollen which are in the barony of Toome Upper and the townland of Tullaghgarley which is in the barony of Antrim Lower. It is bounded on the east by the parishes of Kirkinriola (Ballymena) and Ballyclug, on the north by the parish of Craigs, on the west by the parishes of Portglenone and Grange of Ballyscullion and on the south by the parishes of Drummaul and Connor. Up until the year 1840, the parish of Ahoghill also included all of the civil parishes of Portglenone (*EA* 301) and Craigs (*ibid* 89) and was the largest parish in Co. Antrim, covering an area of roughly 35,400 acres (*Census 1851*).

The Catholic parish of Ahoghill includes all of the civil parish, except for a small district immediately to the west of Ballymena. It also contains the civil parish of Craigs, except the townlands of Killyless, Lisnahunshin and Maboy, and it includes the townlands of Casheltown and Drumraw which belong to the civil parish of Portglenone, and the 425 acres of Ballybollen which lie in the civil parish of Drummaul.

The present Church of Ireland church occupies the site of the ancient church of Ahoghill, in the townland of Carmacmoin. No references to the church are found in the early Christian period. However, the fact that the parish church was dedicated to St Colmanellus, the 6th-century founder of the celebrated monastery of Muckamore, suggests that there may well have been a church on this site from an early date. The earliest reference to the church of Ahoghill occurs in the *Ecclesiastical Taxation* of 1306, where it is referred to as *The church of Achochill* and valued at 20 shillings per annum (*Eccles.Tax.* 89). Numerous other references to the church are found in the course of the 14th and 15th centuries, mostly dealing with the succession of its rectors.

In c. 1542, a list of churches in the rural deanery of Turtrye in the diocese of Connor includes "the rectory and vicarage church of *Ahohill*" (*Reg. Dowdall.* §129 268). The extent of the deanery of Turtrye, which was named from the early Gaelic tribe of the *Uí Thuirtre*, has been discussed above in the county introduction.

In 1584, Ahoghill is referred to as *Hoowhohill alias Magharehowell* (*Eccles. Reg.* 35). The form *Magharehowell* is obviously a corruption of *Magherahoghill* which, according to Reeves, was the name by which the parish was frequently known to country people in the middle of the last century (*EA* 88) and this form of the name is discussed below.

On a number of late 16th- and early 17th-century maps the church of Ahoghill is variously marked as *T. Brian Caragh (Jobson's Ulster (BM))*, *T. Carrogh (Bartlett Maps (Esch. Co. Maps; Speed's Ireland)* and simply *Brian Carrogh (Speed's Antrim & Down)*. The latter was *Brian Carragh O'Neill*, whose daughter Anne was the second wife of Shane O'Neill of Shane's Castle and who ruled over a territory on both sides of the river Bann which was co-extensive with the (pre-division) parish of Ahoghill in Co. Antrim and the barony of Loughinsholin in Co. Derry (*EA* 388). The name Brian Carragh is derived from Irish *Brian Carrach*, i.e. "rough-skinned Brian". According to tradition, Brian had his headquarters west of the Bann on a *crannóg* or fortified island in the Green Lough at **Inishrush** near Portglenone (*O'Laverty* iii 373). The prefix *T.* in the above forms represents the Irish word *teampall* "church".

The *Antrim Inquisition* of 1605 refers to the church as "the parish church of *Hawhohill*, a rectorial cure, with endowed vicarage, the presentation of which belongs to the Crown" (*Inq. Ant. (DK)* 45). The *Terrier* of 1615 remarks: "The church of *Hawhochill* hath four townes, Erinoth Lands" (*Terrier (Reeves)* 65). By this is meant that four townlands in the parish were historically the property of the bishop of the diocese, but that they were rented from him by an *erenagh* or lay custodian. The four townlands in question are Carmacmoin, Gloonan, Killane and Lismurnaghan. According to O'Laverty, it is likely that the church lands of Ahoghill passed into the See property in the time of St Colmanellus, Bishop and Abbot of Connor (+611 A.D.), to whom the church was dedicated (*O'Laverty* iii 383). This would explain why Ahoghill is not listed as being an appendage of any monastery at the time of the dissolution of the monasteries under Henry VIII in 1542. The *Ulster Visitation* of 1622 informs us that at that time "the church of *Agohvill*" was decayed (*Ulster Visit. (Reeves)* 254) and the See-lands were set to Ezechiel Davies for 60 years (*ibid.* 241).

An inquisition of 1657 refers to *Magherehoghill* as a rectory consisting of 66 small townlands and remarks: "the church is not in repayre and is seated towards the south of the parish" (*Inq. Par. Ant.* 61). The 66 townlands referred to is the total for the parish before it was divided into the separate parishes of Ahoghill, Portglenone and Craigs, and is very close to today's combined total of 62. The present Church of Ireland church appears to have been built around the year 1700 (*OSM* xxiii 25), though it has undergone major renovations since then.

The earliest source which lists names of townlands in the parish is the aforementioned *Antrim Inquisition* of 1605 (*Inq. Ant. (DK)* 45-6), a full description of which is given in the introduction to the parish of **Drummaul**. The portion of the modern parish of Ahoghill which lies west of the river Main (except for the six-and-a-quarter townlands which are in the barony of Toome Upper) was in the Irish territory of **Muntercallie**, which also included all of the modern parish of Portglenone and the portion of the parish of Craigs which lies west of the Main, except for the townland of Craigs. The small portion of the parish of Ahoghill which lies east of the Main was in the territory of **Clanagherty**, which also comprised the parish of Kirkinriola (Ballymena) and the portion of the parish of Craigs which is east of the river Main (see barony intoduction).

As pointed out above in connection with the parish of **Drummaul**, almost all the land in the baronies of Toome except the territory of Clanagherty was granted by King James I to Shane O'Neill of Shane's Castle in 1606 (*CPR Jas I* 93a-b, 94a; *Lodge RR* Jas I i, 351-3). The names of the townlands in this grant are quite similar to those recorded in the *Antrim Inquisition* of 1605. Of the 22 townlands which are listed as making up the tuogh of Muntercallie, 19 can be identified with modern townlands. Of these, only two, i.e. Ballylummin and Tullygowan, are in the parish of Ahoghill. Fourteen are in the parish of Portglenone, and these can be identified with the modern townlands of Killygarn, Slievenagh, Casheltown, Kilcurry, Mullinsallagh, Gortfad, Bracknamuckley, Lisrodden, Gortgole, Finkiltagh, Killycoogan, Gortaheran, Lisnagarran and Tullynahinnion. A further three townlands, i.e. Ballyconnelly, Moboy and Lisnahunshin, are in the parish of Craigs. The list also includes *Ballichilneskine* and *Ballinamagh* which cannot be identified with modern townlands, and *Ballimoddinossagh* which appears to represent the minor place-name Mullanasock in the townland of Tullynahinnion.

In 1617, the lands which had been granted by King James I to Shane O'Neill in 1606 were granted to his son Henry, and the territory of Muntercallie was renamed the *manor of Carridonnaghie* (*CPR Jas I* 324b), the latter taking its name from the townland of **Cardonaghy** in the parish of Ahoghill. In 1637, the tuogh of Muntercallie was regranted to the same Henry by King Charles I and renamed the *Manor of Cashell* (*Lodge RR* Chas I i 407), after the townland of **Casheltown** in the parish of Portglenone. The names of the

townlands in this grant are quite similar to those of the 1606 grant, except that Gortfad, Lisrodden, Gortaheran and the unidentified *Ballinamagh* are absent from the list, while Carmagrim and Garvaghy in the parish of Portglenone, as well as Killyless, Loan and Drumrankin in the parish of Craigs, are included. The 1637 grant also refers to "the rent of £5 English a year out of 20 townlands in the territory of Largy . . . in the tenure of Edmund Stafford". The *territory of Largy* was an alias name for Muntercallie and the Edmund Stafford referred to was a son of Sir Francis Stafford who was Governor of Ulster in the reign of Queen Elizabeth and who resided at the former Castle of Portglenone. The grant also alludes to "the rent of £10 English a year out of the 4 towns of *Carridonoghy* (i.e. **Cardonaghy**) in the Territory of Largy in the tenure of John Davys".

The same list of townlands is repeated, with minor variations in spellings, in a grant to Cormack O'Neill in 1663 (*Lodge RR* Chas II i 106) in which the Manor of Cashel is given the alias name *Tuogh De Largy*, i.e. the tuogh of **Largy**. In 1684, the same territory was granted to Rose O'Neill, Marchioness of Antrim (*Lodge RR* Chas II ii 292), and the list of townlands is similar to that of the 1663 grant, though the townlands of Moyassett, Moneydollog and Glenhugh in the parish of Ahoghill and Aughnahoy in the parish of Portglenone are added. This grant also refers to "the chiefry of £5" out of Ballynafie, Slievenagh, Mullinsallagh, Drumraw, Garvaghy, Gortfad, Killycoogan, Gortaheran, Aughnacleagh, Finkiltagh, Tullynahinnion, all in the parish of Portglenone; Craignageeragh, Ballybeg, Carnearney, Limnaharry and Ballykennedy in the parish of Ahoghill; and Ballyconnelly in the parish of Craigs. Even though these townlands number only 17 rather than 20, they are obviously the townlands stated in the 1637 grant to be in the tenure of Edmund Stafford. An inquisition of 1662 adds Moyasset, Moneydollog and Glenhugh in the parish of Ahoghill and Aughnahoy in the parish of Portglenone to the list of townlands which were in the possession of Edmund Stafford when he died in 1644 (*Inq. Ult.* §6 Car. II).

The aforementioned 1684 grant to Rose O'Neill refers to "the chiefry of £5" out of Ballylummin, an unidentified townland named *Fersidenemeagh*, and the *Qr. of Glasdruman* (also unidentified) (see **Carnearney** below). These were granted by Henry O'Neill of Shane's Castle to Hugh McLorinan of Ballylummin in 1622 (*Inq. Ult.* §19 Car. I). The "four towns of Cardonaghy", which were in the possession of John Davys in 1637, are identified as Cardonaghy, Corbally, and Lisnafillon in the parish of Ahoghill and the townland of Dreen in the parish of Craigs. This grant to Rose O'Neill is reproduced almost *verbatim* in a document entitled *Abstract of Grants of Lands and other Hereditaments under the Commission of Grace* (*Comm. Grace* 10).

A number of townlands in the territory of Muntercallie which had been sublet to Catholics were forfeited as a result of the rebellion of 1641. An inquisition of 1662 finds that *[(?)Phelemy] Duffe O'Neill* of Gortgole held the townlands of Gortgole, Moboy, Killyless, Drumrankin, Loan and [Lisnahunshin] and forfeited them for his part in the rebellion (*Inq. Ult.* §8 Car. II). Kilcurry in the parish of Portglenone had been granted by Sir Henry O'Neill to *Daniel O'Neill McBryan* and was forfeited by his eldest son Bryan for his part in the rebellion (*Lodge RR* Chas II i 106), while *Toole O'Neile McNeile* forfeited the half townland of Killygarn in similar fashion (*Inq. Ult.* §8 Car. II). However, none of these townlands is shown on Petty's Down Survey maps which show Church townlands and lands forfeited during the Cromwellian period. The only townlands in the parish which are shown are the four Church townlands and a portion of the townland of **Ballybollen** in the tuogh of Munterividy, which was forfeited by "Henry O'Neale, Irish papist" (*DS (Reg.)*).

Only six townlands in the parish of Ahoghill lie east of the river Main, in the territory of Clanagherty, these being Galgorm, Galgorm Parks, Brocklamont, Carniny, Ballyloughan and Leymore. Of these, only Galgorm can be identified with certainty with one of the 21

townlands which are listed as making up the *tuogh of Clinaghartie* in 1605 (*Inq. Ant. (DK)* 45–6). Five of the townland names in the list are now obsolete, namely *Ballichillony, Ballidromleggagh, Ballydromnedarragh, Ballytulline* and *Ballikilly*. It is possible that the modern townland of **Galgorm Parks** represents one of these, or possibly a combination of more than one. Galgorm Parks contains the site of an ancient church (*OSM* xxiii 24), which would lead one to suspect that *Ballikilly* may now form part of that townland, since its name appears to be derived from Irish *Baile na Cille* "townland of the church". The territory of Clanagherty was granted by King James I to Rory Oge MacQuillan in 1607 (*CPR Jas I* 114a; *Lodge RR* Jas I i 300), and the names of the townlands listed in the grant are similar to those in the *Antrim Inquisition* of 1605.

Two inquisitions of 1627 find that at the time of his death in 1626 William Edmonston was in possession of a quarter of each of the townlands granted to Rory Oge MacQuillan in 1607, while William Adair who died in the same year was in possession of half of each of the townlands (*Inq. Ult.* §3, §4 Car. I). The forms of the names of the townlands in these inquisitions are similar, but not identical, to those in the original 1607 grant to MacQuillan. In 1638, Robert Adair, son of the aforesaid William Adair, was granted a large tract of land in the Ballymena area which included most of the parish of Kirkinriola or Ballymena, along with the townlands of Loughmagarry and part of Teeshan in the parish of Craigs. The grant also includes the townlands of Ballyloughan and Leymore in the parish of Ahoghill, as well as most of Brocklamont and the *fourth part of Cerumucke in Carrowdunway* (*Lodge RR* Chas I ii 40). *Cerumucke* appears to represent the modern townland of **Carniny**. In a deed of c.1660, *Cardonaway* is described as "the parcell of land lying nixt to the same" (i.e. Carniny) (*Exch. Deeds & Wills* 595). The name *Carrowdunway* is now obsolete, and in the absence of knowledge of the local pronunciation it is impossible to establish its derivation. This eastern portion of the tuogh of Clanagherty, which was granted to Robert Adair in 1638, was "created the *Manor of Kinhilstowne alias Ballymeanagh*" (*Lodge RR* Chas I ii 40), Kinhilt in Wigtownshire in Scotland being the name of the town from which hailed the aforementioned William Adair who died in 1626. The names of the townlands in this estate are well documented in the Adair Estate Papers (*EP Adair*) which date from the early 17th century until 1905.

The western portion of Clanagharty, consisting of the civil parish of Craigs (except for the townland of Loughmagarry and part of Teeshan), plus the townlands of Galgorm, Galgorm Parks, and the remainder of Carniny and Brocklamont in the parish of Ahoghill, along with the townlands of Carnlea and Tullyreagh in the parish of Kirkinriola and the portion of Tullaghgarley which is in the parish of Ahoghill formed the Galgorm estate, which was later to become the property of the Colville family. An inquisition of 1631 finds that Archibald Edmonston was in possession of the townlands of Galgorm and Carniny in the parish of Ahoghill, as well as Ballyclosh and Teeshan (except ½ quarter) in the parish of Craigs and the unidentified denominations *Ballikille* (possibly part of Galgorm Parks), *Killelea* and *Magherysoske*, the latter being described as a part of Brocklamont (*Inq. Ult.* §11 Car. I).

The *Hearth Money Rolls* for Co. Antrim (1669) list almost all the townlands of the modern parishes of Ahoghill, Portglenone and Craigs, except for that portion of Craigs which lies east of the river Main, in the Galgorm estate. This estate is designated *Ballyconnell wast, Pt. of Glanagherty* and the names of the individual townlands are not given (*HMR Ant.* 159).

The 18th- and 19th-century sources for the study of the place-names of the parish are similar to those for the parish of **Drummaul**. However, as the *Tithe Applotment Book (Tithe Applot.)* for the parish of Ahoghill (1825) is earlier than normal, predating the fixing of the official spellings of the place-names by the Ordnance Survey in c. 1830, forms of the place-names from this source are included when they are judged to be significant.

PARISH NAME

**Ahoghill**                                    *Achadh Eochaille*
                                                "field of the yew-wood'

| | | |
|---|---|---|
| 1. (?)Ratheochuil | Trias Thaum. 183 col. 2n | 1647 |
| 2. Achochill, Ecclesia de | Eccles. Tax. 88 | 1306 |
| 3. Alytrhill | Eccles. Tax. (CDI) 210 | 1306c |
| 4. Athokill, Rectorem parrochialis ecclesie sancti Colmaneli de | Theiner's Vet. Mon. 352 | 1374 |
| 5. Ochohill | EA 257 | 1375 |
| 6. Atholrill, church of St. Colmanell of | Ware (Harris) i 222 | 1376 |
| 7. Ohorhill | Cal. Canc. Hib. (EA) 88 | 1376 |
| 8. Acochill | Cal. Canc. Hib. (EA) 89 | 1376 |
| 9. Atheochailli | Annates Ulst. 134 | 1411 |
| 10. Acheochayll | Annates Ulst. 136 | 1418 |
| 11. Atheocaill | Annates Ulst. 130 | 1429 |
| 12. Athacochaill | Annates Ulst. 131 | 1440 |
| 13. Achioghill | Reg. Prene (EA) 89 | 1441 |
| 14. Atheochtaill | Annates Ulst. 140 | 1456 |
| 15. Gaghowill | Reg. Prene (EA) 89 | 1458 |
| 16. Ahohill, Rect. & Vic. Ec. de | Reg. Dowdall §129 268 | 1542c |
| 17. Hoowhohill al. Magharehowell | Eccles. Reg. 35 | 1584 |
| 18. T:Brian Caragh | Jobson's Ulster (BM) | 1590c |
| 19. T:Carrogh | Bartlett Maps (Esch. Co. Maps) | 1603 |
| 20. Hawhohill, the parish church of | Inq. Ant. (DK) 45 | 1605 |
| 21. Hawhohill | CPR Jas I 78a | 1605 |
| 22. Hawhohill | CPR Jas I 121b | 1608 |
| 23. Acheohill | Jas I to Connor Cath. 262 | 1609 |
| 24. T:Carrogh | Speed's Ireland | 1610 |
| 25. Brian Carrogh | Speed's Antrim & Down | 1610 |
| 26. Hawhochill, Ecclesia de | Terrier (Reeves) 65 | 1615 |
| 27. Ahahill | Terrier (Reeves) 105 | 1615 |
| 28. Aghohill, Quator Vill de | First Fruits Roll (Reeves) | 1616 |
| 29. Aghohill | CPR Jas I 329b | 1617 |
| 30. Howhohill | Inq. Ult. (Antrim) §7 Jac. I | 1621 |
| 31. Magharehowell al. Howhohell | Inq. Ult. (Antrim) §7 Jac. I | 1621 |
| 32. Hawhohell | CPR Jas I 483b | 1621 |
| 33. Hawhohill al. Maherohohill | CPR Jas I 524a | 1621 |
| 34. Hawohill al. Maherhohill | CPR Jas I 524b | 1621 |
| 35. Magharehoghill, lands and Mannor of | Ulster Visit. (Reeves) 241 | 1622 |
| 36. Agohvill, Ecclesia de | Ulster Visit. (Reeves) 254 | 1622 |
| 37. Hawhowill als. Magherohohill | Deed (Clotworthy) | 1627 |
| 38. Aghoghill | Regal Visit. (PROI) 1 | 1634 |
| 39. Aghoghill al. Machararahohill Rectory | Regal Visit. (PROI) 7 | 1634 |
| 40. Maherahohill, the advowson of the Church of | EP Mass. & Ferr. | 1641 |

| | | |
|---|---|---|
| 41. Aheghell, the parish of | Exch. Deeds & Wills 653 | 1644 |
| 42. Magheryhoghill, the church of | Lodge RR Chas II i 371 | 1652 |
| 43. Magherehoghill | Inq. Par. Ant. 61 | 1657 |
| 44. Macharieochill, the Parish of | DS (Par. Map) Ahoghill | 1657c |
| 45. Macharreochill, the Parish of | Hib. Reg. Toome | 1657c |
| 46. Machariochill | BSD 135 | 1661 |
| 47. Aghoghill | Trien. Visit. (Bramhall) 6 | 1661 |
| 48. Maghereoghill | Hib. Del. Antrim | 1672c |
| 49. Aghogill | Trien. Visit. (Boyle) 38 | 1679 |
| 50. Maghrehoghill | Dobbs' Descr. Ant. 386 | 1683 |
| 51. Maghereoghill, a poor Village | Journey to ye North 157 | 1708 |
| 52. Aaghochill | Grand Jury Pres. 12 | 1712 |
| 53. Agheoghill, parish of | Reg. Deeds 53-170-34925 | 1726 |
| 54. Agheoghill or Aghoghill | State Connor | 1765 |
| 55. Ahoghill | Lendrick Map | 1780 |
| 56. Ahoghill | Duff's Lough Neagh | 1785 |
| 57. Magherehill | Mon. Hib. 24 | 1786 |
| 58. Ahoghill | OSNB B 35 B 131 | 1830c |
| 59. Magherahoghill | O'Laverty iii 382 | 1833 |
| 60. Parish of Ahoghill, by the country people frequently called Magherahoghill | EA 88 | 1847 |
| 61. Áth Thuathghail "Toughill's ford" | J O'D (OSNB) B 35 B 131 | 1830c |
| 62. Ath-Eochoille "ford of the yew wood" | Joyce iii 35 | 1913 |
| 63. Áth-Eochaille "ford of the yew wood" | BUPNS ser. I i 42 | 1952 |
| 64. Achadh Eochaille | GÉ 3 | 1989 |
| 65. aˈhɔːxəl | Local pronunciation | 1987 |

The Irish forms *Achadh Eochaille* "field of the yew-wood" and *Áth Eochaille* "ford of the yew-wood" are both reconcilable with the documentary evidence. In favour of the latter is the fact that the site of the ancient church of Ahoghill is only a short distance from a stream known as the Ballyminstra Burn, which divides the baronies of Toome Upper and Lower, and it is possible that the church could have been named from a former ford across the stream. However, Mac Giolla Easpaig (1981, 152) has pointed out that noun-plus-noun compounds (such as *eochaill* "yew-wood") are found in combination with only a very small range of other place-name elements, most notably *droim* "ridge", *cluain* "meadow" and *achadh* "field", all of which themselves occur as elements in the compounds. While the element *áth* "ford" is indeed found in combination with noun-plus-noun compounds in a small number of place-names (including an unidentified place named *Áth Eochaille* "ford of the yew-wood" (*Onom. Goed.* 59)), *achadh* "field" is more widely attested in place-names of this structure and must be regarded as the more likely first element.

Writing c. 1847, Reeves informs us that the parish of Ahoghill is "by the country people frequently called Magherahoghill" (60). This form of the place-name is recorded in a number of sources from the late 16th century onwards and it shows that the name of the parish was sometimes prefixed by the element *machaire* "plain".

There is no certain identification of the name of the parish of Ahoghill in Irish language sources. However, Reeves (*EA* 345) has made a tentative identification of Ahoghill with *Ratheochuil* (Mod. Ir. *Ráth Eochaille* "fort of the yew-wood"), the name of one of four churches referred to in Colgan's *Triadis Thaumaturgae* (1) in 1647 as being in the barony of Antrim. The fact that *Ratheochuil* is stated by Colgan to be in the barony of Antrim appears to immediately rule out its identification with the church of Ahoghill; however, the site of the church of Ahoghill is only a few miles west of the boundary with the barony of Antrim, and it is possible that it could have been mistakenly placed by Colgan in that barony. It is also possible that Colgan may have written the first element of the name of the church as *ráth* "fort" by analogy with the names of the other three churches referred to in his list, all of which have *ráth* as their first element. Given that the final element of Ahoghill is certainly *eochaill* "yew-wood" its identification with Colgan's *Ratheochuil* cannot be ruled out, though the original Irish form of the place-name is most likely *Achadh Eochaille* "field of the yew-wood". In the parish of Kilkeel in Co. Down there is a townland named **Aghyoghill** the name of which is also derived from *Achadh Eochaille* "field of the yew-wood" (*PNI* iii 17).

<div align="center">TOWNLAND NAMES</div>

**Aughterclooney**                         *Uachtar Cluana*
J 0398                                     "upper part of the meadow"

| | | | |
|---|---|---|---|
| 1. | Ballyoughterclony | Inq. Ult. (Antrim) §106 Car. I | 1636 |
| 2. | Ballyaterclony | Lodge RR Chas I i 407 | 1637 |
| 3. | Balleuttercloony | Lodge RR Chas II i 106 | 1663 |
| 4. | The half of Ballybollan al. | | |
| | Uterclony | ASE 96 a 48 | 1665 |
| 5. | Outerclouny | ASE 106 a 1 | 1666 |
| 6. | Waterclooney | HMR Ant. 157 | 1669 |
| 7. | Ballyontarclony | Comm. Grace 10 | 1684 |
| 8. | Ballyouterclony | Lodge RR Chas II ii 292 | 1684 |
| 9. | Ballyoughterclony | Reg. Deeds 10-133-3227 | 1712 |
| 10. | Outercloney | Lendrick Map | 1739 |
| 11. | Aughtercloney | Tithe Applot. | 1825 |
| 12. | Aughtercloonen | Bnd. Sur. (OSNB) | 1829c |
| 13. | Aughtercloney | OSNB B 35 B 131 | 1830c |
| 14. | Watercloney or Aughter-clooney | O'Laverty iii 388 | 1884 |
| 15. | Uachtar na cluaine "upper part | | |
| | of the lawn or meadow' | J O'D (OSNB) B 35 B13 | 1830c |
| 16. | Uachtar-cluaine "the upper part | | |
| | of the *cloon* or meadow" | Joyce iii 55 | 1913 |
| 17. | 'ɔːxtərˈkloːni | Local pronunciation | 1987 |

This is one of the six full townlands in the parish of Ahoghill which are situated in the barony of Toome Upper. In a number of dialects of Ulster Irish *ch* in the combination *cht* is silent (O'Rahilly 1932, 210), a pronunciation which is reflected in the absence of evidence of the *ch* of *uachtar* "upper part", in all the 17th-century forms except form 1. The anglicization of Irish *uachtar* as "water" (6, 14a), is well attested in Irish place-names. For example, the name of the townland of **Ballywatermoy** in the parish of Craigs goes back to Irish *Baile Uachtar*

*Maí* "townland of the upper part of the plain" (see below). Aughterclooney is written *Watercloney* on the disused National School, on which the *OSRNB* of c. 1858 remarks: "This is the general name now in use among the peasantry. Aughterclooney is the ancient name of the townland, but latterly changed to Watercloney". Nowadays, the townland is generally known as simply "Cloney", the first element having gradually dropped out of use through time. The local pronunciation of the place-name reflects the tendency for Irish *ua(i)* to develop to [o:] (see **Artlone** above).

| **Ballybeg** | *An Baile Beag* | |
|---|---|---|
| D 0301 | "the little village/farmstead/townland(?)" | |
| 1. Ballibegg | Inq. Ult. (Antrim) §6 Car. II | 1662 |
| 2. Ballybeg | HMR Ant. 158 | 1669 |
| 3. Ballybegg | Comm. Grace 10 | 1684 |
| 4. Ballybegg | Lodge RR Chas II ii 292 | 1684 |
| 5. Ballybogg | Williamite Forf. | 1690s |
| 6. Ballybog | Indent. (Staff.) | 1692 |
| 7. Ballybegg | Reg. Deeds 10-133-3227 | 1712 |
| 8. Ballybeg | Lendrick Map | 1780 |
| 9. Ballybeg | OSNB B 35 B 131 | 1830c |
| 10. Baile Beag "little town" | J O'D (OSNB) B 35 B 131 | 1830c |
| 11. ˌbali ˈbɛːg | Local pronunciation | 1987 |

The element *baile*, which is most frequently interpreted as "townland", has, in fact, a wide range of meanings, including "a town, a village, a home, a place, a farmstead, a homestead" (*Dinneen* sv.; see also Price 1963, 119–26; Flanagan 1978(b), 8–13). The fact that *baile* in the name of this townland is qualified by the adjective *beag* "small" raises a question as to whether "townland" is in this case the most appropriate interpretation since Ballybeg is roughly equal in size to the Co. Antrim average, and is larger than the neighbouring townlands of Carnearney and Lismurnaghan. If *baile* does in this case signify "townland", then one must conclude that Ballybeg is now larger than it was when the name was coined. However, it is perhaps more likely that *baile* may in this case carry one of its alternative meanings, possibly "village". There is a small hamlet adjacent to Ballybeg National School, and it may mark the site of an older settlement which gave name to the townland. Otherwise, *baile* in this place-name could have the meaning of "homestead" or "farmstead".

| **Ballybollen** (part of) | *Baile na bPollán* | |
|---|---|---|
| J 0397 | "townland of the marshy hollows" | |
| 1. ¼ of Ballenebollan in Macharicochill Parish | BSD 135 | 1661 |
| 2. B:nebolen | Hib. Del. Antrim | 1672c |
| 3. ¼ Ballybollan | Tithe Applot. | 1825 |
| 4. Ballybolan | Bnd. Sur. (OSNB) | 1829c |
| 5. Ballybollen | OSNB B 35 B 131 | 1830c |
| 6. Baile Balláin "town of the spring well" | J O'D (OSNB) B 35 B 131 | 1830c |

see **Ballybollen**, parish of **Drummaul**.

**Ballykennedy**
D 0701

*Baile Uí Chinnéide*
"O'Kennedy's townland"

| | | |
|---|---|---|
| 1. Ballynekenndish al. Tullycarnune | Inq. Ult. (Antrim) §6 Car. II | 1662 |
| 2. Kennedys | HMR Ant. 159 | 1669 |
| 3. Ballykenautis | Comm. Grace 10 | 1684 |
| 4. Ballykenantis | Lodge RR Chas II ii 292 | 1684 |
| 5. Ballykennedys | Indent. (Staff.) | 1692 |
| 6. Ballykenanties | Reg. Deeds 10-133-3227 | 1712 |
| 7. Ballykennedys | Reg. Deeds 30-26-16158 | 1720 |
| 8. Ballykenedy | Reg. Deeds 40-309-25982 | 1722 |
| 9. Ballykennedy | Lendrick Map | 1780 |
| 10. Ballykenedy | Tithe Applot. | 1825 |
| 11. Ballykennedy | Bnd. Sur. (OSNB) | 1829c |
| 12. Ballykennedy | OSNB B 35 B 131 | 1830c |
| | | |
| 13. Baile Uí Cheinnéide "O'Kennedy's Town" | J O'D (OSNB) B 35 B 131 | 1830c |
| 14. Baile Uí Chinnéide | GÉ 27 | 1989 |
| | | |
| 15. ˌbaliˈkɛːnədi | Local pronunciation | 1987 |

The surname Kennedy can be of either Irish or Scottish origin. In Ireland, the name is derived from *Ó Cinnéide*, an important sept of East Clare, who settled in north Tipperary and thence spread to Wexford, and a branch of whom settled in Co. Antrim at the beginning of the 17th century. The Scottish MacKennedys (who were probably in remote times of Irish O'Kennedy stock) were particularly numerous in Galloway and Ayrshire (Bell 1988, 110–11) and one might suggest that the name could have been brought here by settlers from one of those districts. However, since none of the recorded spellings contain any evidence of the surname particle *Mac*, it is more likely that we are dealing with Irish *Ó Cinnéide* than with Scottish *Mac Cinnéide*. The genitive form of the surname particle *Ó*, i.e. *Uí*, would naturally be lost by being merged with the final vowel of *baile*.

The plural ending of many of the earlier recorded spellings of the place-name suggests that the townland may have been formerly divided into different portions, the whole being referred to collectively as "Ballykennedys". The surname Kennedy/O'Kennedy is well represented in the *Hearth Money Rolls* for Co. Antrim of 1669.

The name *Tullycarnune* (1b) is now unknown in the locality. One might speculate that the second *u* is a scribal error for *a*, and that the name is derived from Irish *Tulaigh Charnáin* "hillock of the little cairn", but in the absence of further evidence, this suggestion must be regarded as tentative.

**Ballyloughan**
D 0906

*Baile an Locháin*
"townland of the little lake"

| | | |
|---|---|---|
| 1. Ballyloughaw | Indent. Adair (MacDonells Ant.) | 1636 |
| 2. Ballyloghane | EP Adair Mar. 12 | 1636 |
| 3. Ballíloghan | Lodge RR Chas I ii 40 | 1638 |
| 4. towne land of Ballylochan | Exch. Deeds & Wills 642 | 1655c |
| 5. Ballyloughan | Inq. Par. Ant. 85 | 1657 |
| 6. Ballytoughan | Inq. Ult. (Antrim) §1 Car. II | 1661 |

| | | |
|---|---|---|
| 7. Ballyloughan | Inq. Ult. (Antrim) §3 Car. II | 1661 |
| 8. Ballyloghan | Lodge RR Geo I & II 67 | 1720 |
| 9. Ballyloghan | Reg. Deeds 245-270-161464 | 1763 |
| 10. Ballyloghin | Lendrick Map | 1780 |
| 11. Ballyloughan | OSNB B 35 B 131 | 1830c |
| 12. Baile Locháin "town of the small lake" | J O'D (OSNB) B 35 B 131 | 1830c |
| 13. ˌbaliˈlɔːxən | Local pronunciation | 1987 |

There is no reason to disagree with O'Donovan's suggestion that the final element of the place-name is derived from *lochán* "small lake" (12). However, the form *Baile an Locháin* "townland of the little lake" appears more likely than *Baile Locháin* which has an identical meaning. While none of the recorded spellings shows any evidence of the definite article *(an)*, in the form *Baile an Locháin* the *-n* of the article could have been lost by assimilation to the initial *l-* of *lochán* while the *a-* would then be merged with the final *-e* of *baile* which would explain the absence of any trace of the article from the historical forms. There is now no trace of a natural lake in the townland. There is a little lake in the "People's Park" in the extreme south-east corner of the townland but this was artificially created by damming the river to form a mill-dam. The *OS 6-inch* map of 1833 shows a large bog in the north-east of the townland and it is possible that this marks the site of a lake at an earlier date.

## Ballylummin
J 0399

Of uncertain origin

| | | |
|---|---|---|
| 1. Ballylunes | Inq. Ant. (DK) 45 | 1605 |
| 2. Ballilymee | Lodge RR Jas I i 253 | 1606 |
| 3. Ballilymee | CPR Jas I 93b | 1606 |
| 4. Ballimunyn | Inq. Ult. (Antrim) §19 Car. I | 1633 |
| 5. (?)Balleliny | Inq. Ult. (Antrim) §19 Car. I | 1633 |
| 6. Ballylymy | Lodge RR Chas I i 407 | 1637 |
| 7. Ballylinny | BSD 135b | 1661 |
| 8. Ballylumny | Lodge RR Chas II i 106 | 1663 |
| 9. Ballyamine | Lodge RR Chas II i 106 | 1663 |
| 10. Ballylyny | EP Edenduffcarrick | 1666 |
| 11. Ballelymy | ASE 106 a 1 | 1666 |
| 12. Ballyloman | HMR Ant. 156 | 1669 |
| 13. Ballylinny | Comm. Grace 10 | 1684 |
| 14. Ballylumine | Comm. Grace 10 | 1684 |
| 15. Ballylinny or Ballylimye | Lodge RR Chas II ii 292 | 1684 |
| 16. Ballylumine | Lodge RR Chas II ii 292 | 1684 |
| 17. Ballylumon | Williamite Forf. | 1690s |
| 18. Ballylumine | Reg. Deeds 10-133-3227 | 1712 |
| 19. Ballylenye | Reg. Deeds 10-133-3227 | 1712 |
| 20. Ballyhimin | Reg. Deeds 30-103-16653 | 1720 |
| 21. Ballylinny | Reg. Deeds 90-171-62470 | 1739 |
| 22. Ballylumine | Reg. Deeds 90-171-62470 | 1739 |
| 23. Ballylummin | Lendrick Map | 1780 |

| | | |
|---|---|---|
| 24. Ballylomine | Reg. Deeds 640-148-438470 | 1811 |
| 25. Ballylummun | Reg. Deeds 660-290-457358 | 1813 |
| 26. Ballylummin (Davelin's) + Ballylummin | Tithe Applot. | 1825 |
| 27. Ballylummin | OSNB B 35 B 131 | 1830c |
| 28. Ballylimnie | Sett. O'Neill Ests (O'Laverty) | 1863 |
| 29. Baile Lomáin "Lomond's town" | J O'D (OSNB) B 35 B 131 | 1830c |
| 30. ˌbaliˈlomən | Local pronunciation | 1987 |

It is difficult to establish a reliable Irish form for the name of this townland. One might suggest that the final element is the common noun *lomán* "a bare, bark-stripped log; a peak, a rock of which only the summit is exposed" (*Dinneen* sv.); "bare, stripped, tree-trunk; pinnacle of rock; outcrop, cropping rock" (*Ó Dónaill* sv.). One could also understand *lomán* as consisting of the adjective *lom* "bare" plus the termination *-án* and having the significance of "bare or exposed place". However, *Lomán* is also attested as a personal name, and was particularly commonly applied to saints (Ó Corráin & Maguire 1981, 124). That the name was in use in this area is attested by the name of the townland of **Artiloman** in the nearby parish of Finvoy in Co. Antrim, which appears to be derived from Irish *Ard Tí Lomáin* "height of Loman's house". One could, then, argue for O'Donovan's Irish form *Baile Lomáin* (29), though this would signify "*Lomán's* townland", rather than "Lomond's town" where "Lomond" appears to represent a surname.

There are a number of difficulties with this derivation. One is that names of early Irish saints are rarely found in combination with *baile* "townland". Even if we concede that in this case *Lomán* may not be a saint's name, it has been noted that personal names found in combination with *baile* tend to be of Norman origin (Price 1963; Flanagan 1978(b)). Another objection to this explanation (and also to the understanding of *lomán* as "rocky outcrop/bare, exposed place") is that it is difficult to reconcile with the earlier recorded spellings, the majority of which end in *-ee* or *-y*. One might suggest that these forms support the Irish form *Baile Luimnigh*, the final element being the genitive form of *Luimneach*, an element of obscure meaning which forms the name of places throughout the country and is variously anglicized as *Limnagh, Lumnagh* and *Luimnagh*, as well as (in the case of the city), *Limerick*. According to Joyce, *loimneach (al. luimneach)* is derived from the adjective *lom* "bare", and signifies "a bare or barren spot of land" (*Joyce* i 49–50). *Baile Luimnigh*, then, might signify "townland of the (?)bare place". However, it is difficult to see how the modern form *Ballylummon* could have developed from this form.

One might consider that the final element of the place-name could represent the surname *Ó Lomáin*, which, according to Woulfe (1923, 587–8), can be anglicized *Loman, Lomand, Lomond* etc. and is "the name of an Ulidian family, once a clan of note, but now scarcely known". This may be the surname intended by O'Donovan in his interpretation of the place-name. Surnames prefixed by *Ó* often have alternative forms including the definite article *an* and with the suffix *-(e)ach* added; for example, a person named *Ó Briain* "O'Brien" could be referred to as *An Brianach*. Thus it could be argued that *Baile an Lománaigh* "O'Loman's townland" is the form suggested by the majority of the earlier recorded spellings. However, while the absence of documentary evidence of the definite article *an* could be accounted for by the assimilation of the *-n* to the initial *l-* of *Lománaigh* and the merging of the *a-* with the final *-e* of *baile*, it is difficult to see how the final *-aigh* of *Lománaigh* would have totally disappeared in the modern version of the place-name. The origin of the name of the townland therefore remains obscure.

**Ballyminstra**                          *Baile Mainistreach*
D 0600                                    "townland of the monastery"

| | | |
|---|---|---|
| 1. Ballimonastragh | Inq. Ant. (DK) 45 | 1605 |
| 2. the stream Owenmonastragh | Inq. Ant. (DK) 45 | 1605 |
| 3. the river Owen-Monastragh | CPR Jas I 93b | 1606 |
| 4. Towne of Ballemonestragh . . . a Gleabb being part of the town of | Inq. Par. Ant. 61 | 1657 |
| 5. Ballimonistragh | HMR Ant. 156 | 1669 |
| 6. Ballymonistra | Comm. Grace 10 | 1684 |
| 7. Ballymonistragh | Lodge RR Chas II ii 292 | 1684 |
| 8. Ballymonstragh | O'Laverty iii 397 | 1704 |
| 9. Ballyminstragh bridge | Grand Jury Pres. 10 | 1712 |
| 10. Ballymonistragh | Reg. Deeds 10-133-3227 | 1712 |
| 11. Ballymonistragh | Reg. Deeds 90-171-62470 | 1739 |
| 12. Ballyministra | Lendrick Map | 1780 |
| 13. Ballyminestra | Tithe Applot. | 1825 |
| 14. Ballymenistra | OSNB B 35 B 131 | 1830c |
| 15. Baile mainistreach "town of the monastery" | J O'D (OSNB) B 35 B 131 | 1830c |
| 16. "the town of the monastery" | Joyce ii 234 | 1875 |
| 17. Baile Mainistreach; Ballyminstra in Co. Antrim | Onom. Goed. 83 | 1910 |
| 18. ˌbaliˈmïnstrə | Local pronunciation | 1987 |

This is one of the six full townlands of the parish of Ahoghill which lie in the barony of Toome Upper. The name of the townland has been correctly interpreted as *Baile Mainistreach* "townland of the monastery" (15, 16). In all the recorded spellings up to the year 1712, the first vowel of the final element is represented as *o*, rather than *i*, which appears to reflect the tendency for short *ai* after a labial consonant to be pronounced [ɔ] in the Irish of East Ulster (Holmer 1940, 75). The forms *Owenmonastragh* (2) and *Owen-Monastragh* (3) obviously represent Irish *Abhainn Mainistreach* "the river of the monastery", and refer to the stream (now known as the Ballyminstra Burn) which forms the northern boundary of the townland and divides the baronies of Toome Upper and Lower.

There is now no trace, record or tradition of a monastery in the townland. O'Laverty comments: "It is probable that there is the site of some ecclesiastical building in the townland of Ballyministra, though every effort to discover it has hitherto failed" (*O'Laverty* iii 383). One is tempted to suggest that the element *mainistir* "monastery" in the place-name could in fact refer to the nearby site of the ancient parish church of Ahoghill. Flanagan (1979(a), 4) has pointed out that *mainistir* normally refers to a monastery founded after the 12th-century reform of the Irish church, though it gradually came to be applied also to reformed native monasteries which had been founded at an earlier period. Like most early Irish churches, the church of Ahoghill was no doubt formerly monastic in character, and one might argue that the name *Baile Mainistreach* "townland of the monastery" could have been coined in the post-12th century period, to refer to land belonging to the reformed monastery of Ahoghill. However, the church of Ahoghill would have in all likelihood been designated a parish church in the 12th century, and the question is whether the element *mainistir* "monastery" is likely to have been used to refer to a parish church. There is insufficient evidence to enable

a firm conclusion to be drawn. However, the fact that the *Antrim Inquisition* of 1605 informs us that at that time the townland of *Ballimonastragh* (along with another townland the name of which is illegible) belonged to the rector of Ahoghill as glebe (*Inq. Ant. (DK)* 45) points to a link between Ballyminstra and the church of Ahoghill at an earlier period and one feels justified in at least tentatively concluding that the monastery referred to in the final element of the place-name may be the parish church of Ahoghill.

## Ballymontenagh
J 0699

*Baile Móinteánach*
"boggy townland"

| | | |
|---|---|---|
| 1. Ballymundunagh | Lodge RR Chas I i 407 | 1637 |
| 2. Ballymandunagh al. Ballymuntunagh | BSD 135b | 1661 |
| 3. Ballemuntenagh ½ tl. | Lodge RR Chas II i 106 | 1663 |
| 4. ½ of Ballymodinagh al. Ballymuntunagh | Comm. Grace 10 | 1684 |
| 5. Ballymondunagh al. Ballymuntunagh | Lodge RR Chas II ii 292 | 1684 |
| 6. Ballymnuntenagh | Reg. Deeds 10-133-3227 | 1712 |
| 7. Ballymuntenagh | Grand Jury Pres. 53 | 1713 |
| 8. Ballymundunagh als. Ballymuntinagh | Reg. Deeds 90-171-62470 | 1739 |
| 9. Ballymountenagh | Lendrick Map | 1780 |
| 10. Ballymontena | Reg. Deeds 660-290-457358 | 1813 |
| 11. Ballymontena | Tithe Applot. | 1825 |
| 12. Ballymontenagh | Bnd. Sur. | 1829c |
| 13. Ballymontenagh | OSNB B 35 B 131 | 1830c |
| 14. Baile Móinteanach "boggy town" | J O'D (OSNB) B 35 B 131 | 1830c |
| 15. ˌbaliˈmɒntənə | Local pronunciation | 1987 |

This is another of the six townlands of the parish of Ahoghill which lie in the barony of Toome Upper. The most likely Irish form of the place-name appears to be *Baile Móinteánach* "boggy townland", as suggested by O'Donovan (14). A number of the earlier forms show medial *d* rather than *t*. However, it is likely that *d* in form 1 is a mistranscription of *t*, an error which has been duplicated in the later, related, sources. The word *móinteánach* does not appear in the standard dictionaries. However, it is obviously an adjectival form of *móinteán* which is defined as: "land growing rough, coarse herbage; reclaimed moor, peat-land, a bog, turbary" (*Dinneen* sv.); "stretch of bogland, bog, moor" (*Ó Dónaill* sv.). Most of the townland is now under cultivation, but the *OS 6-inch* map of 1833 shows four separate areas of bog within its boundaries.

## Brocklamont
D 1002

*Bruach na Molt*
"bank of the wethers"

| | | |
|---|---|---|
| 1. Braghnamolte | Exch. Deeds & Wills 100 | 1630 |
| 2. Braghnamolt | Inq. Ult. (Antrim) §11 Car. I | 1631 |
| 3. the ¾ of Broghnemalte | Indent. Adair (MacDonnells Ant.) | 1636 |
| 4. the half of Broghmolt | Lodge RR Chas I ii 40 | 1638 |

| | | |
|---|---|---|
| 5. the quarter land of Broghnemollt | Exch. Deeds & Wills 492 | 1656 |
| 6. parcel of Brochmollt | Exch. Deeds & Wills 492 | 1656 |
| 7. the halfe towne of Brockinmolt | Exch. Deeds & Wills 585 | 1660 |
| 8. Broghmolt | Inq. Ult. (Antrim) §1, §3 Car. II | 1661 |
| 9. townland of Burghnemult | EP Adair Sep. 26 | 1683 |
| 10. Brughnemult | Lodge RR Anne 461 | 1705 |
| 11. Brochlemount | EP Adair July 4 | 1709 |
| 12. Broghlimont al. Broghnemolt | Lodge RR Geo I & II 67 | 1720 |
| 13. Brocklimount | Indent. (Colville) | 1720 |
| 14. Braghlamont | Indent. (Colville) | 1720 |
| 15. Brochlemont | Reg. Deeds 43-89-27472 | 1724 |
| 16. Broghlimont al. Broghnemolt | Reg. Deeds 245-270-161474 | 1763 |
| 17. Bruckle Mount | Lendrick Map | 1780 |
| 18. Broclamount | EP Adair Oct. 7 | 1795 |
| 19. farm, formerly called Broccolimount, now called Leghinmore | EP Adair May 21 | 1819 |
| 20. Brocklamount | Tithe Applot. | 1825 |
| 21. Brocklamont | Bnd. Sur. (OSNB) | 1829c |
| 22. Brocklamont | OSNB B 35 B 131 | 1830c |
| | | |
| 23. Broclach "a badger warren, mount is English" | J O'D (OSNB) B 35 B 131 | 1830c |
| 24. Brugh-na-molt "the brugh or dwelling of the wethers" | Joyce ii 305 | 1875 |
| | | |
| 25. 'brɔkləmǫnt | Local pronunciation | 1987 |

Joyce is correct in his interpretation of the final two elements of the place-name as . . . *na Molt* ". . . of the wethers" (24). However, the first element is unlikely to represent *brugh* "dwelling/ mansion". This is a literary term which invariably refers to a place of human, rather than animal, habitation. Moreover, the situation of the townland on the north bank of the river Braid supports the interpretation of the first element as *bruach* "bank/brink/margin", rather than *brugh* "dwelling/mansion". The anglicization of Irish *Bruach na Molt* as "Brocklamont" may be explained by the process of metathesis, the *l* changing places with *n*. O'Donovan's lack of access to earlier forms of the place-name has led him to mistakenly interpret the place-name as Irish *Broclach* "badger-warren", followed by the English element "mount" (23). The place-name has undergone a change of stress as in the Irish form *Bruach na Molt* the main stress would have fallen on the final syllable.

**Cardonaghy**     *Coraidh Uí Dhonnchaidh*
D 0504                "Donaghy's weir or rock"

| | | |
|---|---|---|
| 1. the manor of Carridonnaghie | CPR Jas I 324b | 1617 |
| 2. (?)Carrickmcdonoghie | CPR Jas I 330b | 1617 |
| 3. the four towns of Carridonoghy | Lodge RR Chas I i 407 | 1637 |
| 4. the four townlands of Carrydonchry | Lodge RR Chas II i 105 | 1663 |
| 5. ye four towns of Carrowdonoghie | ASE 106 a 1 | 1666 |

| 6. Brindonohy | HMR Ant. 159 | 1669 |
|---|---|---|
| 7. Carrydonagh | Comm. Grace 10 | 1684 |
| 8. 4 townlands of Carighdonaghy, viz. Carrydonaghy or Cordonnagh ... | Lodge RR Chas II ii 292 | 1684 |
| 9. Cardonaghy | Williamite Forf. | 1690s |
| 10. Careydonoghy | Reg. Deeds 10-133-3227 | 1712 |
| 11. Carydonaghy | Reg. Deeds 90-171-62470 | 1739 |
| 12. Cardonnaghy | Lendrick Map | 1780 |
| 13. Carrdonaghy | Reg. Deeds 640-148-438470 | 1811 |
| 14. Cardonaghy | Tithe Applot. | 1825 |
| 15. Cardonagh | Bnd. Sur. (OSNB) | 1829c |
| 16. Cardonaghy | OSNB B 35 B 131 | 1830c |
| 17. Carn (or Car) Donnchadha "Donagh's round hill or pit (or perhaps carn)" | J O'D (OSNB) B 35 B 131 | 1830c |
| 18. Donaghy's quarter | Joyce iii 164 | 1913 |
| 19. ˌkɑrˈdɔnəxi | Local pronunciation | 1987 |

Form 5 appears to provide support for Joyce's interpretation of the first element of the place-name as *ceathrú* "quarter" (18), since *carrow* is one of the recognized anglicized forms of Irish *ceathrú* (*Joyce* i 244). However, while this suggestion cannot be ruled out, it must be treated with some caution, since the orthography *carrow* is unique to form 5 and it is known that the editor of this source had a tendency to standardize spellings of place-name elements. The fact that the townland is situated on the bank of the river Main seems to render it more likely that the first element is derived from *coraidh*, a variant form of *cora* "weir, rocky crossing place in river" (*Ó Dónaill* sv.). *Cora* is a common element in place-names which in the north of Ireland is commonly anglicized *carry* and is found in the names of the townlands of **Knocknacarry** near Cushendun (Ir. *Cnoc na Cora* "hill of the rocky ford" (*GÉ* 71)) and **Ballycarry** near Larne (Ir. *Baile Cora* "townland of the rocky ford" (*GÉ* 17)). The OS 6-inch map of 1858 marks "stepping stones" across the river at the southern extremity of the townland of Cardonaghy and it is possible that this marks the site of a much earlier crossing-place.

The word *coraidh* may also signify simply "rock", a sense in which it is attested in the Irish of Tory Island (Hamilton 1974, 259). It could be argued, therefore, that the first element of the place-name could have its origin in a large and prominent rock (or possibly a cairn?), no trace of which now remains. Form 2 suggests that the place-name is derived from Irish *Carraig Mhic Dhonnchaidh* "Donaghy's rock". The surname *Mac Donnchaidh* is a variant in Tyrone and Derry of MacDonagh and is anglicized as Donaghy (MacLysaght 1985, 85). However, none of the other historical forms support this derivation and it can hardly be regarded as conclusive evidence. The weight of the documentary evidence favours the interpretation of the final element of the place-name as deriving from *Ó Donnchaidh*, a surname which is also anglicized as "Donaghy" and which is now common in all parts of Ireland (Woulfe 1923, 503-4). *Coraidh Uí Dhonnchaidh* "Donaghy's weir or rock" is therefore put forward as the most satisfactory interpretation of the place-name, though *Ceathrú Uí Dhonnchaidh* "Donaghy's Quarter" cannot be entirely ruled out.

The form *Brindonohy* (6) may suggest that *bruion* "fairy fort" at one time formed an alternative first element of the place-name but, since this spelling is unsupported by the other historical forms, this suggestion must be regarded as extremely tentative.

**Carmacmoin**
D 0401

*Carn Mic Mhuáin(?)*
"cairn of the son of *Muán*"

| | | |
|---|---|---|
| 1. Carrinmackmoyne | DS (Reg.) | 1657c |
| 2. Carinmcmoyne | Hib. Reg. Toome | 1657c |
| 3. Carin mc:Moyne | BSD 135 | 1661 |
| 4. Cormc Moyne | HMR Ant. 158 | 1669 |
| 5. Carrick mc:moyne | BSD (Head.) | 1680c |
| 6. Cornit Mc Moon | Lendrick Map | 1780 |
| 7. Carmacmoin | Bnd. Sur. (OSNB) | 1829c |
| 8. Carmacmoin | OSNB B 35 B 131 | 1830c |
| 9. Carn mic Mudháin "Mac Moin's carn or heap" | J O'D (OSNB) B 35 B 131 | 1830c |
| 10. ˌkɑrmək'mɔin | Local pronunciation | 1987 |

This was one of the four Church townlands of the parish of Ahoghill, and recorded spellings of the place-name are accordingly fewer than normal. However, the weight of the available evidence suggests that the first element of the place-name is likely to be *carn* "a cairn" as suggested by O'Donovan (9). O'Donovan's suggestion that the final element is the surname *Mac Mudháin* (Stand. Ir. *Mac Muáin*) "Mac Moin" is worthy of consideration. The surname *Mac Muáin* appears to be otherwise unattested, but it is not uncommon for obscure surnames to occur in place-names. Otherwise, one might argue that the final element of the place-name is an unusual anglicization of a well-attested surname. The surname *Ó Mocháin*, which can be anglicized as *Mohan, Moan* and *Moen*, is common in Monaghan and Fermanagh (Bell 1988, 193). In surnames, variation between forms in *Ó* and *Mac* is not uncommon, and it would not be surprising if *Mac Mocháin* were found as a variant of *Ó Mocháin*.

Nonetheless, it must be borne in mind that the presence of *mac* in a place-name is not necessarily evidence of a surname. Place-names containing the element *carn* "cairn' are often of some antiquity, and it would be no great surprise if this townland name predated the beginning of the system of surnames in the 10th century. It is just as likely, then, that the place-name is made up of *carn* plus a form of *mac* "son of" plus a personal name. One might suggest it derives from *Carn Mic Mhaoin* "cairn of the son of *Maon*". According to Ó Corráin & Maguire (1981, 131), *Maon* (O. Ir. *Máen*) occurs in the earliest mythology as a god-name, but is more frequently a female name in the legendary material. *Máen* was daughter of Conn of the Hundred Battles, while another *Máen* was daughter of the king of Ulaid and mother of the legendary judge Morann. It is also possible that the final element of the place-name is the personal name *Muán*, which is the basis of the afore-mentioned (unattested) surname *Mac Muáin* and which forms the final element of the name of the parish of **Ramoan** in Co. Antrim (*EA* 79). On the basis of the available evidence, it is impossible to tell which of these personal names is represented in our place-name. The fact that the final element is represented as *Moon* in form 6 may tilt the balance in favour of *Muán*, but one cannot reach a definite verdict on the basis of this one form.

It is worth noting that an individual named "Moyn McConnell" is recorded as residing in the nearby townland of Finkiltagh in the parish of Portglenone in 1669 (*HMR Ant.* 154).

| **Carnearney** | *Carn Fhearaigh(?)* | |
|---|---|---|
| D 0400 | "Farry's cairn" | |

| 1. | Carnary | HMR Ant. 158 | 1669 |
|---|---|---|---|
| 2. | Cornary | Lodge RR Chas II ii 292 | 1684 |
| 3. | Carnary | Indent. (Staff.) | 1692 |
| 4. | Cornary | Reg. Deeds 10-133-3227 | 1712 |
| 5. | Carnary | Reg. Deeds 30-26-16158 | 1720 |
| 6. | Cornary | Reg. Deeds 90-171-62470 | 1739 |
| 7. | Carnary | Belfast News Letter Feb. 7 | 1758 |
| 8. | Carnerny | Lendrick Map | 1780 |
| 9. | Carnearney | Tithe Applot. | 1825 |
| 10. | Carncarney | Bnd. Sur. (OSNB) | 1829c |
| 11. | Carnearney | OSNB B 35 B 131 | 1830c |

| 12. | Carn Eireann "Erin's carn or monumental heap" | J O'D (OSNB) B 35 B 131 | 1830c |
|---|---|---|---|
| 13. | Carn-Ereann "Eire's monumental mound" | Joyce i 110 | 1869 |
| 14. | "the land of the fairy-mound of Erna" | O'Laverty iii 387 | 1884 |

| 15. | ˌkɑrˈneːrni | Local pronunciation | 1987 |
|---|---|---|---|

O'Laverty has identified Carnearney with a townland whose name appears as *Tersidernagh* in the *Deed of Settlement of the O'Neill Estates* in 1863 and as *Ballydumanameagh* in an inquisition of 1622 (*O'Laverty* iii 387). The name of this townland is written *Fersidenemeagh* in 1684 (*Lodge RR* Chas II ii 292). O'Laverty interprets the name as "the land of the fairy-mound of Erna", obviously understanding it to be derived from Irish *Tír Sí(dhe) Eirne* and perceiving a linguistic connection between this form and the modern form of the place-name *(ibid.)*. However, this appears unlikely since Carnearney was clearly one of the "Stafford" townlands whereas both *Fersidenemeagh* and the *Qr. of Glasdruman* were granted by Henry O'Neill of Shane's Castle to Hugh McLorinan of Ballylummin in 1622 (*Inq. Ult.* §19 Car. I) (see parish introduction). It is perhaps more likely that *Fersidemeagh* and the *Qr. of Glasdruman* have now been incorporated in the very large townland of **Ballylummin**.

O'Donovan's Irish form of Carnearney, i.e. *Carn Eireann* "Erin's carn or monumental heap" (12) is not supported by the recorded spellings, none of which show any evidence of the modern second -*n*- until 1780 (8). While *n* in the combination *rn* sometimes disappears due to scribal error, in this case forms lacking the second *n* appear too consistent to be attributed to this cause. A more satisfactory interpretation of the place-name is therefore *Carn Fhearaigh* "Farry's cairn". According to Ó Corráin & Maguire (1981, 96), *Fearadhach* (*>Fearaíoch*) was a fairly common personal name throughout early medieval Ireland and was first anglicized as *Farreagh* and later latinized *Fergus* and *Fergusius*. It was also anglicized as *Frederick, Ferdinand* and *Farry*. The personal name *Fearaíoch* also appears to form the final element of the name of the townland of **Aghavary** in the parish of Grange of Ballyscullion. In the townland of Carnearney there was formerly a cairn, or moat, which was destroyed in 1828 (*O'Laverty* iii 387), and which is marked as "mound (site of)" by *NISMR* and it is quite likely that the place-name has its origin in this feature.

Hogan suggests that both the name of this townland and the name of the townland of **Carnearny** in the parish of Connor are derived from the Irish form *Carn Érenn*, the final element being the genitive form of *Ériu* who was "daughter of Eacha Saillne of Ethach

174

Tuatha of Dalnaraidi" (*Onom. Goed.* 160). Hogan's form *Carn Érenn* is taken from the *Annals of the Four Masters* and is referred to in 912 A.D. as the site of a battle in which *Loingsech Ó Leathlobhair*, lord of Dál nAraide, was defeated for the second time by Niall, son of *Aodh Finnliath*, King of Ailech, having already been defeated by the same prince at the Ravel Water (*AFM* ii 584), a river to the north of Ballymena. Reeves points out that "the hill of Carnearny, in the parish of Connor, is called *Carneirin* in the Inquisition of 1605" (*EA* 341) and there is no doubt that it was this place, rather than Carnearney in Ahoghill, which was the site of the battle. The historical form *Carneirin* referred to by Reeves could support the interpretation of Carnearny in the parish of Connor as *Carn Éireann* "the cairn of *Ériu*". However, this interpretation is clearly not reconcilable with the historical forms of the place-name under consideration. It is possible that the modern form of Carnearney grew up by analogy with the name of the better-known townland and mountain of Carnearny in the parish of Connor.

**Carniny**                                  *Carn Fhainche*
D 0904                                       *"Fainche's cairn"*

| | | |
|---|---|---|
| 1. Carncunkey | Exch. Deeds & Wills 100 | 1630 |
| 2. Carnunkey | Inq. Ult. (Antrim) §11 Car. I | 1631 |
| 3. Cormunkey | Inq. Ult. (Antrim) §11 Car. I | 1631 |
| 4. the ¼ of Garmenicke | Indent. Adair (MacDonnells Ant.) | 1636 |
| 5. Caninecke | EP Adair Mar. 12 | 1636 |
| 6. the fourth part of Cerumucke in Carrowdunway | Lodge RR Chas I ii 40 | 1638 |
| 7. Carmcninck | EP Adair Mar. 11 | 1644 |
| 8. the quarter of Carnevricke | Inq. Par. Ant. 85 | 1657 |
| 9. the Quarter Land of Cormuck | Exch. Deeds & Wills 585 | 1660c |
| 10. the Quarter Land of Carmunck | Exch. Deeds & Wills 585 | 1660c |
| 11. Carninny | EP Adair Dec. 6 | 1681 |
| 12. Carninuke | EP Adair June 27 | 1683 |
| 13. Carminick | Lodge RR Anne 461 | 1705 |
| 14. Carniny al. Carnenick | Reg. Deeds 28-358-17871 | 1720 |
| 15. Corninick | Reg. Deeds 28-358-17871 | 1720 |
| 16. One Quarter of Carmacky | Reg. Deeds 28-358-17871 | 1720 |
| 17. Caruniny al. Carnenick | Lodge RR Geo I & II 67 | 1720 |
| 18. One quarter of Carmacky | Lodge RR Geo I & II 67 | 1720 |
| 19. Corimuck | Lodge RR Geo I & II 67 | 1720 |
| 20. Carninick | EP Adair Feb. 1 | 1722 |
| 21. Carumeny orw. Carnumnick | Reg. Deeds 245-270-161474 | 1763 |
| 22. Corminick | Reg. Deeds 245-270-161474 | 1763 |
| 23. Carninny | Lendrick Map | 1780 |
| 24. Carniny | Tithe Applot. | 1825 |
| 25. Carniny | Bnd. Sur. (OSNB) | 1829c |
| 26. Carniny | OSNB B 35 B 131 | 1830c |
| 27. Carn Eithne "Eithne's Carn or sepulchral or monumental heap of stones" | J O'D (OSNB) B 35 B 131 | 1830c |
| 28. ˌkarˈnïni | Local pronunciation | 1987 |

A large number of the earlier recorded spellings appear to suggest an Irish form such as *Carn Fhionnóg* "cairn of the scald crows". Final voiced consonants are often devoiced in the process of anglicization. For example, the Irish word *bonnóg* "cake of bread" is anglicized "bannock". The form *Carn Fhionnóg* could be understood as a dative form, which would explain the otherwise irregular lenition of the initial *f* of the final element after the masculine noun *carn*. However, the problem with this interpretation of the place-name is that it is highly unlikely that the final *k* would have developed to *y* as in the modern form of the place-name. A more plausible suggestion is therefore that the place-name is derived from Irish *Carn Fhainche* "*Fainche*'s cairn" and that *-ick(e)* in the earlier forms is a misreading of *-ich(e)* which may be an attempt to convey the final *-che* of *Fainche*. The personal name *Fainche* (O. Ir. *Fuinche*) which is sometimes anglicized "Fanny", signifies "a scald crow" and was probably another name for the Irish goddess of war. There are also 14 saints so-named (Ó Corráin & Maguire 1981, 107–8). O'Donovan's interpretation of this place-name as *Carn Eithne* "Eithne's cairn" (27) is not supported by the earlier historical forms.

| **Corbally** | *An Corrbhaile* | |
| D 0603 | "the prominent townland/farmstead(?)" | |
| | | |
| 1. Corbally | Comm. Grace 10 | 1684 |
| 2. Corbally | Lodge RR Chas II ii 292 | 1684 |
| 3. Corbally | Reg. Deeds 10-133-3227 | 1712 |
| 4. Corbilly | Reg. Deeds 29-160-16654 | 1720 |
| 5. Corbolly | Reg. Deeds 30-103-16653 | 1720 |
| 6. Corbilly | Lendrick Map | 1780 |
| 7. Corbilly | Tithe Applot. | 1825 |
| 8. Corbally | Bnd. Sur. (OSNB) | 1829c |
| 9. Corbally | OSNB B 35 B 131 | 1830c |
| | | |
| 10. Corrbhaile "odd town" | J O'D (OSNB) B 35 B 131 | 1830c |
| 11. Cor-bhaile "odd town" | Joyce iii 253 | 1913 |
| | | |
| 12. 'kɔːrbali | Local pronunciation | 1987 |

The recorded spellings of the name of this townland are quite uniform and there is no doubt that the name is derived from Irish *An Corrbhaile*, as suggested by O'Donovan (10) and Joyce (11). The place-name *An Corrbhaile* is very common throughout Ireland where it is almost invariably anglicized as *Corbally*, with delenition of the initial *b* of *-bhaile*, suggesting that the final element of the name was recognized as *baile* and anglicized accordingly. According to Joyce, the significance of *Corrbhaile* is "odd town" (*Joyce* iii, 253). Why this particular townland should have been designated as "odd" is not apparent. However, it should be borne in mind that the element *baile* may originally have been applied to a settlement or farmstead within the townland, rather than to the entire townland unit (see **Ballybeg** above). The element *corr* could possibly signify "odd" in the sense of "prominent" or, perhaps, "remote". Again, since one of the meanings of *corr* is "smooth/rounded", it is possible that *An Corrbhaile* may signify "smooth townland or farmstead", referring to the contours of the land.

| **Craignageeragh** | *Creag na gCaorach* | |
| D 0303 | "rock/rocky ground of the sheep" | |
| | | |
| 1. Ballycreanekeeragh | Inq. Ult. (Antrim) §6 Car. II | 1662 |
| 2. Crayngarragh | HMR Ant. 159 | 1669 |

176

| | | |
|---|---|---|
| 3. Cregnegira | Comm. Grace 10 | 1684 |
| 4. Cregnegire | Lodge RR Chas II ii 292 | 1684 |
| 5. Cregnekeeragh | Indent. (Staff.) | 1692 |
| 6. Creignegira | Reg. Deeds 10-133-3227 | 1712 |
| 7. Cragnegeragh | Reg. Deeds 29-160-16654 | 1720 |
| 8. Cregnekeiragh | Reg. Deeds 30-26-63470 | 1720 |
| 9. Cregnegeeragh al. Cregnekeiragh al. Cregnekiragh | Reg. Deeds 66-434-47346 | 1731 |
| 10. Cregnakeeragh | Reg. Deeds abstracts i §621 | 1736 |
| 11. Cregnegirah | Reg. Deeds 90-171-62470 | 1739 |
| 12. Craignageerah | Lendrick Map | 1780 |
| 13. Craignageragh | Tithe Applot. | 1825 |
| 14. Craignageragh | Bnd. Sur. (OSNB) | 1829c |
| 15. Craignageragh | OSNB B 35 B 131 | 1830c |
| 16. Craignageragh | OS Name Sheets | 1832 |
| 17. Craignageeragh | OS Name Sheets (J O'D) | 1832 |
| 18. Creag na gcaerach "rock of the sheep" | J O'D (OSNB) B 35 B 131 | 1830c |
| 19. ˌkreːgnəˈgiːrəx | Local pronunciation | 1987 |

The name of this townland is clearly derived from Irish *Creag na gCaorach*, "rock/rocky ground of the sheep" as suggested by O'Donovan (18). The representation of the vowel of the first element as *e* in many of the earlier spellings may suggest an oblique form of *creag* i.e. *creig*. However, it is probably safer to accept O'Donovan's *creag*, on the grounds that in East Ulster Irish *ea* was pronounced [ɛ] before *d*, *s* and *g* (Holmer 1940, 76). The word *creig* *(creag)* is defined as "crag; rocky eminence, rock; stony, barren ground; rocky shore" (*Ó Dónaill* sv.). Of these definitions, "stony, barren ground" may in this case be the most appropriate; the *OSNB* (B 35 B 131) of c.1830 describes the townland as "three-quarters cultivated. Remainder is rough, heathery land found in scattered patches . . . soil of very middling quality". The *OS 6-inch* map of 1833 marks a gravel-pit in the townland, which is evidence of rocky soil.

## Drumramer
J 0598

*Droim Ramhar*
"broad ridge"

| | | |
|---|---|---|
| 1. Ballydromraverd | Inq. Ult. (Antrim) §106 Car. I | 1636 |
| 2. Ballydrumraver | Lodge RR Chas I i 407 | 1637 |
| 3. Ballydrumraner | BSD 135b | 1661 |
| 4. Ballydrumravir | Lodge RR Chas II i 106 | 1663 |
| 5. Drumraner | HMR Ant. 156 | 1669 |
| 6. Ballydrumraver | Lodge RR Chas II ii 292 | 1684 |
| 7. Drumraver | Reg. Deeds 10-133-3227 | 1712 |
| 8. Ballydrumraver | Reg. Deeds 90-171-2470 | 1739 |
| 9. Drumraver | Lendrick Map | 1780 |
| 10. Drumramer | Bnd. Sur. (OSNB) | 1829c |
| 11. Drumramer | OSNB B 35 B 131 | 1830c |
| 12. Druim Reamhar "thick or fat ridge" | J O'D (OSNB) B 35 B 131 | 1830c |
| 13. ˌdromˈraːmər | Local pronunciation | 1987 |

This is another of the six full townlands in the parish of Ahoghill which lie in the barony of Toome Upper. The name of the townland is clearly derived from Irish *Droim Ramhar* (<*Druim Reamhar*) "fat/broad ridge", as suggested by O'Donovan (12). The anglicization of Ir. *ramhar* as "ramer" has been discussed above, in connection with the townland of **Muckleramer** in the parish of Drummaul. The word *ramhar* literally signifies "fat", but topographically it is applied most frequently to hills or rocks (*Joyce* ii 419), apparently in the sense of "broad" or "bulky". There is a conspicuous ridge of 300 feet in the middle of the townland, and this seems most likely to be the feature which has given rise to the placename.

| | | | |
|---|---|---|---|
| **Galgorm** | | *Gall Gorm* | |
| D 0802 | | "blue-black rock/castle" | |
| 1. | Gilgorm or Gealgorm Castle | UJA ser. 1 ix 64 | 1569 |
| 2. | Ballystraboy | Inq. Ant. (DK) 64 | 1605 |
| 3. | Ballisraboy or Ballyscaboy or Ballyrasboy | CPR Jas I 114a | 1607 |
| 4. | Ballisraboy or Ballyscaboy or Ballyrasboy | Lodge RR Jas I i 300 | 1607 |
| 5. | Ballesaravoy | Inq. Ult. (Antrim) §3 Car. I | 1627 |
| 6. | Gallgrowne al. Straboy | Exch. Deeds & Wills 100 | 1630 |
| 7. | Galgrom al. Straboy | Inq. Ult. (Antrim) §11 Car. I | 1631 |
| 8. | Gallygorme | EP Adair May 16 | 1656 |
| 9. | Galgorme | Census 7 | 1659 |
| 10. | Galgorme | Dobbs' Descr. Ant. 386 | 1683 |
| 11. | Galgorme | Williamite Forf. | 1690s |
| 12. | Gallgorme | Grand Jury Pres. 1 | 1711 |
| 13. | Gallgorme | Grand Jury Pres. 27 | 1712 |
| 14. | Gilgoran | Indent. (Colville) | 1720 |
| 15. | Galgorum | Indent. (Colville) | 1720 |
| 16. | Manor of Strayboy als. Gal Garn | Indent. (Colville) | 1720 |
| 17. | Galgorm | Reg. Deeds 245-270-161474 | 1763 |
| 18. | Galgorm | Lendrick Map | 1780 |
| 19. | Gillgorum | Taylor & Skinner (Rev.) 18 | 1783 |
| 20. | Gilgorm | Statist. Sur. Ant. 490 | 1812 |
| 21. | Kilgoreem | Trav. New Guide Ire. | 1815 |
| 22. | Galgorm | Bnd. Sur. (OSNB) | 1829c |
| 23. | Galgorm | OSNB B 35 B 131 | 1830c |
| 24. | Geal gorm "bright blue" | J O'D (OSNB) B 35 B 131 | 1830c |
| 25. | Galgorm | GÉ 107 | 1989 |
| 26. | gal'gɔ:rm | Local pronunciation | 1987 |

The earlier forms show that the townland of Galgorm was formerly known as *Ballystraboy* (2), a name which is clearly derived from Irish *Baile (an t)Sratha B(h)uí* "townland of the yellow river-holm", the holm in question being no doubt the flat plain in the angle between the rivers Main and Braid. The origin of the modern name of the townland is not so easily accounted for: O'Donovan's suggestion that the name is derived from Irish *Geal gorm* "bright blue" (24) is hardly convincing.

According to Ó Máille (1989–90, 133), the element *gall*, which commonly means "stone/rock", can be used metaphorically to signify a castle, in the same way as *cloch* "stone" and *carraig* "rock". I would tentatively suggest that the first element of this place-name is *gall*, in this case referring to a castle of the McQuillans which formerly stood in the west of the townland and that the second element is the adjective *gorm* "blue/blue-black", referring to the colour of the rock of the castle. It seems not at all unlikely that the name *Gall Gorm* was originally applied to the castle and gradually came to be applied to the townland, replacing the older name, *Baile (an t)Sratha B(h)uí*. No trace of the castle now remains, and it is not to be confused with the building at present known as Galgorm Castle, which was not constructed until the year 1696 (*OSM* xxiii 12). According to the *Ordnance Survey Memoir*, the older castle was a stronghold of the McQuillans after their expulsion from Dunluce Castle by the MacDonnells and it was burned down in the Rebellion of 1641 but traces of the foundations were still visible in 1835. The *Memoir* also suggests that the castle: "appears to have been built on a danish fort (sic)" (*ibid.* 26). The latter suggestion is borne out by *NISMR* which marks the site as a motte-and-bailey.

### Galgorm Parks
D 0703

A hybrid name

| | | |
|---|---|---|
| 1. manor of Fortesque, with 1000 acres in demesne | CPR Jas I 363b | 1618 |
| 2. Deer Park | Dobbs' Descr. Ant. 388 | 1683 |
| 3. ye Deer Park of Galgorme | Williamite Forf. | 1690s |
| 4. the two Deer Parks containing 1150a. or thereabouts of Galgorm | Lodge RR Geo I & II 67 | 1720 |
| 5. Galgorme Park | Reg. Deeds 53-170-34925 | 1726 |
| 6. Deer Park | Lendrick Map | 1780 |
| 7. Galgorm Parks | Bnd. Sur. (OSNB) | 1829c |
| 8. Galgorm Parks | OSNB B 35 B 131 | 1830c |
| 9. the Deerpark of Galgorm, now called Galgorm Park | O'Laverty iii 383 | 1884 |
| 10. the original Deer Park . . . now known as "The Parks" | Buick's Ahoghill 15 | 1901 |
| 11. gal'gɔːrm 'pɑrkz | Local pronunciation | 1987 |

The unnaturally regular shape of this townland shows it is an artificial creation, no doubt carved out of older Irish land units. It appears to owe its origin to a grant in 1618 from King James I to Sir Faithful Fortescue (a nephew of Sir William Chichester, Lord Deputy of Ireland) which refers to the creation of the "manor of Fortescue, with 1000 acres in demesne" (1). The townland, which was formerly known as the Deerpark of Galgorm, has obviously taken its name from the neighbouring townland of Galgorm.

### Glebe
J 0499

An English form

| | | |
|---|---|---|
| 1. (?)Cill Fhinnshreibh | LCABuidhe 127 | 1680c |
| 2. "two tls. in Munter Rinidy, Ballimonastragh and . . . belong to the rector as Glebe" | Inq. Ant. (DK) 45 | 1605 |

| | | | |
|---|---|---|---|
| 3. | a Gleabb . . . being part of the Towne of Ballemonestragh | Inq. Par. Ant. 61 | 1657 |
| 4. | Glebe | Bnd. Sur. | 1829c |
| 5. | Glebe | OSNB B 35 B 131 | 1830c |
| 6. | 'gli:b | Local pronunciation | 1987 |

Glebe is the most common townland name in Ireland, there being, in all, 235 townlands which carry this name. The term *glebe* refers to land set aside for the upkeep of the clergy-man in a parish. In this case, the amount of land set aside for this purpose was in the past much greater that the modern townland of Glebe, for the *Antrim Inquisition* of 1605 informs us that in that year the glebe consisted of two full townlands, Ballyminstra and another town-land, whose name is unfortunately impossible to read (*Inq. Ant. (DK)* 45). The fact that this arrangement was in place at the beginning of the 17th century suggests that it dates back to an earlier period, possibly to pre-Reformation times. The *Inquisition into the Parishes of Co. Antrim* of 1657 states that in that year the townland of Glebe was part of the townland of Ballyminstra and that it was recovered by means of the late bishop of Derry not long before the rebellion of 1641 (*Inq. Par. Ant.* 61). This suggests that some time between 1605 and 1641 the original glebe-lands were in the hands of a layman and that, when the bishop of Derry recovered the glebe for the church, he did not succeed in recovering the entire ancient glebe consisting of two townlands, but only a portion of one of the townlands, which is now the modern townland of Glebe. The circumstances in which the bishop of Derry was involved in the recovery of the glebe are not known.

Although not constituting one of the four "church" townlands of Ahoghill, which were the property of the diocese of Connor, the fact that the townland of Glebe was set aside for the upkeep of the clergyman means that it is not documented in the usual sources between 1657 and 1830c.

Lloyd (*Meyer Miscellany* 55) has identified this townland with *Cill Fhinnshreibh* (1), a place referred to in a late 17th-century poem by Séamus Ó hUid (see **Clare,** parish of Drummaul). While Lloyd's identification cannot be dismissed out of hand, he provides no evidence in support of it and it is impossible to make a firm judgement as to its accuracy.

## Glenhugh
D 0303

*Gleann Aodha*
"Hugh's glen"

| | | | |
|---|---|---|---|
| 1. | Glanhue | BSD 135c | 1661 |
| 2. | Ballyglanhugh | Inq. Ult. (Antrim) §6 Car. II | 1662 |
| 3. | Ballyglanhugh | Inq. Ult. (Antrim) §6 Car. II | 1662 |
| 4. | Glanhue | HMR Ant. 159 | 1669 |
| 5. | Glanhugh | Lodge RR Chas II ii 292 | 1684 |
| 6. | Glenhue | Reg. Deeds 10-133-3227 | 1712 |
| 7. | Glenhue | Lendrick Map | 1780 |
| 8. | Glenhugh | Reg. Deeds 511-461-332878 | 1797 |
| 9. | Glenhue | Tithe Applot. | 1825 |
| 10. | Glenhue | OS Name Sheets | 1832 |
| 11. | Glenhugh | OS Name Sheets (J O'D) | 1832 |
| 12. | Glenhue | OSNB B 35 B 131 | 1830c |
| 13. | Gleann Aodha "Hugh's glen or valley" | J O'D (OSNB) B 35 B 131 | 1830c |
| 14. | ˌglɛn'hju: | Local pronunciation | 1987 |

There is no reason to disagree with O'Donovan's interpretation of the name of this townland as *Gleann Aodha* "Hugh's glen or valley" (13). The anglicization of the Irish personal name *Aodh* as "Hugh" is well-attested throughout Ireland. Ó Corráin & Maguire (1981, 13) inform us that the name signifies "fire", and that it was "the commonest of all names in use in early Ireland, and it is now everywhere anglicized Hugh, a name with which it has no connection". The recorded spellings of this place-name indicate that the name *Aodh* was anglicized as "Hugh" as early as the middle of the 17th century. There is a long valley along the southern boundary of the townland, and this appears to be the feature which has given rise to the place-name.

| **Gloonan** | *Cluanán* | |
|---|---|---|
| D 0510 | "little meadow" | |
| 1. Ballyglonan | CPR Jas I 329b | 1617 |
| 2. Clownan | DS (Reg.) | 1657c |
| 3. Clounan | Hib. Reg. Toome | 1657c |
| 4. Clownan | BSD 135 | 1661 |
| 5. Glowan | HMR Ant. 158 | 1669 |
| 6. Gloonin | Lendrick Map | 1780 |
| 7. Gloonan | Bnd. Sur. (OSNB) | 1829c |
| 8. Gloonan | OSNB B 35 B 131 | 1830c |
| 9. Cluanán "a small lawn or meadow" | J O'D (OSNB) B 35 B 131 | 1830c |
| 10. 'glunən | Local pronunciation | 1987 |

This is another of the four Church townlands of Ahoghill and consequently documentation of the place-name is sparser than normal. Forms 2, 3 and 4 display initial *c* rather than initial *g*, suggesting that the name of the townland is derived from *Cluanán*, a diminutive form of *cluain* "meadow", as suggested by O'Donovan (9). None of the standard Irish dictionaries gives *cluanán* or *cluainín* as diminutive forms of *cluain* "meadow". However, Joyce points out that there are a great many townlands named Clooneen, mainly in the west of Ireland, whose names all go back to the Irish form *Cluainín* "little meadow" (*Joyce* i 236). The form *cluanán* would constitute an acceptable variant form of *cluainín* and this is the most satisfactory interpretation of the place-name. Dwelly gives the Scottish Gaelic diminutive *cluainean* (Mid Perth): "little pasture, little meadow, little lawn, pleasure ground" (*Dwelly* sv).

| **Killane** | Of uncertain origin | |
|---|---|---|
| D 0402 | | |
| 1. Killene | DS (Reg.) | 1657c |
| 2. Killeon | Hib. Reg. Toome | 1657c |
| 3. Killeene | BSD 135 | 1661 |
| 4. Killin | HMR Ant. 158 | 1669 |
| 5. Killin | Lendrick Map | 1780 |
| 6. Killain | Bnd. Sur. (OSNB) | 1829c |
| 7. Killain | OSNB B 35 B 131 | 1830c |
| 8. Killain | OS Name Sheets (J O'D) | 1832 |
| 9. Killane | OSM xxiii 12 | 1835 |

| | | |
|---|---|---|
| 10. Coill Leathan "broad wood" | J O'D (OSNB) B 35 B 131 | 1830c |
| 11. ki'le:n | Local pronunciation | 1987 |

This is another of the four Church townlands of Ahoghill. There is insufficient evidence to enable a judgement to be made about its original Irish form. Forms 2 and 3 are based on form 1 and variations in spelling in these forms are therefore due to scribal mistranscriptions. While form 1 suggests that the final syllable of the place-name was earlier pronounced as [i:n], it is unlikely that this would have developed into the modern [e:n]; it is more probable that the first *e* is to be read as *a* and that the intended spelling is *Killane*.

It is impossible to tell whether the first element of the place-name represents *cill* "church" or *coill* "wood". Since the townland was formerly the property of the church, one is tempted to opt for *cill* "church". However, it is difficult to suggest a satisfactory final element. One might suggest the Irish form *Cill Liáin* "Lián's church" or *Cill Liatháin* "Liathán's church". The personal names *Lián* (<*Lighean*) and *Liathán* have been referred to above in connection with the townland of **Carlane** in the parish of Duneane. However, as no saints named *Lián* or *Liathán* appear to be attested, this explanation must be regarded as unlikely.

It is possible that the first element of the place-name is *coill* "wood", and if so O'Donovan's Irish form, i.e. *Coill Leathan* "broad wood" (10) appears as likely as any, since the element *leathan* "broad" is often anglicized as *lane* in the north of Ireland (see **Magheralane** above). One might suggest that the wood in question may have been the yew wood which forms the final element of the name of the parish of **Ahoghill** (Ir. *Achadh Eochaille* "field of the yew wood"), though this suggestion is admittedly somewhat speculative. *Coill Éan* "wood of the birds" might be put forward as another possible derivation, or, perhaps, *Coill Eidhinn* "wood of ivy".

| **Leymore**<br>D 0906 | *An Leath Mhór*<br>"the large field/area of land" | |
|---|---|---|
| 1. Laymoir | McQ. Doc. (MacDonnells Ant.) | 1634 |
| 2. Laymore | McQ. Doc. (MacDonnells Ant.) | 1634 |
| 3. the townland of Lymore | Indent. Adair (MacDonnells Ant.) | 1636 |
| 4. Laymore | EP Adair Mar. 12 | 1636 |
| 5. Ballyloymore | Lodge RR Chas I ii 40 | 1638 |
| 6. Leymoore | Inq. Par. Ant. 85 | 1657 |
| 7. half parcel of Leagemor | EP Adair Sep. 1 | 1658 |
| 8. Ballyloymore | Inq. Ult. (Antrim) §1, §3 Car. II | 1661 |
| 9. Leimore or Leunore | Lodge RR Geo I & II 67 | 1720 |
| 10. Leymore | Reg. Deeds 37-489-23607 | 1722 |
| 11. Lymore | EP Adair Feb. 1 | 1722 |
| 12. Laymore | EP Adair Nov. 12 | 1766 |
| 13. Laymore | Lendrick Map | 1780 |
| 14. Leymore | Tithe Applot. | 1825 |
| 15. Laymore | Bnd. Sur. (OSNB) | 1829c |
| 16. Leymore | OSNB B 35 B 131 | 1830c |
| 17. Liath Mór "great grey land"<br>or Ligh Mór "great grave" | J O'D (OSNB) B 35 B 131 | 1830c |
| 18. 'le:'mo:r | Local pronunciation | 1987 |

O'Donovan's suggested Irish forms i.e. *Liath Mór* "great grey land" or *Ligh Mór* "great grave" (17) are not supported by the historical forms of the place-name, none of which display any sign of the long [i] which is found in both *liath* "grey land" and *ligh* "grave/tomb". It is much more likely that the first element of the townland name is *leath* which literally means "half", but which can also have the significance of: "side, a district or countryside" (*Dinneen* sv.); "side, part, direction" (*Ó Dónaill* sv.). The place-name *Lieh Bog* occurs on the Isle of Man, where it is interpreted as "soft half, a *field* at Cregneash" (Kneen 1925, 44). It is likely that the element *leath* in the name of this townland may also have the significance of simply "area of land, field", and that *An Leath Mhór* may signify a large field or large portion of (workable?) land. The *OSNB* of c. 1830 describes the townland as "cultivated with the exception of a few scattered portions of rough ground, and a small quantity of bog along the east boundary".

| **Limnaharry** | *Léim an Charria* | |
| D 0201 | "the deer's leap" | |
| 1. Ballyhinechere | Inq. Ult. (Antrim) §6 Car. II | 1662 |
| 2. Lemonherry | HMR Ant. 158 | 1669 |
| 3. Lumagherie | Comm. Grace 10 | 1684 |
| 4. Lymagherie | Lodge RR Chas II ii 292 | 1684 |
| 5. Limnehery | Indent. (Staff.) | 1692 |
| 6. Limahire | Reg. Deeds 10-133-3227 | 1712 |
| 7. Limneherry | Reg. Deeds 30-26-16158 | 1720 |
| 8. Limneherey al. Limnekerry | Reg. Deeds 66-434-47346 | 1731 |
| 9. Lymcheire | Reg. Deeds 90-171-62470 | 1739 |
| 10. Limnahery orw. Limneherry | Reg. Deeds 196-2-128858 | 1758 |
| 11. Limnahery | Belfast News Letter Feb. 7 | 1758 |
| 12. Limnhary | Lendrick Map | 1780 |
| 13. Limnahary | Tithe Applot. | 1825 |
| 14. Limnaharry | Bnd. Sur. (OSNB) | 1829c |
| 15. Limnaharry | OSNB B 35 B 131 | 1830c |
| 16. Léim an araidh "the charioteer's leap" | J O'D (OSNB) B 35 B 131 | 1830c |
| 17. ˌlïmnəˈhɑːri | Local pronunciation | 1987 |

The modern form of the place-name suggests that the final element is a feminine noun preceded by the feminine genitive form of the article i.e. *na*. However, the earliest recorded spellings indicate that the modern medial -*na*- is a corruption of the masculine genitive article i.e. *an*. Lenition of the initial letter of the final element, which in Irish follows the masculine genitive article, appears to be indicated by the -*ch*- of forms 1 and 9, the -*gh*- of forms 3 and 4, and the -*h*- of the modern version, which is documented as early as 1669 (2). Form 1 is clearly corrupt, the first *h* being a mistranscription of *l*, and the *n* a mistake for *m*, the intended spelling being, apparently, *Ballylimechere*. The element *léim*, which literally signifies "leap", has a variety of meanings in place-names. *Ó Máille* (1989–90, 135) gives "a narrow watercourse", while Joyce suggests that it often designates a spot where animals were in the habit of passing: ". . . a narrow part of a river where they crossed by bounding from one bank to the other, a rent in a line of rocks affording just room to pass, a narrow pass across a hill ridge leading from one path to another etc". He also points out that some names in which

*léim* is followed by the name of an animal have their origin in a legend which told of an amazing leap made by the animal in question (*Joyce* ii 317).

In the case of this place-name, there is no surviving legend of an extraordinary leap by a deer. A stream forms the southern boundary of the townland, and there are two other streams which flow through it. It is possible that the townland was named from a remarkable leap by a deer over one of the streams. In Co. Antrim the word *léim* seems to have been used in the sense of "hill" or "mountain", for the *Civil Survey* of c. 1655 refers to to a *mountain* called *Lemnesellidragh* in the barony of Cary (*Civ. Surv.* x §60) and to a little *hill* named *Lemnacullenagh* in the barony of Glenarm (*ibid.* §61). There are hills of 498 feet and 400 feet in this townland and it is possible that one of them marks the site of a remarkable leap by a deer in the past.

A case could also be made for interpreting the place-name as *Léim an Ghiorria* "the hare's leap", but since the medial *-h-* is more likely to represent Irish *-ch-* than *-gh-*, *Léim an Charria* "the deer's leap" must be regarded as the more likely derivation. O'Donovan's suggested Irish form i.e. *Léim an araidh* "the charioteer's leap" (16) is rejected on the grounds that it is not supported by the documentary evidence.

| **Lismurnaghan** | *Lios Muirneacháin* | |
|---|---|---|
| D 0401 | "*Muirneachán*'s fort" | |
| 1. Lismorneghan | DS (Reg.) | 1657c |
| 2. Lismornhan | Hib. Reg. Toome | 1657c |
| 3. Lismornoghan | BSD 135 | 1661 |
| 4. Lisnemurgan | HMR Ant. 158 | 1669 |
| 5. Lismornehan | Hib. Del. Antrim | 1672c |
| 6. Lismurnaghin | Lendrick Map | 1780 |
| 7. Lismurnaghan | Bnd. Sur. (OSNB) | 1829c |
| 8. Lismurnaghan | OSNB B 35 B 131 | 1830c |
| 9. Lios Muirneacháin "Murnaghan's Fort" | J O'D (OSNB) B 35 B 131 | 1830c |
| 10. ˌlïsˈmọrnəxən | Local pronunciation | 1987 |

This is another of the four Church townlands of Ahoghill. The name of the townland is clearly derived from Irish Lios *Muirneacháin* as suggested by O'Donovan (9), i.e. "*Muirneachán*'s fort". The personal name *Muirneachan* (Mod. *Ir. Muirneachán*) occurs four times in an early East Ulster genealogy (*Descendants Ir* xiv 137). Under the surname *Ó Muirneacháin* "Murnaghan", Woulfe (1923, 622) remarks: "descendant of *Muirneachán* (diminutive of *muirneach* "loveable"), a rare Ulster surname". None of the recorded spellings show any evidence of the surname particle *Ó*, and it is more likely that we are dealing with the personal name *Muirneachán* rather than the surname *Ó Muirneacháin* which is derived from it. *NISMR* marks an "enclosure" in the townland, all trace of which has now disappeared, and it is possible that this is the feature which gave rise to the place-name.

| **Lisnafillon** | *Lios na bhFaoileán* | |
|---|---|---|
| D 0602 | "fort of the seagulls" | |
| 1. Lisnefillin | HMR Ant. 159 | 1669 |
| 2. Lissepillin | Comm. Grace 10 | 1684 |
| 3. Lissnepillin | Lodge RR Chas II ii 292 | 1684 |

| | | |
|---|---|---|
| 4. Lissepillin | Reg. Deeds 10-133-3227 | 1712 |
| 5. Lisnefillin | Reg. Deeds 29-160-16654 | 1720 |
| 6. Lissfillin | Reg. Deeds 30-103-16653 | 1720 |
| 7. Lisnafillin | Lendrick Map | 1780 |
| 8. Lisnafillan | Tithe Applot. | 1825 |
| 9. Lisnafillon | Bnd. Sur. (OSNB) | 1829c |
| 10. Lisnafillon | OSNB B 35 B 131 | 1830c |
| 11. Lisnafallan | OSM xxiii 31 | 1835 |
| | | |
| 12. Lios na faoileán "fort of the seagulls" | J O'D (OSNB) B 35 B 131 | 1830c |
| 13. Lios-na-bhfaoileann "fort of the *feelans* or seagulls" | Joyce iii 477 | 1913 |
| | | |
| 14. ˌlïsnəˈfilən | Local pronunciation | 1987 |

Forms 2, 3 and 4 are related, and the medial *p* is most likely a scribal mistranscription of *f*, the error in the earliest form being reproduced in the later two. There is no reason to disagree with the previous interpretation of the place-name as "fort of the seagulls" though the genitive plural eclipsis of the initial *f* of *faoileán* has been omitted in O'Donovan's Irish form (12). The medial *-aoi-* of *faoileán* "seagull" is normally anglicized as [i:] (*Joyce* i 486), and we might expect the place-name to be anglicized as *Lisnafeelon* rather than *Lisnafillon*. However, *-aoi-* in *faoileog* (a variant form of *faoileán*) is pronounced as short [I] rather than as [i:] in a number of Irish dialects of Donegal (*LASID* i 216) and the anglicization of *faoileán* as *fillon* in this place-name may reflect a similar pronunciation of *-aoi-* in the original Irish form. A case could be made for the Irish form *Lios na Faoilinne* "fort of the seagull", with a singular form of the final element, since *faoileann* is attested in Rathlin as a feminine variant form of *faoileán* (Holmer 1942, 193). However, *Lios na bhFaoileán* "fort of the seagulls" appears the more likely of the two forms. There is now no trace of a fort in the townland, but *NISMR* marks a possible "site of rath", and this may be the naming feature of the townland.

## Moneydollog
D 0403

*Muine Duilleog*
"leafy thicket"

| | | |
|---|---|---|
| 1. Monidilloge | BSD 135c | 1661 |
| 2. Ballymonydollogg | Inq. Ult. (Antrim) §6 Car. II | 1662 |
| 3. Monidcloge | HMR Ant. 159 | 1669 |
| 4. Monnydilloge | Lodge RR Chas II ii 292 | 1684 |
| 5. Munidulloge | Reg. Deeds 10-133-3227 | 1712 |
| 6. Monydilloge | Reg. Deeds 90-171-62470 | 1739 |
| 7. Moneydollog | Lendrick Map | 1780 |
| 8. Monnydilloge | Reg. Deeds 636-545-639977 | 1811 |
| 9. Monnydolloge | Reg. Deeds 660-290-457358 | 1813 |
| 10. Moneydollag | Tithe Applot. | 1825 |
| 11. Moneydollog | Bnd. Sur. (OSNB) | 1829c |
| 12. Moneydollog | OSNB B 35 B 131 | 1830c |
| | | |
| 13. Muine dealg "thorny brake" | J O'D (OSNB) B 35 B 131 | 1830c |
| 14. Muine-dealg "the thorny shrubbery" | Joyce iii 354 | 1875 |
| | | |
| 15. ˌmǫniˈdɔːləg | Local pronunciation | 1987 |

In form 3, *c* is obviously a mistranscription of *o*. Joyce informs us that the element *dealg* "thorn" can be anglicized *dollig*, and he gives the name of this townland as an example, suggesting that it is derived from Irish *Muine-dealg* "the thorny shrubbery" (14), an interpretation which is also suggested by O'Donovan (13). However, this explanation is not supported by the earlier spellings of the place-name. Forms 1, 4, 6 and 8 in particular provide evidence that the final element of the townland name is likely to represent Irish *duilleog* "leaf" rather than *dealg* "thorn".

| | | |
|---|---|---|
| **Moyasset** | Of uncertain origin | |
| D 0403 | | |

| | | | |
|---|---|---|---|
| 1. | Moyassett | BSD 135b | 1661 |
| 2. | Ballymoyesset | Inq. Ult. (Antrim) §6 Car. II | 1662 |
| 3. | Moyfett | HMR Ant. 159 | 1669 |
| 4. | Moyasset | Lodge RR Chas II ii 292 | 1684 |
| 5. | Moyesset | Reg. Deeds 10-133-3227 | 1712 |
| 6. | Moyassett | Reg. Deeds 90-171-62470 | 1739 |
| 7. | Moyesset | Grand Jury Pres. May 9 | 1775 |
| 8. | Moyasig | Lendrick Map | 1780 |
| 9. | Moyassett | Reg. Deeds 636-545-639977 | 1811 |
| 10. | Moyasset | Tithe Applot. | 1825 |
| 11. | Moyassett | Bnd. Sur. (OSNB) | 1829c |
| 12. | Moyassett | OSNB B 35 B 131 | 1830c |
| 13. | Magh Easait "Hassett's plain" | J O'D (OSNB) B 35 B 131 | 1830c |
| 14. | "Hasset's plain" | Joyce iii 514 | 1913 |
| 15. | mɔi'a:sət | Local pronunciation | 1987 |

The first element of this place-name is clearly *maigh* "plain", but the final element is problematic. O'Donovan's interpretation, i.e. *Magh Easait* "Hassett's plain" (13) suggests that he considered the final element to be a personal name *Easat* which is, however, otherwise unattested. It is also possible that O'Donovan had in mind the surname Hassett, even though his Irish form shows no trace of the surname particle *Ó* or *Mac*. Hassett is an anglicized form of the Co. Clare surname *Ó hAiseadha*. There, the anglicization of *Ó hAiseadha* as Hassett seems to have grown up in the 17th century, based on an early anglicization of the name as O'Hessedy (MacLysaght 1985, 123). In this area, *Ó hAiseadha* would most likely be anglicized as Hassey, and the suggestion that the final element of the place-name is the surname Hassett can be safely ruled out.

There is a townland named **Moyesset** in the parish of Kilcronaghan in Co. Derry, for which O'Donovan suggests the Irish form *Magh-Aisiada* "Hasset's plain". In this form, the final element could be a form of the personal name *Aisiodh* from which is derived the aforementioned surname *Ó hAiseadha* "Hassett". However, it is clear that in this area it would not be anglicized as *esset* or *asset* any more than the surname *Ó hAiseadha* would be anglicized as *Hassett*.

No satisfactory interpretation of the place-name comes to mind. The word *osaid/asaid* "parturition, delivery" is recorded by Dinneen and one might argue for the form *Maigh Asaide* "birthing plain", perhaps referring to a plain where the young of animals (possibly lambs?) were delivered. However, all the examples of the use of this word in the earlier language refer to human birth (*DIL* sv. *asaít*) and in the absence of evidence of its use to refer

to the birth of animals it must be regarded as a tentative explanation. The origin of the place-name must therefore remain obscure.

| **Straid** | *Sráidbhaile Thomáis* | |
|---|---|---|
| J 0799 | "Thomas's village" | |

| | | | |
|---|---|---|---|
| 1. | Stradbally-Thomas (the half-town of) | Lodge RR Chas I ii 407 | 1637 |
| 2. | Stradbally Thomas, Half Town of | BSD 135b | 1661 |
| 3. | Stradbally-Thomas ½ tl. | Lodge RR Chas II i 106 | 1663 |
| 4. | Shad | HMR Ant. 156 | 1669 |
| 5. | Half of Stradbally-Thomas | Lodge RR Chas II ii 292 | 1684 |
| 6. | Stradballythomas | Reg. Deeds 10-133-3227 | 1712 |
| 7. | Stradbally Thomas | Reg. Deeds 90-171-62470 | 1739 |
| 8. | Strade | Lendrick Map | 1780 |
| 9. | Straid | Reg. Deeds 660-290-457358 | 1813 |
| 10. | Stradbally Thomas | Reg. Deeds 756-26-51361 | 1820 |
| 11. | Straid | Tithe Applot. | 1825 |
| 12. | Straid | Bnd. Sur. (OSNB) | 1829c |
| 13. | Straid | OSNB B 35 B 131 | 1830c |
| 14. | Stráid "a street" | J O'D (OSNB) B 35 B 131 | 1830c |
| 15. | Sráid "a street" | Joyce i 352 | 1869 |
| 16. | 'stre:d | Local pronunciation | 1987 |

This is another of the six full townlands of the parish of Ahoghill which lie in the barony of Toome Upper. According to Joyce, the element *sráid*, which literally signifies "street" and is normally anglicized as *Straid* or *Strade*, is applied to a "village consisting of one street unde-fended by either walls or castle – a small unfortified hamlet – often called *sráidbhaile* i.e. street-town" (*Joyce* i 351–2). The documentary evidence demonstrates that the name of this townland goes back to Irish *Sráidbhaile Thomáis* "Thomas's village" and that it was later shortened to simply *An tSráid* "the street or village". In Co. Antrim, there are two other townlands named **Straid**, including one in the parish of Ballynure, the older name of which, interestingly, was also Straidballythomas (McKeown 1937, 38).

Since speakers of English have difficulty in pronouncing the combination of the letters *s* and *r*, there is a tendency (especially in Ulster) to insert a *t* between the two letters when they occur in Irish, which explains the anglicization of *sráid* "street, village" as *Straid*. Similarly, *srath* "river-holm" is commonly anglicized as *Strath* (*Joyce* i 60).

There is a modern road which runs the full length of the townland and on which there is a hamlet named Straid, and it is possible that this hamlet could mark the site of the feature which originally gave name to the townland.

| **Tullaghgarley** | *Tulach Ghreallaí* | |
|---|---|---|
| D 0801 | "hillock of the marsh" | |

| | | | |
|---|---|---|---|
| 1. | town of Crevagh (Grenagh) als. Tullaghgarly | Bnd. Connor Par. | 1604 |
| 2. | Tullygarley (alias Grenoge) | O'Laverty iii 288 | 1606c |

| | | |
|---|---|---|
| 3. Tullaghgarly | Inq. Ult. (Antrim) §144 Car. I | 1640 |
| 4. Ballytullaghgarly | Inq. Ult. (Antrim) §144 Car. I | 1640 |
| 5. Tullaghgarly, the ½ town of | Inq. Par. Ant. 84 | 1657 |
| 6. Tullgurly or Tullygarly | ASE 125 a §26 | 1667 |
| 7. Tullygarly | HMR Ant. 123 | 1669 |
| 8. Tullagarty | Hib. Del. Antrim | 1672c |
| 9. ½ Tullaghgarly | BSD (Annes.) 7 | 1680 |
| 10. Tullaghgarly | Lodge RR Geo I & II 67 | 1720 |
| 11. ½ town of Grenagh als Tullaghgarly | Lodge RR Geo I & II 72 | 1720 |
| 12. Tullaghgarly | Reg. Deeds 43-177-27809 | 1724 |
| 13. Tullaghgarley | Lendrick Map | 1780 |
| 14. Tullaghgarley | OSNB B 35 B 131 | 1830c |
| 15. Tullygarley (East and West) | Encumbered Ests. (O'Laverty) | 1851 |
| 16. Tulach Garbhlaigh "rough hill" | J O'D (OSNB) B 43 B 94 | 1830c |
| 17. 'tọli'gɑːrli | Local pronunciation | 1987 |

This townland is entirely situated in the barony of Lower Antrim. Approximately half of the townland lies in the parish of Ahoghill, while the other half lies in the parish of Connor. The place-name is known locally as "Tullygarley", which suggests that the first element is an oblique form of *tulach* i.e. *tulaigh*. However, since the majority of the recorded forms show the spelling *tullagh*, it is probably safer to opt for *tulach* as the original form of the first element. In the parish of Craigs, there is a townland which is also named **Tullaghgarley** but which has the oblique form *tulaigh* as its first element.

The final element of the place-name is *greallaí*, the genitive form of *greallach* which is defined as "mire; slush, puddle; puddly ground" (*Ó Dónaill* sv.); "a miry or marshy place" (*Joyce* iii 388), and has in this case been anglicized *-garley* by the process of metathesis (see Appendix). None of the early spellings of the place-name reflect the original Irish pronunciation of *greallach*, which suggests that the metathesis must have taken place before the name of the townland was first recorded.

**Tullygowan**
D 0700

*Tulaigh Gabhann*
"hillock of the smith"

| | | |
|---|---|---|
| 1. Ballytollygone | Inq. Ant. (DK) 45 | 1605 |
| 2. Ballitolligoen | Lodge RR Jas I i 252 | 1606 |
| 3. Ballitolligoen | CPR Jas I 93b | 1606 |
| 4. Balletullegowen | Lodge RR Chas I i 407 | 1637 |
| 5. Ballytullygowen | BSD 135a | 1661 |
| 6. Ballytullygan | Lodge RR Chas II i 106 | 1663 |
| 7. Tullygowne | HMR Ant. 156 | 1669 |
| 8. Ballytullegowen | Lodge RR Chas II ii 292 | 1684 |
| 9. Ballytullygoan | Reg. Deeds 10-133-3227 | 1712 |
| 10. Ballytullegowen | Reg. Deeds 29-160-16654 | 1739 |
| 11. Tullygowan | Lendrick Map | 1780 |
| 12. Tullygowan | Tithe Applot. | 1825 |
| 13. Tullygowan | Bnd. Sur. (OSNB) | 1829c |
| 14. Tullygowan | OSNB B 35 B 131 | 1830c |

| | | |
|---|---|---|
| 15. Tulaigh Gobhann "the smith's hill" | J O'D (OSNB) B 35 B 131 | 1830c |
| 16. "hill of the smith" | Joyce iii 590 | 1913 |
| 17. ˌtọliˈgəuən | Local pronunciation | 1987 |

There is no reason to disagree with the previous interpretation of the place-name as *Tulaigh Gabhann* "hillock of the smith" (15,16). There is a conspicuous little hill in the middle of the townland, on the summit of which there are the remains of a fort (marked "enclosure" by *NISMR*), and this appears most likely to be the feature which gave rise to the name of the townland.

<div align="center">OTHER NAMES</div>

**Advernis**
D 0704

Of uncertain origin

| | | |
|---|---|---|
| 1. ˌadˈveːrnïs | Local pronunciation | 1987 |

The *OSRNB* of c. 1858 (sheet 32) records this place-name as *Ardvernis* rather than *Advernis*, and remarks that it is the name of a cottage in the townland of Galgorm Parks, erected by "widow Jane Cunningham" in 1849. The origin of the name is obscure. One might suggest that it derives from Irish *Ardbhearnais* "high gap", but there is no such natural feature in the vicinity. There is a townland named **Ardvarness** in the parish of Macosquin in Co. Derry and a townland named **Ardvarnish** in the parish of Derryloran in Co. Tyrone, and it is possible that the cottage was named after one of those places, but this suggestion must be regarded as speculative. The *OSRNB* remarks: "the name is known as being only a matter of choice, having no particular origin".

**Ahoghill** (town)
D 0401

*Achadh Eochaille*
"field of the yew wood"

See parish name

**Bridge End**
D 0603

An English form

| | | |
|---|---|---|
| 1. ˈbrïdʒ ˈɛːnd | Local pronunciation | 1987 |

This is the name of a small settlement just inside the townland of Corbally at the west end of a bridge over the river Main. This bridge carries what was formerly the main road from Ballymena to Ahoghill and appears to be that which is referred to by Dobbs in 1683 as "a handsome Bridge of lime and stone of ten or eleven arches" (*Dobbs' Descr. Ant.* 388). There are also two smaller bridges here, over a stream which runs parallel to the Main.

**The Flush**
D 0202

An English form

| | | |
|---|---|---|
| 1. ðə ˈflọʃ | Local pronunciation | 1987 |

This is the name of a cluster of houses in the west of the townland of Ballybeg. According to the *OSRNB* of c. 1858 (sheet 36), it was "named from overflowing of river at small bridge roughly 3 chains east of it". The word "Flush" is attested in the English language in the sense of "a sudden flow, especially of water" (*Longman Dict.* sv.).

| **Gracehill**<br>D 0602 | An English form | |
|---|---|---|
| 1. 'gre:s'hïl | Local pronunciation | 1987 |

Gracehill is the name of a village which was founded in 1755 by the Moravians (a religious sect also known as the United Brethern) in the townland of Ballykennedy. The land was leased from Lord O'Neill of Shane's Castle (*OSM* xxiii 10). The name Gracehill reflects the religious outlook of its founders and is self-explanatory.

| **Irish Hill**<br>D 0900 | An English form | |
|---|---|---|
| 1. ˌairiʃ 'hïl | Local pronunciation | 1987 |

This is a prominent hill in the townland of Tullaghgarley. According to the *Ordnance Survey Memoir*, it was so named on account of the fact that the Irish army was encamped on it during the Cromwellian Wars (*OSM* xxiii 34).

| **Prieststown**<br>D 0100 | An English form | |
|---|---|---|
| 1. 'pri:sts,təun | Local pronunciation | 1987 |

This is a small hamlet on the western boundary of the townland of Ballylummin. It was named Prieststown on account of the fact that it was formerly a place of residence for the Catholic priests of Ahoghill.

## Parish of Craigs
Barony of Toome Lower (one townland in barony of Kilconway)

| *Townlands* | Drumrankin | Moylarg |
|---|---|---|
| Artibrannan | Dunnygarran | Teeshan |
| Ballyclosh | Fenagh | Tullaghgarley |
| Ballyconnelly | Fenaghy | |
| Ballywatermoy | Kildowney | *Town* |
| Broughdone | Killyless | Cullybackey |
| Craigs (Kilconway) | Lisnahunshin | |
| Crankill | Loan | |
| Cullybackey | Loughmagarry | |
| Dreen | Moboy | |

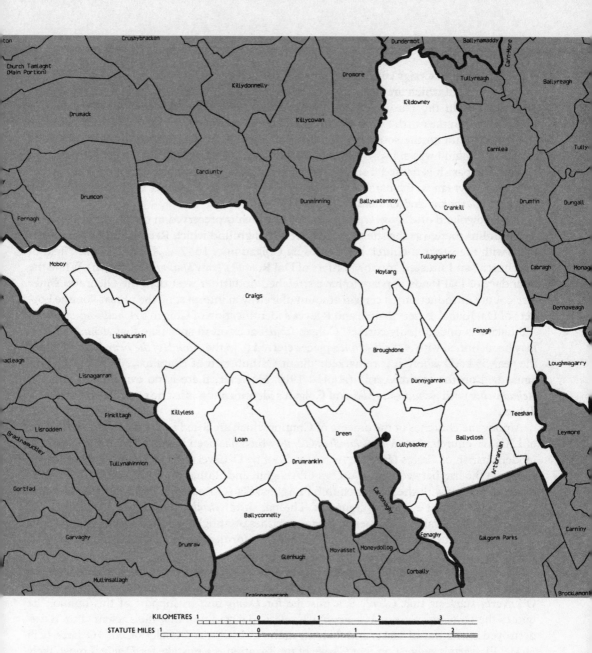

**Parish of Craigs**

# THE PARISH OF CRAIGS

The civil parish of Craigs consists of some 12,366 acres (*Census 1871*) and is made up of 22 townlands, 21 of which are in the barony of Toome Lower and one of which (the townland of Craigs), is in the barony of Kilconway. It is bounded on the west by the parish of Portglenone, on the north by the parish of Rasharkin, on the east by the parish of Kirkinriola (Ballymena) and on the south by the parish of Ahoghill. It was formed in 1840, when the parish of Ahoghill was sub-divided, and 22 of its townlands were constituted the parish of Craigs. The parish is named from the large townland of Craigs which formerly consisted of four small townlands, the names of which were recorded by Reeves c. 1847 as *Aughnakeely, Groogagh, Carhunny* and *Grannagh* (*EA* 89) (see below).

In the townland of *Aughnakeely* (the name of which is preserved in the minor place-name **Aghnakilla**) there was the site of an ancient burial ground which Reeves (*EA* 89) has identified with the site of a church referred to by Colgan in c. 1647 as *Achadh-na-cille* "field of the church" and situated "on the borders of Dál Riada" (*Trias Thaum.* 182 col.1n). While the boundary of Dál Riada appears to have stretched no farther west than the Glenravel Water (see county introduction), a certain amount of leeway in interpreting the phrase "on the borders of Dál Riada" is permissible and Reeves's identification of Colgan's *Achadh-na-cille* with Aghnakilla is undoubtedly correct. Colgan (*ibid.*) goes on to speculate that *Achadh-na-cille* may be identified with *Achadh-cinn*, a place referred to in the *Annals of the Four Masters* under the year 554 AD where it is remarked: "Saint Cathub, son of Fearghus, Abbot of Achadh-cinn, died on the 6th of April" (*AFM* i 190). However, there is no evidence to connect *Achadh-cinn* with *Achadh-na-cille*, and Colgan's identification must be regarded as extremely dubious.

Among the churches of the diocese of Connor which are listed in the *Ecclesiastical Taxation* of 1306 is a church named *The church of Clemly* which has been identified by Reeves with the modern parish of Craigs (*EA* 89). As pointed out by O'Laverty, the position of the *church of Clemly* in the list, between the churches of Ahoghill and Rasharkin, would certainly support its identification with the former church in Aghnakilla (*O'Laverty* iii 364) and Reeves's suggestion appears to be beyond argument. The parish of *Clemly* is valued at 20 shillings per annum, the same value as the neighbouring parishes of Ahoghill and Rasharkin. It must have been later absorbed into the parish of Ahoghill, as it formed part of that parish until the year 1840.

While there is little doubt about the identification of the parish church of Craigs with the *church of Clemly* of the *Ecclesiastical Taxation*, the origin of the name *Clemly* is obscure. O'Laverty suggests that *Clemly* is a mistake for *Demly* and in support of this opinion he quotes the *Ordnance Survey Memoir* which refers to a tradition that the ancient church was destroyed in the war of 1641, and that "its name in Irish was Donelly's Cell" (*O'Laverty* iii 364). O'Laverty's suggestion that *Clemly* of the Taxation is a mistake for *Demly* is most likely correct, since *d* could easily be misread as *cl*. However, the suggestion that *Demly* is the basis of the local interpretation of the name of the church as "Donelly's cell" (based on a projected form *Kildemly*) is perhaps rather conjectural. Could the name of the former parish church of Craigs have perhaps been confused with **Killydonnelly**, the name of a townland a few miles to the north of the site of the former church of Craigs in the parish of Rasharkin? O'Laverty also calls attention to a reference in the *Tripartite Life of Saint Patrick* to a monk named *Deman* who was a disciple of St Patrick and after whom the church of *Demly*, he believes, is likely to have been named (*O'Laverty* iii 385). Again, this suggestion is worthy of consideration, since the location of the church of Craigs appears to fit the general location referred to in the *Tripartite Life*, though it is difficult to see how the form *Demly* would have developed

from the name *Deman*. The personal name *Demle* is attested in a number of early southern genealogies (*CGH* 584) and it might be suggested that this is the name represented in the *Ecclesiastical Taxation*, but whether it is in any way connected with the name Deman is a matter of uncertainty.

In a list of churches in the deanery of Turtrye in the diocese of Connor (c. 1542), a church named *Rect. Ecclesia de Flynwo* has been identified by the editor with "Clemly, now Craigs" (*Reg. Dowdall* §129 268). However, *Flynwo* appears more likely to be a corruption of **Finvoy**, the name of a nearby parish in the barony of Kilconway. While Reeves (*EA* 71) informs us that most of the barony of Kilconway was included in the rural deanery of *Twescard* rather than in the deanery of Turtrye, the identification of *Flynwo* with Finvoy rather than with *Clemly* or Craigs is surely more acceptable.

The fact that there is no mention of the church of Craigs in the *Terrier* of 1615 or the *Ulster Visitation* of 1622 suggests that by the early 17th century the parish had been absorbed into the parish of **Ahoghill** to which the reader is referred for an account of the sources of the place-names.

PARISH NAME

| | | | |
|---|---|---|---|
| **Craigs** | | *Na Creaga*<br>"the rocks" | |
| 1. | Achadh-na-cille | Trias Thaum. 182 col.1n | 1647 |
| 2. | Ecclesia de Clemly | Eccles. Tax. 88 | 1306 |
| 3. | (?)the 4 towns, villages or<br>hamlets called the Creggs | CPR Jas I 58a | 1604 |
| 4. | the 4 Towns of the Cregges | Lodge RR Car I i 191 | 1629 |
| 5. | (?)Craganagorton | DS (Reg.) Toome | 1657c |
| 6. | the small Towne ½ of ye Creggs | BSD 148 | 1661 |
| 7. | (?)Cragnagortan | ASE 97 b 30 | 1666 |
| 8. | 4 Small Townes of ye Creage | HMR Ant. 82 | 1669 |
| 9. | (?)Craganagorton | Hib. Del. Antrim | 1672c |
| 10. | Craigs | Lendrick Map | 1780 |
| 11. | Craigs | OSNB B 35 B 131 | 1830c |
| 12. | (?)Donelly's Cell | OSM xxiii 25 | 1835 |
| 13. | The Craigs or Aughnakeely | OSM xxiii 50 | 1835 |
| 14. | "four towns of Craigs –<br>Aughnakeely, Groogagh,<br>Carhunny, Grannagh" | EA 89 | 1847 |
| 15. | Kildemly . . . Donelly's Cell | O'Laverty iii 364 | 1884 |
| 16. | Creaga "rocks" | J O'D (OSNB) B 35 B 131 | 1830c |
| 17. | Na Creaga | GÉ 95 | 1989 |
| 18. | 'kre:gz | Local pronunciation | 1987 |

The modern name of the parish is obviously taken from the townland which contains the site of the ancient church, and it is clearly derived from Irish *Na Creaga* "the rocks" as suggested in *GÉ* (17). The *Ordnance Survey Memoir* (xxiii 25) of 1835 informs us that the site of the graveyard of the ancient church of Craigs "stands on the side of a bleak stony hill" and this is likely to be the feature from which the townland and the parish have been named. The

plural ending of the anglicized version of the place-name appears to reflect the plural form of the original Irish. The modern name Craigs may represent a shortened form of *Craganagortan*, which is the name of one of the smaller divisions of the townland recorded in c. 1657 (5) and which is reproduced in forms 7 and 9. The name of this denomination is now obsolete and, while the first element is clearly a form of Irish *creag* "rock", it is impossible to suggest a satisfactory derivation for the entire place-name.

| **Artibrannan** | *Ard Tí Bhranáin* | |
| D 0805 | "height of *Branán*'s house" | |
| | | |
| 1. Taunebrannan | Lodge RR Geo I & II 67 | 1720 |
| 2. Tannebrannan | Reg. Deeds 245-270-161474 | 1763 |
| 3. Tannybranon | Tithe Applot. | 1825 |
| 4. Artibrannan | Bnd. Sur. (OSNB) | 1829c |
| 5. Artibrannan | OSNB B 35 B 131 | 1830c |
| 6. Tannybrannon | OSM xxiii 46 | 1835 |
| 7. Artibrannon | Encumbered Est. (O'Laverty) 396 | 1851 |
| | | |
| 8. Ard tigh(e) Branáin "height (or hill) of Branan's house | J O'D (OSNB) B 35 B 131 | 1830c |
| 9. Ard-tighe-Breannain "the height of Brennan's house" | Joyce iii 50 | 1913 |
| | | |
| 10. ˌɑrtiˈbranən | Local pronunciation | 1987 |

In spite of the scarcity of documentary evidence, there is no reason to disagree with O'Donovan's interpretation of this place-name as "height of *Branán*'s house" (8). The structure *Ard Tí* plus a person's name, signifying "height of the house of . . ." is a fairly common one in place-names and is found in the name of the townland of **Artigarvan** in Tyrone, which is derived from Irish *Ard Tí Garbháin* "height of *Garbhán*'s house" (*GÉ* 7). Other examples of place-names which appear to show the same formation are **Artimacormac** in Antrim, **Artidowney** in Cavan and **Artikelly** in Derry (*Joyce* iii 50). The personal name *Branán* is a diminutive form of the name *Bran* which signifies "a raven", and from it is derived the surname *Ó Branáin* which can be anglicized as Brannon or Brennan and is "the name of an ecclesiastical family in Ulster who were erenaghs of the church of Derry and of Derryvullan, Fermanagh" (Woulfe 1923, 323). According to Ó Ceallaigh, the name *Ó Branáin*, in the anglicized form *Brennan*, is well-known in the area south of Coleraine (*GUH* 46).

Forms 1–3 and 7 suggest that the townland was also known by the alternative name *Tamhnaigh Bhranáin* "*Branán*'s field".

The size of the townland has obviously been reduced by the creation of the very large townland of **Galgorm Parks** in the parish of Ahoghill, whose border with Artibrannan is artificially straight.

| **Ballyclosh** | *Baile na Cluaise* | |
| D 0705 | "townland of the margin/long stripe" | |
| | | |
| 1. Ballinacloiss | Inq. Ant. (DK) 46 | 1605 |
| 2. Ballinecloisse | CPR Jas I 114a | 1607 |
| 3. Ballinecloisse | Lodge RR Jas I i 300 | 1607 |
| 4. Ballynecloss | CPR Jas I 577b | 1624 |

| | | | |
|---|---|---|---|
| 5. | Ballineclosse | Inq. Ult. (Antrim) §3 Car. I | 1627 |
| 6. | Ballyneclosse | Inq. Ult. (Antrim) §4 Car. I | 1627 |
| 7. | Ballyneclosse | Exch. Deeds & Wills 100 | 1630 |
| 8. | Ballieloise | Inq. Ult. (Antrim) §10 Car. I | 1631 |
| 9. | Ballyneclosse | Inq. Ult. (Antrim) §11 Car. I | 1631 |
| 10. | Ballycloys | Lodge RR Geo I & II 67 | 1720 |
| 11. | Ballynecloss | Lodge RR Geo I & II 67 | 1720 |
| 12. | Ballycloys | Reg. Deeds 41-424-26662 | 1724 |
| 13. | Ballyneclosse | Reg. Deeds 41-424-26662 | 1724 |
| 14. | Ballyclosh | Lendrick Map | 1780 |
| 15. | Ballyclosh | Tithe Applot. | 1825 |
| 16. | Ballyclosh | Bnd. Sur. (OSNB) | 1829c |
| 17. | Ballyclosh | OSNB B 35 B 131 | 1830c |
| 18. | Ballyclose | Encumbered Est. (O'Laverty) | 1851 |
| 19. | Baile Claise "town of the trench or furrow" | J O'D (OSNB) B 35 B 131 | 1830c |
| 20. | ˌbaliˈkloːs | Local pronunciation | 1987 |
| 21. | ˌbaliˈkloːʃ | Local pronunciation | 1987 |

O'Donovan's suggestion (19) that the final element of this place-name is derived from *clais* "trench/furrow" is not reconcilable with the local pronunciations (20, 21). Moreover, the element *clais* "trench/furrow" is of rare occurrence in the north of Ireland (*Joyce* ii 221). Irish *ua(i)* is often anglicized as [oː] (see **Artlone** above) and a more plausible Irish form is *Baile na Cluaise* which literally signifies "townland of the ear". The word *cluas* is also cited by Ó Dónaill in the sense of "corner, margin" (*Ó Dónaill* sv.). According to Joyce, *cluas* can be used to designate places by their shape, and it often refers to "a lateral, semi-detached portion of land, or a long stripe" (*Joyce* ii 427). Ballyclosh therefore appears to signify something like "townland of the margin/long stripe" but it is now impossible to identify the feature referred to by the final element of the place-name.

**Ballyconnelly**                  *Baile Chonnla*(?)
D 0204                             "*Connla*'s townland"

| | | | |
|---|---|---|---|
| 1. | Ballychonlay | Inq. Ant. (DK) 45 | 1605 |
| 2. | Ballychonlary | CPR Jas I 93b | 1606 |
| 3. | Balliconlary | Lodge RR Jas I i 253 | 1606 |
| 4. | Ballyiconlary | Lodge RR Chas I i 407 | 1637 |
| 5. | Ballyconner | Inq. Ult. (Antrim) §6 Car. II | 1662 |
| 6. | Ballichinlary | Lodge RR Chas II i 106 | 1663 |
| 7. | Ballyconan | Lodge RR Chas II ii 292 | 1684 |
| 8. | Ballyconnen | Indent. (Staff.) | 1692 |
| 9. | Ballyconane | Reg. Deeds 10-133-3227 | 1712 |
| 10. | Ballyrevan | Reg. Deeds abstracts i §301 | 1722 |
| 11. | Ballyronan al. Ballyconelly | Reg. Deeds abstracts i §621 | 1736 |
| 12. | Ballyconan | Reg. Deeds 90-171-62460 | 1739 |
| 13. | Ballyconnelly | Lendrick Map | 1780 |
| 14. | Ballyconoly | Tithe Applot. | 1825 |
| 15. | Ballyconly | Bnd. Sur. (OSNB) | 1829c |

| | | |
|---|---|---|
| 16. Ballyconnelly | OSNB B 35 B 131 | 1830c |
| 17. Baile Uí Chonghalaigh "Connolly's town" | J O'D (OSNB) B 35 B 131 | 1830c |
| 18. Baile-Ui-Chonghaile "O'Connolly's or O'Conneely's town" | Joyce iii 77 | 1913 |
| 19. ˌbaliˈkɔːnəli | Local pronunciation | 1987 |

The penultimate *r* in forms 2, 3, 4 and 6 (which are all ultimately derived from form 1), appears to be the result of a mistranscription in form 2 which has been reproduced in the later forms, and the intended spelling in all these forms appears to be *Ballyconlay*. Form 5, i.e. *Ballyconner* (which is reproduced with variations in spelling in some later sources) is puzzling. I can only suggest that it, too, has been heavily corrupted by scribal error, the second *n* being a mistranscription of *l* and the final *r/n* a mistranscription of *y*. Given the inconsistent nature of the documentary evidence, it is impossible to establish a reliable Irish form.

One might propose that the final element of the place-name is the surname "Connolly", as suggested by both O'Donovan (17) and Joyce (18). According to MacLysaght (1985, 55), this surname can derive from either *Ó Conghaile* (Connaught and Monaghan) or *Ó Coingheallaigh* (Munster) and it is widely distributed over all the provinces. Bell (1988, 39), however, suggests that the Connollys of Antrim (where the name is very common) were originally MacIlchonnelies of Kintyre (Bell 1988, 39). There is no documentary evidence to suggest that the final element of this place-name is the Scottish surname MacIlchonnely, nor do the earlier recorded spellings appear to support the form *Baile Uí Chonghaile*, since they seem to indicate a disyllabic, rather than a trisyllabic, final element.

Perhaps a more plausible (though obviously still tentative) interpretation of the place-name is *Baile Chonnla*, the final element being the personal name *Connla* which is well attested in early East Ulster genealogies (*Descendants Ir* 123 (index)). Ó Corráin and Maguire (1988, 58–9) inform us that this personal name (which can be anglicized *Conle* or *Conly*) remained in use down to the 17th century and later. Another possibility is that the final element of the place-name is *Con Uladh*, the genitive form of the personal name *Cú Uladh* which signifies "hound of the Ulstermen" and was also popular in the north of Ireland (*op. cit.* 65). However, since the latter interpretation involves a change of stress, it must be regarded as less likely.

## Ballywatermoy
D 0510

*Baile Uachtar Maí*
"townland of the upper portion of the plain"

| | | |
|---|---|---|
| 1. Ballewatermoy | Inq. Ult. (Antrim) §10 Car. I | 1631 |
| 2. Ballyoughtermoyn | Inq. Ult. (Antrim) §17 Car. I | 1633 |
| 3. Ballywatermoy | Lodge RR Geo. I & II 67 | 1720 |
| 4. Ballywatermoy | Reg. Deeds 245-270-161474 | 1763 |
| 5. B:watermoy | Lendrick Map | 1780 |
| 6. Ballywatermoy | Tithe Applot. | 1825 |
| 7. Ballywatermay | Bnd. Sur. (OSNB) | 1829c |
| 8. Ballywatermoy | OSNB B 35 B 131 | 1830c |
| 9. Baile Uachtair Maighe "town of the upper plain" | J O'D (OSNB) B 35 B 131 | 1830c |

| | | |
|---|---|---|
| 10. "the town of the upper plain" | Joyce i 40 | 1869 |
| 11. ˌbaliwatər'mɔi | Local pronunciation | 1987 |

O'Donovan's Irish form of the place-name (9) is acceptable, though the name is best inter-
preted as "townland of the upper portion of the plain", rather than "townland of the upper
plain", which is also the interpretation proposed by Joyce (10). Ballywatermoy borders on
the townland of **Moylarg**, whose name is derived from Irish *Maigh Leargadh* "plain of the
slope", and it appears that in both place-names the element *maigh* "plain" refers to the same
level plain, lying on the east bank of the river Main. The anglicization of the element *uachtar*
"upper portion" as "water" has been discussed above, under the townland of **Aughter-
clooney** in the parish of Ahoghill.

The *OS 6-inch* map of 1858 marks *Tullypatrick* as a sub-division in the north of this town-
land, a name which is recorded as a separate denomination in 1628 (*Colville Doc.*) and in
1720 (*Lodge RR* Geo. I & II 67). This section of the townland borders on the townland of
**Kildowney**, the final element of which is a form of *domhnach* "Patrician church" and the
name *Tulaigh Phádraig* "hill of Patrick" may provide evidence of a link between this church
and St Patrick.

| **Broughdone** | *Bruach Duáin*(?) | |
|---|---|---|
| D 0507 | "river bank of the bend/black soil(?)" | |
| 1. Ballyranaghdone | Inq. Ant. (DK) 46 | 1605 |
| 2. Ballibruaghdore orw. | | |
| Ballynivaghdore | CPR Jas I 114a | 1607 |
| 3. Ballibruaghdone or. | | |
| Ballynivaghdone | Lodge RR Jas I i 300 | 1607 |
| 4. Ballinmaghdore | CPR Jas I 577b | 1624 |
| 5. Ballenynaghdore | Inq. Ult. (Antrim) §3, §4 Car. I | 1627 |
| 6. Broghdeem | Inq. Ult. (Antrim) §10 Car. I | 1631 |
| 7. Broghdone al. Broghdohane | Lodge RR Geo I & II 67 | 1720 |
| 8. Broghdone orw. Broghdohane | Reg. Deeds 245-270-161474 | 1763 |
| 9. Broughdone | Lendrick Map | 1780 |
| 10. Broughdone | Tithe Applot. | 1825 |
| 11. Broughdone | Bnd. Sur. (OSNB) | 1829c |
| 12. Broughdone | OSNB B 35 B 131 | 1830c |
| 13. Broughdown | OSM xxiii 33 | 1835 |
| 14. Bruach dúin "brink, margin | | |
| of the fort" | J O'D (OSNB) B 35 B 131 | 1830c |
| 15. brǫx 'doən | Local pronunciation | 1987 |

While the first element of the place-name is clearly *bruach* "bank/river margin",
O'Donovan's suggestion that the final element is a form of *dún* "fort" must be regarded as
improbable. While Irish [u:] is often anglicized as [o:], it appears unlikely that it would
develop into the diphthong which is characteristic of the local pronunciation of the place-
name. A possible interpretation of the name is *Bruach Domhain* "deep/steep bank or river
margin". The townland is situated on the east bank of the river Main and one might argue
that its name refers to the steep bank of the river at this point. However, the adjective
*domhain* "deep", while attested as an element in place-names, is not a common one.

Moreover, *bruach* in place-names seems to refer most commonly to an area of land on the edge of a stream or river, rather than to the actual fall to the river, and I am inclined to regard this explanation as somewhat unlikely.

The element *duán* (<*dubhán*) is attested in a number of Irish place-names and can be interpreted as "hook/kidney" (O'Kane 1970, 140). It has been anglicized as *doan* in the name of the townland of Meenadoan in the parish of Inniskeel in Co. Donegal (*ibid.* 96). I would suggest that this is most likely to form the final element of the place-name, but there is some doubt as to the feature to which it refers. *Duán* could conceivably be used to refer to a hook-like or kidney-like feature, perhaps to the bend in the river Main at this point. Otherwise, one might suggest that in its topographical application it could refer to "black soil/land" though this explanation is not found in any of the standard dictionaries. It is also possible that the final element of the place-name could be derived from the personal name *Duán* <*Dubhán* "dark(-haired) person" (Ó Corráin & Maguire 1981, 78) but the exact significance of this element remains uncertain.

| Craigs | Na Creaga |
|---|---|
| D 0308 | "the rocks" |

See parish name

The townland of Craigs was formerly divided into four townlands, the names of which were recorded by Reeves c. 1847 as *Aughnakeely, Groogagh, Carhunny* and *Grannagh* (see parish introduction). *Aughnakeely* is the modern **Aghnakilla** while *Groogagh* may represent the modern **Grouba** (see below). *Grannagh* is written the *halfe Towne of Granagh* in Petty's Down Survey of c. 1657 (*DS (Reg) Ahoghill*) and its name appears to be derived from Irish *Greanach* "place of gravel". The origin of the name *Carhunny* is obscure. It is worth remarking that there is a townland named **Carclunty** which borders the townland of Craigs on the north, and one is inclined to wonder if this was accidentally designated one of "the four towns of Craigs" in 1847. The Down Survey also records the names of two of the former subdivisions of Craigs as *Tanebracke als. Tanaghnabrooke* and *Claskill (DS (Reg.))*. However, in the absence of further evidence, it is impossible to establish reliable Irish forms for these obsolete place-names.

| Crankill | Creamhchoill |
|---|---|
| D 0710 | "wild-garlic wood" |

| | | | |
|---|---|---|---|
| 1. | Balligrawchill | Inq. Ant. (DK) 46 | 1605 |
| 2. | Balligrawchild | CPR Jas I 114a | 1607 |
| 3. | Balligrawchill | Lodge RR 92 Jas I i 300 | 1607 |
| 4. | Ballygranoghill | CPR Jas I 577b | 1624 |
| 5. | Ballegranchill | Inq. Ult. (Antrim) §3, §4 Car. I | 1627 |
| 6. | Crawchill | Colville Doc. | 1628 |
| 7. | Crabchilly | Inq. Ult. (Antrim) §10 Car. I | 1631 |
| 8. | Crankill al. Cramkilly | Lodge RR Geo I & II 67 | 1720 |
| 9. | Crankill or. Cramkilly | Reg. Deeds 245-270-161474 | 1763 |
| 10. | Crankill | Lendrick Map | 1780 |
| 11. | Crankill | Tithe Applot. | 1825 |
| 12. | Crankill | Bnd. Sur. (OSNB) | 1829c |
| 13. | Crankill | OSNB B 35 B 131 | 1830c |

| 14. Creamh-choill "wood of wild | | |
|---|---|---|
| garlic" | J O'D (OSNB) B 35 B 131 | 1830c |
| 15. Creamhchoill "wild garlic wood" | Joyce i 348 | 1869 |
| 16. 'krankil | Local pronunciation | 1987 |

The name of this townland has been correctly interpreted as *Creamhchoill* "wild-garlic wood" (14, 15). The anglicization of Irish medial *-mh-* as [n] or [m] has been discussed above, under the name of the parish of **Cranfield**, which is derived from the same Irish form, as is the name of the townland of **Cranfield** in Co. Down (*PNI* iii 34). Forms 1–3 and 6 show evidence of the pronunciation of *-mh-* as [w], before the sound was anglicized as [n], while forms 8b and 9b appear to show evidence of the anglicization of *-mh-* as [m] (cf. **Drumramer** (<*Droim Ramhar* "broad ridge" in the parish of Ahoghill). It is difficult to account for the medial *-g-* of forms 1–5. A tendency for *c* to develop to *g* has been noted in a number of place-names in this area (see **Gortgarn, Gloonan** above). In this case, the development of *c* to *g* seems to have occurred in the earlier forms due to the influence of the prefix *Bally-* but the exact factors which have led to this are unclear. Whereas in the name of the parish of Cranfield the final element has been anglicized as *field*, in this case Irish *coill* "wood" has been conventionally anglicized as *kill*.

| **Cullybackey** | *Cúil na Baice* | |
|---|---|---|
| D 0705 | "angle/corner of the river bend" | |
| 1. Ballycolinbacky | Inq. Ant. (DK) 46 | 1605 |
| 2. Ballicholnabacky | CPR Jas I 114a | 1607 |
| 3. Ballicholnabacky | Lodge RR Jas I i 300 | 1607 |
| 4. Ballychollnabackie | CPR Jas I 577b | 1624 |
| 5. Ballecollrabaky | Inq. Ult. (Antrim) §3 Car. I | 1627 |
| 6. Ballecollrabacky | Inq. Ult. (Antrim) §4 Car. I | 1627 |
| 7. Calnebackie | Inq. Ult. (Antrim) §10 Car. I | 1631 |
| 8. Culnibackie | Indent. Adair (MacDonnells Ant.) | 1636 |
| 9. Cullybaccy | Exch. Deeds & Wills 492 | 1656 |
| 10. Collibackie | Exch. Deeds & Wills 579 | 1660 |
| 11. Coulnebackie | EP Adair May 2 | 1662 |
| 12. Cullybackey | Grand Jury Pres. 52 | 1713 |
| 13. Cullebacky al. Collngbachy | Lodge RR Geo I & II 67 | 1720 |
| 14. Tullybacky orw. Collnabacky | Reg. Deeds 245-270-161474 | 1763 |
| 15. Cullybackey | Lendrick Map | 1780 |
| 16. Cullybackey | Reg. Deeds 418-547-27308 | 1781 |
| 17. Cullybacky | Tithe Applot. | 1825 |
| 18. Cullybacky | Bnd. Sur. (OSNB) | 1829c |
| 19. Cullybackey | OSNB B 35 B 131 | 1830c |
| 20. Cúil a' bhacaigh "corner of | | |
| the beggar" | J O'D (OSNB) B 35 B 131 | 1830c |
| 21. Coillidhe-bacaigh "the woodland | | |
| of the bacach or cripple, or | | |
| in a secondary sense, a beggar" | Joyce iii 282 | 1913 |
| 22. Coill na Baice | GÉ 73 | 1989 |
| 23. ˌkɔləˈbaːki | Local pronunciation | 1987 |

The previous suggestions that the final element of the place-name is derived from *bacach* "beggar/cripple" (20, 21) must be regarded as unlikely since the medial *-na-* of the majority of the earlier spellings suggests a following feminine noun. A more plausible suggestion is that this element is *baice*, the genitive form of the feminine noun *bac*. Among the definitions of *bac* are "barrier; bend (in river etc)" (*Ó Dónaill* sv.); "a quirk, an angular space, hollow or object; a river turn" (*Dinneen* sv.). According to Joyce, its most common meaning in place-names is "a bend or crook" (*Joyce* iii 56). There are two conspicuous bends on the river Main here, suggesting that in this case "river bend" may be the most appropriate interpretation of *bac*. It is difficult to be certain if the first element of the place-name is *coill* "wood" or *cúil* "corner, nook, angle" since the long [u:] of *cúil* would be shortened in unstressed position. However, since none of the historical spellings represents the first element as *kill-*, which is the usual anglicized form of *coill*, *cúil* must be accepted as the more likely derivation. The most appropriate interpretation of the place-name is, therefore, *Cúil na Baice* "angle/corner of the river bend" perhaps referring to the area of land partially enclosed by the bend in the river.

**Dreen**                                   *Draighean*
D 0405                                      "place of blackthorns"

| | | | |
|---|---|---|---|
| 1. | townland of Ballydreen | Civ. Surv. x §65a | 1655c |
| 2. | Drem Water | Civ. Surv. x §66a | 1655c |
| 3. | Drein | HMR Ant. 158 | 1669 |
| 4. | Dreene | Lodge RR Chas II ii 292 | 1684 |
| 5. | Dreen | Reg. Deeds 10-133-3227 | 1712 |
| 6. | Dreen | Lendrick Map | 1780 |
| 7. | Dreen | Tithe Applot. | 1825 |
| 8. | Dreen | Bnd. Sur. (OSNB) | 1829c |
| 9. | Dreen | OSNB B 35 B 131 | 1830c |
| 10. | Droighin "land producing blackthorn or sloe bushes" | J O'D (OSNB) B 35 B 131 | 1830c |
| 11. | dri:n | Local pronunciation | 1987 |

There is no reason to disagree with O'Donovan's interpretation of the name of this town-land as *Droighin* (>*Draighean*) "land producing blackthorn or sloe bushes" (10). The word *draighean* in Irish signifies a single blackthorn or sloe tree, but is applied by extension to a place abounding in such trees. The reference in c. 1655 to *Drem Water* (2) (*recte Dreen Water*) is clearly to the little stream which forms part of the northern boundary of the townland, which is also the boundary between the baronies of Toome Lower and Kilconway. There is now no trace or record of a blackthorn wood in the townland. There is another townland named **Dreen** in the neighbouring parish of Rasharkin.

**Drumrankin**                             *Droim Rionnagáin*(?)
D 0305                                      "*Rionnagán*'s ridge"

| | | | |
|---|---|---|---|
| 1. | Dromeringan | Lodge RR Chas I i 407 | 1637 |
| 2. | Dromeringane | BSD 135b | 1661 |
| 3. | Ballydramringan | Inq. Ult. (Antrim) §8 Car. II | 1662 |
| 4. | Drumverinyan | Lodge RR Chas II i 106 | 1663 |
| 5. | Ballydrumringan | Lodge RR Chas II i 106 | 1663 |

| | | |
|---|---|---|
| 6. Drumrenkin | HMR Ant. 155 | 1669 |
| 7. Dromeungare | Comm. Grace 10 | 1684 |
| 8. Dromeringane | Lodge RR Chas II ii 292 | 1684 |
| 9. Drumringan | Reg. Deeds 10-133-3227 | 1712 |
| 10. Drumrinkan | Reg. Deeds 90-171-62470 | 1739 |
| 11. Drumrankan | Lendrick Map | 1780 |
| 12. Drumrinkan | Reg. Deeds 636-545-639977 | 1811 |
| 13. Drumrankin | Reg. Deeds 660-290-457358 | 1813 |
| 14. Drumrankin | Tithe Applot. | 1825 |
| 15. Drumrankin | Bnd. Sur. (OSNB) | 1829c |
| 16. Drumrankin | OSNB B 35 B 131 | 1830c |
| 17. Druim Rancáin "Rancan's Ridge" | J O'D (OSNB) B 35 B 131 | 1830c |
| 18. ˌdrọmˈrankən | Local pronunciation | 1987 |

O'Donovan's Irish form i.e. *Druim Rancáin* (*>Droim Rancáin*) "Rancan's Ridge" (17) suggests that the final element is the Irish personal name *Rancán*. While this personal name, along with the derived sept name *Uí Rancáin*, occurs in a pedigree of the *Cenél mBinnigh* (*L. Lec.* 55 rb), a branch of the O'Neills of *Cenél nEógain* who were settled in the modern county of Derry, this interpretation of the final element of the place-name is not supported by the earlier recorded spellings of Drumrankin, all of which suggest that the initial *r* of the first element was followed by an *i* vowel. Interestingly, Ó Ceallaigh (*GUH* 56n) notes a similar vowel in the final element of the name of the townland of **Tamnyrankin** north of Swatragh in Co. Derry, but is still happy to derive this element from the native Irish surname *Ó Rancáin* "Rankin", pointing out that *Rendagán* occurs as an alternative form of *Rancán* in the aforementioned pedigree of the *Cineál Binnigh*. In Mod. Ir. *Rendagán* could take the form *Reannagán* but as *ea* and *io* sometimes interchange (cf. *feannóg/fionnóg* "scald crow"; *greallach/griollach* "quagmire" etc.) it could also take the form *Rionnagán* and it is possible that this is the form which (with loss of the medial *-a-*) is represented by the earlier spellings of the place-name. Irish *Rionnagán* could have been anglicized *-rankin* by analogy with the surname Rankin, which is fairly common in this area. According to MacLysaght (1985, 254), in Derry and the adjacent counties Rankin is the name of a branch of the clan MacLean which came to Ireland during the Plantation of Ulster.

## Dunnygarran
D 0607

*Doire Uí Ghearáin*
"O'Garran's oak-wood"

| | | |
|---|---|---|
| 1. Ballydirryarran | Inq. Ant. (DK) 46 | 1605 |
| 2. Ballidirriarane | CPR Jas I 114a | 1607 |
| 3. Ballidirriarane | Lodge RR Jas I i 300 | 1607 |
| 4. Ballyderyarane | CPR Jas I 577b | 1624 |
| 5. Ballesirryinane | Inq. Ult. (Antrim) §3 Car. I | 1627 |
| 6. Ballesirryanane | Inq. Ult. (Antrim) §4 Car. I | 1627 |
| 7. Derrigarren | Inq. Ult. (Antrim) §10 Car. I | 1631 |
| 8. Dirrygareen | Lodge RR Geo I & II 67 | 1720 |
| 9. Derrygarreen | Reg. Deeds 245-270-161474 | 1763 |
| 10. Dunigerran | Lendrick Map | 1780 |
| 11. Doneygarron | Tithe Applot. | 1825 |
| 12. Dunneygarran | Bnd. Sur. (OSNB) | 1829c |

| | | |
|---|---|---|
| 13. Dunneygarran | OSNB B 35 B 131 | 1830c |
| 14. Dún Uí Ghearáin "O'Gearan's *dún* or fort" | J O'D (OSNB) B 35 B 131 | 1830c |
| 15. ˌdǫniˈgɑːrən | Local pronunciation | 1987 |

The documentary evidence suggests that the first element of this place-name was originally *doire* "oak-wood", rather than *dún* "fort", which is suggested by the modern form and accepted by O'Donovan (14). The *-r-* of *doire* may have developed to *-n-* by dissimilation from the *-r-* of the final syllable. This appears to be a late development, as it is not documented until 1780 (10). It is difficult to be certain about the derivation of the final element of the place-name. The surname *Ó hÁráin* "Haran" which, according to MacLysaght (1985, 146–8) is the name of an erenagh family of Fermanagh, forms the final element of the name of the townland of **Aghyaran** in Co. Tyrone (*GÉ* 4) and also of the village of **Straidarran** in Co. Derry (*ibid.* 160). A possible interpretation of Dunnygarran is, therefore, *Doire Uí Áráin* "Haran's oak wood". One might also consider the form *Doire Uí (Fh)aracháin*, the final element being the genitive form of the surname *Ó (F)aracháin* which is a Donegal surname and can be anglicized *Farran* (Woulfe 1923, 522). However, O'Donovan's suggestion that the final element of the place-name is *Uí Ghearáin*, the genitive form of the surname *Ó Gearáin*, is perhaps the most acceptable. Even though this surname does not appear to be otherwise attested, the final element of the name of the nearby townland of **Lisnagarran** in the parish of Portglenone appears to be the personal name *Gearán*, and it would not be at all surprising if a surname derived from this personal name were to be found in this area. The radical *g* of the final element of the place-name has been restored in the modern form and is documented from 1631 onwards.

**Fenagh**                          *Fionach*
D 0707                              "wooded place"

| | | |
|---|---|---|
| 1. Fenagh | Lodge RR Geo I & II 67 | 1720 |
| 2. Fenagh | Reg. Deeds 245-270-161474 | 1763 |
| 3. Fenagh | Lendrick Map | 1780 |
| 4. Fenagh | Tithe Applot. | 1825 |
| 5. Fenagh | Bnd. Sur. (OSNB) | 1829c |
| 6. Fenagh | OSNB B 35 B 131 | 1830c |
| 7. Fiodhnach "woodland" | J O'D (OSNB) B 35 B 131 | 1830c |
| 8. the Fenagh, that is *Fiodhnach* | PRIA vii 157 | 1862 |
| 9. ðə ˈfenəx | Local pronunciation | 1987 |

The name of this large townland is surprisingly not documented until 1720. However, in spite of the absence of 17th-century forms, it seems safe to accept O'Donovan's suggestion that the place-name is derived from Irish *Fiodhnach* (>*Fíonach*) "wooded place" (7). There is a townland and parish named Fenagh in Co. Leitrim whose name is written *Fiodhnach* in the *Annals of the Four Masters* (*AFM* iii 310) and which, according to Joyce, was wooded as late as the 17th century (*Joyce* i 441).

Reeves has identified this townland name with the final element of the name of a lake referred to in the *Antrim Inquisition* of 1605 as *Lough inchefeaghny*, and goes on to suggest that the name *Lough inchefeaghny* represents Irish *Loch-inse-fiodhnaigh* "lake of the island of

Feenagh" (*PRIA* vii 157). This lake (which has now been drained) formerly had a portion in each of three townlands, i.e. Loughmagarry, Fenagh and Teeshan, and contained a crannog or artificial island, the site of which is in the townland of Teeshan. Reeves's suggestion that the final element of the name of this lake may represent the name of the townland under consideration is at first sight a plausible one. However, it is worth pointing out that Ó Donnchadha has identified a lake named *Loch Innse Fiachna*, mentioned in an early 17th-century poem, with Reeves's *Loch-inse-fiodhnaigh* (*LCABuidhe* 311). The poem is a lament by Lughaidh Ó hEachaidhéin on the death of Shane O'Neill of Shane's Castle (+1617) and in it the poet extols the warlike escapades of the latter, which included the capture of *Loch Innse Fiachna* from Brian Carragh O'Neill (*op. cit.* 158 §21 l.145). "Brian Carragh's Country", which lay on both sides of the Bann, included the (pre-division) parish of **Ahoghill** (see county introduction) and it appears highly likely that the stronghold of Brian Carragh at *Loch Innse Fiachna* is indeed to be identified with the crannog of *Lough inchefeaghny* of the *Antrim Inquisition*. However, the final element of the name of the lake as written in the poem is clearly the personal name *Fiachna*, and the place-name is to be interpreted as "lake of the island of *Fiachna*", rather than "lake of the island of Feenagh", as suggested by Reeves. It is likely, therefore, that the name of the townland of Fenagh is unconnected with the name of the former lake named *Loch Innse Fiachna* and it is a mere coincidence that the name of the townland is similar in sound to the name of the lake.

| **Fenaghy** | *Fionnachadh* | |
|---|---|---|
| D 0603 | "white field" | |
| 1. Funaghie | Inq. Ult. (Antrim) §10 Car. I | 1631 |
| 2. Fenaghy | Lodge RR Geo I & II 67 | 1720 |
| 3. Fenaghy | Reg. Deeds 245-270-161474 | 1763 |
| 4. Finaghey | Lendrick Map | 1780 |
| 5. Fenaghy | Tithe Applot. | 1825 |
| 6. Fenaghy | Bnd. Sur. (OSNB) | 1829c |
| 7. Fenaghy | OSNB B 35 B 131 | 1830c |
| 8. Fionnachadh "fair or white field" | J O'D (OSNB) B 35 B 131 | 1830c |
| 9. 'fenəxi | Local pronunciation | 1987 |

The most satisfactory interpretation of the name of this townland is *Fionnachadh* "white field", as suggested by O'Donovan (8). The prefix *fionn* "white, fair" is a common one in Irish place-names and is found in such names as **Fintona** in Tyrone which is derived from *Fionntamhnach* "white field", **Finglas** near Dublin (<*Fionnghlas* "white/clear stream") and **Finaghy** near Belfast which has the same derivation as the name of this townland (*GÉ* 106).

| **Kildowney** | *Cill Domhnaigh* | |
|---|---|---|
| D 0611 | "Patrician church" | |
| 1. Ballikildoony | Inq. Ant. (DK) 46 | 1605 |
| 2. Ballichildonie | CPR Jas I 114a | 1607 |
| 3. Ballichildonie or Ballikildonie | Lodge RR Jas I i 300 | 1607 |
| 4. Ballichildome | CPR Jas I 577b | 1624 |
| 5. Ballechildony | Inq. Ult. (Antrim) §3 Car. I | 1627 |
| 6. Ballekildony | Inq. Ult. (Antrim) §4 Car. I | 1627 |

| 7. | Kildony | Colville Doc. | 1628 |
|---|---|---|---|
| 8. | Kildony | Inq. Ult. (Antrim) §10 Car. I | 1631 |
| 9. | Killdony | Exch. Deeds & Wills 387 | 1638 |
| 10. | Kildony | Lodge RR Geo I & II 67 | 1720 |
| 11. | Killdony | Reg. Deeds 245-270-161474 | 1763 |
| 12. | Kildowney | Lendrick Map | 1780 |
| 13. | Kildowney | Tithe Applot. | 1825 |
| 14. | Kildowney | Bnd. Sur. (OSNB) | 1829c |
| 15. | Kildowney | OSNB B 35 B 131 | 1830c |
| 16. | Coill Domhnaigh "wood of Sunday" | J O'D (OSNB) B 35 B 131 | 1830c |
| 17. | ˌkɪlˈdəuni | Local pronunciation | 1987 |

O'Donovan's suggestion that the first element of Kildowney is *coill* "wood" (16) rather than *cill* "church" seems plausible. However, since *coill* does not appear to occur in combination with *domhnach* whereas the form *Cill Domhnaigh* is a well attested one in Irish place-names (*Onom. Goed.* 189), it seems safe to accept the latter as the derivation of the place-name. The element *domhnach* is normally interpreted as "Patrician church" and while the tradition that all *domhnach*-named churches were founded by St Patrick himself is open to question, there is no doubt that the element *domhnach* "church" is connected with the earliest period of Christianity in Ireland (Flanagan 1981–2(c) 70). Flanagan (*ibid.*) suggests that it may have originally applied to a parish church and that it came to be superseded by *cill* as the standard ecclesiastical settlement term, partly as a result of the transition in Ireland from an episcopal church to a monastic church. One might suggest, then, that in the place-name *Cill Domhnaigh* the element *cill* may have been prefixed to the name at a later date (possibly in the monastic period), the original name being simply *Domhnach* "Patrician church" or perhaps *Domhnach* followed by another element which has now been lost. It is possible that by the time the element *cill* was prefixed the original meaning of *domhnach* had been lost.

O'Donovan's interpretation of the final element of Kildowney as "Sunday" reflects the meaning of the word *domhnach* in popular usage, a meaning which dates back to the O. Ir. period (*DIL* sv. *domnach*). One might suggest therefore that the name *Cill Domhnaigh* could signify "the church of Sunday", possibly referring to a church visited on Sundays. However, since *domhnach* in townland names is much more frequently attested in the sense of "church" than of "Sunday" (*Joyce* i 319), this suggestion must be the regarded as a less likely one.

The townland of Kildowney contains the site of an ancient graveyard (*O'Laverty* iii 385). A possible link between the church referred to and St Patrick is the fact that the northern section of the neighbouring townland of **Ballywatermoy** was formerly known as *Tullypatrick*, which appears to be derived from Irish *Tulaigh Phádraig* "hill of Patrick".

**Killyless**
D 0206

*Coillidh Leasa*
"wood of the fort"

| 1. | Killelesluan or Killeless, Luan | Lodge RR Chas I i 407 | 1637 |
|---|---|---|---|
| 2. | Ballykilleless | Inq. Ult. (Antrim) §8 Car. II | 1662 |
| 3. | Killeseluan | Lodge RR Chas II i 106 | 1663 |
| 4. | Ballykilleless | Lodge RR Chas II i 106 | 1663 |
| 5. | Killeless | HMR Ant. 155 | 1669 |

| | | |
|---|---|---|
| 6. Killelesscluane | Comm. Grace 10 | 1684 |
| 7. Killelesse, Luane or Killelisluan | Lodge RR Chas II ii 292 | 1684 |
| 8. Killyless | Reg. Deeds 10-133-3227 | 1712 |
| 9. Killelash | Grand Jury Pres. 52 | 1714 |
| 10. Killyless | Reg. Deeds 90-171-62470 | 1739 |
| 11. Killylash | Lendrick Map | 1780 |
| 12. Killeese | Reg. Deeds 636-545-639977 | 1811 |
| 13. Killyless | Tithe Applot. | 1825 |
| 14. Killylass | Bnd. Sur. (OSNB) | 1829c |
| 15. Killyless | OSNB B 35 B 131 | 1830c |
| 16. Coill a' leasa "wood of the fort" | J O'D (OSNB) B 35 B 131 | 1830c |
| 17. Coill-a'-leasa "wood of the *lis* or fort" | Joyce iii 420 | 1913 |
| 18. ˌkɪliˈlɛːʃ | Local pronunciation | 1987 |

In a number of the earlier historical forms, the name of the neighbouring townland of **Loan** has been accidentally attached to the end of this place-name. The previous interpretation of the name as *Coill a' leasa* "wood of the fort" (16, 17) is broadly acceptable, except that the first element is more likely to represent *coillidh*, an oblique form of *coill*. The rendition of the medial vowel of the final element as [ɛː], a sound which is suggested by most of the recorded spellings, may reflect the pronunciation of *ea* before *d, s* and *g* in East Ulster Irish (Holmer 1940, 76). *NISMR* marks one "enclosure" in the townland, no trace of which now remains. There is now no trace or record of a wood in the vicinity.

## Lisnahunshin
D 0007

*Lios na hUinseann*
"fort of the ash-tree"

| | | |
|---|---|---|
| 1. Ballilissnehinchin | Inq. Ant. (DK) 45 | 1605 |
| 2. Ballilissenehinchin or Ballisnehinchine | Lodge RR Jas I i 253 | 1606 |
| 3. Ballilissenehinchin | CPR Jas I 93b | 1606 |
| 4. Ballylisnehinsin | Lodge RR Chas I i 407 | 1637 |
| 5. a hill called Lisnahancon or Tonergy | Civ. Surv. x §66a | 1655c |
| 6. Ballylisnehinsen | BSD 135b | 1661 |
| 7. Ballylissnehunsen | | |
| 8. Ballylisnehunis | Lodge RR Chas II i 106 | 1663 |
| 9. Lisnehusten | HMR Ant. 155 | 1669 |
| 10. Ballylisnehunsin | Comm. Grace 10 | 1684 |
| 11. Ballylisnehunchin | Reg. Deeds 10-133-3227 | 1712 |
| 12. Lisnehunshian | Reg. Deeds 64-326-44070 | 1730 |
| 13. Lisnahunshin | Lendrick Map | 1780 |
| 14. Lisnahunchin | Reg. Deeds 660-290-457358 | 1813 |
| 15. Lisnahuncheon | Tithe Applot. | 1825 |
| 16. Lisnahuncheon | Bnd. Sur. (OSNB) | 1829c |
| 17. Lisnahuncheon | OSNB B 35 B 131 | 1830c |

| | | |
|---|---|---|
| 18. Lios na huinseann (uinnsinne) "fort of the ash trees" | J O'D (OSNB) B 35 B 131 | 1830c |
| 19. Lios-na-huinsinn "fort of the ash-tree" | Joyce iii 479 | 1913 |
| 20. ˌlïsnə'họnʃən | Local pronunciation | 1987 |

There is no reason to disagree with O'Donovan's Irish form of the place-name, i.e. *Lios na hUinseann* (18), though the interpretation of the name as "fort of the ash *trees*" is obviously a mistake for "fort of the ash *tree*". The normal word for ash-tree in Mod. Ir. is *fuinseog*. However, *uinse* is attested as another form of the word (*Dinneen* sv. *uinnse*) and *uinseann* is clearly a genitive form of this, though not recorded as such in the standard dictionaries. The genitive form *uinseann* appears to occur in a number of other northern townland names including **Drumnahunshin,** of which there are two in Armagh and one in Monaghan, **Mullynahunshin** in Fermanagh and **Aghnahunshin** in Monaghan.

A reference to a *hill called Lisnahancon or Tonergy* occurs in a description of the boundary between the baronies of Toome and Kilconway in c. 1655 (*Civ. Surv.* x §66a). *Lisnahancon* clearly represents Lisnahunshin, and the name of the fort has obviously been transferred to the hill on which it stood, the alias name *Tonergy* being apparently the true hill name. There is a prominent hill of 500 feet near the northern boundary of the townland, on the summit of which are the remains of a fort (marked "enclosure" by *NISMR*). The name *Tonergy* is obsolete and it is impossible to suggest a reliable Irish derivation. A tentative suggestion is that the name is an error for *Tonregy* and that it may derive from Irish *Tóin re Gaoith* "backside to the wind" which is fairly common as a place-name and is the origin of the name of the town of **Tandragee** in Co. Armagh (*GÉ* 168).

| **Loan** | *Luan* | |
|---|---|---|
| D 0206 | "haunch-like hill"(?) | |
| 1. Killelesluan or Killelesse, Luan | Lodge RR Chas I i 407 | 1637 |
| 2. KillelessLicane | BSD 135b | 1661 |
| 3. Balleluan | Inq. Ult. (Antrim) §8 Car. II | 1662 |
| 4. Balleluan | Lodge RR Chas II i 106 | 1663 |
| 5. Killeseluan | Lodge RR Chas II i 106 | 1663 |
| 6. Looan | HMR Ant. 155 | 1669 |
| 7. Killelesscluane | Comm. Grace 10 | 1684 |
| 8. Killelesse, Luane or Killelisluan | Lodge RR Chas II ii 292 | 1684 |
| 9. Luan | Reg. Deeds 10-133-3227 | 1712 |
| 10. Luan | Reg. Deeds 242-379-157172 | 1765 |
| 11. Lone | Lendrick Map | 1780 |
| 12. Luan | Reg. Deeds 636-545-669977 | 1811 |
| 13. Loan | Reg. Deeds 660-290-457358 | 1813 |
| 14. Loan | Tithe Applot. | 1825 |
| 15. Loan | Bnd. Sur. (OSNB) | 1829c |
| 16. Loan | OSNB B 35 B 131 | 1830c |
| 17. Lúan "a fat calf" (some prefix omitted) | J O'D (OSNB) B 35 B 131 | 1830c |
| 18. ðə'lo:n | Local pronunciation | 1987 |

O'Donovan's interpretation of the name of this townland as *Lúan* "a fat calf (some prefix omitted)" (17) is not at all convincing. The word *lubhán* (of which *luán* could represent a variant form) is indeed attested in the sense of "a lamb; a fatted lamb or kid" (*Dinneen* sv.) and, in the earlier language, "young of animals; foal; lamb" (*DIL* sv. *lubán*). However, none of the historical forms suggest that the place-name was formerly prefixed by another element, and this proposal must be regarded as unlikely (the prefix *Killeles- et. var.* in a number of forms obviously refers to the neighbouring townland of **Killyless**). One might suggest the Irish form *Leamháin* "elm trees". The name of the townland of Loan in Kilkenny is derived from *Na Leamháin* "the elm trees" (*L. Log. C. Chainnigh* 81) and is locally spelt "Loon" (O'Kelly 1985, 36). However, in the Antrim dialect one would expect either [v] or a diphthong in this word.

The documentary evidence is overwhelmingly in favour of the Irish form *Luan*. Irish *ua(i)* is often anglicized as [o:] (see **Artlone** above) and the historical forms suggest that in this case the development is a fairly recent one. In a discussion of the place-name **Malone** in Belfast, Flanagan proposes the Irish form *Maigh Lón* (*<Luan*) and suggests that the final element may be the word *luan* "haunch/rump/buttock/hip" and that it is used figuratively (in the same way as *lorgain* "shin", *más* "hip/thigh" and *droim* "back") to refer to a feature of the landscape, in this case to the height which is known as "The Malone Ridge" (Uí Fhlannagáin 1970(k), 22). I am inclined to believe that *luan* in this place-name may have similar significance, i.e. "haunch-like hill", and that it applies to the conspicuous hill of 600 feet, known as "Loan Hill", which is situated in the middle of the townland.

**Loughmagarry**
D 0907

*Loch na gCoraí*
"lake of the rocky ridges"

| | | |
|---|---|---|
| 1. Ballilougho Karry | Inq. Ant. (DK) 46 | 1605 |
| 2. Balliloghcarry | Lodge RR Jas I i 300 | 1606 |
| 3. Balliloghcarry | CPR Jas I 114a | 1607 |
| 4. Ballyloghcarey | CPR Jas I 577b | 1624 |
| 5. Balleloghcarry | Inq. Ult. (Antrim) §3 Car. I | 1627 |
| 6. Balleloughcarry | Inq. Ult. (Antrim) §4 Car. I | 1627 |
| 7. Loghnegarrye | McQ. Doc. (MacDonnells Ant.) | 1634 |
| 8. Loghnegary | EP Adair Mar. 12 | 1636 |
| 9. Ballyloghcarry al. Ballyloughnegerry | Lodge RR Chas I ii 40 | 1638 |
| 10. Leaghgarry | Inq. Par. Ant. 85 | 1657 |
| 11. Lochnegarie | EP Adair Sep. 1 | 1658 |
| 12. Ballycloghcarry al. Ballyloghnegarry | Inq. Ult. (Antrim) §1, §3 Car. II | 1661 |
| 13. Loughnagarie | EP Adair Sep. 26 | 1683 |
| 14. Loghnagary | Lodge RR Will. Anne 461 | 1705 |
| 15. Loghnegarry | Lodge RR Geo I & II 67 | 1720 |
| 16. Loghnegarly | Reg. Deeds 345-270-161474 | 1763 |
| 17. Loughnagerry | Lendrick Map | 1780 |
| 18. Loughnagary | Tithe Applot. | 1825 |
| 19. Loughmagarry | Bnd. Sur. (OSNB) | 1829c |
| 20. Loughnmagarry | OSNB B 35 B 131 | 1830c |
| 21. Loughnagarry | O'Laverty iii 393 | 1884 |

| 22. | Loch Meic Gafhraidh |  |  |
|  | "Magarry's Lough" | J O'D (OSNB) B 35 B 131 | 1830c |
| 23. | ˌlɔxməˈɡɑːri | Local pronunciation | 1987 |

While the modern form of the place-name suggests that the final element is the surname "Magarry" as suggested by O'Donovan (22), this explanation is not supported by the documentary evidence. Form 1 suggests a surname with an *Ó* prefix, possibly *Ó Carraigh*, which, according to MacLysaght (1985, 43), is anglicized as "Carry" and belongs mainly to Oriel. However, since this is the only historical form which suggests this interpretation, it hardly constitutes conclusive evidence. It is perhaps more likely that the final element of the place-name is not a surname but a form of the word *cora* "weir, rocky crossing place", which is a common element in place-names and in the north of Ireland is normally anglicized as "carry" (see **Cardonaghy** in the parish of Ahoghill above). Ó Dónaill gives "rocky ridge extending into sea or lake" as one of the meanings of *cora (Ó Dónaill* sv.) and this appears the most appropriate interpretation of the final element of the place-name. The documentary evidence points to an earlier form *Loch Coraí* "lake of the rocky ridges", with a form with similar meaning but containing the definite article, i.e. *Loch na gCoraí*, developing at a later date.

The *OSNB* (B 35 B 131) informs us that in c. 1830 the townland contained a number of small lakes, only one of which remains today. However, it is impossible to tell if this is the lake which gave name to the townland.

**Moboy**
C 9809

*Maigh Buí*
"yellow plain"

| 1. | a wood called Kilmaboy | Inq. Ant. (DK) 43 | 1605 |
| 2. | the causie of Cloghamnaboy | Inq. Ant. (DK) 43 | 1605 |
| 3. | Balliwyboy | Inq. Ant. (DK) 45 | 1605 |
| 4. | Balliwyboy | CPR Jas I 93b | 1606 |
| 5. | Balliwyboy | Lodge RR Jas I i 253 | 1606 |
| 6. | Ballymoboy al. Moyboy | Lodge RR Chas I i 407 | 1637 |
| 7. | Cloghanmoyboge | Civ. Surv. x §65a | 1655c |
| 8. | A cerne called Cloghanmabog | Hib. Reg. Kilconway | 1657c |
| 9. | Ballymoboy als. Moboy | BSD 135b | 1661 |
| 10. | Ballymeghboy | Inq. Ult. (Antrim) §8 Car. II | 1662 |
| 11. | Ballymoboy als. Moyboy | Lodge RR Chas II i 106 | 1663 |
| 12. | Ballymeghboy | Lodge RR Chas II i 106 | 1663 |
| 13. | Meeboy | HMR Ant. 155 | 1669 |
| 14. | Ballymoboy al. Moyboy | Comm. Grace 10 | 1684 |
| 15. | Ballymoyboy al. Moyboy | Reg. Deeds 10-133-3227 | 1712 |
| 16. | Mobuoy | Reg. Deeds 64-326-44070 | 1730 |
| 17. | Moyboy | Lendrick Map | 1780 |
| 18. | Moboy | Tithe Applot. | 1825 |
| 19. | Moboy | Bnd. Sur. (OSNB) | 1829c |
| 20. | Moboy | OSNB B 35 B 131 | 1830c |
| 21. | Magh Buidhe "yellow plain" | J O'D (OSNB) B 35 B 131 | 1830c |
| 22. | Magh-buidhe "yellow plain" | Joyce iii 505 | 1913 |
| 23. | mọˈbɔi | Local pronunciation | 1987 |

The name of this townland has been correctly interpreted by both O'Donovan (21) and Joyce (22) as "yellow plain", though the first element is likely to represent an oblique form of *magh* "plain", i.e. *maigh*. The medial *-w-* of forms 3, 4 and 5 appears to be a scribal error for *-m-*.

In a description of the boundary of the territory of Lower Clandeboy in 1605 we find a reference to *a wood called Kilmaboy* (1) and *the causie of Cloghamnaboy* (2). The prefix *Kil-* in the former obviously represents Irish *coill* "wood", while *Cloghamnaboy* is clearly a mistranscription of *Cloghanmaboy*, the prefix *Cloghan-* representing Irish *clochán* "stepping stones or causeway", a term which is commonly abbreviated to "causie". From the boundary description, it is obvious that the features referred to lay on the northern border of the townland, but there is now no trace of either feature. A map of c. 1657 shows *A Cerne called Cloghanmabog* on the northern boundary of the townland (*Hib. Del.* Kilconway), suggesting that *clochán* in this source was understood as signifying "cairn/heap of stones".

This townland is predominantly a hilly one, there being only one small area of level land in the south.

| **Moylarg** | *Maigh Leargadh* | | |
|---|---|---|---|
| D 0508 | "plain of the slope"(?) | | |
| | | | |
| 1. Meaghlargie | Inq. Ult. (Antrim) §10 Car. I | 1631 | |
| 2. Meaghlergie | Inq. Ult. (Antrim) §10 Car. I | 1631 | |
| 3. Ballymeaghlargie | Inq. Ult. (Antrim) §17 Car. I | 1633 | |
| 4. Moylargg al. Moyghlargy | Lodge RR Geo I & II 67 | 1720 | |
| 5. Moylarg orw. Moighlargy | Reg. Deeds 245-270-161474 | 1763 | |
| 6. Maylorg | Lendrick Map | 1780 | |
| 7. Moylarg | Tithe Applot. | 1825 | |
| 8. Moylarg | OSNB B 35 B 131 | 1830c | |
| | | | |
| 9. Magh Learg "plain of slopes" | J O'D (OSNB) B 35 B 131 | 1830c | |
| 10. Magh-learg "plain of the hill-slopes" | Joyce iii 515 | 1913 | |
| | | | |
| 11. ˌmɔiˈlɑːrg | Local pronunciation | 1987 | |

Both O'Donovan (9) and Joyce (10) suggest a genitive plural form of the final element *learg*, interpreting the place-name as "plain of slopes or the hill-slopes". However, most of the earlier historical forms indicate an extra syllable at the end of the name which has since disappeared and it is more likely that the final element represents *leargadh*, a genitive singular form of *learg*. The element *learg* is widely attested in place-names in the sense of "the side or slope of a hill", and only in the north of Ireland is it found in its oblique form *leargaidh* (*Joyce* i 403). A good example of the latter use of the word is the place-name **The Largy** which is applied to a long sloping area of land south of Portglenone.

It is difficult to identify with certainty the feature which has given name to the townland. The first element may refer to the plain along the river Main which runs into the neighbouring townland of **Ballywatermoy** and which may also be the feature referred to by the final element of the latter place-name. There is no noticeable slope on this plain. There is, however, a prominent hill, known as **Fort Hill** (300 feet) on the bank of the river Main, in the extreme north of the townland, and a less conspicuous hill, known as **Dromona**, in the south. It is worth noting that the word *learg* is attested in Scottish Gaelic in the sense of "little eminence/small hill" (*Dwelly* sv.).

| **Teeshan** | *Taosán*(?) | |
| D 0806 | "muddy/clayey place(?)" | |
| | | |
| 1. Ballytisin | Inq. Ant. (DK) 46 | 1605 |
| 2. Ballitissane | CPR Jas I 114a | 1607 |
| 3. Ballytissane | Lodge RR Jas I i 300 | 1607 |
| 4. Ballytissane | CPR Jas I 577b | 1624 |
| 5. Balletissane | Inq. Ult. (Antrim) §3, §4 Car. I | 1627 |
| 6. Theeson | Deed (O'Shane) | 1631c |
| 7. Tinshane | EP Adair Mar. 12 | 1636 |
| 8. the half quarter of Twishen | Indent. Adair (MacDonnells Ant.) | 1636 |
| 9. Ballytissane | Lodge RR Chas I ii 40 | 1638 |
| 10. Ballytissane | Inq. Ult. (Antrim) §1, §3 Car. II | 1661 |
| 11. the parcel of Tissan | Lodge RR Will. Anne 461 | 1707 |
| 12. Tyson al. Tyson 3 Qrs.+ ½ | Lodge RR Geo I & II 67 | 1720 |
| 13. the parcel of Tyssan | EP Adair Feb. 1 | 1722 |
| 14. Tyson orw. Thyson | Reg. Deeds 245-270-161474 | 1763 |
| 15. Teeshan | Lendrick Map | 1780 |
| 16. Teeshan | Bnd. Sur. (OSNB) | 1829c |
| 17. Teeshan | OSNB B 35 B 131 | 1830c |
| | | |
| 18. Toigh Seaáin "Shane's House" | J O'D (OSNB) B 35 B 131 | 1830c |
| | | |
| 19. 'tiːʃən | Local pronunciation | 1987 |

Since the name of this townland is stressed on the first syllable, rather than on the second, it is most unlikely that it is derived from Irish *Toigh Seaáin* (>*Tigh Sheáin*) "Shane's House" as suggested by O'Donovan (18). The word *taos* in Irish signifies "dough/paste" (*Dinneen* sv.). While it does not appear to be attested in a topographical sense, the phrase *taoisleadh cré* is cited by Ó Dónaill in the sense of "mass of earth" (*Ó Dónaill* sv. *taoisleadh*). There is a townland named Teesan in the parish of Drumcliff in Co. Sligo, the name of which is interpreted by O'Donovan as *Taosán* "muddy ford, name of a ford" (*OSNB* 117 vol. 2 p. 34) and it is likely that the name of our townland goes back to the same Irish form. The anglicization of the medial *s* as *sh* is not suggested by the earliest forms and seems to have grown up in the English dialect of the area. As there is no river of any significance here the place-name may be best interpreted as simply "muddy, clayey place", rather than "muddy ford". The townland is now almost all under cultivation, but the *OS 6-inch* map of 1833 shows the western portion as consisting entirely of bog, while the *OSNB* (B 35 B 131) of c. 1830 comments that a third of the townland at that time consisted of "bog and rough pasture". This townland contains the site of the crannog referred to above in connection with the townland of **Loughmagarry**.

| **Tullaghgarley** | *Tulaigh Ghreallaí* | |
| D 0709 | "hillock of the marsh" | |
| | | |
| 1. Tawnegrallie | Colville Doc. | 1628 |
| 2. Tannaghgrally | Inq. Ult. (Antrim) §10 Car. I | 1631 |
| 3. Tullygrilly al. Tavaghgrilly | Lodge RR Geo I & II 67 | 1720 |
| 4. Tullygrilly al. Tavaghgreely | Reg. Deeds 245-270-161474 | 1763 |
| 5. Tullygrally | Lendrick Map | 1780 |

| | | |
|---|---|---|
| 6. Tullygrawly | Tithe Applot. | 1825 |
| 7. Tullygarley | Bnd. Sur. (OSNB) | 1829c |
| 8. Tullygarley | OSNB B 35 B 131 | 1830c |
| 9. Tullaghgarley | OS Name Sheets | 1832 |
| 10. Tullygrawly | O'Laverty iii 396 | 1851 |
| 11. Tulach Garbhlaigh "rough hill" | J O'D (OSNB) B 35 B 131 | 1830c |
| 12. 'toli'grɔːli | Local pronunciation | 1987 |

O'Donovan's interpretation of this place-name as *Tulach Garbhlaigh* "rough hill" (11) is not supported by the earliest historical forms or by the local pronunciation. The evidence suggests that the place-name is derived from Irish *Tulaigh Ghreallaí* "hillock of the marsh", *tulaigh* being an oblique form of *tulach* "hillock" which forms the first element of the name of the townland of **Tullaghgarley** (< *Tulach Ghreallaí*) in the parish of Ahoghill (see above). The common local rendition of the medial vowel of the final element as [ɔː] is not suggested by any of the historical forms until 1825 (6) and appears to be a fairly recent development, having its origin in the English language. The name of the townland is recorded as *Tullygarley* in the *OSNB* of c. 1830 (8). However, the official spelling which has been adopted, i.e. *Tullaghgarley*, is at odds with the historical spellings and the local pronunciation.

A number of the earlier forms of the place-name suggest that *Tamhnach Ghreallaí* "field of the marsh" was for a time in use as an alternative name for the townland.

OTHER NAMES

**Aghnakilla**          *Achadh na Cille*
D 0408                    "field of the church"

| | | |
|---|---|---|
| 1. Achadh-na-cille | Trias Thaum. 182 col.1n | 1647 |
| 2. townland of Aughnaheely | OSM xxiii 22 | 1835 |
| 3. The Craigs or Aughnakeely | OSM xxiii 50 | 1835 |
| 4. Aughnakeely | EA 89 | 1847 |
| 5. ˌaxnəˈkïlə | Local pronunciation | 1987 |

This name is not recorded on the *OS 1:50,000* map (see *OS 1:10,000* sheet 55). It marks the site of the former parish church of Craigs and is clearly to be identified with *Achadh-na-cille* the name of a church referred to by Colgan in 1647 (see parish introduction).

**Arthur House**          An English form
D 0405

| | | |
|---|---|---|
| 1. 'arθər 'həus | Local pronunciation | 1987 |

This little cottage in the townland of **Dreen** is the ancestral home of Chester Allan Arthur who was born in 1830 in Vermont, USA and who was a Republican President of the United States from 1881 to 1885.

**Colvillestown**          An English form
D 0805

| | | |
|---|---|---|
| 1. 'kɔlvïlzˌtəun | Local pronunciation | 1987 |

Colvillestown is a cluster of houses in the townland of Artibrannan. In c. 1858, a William Colville resided here, and it was noted that the place was "named from Colvilles who have lived here for many years" (*OSRNB*, sheet 32). The surname Colville in this area originated with one Alexander Colville, a Scotsman who came into possession of the Galgorm estate (including the townland of Artibrannan) early in the 17th century and whose descendants held it until it was sold in 1851 by the Commissioners of Encumbered Estates (*O'Laverty* iii 394–6).

| **Dromona House** | A hybrid form | |
|---|---|---|
| D 0508 | | |
| | | |
| 1. drọ'moːna 'hǝus | Local pronunciation | 1987 |

This is the name of a house on the summit of a low, tree-covered ridge. In 1835 it was the residence of William Cunningham (*OSM* xxiii 13). The first element of the place-name appears to represent Irish *Droim Móna* "ridge of the bog/moor". The name has been adopted by the well-known Dromona Creamery, which is situated on the opposite side of the river Main, in the townland of **Dunminning**, parish of Rasharkin.

| **Grouba** | *Gruagach*(?) | |
|---|---|---|
| D 0408 | "place of sedge" | |
| | | |
| 1. (?)Bordell tl. | DS (Reg.) Toome | 1657c |
| 2. (?)Bordell's Town | BSD 148 | 1661 |
| 3. (?)Bordell | ASE 98 a 30 | 1666 |
| 4. (?)Bordell | Hib. Del. Antrim | 1672c |
| 5. (?)Groogagh | EA 89 | 1847 |
| | | |
| 6. ðǝ 'gruːbǝ | Local pronunciation | 1987 |

This is the name of a cluster of houses adjacent to a little hill on the west bank of the river Main, in the townland of **Craigs**. The origin of the name is obscure, but it may represent a development from an earlier form *Groogagh* which is recorded as the name of one of the four townlands of Craigs in 1847 (*EA* 89) and may be derived from Irish *Gruagach* "place of sedge" (see townland of **Craigs** above). One might suggest that the medial -*g*- has developed to -*b*- by the process of dissimilation (see **Ballygrooby** above). *Groogagh*, in turn, appears to correspond with a denomination named *Bordell tl. et. var.* (1–4). However, the two names are obviously linguistically unconnected, and in the absence of further evidence it is pointless to speculate about the origin of *Bordell*.

| **Knockbane** | *Cnoc Bán* | |
|---|---|---|
| D 0208 | "white hill" | |
| | | |
| 1. nɔk'baːn | Local pronunciation | 1987 |

This is a hamlet near the centre of the townland of Craigs.

| **Moorfield** | An English form | |
|---|---|---|
| D 0304 | | |
| | | |
| 1. 'muːrfild | Local pronunciation | 1987 |

This is the name of a house in the townland of Ballyconnelly. It is noted as a "two-storey house" in the *OSRNB* of c. 1858 (sheet 32), and early this century it was the residence of Mr. William Moore J.P. (Shaw 1913, 135). The Moore family were long associated with the linen industry in this area (*loc. cit.*) and it appears likely that it is the surname Moore which is represented in the first element of the place-name.

## Parish of Kirkinriola
### Barony of Toome Lower

| Townlands | | | | Town |
|---|---|---|---|---|
| Ballygarvey | Carnlea | Drumfane | Kirkinriola | Ballymena |
| Bellee | Clinty | Drumfin | Monaghan | |
| Bottom | Clogher | Dunclug | Town Parks | |
| Cabragh | Craigywarren | Dungall | Tullyreagh | |
| | Dernaveagh | Killyflugh | | |

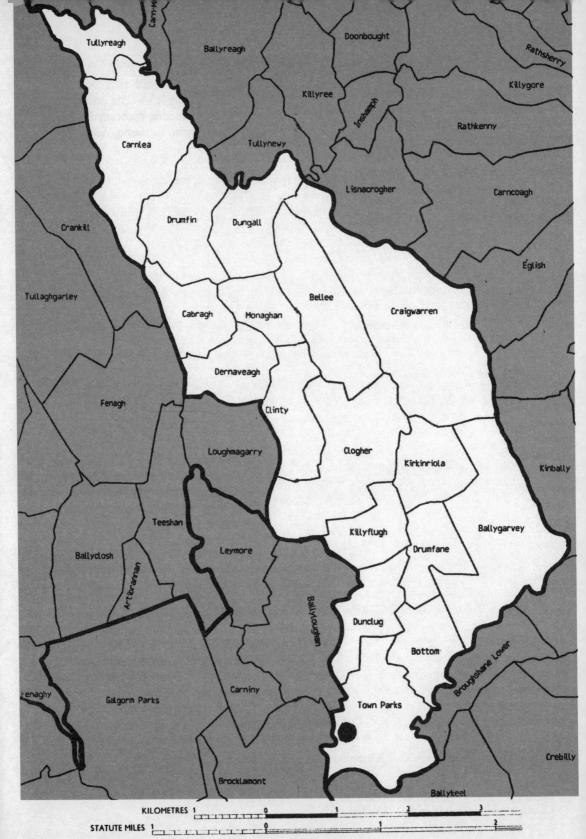

**Parish of Kirkinriola**

214

# PARISH OF KIRKINRIOLA

The civil parish of Kirkinriola or Ballymena consists of 18 townlands and covers an area of some 6,390 acres (*Census 1851*). It lies entirely in the barony of Toome Lower and is bounded on the west by the parishes of Ahoghill and Craigs, on the north by the parish of Grange of Dundermot, on the north-east by the parish of Dunaghy, on the east by the parish of Skerry, on the south-east by the parish of Racavan and on the south by the parish of Ballyclug. The parish takes its name from the townland of the same name, which lies roughly two miles north of the town of Ballymena, and contains an ancient graveyard and the last remnants of the ruins of the former parish church.

The name of the parish is not documented until the year 1584, when it is stated to have been formerly a possession of Muckamore Abbey (*Eccles. Reg.* 35). According to Reeves, the church of Kirkinriola is not referred to in the *Ecclesiastical Taxation* of 1306 either because it was then rated among the possessions of Muckamore Abbey, or because at that time it formed part of the parish of Ahoghill (*EA* 89–90). O'Laverty proposes a connection between the parishes of Ahoghill and Kirkinriola on the grounds that the latter was an appropriation of the Abbey of Muckamore at the time of the dissolution of that monastery in 1542 and that the parish of Ahoghill was dedicated to St Colmanellus, the founder of Muckamore (*O'Laverty* iii 410).

According to the *Terrier* of 1615, the church of *Kiloconrella* "hath no land but 6 acres gleabe . . . Captain Langford hath it" (*Terrier (Reeves)* 65). The *Ulster Visitation* of 1622 remarks: "church of *Killoconriole* decayed. Rectory impropriate to the Abbey of Muckamore, possessed by Sir Hercules Langford Knight" (*Ulst. Visit. (Reeves)* 257). After the dissolution of Muckamore Abbey, its possessions had been granted to Sir Thomas Smith, and subsequently to Sir James Hamilton who, in turn, conveyed them to Sir Robert Langford (*EA* 302). An inquisition of 1657 remarks that "*Kilconreally Grange* is a Rectory Impropriate, anciently belonging to the Abbot of Muckamore, now belonging to Dr. Alex Colvill who enjoyeth all the tythes thereof, great and small. Composed of 14 small townes" (*Inq. Par. Ant.* 62). As stated above, the parish of Kirkinriola now consists of 18 townlands, which suggests that a small number have been sub-divided in the interim period.

In 1765, the *State of the diocese of Connor as per return to the House of Lords* remarks: "Ballymenagh – Rect. – Ld. M'Cashell, Impropriator – Church is in good repair – Curate resides in his Glebe house" (*State Connor*). The church which is here stated to be in good repair was the Church of Ireland church which was built in 1707 in the middle of the town of Ballymena, a much more convenient site than the previous site in the townland of Kirkinriola.

The parish of Kirkinriola lay in the Irish tuogh of *Clanagherty* (see barony introduction). Of the 21 townlands which are listed as making up the territory in 1605 (*Inq. Ant. (DK)* 45–6), seven can be identified with modern townlands in the parish of Kirkinriola, these being Tullyreagh, Clogher, Craigywarren, Drumfin, Drumfane, Ballygarvey and Bellee. The names of the 21 townlands are reproduced, with roughly similar spellings, in a grant of the territory from King James I to Rory Oge McQuillan in 1607 (*CPR Jas I* 114a; *Lodge RR* Jas I i 300); in a grant of half of each townland to William Adair of Kinhilt in Scotland in 1624 (*CPR Jas I* 577b); in an inquisition of 1627 (*Inq. Ult.* §4 Car. I) which confirms that half of each townland was in the possession of William Adair at the time of his death in 1626; and in a conveyance of the same lands to his son Robert Adair in 1627 (*EP Adair* Dec. 27 1627).

In 1636, the latter granted his half of Clanagherty to John Edmonstone, William Houstone and Alexander Adair. The names of the townlands in this grant differ substantially

from those in the earlier lists and are obviously not copies of the earlier forms. Twelve of the 21 names listed can be identified with modern townlands in the parish of Kirkinriola, these being Ballymena (now Town Parks), the half of Cabragh, the half of Drumfin, the half of Dungall, Monaghan, the half of Bellee, Craigywarren, Ballygarvey, Drumfane, Clogher, the half of Killyflugh, the half quarter of Dunclug (*Indent. Adair* (*MacDonnells Ant.*)). In 1638, a grant from King Charles I to the aforesaid Robert Adair contains the same twelve townland names, though Clinty is added to the list (*Lodge RR* Chas I ii 40). An almost identical list of townland names appears in two inquisitions of 1661 which find that at the time of his death in 1661 the same territory was held by William Adair, son of the aforementioned Robert Adair who had been granted it in 1638 (*Inq. Ult.* §1, §3 Car. I).

The *Hearth Money Rolls*, which are such a valuable source of earlier forms of the townland names of the baronies of Toome, are unfortunately of little value for this parish, since individual townland names are not recorded. The entire parish is covered by two rolls each designated *Ballymenock* (representing the town of Ballymena), and two rolls named *Kinhelts Estate* and *Kinhelta Estate* (representing the Ballymena Estate of the Adairs) (*HMR Ant.* 161–2).

The *Ordnance Survey Name Book* for the parish of Kirkinriola (*OSNB* B 37 159), which is dated 1827, is unique within the baronies of Toome in that it contains suggested Irish forms of the place-names not only from the usual authority John O'Donovan, but from Samuel Bryson, a Belfast surgeon who lived from 1778 to 1853. The latter's interpretations are often extremely fanciful, and he is frequently contradicted by O'Donovan, who has added his own (much more plausible) Irish forms at a later date.

Another useful 19th-century source is two articles entitled "Walks About Ballymena", published in the *Ballymena Observer* on Jan. 23 and Feb. 6 1858 (*Walks Ballymena*). The anonymous author gives a suggested interpretation of almost all the townland names, as well as a few historical forms from (unspecified) "ancient records" and useful information about the local topography of each townland.

PARISH NAME

**Kirkinriola**

*Cill Chon Riala*
"*Cú Riala*'s church"

| | | |
|---|---|---|
| 1. Kilconriola | Eccles. Reg. 35 | 1584 |
| 2. Killowan | Mon. Hib. 19 | 1603 |
| 3. Kilocon Reola (or Kilconriola), a chapel called | Inq. Ant. (DK) 46 | 1605 |
| 4. Kilcon-Riola | Inq. Ant. (DK) 49 | 1605 |
| 5. Killocanrally | CPR Jas I 72b | 1605 |
| 6. Killoconriola | Jas I to Connor Cath. 263 | 1609 |
| 7. Killoconrella (Killconreolla), Ecclesia de | Terrier (Reeves) 65 | 1615 |
| 8. Killoconriole, Ecclesia de | Ulster Visit. (Reeves) 257 | 1622 |
| 9. Killaconriola | Ulster Visit. (Reeves) 263 | 1622 |
| 10. Killoconriola | Regal Visit. (PROI) 1 | 1634 |
| 11. Kirkomrelagh | Exch. Deeds & Wills 602 | 1655 |
| 12. Kilconreally Grange | Inq. Par. Ant. 62 | 1657 |
| 13. Killconreallay al. Ballymenagh | Inq. Par. Ant. 85 | 1657 |
| 14. The Parish of Killcunrely | Hib. Reg. Toome | 1657c |
| 15. Kelloconriolla vicaria | Trien. Visit. (Bramhall) 4 | 1661 |

| | | |
|---|---|---|
| 16. Killoconriola | Trien. Visit. (Margetson) 30 | 1664 |
| 17. Killoconriolla | EA 301 | 1666 |
| 18. Kilcouriola | Trien. Visit. (Boyle) 37 | 1679 |
| 19. Killoconriola | EA 301 | 1693 |
| 20. Killieconriola | EA 301 | 1693 |
| 21. Kilconriola | Eccles. Reg. 73 | 1703 |
| 22. Kirkenrelagh | Lodge RR Will, Anne 461 | 1705 |
| 23. the Grange of Killconriola | Reg. Deeds 28-354-17871 | 1720 |
| 24. Grange of Kilconriola, the Church or Chapel of Ballymenagh | Lodge RR Geo I & II 67 | 1720 |
| 25. Kilconriola | Lodge RR Geo I & II 67 | 1720 |
| 26. Kirkinrelagh | EP Adair Feb. 1 | 1722 |
| 27. the Parish of Kirkconriola al. Ballymenagh | Reg. Deeds 43-89-27472 | 1724 |
| 28. Parish of Kilconriola al. Ballymena | EP Adair Nov. 11 | 1737 |
| 29. Killconriola | Reg. Deeds 245-270-161474 | 1763 |
| 30. Ballymenagh, Rect. | State Connor | 1765 |
| 31. Kirkinriola | Lendrick Map | 1780 |
| 32. Kirconriola | EP Adair Feb. 24 | 1807 |
| 33. Kirkinriola | Bnd. Sur. (OSNB) | 1826 |
| 34. Parish of Kilconriola | OSNB B 37 159 | 1827 |
| 35. The Church of Kirconriola, or as it should be correctly written, Kilconriola | O'Laverty iii 410 | 1884 |
| 36. Cill-Coinn-Righ-Uladh "burying place of Con, King of Ulster" | Samuel Bryson (OSNB) B 37 159 | 1827 |
| 37. Cill Conriaghla "St. Curiala's Church" | J O'D (OSNB) B 37 159 | 1827 |
| 38. Cill Conrailgeach "Kilconreelagh", which is probably the origin of the name Killconriola | EA 387 | 1847 |
| 39. "the church of Cu-Riagla" (Hennessy) | O'Laverty iii 411 | 1884 |
| 40. ˌkirkənriˈoːlə | Local pronunciation | 1987 |
| 41. ˌkirkməˈriːli | Local pronunciation | 1987 |

The name of this parish is not documented in any Irish language source and a number of interpretations have previously been suggested. The unanimous explanation of the first element of the place-name as *cill* "church" is clearly correct, since the element has in latter times assumed the form *kirk* (in fact, documented as early as 1655), a Scottish word for church, derived from Norse *kirkja*. Moreover, the townland of Kirkinriola does, indeed, contain the site of an ancient church, referred to above. However, Samuel Bryson's suggestion that the name is derived from Irish *Cill-Coinn-Righ-Uladh* "burying place of Con, King of Ulster" (36) is clearly unacceptable and can immediately be ruled out. Reeves (*EA* 387) suggests the Irish form *Cill Conrailgeach* "*Cu-railgeach*'s church", the final element being a male personal name which occurs in a genealogy of the *Cenél mBinnigh* (*L. Lec.* fol. 56v e 17), a

217

branch of the *Cenél nEógain* who were apparently located in the modern county of Derry. Flanagan (1979(g), 55) accepts that Reeves's interpretation is probably correct, but suggests that some of the earlier spellings may indicate that the final element is a surname, possibly *Ó Conraileach*. While this conclusion may be supported by the presence of a medial -*o*- in many of the earlier recorded spellings, no such surname is otherwise attested. Moreover, place-names which display *cill* "church" followed by a surname are not widely attested and this suggestion must be regarded as unlikely. Reeves's suggested Irish form, i.e. *Cill Conrailgeach* "*Cú Railgeach*'s church" must also be regarded as unsatisfactory, on the grounds that *Railgeach* would not have been pronounced "reelagh" in the Irish of this area or developed into "reely" which is the pronunciation heard among older people today. Nor is any saint of the name *Cú Railgeach* attested.

The personal name *Riaguil* (Mod. Ir. *Riail<Riaghail*) is an early ecclesiastical one, and three saints of the name are recognized, these being St Riaguil mac Búachalla; St Riaguil, abbot of Muccinis on Lough Derg on the Shannon; and St Riaguil of Bangor (Ó Corráin & Maguire 1981, 155). The genitive form of this name forms the final element of the name of the parish of **Tyrella** in Co. Down which is derived from Irish *Tigh Riala* (*Éire Thuaidh*) and signifies "*Riail*'s monastic house". The name *Riail* is derived from Latin *regula* "rule" and means "one who laid down the rule" (i.e. in a monastery). The name *Cú Riagaill* is attested in a genealogy of the Munster tribe the *Eoghanacht* (*CGH* 219), signifying, apparently "hound (i.e. servant or devotee) of *Riail*", and I would suggest that it is this personal name (in the variant form *Cú Riala*) which is represented in the final element of the place-name. In the genitive, this name would assume the form *Con Riala*. O'Donovan's interpretation of the parish name as *Cill Conriaghla* (37) is therefore acceptable, though in standard Irish this would assume the form *Cill Chon Riala* "*Cú Riala*'s church". This is also the interpretation attributed to Hennessy by O'Laverty (39).

<div align="center">TOWNLAND NAMES</div>

**Ballygarvey** — *Baile Mhic Gairbhith*
D 1206 — "MacGarvey's townland"

| | | |
|---|---|---|
| 1. Ballimagarvy | Inq. Ant. (DK) 46 | 1605 |
| 2. Ballimagherry | CPR Jas I 114a | 1607 |
| 3. Ballimaghervy | Lodge RR Jas I i 300 | 1607 |
| 4. Ballymagheriny | CPR Jas I 577a | 1624 |
| 5. Ballemagheroy | Inq. Ult. (Antrim) §3 Car. I | 1627 |
| 6. Ballemagherry | Inq. Ult. (Antrim) §4 Car. I | 1627 |
| 7. Ballinagervy | EP Adair Dec. 14 | 1627 |
| 8. Ballygarvy | Indent. Adair (MacDonnells Ant.) | 1636 |
| 9. Ballygarvy | EP Adair Mar. 12 | 1636 |
| 10. Ballydownefanie al. Ballynegarvy | Lodge RR Chas I ii 40 | 1638 |
| 11. Belligarvie | EP Adair Oct. 23 | 1655 |
| 12. Ballynegarvy | Civ. Surv. x §64a, §65b | 1655c |
| 13. Ballygarvy | Inq. Ult. (Antrim) §1 Car. II | 1661 |
| 14. Ballynegarvy | Inq. Ult. (Antrim) §1, §3 Car. II | 1661 |
| 15. Ballygarvy | EP Adair Dec. 6 | 1681 |
| 16. Ballygarvy | Lodge RR Geo I & II 67 | 1720 |
| 17. Ballyarvey | Reg. Deeds 245-270-161474 | 1763 |
| 18. B:garvey | Lendrick Map | 1780 |
| 19. Ballygarvey | Bnd. Sur. (OSNB) | 1826 |

| | | |
|---|---|---|
| 20. Ballygarvey | OSNB B 37 159 | 1827 |
| 21. Baile Garbhaidh "the Grandson's Townland" | Samuel Bryson (OSNB) B 37 159 | 1827 |
| 22. Baile Uí Ghairbhith "O'Garvey's town" | J O'D (OSNB) B 37 159 | 1827 |
| 23. Baile na Garbh "the rugged townland" or Baile Garbaic "townland of roughness" | Walks Ballymena Jan. 23 | 1858 |
| 24. Baile-Ui-Garbhaigh "O'Garvey's town" | Joyce iii 87 | 1913 |
| 25. ˌbaliˈgɑːrvi | Local pronunciation | 1987 |

The earlier recorded spellings of the name of this townland suggest that it goes back to Irish *Baile Mhic Gairbhith* "MacGarvey's townland", rather than *Baile Uí Ghairbhith* "O'Garvey's town" as has been previously suggested. In a number of the subsequent forms the surname particle *Mac* has been rendered *-na-/-ne-* (cf. **Lismacloskey**, parish of Duneane) while in the later forms it has been entirely discarded. According to Bell (1988, 159), *MacGairbhith* "MacGarvey" is a Donegal surname, derived from the Irish word *garbh* "rough". The name is virtually exclusive to Ulster "where the majority are in Co. Donegal and most of the rest in Co. Derry". The names MacGarvey and MacGarva are also found in Galloway, where they are of Irish origin.

The suggestion in the Ballymena Observer in 1858 that the final element of the place-name is a form of *garbh* "rough" (23) is worthy of consideration, as the *OSNB* of 1827 describes the townland as "half rocky heathy pasture, with portions of turbary". One might suggest the Irish form *Baile na Garbhaí* "townland of the rough land". However, the presence of the medial *-m-* in the earlier spellings appears too constant to be attributed to mere scribal error, and *Baile Mhic Gairbhith* "MacGarvey's townland" must be regarded as the more likely interpretation.

**Bellee**
D 1009

*Baile an Bhealaigh*
"townland of the road/pass"

| | | |
|---|---|---|
| 1. Ballivall | Inq. Ant. (DK) 46 | 1605 |
| 2. Ballivally | CPR Jas I 114a | 1607 |
| 3. Ballivally | Lodge RR Jas I i 300 | 1607 |
| 4. Ballynallye | CPR Jas I 577b | 1624 |
| 5. Ballyvally | Inq. Ult. (Antrim) §3 Car. I | 1627 |
| 6. Ballevally | Inq. Ult. (Antrim) §4 Car. I | 1627 |
| 7. the halfe of Ballye | Indent. Adair (MacDonnells Ant.) | 1636 |
| 8. Bally | EP Adair Mar. 12 | 1636 |
| 9. Ballyvally al. Bally | Lodge RR Chas I ii 40 | 1638 |
| 10. the halfe Towne of Ballie al. Ballinallie | Exch. Deeds & Wills 542 | 1658 |
| 11. Ballyie | Exch. Deeds & Wills 557 | 1660 |
| 12. the half towne land of Ballie | Exch. Deeds & Wills 557 | 1660 |
| 13. Ballyvally al. Bally | Inq. Ult. (Antrim) §1 Car. II | 1661 |
| 14. Ballie | EP Adair Feb. 1 | 1722 |
| 15. parcel of land called the Belly | EP Adair Aug. 16 | 1726 |

| 16. Belly | Lendrick Map | 1780 |
| 17. Belly | Bnd. Sur. (OSNB) | 1826 |
| 18. Bellee | OSNB B 37 159 | 1827 |
| 19. "The Belly" | Walks Ballymena Jan. 23 | 1858 |
| 20. Bileadha "ancient trees" | J O'D (OSNB) B 37 159 | 1827 |
| 21. Biailigh "The Hatchets" | Samuel Bryson (OSNB) B 37 159 | 1827 |
| 22. Bel-lig or Bel lice "the mouth of the river or ford" | Walks Ballymena Jan. 23 | 1858 |
| 23. ðə ˈbɛːli | Local pronunciation | 1987 |
| 24. ðə ˈbaːli | Local pronunciation | 1987 |

None of the previous interpretations of this place-name are supported by the documentary evidence, which points to the Irish form *Baile an Bhealaigh* "townland of the road/pass". The historical forms suggest that the first element of the place-name, i.e. *baile* "townland", gradually dropped out of use, leaving only the final element which was anglicized as "Bally", and later as "Belly". In 1858 the Ballymena Observer remarks that country people generally called the townland "The Belly" and supposed it was so named because it lies in a hollow (*Walks Ballymena* Jan. 23 1858).

There is now no trace or tradition of an ancient roadway in the townland, but the modern road which passes the site of the ancient church in the townland of Kirkinriola also runs almost the full length of the townland of Bellee, and it is possible that it follows the course of a former primitive road or pass. There is a townland named **Ballyvally** in the parish of Clonallan in Co. Down, the name of which is also derived from *Baile an Bhealaigh* "townland of the path/pass" (*PNI* i 63).

The choice of "Bellee" as the official spelling of the name of this townland in 1827 is surprising, in view of the fact that this orthography is not documented in any pre-Ordnance Survey source.

**Bottom**     An English form
D 1204

| 1. the lands of Bottome | Reg. Deeds 37-489-23607 | 1722 |
| 2. parcel of land in Bottom | EP Adair May 3 | 1734 |
| 3. Botum | EP Adair May 21 | 1740 |
| 4. Bottom | EP Adair Dec. 28 | 1753 |
| 5. Bottom | Bnd. Sur. (OSNB) | 1826 |
| 6. Bottom | OSNB B 37 159 | 1827 |
| 7. Bot-nam "The Fire Cave" | Samuel Bryson (OSNB) B 37 159 | 1827 |
| 8. It is English | J O'D (OSNB) B 37 159 | 1827 |
| 9. ˈbɔːtəm | Local pronunciation | 1987 |

The name of this townland has been fancifully and erroneously interpreted by Samuel Bryson as *Bot-nam* "the fire cave" (7). In fact, it is one of the very small number of townland names in the baronies of Toome which have their origin in the English language. In 1858 the *Ballymena Observer* remarks:

The lands, for the most part, slope down to the margin of the Braid river . . . They are, to some extent, subject to inundation, and, throughout the country, such premises are frequently called a "bottom" of land (*Walks Ballymena* Jan. 23 1858).

The name of the townland is not documented until 1722, which suggests that it may have previously formed part of a neighbouring townland, or perhaps the land, being extremely poor, was regarded as lying outside the townland network.

**Cabragh**　　　　　　　　　　　　　　*An Chabrach*
D 0808　　　　　　　　　　　　　　　"the rough/bad land"

| | | |
|---|---|---|
| 1. ½ Ballycabragh | Colville Doc. | 1628 |
| 2. Cabbra | Inq. Ult. (Antrim) §10 Car. I | 1631 |
| 3. the half of Cabragh | Indent. Adair (MacDonnells Ant.) | 1636 |
| 4. Cobraghe | EP Adair Mar. 12 | 1636 |
| 5. Ballynecabragh al. Ballynecabra | Lodge RR Chas I ii 40 | 1638 |
| 6. Ballynecabragh al. Ballynecabra | Inq. Ult. (Antrim) §1, §3 Car. II | 1661 |
| 7. Cabrough | EP Adair Dec. 6 | 1681 |
| 8. Cabroch | Reg. Deeds 37-489-23607 | 1722 |
| 9. ½ tl. of Cabroch | EP Adair June 25 | 1735 |
| 10. Cabra | Reg. Deeds 245-270-161474 | 1763 |
| 11. Cabragh | Lendrick Map | 1780 |
| 12. Cabra | Bnd. Sur. (OSNB) | 1826 |
| 13. Cabragh | OSNB B 37 159 | 1827 |
| 14. Cabraigh "Deer's Horns (a place where they were found)" | Samuel Bryson (OSNB) B 37 159 | 1827 |
| 15. Cabrach "rubbish, bad land" | J O'D (OSNB) B 37 159 | 1827 |
| 16. Cabrac "belonging to the Goats" | Walks Ballymena Jan. 23 | 1858 |
| 17. ðə ˈkaːbrə | Local pronunciation | 1987 |

The documentary evidence for the name of this townland is quite consistent, and the name is clearly derived from the Irish word *cabrach*, as suggested by O'Donovan (15). The townland name Cabragh is found throughout Ireland, but it is more common in the north than in the south. According to Joyce, it is "everywhere understood to mean bad, rough, unprofitable land" (*Joyce* iii 155). The word is not found in this sense in any of the standard dictionaries. It does not appear at all in Dinneen's dictionary, while Ó Dónaill cites it as a collective noun meaning "poles, rafters" and also in the sense of "pole, structure, hut; copse" (*Ó Dónaill* sv.). Dwelly gives: "deer, stag; copse, thicket; timber-moss". He also gives the adjective *cabrach* signifying "of, or belonging to, poles, rafters, or antlers. 2. branchy, branching" (*Dwelly* sv.). One of the Scottish meanings of *cabrach* i.e. "of, or belonging to, antlers" is no doubt the basis of Bryson's interpretation of the place-name as "Deer's Horns (a place where they were found)" (14), while the *Ballymena Observer*'s explanation of the name as "belonging to the Goats" (16) appears to be connected with another Scottish meaning of *cabrach* i.e. "deer, stag". It is clear, however, that neither of these suggestions provides the true explanation of this townland name.

The most satisfactory interpretation of the place-name is "rough, unprofitable land", which is the significance of the names of the townlands of **Cabragh** in the parishes of Clonallan and Clonduff in Co. Down (*PNI* i 66; iii 83). The local understanding of *cabrach* as "rough, unprofitable land" referred to by Joyce (*loc. cit.*) seems likely to be derived from the original meaning of "poles" etc., which has come to be applied to a copse or thicket, and also to rough, unprofitable land, covered with brushwood and undergrowth. The *Ballymena Observer* remarks that in 1858 the townland was generally called "*The* Cabragh" and was

made up of hill and bog, the former being previously covered with bushes (*Walks Ballymena* Jan. 23 1858). There is still an area of bog in the west of this townland.

Forms 5 and 6 point to the presence of the Irish definite article and for this reason *An Chabrach* is recommended as the most satisfactory Irish form of the place-name.

| | | | |
|---|---|---|---|
| **Carnlea** | | *An Carn Liath*(?) | |
| D 0711 | | "the grey cairn" | |
| 1. Carrowlea | | Inq. Ult. (Antrim) §10 Car. I | 1631 |
| 2. Carnelea | | Lodge RR Geo I & II 67 | 1720 |
| 3. Carnlea | | Reg. Deeds 43-89-27472 | 1724 |
| 4. Cornelea | | Reg. Deeds 245-270-161474 | 1763 |
| 5. Carnelea | | Lendrick Map | 1780 |
| 6. Carnlea | | Bnd. Sur. (OSNB) | 1826 |
| 7. Carnlea | | OSNB B 37 159 | 1827 |
| 8. Carn Liath "Grey Carn" | | J O'D (OSNB) B 37 159 | 1827 |
| 9. Carn-Liath "the grey cairn or the old man's cairn" | | Samuel Bryson (OSNB) B 37 159 | 1827 |
| 10. Carnliath "the heap of grey stones" | | Walks Ballymena Jan. 23 | 1858 |
| 11. 'karn'li: | | Local pronunciation | 1987 |

The name of this townland is likely to go back to Irish *An Carn Liath* "the grey cairn". The form *Carrowlea* (1) appears to suggest that the first element of the place-name is *ceathrú* "quarter". However, since this spelling is unique to form 1 and since there is evidence of a former cairn in the townland, *carn* "cairn" is the more likely interpretation. The *OSRNB* (sheet 26) informs us that in c. 1858 there was in the townland a

> Conical mound of rocks – on its summit, remains of an ancient cairn, much defaced, diameter measuring 4 ft. x 1 ft. and commanding the highest elevation within the townland. Several antiquaries have visited the cairn, and it is said that the townland is named from it.

This is clearly the feature which is marked "Carnlea" in Old English letters on the OS *1:10,000* map (sheet 55) and as a "mound or enclosure" by *NISMR*, but all trace of which has now disappeared.

One might consider the possibility that the final element of the place-name may be derived from the word *lao* "calf". The place-name *Carn Laoigh* (>*Carn Lao*) "cairn of the calf" is attested in the 12th-century *Book of Leinster* and has been tentatively identified by Hogan with the townland of **Carnalea** in the parish of Bangor, Co. Down (*Onom. Goed.* 162). However, while this interpretation cannot be ruled out, the fact that the element *carn* is very commonly qualified by colours in townland names means that *liath* "grey" must be regarded as the more likely derivation.

In 1858 the *Ballymena Observer* remarks:

> The entire townland may be regarded as a well-defined natural tumulus of a conical shape, dotted all over with large, grey, lichen-clad stones; and hence the people of the neighbourhood frequently speak of it as "The Cairn" or "Carn" (*Walks Ballymena* Jan. 23 1858).

It is surprising that the name of this large townland appears in only one 17th-century source. A number of early 17th-century sources list a now-obsolete townland named *Ballydromnedarragh* which appears to have been in the vicinity of Carnlea or may even represent all or a portion of the modern townland. The name *Ballydromnedarragh* appears to represent Irish *Droim na Darach* "ridge of the oak tree" (assuming that the prefix *Bally-* is in this case unhistorical) and the name could refer to one of several ridges in the townland.

| **Clinty** | *Na Cluainte* | |
|---|---|---|
| D 1007 | "the meadows" | |
| 1. Clontyconnellagh al. | | |
| Clonticonnelle | Lodge RR Chas I ii 40 | 1638 |
| 2. the parcel of land called | | |
| Clonticonnell | Exch. Deeds & Wills 572 | 1660 |
| 3. Clonteconnelleighe al. | | |
| Clonteconnelle | Inq. Ult. (Antrim) §1 Car. II | 1661 |
| 4. Clonteconnelagh al. | | |
| Clonteconnelle | Inq. Ult. (Antrim) §3 Car. II | 1661 |
| 5. Clinticonnell | EP Adair June 27 | 1683 |
| 6. Clinticonell | EP Adair Dec. 28 | 1753 |
| 7. Clonteconnell | Reg. Deeds 245-270-161474 | 1763 |
| 8. Clinty | Lendrick Map | 1780 |
| 9. Clinty | Bnd. Sur. (OSNB) | 1826 |
| 10. Clentagh | Comm. Inq. Irish Educ. | 1826c |
| 11. Clinty | OSNB B 37 159 | 1827 |
| 12. Claon-tigh "The Crooked House" | Samuel Bryson (OSNB) B 37 159 | 1827 |
| 13. Cluainte "lawns or meadows" | J O'D (OSNB) B 37 159 | 1827 |
| 14. Claentig "a sloping place or | | |
| sloping places" | Walks Ballymena Jan. 23 | 1858 |
| 15. Cluainte "meadows" | Joyce i 236 | 1869 |
| 16. 'klïnti | Local pronunciation | 1987 |

The name of this townland is clearly derived from the Irish word *cluainte* "meadows" as suggested by O'Donovan (13) and Joyce (15). The element *cluainte* is often anglicized as "Cloonty", which is the name of five townlands, but in Ulster it is occasionally rendered "Clinty" (*Joyce* i 236). The earlier spellings indicate that *cluainte* was formerly qualified by another element, which has now been lost. In the absence of knowledge of the pronunciation of this element, it is impossible to identify it with any degree of certainty. One might suggest that it could represent *Conallaigh*, the genitive of *Conallach* "Donegal man" but this suggestion can only be regarded as speculative. The *OSNB* of 1827 remarks that at that time roughly half of the townland was heathy and mountain pasture (*OSNB* B 37 159).

| **Clogher** | *Clochar* | |
|---|---|---|
| D 1006 | "stony place" | |
| 1. Balliclogher | Inq. Ant. (DK) 46 | 1605 |
| 2. Balliclogher | CPR Jas I 114a | 1607 |
| 3. Balliclogher or Ballicloghet | Lodge RR Jas I i 300 | 1607 |
| 4. Ballyclogher | CPR Jas I 577b | 1624 |

| | | |
|---|---|---|
| 5. Balleclogher | Inq. Ult. (Antrim) §3, §4 Car. I | 1627 |
| 6. Clogher | Indent. Adair (MacDonnells Ant.) | 1636 |
| 7. Clogher | EP Adair Mar. 12 | 1636 |
| 8. the Towne Lande of Cloghir | Exch. Deeds & Wills 608 | 1655 |
| 9. the Towne Lande of Cloghart | Exch. Deeds & Wills 572 | 1660 |
| 10. Ballyclogher | Inq. Ult. (Antrim) §1, §3 Car. II | 1661 |
| 11. part of Clogher | Reg. Deeds 37-489-23607 | 1722 |
| 12. Clogher | Reg. Deeds 245-270-161474 | 1763 |
| 13. Clogher | Bnd. Sur. (OSNB) | 1826 |
| 14. Clogher | OSNB B 37 159 | 1827 |
| | | |
| 15. Clochar "a stony place" | J O'D (OSNB) B 37 159 | 1827 |
| 16. Clock "The Golden Stone" | Samuel Bryson (OSNB) B 37 159 | 1827 |
| 17. Clochar "a stony place" | Walks Ballymena Jan. 23 | 1858 |
| | | |
| 18. 'klɔxər | Local pronunciation | 1987 |

The name of this townland has been correctly interpreted by O'Donovan as *Clochar* "a stony place" (15). The *OSNB* of 1827 describes the townland as "chiefly arable, with portion of rocky pasture and turbary" (*OSNB* B 37 159), while the *Ballymena Observer* describes the terrain as being "for the most part a hill of basaltic rock, with a slight covering of soil – no evidence of Clogher nuggets!" (*Walks Ballymena* Jan. 23 1858), the latter remark being clearly a reference to Bryson's interpretation of the place-name as *Clock* (*recte Cloch óir*) "The Golden Stone" (16). There is a large quarry on the boundary between this townland and the neighbouring townland of Clinty. Clogher is a common townland name, there being in all 35 townlands so-named, scattered thoughout Ireland.

**Craigywarren**
D 1109

*Creag Bharráin*
"*Barrán*'s rock/rocky hill"

| | | |
|---|---|---|
| 1. a rock called Criggburran | Inq. Ant. (DK) 45 | 1605 |
| 2. the rocks of Crigburran | Lodge RR Jas I i 254 | 1606 |
| 3. Ballicrighbarrane | CPR Jas I 114a | 1607 |
| 4. the rock Criburrane | CPR Jas I 114a | 1607 |
| 5. Ballycrighbarrane | Lodge RR Jas I i 300 | 1607 |
| 6. Ballycrigbarran | CPR Jas I 577b | 1624 |
| 7. Ballecriggbarrane | Inq. Ult. (Antrim) §3 Car. I | 1627 |
| 8. Ballecragbarrane | Inq. Ult. (Antrim) §4 Car. I | 1627 |
| 9. Ballicraggebarrane | EP Adair Dec. 14 | 1627 |
| 10. Cragewarrin | Indent. Adair (MacDonnells Ant.) | 1636 |
| 11. Craigevaren | EP Adair Mar. 12 | 1636 |
| 12. Ballycrygybarren al. Ballygreegyvarran | Lodge RR Chas I ii 40 | 1638 |
| 13. Cregwarren | Civ. Surv. x §64a | 1655c |
| 14. Cregaveiran | Exch. Deeds & Wills 512 | 1656 |
| 15. Craigevarran | Exch. Deeds & Wills 529 | 1658 |
| 16. Ballyerggrebarren al. Cregiewarrane | Exch. Deeds & Wills 542 | 1658 |
| 17. Ballycrygbarran al. Ballycreegyvarran | Inq. Ult. (Antrim) §1 Car. II | 1661 |

| | | |
|---|---|---|
| 18. Cregyvarrane | Inq. Ult. (Antrim) §1 Car. II | 1661 |
| 19. Ballycreegyburran | Inq. Ult. (Antrim) §3 Car. II | 1661 |
| 20. Ballycreegyvarran | Inq. Ult. (Antrim) §3 Car. II | 1661 |
| 21. Craiggawarrand | EP Adair Dec. 6 | 1681 |
| 22. quarterland of Craigawarane | EP Adair May 6 | 1696 |
| 23. Craigwarren | Reg. Deeds 37-489-23607 | 1722 |
| 24. Craigywarrin | Lendrick Map | 1780 |
| 25. Craigwarren | Bnd. Sur. (OSNB) | 1826 |
| 26. Craigywarren | OSNB B 37 159 | 1827 |
| 27. Craig a waran "The Fresh Water Rock" or Craig a Fairin "the rock of the multitude" | Samuel Bryson (OSNB) B 37 159 | 1827 |
| 28. "It means a rocky warren" | J O'D (OSNB) B 37 159 | 1827 |
| 29. Craig an barain "the Baron's rocks" or Craig Uaran "rock of fresh water" | Walks Ballymena Jan. 23 | 1858 |
| 30. ˌkreːgiˈwarən | Local pronunciation | 1987 |

None of the previously suggested interpretations of this place-name are supported by the documentary evidence. While the first element is obviously *creag* "rock/rocky hill", the earlier recorded spellings show that the initial letter of the final element was originally *b* and this rules out the suggestion that it represents Ir. *uarán* "spring/fountain" (27a, 29b) or *Fairin* (<*Foireann*) "multitude" (27b) as well as O'Donovan's suggestion that it is the English word "warren" (28). The representation of the first vowel in the final element as *-u-* in a number of the recorded spellings appears to be a scribal error for *-a-* and the most satisfactory interpretation of the place-name is *Creag Bharráin* "Barrán's rock". According to Ó Corráin & Maguire (1981, 29), the personal name *Barrán* is a diminutive of the name *Barr* "tip, point, top", and is the name of the father of the wife of the warrior *Caílte* in the Finn cycle of tales.

The surname *Ó Bearáin*, which is anglicized "Barron", is described by Woulfe (1923, 435) as "an old surname in Thomond and Tirconnell". The *Uí Bhearráin* are also listed as a family of the *Dál Fiatach* of Co. Down (*Descendants Ir* 88). "Barron" can also represent an anglicized form of *Mac Barúin*, a branch of the O'Neills in Armagh and Louth, while MacBarron is a Scottish surname, popular in Angus and Inverness (Bell 1988, 13–14). An individual named Phelim Barron was residing in the parish of Finvoy in the neighbouring barony of Kilconway in 1669 (*HMR Ant.* 80a). However, none of the earlier recorded spellings provide any evidence that the final element of the place-name is a surname, and it seems safe to conclude that we are dealing with the Irish personal name *Barrán*.

In 1607 a description of the boundary of the tuogh of Clanagherty informs us that the boundary runs "by the E. and N. foot of the rock *Criburrane*" (*CPR Jas I* 114a). This appears to refer to the rocky hill of roughly 500 feet, known as **Priest Hill**, in the north-east of the townland and this may be the feature which has given rise to the place-name. There is another rocky hill near the little hamlet of Craigywarren.

| | | |
|---|---|---|
| **Dernaveagh** | *Dún na bhFiach* | |
| D 0907 | "fort of the ravens" | |
| 1. the ½ of Donaveagh | Indent. Adair (MacDonnells Ant.) | 1636 |
| 2. Doneveagh | EP Adair Mar. 12 | 1636 |

| | | |
|---|---|---|
| 3. Duneveagh | Lodge RR Chas I ii 40 | 1638 |
| 4. the parcel of land or the halfe towneland called Duneveagh | Exch. Deeds & Wills 572 | 1660 |
| 5. the halfe-towne or parcell of Land of Duniveigh | Exch. Deeds & Wills 595 | 1660 |
| 6. Duneveagh | Inq. Ult. (Antrim) §1, §3 Car. II | 1661 |
| 7. Duniveagh | EP Adair Sep. 26 | 1683 |
| 8. Dinniveigh | Lodge RR Will, Anne 461 | 1705 |
| 9. Dirneveach | EP Adair June 1 | 1709 |
| 10. Drinevagh | Lodge RR Geo I & II 67 | 1720 |
| 11. Driniveagh | Reg. Deeds 37-489-23607 | 1722 |
| 12. Doinneveagh | EP Adair Feb. 1 | 1722 |
| 13. Duneveagh | EP Adair Dec. 10 | 1723 |
| 14. Dinneveagh | EP Adair Feb. 8 | 1733 |
| 15. Drunveagh | Reg. Deeds 245-270-161474 | 1763 |
| 16. Dirniveagh | Lendrick Map | 1780 |
| 17. Dernaveagh | Bnd. Sur. (OSNB) | 1826 |
| 18. Dernaveagh | OSNB B 37 159 | 1827 |
| | | |
| 19. Durnabhfiadhbhiathack "stronghold of the wild beasts" | Samuel Bryson (OSNB) B 37 159 | 1827 |
| 20. Doire na bhFiadh "oak-wood of the deer" | J O'D (OSNB) B 37 159 | 1827 |
| 21. Doire na bfeadh "the oak (or ash) wood" | Walks Ballymena Feb. 6 | 1858 |
| 22. Doire-na-bhfiadh "oak-wood of the deer" | Joyce iii 290 | 1913 |
| | | |
| 23. ˌdɛrnəˈvɛː | Local pronunciation | 1987 |

The documentary evidence suggests that the modern version of this place-name is a corruption of an earlier form *Doneveagh*. The initial element of the name is therefore likely to be *dún* "fort", rather than *doire* "oak-wood", as suggested by most of the previous investigators. It is interesting that the historical forms of the name of the townland of **Dunnygarran** in the neighbouring parish of Craigs show an opposite development, the earlier forms suggesting Irish *doire* and the later forms suggesting *dún*. The most satisfactory interpretation of Dernaveagh is *Dún na bhFiach* "fort of the ravens". There were formerly two "enclosures" in the townland (*NISMR*), but it is impossible to tell which (if any) of these is the feature which gave rise to the townland-name.

| **Drumfane** | *Dún Fiann* | |
|---|---|---|
| D 1105 | "fort of the *Fianna*" | |
| 1. Balledownefaine | Inq. Ant. (DK) 46 | 1605 |
| 2. Ballidownefiane | CPR Jas I 114a | 1607 |
| 3. Ballidownefiane | Lodge RR Jas I i 300 | 1607 |
| 4. Ballydonnefrane | CPR Jas I 577b | 1624 |
| 5. Balledownsiand | Inq. Ult. (Antrim) §3 Car. I | 1627 |
| 6. Balledownesyand | Inq. Ult. (Antrim) §4 Car. I | 1627 |
| 7. Ballydownefyand | EP Adair Dec. 14 | 1627 |
| 8. Downfean | Indent. Adair (MacDonnells Ant.) | 1636 |

| | | |
|---|---|---|
| 9. Dunefean | EP Adair Mar. 12 | 1636 |
| 10. Ballydonefanie al. Ballynegarvy | Lodge RR Chas I ii 40 | 1638 |
| 11. Dumfean, Downfean | Exch. Deeds & Wills 512 | 1655 |
| 12. Dumphien | EP Adair Oct. 23 | 1655 |
| 13. Downfiane | Exch. Deeds & Wills 542 | 1658 |
| 14. Towne Land of Duniefraine | Exch. Deeds & Wills 542 | 1658 |
| 15. Downfiane | Inq. Ult. (Antrim) §1 Car. II | 1661 |
| 16. Ballydownefiane | Inq. Ult. (Antrim) §1, §3 Car. II | 1661 |
| 17. Drumfain | EP Adair Dec. 6 | 1681 |
| 18. Dunfean | Lodge RR Will, Anne 461 | 1705 |
| 19. Donfoan | Lodge RR Geo I & II 67 | 1720 |
| 20. Dunfean | Reg. Deeds 37-489-23607 | 1722 |
| 21. Drumfane | Lendrick Map | 1780 |
| 22. Dunfane | EP Adair Feb. 24 | 1807 |
| 23. Drumfane | Bnd. Sur. (OSNB) | 1826 |
| 24. Drumfane (called); Dunfane (gen. in deeds) | OSNB B 37 159 | 1827 |
| 25. Druim Favin "the sloping side of a ridge" | Samuel Bryson (OSNB) B 37 159 | 1827 |
| 26. Druim Fáin "sloping ridge" | J O'D (OSNB) B 37 159 | 1827 |
| 27. Dún feinne "fort of the Fenii" | Walks Ballymena Feb. 6 | 1858 |
| 28. Dun-na-Feinne "the fort of the Fenians" | O'Laverty iii 412 | 1884 |
| 29. drọm'fe:n | Local pronunciation | 1987 |

The earlier spellings suggest that the first element of the name was originally *dún* "fort" rather than *droim* "ridge" as suggested by the modern version. Flanagan (1980–1(a), 18) points out that in Co. Antrim when *dún* is seen to apply to a ring fort the latter feature is often situated in a commanding position and it is not uncommon for *droim* "ridge" and *dún* "fort" to interchange in earlier documentation, the element *dún* referring to the fort itself and *droim* referring to the ridge on which it was located. She cites Drumfane as an example, quoting the form *Balledownefaine* (1). In fact, the element *dún* in this place-name appears to refer not to a ring fort but to the very prominent motte-and-bailey, commonly known as Drumfane Motte (formerly in this townland, but which an alteration in townland boundaries has left just inside the boundary of the townland of Ballygarvey). Nonetheless, it appears likely that the motte was constructed on the site of an earlier Irish fort and that the name was transferred from the earlier to the later settlement. This opinion is supported by the fact that the final element of the place-name is *Fiann*, the genitive of *Fianna*, signifying the warriors of the mythological hero Finn McCool. Moreover, there is archaeological evidence that the motte was constructed on the site of a pre-existing settlement (*PSAMNI* 27). It is situated on a low ridge, which would support Flanagan's suggestion that *dún* "fort" and *droim* "ridge" may have formed alternative first elements of the place-name, though the use of *droim* as the first element of the name is not documented until 1681(17).

Writing in 1647, Colgan remarks that the nearby valley of the Braid was at an early date known as *Gleann-fada-na-feine* i.e. "the long valley of the *Fianna*" (*Trias Thaum.* 183 col.1n), while the name of the townland of **Tobernaveen** in the parish of Grange of Shilvodan is derived from Irish *Tobar na bhFiann* "well of the *Fianna*".

**Drumfin**
D 0810

*Droim Fionn*
"white ridge"

| | | |
|---|---|---|
| 1. Ballidromyn | Inq. Ant. (DK) 46 | 1605 |
| 2. Ballidromine | CPR Jas I 114a | 1607 |
| 3. Ballydromine | Lodge RR Jas I i 300 | 1607 |
| 4. Ballydromine | CPR Jas I 577b | 1624 |
| 5. Balledromny | Inq. Ult. (Antrim) §3 Car. I | 1627 |
| 6. Baldromny | Inq. Ult. (Antrim) §4 Car. I | 1627 |
| 7. Ballydromine | EP Adair Dec. 14 | 1627 |
| 8. Drompline | Inq. Ult. (Antrim) §10 Car. I | 1631 |
| 9. Dromyne | Indent. Adair (MacDonnells Ant.) | 1636 |
| 10. Ballydromyn | Lodge RR Chas I ii 40 | 1638 |
| 11. Drumine | Exch. Deeds & Wills 557 | 1660 |
| 12. Dromfine | Exch. Deeds & Wills 572 | 1660 |
| 13. Balleydromin | Inq. Ult. (Antrim) §1 Car. II | 1661 |
| 14. Ballydromin | Inq. Ult. (Antrim) §3 Car. II | 1661 |
| 15. Drumfine | Lodge RR Geo I & II 67 | 1720 |
| 16. Drumfinn | EP Adair Feb. 1 | 1722 |
| 17. Drumfine | Reg. Deeds 245-270-161474 | 1763 |
| 18. Drumfin | Lendrick Map | 1780 |
| 19. Drumfin | Bnd. Sur. (OSNB) | 1826 |
| 20. Drumfin | OSNB B 37 159 | 1827 |
| 21. Druim Fionn "white ridge" | OSNB B 37 159 | 1827 |
| 22. Druim-fion "The Fair Hill" | Samuel Bryson (OSNB) B 37 159 | 1827 |
| 23. Dromfionn "the white (or long) narrow ridge" | Walks Ballymena Feb. 6 | 1858 |
| 24. drom'fin | Local pronunciation | 1987 |

The name of this townland has been correctly interpreted as *Droim Fionn* "white ridge". Earlier spellings such as *Dromyne* and *Dromine*, which lack the medial *-f-*, suggest a lenited form of the final element. This may reflect genitive singular lenition after the element *baile* in the form *Baile Droma Fhinn* "townland of the white ridge" which seems to be suggested by the earlier forms, or, if we accept that the prefix *Bally-* in these forms is not historical, lenition of the initial *f* may have its origin in a dative singular form, i.e. *Droim Fhionn*. In 1858 it is remarked that the townland contains "an exceedingly well-defined long hill or ridge, on the summit of which stands the only fort in the townland". It is also noted that the hill was at that time well-cultivated, but that previous to reclamation it was generally called a "white hill, meaning that it was a wet, spongy and unprofitable territory" (*Walks Ballymena* Feb. 6 1858).

**Dunclug**
D 1005

*Dún Cloig*
"fort of the bell"

| | | |
|---|---|---|
| 1. the half-quarter held by William Moore and John Magee | Indent. Adair (MacDonnells Ant.) | 1636 |
| 2. the half quarter or parcel of William Moore and John Magee | EP Adair Mar. 12 | 1636 |

| | | |
|---|---|---|
| 3. parcell called Ballylug al. Wm. McGee's parcell | Lodge RR Chas I i 40 | 1638 |
| 4. Wm. McKie's parcel al. Ballilug | EP Adair May 20 | 1655 |
| 5. the half Quarter Land called Ballecluge al. Wm. Mc Gee's Land | Exch. Deeds & Wills 542 | 1658 |
| 6. pcell ter' vocat Ballylugg al. Wm. McGee's pcell | Inq. Ult. (Antrim) §3 Car. II | 1661 |
| 7. Kililugge | EP Adair June 27 | 1683 |
| 8. Downclage | EP Adair June 27 | 1683 |
| 9. Dunclage | EP Adair Sep. 26 | 1683 |
| 10. Kilclugg | Lodge RR Geo I & II 67 | 1720 |
| 11. Dunlugg | Reg. Deeds 37-489-23607 | 1722 |
| 12. Dunlugg al. Magee's Parcel | EP Adair Feb. 1 | 1722 |
| 13. Dunlugg al. Magee's Parcel | EP Adair Feb. 26 | 1722 |
| 14. farm of land called Dunclug | EP Adair Aug. 26 | 1730 |
| 15. Dunlugg | EP Adair Dec. 28 | 1753 |
| 16. Killelug | Reg. Deeds 245-270-161474 | 1763 |
| 17. Dunclug | Lendrick Map | 1780 |
| 18. Dunclog | Bnd. Sur. (OSNB) | 1826 |
| 19. Dunclug | OSNB B 37 159 | 1827 |
| 20. Dun Clog "fort of the bells" | J O'D (OSNB) B 37 159 | 1827 |
| 21. Dun-chlug "Bellfort" | Samuel Bryson (OSNB) B 37 159 | 1827 |
| 22. Dun Clog "fort of the bell" | Walks Ballymena Feb. 6 | 1858 |
| 23. dọn'klọg | Local pronunciation | 1987 |

O'Donovan's interpretation of Dunclug as *Dún Clog* "fort of the bells" (20) cannot be ruled out. However, the genitive singular inflection of *clog* is unlikely to be reflected in the anglicized spellings and *Dún Cloig* "fort of the bell" seems a more satisfactory explanation.

In forms 3a, 4b, 5a and 6a the name of the townland appears to have been confused with that of the nearby parish of **Ballyclug**. The substitution of *Kili-/Kil-* for *Dun* in a number of forms, which may suggest the Irish form *Cill Chloig* "church of the bell", is perhaps attributable to confusion with the name of the neighbouring townland of **Killyflugh**. The absence of medial *-c-* in a number of the historical forms is likely to be due to mere scribal error.

There is no sign or record of a fort in the townland, though *NISMR* marks a large "enclosure" in a part of the neighbouring townland of Town Parks which may previously have been included in the townland of Dunclug, while in the neighbouring townland of Killyflugh there are the remains of a former cashel or circular stone fort, known as "MacQuillan's Castle" (*O'Laverty* iii 413).

The name of the adjoining parish of **Ballyclug** is interpreted by Reeves as *Baile an Chluig* (>*Baile an Chloig* "town of the bell" (*EA* 84)) and there is another parish of the same name in Co. Tyrone. O'Laverty connects the name of the Co. Antrim parish of Ballyclug with a story from the Life of St Molagga of Cork who is said to have lost, and then miraculously recovered, his bell on his way to the town of Connor (a little to the south-east of Ballymena) from the "Crossing of Camus" on the Bann river (south of Coleraine), in consequence of which all the intervening lands were donated to his church by the owners and were called *Tearmann an Chloig* (or "the Termon lands of the Bell" (*O'Laverty* iii 419–20)). It is possible

that the townland of Dunclug may be in some way connected with the parish of Ballyclug, the former parish church of which was situated only a short distance to the south-east, in the townland of **Ballylesson**. One might also speculate that the townland may have some connection with the nearby site of the former parish church of Kirkinriola. An ancient bell, said to be from this church, was found in the townland of Cabragh in 1870 (Hamlin 1976, 449). However, there is no hard evidence to connect either of these bells with the name of the townland under consideration and the exact significance of the final element of the place-name remains a matter of uncertainty.

| **Dungall** | *Dún Gall* | |
|---|---|---|
| D 0910 | "fort of the foreigners" | |
| 1. half of Dungall | Indent. Adair (MacDonnells Ant.) | 1636 |
| 2. Dungale | EP Adair Mar. 12 | 1636 |
| 3. Dungall | Lodge RR Chas I ii 40 | 1638 |
| 4. the halfe Towne Land of Donnegall | Exch. Deeds & Wills 542 | 1658 |
| 5. Dungall | Exch. Deeds & Wills 557 | 1660 |
| 6. Dungall | Inq. Ult. (Antrim) §1, §3 Car. II | 1661 |
| 7. Dungaal | EP Adair Dec. 6 | 1681 |
| 8. Dungall | Reg. Deeds 37-489-23607 | 1722 |
| 9. Dungall | Lendrick Map | 1780 |
| 10. Dungall | Bnd. Sur. (OSNB) | 1826 |
| 11. Dungall | OSNB B 37 159 | 1827 |
| 12. Dún na nGall "Fort of the Foreigners" | OSNB B 37 159 | 1827 |
| 13. Dun-gall "the strangers' fort" | Samuel Bryson (OSNB) B 37 159 | 1827 |
| 14. Dun nan Gall "fort of the stranger" | Walks Ballymena Feb. 6 | 1858 |
| 15. Dungall "the fort of the strangers – (the Danes)" | O'Laverty iii 413 | 1884 |
| 16. dǫn'gɔːl | Local pronunciation | 1987 |

There is no doubt that the name of this townland is derived from Irish *Dún Gall* "fort of the foreigners" as previously suggested. However, O'Laverty's proposal that the foreigners in question were in this case the Danes (15) appears unlikely. The first element of the place-name obviously refers to the large and well-known motte which stands in the north of the townland, on the border between the barony of Toome Lower and the barony of Kilconway. (Flanagan 1980–1(a), 18) cites Dungall as one of only two *dún*-named mottes whose names, she tentatively suggests, appear to have been specifically coined during the Anglo-Norman period to refer to Norman mottes, rather than transferred from Irish forts to Norman mottes which were constructed on the same sites. She suggests that *Dún Gall* may signify "fort of the Normans" to distinguish it from Irish forts in the vicinity. As pointed out above in connection with the townland of **Randalstown** (originally Dunmore) in the parish of Drummaul, it is possible that some of the mottes in Irish territory which adjoins Norman lands may have been built by the Irish themselves as protection against the Normans. There is a string of mottes along the eastern boundary of the baronies of Toome, and it is striking how many of these carry *dún*-names: Dunhin (in Shane's Castle Park townland); Dunmore

(*ibid.*): Dunsilly; Downkillybegs; Drumfane (recte Dunfane). In the context of a chain of Irish-constructed mottes (and other Irish forts in the vicinity), the significance of the name *Dún Gall* could well be "fort built by the Normans", to distinguish it from the other earthworks in the area.

| **Killyflugh** | *Coillidh Fhliuch* | |
|---|---|---|
| D 1006 | "wet wood" | |
| 1. the half of Kilfluigh | Indent. Adair (MacDonnells Ant.) | 1636 |
| 2. Killflugh | EP Adair Mar. 12 | 1636 |
| 3. the half towneland of Killflugh al. Killyflugh | Lodge RR Chas I ii 40 | 1638 |
| 4. the half towneland of Killyflugh | Exch. Deeds & Wills 542 | 1658 |
| 5. Killfleigh al. Killflugh | Inq. Ult. (Antrim) §1 Car. II | 1661 |
| 6. Kilflegh al. Kilflugh | Inq. Ult. (Antrim) §3 Car. II | 1661 |
| 7. Killiflugh, Killifluch | EP Adair June 27 | 1683 |
| 8. Killifluch | EP Adair Sep. 26 | 1683 |
| 9. Killifleugh | Lodge RR Will, Anne 461 | 1705 |
| 10. Kilflugh | Lodge RR Geo I & II 67 | 1720 |
| 11. Killifleugh | Reg. Deeds 37-489-23607 | 1722 |
| 12. Killflugh | Reg. Deeds 245-270-161474 | 1763 |
| 13. Killyflugh | Lendrick Map | 1780 |
| 14. Killyflugh | Bnd. Sur. (OSNB) | 1826 |
| 15. Killyflugh | OSNB B 37 159 | 1827 |
| 16. Coille Fliuch "the swampy wood" | Samuel Bryson (OSNB) B 37 159 | 1827 |
| 17. Coillidh Fliuch "wet or swampy wood" | J O'D (OSNB) B 37 159 | 1827 |
| 18. Caoille fliuc "narrow wet place" or coill fliuc "wet wood" | Walks Ballymena Feb. 6 | 1858 |
| 19. Coill-fliugh "the wet wood" | O'Laverty iii 412 | 1884 |
| 20. ˌkĭliˈfluː | Local pronunciation | 1987 |
| 21. ˌkĭliˈflọx | Local pronunciation | 1987 |

While the common local pronunciation is [ˌkĭliˈfluː], the oldest people in the area pronounce the place-name [ˌkĭliˌflọx] and there is no doubt that it is derived from Irish *Coillidh Fhliuch* "wet wood", as suggested by the majority of the previous authorities. In 1858 the *Ballymena Observer* comments: "Very low-lying district, and, though reclaimed, still swampy in many places – evidence of its general swampiness in earlier days" (*Walks Ballymena* Feb. 6 1858). It goes on to refer to a local memory of a great quantity of dwarf hazel in the area, while the Adair Estate Papers in 1683 refer to "75 acres of woodland measure in the townland of Killifluch" (*EP Adair* Sep. 26 1683).

| **Kirkinriola** | *Cill Chon Riala* |
|---|---|
| D 1107 | "*Cú Riala*'s church" |

See parish name.

## Monaghan
D 0909

*Muineachán*
"place of thickets"

| | | |
|---|---|---|
| 1. Monaghan | Indent. Adair (MacDonnells Ant.) | 1636 |
| 2. Monaghane | EP Adair Dec. 14 | 1636 |
| 3. Monaghan | Lodge RR Chas I ii 40 | 1638 |
| 4. Monachen | Exch. Deeds & Wills 322 | 1660 |
| 5. Monnaghan | Exch. Deeds & Wills 557 | 1660 |
| 6. Monaghan | Inq. Ult. (Antrim) §1, 3 Car. II | 1661 |
| 7. Monghan | Reg. Deeds 37-489-23607 | 1722 |
| 8. Monachan | EP Adair Feb. 1 | 1722 |
| 9. Monaghin | Lendrick Map | 1780 |
| 10. Monaghan | Bnd. Sur. (OSNB) | 1826 |
| 11. Monaghan | OSNB B 37 159 | 1827 |
| 12. Monach-thuin "district abounding in bogs" | Samuel Bryson (OSNB) B 37 159 | 1827 |
| 13. Muineachán "abounding in brakes or shrubberies" | J O'D (OSNB) B 37 159 | 1827 |
| 14. ˈmɔːnəxən | Local pronunciation | 1987 |

While the Irish form of this place-name is clearly *Muineachán* as suggested by O'Donovan (13), there are a number of different ways in which the name could be interpreted. It could be understood as being made up of *muine* "thicket" plus the diminutive ending *-achán* which can sometimes have the significance of "place of" (*Joyce* ii 33). *Muineachán* could therefore denote either "little thicket" or "place of thickets". The word *muineach* is also attested as a variant form of *muine*, and the name could therefore be understood as consisting of *muineach* plus the diminutive suffix *-án* (which can also carry the meaning "place of"), in which case the name would have an identical meaning to that suggested already. Again, the name could be understood as comprising *muine* "thicket" plus the collective ending *-ach* "place of", plus the diminutive suffix *-án*, in which case it would signify "little place of thickets". It is impossible to adjudicate with certainty between these possible interpretations, but "place of thickets" appears the most acceptable explanation of the name. According to Joyce, the element *muine* in place-names can sometimes have the significance of "hill" (*Joyce* i 496) and one might argue that *Muineachán* could signify "place of hills" or "little hill". However, since *muine* in townland names is less frequently attested in the sense of "hill" than in the sense of "thicket" (see **Moneyglass**, parish of Duneane above), this interpretation of the place-name must be regarded as less likely. There is now no trace or record of any thicket in the townland, which suggests that the name refers to a feature of the landscape which has long disappeared.

## Town Parks
D 1103

An English form

| | | |
|---|---|---|
| 1. townland of Ballymanagh | Indent. Adair (MacDonnells Ant.) | 1636 |
| 2. townland of Ballymena | EP Adair Mar. 12 | 1636 |
| 3. the castle, town and lands of Ballymeanagh al. Kinhiltstowne | Lodge RR Chas I ii 40 | 1638 |
| 4. town and lands of Ballymenough | EP Adair Dec. 6 | 1681 |

| | | |
|---|---|---|
| 5. Town-acres . . . of the Town and Manor of Ballymenagh al. Kinhillstown | Lodge RR Will, Anne 461 | 1705 |
| 6. the Town and lands of Ballymenagh . . . the Town-Acres thereof | Lodge RR Geo I & II | 1720 |
| 7. Town and Town Parks of Ballymenagh | Reg. Deeds 37-489-23607 | 1722 |
| 8. lands of Ballymenagh | EP Adair Aug. 28 | 1723 |
| 9. the Town Parks of Ballymena | EP Adair Mar. 13, 14 | 1729c |
| 10. townland of Ballymena | EP Adair Aug. 6 | 1730 |
| 11. Ballymena | Lendrick Map | 1780 |
| 12. Ballymena Town Parks | EP Adair Feb. 24 | 1807 |
| 13. Ballymena | Bnd. Sur. (OSNB) | 1826 |
| 14. Ballymena – "it is a townland situated around the town of Ballymena" | J O'D (OSNB) B 37 159 | 1827 |
| 15. Ballymena Demesne and Town Parks | Tithe Applot. | 1833 |
| 16. 'təun 'pɑ:rks | Local pronunciation | 1987 |

The modern townland of Town Parks is clearly to be identified with the townland formerly known as Ballymena which has given name to the modern town of that name. The name *Town Parks of Ballymenagh* is documented as early as 1722 (7). This appears to correspond with the *Town-acres* of 1705 (5), which, judging by form (6), seems to have applied to only a small area around the middle of the town of Ballymena, rather than to the entire townland of Ballymena, which is referred to as the *Town and lands of Ballymenagh* in the same source. However, the modern townland of Town Parks covers approximately 452 acres, and can be safely assumed to be roughly co-extensive with the former townland of Ballymena. The derivation of the name of the townland is *An Baile Meánach* "the middle townland/homestead" and is discussed fully under **Ballymena Town** below.

| **Tullyreagh** | *An Tír Riabhach* | |
|---|---|---|
| D 0712 | "the grey/streaked district" | |
| 1. Ballitinagh | Inq. Ant. (DK) 46 | 1605 |
| 2. Ballicurraghe | CPR Jas I 114a | 1607 |
| 3. Ballicurragh or Ballytirragh | Lodge RR Jas I i 300 | 1607 |
| 4. Ballitirragh | CPR Jas I 577b | 1624 |
| 5. Ballentirriagh | Inq. Ult. (Antrim) §3, §4 Car. I | 1627 |
| 6. Ballytirriagh | EP Adair Dec. 14 | 1627 |
| 7. Tirrereagh al. Terreagh | Lodge RR Geo I & II 67 | 1720 |
| 8. Firrcragh or Tirrcregh | Indent. (Colville) | 1720 |
| 9. Tirreagh | Reg. Deeds 43-89-27472 | 1724 |
| 10. Tyncreagh | EP Adair Nov. 2 | 1724 |
| 11. Tirrereagh orw. Tirreagh | Reg. Deeds 245-270-161474 | 1763 |
| 12. Tullyreagh | Lendrick Map | 1780 |
| 13. Tullyreagh | Bnd. Sur. (OSNB) | 1826 |
| 14. Tullyreagh | OSNB B 37/159 | 1827 |

| | | |
|---|---|---|
| 15. Tullaidh-riagh "The Royal Hill" | Samuel Bryson (OSNB) B 37 159 | 1827 |
| 16. Tulaigh Riach "Grey Hill" | J O'D (OSNB) B 37 159 | 1827 |
| 17. Tullaig riabhach "streaked or dark-grey hill" | Walks Ballymena Feb. 6 | 1858 |
| 18. "grey hill" | Joyce iii 592 | 1913 |
| 19. ˌtɔli'rɛ: | Local pronunciation | 1987 |

A number of the earliest spellings of this townland name display the common scribal confusion of *t* with *c* and *n* with *r*. However, the evidence suggests that the derivation of the place-name is *An Tír Riabhach* "the grey/streaked district", rather than *Tulaigh Riach* (>*Riabhach*) "grey/streaked hill" as suggested by the modern version and accepted by the previous investigators. The replacement of the medial -*r*- of the place-name with -*l*- (first documented in 1780) is likely to be due to the process of dissimilation. As pointed out above in connection with the townland of **Maghereagh** in the parish of Drummaul, the adjective *riabhach* "grey, streaked" in its topographical application appears to have connotations of "uncultivated, fallow". The *OSNB* of 1827 describes the townland as "one-eighth bog and boggy pasture, remainder arable" (*OSNB* B 37 159). There are still areas of heathy pasture in the townland.

OTHER NAMES

**Ballymena** (town)
D 1203

*An Baile Meánach*
"the middle townland/farmstead"

| | | |
|---|---|---|
| 1. town of Ballymeanagh | Lodge Fairs & Markets 2 | 1626 |
| 2. Ballymenagh | Inq. Ult. (Antrim) §23 Car. I | 1633 |
| 3. Ballymeannagh | Inq. Ult. (Antrim) §35 Car. I | 1635 |
| 4. Ballymanagh | Indent. Adair (MacDonnells Ant.) | 1636 |
| 5. the Manor of Kinhilstowne al. Ballymeanagh | Lodge RR Chas I i 40 | 1638 |
| 6. Ballymenagh | Exch. Deeds & Wills 604 | 1655 |
| 7. the Towne of Ballymeanagh al. Kinhilstowne | Exch. Deeds & Wills 492 | 1656 |
| 8. Ballymeanagh | Exch. Deeds & Wills 512 | 1656 |
| 9. Ballimene Towne | Hib. Reg. Toome | 1657c |
| 10. Ballymeanagh | Exch. Deeds & Wills 483 | 1658 |
| 11. Ballymenagh | Exch. Deeds & Wills 529 | 1658 |
| 12. Ballymenagh | Census 7 | 1659 |
| 13. Towne and River of Ballimenagh | Exch. Deeds & Wills 572 | 1660 |
| 14. Ballymeanagh al' Kinhilstowne | Inq. Ult. (Antrim) §1 Car. I | 1661 |
| 15. Ballymenock | HMR Ant. 161 | 1669 |
| 16. B:min | Hib. Del. Antrim | 1672c |
| 17. Ballymeanogh | Dobbs' Descr. Ant. 386 | 1683 |
| 18. Ballymenagh | EP Adair June 27 | 1683 |
| 19. Town and Manor of Ballymenagh al. Kinhillstown | Lodge RR Will, Anne 461 | 1705 |
| 20. Ballymenagh | EA 302 | 1707 |
| 21. Ballymenagh | Grand Jury Pres. 27 | 1711 |
| 22. the Manor of Killhillstown al. Ballymenoch | EP Adair Dec. 10 | 1721 |
| 23. manor of Ballymenah al. Kinhiltstown | EP Adair Dec. 28 | 1753 |

| | | |
|---|---|---|
| 24. Ballymena | Lendrick Map | 1780 |
| 25. Ballymena | Bnd. Sur. (OSNB) | 1826 |
| 26. Ballymena | OSNB B 37 159 | 1827 |
| 27. Ballymena, formerly called Kilhiltstown | OSM xxiii 117 | 1838 |
| 28. Baile Meodhun-ath "the townland of the middle of the ford" or Baile-maoin-ath "townland at the ford or mouth of the Main" | Samuel Bryson (OSNB) B 37 159 | 1827 |
| 29. "it means middletown" | J O'D (OSNB) B 37 159 | 1827 |
| 30. Baile meadhanach which is synonymous with Middletown | OSNB Inf. B 37 159 | 1827 |
| 31. Baile-meadhonach "middle town" | Joyce i 53 | 1869 |
| 32. An Baile Meánach | GÉ 20 | 1989 |
| 33. ˌbaləˈmiːnə | Local pronunciation | 1987 |

The town of Ballymena is named from the townland of that name, which appears to have been roughly equal in extent to the modern townland of **Town Parks**. The name Ballymena is derived from Irish *An Baile Meánach* "the middle townland, farmstead". Final *-agh*, representing Ir. *-ach*, is found in almost all the documented versions of the place-name up until the year 1711, after which the final *-gh* is generally absent, as it is in the modern version of the place-name.

While the name Ballymena can indeed be interpreted as "Middletown" as suggested by O'Donovan (29) and Joyce (31), the town of Ballymena has not been named as being the "middle town" of Co. Antrim, as is sometimes suggested. The name obviously predates by many years the setting up of the county of Antrim at the beginning of the 17th century. Moreover, the element *baile* in the place-name originally referred not to the town of Ballymena but to the townland of the same name. The townland name *An Baile Meánach* "the middle townland, farmstead" is a fairly common one: there is a townland named **Ballymena** not far to the north-east of this one, in the parish of Skerry, and a townland named **Ballymena Little** in the parish of Ballynure, Co. Antrim. There are also six townlands named **Ballymenagh**, two in each of the counties of Down, Derry and Tyrone as well as eleven townlands named "Middletown", spread throughout Ireland. While all these places have obviously been named as occupying a "middle" situation, in this case it is not at all apparent why the townland should have been so designated. It is possible that the element *baile* in the place-name may carry a meaning other than "townland", perhaps "farmstead" (*Dinneen* sv.). The name could therefore have originally referred to a farmstead which occupied a middle situation between two others.

The name *Kinhiltstowne*, which is recorded (with variations in spelling) as an alias name for Ballymena in a number of sources, has its origin in the name of the town of Kinhilt in Wigtownshire in Scotland. This was the home town of William Adair who was granted a large tract of land in the Ballymena area in 1624 (*CPR Jas. I* 577b) and it was he who bestowed the name *Kinhiltstowne* on Ballymena when he founded the town shortly after that date. However, this name for the town was never adopted by the population, and is entirely unknown in the area today. *Kinhiltstown* was also adopted as an alias title for the *Manor of Ballymeanagh*, which was the name given to the eastern portion of the tuogh of Clanagherty in 1638 (*Lodge RR* Chas I i 40), but, again, the name never achieved any currency in the area.

| **Brigadie** | An English form | |
| D 1104 | | |
| | | |
| 1. ˌbrïgə'di: | Local pronunciation | 1987 |

Although well-known in the area, this place-name is ignored on the *OS 1:50,000* map (see *OS 1:10,000* sheet 67). It is the name of a mansion in the townland of Bottom, the name of which has been recently adopted for a housing estate. According to the *OSNB*, the name Brigadie is "a supposed corruption of Brigadier, the rank of the person who originally built on the ground" (*OSNB* B 37 159). In 1827, a new house was constructed on the same site, and was occupied by a "John Treacey Esq." (*ibid.*).

| **Forttown** | An English form | |
| D 0811 | | |
| | | |
| 1. 'fortəun | Local pronunciation | 1987 |

This is the name of a small settlement in the north-east of the townland of Carnlea, near the Clogh River, which forms the boundary between the baronies of Toome Lower and Kilconway. According to the *OSRNB* (sheet 27) it was named from a large fort close to the houses, portion of which had already been destroyed in 1858 and no trace of which now remains.

| **Hugomont** | An English form | |
| D 1104 | | |
| | | |
| 1. 'hjugo͵məunt | Local pronunciation | 1987 |

This place-name does not appear on either the *OS 1:50,000* or *1:10,000* map, though well-known in the area (see *OS 6-inch* sheet 32). It is the name of a former mansion house, situated in the townland of Bottom. The *OSNB* informs us that the house was named from a Captain Hugh Harrison who was in residence there in 1827 (*OSNB* B 37 159). At that time it was "a house recently built, the ground just laid out, the plantations in consequence very young" (*ibid.*).

| **Parade Road** | An English form | |
| D 1206 | | |
| | | |
| 1. pə'red 'ro:d | Local pronunciation | 1987 |

The name of this road in the townland of Ballygarvey is not marked on the *OS 1:50,000* map (see *OS 1:10,000* sheet 55). It is named from a field where the Irish Volunteers assembled on parade in 1782 (*OSRNB* sheet 32).

| **Priest Hill** | An English form | |
| D 1109 | | |
| | | |
| 1. 'pri:st 'hïl | Local pronunciation | 1987 |

This is a rocky hill of roughly 500 feet which has been referred to above in connection with the townland of **Craigywarren** in which it is situated. On this hill, there is a rock formation known as the Priest's Chair. I could not learn the origin of either name, but it appears very likely that the hill was a place where Mass was said in penal times.

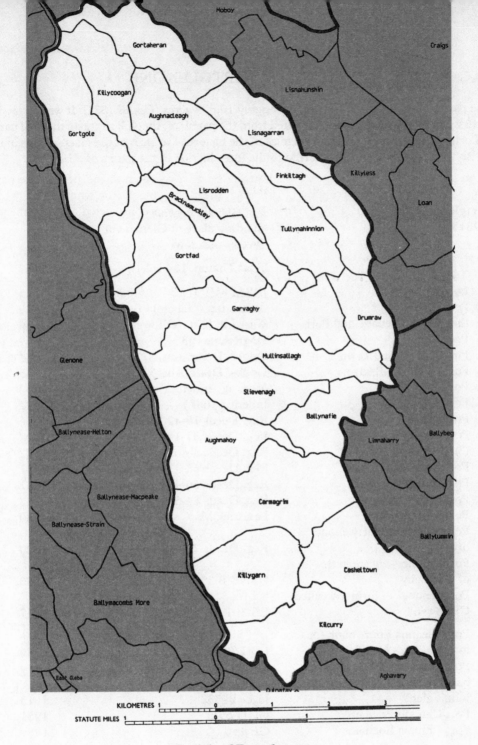

KILOMETRES 1       0       1       2       3

STATUTE MILES 1       0       1       2

## Parish of Portglenone
### Barony of Toome Lower

| *Townlands* | | | *Town* |
|---|---|---|---|
| Aughnacleagh | Drumraw | Killycoogan | Portglenone |
| Aughnahoy | Finkiltagh | Killygarn | |
| Ballynafie | Garvaghy | Lisnagarran | |
| Bracknamuckley | Gortaheran | Lisrodden | Based upon Ordnance Survey 1:50,000 mapping, with |
| Carmagrim | Gortfad | Mullinsallagh | permission of the Director of the Ordnance Survey of |
| Casheltown | Gortgole | Slievenagh | Northern Ireland, Crown copyright reserved. |
| | Kilcurry | Tullynahinnion | |

# PARISH OF PORTGLENONE

The parish of Portglenone consists of roughly 10,879 acres (*Census 1871*). It was formed in 1840 when 20 townlands were separated from the parish of Ahoghill to create the civil parish of Portglenone (*EA* 301). For an account of the historical sources of the place-names of this parish the reader is therefore referred to the introduction to the parish of **Ahoghill**.

**Portglenone**                           *Port Chluain Eoghain*
C 9813                                     "landing place of Glenone/of
                                           Owen's meadow"

| | | |
|---|---|---|
| 1. (?)Cluain-eoin | Trias Thaum. 184 col.1n | 1647 |
| 2. Portecloneonone | JRSAI iv II 310 | 1593 |
| 3. Port Clanone | Affairs Ire. (Gilbert) i II 515 | 1642 |
| 4. the Fort of Glenane and Port | Warr Ire. Hist. (O'Laverty) iii 346 | 1650 |
| 5. Portglonan | HMR Ant. 153 | 1669 |
| 6. Portglenoine and Town | Dobbs' Descr. Ant. 377 | 1683 |
| 7. Port Glenoyne Bridge | Dobbs' Descr. Ant. 377 | 1683 |
| 8. Portclanone | Marriage Indent. (Staff.) | 1692 |
| 9. Portilanone | Indent. (Staff.) | 1692 |
| 10. Portlanone | Reg. Deeds 18-420-9513 | 1716 |
| 11. Portlenon | Reg. Deeds 37-104-21527 | 1722 |
| 12. (?)Glenon | Reg. Deeds abstracts i §301 | 1722 |
| 13. Port Gleone | Reg. Deeds 66-434-47346 | 1731 |
| 14. Portglenone | Reg. Deeds 66-434-47346 | 1731 |
| 15. Portlenone Town | Reg. Deeds 84-500-622451 | 1737 |
| 16. Portglenone | Lendrick Map | 1780 |
| 17. Portglenone al. Portylenone orw. Garvaghy | Reg. Deeds 761-596-517131 | 1820 |
| 18. Portglenone – village in tl. of Garvaghy | OSNB B 35 B 131 | 1830c |
| 19. Portglenone . . . formerly called Clanowen | EA 301 | 1847 |
| 20. Port Gleanna Eoin "bank (or fort) of John's Glen" | J O'D (OSNB) B 35 B 131 | 1830c |
| 21. Port-gleanna-Eóin "the port, bank, or landing-place of John's glen" | Joyce iii 532 | 1913 |
| 22. Port Chluain Eoghain | GUH 65-6 | 1951 |
| 23. Port Chluain Eoghain | GÉ 146 | 1989 |
| 24. ˌpoːrtglɛˈnoːn | Local pronunciation | 1987 |

Though situated in the townland of Garvaghy, the town from which the parish takes its name has obviously been named from the townland of **Glenone**, which lies adjacent to it, but on the Co. Derry side of the river Bann. The documentary evidence for the name of that townland suggests that the first element (and hence the second element of the name of the parish of Portglenone) is *cluain* "meadow", rather than *gleann* "glen", as suggested by the modern

form of the place-name and accepted by both O'Donovan (20) and Joyce (21). This conclusion is supported by the earliest recorded spellings of Portglenone (2, 3).

Reeves (*EA* 301) identifies Portglenone with *Cluain-eoin* (1), one of a number of places in the district of *Uí Thuirtre* which are listed by the 17th-century scholar Colgan as either being in his day regarded as "holy places" or appearing to have been formerly so regarded (see **Clonboy**, parish of Drummaul above). By the "district of *Uí Thuirtre*" Colgan most likely intended the medieval deanery of Turtrye which, at his time of writing, was coterminous with the baronies of Toome Upper and Lower, Antrim Lower, Glenarm Lower and part of Kilconway (see county introduction). This means that Portglenone lies in the right area to be identified with Colgan's *Cluain-eoin*, even though there is no trace or record of an early ecclesiastical site in the immediate vicinity of the town. There are, however, nearby early graveyards at **Gortfad** and **Aughnahoy**, which could have led Colgan to include Portglenone in his list of "holy places".

The name *Eoin* is an Irish borrowing of the biblical name John (Ó Corráin & Maguire 1981, 88) while *Eoghan* is a native Irish name, which has sometimes been anglicized as "Owen" (ibid. 87–88). In the Irish language, the names *Eoin* and *Eoghan* would be pronounced in similar fashion in the genitive case rendering it impossible to tell which is represented in this place-name. The name *Cluain Eoin*, i.e. "John's meadow", could be understood as signifying land dedicated to St John (i.e. church land). However, this interpretation must be regarded as unlikely, since dedications to St John tend to be found in areas heavily influenced by the Normans, whereas there is little evidence of Norman influence in this area. Nor is there any evidence to suggest that the name Eoin was widely adopted by the native Irish in this area after it was brought to Ireland by the Anglo-Normans. It is more likely, therefore, that the final element of the place-name is the native Irish name *Eoghan*. However, I would suggest that this does not entirely rule out the identification of Colgan's *Cluain-eoin* with Portglenone, as some confusion between the names *Eoghan* and *Eoin* is not at all unlikely.

The element *port* in place-names can signify either "a bank or landing-place, a harbour, port or haven" or "a fortress or military station, a royal fort, a chieftain's residence" (*Joyce* ii 230). Given the situation of Portglenone on the navigable river Bann, the significance of *port* is in this case clearly a landing place or port.

<div align="center">TOWNLAND NAMES</div>

**Aughnacleagh**
C 9807

*Achadh na Cléithe*
"field of the wattled ford/fence(?)"

| | | |
|---|---|---|
| 1. Ballydromadan al. Aghcleagh | Inq. Ult. (Antrim) §6 Car. II | 1662 |
| 2. Aghieclan | HMR Ant. 154 | 1669 |
| 3. Aghecleagh | Lodge RR Chas II ii 292 | 1684 |
| 4. Aghcleagh | Indent. (Staff.) | 1692 |
| 5. Aghecleagh | Reg. Deeds 10-133-3227 | 1712 |
| 6. Aghocleagh | Reg. Deeds 30-26-16258 | 1720 |
| 7. Aghnacleagh | Reg. Deeds 30-39-16255 | 1720 |
| 8. Aagholeagh al. Aghcleagh al. Aghnecleagh | Reg. Deeds 66-434-47346 | 1731 |
| 9. Aughinacliay | Lendrick Map | 1780 |
| 10. Aughnacleagh | Tithe Applot. | 1825 |
| 11. Aughnacleagh | Bnd. Sur. (OSNB) | 1829c |
| 12. Aughnacleagh | OSNB B 35 B 131 | 1830c |

| | | |
|---|---|---|
| 13. Áth na gCliath "ford of the hurdles" | J O'D (OSNB) B 35 B 131 | 1830c |
| 14. Aughnacliath "hurdle-ford" | Joyce iii 55 | 1913 |
| 15. ˌɔːxnəˈkleːx | Local pronunciation | 1987 |

The previous interpretation of the place-name as *Áth na gCliath* "ford of the hurdles" (13, 14) must be regarded as unlikely, as the combination *Áth na ...* "ford of the ... " is regularly anglicized *Anna-*, as in the Co. Down place-names **Annalong** (<*Áth na Long* "ford of the ships") (*PNI* iii 54) and **Annacloy** (<*Áth na Cloiche* "ford of the stone") (*GÉ* 9). A more satisfactory interpretation of Aughnacleagh is *Achadh na Cléithe* "field of the wattled ford of fence". The element *cliath* literally signifies "wattled, latticed, frame; hurdle" (*Ó Dónaill* sv.) and in place-names it is often used to refer to a wickerwork causeway (*Joyce* i 362). It is difficult to determine its exact significance in this place-name. There is a small stream in the townland and it is possible that it could refer to a former hurdle ford over this stream. Otherwise one might suggest that it could refer to a former wattled fence, or possibly the place-name could have the significance of a field in which there grew wood which was suitable for wattle (usually alder or willow).

The alias name for the townland, i.e. *Ballydromadan* (1a) is now obsolete, and in the absence of further evidence it is impossible to establish its origin, though the element after *Bally* does appear to be *droim* "ridge".

**Aughnahoy**
C 9802

*Achadh na hÁithe*
"field of the kiln"

| | | |
|---|---|---|
| 1. Ballyaghnehoy | Inq. Ult. (Antrim) §6 Car. II | 1662 |
| 2. Aghnehey | HMR Ant. 153 | 1669 |
| 3. Aghnehoy | Lodge RR Chas II ii 292 | 1684 |
| 4. Aghnehoy | Indent. (Staff.) | 1692 |
| 5. Aghnehay | Reg. Deeds 10-133-3227 | 1712 |
| 6. Aghnehoy | Reg. Deeds 84-259-59992 | 1736 |
| 7. The Island of Aghnehoy | Reg. Deeds 84-259-59992 | 1736 |
| 8. Aughnahoy | Lendrick Map | 1780 |
| 9. Aughnahoy | Tithe Applot. | 1825 |
| 10. Aughnahoy | Bnd. Sur. (OSNB) | 1829c |
| 11. Aughnahay | OSNB B 35 B 131 | 1830c |
| 12. Achadh na hAithe "field of the kiln" | J O'D (OSNB) B 35 B 131 | 1830c |
| 13. "the field of the kiln" | Joyce i 377 | 1869 |
| 14. ˌɔːxnəˈhɔi | Local pronunciation | 1987 |

The historical forms of this place-name are quite uniform, and clearly point to the Irish form *Achadh na hÁithe* "field of the kiln", as suggested by O'Donovan (12). In East Ulster Irish, *th* between two vowels would have been dropped, with coalescence of the vowels (O'Rahilly 1932, 175), which would explain the anglicization of Irish *háithe* as *hoy*. The element *áith* "kiln" can signify either a lime kiln or a kiln for drying corn (*Joyce* i 377). There is now no trace or record of a kiln in this townland, and so it is impossible to determine which type is referred to in the place-name.

## Ballynafie
D 0002

*Baile na Faiche*
"townland of the green"

| | | | |
|---|---|---|---|
| 1. | Ballinefeaghy | Inq. Ult. (Antrim) §120 Car. I | 1637 |
| 2. | Ballynefeigh | Inq. Ult. (Antrim) §6 Car. II | 1662 |
| 3. | Ballmefoy | HMR Ant. 154 | 1669 |
| 4. | Ballynefey | Lodge RR Chas II ii 292 | 1684 |
| 5. | Ballynafeigh | Indent. (Staff.) | 1692 |
| 6. | Ballynafeigh | Reg. Deeds 30-26-16158 | 1720 |
| 7. | Bellynafey | Reg. Deeds 30-39-16355 | 1720 |
| 8. | Ballinafay | Reg. Deeds 37-104-21527 | 1722 |
| 9. | Ballynafeigh al. Ballynafey al. Ballynefey | Reg. Deeds 66-434-47346 | 1731 |
| 10. | Ballynafie | Reg. Deeds 90-171-62470 | 1739 |
| 11. | Ballinafoy | Lendrick Map | 1780 |
| 12. | Ballynafie | Tithe Applot. | 1825 |
| 13. | Ballynafie | Bnd. Sur. (OSNB) | 1829c |
| 14. | Ballinafie | OSNB B 35 B131 | 1830c |
| 15. | Baile na Faithche "town of the green" | J O'D (OSNB) B 35 B 131 | 1830c |
| 16. | "the town of the green" | Joyce i 297 | 1869 |
| 17. | ˌbalənəˈfai | Local pronunciation | 1987 |

The name of this townland has been correctly interpreted as *Baile na Faiche* "townland of the green" by both O'Donovan (15) and Joyce (16). According to Dinneen, the word *faiche* means "a lawn, green, field, exercise ground, esp. the lawn or esplanade in front of a fort or residence" (*Dinneen* sv. *faithche*). There is a large and particularly prominent fort in the south of the townland (marked "enclosure" by *NISMR*), which is at an elevation of 500 feet, and commands an extensive view over all the surrounding countryside. It is possible that the element *faiche* in this townland name may have referred to a lawn or green attached to this fort or, on the other hand, it may have the more ordinary meaning of simply a green field or piece of land. *Baile na Faiche* is also the Irish form of the name of the townland of **Ballynafey** in the parish of Duneane.

## Bracknamuckley
C 9706

*Breacach na Muclaí*
"speckled (stony) land of the piggery"

| | | | |
|---|---|---|---|
| 1. | Ballibrackaghnamuckeley | Inq. Ant. (DK) 45 | 1605 |
| 2. | Ballibrackaghnamuckelly | Lodge RR Jas I i 253 | 1606 |
| 3. | Ballibrackaghnamukally | CPR Jas I 93b | 1606 |
| 4. | Ballybracklaghnemuckly or Ballybrackcaghnemuckly | Lodge RR Chas I i 407 | 1637 |
| 5. | Ballybrackaghnemuckly | BSD 135b | 1661 |
| 6. | Brackaghnemuckly | Lodge RR Chas II i 106 | 1663 |
| 7. | Ballybracklaghnemuckely | EP Edenduffcarrick | 1666 |
| 8. | Bracknemuckly | HMR Ant. 156 | 1669 |
| 9. | Ballybrackaghnemuckly | Lodge RR Chas II ii 292 | 1684 |
| 10. | Ballybrackaghnemuckly | Reg. Deeds 10-133-3227 | 1712 |

| | | |
|---|---|---|
| 11. Bricknamuckley | Lendrick Map | 1780 |
| 12. Ballybrackaghnemuckly | Reg. Deeds 636-545-639977 | 1811 |
| 13. Brecknamuckley | Reg. Deeds 660-290-457358 | 1813 |
| 14. Breaknamuckly | Tithe Applot. | 1825 |
| 15. Bracknamuckley | Bnd. Sur. (OSNB) | 1829c |
| 16. Bracknamuckley | OSNB B 35 B 131 | 1830c |
| 17. Breac na muclaighe "speckled land of the piggery or places where swine feed" | J O'D (OSNB) B 35 B 131 | 1830c |
| 18. "speckled land of the muclach or piggery" | Joyce ii 289 | 1875 |
| 19. ˌbraknəˈmo̞kli | Local pronunciation | 1987 |

The adjective *breac* "speckled" is in this case found in combination with the adjectival suffix *-ach* and the significance of the first element of the place-name is clearly "speckled land". Forms 4a and 7 suggest that a variant form of *breacach*, i.e. *breaclach*, may have been for a time in use. The word *breaclach* is attested in the sense of "patch of stony ground" (*Ó Dónaill* sv.) and it is likely that *breacach* may also have connotations of stoniness. There are in all 17 townlands in Ireland named Brackagh, all of which appear to derive their names from the Irish form *Breacach*.

The final element of the place-name is *muclaí*, the genitive form of *muclach*, a common element in place-names signifying "a place where swine were fed, or where they resorted or slept" (*Joyce* i 428). The *OSNB* of c.1830 describes this townland as "cultivated, with some areas of rough, rocky ground" (*OSNB* B 35 B 131).

## Carmagrim
C 9900

*Carn Mhig Ráine*
"Granny's/Grant's cairn"

| | | |
|---|---|---|
| 1. Carnevegrian | Inq. Ult. (Antrim) §32 Car. I | 1635 |
| 2. Ballycarnevigrane | Lodge RR Chas I i 407 | 1637 |
| 3. Ballyoanevigran | BSD 135b | 1661 |
| 4. Ballycarneirgrean | Lodge RR Chas II i 106 | 1663 |
| 5. (?)Kennighohan | HMR Ant. 153 | 1669 |
| 6. Ballycarnyvograne | Comm. Grace 10 | 1684 |
| 7. Ballycarnyvigrane | Lodge RR Chas II ii 292 | 1684 |
| 8. Carnevigrane | Reg. Deeds 10-133-3227 | 1712 |
| 9. Ballycarny vigrane | Reg. Deeds 90-171-62470 | 1739 |
| 10. Carmegrim | Grand Jury Pres. April 23 | 1777 |
| 11. Carmegram | Lendrick Map | 1780 |
| 12. Carrumegrim | Reg. Deeds 660-290-457358 | 1813 |
| 13. Carmagrim | Tithe Applot. | 1825 |
| 14. Carnmegrum | Comm. Inq. Irish Educ. 205 | 1826c |
| 15. Carmagrim | Bnd. Sur. (OSNB) | 1829c |
| 16. Carmagrim | OSNB B 35 B 131 | 1830c |
| 17. Carmaigraw | OSM xxiii 35 | 1835 |
| 18. Carn meig Rime "Magrim's carn or mounumental heap" | J O'D (OSNB) B 35 B 131 | 1830c |
| 19. ˌkɑrˈmɛːɡrim | Local pronunciation | 1987 |

The earlier recorded spellings all support O'Donovan's suggestion that the first element of the place-name is *carn* "cairn, heap of stones" (18). However, the proposal that the final element is an otherwise unattested surname *Mag Rime* "Magrim" can be ruled out on the grounds that the final *m* of the modern form of the place-name is not recorded until 1777 (10) and appears to have grown up by assimilation to the medial *m* which is also first recorded at that date. The majority of the earlier recorded spellings suggest that the derivation of the place-name is likely to be *Carn Mhig Ráine* "Granny's or Grant's cairn". According to MacLysaght (1985, 134) *Mag Raighne (>Mag Ráine)*, which is anglicized as (Mac) Graney and Granny, is "a north Ulster name sometimes changed to Grant" while Bell (1988, 82–3) points out that in many parts of Ulster where the name *Mag Raighne* predominates, Grant is found overlapping. The surname Grant, which is quite common in the Toomebridge area, is sometimes known locally as "Granny", which suggests it is likely to go back to Irish *Mag Ráine*. The same surname appears to be represented in the minor place-name **Grannystown** in the nearby townland of Finkiltagh.

The place-name has obviously undergone a change of stress, as the main stress in the Irish version of the name would have fallen on the final syllable.

There is no trace or record of any cairn in the townland, but O'Laverty informs us that in the Largy Bog (i.e. in the western portion of Carmagrim) there is a place called Tamlaght (<*Tamhlacht* "burial place") where human bones have been found (*O'Laverty* iii 366). Moreover, the Largy Bog runs into the neighbouring townland of **Killygarn**, whose name is derived from Irish *Coill na gCarn* "wood of the cairns".

| **Casheltown** | *Baile an Chaisil* | |
|---|---|---|
| J 0299 | "townland of the stone fort" | |
| 1. Ballycashillfin | Inq. Ant. (DK) 45 | 1605 |
| 2. Ballycashillfin(e) | Lodge RR Chas I i 253 | 1606 |
| 3. Ballicashillfin | CPR Jas I 93b | 1606 |
| 4. Cashell | Inq. Ult. (Antrim) §32 Car. I | 1635 |
| 5. Ballycashellfynn | Lodge RR Chas I i 407 | 1637 |
| 6. The Quarter of Cashell | Lodge RR Chas I i 407 | 1637 |
| 7. the Manor of Cashell | Lodge RR Chas I i 407 | 1637 |
| 8. Ballycashalfin | BSD 135b | 1661 |
| 9. The Qr. of Cashell | BSD 135b | 1661 |
| 10. Ballycashellfyne | Lodge RR Chas II i 106 | 1663 |
| 11. The Quarter of Cashell | Lodge RR Chas II i 106 | 1663 |
| 12. Castletown | HMR Ant. 152 | 1669 |
| 13. Ballycashallfin | Lodge RR Chas II ii 292 | 1684 |
| 14. the Quarter of Cashel | Lodge RR Chas II ii 292 | 1684 |
| 15. the Manor of Cashell | Lodge RR Chas II ii 292 | 1684 |
| 16. Ballycastlefine | Reg. Deeds 10-133-3227 | 1712 |
| 17. Cashell | Reg. Deeds 10-133-3227 | 1712 |
| 18. Ballycashallfin | Reg. Deeds 90-171-62470 | 1739 |
| 19. Castletown | Lendrick Map | 1780 |
| 20. Casheltown | Reg. Deeds 660-290-457358 | 1813 |
| 21. Casheltown | Tithe Applot. | 1825 |
| 22. Casheltown | Bnd. Sur. (OSNB) | 1829c |
| 23. Casheltown | OSNB B 35 B 131 | 1830c |

| | | |
|---|---|---|
| 24. Baile an Chaisil "town of the stone fort" | J O'D (OSNB) B 35 B 131 | 1830c |
| 25. ˈkaʃəlˌtəun | Local pronunciation | 1987 |

This townland is locally known as "Castletown", but the historical forms leave no doubt that the first element was originally not "castle" but *caiseal* "stone fort". Flanagan remarks on the frequency with which Irish *caiseal* in place-names is locally anglicized as "castle". For example, **Stracashel** (<*Srath Caisil* "holm of the stone fort"), a townland beside the town of Glenties in Co. Donegal, is locally known in English as "Stra*castle*", and the townland of **Gorticashel** (<*Gort an Chaisil* "field of the stone fort") in the parish of Bodoney Lower, Co. Tyrone is called locally "Gorti*castle*" (Uí Fhlannagáin 1970(d)). Form 12 provides evidence of the anglicization of Irish *caiseal* as "castle" and of *baile* as "town" as early as 1669.

The element *caiseal* is fairly rare in the eastern half of Ireland, since it refers to a fort made of stone, and it is only natural that these forts are much more plentiful in rocky western parts of the country *(ibid.)*. The *OSNB* of c. 1830 remarks: "there is no 'castle' here, but numerous rocks. Therefore 'cashel' is most probable" (*OSNB* B 35 B 131).

The documentary evidence suggests that there were originally two separate land-units, one called *Ballycashellfynn et. var.* and the other called *The Quarter of Cashell*. The qualifying element in the former appears to be *fionn* "bright, fair", and this may have referred to the colour of the *caiseal* or stone fort. It could also be understood as qualifying the name of the entire land unit, in which case it may have referred to the colour of the soil and been used to distinguish between the two land units. It seems likely that the large modern townland of Casheltown, which measures approximately 675 acres, comprises both of these former divisions. There is now no trace or record of a stone fort in the townland. There is an area of rocky land west of the hamlet of Hillistown, which is marked as a quarry on the *OS 6-inch* map of 1833, and this seems most likely to mark the site of the former stone fort.

In 1637, the name of this townland was chosen to give name to the "Manor of Cashel" (7), which corresponded to the Irish *tuogh* or territory of Muntercallie, though why the name of this particular townland was chosen as the name of the manor is not apparent.

| | | |
|---|---|---|
| **Drumraw** | *Droim Rátha* | |
| D 0104 | "ridge of the fort" | |
| 1. Ballydromra | Inq. Ult. (Antrim) §6 Car. II | 1662 |
| 2. Drumon | HMR Ant. 154 | 1669 |
| 3. Drumra | Lodge RR Chas II ii 292 | 1684 |
| 4. Drumra | Indent. (Staff.) | 1692 |
| 5. Drumra | Reg. Deeds 10-133-3227 | 1712 |
| 6. Drumralx | Reg. Deeds 30-26-16158 | 1720 |
| 7. Drumra | Reg. Deeds 30-39-16255 | 1720 |
| 8. Drumralx al. Drumra | Reg. Deeds 66-434-47346 | 1731 |
| 9. Drumraw | Lendrick Map | 1780 |
| 10. Drumra | Reg. Deeds 636-545-639977 | 1811 |
| 11. Drumraw | Tithe Applot. | 1825 |
| 12. Drumraw | Bnd. Sur. (OSNB) | 1829c |
| 13. Drumraw | OSNB B 35 B 131 | 1830c |
| 14. Druim Rátha "ridge of the fort" | J O'D (OSNB) B 35 B 131 | 1830c |

| | | |
|---|---|---|
| 15. Druim-rátha "ridge of the *rath* or fort" | Joyce iii 336 | 1913 |
| 16. dromˈrɔː | Local pronunciation | 1987 |
| 17. dromˈraː | Local pronunciation | 1987 |

There is no reason to disagree with the previous interpretation of this place-name as *Druim* (>*Droim) Rátha* "ridge of the fort" (14,15). The representation of the final element as *raw* is not recorded until 1780 (9), and appears to have grown up in the English dialect of the area. The place-name is sometimes locally pronounced "Drumra" (17), which appears to more accurately reflect the original Irish language pronunciation. There is a conspicuous hill of 500 feet in the south of the townland, on the summit of which *NISMR* marks an "enclosure" (now destroyed) and this seems most likely to be the feature which has given rise to the place-name.

**Finkiltagh**
D 0006

*An Fhionnchoillteach*
"the fair/white wooded place"

| | | |
|---|---|---|
| 1. (?)Ballichifine | Inq. Ant. (DK) 45 | 1605 |
| 2. (?)Ballichifine | Lodge RR Jas I i 253 | 1606 |
| 3. (?)Ballichifine | CPR Jas I 93b | 1606 |
| 4. (?)Ballylicky or Ballylickyfin | Lodge RR Chas I i 407 | 1637 |
| 5. (?)Ballylickfine al. Lickea | BSD 135b | 1661 |
| 6. Ballynanunkiltagh al. Aghnemelty | Inq. Ult. (Antrim) §6 Car. II | 1662 |
| 7. (?)Ballylickfeny | Lodge RR Chas II i 106 | 1663 |
| 8. ffinkillogh | HMR Ant. 154 | 1669 |
| 9. (?)Ballyluckefin | Inst. Edenduffcarrick | 1672c |
| 10. Finkillagh | Inst. Edenduffcarrick | 1672c |
| 11. (?)Ballylickenfine al. Lickea | Comm. Grace 10 | 1684 |
| 12. Finkiltagh | Lodge RR Chas II ii 292 | 1684 |
| 13. (?)Ballylickefine al. Lickea | Lodge RR Chas II ii 292 | 1684 |
| 14. ffinkiltagh | Indent. (Staff.) | 1692 |
| 15. (?)Ballylickfin | Reg. Deeds 10-133-3227 | 1712 |
| 16. Tinkilkagh | Reg. Deeds 30-39-16255 | 1720 |
| 17. Finkillagh | Reg. Deeds 37-104-21527 | 1722 |
| 18. Finkiltagh al. Finkilltagh | Reg. Deeds 66-434-47346 | 1731 |
| 19. (?)Ballylickifine al. Lickea | Reg. Deeds 90-171-61470 | 1739 |
| 20. Finkiltagh | Reg. Deeds 220-158-146376 | 1762 |
| 21. (?)Ballylickefine or Lickea | Reg. Deeds 220-158-146376 | 1762 |
| 22. Finkiltagh | Lendrick Map | 1780 |
| 23. Finkiltagh | Tithe Applot. | 1825 |
| 24. Finkiltagh | Bnd. Sur. (OSNB) | 1829c |
| 25. Finkiltagh | OSNB B 35 B 131 | 1830c |
| 26. Fionn Choillteach "fair (white) woodland" | J O'D (OSNB) B 35 B 131 | 1830c |
| 27. Fionn-coilltech "whitish woodland" | Joyce iii 353 | 1913 |
| 28. ˌfinˈkïlta | Local pronunciation | 1987 |

The historical forms marked with a question mark cannot with certainty be identified with Finkiltagh. However, from the position of the name in the early townland lists, a tentative identification appears to be justified. The name of the next townland in all these sources is *Killoghskeaghan* (modern **Killycoogan**), and it is possible that the element *killogh* was also intended to be suffixed to *Ballichifine* et var. in these sources. In spite of the confused nature of the earlier documentary evidence, it seems safe therefore to accept that the name of the townland goes back to Irish *An Fhionnchoillteach* "the fair/white wooded place", which is clearly the form intended by O'Donovan (26). Forms 8, 10 and 17 appear to suggest a variant form without *t*, i.e. *Fionnchoilleach* "fair or white place of woods", but it is more likely that the second *l* in these forms is a scribal error for *t* and that the intended orthography is *ffinkiltogh*. There is now no sign of a wood in the townland, but the *OS 6-inch* map of 1833 shows a small area of what appears to be native woodland in the north-west corner.

**Garvaghy**  *Garbhachadh*
C 9904  "rough field"

| | | |
|---|---|---|
| 1. Ballygarvaghy | Lodge RR Chas I i 407 | 1637 |
| 2. Garraghy | Inq. Ult. (Antrim) §6 Car. II | 1662 |
| 3. Garaghy | Inq. Ult. (Antrim) §6 Car. II | 1662 |
| 4. Balligarvaghy | Lodge RR Chas II i 106 | 1663 |
| 5. Garvaghy | HMR Ant. 154 | 1669 |
| 6. Garvaghy | Comm. Grace 10 | 1684 |
| 7. Garvaghy | Lodge RR Chas II ii 292 | 1684 |
| 8. Garvaghy | Indent. (Staff.) | 1692 |
| 9. Garvaghy | Reg. Deeds 10-133-3227 | 1712 |
| 10. Garvachy al. Garvaghy | Reg. Deeds 66-434-47346 | 1731 |
| 11. Garvagh | Reg. Deeds abstracts i §621 | 1736 |
| 12. Garvaghey | Lendrick Map | 1780 |
| 13. Portglenone orw. Garvaghy | Reg. Deeds 761-596-517131 | 1820 |
| 14. Garvaghy | Tithe Applot. | 1825 |
| 15. Garvaghy | Bnd. Sur. (OSNB) | 1829c |
| 16. Garvaghy | OSNB B 35 B 131 | 1830c |
| 17. Garbh Achadh "rough field" | J O'D (OSNB) B 35 B 131 | 1830c |
| 18. ˌgɑr'vaːxi | Local pronunciation | 1987 |

This is a fairly common townland name in the north of Ireland, there being in all nine townlands so-named, the best-known of which are **Garvaghy** near Banbridge in Co. Down (which gives name to the parish in which it is situated) and **Garvaghy** near Dungannon in Co. Tyrone. The local pronunciation suggests that this place-name has undergone a change of stress since in the original Irish version the stress would have fallen on the first syllable. A similar change of stress appears to have occurred in the names of most of the other **Garvaghy** townlands. The anglicization of Irish final *-adh* as *y* is well attested, as in the name of the town of **Finaghy** near Belfast, which is derived from Irish *Fionnachadh* "white field" (*GÉ* 106), and the townland of **Slievenalargy** in the parish of Kilcoo in Co. Down, which is from Irish *Sliabh na Leargadh* "mountain of the sloping expanse" (*PNI* iii 113). The *OSNB* of c. 1830 describes the townland of Garvaghy as: "roughly two-thirds cultivated; remainder rough ground with a very small portion of bog" (*OSNB* B 35 B 131). There is still an area of rough land in the middle of the townland and this may be the feature which has given rise to the place-name.

In this townland is situated the town of **Portglenone**, which explains the reference to *Portglenone orw. Garvaghy* in 1820 (13).

| **Gortaheran** | *Gort an Chaorthainn* | |
|---|---|---|
| C 9808 | "field of the rowan-tree" | |
| 1.  (?)a nGort an Chairn(n) | LCABuidhe 186n | 1680 |
| 2.  Balligortcherin | Inq. Ant. (DK) 45 | 1605 |
| 3.  Balligortcherin | Lodge RR Jas I i 253 | 1606 |
| 4.  Balligortcherin | CPR Jas I 93b | 1606 |
| 5.  Gortichiryn | Civ. Surv. x §66a | 1655c |
| 6.  Ballygortkeene | Inq. Ult. (Antrim) §6 Car. II | 1663 |
| 7.  Gortnakerine | Lodge RR Chas II ii 292 | 1684 |
| 8.  Gortkeerin | Indent. (Staff.) | 1692 |
| 9.  Gorterekerine | Reg. Deeds 10-133-3227 | 1712 |
| 10. Gortnakiran | Reg. Deeds 30-26-16158 | 1720 |
| 11. Gortkeeren al. Gortnakiran | Reg. Deeds 66-434-47346 | 1731 |
| 12. Gortkeerin al. Gortkeeren al. | | |
| Gortnakiran | Reg. Deeds 84-500-622451 | 1737 |
| 13. Gortakeiran | Lendrick Map | 1780 |
| 14. Gortaherine | Reg. Deeds 511-461-332878 | 1797 |
| 15. Gortaherin | Reg. Deeds 511-461-332878 | 1797 |
| 16. Gortnakerine | Reg. Deeds 636-545-6389977 | 1811 |
| 17. Gortaheron | Tithe Applot. | 1825 |
| 18. Gortaheron | Bnd. Sur. (OSNB) | 1829c |
| 19. Gortaheron | OSNB B 35 B 131 | 1830c |
| 20. Gort an Chaorthainn "field of | | |
| the rowan trees" | J O'D (OSNB) B 35 B 131 | 1830c |
| 21. Gort-a'chaorthainn "field of | | |
| the keerans or rowans" | Joyce iii 372 | 1913 |
| 22.  ˌgɔrtəˈhɛrən | Local pronunciation | 1987 |

As discussed above under the townland of **Gortagharn** in the parish of Drummaul, Lloyd's identification of Gortaheran with *Gort an Chairn(n)* of *Leabhar Cloinne Aodha Buidhe* (1) can almost certainly be ruled out. The Irish form of Gortaheran is clearly *Gort an Chaorthainn*, as suggested by both O'Donovan (20) and Joyce (21), though this is obviously to be translated "field of the rowan tree" rather than "field of the rowan trees".

| **Gortfad** | *An Gort Fada* | |
|---|---|---|
| C 9804 | "the long field" | |
| 1.  Balligortfadda | Inq. Ant. (DK) 45 | 1605 |
| 2.  Balligortfadda | Lodge RR Jas I i 253 | 1606 |
| 3.  Balligortfadda | CPR Jas I 93b | 1606 |
| 4.  Grangia de Gortfadd | Ulster Visit. (Reeves) 260 | 1622 |
| 5.  Gortfayd | Ulster Visit. (Reeves) 263 | 1622 |
| 6.  Gortfadda | Inq. Ult. (Antrim) §120 Car. I | 1637 |
| 7.  Ballygortfadd | Inq. Ult. (Antrim) §6 Car. II | 1662 |

| | | |
|---|---|---|
| 8. Gortfad | HMR Ant. 154 | 1669 |
| 9. Gortfaddy | Lodge RR Chas II ii 292 | 1684 |
| 10. Gortfad | Indent. (Staff.) | 1692 |
| 11. Gortfaddy | Reg. Deeds 10-133-3227 | 1712 |
| 12. Gortfad | Reg. Deeds 37-104-21527 | 1722 |
| 13. Gorfadd | Lendrick Map | 1780 |
| 14. Gortfad | Tithe Applot. | 1825 |
| 15. Gortfad | Bnd. Sur. (OSNB) | 1829c |
| 16. Gortfad | OSNB B 35 B 131 | 1830c |
| 17. Gort Fada "long field" | J O'D (OSNB) B 35 B 131 | 1830c |
| 18. gɔrt'faːd | Local pronunciation | 1987 |

The name of this townland has been correctly identified by O'Donovan as deriving from Irish *Gort Fada* "long field" (17). Unstressed final vowels sometimes disappear in place-names, which explains the absence of the final *a* in the modern version of the name, and also in most of the recorded spellings from 1622 onwards (see **Killyfad** in the parish of Drummaul above). The townland is well-known as containing the site of the ancient burying place known as "St. Columb's Thorn", from an old thorn tree which stood beside it and which was cut down c. 1770 (*OSM* xxiii 25). According to the *Ordnance Survey Memoir*, the site was also occupied by an old church, in which St Columbkille often preached (*ibid.*). The *Ulster Visitation* of 1622 refers to the townland as "*Grangia de Gortfadd* – noe church or chappell no walls. The second part of all tithes impropriate to the Abbey of Armagh . . . ." (*Ulster Visit. (Reeves)* 260). As referred to above, the parish of **Grange of Ballyscullion** was also formerly linked to the Augustinian Abbey of SS Peter and Paul in Armagh. The field in which the graveyard of **Gortfad** was situated is still known as "The Graveyard Field". Discussing the name of the townland of **Gortfad Glebe** in the parish of Desertcreat in Co. Tyrone, McCann remarks that "ecclesiastical farmland is often termed *gort*" and that "the phrase *Gort or Glebe* is often found in 17th century grants" (*McCann's Desertcreat* 86). It is possible that the element *gort* in the name of this townland may also carry ecclesiastical connotations, though it is clear that *gort* does not always have this significance in place-names.

**Gortgole**
C 9606

*Gort Gabhail*
"field of the fork"

| | | |
|---|---|---|
| 1. Balligortgall | Inq. Ant. (DK) 45 | 1605 |
| 2. Balligortgole | Lodge RR Jas I i 253 | 1606 |
| 3. Balligortgole | CPR Jas I 93b | 1606 |
| 4. Ballygortgoale or gould | Lodge RR Chas I i 407 | 1637 |
| 5. Ballygortgole | BSD 135b | 1661 |
| 6. Portgole | Inq. Ult. (Antrim) §8 Car. II | 1662 |
| 7. Ballygortgele | Inq. Ult. (Antrim) §8 Car. II | 1662 |
| 8. Gortgole | HMR Ant. 155 | 1669 |
| 9. Ballygortgole | Lodge RR Chas II ii 292 | 1684 |
| 10. Gortgole | Indent. (Staff.) | 1692 |
| 11. Ballygortgole | Reg. Deeds 10-133-3227 | 1712 |
| 12. Gortgole | Reg. Deeds 64-326-44070 | 1730 |
| 13. the six towns of Gortgole | Reg. Deeds 242-379-157072 | 1765 |
| 14. Gortgole | Lendrick Map | 1780 |

| | | |
|---|---|---|
| 15. Gortgole | Tithe Applot. | 1825 |
| 16. Gortgole | Bnd. Sur. (OSNB) | 1829c |
| 17. Gortgole | OSNB B 35 B 131 | 1830c |
| 18. Gort Góbháil "field of the fork" | J O'D (OSNB) B 35 B 131 | 1830c |
| 19. Gort-gabhail "field of the (river-) fork" | Joyce iii 378 | 1913 |
| 20. ˌgɔrt'goːl | Local pronunciation | 1987 |

The name of this townland is clearly derived from Irish *Gort Gabhail* as suggested by both O'Donovan (18) and Joyce (19). The normal meaning of *gabhal* in Irish is "a fork, anything forked" (*Dinneen* sv.). However, in the case of this place-name it is difficult to identify the feature referred to. Joyce suggests that in place-names *gabhal* usually signifies a river-fork (*Joyce* i 529), and he interprets the name of this townland as *Gort-gabhail* "field of the (river-) fork" (*Joyce* iii 378). While the position of the townland on the bank of the river Bann would lead one to propose such an interpretation, there is no fork in the river in the vicinity. It is, however, possible that *gabhal* may in this case have one of its alternative meanings such as "an opening, estuary or creek" (*Dinneen* sv.) or "forked inlet, creek" (*Ó Dónaill* sv.) and that it may refer to a feature of the course of the river which has been destroyed, perhaps by a scheme for the deepening of the river.

It is also possible that *gabhal* may refer to a feature of the landscape unconnected with the river Bann and that *Gort Gabhail* may signify simply "field of the fork", i.e. "fork-shaped field", referring to a feature which is not apparent from the modern landscape. It is worth noting that the word *gabhal* appears in phrases such as *gabhal tíre* "a fork of land" (Dinneen sv.) and *gabhal portaigh* "cut-away section of bog" (*Ó Dónaill* sv.).

The reference to "the six towns of Gortgole" (13) is to the townland of Gortgole in the parish of Portglenone, along with Moboy, Killyless, Lisnahunshin, Loan and Drumrankin in the parish of Craigs, which were granted by Sir Henry O'Neill of Shane's Castle to [Phelemy] Duff O'Neill of Gortgole, and forfeited by the latter on account of his part in the rebellion of 1641 (*Inq. Ult.* §8 Car. II).

## Kilcurry
J 0198

*Coill Chorraigh(?)*
"wood of the marsh"

| | | |
|---|---|---|
| 1. Ballikillcurry | Inq. Ant. (DK) 45 | 1605 |
| 2. Ballikillcurry | Lodge RR Jas I i 253 | 1606 |
| 3. Ballikillcurry | CPR Jas I 93b | 1606 |
| 4. Killcorry | Inq. Ult. (Antrim) §32 Car. I | 1635 |
| 5. Killecorry | Inq. Ult. (Antrim) §32 Car. I | 1635 |
| 6. Ballekillcurry al. Killtecurry | Lodge RR Chas I i 407 | 1637 |
| 7. Ballykilcurry al. Killecurry | BSD 135b | 1661 |
| 8. Kilcorr | HMR Ant. 153 | 1669 |
| 9. Ballykillcurry al. Killtecurry | Lodge RR Chas II ii 292 | 1684 |
| 10. Killtecurry | Reg. Deeds 10-133-3227 | 1712 |
| 11. Ballykillcurry al. Killtecurry | Reg. Deeds 90-171-62470 | 1739 |
| 12. Killcurry | Lendrick Map | 1780 |
| 13. Kilcury | Reg. Deeds 660-290-457358 | 1813 |
| 14. Ballykilcarry orw. Killtecurry | Reg. Deeds 835-340-561276 | 1821 |

| 15. Kilcurry | Tithe Applot. | 1825 |
| 16. Kilcurry | Bnd. Sur. (OSNB) | 1829c |
| 17. Kilcurry | OSNB B 35 B 131 | 1830c |
| 18. Coill a' Churraigh "wood of the moor" | J O'D (OSNB) B 35 B 131 | 1830c |
| 19. ˌkilˈkọri | Local pronunciation | 1987 |

Forms 6b, 9b, 11b and 14b may suggest a plural form of the first element, i.e. *coillte* "woods", rather than the singular form *coill* "wood", though it is perhaps more likely that the addition of the *t* is merely a scribal error (see **Killyfad** above). There is now no native woodland in the townland, but near its southern boundary there is a hill named Wood Hill of which the *OSRNB* of c. 1858 (sheet 36) remarks: "*The Royal Oak*, man-of-war, was built with the timber that grew on the hill".

While the first element of the place-name is clearly *coill* "wood", it is difficult to be certain about the origin of the final element. O'Donovan's suggestion that it derives from *currach* (>*corrach*) "marsh/bog" (18) appears the most likely, though in the absence of evidence of the definite article among the recorded spellings the original Irish form of the place-name is likely to be *Coill Chorraigh* "wood of the marsh" rather than *Coill a' Churraigh (Coill an Chorraigh)* which has the same meaning. The *OSNB* (*B 35 B* 131) of 1830c refers to a portion of bog on the east boundary of the townland as well as to some scattered portions of rough ground. Several other interpretations of the final element are also possible. One might consider the element *corr* which has a wide range of meanings including "hollow/pit; rounded hill/hump" (*Ó Dónaill* sv.). Thus, it could be argued that the form *Coill Choirre* "wood of the rounded hill" could refer to the aforementioned wood which formerly grew on Wood Hill. Another possible derivation is *Coill Chorra* "*Corr*'s wood", the final element being the personal name *Corr* which is attested in early east Ulster genealogies (*Descendants Ir* 100, 354).

**Killycoogan**
C 9607

*Coill Uí Cheogáin(?)*
"Coogan's wood"

| 1. Ballikilloghkeghan | Inq. Ant. (DK) 45 | 1605 |
| 2. Ballikilloghskeaghan(e) | Lodge RR Jas I i 253 | 1606 |
| 3. Ballikilloghskeaghan | CPR Jas I 93b | 1606 |
| 4. Ballykillogh | BSD 135b | 1661 |
| 5. Ballykillterogher al. Ballykillyegogan | Inq. Ult. (Antrim) §6 Car. II | 1662 |
| 6. Ballykillogh Sheaghan | EP Edenduffcarrick | 1666 |
| 7. Killosingan | Comm. Grace 10 | 1684 |
| 8. Ballykilloghskechane | Comm. Grace 10 | 1684 |
| 9. Killoseugan | Lodge RR Chas II ii 292 | 1684 |
| 10. Ballykilloghskechan or Ballykilloghskeaghane | Lodge RR Chas II ii 292 | 1684 |
| 11. Killicoogan | Indent. (Staff.) | 1692 |
| 12. Killosengan | Reg. Deeds 10-133-3227 | 1712 |
| 13. Killoghskehane | Reg. Deeds 10-133-3227 | 1712 |
| 14. Killycogan | Reg. Deeds 30-26-16158 | 1720 |
| 15. Killcugan | Reg. Deeds 30-39-16255 | 1720 |

| | | |
|---|---|---|
| 16. Killicogan al. Killycogan | | |
|     al. Killingan | Reg. Deeds 84-500-622451 | 1737 |
| 17. Killycoagan | Reg. Deeds 84-500-622451 | 1738 |
| 18. Ballykillaghskechane | Reg. Deeds 90-171-62470 | 1739 |
| 19. Killosengen | Reg. Deeds 220-158-146376 | 1762 |
| 20. Ballykillagh Skechane | Reg. Deeds 220-158-146376 | 1762 |
| 21. Killycoogin | Lendrick Map | 1780 |
| 22. Killesingen | Reg. Deeds 636-545-639977 | 1811 |
| 23. Ballyhillogh Shekane | Reg. Deeds 756-26-513561 | 1820 |
| 24. Ballyhillagh Shekane | Reg. Deeds 756-26-513561 | 1820 |
| 25. Killycoogan | Tithe Applot. | 1825 |
| 26. Killycoogan | OSNB B 35 B 131 | 1830c |
| | | |
| 27. Coill Uí Chuagáin | | |
|     "O'Coogan's wood" | J O'D (OSNB) B 35 B 131 | 1830c |
| | | |
| 28. ˌkili'kugən | Local pronunciation | 1987 |

The documentary evidence for the name of this townland is inconsistent, rendering it impossible to establish a reliable derivation. The presence of the medial -gh- in the earliest forms (reproduced in a number of later, related, sources) appears to be the result of confusion with the final element of the name of the townland of **Finkiltagh** which immediately precedes Killycoogan in all these sources, while the -s- is likely to be a scribal error for -o-. The intended spelling appears to be something like *Ballykillokeaghan*. The townland contains the site of a former graveyard and church (*OSM* xxiii, 26) which may suggest that the first element of the place-name may be *cill* "church", rather than *coill* "wood" as proposed by O'Donovan (27). However, since the final element of the place-name appears to be a surname, it is more likely that this would be found in combination with *coill* "wood" than with *cill* "church". Nonetheless, O'Donovan's suggestion that the final element is the surname *Ó Cuagáin* "Coogan" must be regarded as improbable, since *Ó Cuagáin* is the name of a sept of the *Uí Maine* of Galway (MacLysaght 1985, 57) and there is no evidence that it was to be found in this area. I would tentatively suggest that the earliest recorded spellings of the place-name exhibit a corrupt form of the surname *Mac Eochagáin* which, according to Woulfe (1923, 358), is a rare surname, found only in Cavan and a few other parts of Ulster and can be anglicized *Kehigan, MacCogan, Keogan* and *Coogan*. MacLysaght (*op. cit.* 176) informs us that *Mac Eochagáin* has been corrupted to *Ó Ceogáin* and I would suggest that the genitive form of this surname, i.e. *Uí Cheogáin*, is the form represented in the final element of our place-name. It is worth remarking that an individual named "Hugh Cugin" is recorded as residing in the nearby townland of Carmagrim in 1669 (*HMR Ant.* 153).

**Killygarn**
H 9999

*Coill na gCarn*
"wood of the cairns"

| | | |
|---|---|---|
| 1. Ballychillnegarie | Inq. Ant. (DK) 45 | 1605 |
| 2. Ballichilnegarne | Lodge RR Jas I i 253 | 1606 |
| 3. Ballichilnegarne | CPR Jas I 93b | 1606 |
| 4. Ballakillnegarne | Lodge RR Chas I i 407 | 1637 |
| 5. Ballykilnegarne | BSD 135a | 1661 |
| 6. ½ town + lands of Kilnegarne | Inq. Ult. (Antrim) §8 Car. II | 1662 |
| 7. Ballykillnegarne | Lodge RR Chas II i 106 | 1663 |

| | | |
|---|---|---|
| 8. Killnegarne | Lodge RR Chas II i 106 | 1663 |
| 9. (?)Kennighohan | HMR Ant. 153 | 1669 |
| 10. Ballykilnegarne | Lodge RR Chas II ii 292 | 1684 |
| 11. Killnegarne | Reg. Deeds 10-133-3227 | 1712 |
| 12. Ballykilnegarne | Reg. Deeds 90-171-62470 | 1739 |
| 13. Killygarn | Lendrick Map | 1780 |
| 14. Killygarn | Reg. Deeds 660-290-457358 | 1813 |
| 15. Killygarn | Tithe Applot. | 1825 |
| 16. Killygarn | Bnd. Sur. (OSNB) | 1829c |
| 17. Killygarn | OSNB B 35 B 131 | 1830c |
| 18. Killygarron | OSM xxiii 35 | 1835 |
| 19. Killygarrin | O'Laverty iii 376 | 1884 |
| 20. Coill a' gharráin "wood of the copse" | J O'D (OSNB) B 35 B 131 | 1830c |
| 21. Coill na gCarn | GÉ 73 | 1989 |
| 22. ˌkïli'gɑ:rn | Local pronunciation | 1987 |

O'Donovan's interpretation of the place-name as *Coill a' gharráin* "wood of the copse" (20) is unlikely for a number of reasons. It is not supported by the evidence of the earlier spellings, all of which display medial *-ne-*. Nor does the element *garrán* "copse, grove" appear to be attested in Ulster place-names outside of Monaghan (*Joyce* i 498). Moreover, the formation "wood of the copse, grove" is tautologous. A more satisfactory interpretation of the place-name is *Coill na gCarn* "wood of the cairns" as suggested in *GÉ* (21). Although there is now no trace or record of either a wood or cairns in the townland, the element *coill* "wood" does occur in the name of the neighbouring townland of **Kilcurry**, and it seems likely that the two townlands were named from small and closely adjoining areas of woodland. As for the second element of the place-name, there is plenty of evidence of former burial in the vicinity. O'Laverty informs us that human bones were found at a place called "Tamlaght" in the Largy Bog, which covers part of both Carmagrim and Killygarn townlands (*O'Laverty* iii 366). The first element of the name of the neighbouring townland of **Carmagrim** also appears to represent Irish *carn* "cairn".

**Lisnagarran**  *Lios Tí Ghearáin*
C 9907  "the enclosure of *Gearán*'s house"

| | | |
|---|---|---|
| 1. Ballilistigaran | Inq. Ant. (DK) 45 | 1605 |
| 2. Ballylistygarran(e) | Lodge RR Jas I i 253 | 1606 |
| 3. Ballilistygarran | CPR Jas I 93b | 1606 |
| 4. Ballylistegarran | Lodge RR Chas I i 407 | 1637 |
| 5. Ballislegarran | BSD 135b | 1661 |
| 6. Ballyhftegarran | Lodge RR Chas II i 106 | 1663 |
| 7. Lisnegarran | HMR Ant. 155 | 1669 |
| 8. Ballylistegarrane | Lodge RR Chas II ii 292 | 1684 |
| 9. Listegarran | Reg. Deeds 10-133-3227 | 1712 |
| 10. Ballylistegarrane | Reg. Deeds 90-171-62470 | 1739 |
| 11. Lisnageeran | Lendrick Map | 1780 |
| 12. Ballylisnegarne | Reg. Deeds 636-545-639977 | 1811 |
| 13. Lisnagarn | Reg. Deeds 660-290-457358 | 1813 |

| | | |
|---|---|---|
| 14. Lisnagaron | Tithe Applot. | 1825 |
| 15. Lisnagarron | Bnd. Sur. (OSNB) | 1829c |
| 16. Lisnagarron | OSNB B 35 B 131 | 1830c |
| 17. Lios na gCarn "fort of the cairns" | J O'D (OSNB) B 35 B 131 | 1830c |
| 18. ˌlïsnə'gɑːrən | Local pronunciation | 1987 |

The modern version of Lisnagarran would lead one to suggest an Irish form such as O'Donovan's *Lios na gCarn* "fort of the cairns" (17), or possibly *Lios na nGearrán* "the enclosure of the horses". However, the earlier recorded spellings point to the form *Lios Tí Ghearáin* "the enclosure of *Gearán*'s house". The personal name *Gearán* does not appear to be widely attested, but it could represent a development from *Gearadán*, a personal name which is found as a variant of *Erodán* in an early genealogy of the Airgialla of Mid-Ulster (*CGH* 334a21). A variant form of *Erodán*, i.e. *Errudan* is also found in an early East Ulster genealogy (*Descendants Ir* 101). A surname derived from the personal name *Gearán* (i.e. *Ó Gearáin* "O'Garran") appears to form the final element of the name of the townland of **Dunnygarran** in the parish of Craigs (see above). A parallel anglicization of Irish *Lios Tí . . .* as *Lisna . . .* appears to have occurred in the name of the townland of **Lisnamurrickin** in the parish of Racavan in Co. Antrim, which is written as *Listymurrickin* in an inquisition of 1637 (*Inq. Ult.* §124 Car. I), suggesting the Irish form *Lios Tí Mhuireagáin* "the fort of *Muireagán*'s house".

## Lisrodden
C 9906

*Lios Rodáin*
"*Rodán*'s fort"

| | | |
|---|---|---|
| 1. Ballylessraddan | Inq. Ant. (DK) 45 | 1605 |
| 2. Balliliske-Roddan | Lodge RR Jas I i 253 | 1606 |
| 3. Ballilish-Roddan | CPR Jas I 93b | 1606 |
| 4. Ballylishdrodan | Inq. Ult. (Antrim) §6 Car. II | 1662 |
| 5. Lisnedden | HMR Ant. 156 | 1669 |
| 6. Lisrodan | Indent. (Staff.) | 1692 |
| 7. Lisroddan | Reg. Deeds 40-309-25982 | 1722 |
| 8. Lisnarodin | Grand Jury Pres. Oct. 8 | 1770 |
| 9. Liswadin | Lendrick Map | 1780 |
| 10. Lisrodden | Tithe Applot. | 1825 |
| 11. Lisrodden | Bnd. Sur. (OSNB) | 1829c |
| 12. Lisrodden | OSNB B 35 B 131 | 1830c |
| 13. Lios Rodáin "Redden's fort" | J O'D (OSNB) B 35 B 131 | 1830c |
| 14. Lios Rodáin | GÉ 126 | 1989 |
| 15. ˌlïs'rɔːdən | Local pronunciation | 1987 |

The Irish form of the name of this townland has been correctly identified as *Lios Rodáin* (13,14), though the final element is likely to represent the personal name *Rodán*, rather than the derived Clare surname "Reddan", which seems to be the interpretation suggested by O'Donovan (13). *Rodán* was the name of an early Irish saint whose feast day is August 24th (Ó Corráin & Maguire 1981, 156) and also the name of a herdsman of St Patrick (*Trip. Life (Stokes)* 574). *Rodán* is also found as the name of a layman in an early East Ulster genealogy (*Descendants Ir* 138) and from the same name are derived the Donegal surnames

253

*Ó Rodáin*, which is anglicized as *Rodden*, and *Mac Rodáin*, which is anglicized as *McCruddan* (MacLysaght 1985, 259). None of the historical forms of this place-name show any evidence of the surname particle *Mac* or *Ó*, and it is safe to conclude that the final element is the personal name *Rodán*, rather than a surname derived from it. The *OSNB* (B 35 B 131) refers to a large fort near the southern boundary of the townland, all trace of which has now disappeared. It is possible that this is the feature which has given name to the townland.

| **Mullinsallagh** | *Mullán Saileach* | |
|---|---|---|
| C 9903 | "summit of the willows" | |
| 1. Ballinowlantarry | Inq. Ant. (DK) 45 | 1605 |
| 2. Ballinowlancally | Lodge RR Jas I i 253 | 1606 |
| 3. Ballinowlantally | CPR Jas I 93b | 1606 |
| 4. Ballenowankelly or | | |
|    Ballylowlankelly | Lodge RR Chas I ii 407 | 1637 |
| 5. Ballnowlankelly | Lodge RR Chas II i 106 | 1663 |
| 6. Mallansallogh | HMR Ant. 154 | 1669 |
| 7. Mullanesallagh | Lodge RR Chas II i 106 | 1684 |
| 8. Mullensallagh | Indent. (Staff.) | 1692 |
| 9. Mullensallagh | Reg. Deeds 10-133-3227 | 1712 |
| 10. Mulinasala | Reg. Deeds 37-104-21527 | 1722 |
| 11. Monanesallagh | Reg. Deeds 90-171-62470 | 1739 |
| 12. Mullanesallagh | Reg. Deeds 220-158-145376 | 1762 |
| 13. Mullinsallagh | Lendrick Map | 1780 |
| 14. Mullenisallagh | Reg. Deeds 636-545-639977 | 1811 |
| 15. Mullinsallagh | Tithe Applot. | 1825 |
| 16. Mullinsallagh | Bnd. Sur. (OSNB) | 1829c |
| 17. Mullinsallagh | OSNB B 35 B 131 | 1830c |
| 18. Mullinasillagh | OSM xxiii 37 | 1835 |
| 19. Muileann salach "dirty mill | | |
|    or Mullán Salach "dirty hill" | J O'D (OSNB) B 35 B 131 | 1830c |
| 20. 'mo̩lən'sa:lə | Local pronunciation | 1987 |

It is difficult to be certain whether this place-name is best interpreted as *Mullán Salach* "dirty/marshy summit" as suggested by O'Donovan (19b) or *Mullán Saileach* "summit of the willows". However, since the most conspicuous height in the townland is the very prominent hill now known as **Tully** (668 feet), the summit of which appears unlikely to have ever been marshy, the latter appears the more appropriate interpretation. This conclusion appears to be supported by the form *Mullinasillagh* (18), though this spelling is admittedly late and consequently of limited value. Forms 1-5 may suggest the Irish form *Maolán Saili* "hillock of the (single) willow", but these forms (which are all related) are obviously corrupt and cannot be regarded as reliable evidence.

| **Slievenagh** | *Sliabhánach* | |
|---|---|---|
| C 9902 | "place of heathy upland" | |
| 1. Balliaghnachivave | Inq. Ant. (DK) 45 | 1605 |
| 2. Balliaghnaclynan or | | |
|    Balliaghnatlyvan | Lodge RR Jas I i 253 | 1606 |

| | | |
|---|---|---|
| 3. Ballyaghnaclynan | CPR Jas I 93b | 1606 |
| 4. Slevenagh | Inq. Ult. (Antrim) §120 Car. I | 1637 |
| 5. Ballyaghnettlevan als Slevanagh (or Slavanagh) or Ballyentlevan | Lodge RR Chas I i 407 | 1637 |
| 6. Ballyantlevan al. Slavanagh | Lodge RR Chas II i 106 | 1663 |
| 7. Slevennagh | HMR Ant. 154 | 1669 |
| 8. Aghettlevane al. Slybanagh | Inst. Edenduffcarrick | 1672c |
| 9. Slevenagh | Lodge RR Chas II ii 292 | 1684 |
| 10. Slavenagh | Indent. (Staff.) | 1692 |
| 11. Slevenagh | Reg. Deeds 10-133-3227 | 1712 |
| 12. Slwenagh | Lendrick Map | 1780 |
| 13. Slavenagh or Slavanagh | Reg. Deeds 761-596-517131 | 1820 |
| 14. Slavenagh | Tithe Applot. | 1825 |
| 15. Slavenagh | Bnd. Sur. (OSNB) | 1829c |
| 16. Slavenagh | OSNB B 35 B 131 | 1830c |
| 17. Slavenagh | OS Name Sheets | 1832 |
| 18. Slievenagh | OS Name Sheets (J O'D) | 1832 |
| 19. Slavanagh | OSM xxiii 35 | 1835 |
| | | |
| 20. Sléibhineach "mountainous" | J O'D (OSNB) B 35 B 131 | 1830c |
| 21. Sliabhnach "a mountainous place" | Joyce iii 558 | 1913 |
| | | |
| 22. 'sla:vənə | Local pronunciation | 1987 |

The earliest recorded spellings of this place-name seem to point to the Irish form *Achadh na Sliabhán* "field of the heathy uplands", or, possibly *Achadh an tSliabháin* "field of the heathy upland". None of the standard dictionaries list the word *sliabhán*, but it is clearly composed of *sliabh* plus the suffix *-án*. *Sliabh* (which is often anglicized *slieve*) can signify: "mountain, mount, range of mountains; a mountainous district, a heathy upland or plain, a moor, a piece of moorland, often low-lying" (*Dinneen* sv.). In the middle of this townland there is an area of high ground, on the summit of which is a conspicuous heathy hill known as **Tully**, which lies almost on the border of this townland with the townland of **Mullinsallagh**. "Heathy upland" may therefore be in this case the most appropriate interpretation of *sliabhán*. In many Irish words, the original diminutive meaning of the suffix-*án* has been lost (*Joyce* ii 18) and the *-án* termination of *sliabhán* seems unlikely in this case to carry any connotation of smallness. The modern form of the place-name, which is documented for the first time in 1637(5b), appears to consist of *sliabhán* "heathy upland", plus the collective suffix *-ach*. The form *Sliabhánach* would therefore signify "place of heathy upland". *Ó Máille* (1955(b), 91) has drawn attention to the place-name suffix *-(e)anach*, which has the same significance as the suffix *-ach*, i.e. "place of", and one could argue for the form *Sliabhanach* (i.e. *sliabh* + the suffix *-anach*), which would be similar in meaning to *Sliabhánach*. However, since the earlier historical forms point to a form containing theelement *sliabhán*, one must regard *Sliabhánach* as the more likely form.

Locally, the name of the townland is usually pronounced "Slavana", a pronunciation which is suggested by many of the recorded spellings from 1637 onwards. The development of the vowel in *sliabh* from [i] to [a] may seem irregular but Stockman (1986, 14) has noted a tendency in Ulster Irish for long stressed vowels to be shortened and lowered under the influence of a following suffix. It is also worth remarking that in Derry Irish Ó Ceallaigh has noted the pronunciation of *ia* as [a] in a few words such as *ciaróg* "beetle" and *Diarmuid*

"Dermot" (*GUH* 115 n.12), and that the surname Slavin is derived from the Irish form *Ó Sléibhín* which appears to be from Irish *sliabh* "mountain" (MacLysaght 1985, 274).

**Tullynahinnion**　　　　　　　　*Tulaigh na hInneona*
D 0005　　　　　　　　　　　　　"hillock of the anvil"

| | | |
|---|---|---|
| 1. Ballivehoman | Inq. Ant. (DK) 45 | 1605 |
| 2. Ballibehoman | Lodge RR Jas I i 253 | 1606 |
| 3. Ballibehoman | CPR Jas I 93b | 1606 |
| 4. Ballybehoman | Lodge RR Chas I i 407 | 1637 |
| 5. Ballybeoman al. Ballylybehenan | BSD 135b | 1661 |
| 6. Ballybohoman | Lodge RR Chas II i 106 | 1663 |
| 7. Tullinehinon | HMR Ant. 154 | 1669 |
| 8. Tullynahone | Comm. Grace 10 | 1684 |
| 9. Ballyveoman al. Ballyvehenan | Comm. Grace 10 | 1684 |
| 10. Tullynahone | Lodge RR Chas II ii 292 | 1684 |
| 11. Ballybehenan | Lodge RR Chas II ii 292 | 1684 |
| 12. Tullyhinnan | Indent. (Staff.) | 1692 |
| 13. Tullynahone | Reg. Deeds 10-133-3227 | 1712 |
| 14. Ballybeoman | Reg. Deeds 10-133-3227 | 1712 |
| 15. Tullyhinans | Reg. Deeds 30-26-16158 | 1720 |
| 16. Tullynakinian | Reg. Deeds 30-39-16255 | 1720 |
| 17. Tullyhinans al. Tullyhinnans al. Tullynakinian | Reg. Deeds 66-434-47346 | 1731 |
| 18. Tullynahone | Reg. Deeds 90-171-62470 | 1739 |
| 19. Ballybeoman al. Ballytehenane | Reg. Deeds 90-171-62470 | 1739 |
| 20. Tullynahunnion | Lendrick Map | 1780 |
| 21. Tullynahinnion | Tithe Applot. | 1825 |
| 22. Tulnahurnian | Bnd. Sur. (OSNB) | 1829c |
| 23. Tulnahenian | OSNB B 35 B 131 | 1830c |
| 24. Tulach na hIngine "hill of the daughter" | J O'D (OSNB) B 35 B 131 | 1830c |
| 25. Tulaigh-na-hingine "hill of the daughter" | Joyce iii 592 | 1913 |
| 26. 'tọlənə'hïnjən | Local pronunciation | 1987 |

The earliest spellings of the name of this townland are clearly corrupt. Forms 1–6, 9, 11, 14 and 19 are all related, the errors in the earliest of these being duplicated (with minor variations) in the later. In spite of the corrupt nature of the earlier spellings, it is clear that the place-name is derived from Irish *Tulaigh na hInneona* "hillock of the anvil", rather than *Tulaigh na hIngine* "hill of the daughter" as suggested by O'Donovan (24) and Joyce (25). There are only two conspicuous hills in the townland, one in the south, which is now known as "Hiltonstown Hill" (600 feet) and another in the north, known as "Mullanasock" (500 feet). Since Mullanasock is documented as a townland in its own right up to the year 1683, it follows that the place-name most likely refers to Hiltonstown Hill. The *Ordnance Survey Memoir* (*OSM* xxiii 34) informs us that this hill was formerly known as *Cloughcurragh*, and that there were previously three standing stones on its summit. *Cloughcurragh* may represent Irish *Clocha Corracha* "upright or pointed stones", and the name could well refer to these

standing stones. Apart from the usual meaning of "anvil", Dinneen also gives "a block of stone" as one of the meanings of *inneoin*, and remarks that, in place-names, it usually signifies "a hill or bluff" (*Dinneen* sv.). Dwelly also gives "rock, hill" as one of the meanings of the same word in Scottish Gaelic (*Dwelly* sv. *innean*). In the case of this place-name, the interpretation of the final element as "hill" would be tautologous. It is more likely, therefore, that *inneoin* "anvil" may be used in a figurative sense to refer to the group of standing stones which formerly stood on top of the hill. It is of course also possible that it may carry its literal meaning of "anvil" and refer to a former blacksmith's forge.

<div align="center">OTHER NAMES</div>

| | | |
|---|---|---|
| **Bishop's Well**<br>C 9703 | An English form | |
| 1. ˌbïʃəps ˈwɛːl | Local pronunciation | 1987 |

This well lies a little to the south of the Cistercian monastery, just inside the townland of Garvaghy. The monastery is in the near vicinity of the former castle of Portglenone, which was erected in 1572 and was originally occupied by Sir Francis Stafford, Governor of Ulster, and at a later date by Francis Hutchinson, Protestant Bishop of Down and Connor (*OSM* xxiii 6). After the old castle had been pulled down, a new mansion house (which forms part of the present monastery) was erected nearby in 1823 by Dr Alexander, the Protestant Bishop of Meath, whose son was rector of the parish in 1835 (*ibid*. 12). The Bishop's Well has obviously been named as being the property of one of the aforementioned bishops, but locally I was unable to discover which. There is no tradition that it was ever a holy well nor is there any evidence to suggest that it is a feature of any great antiquity.

| | | |
|---|---|---|
| **Burnfoot**<br>C 9609 | A hybrid form | |
| 1. ˈbọrnˈfọt | Local pronunciation | 1987 |

This is the name of a little hamlet which lies alongside a by-road from Portglenone to Kilrea. The first element of the place-name is the Scottish word *burn*, in this case referring to a little stream which flows into the river Bann at this point and marks the northern boundary of the townland of Gortaheran which is also the boundary between the baronies of Toome Lower and Kilconway.

| | | |
|---|---|---|
| **Culhame Hill**<br>J 0298 | A hybrid form | |
| 1. kọlˌheːm ˈhïl | Local pronunciation | 1987 |

This is a hill of 420 feet in the townland of Kilcurry. The first element is a variant form of the place-name *Calhame* which is fairly common in Co. Antrim and appears to derive from Scots *cald* "cold" plus *hame* "home(stead)".

| | | |
|---|---|---|
| **Grannystown**<br>C 9806 | An English form | |
| 1. ˈgraːnizˌtəun | Local pronunciation | 1987 |

Of Grannystown the *OSRNB* of c.1858 (sheet 31) remarks: "Village of six farmhouses.

<div align="center">257</div>

Called after family named Granny that lived there for the last century". As referred to above in connection with the townland of **Carmagrim**, the surname *Granny* is derived from Irish *Mag Ráine* and appears to form the final element of the name of that townland. It is sometimes anglicized *Grant*.

| **Largy Bog** | A hybrid form | |
|---|---|---|
| C 9800 | | |
| 1. 'lɑrgi 'bɔg | Local pronunciation | 1987 |

This is the name of an area of bogland which lies on the east bank of the river Bann, partly in the townland of Carmagrim and partly in Killygarn. **The Largy** is the local name for the area of land lying between the summit of Tully Hill in the townland of Mullinsallagh and the Black Hill in the townland of Casheltown on the east, and the river Bann on the west. It roughly comprises the townlands of Aughnahoy, Carmagrim, Killygarn and Kilcurry. The place-name *Largy* is a fairly common one in the north of Ireland and is derived from Irish *leargaidh*, an oblique form of *learg* which signifies "the side or slope of a hill" (*Joyce* i 403); "tract of rising ground, sloping expanse, slope, side" (*Ó Dónaill* sv. *learg*). The name is in this case a particularly apt one, as the entire landscape consists of one long and continuous slope from the river Bann eastwards to the summit of Tully Hill (668 feet), the highest point in the parish. The name *Largy* was also formerly used as an alternative name for the native Irish territory of **Muntercallie** (*Lodge RR* Chas II i 106), though, strictly speaking, Muntercallie was much more extensive (see barony introduction).

| **Mount Stafford** | An English form | |
|---|---|---|
| C 9805 | | |
| 1. Mountstafford | Inq. Ult. (Antrim) §6 Car. II | 1662 |
| 2. Mount Stafford | Reg. Deeds 84-500-622541 | 1737 |
| 3. 'məunt 'stafərd | Local pronunciation | 1987 |

This is the name of a former mansion house in the townland of Gortfad which was so-named as being the chief seat in Co. Antrim of the Stafford family, whose ancestor Sir Francis Stafford was Governor of Ulster in the reign of Queen Elizabeth. To Sir Francis's son Sir Edmund Stafford of Mountstafford was granted a total of 20 townlands in the immediate vicinity of Portglenone, as well as 10 townlands around the hamlet of **Staffordstown** in the parish of Duneane (*Inq. Ult.* §6 Car. II). In 1737, we find a reference to a "Kennedy Stafford of Mount Stafford and Ann, his wife" (*Reg. Deeds* 84-500-622541). According to the *Ordnance Survey Memoir* of 1835, Mount Stafford was at that date occupied by a Mr Adams, a timber merchant (*OSM* xxiii 31). By the middle of the last century, however, the premises had fallen into a bad state of decay, though one portion was still habitable, and was the residence of a family named McCurley. Early in the present century, it was occupied by the McKeown family (Sibbett 1928, 17). There is a tradition that the north Antrim chieftain Sorley Boy MacDonnell spent time at the place now known as Mount Stafford during the course of his war with the English in the 16th century (*ibid.* 49).

| **Portglenone** (town) | *Port Chluain Eoghain* |
|---|---|
| C 9803 | "landing place of Glenone/of |
| | Owen's meadow" |

See parish name

**Rose Gift**                        An English form
C 9706

1. 'ro:z 'gift                       Local pronunciation                    1987

This is the name of an area of land which lies in the west of the townland of Bracknamuckley, bordering on the river Bann. Several explanations of the origin of the name have been put forward. The *OSRNB* of c. 1858 (sheet 31) remarks: "Said to be the gift of one of the Lord O'Neill's to his daughter Rose", while Sibbett (*op. cit.* 28) suggests that Rose Gift was so called as it was a gift from Rose O'Neill to one of her relations who took up residence there. A local informant has told me that the name is properly *Roe's Gift* and that the place was so named as being a gift from Owen Roe O'Neill, an explanation which seems rather improbable since the well-known general Owen Roe O'Neill certainly never owned land in this area. Since the townland was originally granted to Shane O'Neill of Shane's Castle in 1606, and later became the property of his granddaughter Rose O'Neill, one is inclined to believe that the latter may be the Rose referred to in the place-name, though the circumstances in which the name was bestowed remain unclear.

**Skerdan**                          *Sceirdeán*
C 9906                               "bleak/windswept place"

1. 'skɛːrdən                         Local pronunciation                    1987

The *OSRNB* of c. 1858 (sheet 31) remarks that this name refers to "a village of three farm houses (more some time ago)" in the townland of Finkiltagh, that it derives from an Irish word meaning "bare or bleak, being exposed to wind or storm", and that the village was so named as being built on a bleak hill. There are townlands named Scardan, Scardaun and Scardans in the west and north-west of Ireland, whose names, according to Joyce, are derived from *Scardán* (Mod. Ir. *Scairdeán*), signifying "a small cascade or waterfall" (*Joyce* i 460). This also appears to be the origin of the place-name **Scardan Hill** in the Mourne Mountains (*PNI* iii 150). However, since in this case there is no stream in the vicinity this interpretation can be ruled out. It is most likely that the *OSRNB* explanation of the name is correct, and that it goes back to Irish *Sceirdeán*, a variant form of *sceird*, signifying "bleak, windswept place" (*Ó Dónaill* sv. *sceird*).

**Tully**                            *An Tulaigh*
D 0003                               "the hill"

| | | |
|---|---|---|
| 1. Knock Mullagh, a parly hill | Jobson's Ulster (TCD) | 1590c |
| 2. Mo:Tullagh | Bartlett Maps (Esch. Co. Maps) 1 | 1603 |
| 3. Knock Mullagh, a parly Hill | Speed's Ulster | 1610 |
| 4. 'toli | Local pronunciation | 1987 |

This is the name of a very prominent hill in the townland of Mullinsallagh. At 668 feet it is the highest point in the parish. It appears to be the hill which is marked as *"Knock Mullagh, a parly hill"* on two early maps (1, 3), suggesting that it was formerly a place of strategic importance. *Mullagh* in these sources may be an error for *Tully*, though it could

also represent the first element of the townland name **Mullinsallagh**. The element *tulach* in place-names is normally interpreted as "a little hill, a hillock" (*Joyce* i 389) though in this case it clearly applies to a hill of some stature. It may be worthy of remark that one of the meanings of *tulach* listed by Dinneen is "an assembly-hill" or "arena" (*Dinneen* sv.), which may tie in with the aforementioned reference to *"Knock Mullagh, a parly hill"*.

# APPENDIX A

## ASPECTS OF IRISH GRAMMAR RELEVANT TO PLACE-NAMES

The following types of place-names can be identified:

1.  Those which consist of a noun only:

> Sabhall "a barn" (Saul, Dn)
> Tuaim "a tumulus" (Toome, Ant.)

There is no indefinite article in Irish, that is, there is no word for *a*, e.g. *Sabhall* means "barn" or "a barn".

English nouns generally have only two forms, singular and plural, and the plural is normally formed by adding s, e.g. *wall, walls; road, roads*. Occasionally a different ending is added – ox, *oxen* – and occasionally the word is changed internally – *man, men;* sometimes there is both addition and internal change – *brother, brethren*. Irish nouns have not only distinctive forms for the plural but also for the genitive singular and sometimes for the dative and vocative as well. These distinctive forms are made by addition, by internal change and sometimes by both. Five principal types of noun change are identified in Irish and nouns are therefore divided into five major groups known as *declensions*. Examples of change will be seen later.

2.  Singular article + masculine noun:

> An Clar "the plain" (Clare, Arm.)
> An Gleann "the valley" (Glen, Der.)

The only article in Irish is the definite article, that is, the word corresponding to *the* in English.

The singular article *an* "the" prefixes *t* to masculine nouns beginning with a vowel in certain cases. The nouns *eadan* "front, forehead" and *iur* "yew tree", for example, appear in the place-names:

> An tÉadan "the face (of a hill)" (Eden, Ant.)
> An tIúr "the yew tree" (Newry, Dn)

3.  Singular article + feminine noun:

> An Chloch "the stone" (Clough, Dn)
> An Bhreacach "the speckled place" (Brockagh, Der.)

The article *an* aspirates the first consonant of a following feminine noun.

Aspiration is indicated by putting *h* after the consonant *(cloch* "a stone"; *an chloch* "the stone") and the sound of that consonant is modified, just as in English the sound of p, as in the word *praise, is* changed when *h is* added, as in the word *phrase*. Only *b, c, d, f, g, m, p, s,* and *t* are aspirated. The other consonants, and vowels, are not aspirated.

The singular article *an* does not affect feminine nouns beginning with a vowel, e.g.

> An Eaglais "the church" (Eglish, Tyr.)

4.  Masculine noun + adjective:

> Domhnach Mor "great church" (Donaghmore, Tyr.)
> Lios Liath "grey ring fort" (Lislea, Arm.)

In Irish the adjective normally follows the noun (but see §8).

5.  Feminine noun + adjective:

> Bearn Mhín "smooth gap" (Barnmeen, Dn)
> Doire Fhada "long oak-wood" (Derryadd, Arm.)

The first consonant of the adjective is aspirated after a feminine noun.

6.  Singular article + masculine noun + adjective:

> An Caislean Riabhach "the brindled castle" (Castlereagh, Dn)
> An Baile Meánach "the middle town" (Ballymena, Ant.)

7.  Singular article + feminine noun + adjective:

> An Charraig Mhór "the large rock" (Carrickmore, Tyr.)
> An Chloch Fhionn "the white stone" (Cloghfin, Tyr.)

Note that the first consonant of the feminine noun is aspirated after the definite article as in §3 above and that the adjective is aspirated after the feminine noun as in §5 above.

8.  Adjective + noun:

> Fionnshliabh "white mountain" (Finlieve, Dn)
> Seanchill "old church" (Shankill, Ant.)

Sometimes an adjective precedes a noun. In such cases the two words are generally written as one and the second noun is usually aspirated. In compounds aspiration sometimes does not occur when d, t or s is preceded by d, n, t, l or s.

9.  Article + adjective + noun:

> An Seanmhullach "the old summit" (Castledawson, Der.)
> An Ghlasdromainn "the green ridge" (Glasdrumman, Dn)

*Dromainn is* a feminine noun and the initial consonant of the compound is aspirated in accordance with §3 above.

10.  Masculine noun + genitive singular of noun:

> Srath Gabhláin "(the) river valley of (the) fork" (Stragolan, Fer.)
> Port Rois "(the) harbour of (the) headland" (Portrush, Ant.)

These two examples contain the genitive singular forms of the nouns *gabhlán* and *ros*. Many nouns form the genitive singular by inserting i before the final consonant.

11.  Feminine noun + genitive singular of noun:

> Maigh Bhile "(the) plain of (the) sacred tree" (Movilla, Dn)
> Cill Shléibhe "(the) church of (the) mountain" (Killevy, Arm.)

Note that in these examples the qualifying genitive is aspirated after the feminine noun. However the forms *maigh* and *cill* are also both old datives, and in the older language aspiration followed any dative singular noun.

Two other types of genitive are illustrated here: many nouns which end in a vowel, like *bile*, do not change at all, whereas others, like *sliabh*, form their genitive by adding *e* (and sometimes an internal change is necessary).

12. Noun + *an* + genitive singular:

> Léim an Mhadaidh "(the) leap of the dog" (Limavady, Der.)
> Baile an tSéipéil "(the) town of the chapel" (Chapeltown, Dn)

The noun *an madadh* "the dog" has a genitive *an mhadaidh* "of the dog". Note that, as well as the end of the noun changing as in §10 above, the genitive is aspirated after *an*.

Instead of aspirating *s* the article *an* prefixes *t* to it: *an sac* "the sack", *an tsaic* "of the sack"; *an séipéal* "the chapel", *an tséipéil* "of the chapel".

13. Noun + *na* + genitive singular:

> Muileann na Cloiche "(the) mill of the stone/the stone mill"
> (Clogh Mills, Ant.)
> Cúil na Baice "(the) corner/angle of the river bend" (Cullybackey, Ant.)

The genitive singular feminine article is *na*. It does not aspirate the following noun: *an chloch* "the stone", *na cloiche* "of the stone".

It prefixes *h*, however, to words beginning with a vowel e.g.

> Baile na hInse "(the) town of the water-meadow" (Ballynahinch, Dn)

The genitive in all these examples is formed by adding *e* to the nominative singular and making a slight internal adjustment.

14. Plural noun:

> Botha "huts" (Boho, Fer.)

The plural form of a substantial group of nouns in Irish is formed by adding *-a*. In the examples in §15 below an internal adjustment has also to be made.

15. *Na* + plural noun:

> Na Creaga "the rocks" (Craigs, Ant.)
> Na Cealla "the churches" (Kells, Ant.)

*Na* is also the plural article. *Creaga* and *cealla* are the plural forms of the nouns *creig* "rock" and *cin* "church".

16. Noun + genitive plural:

> Droim Bearach "(the) ridge of (the) heifers" (Dromara, Dn)
> Port Muc "(the) harbour of (the) pigs" (Portmuck, Ant.)

As in the case of *bearach* "a heifer" and *muc* "a pig" the genitive plural form is the same as the nominative singular.

17. Noun + *na* + genitive plural:

> Lios na gCearrbhach "(the) fort/enclosure of the gamblers"
> (Lisburn, Dn)
> Lios na nDaróg "(the) fort/enclosure of the little oaks"
> (Lisnarick, Fer.)

After *na* the first letter of the following genitive plural is eclipsed. Eclipsis involves adding to the beginning of a word a consonant which obliterates the sound of the original consonant, e.g.

> *bo* "a cow", pronounced like English "bow" (and arrow)
>
> *(na) mbó* "(of the) cows", pronounced like "mow"

The following are the changes which take place:

| Written letter | Is eclipsed by |
| --- | --- |
| b | m |
| c | g |
| d | n |
| f | bh |
| g | ng |
| t | d |
| vowel | n |

The other consonants are not eclipsed, e.g.

> Áth na Long "(the) ford of the ships" (Annalong, Dn)

18. Noun + genitive of personal name:

> Dún Muirigh "*Muirioch's* fort" (Dunmurry, Ant.)
> Boith Mhéabha "Maeve's hut" (Bovevagh, Der.)

In the older language the genitive of a personal name was not aspirated after a masculine noun but it was after a feminine noun. In the above examples *dun is* masculine and *boith is* feminine. In current Irish aspiration of the personal name is also usual after a masculine noun and this is reflected in many place-names in areas where Irish survived until quite recently, e.g.

> Ard Mhacha, interpreted as "the height of *Macha*" (Armagh, Arm.)

19. Noun + genitive singular of *Ó* surname:

> Baile Uí Dhonnáile "Donnelly's townland" (Castlecaulfield, Tyr.)
> Coill Uí Chiaragáin "Kerrigan's wood" (Killykergan, Der.)

Surnames in *Ó*, e.g. Ó Dochartaigh "(O') Doherty", Ó Flannagáin "Flannagan", etc. form their genitive by changing *Ó* to *Uí* and aspirating the second element – Uí Dhochartaigh, Uí Fhlannagáin .

20. Noun + genitive singular of *Mac* surname:

> Lios Mhic Dhuibhleacháin "*Mac Duibhleachain's* fort/enclosure"
> (Lisnagelvin, Der.)
> Baile Mhic Gabhann "*Mac Gabhann's* town (angl. McGowan, Smith, etc.)
> (Ballygowan, Dn)

Surnames in *Mac*, e.g. Mac Dónaill "McDonnell", Mac Muiris "Morrison, Fitzmaurice", etc. form their genitive by changing *Mac* to *Mhic* and aspirating the second element (except those beginning with *C* or *G*).

264

21. Noun + genitive plural of *Ó* surname:

Doire Ó gConaíle "the oak-wood of the *Ó Conaíle* family (angl. Connelly)" (Derrygonnelly, Fer.)

In the genitive plural of *Ó* surnames the second element is eclipsed.

22. Neuter noun + genitive or adjective:

Sliabh gCuillinn "mountain of (the) steep slope" (Slieve Gullion, Arm.)
Loch gCaol "(the) narrow lake" (Loughguile, Ant.)

The neuter gender no longer exists in Irish but traces of it are found in place-names. The initials of nouns and adjectives were eclipsed after neuter nouns.

# APPENDIX B

## LAND UNITS

### TERRITORIAL DIVISIONS IN IRELAND

The old administrative system, used in the arrangement of these books, consisted of land units in descending order of size: province, county, barony, parish and townland. Theoretically at least the units fit inside each other, townlands into parishes, parishes into baronies, baronies into counties. This system began piecemeal, with the names of the provinces dating back to prehistoric times, while the institution of counties and baronies dates from the 13th to the 17th century, though the names used are often the names of earlier tribal groups or settlements. Parishes originate not as a secular land-unit, but as part of the territorial organization of the Christian Church. There they form the smallest unit in the system which, in descending order of size, goes from provinces to dioceses to deaneries to parishes. Some Irish parishes derive from churches founded by St Patrick and early saints, and appear as parish units in Anglo-Norman church records: parish units are thus older than counties and baronies. Townlands make their first appearance as small land units listed in Anglo-Norman records. However the evidence suggests that land units of this type (which had various local names) are of pre-Norman native origin.

The 17th-century historian Geoffrey Keating outlined a native land-holding system based on the *triocha céad* or "thirty hundreds", each divided in Ulster into about 28 *baile biadhtaigh* "lands of a food-provider" or "ballybetaghs", and about 463 *seisrigh* "six-horse plough-teams" or "seisreachs" *(Céitinn iv* 112f.). The term *triocha céad,* which seems to relate to the size of the army an area could muster, is not prominent in English accounts, though there is a barony called Trough *(Triocha)* in Co. Monaghan. The ballybetagh (land of a farmer legally obliged to feed his lord and retinue while travelling through the area) is mentioned in Plantation documents for west Ulster, and there is some evidence, from townlands grouped in multiples of three and four, that it existed in Armagh, Antrim and Down (McErlean 1983, 318).

Boundaries of large areas, such as provinces and dioceses, are often denoted in early Irish sources by means of two or four extreme points (Hogan 1910, 279–280; *Céitinn* iii 302). There was also a detailed native tradition of boundary description, listing landmarks such as streams, hills, trees and bogs. This can be demonstrated as early as the 8th century in Tírechán's record of a land grant to St Patrick *(Trip. Life (Stokes)* ii 338–9),[1] and as late as the 17th century, when native experts guided those surveying and mapping Ireland for the English administration. The boundary marks on the ground were carefully maintained, as illustrated in the *Perambulation of Iveagh* in 1618 *(Inq. Ult.* xliii), according to which the guide broke the plough of a man found ploughing up a boundary. However very often Irish texts, for example the "Book of Rights" *(Lebor na Cert)*, the "topographical" poems by Seaán Mór Ó Dubhagáin and Giolla-na-naomh Ó hUidhrin *(Topog. Poems)*, and "The rights of O'Neill" *(Ceart Uí Néill)*, refer to territories by the names of the peoples inhabiting them. This custom has been preserved to the present in some place-names, particularly those of provinces and baronies.

### SECULAR ADMINISTRATIVE DIVISIONS

#### Townlands

Twelfth-century charters provide the earliest documentary evidence for the existence in Ireland of small land units, although we do not know what these units were called. Keating's

266

smallest unit, the *seisreach*, a division of the ballybetagh, is given as 120 acres (the word *acra* is apparently borrowed from English). The size of the *seisreach* seems to have been approximately that of a modern townland, but the word does not occur much outside Keating's *schema*. Many other terms appear in the sources: *ceathrú* "quarter" (often a quarter of a ballybetagh), *baile bó* "land providing one cow as rent" (usually a twelfth of a ballybetagh), *seiseach* "sixth" and *trian* "third" (apparently divisions of a ballyboe). In most of Ulster the ballyboe and its subdivisions are the precursors of the modern townlands, and were referred to in Latin sources as *villa* or *carucata*, and in English as "town" or "ploughland" (the term used for similar units in 11th-century England in the Domesday Book). The Irish term *baile* (see below) seems to have been treated as equivalent to English "town", which had originally meant "settlement (and lands appertaining)"; and the compound term "townland" seems to have been adopted to make the intended meaning clear. It was used in 19th-century Ireland as a blanket term for various local words. In the area of Fermanagh and Monaghan the term for the local unit was "tate". In an English document of 1591 it is stated that the tate was 60 acres in size and that there were sixteen tates in the ballybetagh *(Fiants Eliz.* §5674). Tate appears in place-names in composition with Gaelic elements, but was regarded by Reeves (1861, 484) as a pre-1600 English borrowing into Irish.

There is no evidence for the use of the word *baile* in the formation of place-names before the middle of the 12th century. The earliest examples are found in a charter dating to c. 1150 in the Book of Kells which relates to lands belonging to the monastery of Kells. At this period *baile* seems to mean "a piece of land" and is not restricted to its present-day meaning "hamlet, group of houses", much less "town, village". After the coming of the Normans, *baile* appears more frequently in place-names, until it finally becomes the most prevalent type of townland name. By the 14th century, *baile* had acquired its present-day meaning of "town", probably in reference to small medieval towns, or settlements that had arisen in the vicinity of castles. Price suggests that the proliferation of the use of the word in place-names was a result of the arrival of settlers and their use of the word "town" *(tūn)* in giving names to their lands (Price 1963, 124). When the Irish revival took place in the 14th century many English-language names were translated into Irish and "town" was generally replaced by *baile*. The proportion of *baile* names is greatest in those parts of Ireland which had been overrun by the Anglo-Normans but subsequently gaelicized, and is lowest in the counties of mid-Ulster in which there was little or no English settlement *(ibid.* 125).

Despite attempts at schematization none of the units which predated the modern townlands was of uniform size, and it is clear from the native sources that evaluation was based on an area of good land together with a variable amount of uncultivated land. Thus townlands on bad land are usually larger than those on good land. The average size of a townland in Ireland as a whole is 325 acres, and 357 acres in the six counties of Northern Ireland, though these averages include huge townlands like Slievedoo (4551 acres, Co. Tyrone) and tiny townlands like Acre McCricket (4 acres, Co. Down). There is also considerable local variation: townlands in Co. Down average 457 acres (based on the ballyboe), compared to 184 acres (based on the tate) in Fermanagh (Reeves 1861, 490).

### Parishes

Early accounts of the lives of saints such as Patrick and Columcille refer to many church foundations. It seems that land was often given for early churches beside routeways, or on the boundaries of tribal territories. Some of the same church names appear as the names of medieval parishes in the papal taxation of 1302–06 *(Eccles. Tax.)*. Some parish names include ecclesiastical elements such as *ceall, domhnach, lann,* all meaning "church", *diseart* "hermitage" and *tearmann* "sanctuary", but others are secular in origin. Parish bounds are

not given in the papal taxation, but parishes vary considerably in size, probably depending on the wealth or influence of the local church. The medieval ecclesiastical parishes seem to have come into existence after the reform of the native Irish church in the course of the 12th century; in Anglo-Norman areas such as Skreen in Co. Meath the parochial system had already been adopted by the early 13th century (Otway-Ruthven 1964, 111–22). After the Reformation the medieval parish boundaries were continued by the established Church of Ireland, and used by the government as the bounds of civil parishes, a secular land unit forming the major division of a barony. (The boundaries of modern Roman Catholic parishes have often been drawn afresh, to suit the population of worshippers).

As well as the area inhabited by local worshippers, lands belonging to a medieval church often became part of its parish. These were usually close by, but it is quite common, even in the early 19th century when some rationalization had occurred, for parishes to include detached lands at some distance from the main body (Power 1947, 222–3). Kilclief in the barony of Lecale, Co. Down, for example, has five separate detached townlands, while Ballytrustan in the Upper Ards and Trory in Co. Fermanagh are divided into several parts. While an average parish might contain 30 townlands, parishes vary in the number of townlands they contained; for example, Ballykinler in Co. Down contained only 3 townlands, while Aghalurcher contained 237 townlands (including several islands) in Co. Fermanagh plus 17 townlands in Co. Tyrone. Although most of its townlands are fairly small, Aghalurcher is still much larger than Ballykinler. There were usually several parishes within a barony (on average 5 or 6, but, for example, only 2 in the barony of Dufferin, Co. Down, and 18 in the barony of Loughinsholin, Co. Derry). Occasional parishes constituted an entire barony, as did Kilkeel, for example, which is coterminous with the barony of Mourne. However parish units also frequently extended across rivers, which were often used as obvious natural boundaries for counties and baronies: Newry across the Newry River, Clonfeacle over the Blackwater, Artrea over the Ballinderry River, Blaris over the Lagan. This means that civil parishes may be in more than one barony, and sometimes in more than one county.

## Baronies

The process of bringing Irish tribal kingdoms into the feudal system as "baronies" under chieftains owing allegiance to the English crown began during the medieval period, although the system was not extended throughout Ulster until the early 17th century. Many of the baronies established in the later administrative system have population names: Oneilland, Irish *Uí Nialláin* "descendants of Niallán" (Arm.); Keenaght, Irish *Cianachta* "descendants of Cian" (Der.); Clankelly, Irish *Clann Cheallaigh* "Ceallach's children" (Fer.). Others have the names of historically important castles or towns: Dungannon (O'Neills, Tyr.), Dunluce (MacDonnells, Antr.), Castlereagh (Clandeboy O'Neills, Down). The barony of Loughinsholin (Der.) is named after an island fortification or crannog, *Loch Inse Uí Fhloinn* "the lake of O'Flynn's island", although by the 17th century the island was inhabited by the O'Hagans, and the O'Flynn area of influence had moved east of the Bann.

The barony system was revised and co-ordinated at the same time as the counties, so that later baronies always fit inside the county bounds. Both counties and baronies appear on maps from 1590 on. These later baronies may contain more than one older district, and other district or population names used in the 16th and 17th centuries, such as *Clancan* and *Clanbrasil* in Armagh, *Slutkellies* in Down, and *Munterbirn* and *Munterevlin* in Tyrone, gradually fell out of use. Baronies were not of uniform size, though in many cases large baronies have been subdivided to make the size more regular. The barony of Dungannon in Co. Tyrone has three sections (Lower, Middle and Upper) while Iveagh in Co. Down has been divided into four (Lower, Lower Half; Lower, Upper Half; Upper, Lower Half; Upper,

Upper Half). The number of baronies in a county in Ulster varies between five in Co. Monaghan and fifteen in Co. Antrim. Armagh, Fermanagh and Tyrone have eight.

## Counties

Over the centuries following the Anglo-Norman invasion the English government created a new administrative system in Ireland, adapting the native divisions of provinces, tribal districts (as baronies), parishes and townlands, and dividing each province of Ireland into counties. The counties were equivalent to the shire in England, where a sheriff exercized jurisdiction on behalf of the King. To begin with the county system applied to only those areas where English rule was strong, but was eventually extended, through the reigns of Elizabeth and James I, to cover the whole of the country. Although a commission to shire Ulster was set up in 1585 *(Fiants Eliz. §4763)*, the situation in 1604 was expressed, rather hopefully, in a document in the state papers:

> "each province, except Ulster and other uncivil parts of the realm, is subdued into counties, and each county into baronies and hundreds, and every barony into parishes, consisting of manors, towns and villages after the manner of England."
> *(CSP Ire.* 1603–6, 231).

Most of the counties created in the north were given the names of important towns: Antrim, Armagh, Coleraine (later Londonderry), Down, Donegal, Monaghan and Cavan. Fermanagh and Tyrone, however, have population names. *Fir Manach* "the men of the *Manaig"* (probably the *Menapii* of Ptolemy's *Geography)* had been important in the area before the Maguires. *Tír Eoghain* "Eoghan's land" derives its name from the *Cenél nEógain* branch of the *Uí Néill,* who had expanded southwards from *Inis Eógain* (Inishowen) during the centuries and whose dominant position continued right up until the Plantation. Counties were generally formed out of an amalgam of smaller territorial units, some of which were preserved as baronies within each county.[2] The bounds of these older units were often of long standing, and usually followed obvious physical features, like the lower Bann, the Blackwater, and the Newry River.

Down and Antrim, as part of the feudal Earldom of Ulster (see below) had been treated as counties since the 13th or 14th century (Falkiner 1903, 189; *Inq. Earldom Ulster* ii 141, iii 60). However other districts within the earldom could also be called counties, and up to the mid-16th-century the whole area was sometimes called the "county of Ulster" *(Cal. Carew MSS* 1515–74, 223–4). The settling of Down and Antrim with their modern bounds began in 1570–1 *(Fiants Eliz. §1530, §1736)*. Coleraine had also been the centre of an Anglo-Norman county *(Inq. Earldom Ulster* iv 127). Jobson's map of 1590 shows *Antrym, Armagh, Colrane, Downe, Manahan, Farmanaugh, Terconnel,* and *Upper and Nether Terone* as the names of counties. However, Ulster west of the Bann was still referred to as "four seigniories" (Armagh? plus *Terreconnell, Tyren, Formannoche)* in 1603 *(Cal. Carew MSS* 1601–3, 446–454), although Tyrone had been divided into baronies from 1591 *(Colton Vis.* 125–130). Armagh was settled into baronies in 1605 *(CSP Ire.* 1603–6, 318). The "nine counties of Ulster" were first listed in 1608: *Dunegal or Tirconnel, Tirone, Colraine, Antrim, Downe, Ardmagh, Cavan, Monoghan,* and *Fermanagh (CSP Ire.* 1606–8, 401), and these counties are shown on Hole's adaptation of Mercator's map of Ireland for Camden's atlas *Britannia* (1610). The county of Coleraine was renamed as a result of the plantation grant to the London companies. Under the terms of the formal grant of the area in 1613, the barony of Loughinsholin, which had hitherto been part of Tyrone, was amalgamated with the old county of Coleraine, and Londonderry was made the new county name (Moody 1939, 122–3).

## Provinces

Gaelic Ireland, in prehistory and in early historic times, was made up of many small native kingdoms (called *tuatha)*, but a sense of the underlying unity of the island is evident from the name of the earliest division in Ireland, that represented by the four modern provinces of Connaught, Leinster, Munster and Ulster. In Irish each is called *cúige* (older *cóiced)* "a fifth", followed by a district or population name. *Cúige Chonnacht* means "the fifth of the Connaughtmen" *Cúige Laighean* "the fifth of the Leinstermen", *Cúige Mumhan* "the fifth of Munster", *Cúige Uladh* "the fifth of the Ulstermen". The connection between population and place-names is evident at this very early stage. The ancient fifth "fifth" making up the whole was that of Meath, in Irish *Midhe* "middle". The division into these five provinces was taken over when Henry II of England invaded Ireland: Leinster, (North and South) Munster, Connaught, Ulster and Meath *quasi in medio regni positum* (as if placed in the middle of the kingdom), but the number was reduced by the 17th century to the modern four *(CSP Ire.* 1603–6 §402, 231), by incorporating Meath in Leinster.

## The Province of Ulster

As mentioned above, the province of Ulster took its name from the tribal name *Ulaid* "Ulstermen" (Flanagan 1978(d)). The earliest record of the tribal name is the form quoted by the 2nd-century Greek geographer Ptolemy, as *Uoluntii* (O'Rahilly 1946, 7). The precise origin of the English form of the name is obscure, though it has been suggested that it derives from something like *Ulaðstir,* an unusual combination of the original Irish name plus the Norse possessive suffix *-s* and the Irish word *tír* "land" (Sommerfelt 1958, 223–227). Ptolemy mentions various other tribes in the north of Ireland, but it appears that the *Ulaid* were the dominant group.

The ancient province of the Ulstermen, according to the native boundary description, stretched south to a line running between the courses of the rivers *Drobaís* (Drowse, on the border between Donegal and Leitrim) and *Bóann* (Boyne, Co. Meath). The "fifth" of the legendary king of the Ulaid, Conchobar, *(Cóiced Conchobair)* thus included modern Co. Louth (Hogan 1910, 279b). It became contracted in historical times, as a result of the expansion of the *Uí Néill* "descendants of Niall", who drove the rulers of the Ulaid from the provincial capital at *Emain Macha* (Navan fort near Armagh) across the Bann into modern Antrim and Down.[3] From the 5th century the area stretching south from Derry and Tyrone to Monaghan and most of Louth belonged to a confederation of tribes called the *Airgialla,* who have been described "as a satellite state of the Uí Néill" (Byrne 1973, 73). Three groups of Uí Néill established themselves in the west, *Cenél Conaill* "Conall's kin" in south Donegal, *Cenél nÉndae* in the area around Raphoe, and *Cenél nEógain* in Inishowen *(Inis Eógain* "Eógan's island"). On the north coast, east of the river Foyle, the *Cianachta* maintained a separate identity, despite continuing pressure from *Cenél nEógain.*

East of the Bann the *Dál Fiatach* (the historic Ulaid) shared the kingship of the reduced Ulster with *Dál nAraide* and *Uí Echach Coba,* both originally *Cruthin* tribes.[4] In the 12th century the Anglo-Norman conquest of Antrim and Down resulted in the creation of a feudal lordship of the area under the English crown called the Earldom of Ulster. During the same period the kings of Cenél nEógain had extended their influence eastward, and after the extinction of the Dál Fíatach kingship in the 13th century they assumed the title of *rí Ulad* "king of the Ulaid" to forward their claim to be kings of the whole of the North. It is this greater Ulster which was the basis for the modern province, although there was some doubt at the beginning of the 17th century as to whether or not this included Co. Louth. By the time of the Plantation in 1609 Ulster had been stabilized as nine counties and Louth had been incorporated into the neighbouring province of Leinster.

## ECCLESIASTICAL ADMINISTRATIVE DIVISIONS

### Dioceses

Under the Roman Empire Christianity developed an administrative structure of dioceses led by bishops based in the local towns. In early Christian Ireland a bishop was provided for each *tuath*, but since the main centres of population were the monasteries established by the church, the bishop often became part of the monastic community, with less power than the abbot. The invasion of the Anglo-Normans in the 12th century encouraged the re-organization and reform of the native church along continental lines, and by the beginning of the 14th century the territories and boundaries for Irish bishops and dioceses had been settled. Most dioceses are named after important church or monastic foundations: Armagh, Clogher, Connor, Derry, Down, Dromore, Kilmore and Raphoe in the North. The ancient secular province of Ulster was included in the ecclesiastical province of Armagh, which became the chief church in Ireland. The bounds of individual dioceses within the province reflect older tribal areas, for example Derry reflects the development of *Cenél nEógain*, Dromore *Uí Echach Coba*. In the 8th century *Dál Fiatach*, who had settled in east Down, pushed northward into the land of *Dál nAraide*, and the bounds of the diocese of Down reflect their expansion as far north as the river *Ollarba* (the Larne Water). The diocesan bounds differ from those of similarly-named later counties because by the time the county boundaries were settled in the 17th century the leaders of many of the larger native territories had been overthrown. County boundaries were generally not based on large native kingdoms but were put together from an amalgam of smaller districts.

### Deaneries

The medieval church divided dioceses into rural deaneries, the names of which often derive from old population names. *Blaethwyc* (modern Newtownards) in the diocese of Down, for example, derives from *Uí Blathmaic* "the descendants of Blathmac", whereas *Turtrye*, in the diocese of Connor, derives from *Uí Thuirtre* "the descendants of (Fiachra) Tort". The deaneries of Tullyhogue (Irish *Tulach Óc*) in the diocese of Armagh and *Maulyne* (Irish *Mag Line*) in Connor are named after royal sites. *Mag Line* was the seat of the *Dal nAraide* and *Tulach Óc* was probably the original seat of the Uí Thuirtre, whose area of influence had by this time moved east across the Bann, as the deanery name reveals. The deanery of Inishowen reflects the earlier homeland of the Cenél nEógain. Deanery names are often a useful source of information on important tribal groups of medieval times. Some of these same population names were used later as the names of baronies, while in other cases the earlier population group had lost its influence and the area had become known by another name.

## TRIBAL AND FAMILY NAMES

Many personal or population names of various forms have been used as place-names or parts of place-names in Ireland, from provinces, counties, deaneries and baronies to townlands. As with different types of land divisions, different types of family names have come into being at various times.

The names of early Irish tribal groupings were sometimes simple plurals, for example *Ulaid, Cruthin,* and sometimes the personal name of an ancestor or some other element in composition with various suffixes: *Connachta, Dartraige, Latharna*. Other types prefixed *uí* "grandsons", *cenél* "kin", *clann* "children", *dál* "share of", *moccu* "descendants", *siol* "seed", *sliocht* "line" to the name of the ancestor, for example *Dál nAraide* "share of (Fiacha)

Araide", and *Uí Néill* "grandsons of Niall", who are supposedly descended from the 5th-century *Niall Noigiallach* "Niall of the Nine Hostages".

In early Ireland individuals were often identified by patronymics formed by using *mac* "son of" or *ó* (earlier *ua*) "grandson" plus the name of the father or grandfather, rather than by giving the name of the larger group to which the individual belonged. Thus the most straightforward interpretation of *Eoghan mac Néill is* "Eoghan son of Niall", *Eoghan ó Néill* "Eoghan grandson of Niall". Sometimes the same formation can occur with female names. However, in the course of the 10th and 11th centuries patronymics began to be used as surnames. In Modern Irish orthography surnames are distinguished from simple patronymics by using capital *M* or *Ó*: *Eoghan Ó Néill* "Eoghan O'Neill", *Eoghan Mac Néill* "Eoghan MacNeill". However, in early documents, in either Irish or English, it is often difficult to distinguish between surnames and patronymics. This is particularly true of sources such as the *Fiants* where a name such as Donagh M'Donagh may represent the patronymic Donagh, son of Donagh, or the surname Donagh MacDonagh.

As families expanded it was common for different branches to develop their own particular surnames. Some of these have survived to the present, while others, which may have been important enough in their time to be incorporated in place-names, have either died out or been assimilated by similar, more vigorous surnames. In cases such as this the place-name itself may be the only evidence for the former existence of a particular surname in the locality.

Kay Muhr

(1) See also *Geinealach Chorca Laidhe* (O'Donovan 1849, 48–56); *Crichad an Caoilli* (Power 1932, 43–47).
(2) See *Fiants Eliz.* §1736 (1570) for Co. Down; *Colton Vis.* 125–30 (1591) for Cos Derry and Tyrone.
(3) North-east Derry and Louth were also held by the Ulaid, but their influence had been reduced to Down, Antrim and north Louth by the 7th century (Flanagan 1978(d), 41).
(4) The *Cruthin* were a population group widespread in the north of Ireland. The name is of the same origin as "Briton".

# ABBREVIATIONS

| | | | |
|---|---|---|---|
| acc. | Accusative | Mod. Eng. | Modern English |
| adj. | Adjective | Mod. Ir. | Modern Irish |
| al. | Alias | MS(S) | Manuscript(s) |
| angl. | Anglicized | n. | (Foot)note |
| Ant. | Co. Antrim | neut. | Neuter |
| Arm. | Co. Armagh | NLI | National Library of |
| art. cit. | In the article cited | | Ireland, Dublin |
| BM | British Museum | no(s). | Number(s) |
| c. | About | nom. | Nominative |
| cf. | Compare | O. Eng. | Old English |
| Co(s). | County (-ies) | O. Ir. | Old Irish |
| col. | Column | op. cit. | In the work cited |
| coll. | Collective | OSI | Ordnance Survey, Dublin |
| d. | Died | OSNI | Ordnance Survey, Belfast |
| dat. | Dative | p(p). | Page(s) |
| Der. | Co. Derry | par. | Parish |
| Dn | Co. Down | pass. | Here and there |
| eag. | Eagarthóir/Curtha in | pl. | Plural |
| | eagar ag | PRO | Public Record Office, |
| ed. | Editedby | | London |
| edn | Edition | PROI | Public Record Office, |
| Eng. | English | | Dublin |
| et pass. | And elsewhere | PRONI | Public Record Office, |
| et var. | And variations (thereon) | | Belfast |
| f. | Following page | pt | Part |
| fem. | Feminine | r. | Correctly |
| Fer. | Co. Fermanagh | RIA | Royal Irish Academy, |
| ff. | Folios/Following pages | | Dublin |
| fol. | Folio | s. | Shilling |
| gen. | Genitive | sa. | Under the year |
| HMSO | Her Majesty's Stationery | sect. | Section |
| | Office | ser. | Series |
| ibid. | In the same place | sic | As in source |
| IE | Indo-European | sing. | Singular |
| iml. | Imleabhar | SS | Saints |
| IPA | International Phonetic | St | Saint |
| | Alphabet | sv(v). | Under the word(s) |
| l(l). | Line(s) | TCD | Trinity College, Dublin |
| lit. | Literally | trans. | Translated by |
| loc. | Locative | Tyr. | Co. Tyrone |
| loc. cit. | In the place cited | uimh. | Uimhir |
| Lr. | Lower | Up. | Upper |
| masc. | Masculine | viz. | Namely |
| Mid. Eng. | Middle English | voc. | Vocative |
| Mid. Ir. | Middle Irish | vol(s). | Volume(s) |

# PRIMARY BIBLIOGRAPHY

| | |
|---|---|
| Acta SS (Bolland.) | The Bollandist series named *Acta Sanctorum* begun by J. Bollandus (Paris 1643–). |
| Acta SS Colgan | *Acta sanctorum veteris et majoris Scotiae seu Hiberniae*, John Colgan (Lovanii 1645); republished by the Irish Manuscripts Commission, with introduction by Brendan Jennings (Dublin, 1948). |
| Affairs Ire. (Gilbert) | *A contemporary history of affairs in Ireland 1641–1652*, ed. J.T. Gilbert, 3 vols (Dublin 1979–). |
| AFM | *Annála Ríoghachta Éireann: annals of the kingdom of Ireland by the Four Masters from the earliest period to the year 1616*, ed. John O'Donovan, 7 vols (Dublin 1848–51; reprint 1990). |
| AGBP | *Ainmneacha Gaeilge na mbailte poist*, Oifig an tSoláthair (Baile Átha Cliath 1969). |
| Ainm | *Ainm: bulletin of the Ulster Place-name Society* (Belfast 1986– ). |
| ALC | *The annals of Loch Cé: a chronicle of Irish affairs from AD 1014 to AD 1590*, ed. William Hennessy, 2 vols (London 1871; reprint Dublin 1939). |
| Annates Ulst. | *De annatis Hiberniae: a calendar of the first-fruits' fees levied on papal appointments to benefices in Ireland, AD 1400–1535*, vol. i (Ulster), ed. Michael A. Costello and Ambrose Coleman (Dundalk 1909; reprint Maynooth 1912). |
| ASE | "Abstracts of grants of lands and other hereditaments under the acts of settlement and explanation, AD 1666–84", compiled by John Lodge and published in the appendix to the *15th Annual report from the commissioners . . . respecting the Public Records of Ireland* (1825) 45–340. |
| A. Tigern. | "The annals of Tigernach", ed. Whitley Stokes, *Rev. Celt.* xvi (1895), 374–419; xvii (1896), 6–33, 116–263, 337–420; xviii (1897), 9–59, 150–303, 374–91. |
| AU | *Annála Uladh: annals of Ulster; otherwise Annála Senait, annals of Senait: a chronicle of Irish affairs*, 431–1131, 1155–1541, ed. William Hennessy and Bartholomew MacCarthy, 4 vols (Dublin 1887–1901). |
| AU (Mac Airt) | The annals of Ulster (vol. i to AD 1131), ed. Seán Mac Airt and Gearóid Mac Niocaill (Dublin 1983). |
| Bagenal's Descr. Ulst. | "Marshal Bagenal's description of Ulster, anno 1586", ed. Herbert F. Hore, *UJA* ser. 1, vol. ii (1854) 137–60. |

Bartlett Map (Greenwich)  A map of East Ulster by Richard Bartlett containing a drawing of the O'Neill inauguration ceremony at Tullaghoge and preserved in the National Maritime Museum, Greenwich, Dartmouth Collection no. 25. Reproduced in *UJA* ser. iii vol. 33 (1970).

Bartlett Map (PRO)  A map of Lough Neagh showing fortifications, probably by Richard Bartlett, in PRO London. A copy in PRONI T1493/48.

Bartlett Maps (Esch. C. Maps)  Three maps by Richard Bartlett published together with the *Esch. Co. Maps*: (i) *A Generalle Description of Ulster*; (ii) South-east Ulster; (iii) North-west Ulster, (PRO MPF 35–37; copies in PRONI T1652/1–3). These maps have been dated to 1603 by G.A. Hayes-McCoy, *Ulster and Other Irish Maps, c. 1600*, p 2, n. 13 (Dublin 1964).

BB  *The Book of Ballymote* (AD 1390c), ed. R. Atkinson (Dublin 1887).

Beaufort's Mem. Map  *Memoir of a map of Ireland illustrating the topography of that kingdom, and containing a short account of its present state, civil and ecclesiastical; with a complete index to the map,* Daniel Augustus Beaufort (London 1792).

Belfast News Letter  *Belfast News Letter* (1737–), PRONI mic 19.

Bnd. Connor Par.  A description of the boundaries of the parish of Connor contained in an indenture dated Nov. 1 1604 between Arthur Chichester and Manse Kent and Alex Colville, Dr of Theology of Gallgorme, PRONI mic 35 reel 1. The spellings of the place-names are often followed by "amended" spellings in brackets.

Bnd. Sur.  Boundary Survey sketch maps, c. 1825–30, PROI, 2A 18 49.

Bnd. Sur. (OSNB)  Boundary Survey sketch maps, cited in *OSNB passim*.

Boazio's Map (BM)  *Gennerall discripcion or Chart of Irelande*, AD 1599, by Baptista Boazio. Three impressions are known, one in the British Museum, one in TCD, and a third in private hands.

BSD  *Book of survey & distribution, AD 1661: Armagh, Down & Antrim* (Quit Rent Office copy), PRONI T370/A.

BSD (Annes.)  The Annesley edition (AD 1680) of the *Book of survey and distribution*, PRONI mic. 532 reel 11.

BSD (Head.)  The Headford edition (AD 1680c) of the *Book of survey and distribution*, PROI 2B 33 2.

| Buick's Ahoghill | *A filial account (1901) of seceders in the Mid-Antrim village where Rev. Frederick Buick was minister of the Second Presbyterian (now Trinity) congregation from 1835 to 1908*, ed. E. Dunlop (Ballymena 1987). |
|---|---|
| Buile Suibhne | *Buile Suibhne* (the frenzy of Suibhne), ed. J.G. O'Keeffe (London 1913). |
| BUPNS | *Bulletin of the Ulster Place-name Society*, ser. 1, vols i–v (Belfast 1952–7); ser. 2, vols 1–4 (1978–82). |
| Cal. Canc. Hib. (EA) | *Calendarium Rot. Cancellar. Hib.*, cited in *EA passim*. Probably the same as *CPR (Tresham)*. |
| Cal. Carew MSS | *Calendar of the Carew manuscripts preserved in the Archiepiscopal Library at Lambeth*, eds. J.S. Brewer and W. Bullen, 6 vols (London 1867–73). |
| C. Conghail Cláir. | *Caithréim Conghail Cláiringhnigh: Martial career of Conghal Cláiringhneach*, ed. Patrick M. MacSweeney, Irish Texts Society v (London 1904). |
| Ceart Uí Néill | *Ceart Uí Néill*, ed Myles Dillon, *Stud. Celt.* 1 (1966) 1–18. Trans Éamonn Ó Doibhlin, "*Ceart Uí Néill*, a discussion and translation of the document", *S. Ard Mh.* vol. 5, no. 2 (1970) 324–58 |
| Céitinn | *Foras Feasa ar Éirinn: the history of Ireland by Seathrún Céitinn (Geoffrey Keating)*, ed. Rev. Patrick S. Dinneen, 4 vols, Irish Texts Society (London 1902–14). |
| Celtica | *Celtica*, Dublin Institute for Advanced Studies (Dublin 1946– ). |
| Census | *A census of Ireland, circa 1659, with supplementary material from the poll money ordinances (1660–1)*, ed. Séamus Pender (Dublin 1939). |
| Census 1851 | *Census of Ireland, 1851. General alphabetical index to the townlands and towns, parishes and baronies of Ireland . . .* (Dublin 1861). |
| Census 1871 | *Census of Ireland, 1871. Alphabetical index to the townlands and towns of Ireland . . .* (Dublin 1877) |
| CGH | *Corpus genealogiarum Hiberniae*, vol. 1, ed. M.A. O'Brien (Dublin 1962). |
| Civ. Surv. | *The civil survey, AD 1654–6*, ed. Robert C. Simington, 10 vols, Irish Manuscripts Commission (Dublin 1931–61). |
| Colton Vis. | *Acts of Archbishop Colton in his metropolitical visitation of the diocese of Derry, Ad 1397*, ed. William Reeves (Dublin 1850) |

Colville Doc.          *Colville document no. 105* PROI D15237.

Comm. Grace            *Abstracts of grants and other hereditaments under the*
                       *Commission of Grace (1684–88)*, supplement to the 3rd
                       vol. of the Reports of the Commissioners of the Public
                       Works in Ireland, 1820–5 (Dublin 1829).

Comm. Inq. Irish Educ. Appendix to the 2nd Report from the Commission of
                       Irish Education Inquiry, vol. XII, 1826–7 (London
                       1827).

CPR Jas. I             *Irish patent rolls of James I: facsimile of the Irish record com-*
                       *missioners' calendar prepared prior to 1830*, with a foreword
                       by M.C. Griffith (Dublin 1966).

CPR (Tresham)          *Rotulorum patentium et clausorum cancellariae Hiberniae*
                       *calendarium*, 2 vols (vol. 2 has no title), ed. Edward
                       Tresham (Dublin 1928–[1830]).

CSH                    *Corpus genealogiarum sanctorum Hiberniae*, ed. Pádraig
                       Ó Riain (Dublin 1985).

CSP Ire.               *Calendar of the state papers relating to Ireland, 1509–1670*,
                       ed. H.C. Hamilton, E.G. Atkinson, R.P. Mahaffy, C.P.
                       Russell and J.P. Prendergast, 24 vols (London
                       1860–1912).

Dartmouth Map 5        A map of the north of Ireland dating to 1590 preserved in
                       the National Maritime Museum, Greenwich, Dartmouth
                       Collection no. 5.

Deed (Clotworthy)      Deed to the use of Simon Clotwothy, 14 Sep. 1627,
                       PRONI D207/14/6/1.

Deed (O'Shane)         Deed concerning Gilleduffe O'Shane and Isabella
                       Edmonston in "Deeds pre–1708", PROI C3446.

Descendants Ir         "The history of the descendants of Ir", 2 parts, ed.
                       Margaret Dobbs, *ZCP* xiii (1921), 308–59; xiv (1923),
                       44–144.

DIL                    *Dictionary of the Irish language: compact edition* (Dublin
                       1983).

Dinneen                *Foclóir Gaedhilge agus Béarla: an Irish-English dictionary*,
                       Rev. Patrick S. Dinneen (Dublin 1904; reprint with addi-
                       tions 1927 and 1934).

Dinnsean.              *Dinnseanchas*, 6 vols (Baile Átha Cliath 1964–75).

Dobbs' Desc. Ant.      A Briefe Description of the County of Antrim, begun the
                       3rd of May, 1683, by Richard Dobbs, appendix ii in
                       *MacDonnells Antrim* 377–389.

Dongl. Ann.            *Donegal Annual: journal of the County Donegal Historical*
                       *Society* (1947– ).

| | |
|---|---|
| DS (Par. Map) | Copies of William Petty's original *Down Survey* parish maps of c.1657, made by D. O'Brien in 1787, PRONI D597. |
| DS (Reg.) | Registers accompanying the above maps, PRONI D597. |
| Duff's Lough Neagh | A map of Lough Neagh made by John Duff (and assisted by James Williamson) for John O'Neill, AD 1785. Copy in Ewart Collection, QUB, Ewart B 1785. |
| Dúiche Néill | *Dúiche Néill: journal of the O'Neill Country Historical Society* (Benburb 1986– ). |
| Duty Book Grange | Estate duty book for Viscount Massereene and Ferrard's property at Grange, Co. Antrim, 1733, PRONI D562/991. |
| Dwelly | *The illustrated Gaelic-English dictionary*, Edward Dwelly (Glasgow 1901–11; reprint 1920 etc.). |
| EA | *Ecclesiastical antiquities of Down, Connor and Dromore, consisting of a taxation of those dioceses compiled in the year 1306*, ed. William Reeves (Dublin 1847). |
| Eccles. Reg. | *Ecclesiastical register of the names of the dignitaries and parochial clergy and of the parishes and their respective patrons, and ecclesiastical annals*, ed. John C. Erck (Dublin 1830). |
| Eccles. Tax. | "Ecclesiastical taxation of the dioceses of Down, Connor, and Dromore", ed. William Reeves, *EA* 2–119. |
| Eccles. Tax. (CDI) | "Ecclesiastical taxation of Ireland", ed. H.S. Sweetman & G.F. Handcock, *Calendar of documents relating to Ireland . . . , 1302–07* (London 1886), 202–323. |
| Éire Thuaidh | *Éire Thuaidh/Ireland North: a cultural map and gazetteer of Irish place-names*, Ordnance Survey of Northern Ireland (Belfast 1988). |
| Encumbered Ests. (O'Laverty) | Reports of the commissioners of encumbered estates, cited in O'Laverty's *Historical account of the diocese of Down and Connor ancient and modern, passim.* |
| Eng. Dial. Dict. | *The English Dialect Dictionary* ed. Joseph Wright. Published 1898, revised 1970 (Oxford). |
| EP Adair | Estate papers of the Adair estate at Ballymena, Co. Antrim, early 17th century-1905, PRONI D929. |
| EP Earl Ant. | Estate papers of the Earl of Antrim dating from the early 17th century onwards, PRONI D265. |
| EP Edenduffcarrick | Estate papers of Lord O'Neill's estate, Shane's Castle, Co. Antrim. MS. dating from 1666, copied in 1814, PRONI D1470. |

| | |
|---|---|
| EP Mass. & Ferr. | Estate Papers of Viscount Massereene and Ferrard's Estate, Antrim, PRONI D207/14. |
| Ériu | *Ériu: the journal of the school of Irish learning devoted to Irish philology and literature* (Dublin, 1904–). |
| Ésch. Co. Map | *Barony maps of the escheated counties in Ireland, AD 1609,* 28 maps, PRO. Published as *The Irish Historical Atlas,* Sir Henry James, Ordnance Survey (Southampton 1861) |
| Ét. Celt. | *Études Celtiques* (Paris 1936–). |
| Exch. Deeds & Wills | Deeds, wills and instruments appearing upon the Inquisitions Post Mortem in the Rolls Office, vol. 24 (Co. Antrim, 1603–85), PROI 1a 48 113. |
| Ex. Inq. (Ant.) | Exchequer Inquisitions covering reigns of several monarchs which are contained in a latin manuscript calendar running to 17 vols. Vol. 1 (Co. Antrim) covers reigns of Jac. I, Car. I, (interregnum), Car. II, William and Mary, PROI 1a 48 73. |
| Fél. Óeng. | *Félire Óengusso Céli Dé: the martyrology of Oengus the culdee* (AD 830c), ed. Whitley Stokes (London 1905; reprint 1984). |
| Fiants Eliz. | "Calendar and index to the fiants of the reign of Elizabeth I", appendix to the *11–13th, 15–18th and 21–22nd Reports of the Deputy Keeper of public records in Ireland* (Dublin 1879–81, 1883–86, 1889–90). |
| First Fruits Roll (Reeves) | First Fruits Roll of Down, Connor and Dromore 1616, copied by Wm. Reeves, PRONI, MS 3.1 4pp. |
| Flem. Letter (MacDonnells Ant.) | Letter from Gerot Flemynge, Hugh O'Neill's secretary, to Sir Thomas Cusack in 1565, in *MacDonnells Antrim* 135–9. |
| Forfeit. Estates | "Abstracts of the conveyances from the trustees of the forfeited estates and interests in Ireland in 1688", appendix to the *15th Annual report from the commissioners . . . respecting the public records of Ireland* (1825) 348–99. |
| Galvia | *Galvia: irisleabhar chumann seandáluiochta is staire na Gaillimhe* (Gaillimh 1954–). |
| GÉ | *Gasaitéar na hÉireann/Gazetteer of Ireland: ainmneacha ionad daonra agus gnéithe aiceanta,* Brainse Logainmneacha na Suirbhéireachta Ordanáis (Baile 5tha Cliath 1989). |
| Grand Jury Pres. | *Grand Jury Presentement Books* for Co. Antrim (1711–1800), PRONI ANT 4/1/1 to ANT 4/1/6. The earliest book (1711–21) is paginated but a number of later volumes are not and the entries are differentiated by date or by session, e.g. Summer 1793. |

Grant Ralph Bp. Down

Grant by John de Courcy to Ralph, Bishop of Down, AD 1202–3, ed. William Reeves, EA 165–7.

GUH

*Gleanings from Ulster History* by Séamus Ó Ceallaigh (Cork 1951), enlarged edition published by Ballinascreen Historical Society (1994).

Hib. Del.

*Hiberniae Delineatio:* an atlas of Ireland by Sir William Petty comprised of one map of Ireland, 4 maps of provinces and 32 county maps. It was engraved c. 1671–72 and first published in London c. 1685 (Goblet 1932, viii). A facsimile reprint was published in Newcastle-Upon-Tyne in 1968 and a further reprint, with critical introduction by J.H. Andrews, in Shannon, 1970.

Hib. Reg.

*Hibernia Regnum*: a set of 214 barony maps of Ireland dating to the period AD 1655–59. These maps were drawn at the same time as the official parish maps which illustrated the Down Survey of Sir William Petty. The original parish maps have been lost but the *Hibernia Regnum* maps are preserved in the Bibliothèque Nationale, Paris (Goblet 1932, v–x). Photographic facsimiles of these maps were published by the Ordnance Survey, Southampton in 1908.

HMR Ant.

Hearth money rolls for the county of Antrim, AD 1669, PRONI T307A.

Hondius Map

*Hyberniae Novissima Descriptio, AD 1591*, drawn by Jodocus Hondius and engraved by Pieter van den Keere, Linen Hall Library, Belfast.

Indent. Adair
(MacDonnells Ant.)

"Indenture between Robert Adare of Ballymanagh Esq. and his wife Jane on the one part and John Edmonstone of Ballibantra, William Houstone, younger, of Culnibackie, Alexander Adare of Ballichug, all of Co. Antrim, gents, and Thos. Adare, provost of Stranraier", dated June 8, 1636, published in *MacDonnells Antrim* 200 n. 20.

Indent. (Colville)

Indenture of Nov. 2 1720 between Robert Colville of Newtown and Andrew Newton of Gilgoran, PRONI mic. 35 reel 1.

Indent. (Staff.)

Indenture of July 21 1692 by which Francis Stafford of Mount Stafford Co. Antrim sells a number of townlands in the Portglenone area to John O'Bryens of Insequin Esq. and John O Neile of Gortgole etc., PROI Palmer Deeds Box 5 no. 22 in "Deeds pre-1708".

Inq. Ant. (DK)

*Inquisition taken at Antrim, 12 July, 1605 [Lower Clandeboy]* in the *26th Report of the Deputy Keeper of the public records in Ireland* (1894), appendix i, 43–51.

Inq. Earldom Ulster

"The earldom of Ulster", Goddard H. Orpen, *JRSAI* xliii (1913) 30–46, 133–43; xliv (1914) 51–66; xlv (1915) 123–42.

Inq. Par. Ant.

*Inquisition into the parishes of Co. Antrim, 1657,* an inquisition held during the Commonwealth by the Commission of the Great Seal of Ireland for dividing and uniting parishes. Representative Church Body Library, Dublin, MS. Libr. 26, also PRONI T808 14886.

Inq. Ult.

*Inquisitionum in officio rotulorum cancellariae Hiberniae asservatarum repertorium,* vol. ii (Ulster), ed. James Hardiman (Dublin 1829).

Inst. Edenduffcarrick

Instrument relating to the Edenduffcarrick estate, 1660–1685, endorsed "Marchioness of Antrim's Recovery", PRONI mic 35 reel 1.

Ireland E. Coast

A map of the east coast of Ireland from Dublin to Carrickfergus, c. 1580, PRO MPF 86. There is also a copy in PRONI T1493/43.

Jas I to Connor Cath.

Grant of James I to the cathedral of Connor, AD 1609, ed. William Reeves, *EA* 262–264.

JDCHS

*Journal of the Down and Connor Historical Society,* 10 vols (Belfast 1928–39).

J Louth AS

*Journal of the Louth Archaeological Society* (Dundalk 1904–).

Jobson's Ulster (BM)

A map of Ulster by Francis Jobson, c.1590, preserved in the British Museum, Cotton MS. Augustus i, vol. ii, no. 19.

Jobson's Ulster (TCD)

A set of three maps of Ulster by Francis Jobson, the first of which dates to AD 1590, TCD MS 1209, 15–17.

J O'D (OSNB)

Irish and anglicized forms of names attributed to John O'Donovan in the *OSNB*.

Journey to ye North

"Journey to ye North, August 7th, 1708", published in *Historical notes of old Belfast and its vicinity* by Robert M. Young, p 152–160 (Belfast 1896).

Joyce

*The origin and history of Irish names of places,* P.W. Joyce, 3 vols (Dublin 1869–1913).

JRSAI

*Journal of the Royal Society of Antiquaries of Ireland* (Dublin 1849–). Also called *Transactions of the Kilkenny Archaeological Society* (vols i–ii, 1849–53); *Proceedings and Transactions of the Kilkenny and South-east Ireland Archaeological Society* (vol. iii, 1854–55); *Journal of the Kilkenny and South-east Ireland Archaeological Society* (new ser., vols i–vi [consecutive ser. vols iv–ix] 1856–67); *Journal of the Historical and Archaeological Association of*

*Ireland* 3rd ser. vol. i [consecutive ser. vol. x], 1868–89); *Journal of the Royal Historical and Archaeological Association of Ireland* (4th ser. vols i–ix [consecutive ser. vols xi–xix] 1870–89); *Journal of Proceedings of the Royal Society of Antiquaries of Ireland* (5th ser. vol. i [consecutive ser. vol. xxi] 1890–91); 5th ser. vols ii–xx [consecutive ser. vols xxii–xl] (1892–1910); 6th ser. vols i–xx [consecutive ser. vols xli–lx] (1911–30); 7th ser. vols i–xiv [consecutive ser. vols lxi–lxxiv] (1931–44); thereafter numbered only as consecutive series vol. lxxv– (1945– ).

L. Ardm.    *Liber Ardmachanus: the Book of Armagh* (AD 807c), ed. John Gwynn (Dublin 1913).

LASID    *Linguistic atlas and survey of Irish dialects*, Heinrich Wagner and Colm Ó Baoill, 4 vols (Dublin 1958–69).

LB    *Leabhar Breac – The Speckled Book, otherwise styled Leabhar Mór Dúna Doighre* (AD 1400c), facsimile edition (Dublin 1872–6).

LCABuidhe    *Leabhar Cloinne Aodha Buidhe*, ed. Tadhg Ó Donnchadha alias Torna (Dublin 1931).

Lebor na Cert    *Lebor na Cert: the Book of Rights*, ed. Myles Dillon, Irish Texts Society xlvi (Dublin 1962).

Lendrick Map    Lendrick's map of Co. Antrim (1780), PRONI T1971/1

Lewis' Top. Dict.    *A topographical dictionary of Ireland, comprising the several counties, cities, boroughs, corporate, market and post towns, parishes and villages with statistical descriptions*, ed. Samuel Lewis, 2 vols and atlas (London 1837; 2nd edn 1842).

L. Gen. DF    *Leabhar Genealach an Dubhaltaigh Mhac Firbhisigh* ed. N. Ó Muraíle (forthcoming).

L. Lec.    *The Book of Lecan: Leabhar Mór Mhic Fhir Bhisigh Leacain*, (AD 1397c), facsimile edition ed. K. Mulchrone (Dublin 1937).

L. Log. C. Chainnigh    *Liostaí logainmneacha: Contae Chill Chainnigh/County Kilkenny*, arna ullmhú ag Brainse Logainmneacha na Suirbhéireachta Ordanáis (Baile Átha Cliath 1993).

L. Log. Lú    *Liostaí logainmneacha: Contae Lú/County Louth*, arna ullmhú ag Brainse Logainmneacha na Suirbhéireachta Ordanáis (Baile Átha Cliath 1991).

Local pronunciation    Local pronunciation recorded by the editors.

Lodge Fairs & Markets    John Lodge's *Records of the Rolls* (vol. xiv); Fairs and Markets: being a repertory of the "grants of all the Fairs and Markets which are enrolled in the offfice of the Rolls of the High Court of Chancery in Ireland", 1338–1773, PROI 1a 53 66.

Lodge RR

John Lodge's *Records of the Rolls*: being "an exact list of the Patent Rolls remaining of record in the Office of the Rolls of His Majesty's High Court of Chancery in Ireland", transcribed in 1755, vols. ii–x (Jas I – George II), PROI 1a 53 51 – 1a 53 59.

Longman Dict.

*Longman Dictionary of the English language* (Harlow 1984, 2nd edn 1991).

McCann's Desertcreat

*The townland names of the parish of Desertcreat, Co. Tyrone*, MA (QUB), 1982.

MacDonnells Antrim

*An historical account of the MacDonnells of Antrim*, Rev. George Hill (Belfast 1873).

McQ. Doc. (MacDonnells Ant.)

Document in which Rorie Oge MacQuillin conveys the power of attorney to his friend Sir Robert Adair of Ballymena in 1634, published in *MacDonnells Antrim* 202.

McSkim. Carrick.

Samuel McSkimin's *The history and antiquities of the county and town of Carrickfergus from the earliest records till 1839*, new edition with notes and appendix by E.J. McCrumm, FRSA (Belfast 1909).

Map Antrim

A map of Co. Antrim dating from 1807, PRONI T1129/234 (Edinburgh 1807).

Marriage Indent. (Staff.)

Marriage indenture of Edmund Stafford, July 22 1692, PROI Palmer Deeds box 5 no. 23 in "Deeds pre-1708".

Marriage Sett. Skeffington

Settlement of lands upon marriage in 1654 between Sir John Skeffington, St Martin's in the Fields Middlesex and Fisherwick Staffordshire, with Mary Clotworthy, daughter and heir to Sir John Clotworthy, St Martin's in the Fields and Antrim, Co. Antrim; included in Massereene and Ferrard estate papers, PRONI D207/16.

Mart. Don.

*The martyrology of Donegal: a calendar of the saints of Ireland* (AD 1630c), trans. John O'Donovan, ed. James H. Todd and William Reeves (Dublin 1864).

Mart. Gorm.

*Félire Húi Gormáin: the martyrology of Gorman* (AD 1170c), ed. Whitley Stokes (London 1895).

Mart. Tal.

*The martyrology of Tallaght* AD 830c, ed. R.I. Best and H.J. Lawlor (London 1931).

Mercator's/Hole's Ire.

A map of Ireland, AD 1610, drawn by Gerard Mercator and engraved by William Hole, and published in William Camden's atlas *Britannia, sive florentissimorum regnorum Angliae, Scotiae, Hiberniae, et insularum adiacentium. . . .*

Mercator's Ire.

*Irlandiae Regnum,* by Gerard Mercator, first published in his atlas entitled *Atlas sive Cosmographicae Meditationes de Fabrica Mundi et Fabricati Figura,* AD 1595.

Mercator's Ulst.

*Ultoniae Orientalis Pars* by Gerard Mercator, first published in his *Atlas sive Cosmographicae Meditationis de Fabrica Mundi et Fabricati Figura,* AD 1595.

Meyer Miscellany

*Miscellany presented to Kuno Meyer,* ed. Osborn Bergin and Carl Marstrander (Halle 1912).

Mon. Hib.

*Monasticon Hibernicum: or a history of the abbeys, priories and other religious houses in Ireland,* Mervyn Archdall, 3 vols (Dublin 1786). New edn Patrick F. Moran (Dublin 1873–6).

NHI

*A new history of Ireland,* ed. T.W. Moody, F.X. Martin and F.J. Byrne (Oxford 1976–).

NISMR

*Northern Ireland sites and monuments record: stage 1* (1979), published privately by the Department of the Environment (NI) and the Archaeological Survey (Belfast 1979).

NMAJ

*North Munster Antiquarian Journal* (1936–).

Norden's Map

"The plott of Irelande with the confines", formerly included in *A discription of Ireland,* c. 1610, by John Norden. This map had been preserved in the State Paper Office but is now in PRO MPF 67. It is reproduced in *SP Hen. VIII* vol. ii, pt. 3.

Nowel's Ire. (1)

A map of Ireland, c. 1570, attributed to Laurence Nowel, dean of Lichfield (d. 1576). British Museum Cotton MS, Domitian A18, ff. 101–103. Reproduced by the Ordnance Survey, Southampton.

Ó Dónaill

*Foclóir Gaeilge-Béarla,* eag. Niall Ó Dónaill (Baile Átha Cliath 1977).

O'Duygenan Grant

Grant from Randal MacDonnell to Farfesse O'Duygenan (1637) in PRONI D265/22.

O'Flaherty's Ogygia

O'Flaherty's *Ogygia seu Rerum Hibericarum Chronologia or a Chronological Account of Irish Events* (1685), translated by J. Hely (Dublin, 1793).

O'Laverty

*An historical account of the diocese of Down and Connor ancient and modern,* Rev. James O'Laverty, 5 vols. (Dublin 1878–95).

Onom. Goed.

*Onomasticon Goedelicum locorum et tribuum Hiberniae et Scotiae,* Edmund Hogan (Dublin 1910).

Ortelius Map

*Eryn. Hiberniae, Britannicae Insulae, Nova Descriptio. Irlandt* by Abraham Ortelius. Published in the second edition of his *Theatrum Orbis Terrarum* (Antwerp 1573).

| | |
|---|---|
| OS 1:10,000 | *The Ordnance Survey 1:10,000 series maps,* Ordnance Survey of Northern Ireland (Belfast 1968– ). |
| OS 1:50,000 | *The Ordnance Survey 1:50,000 series maps,* also known as *The Discoverer Series,* Ordnance Survey of Northern Ireland (Belfast 1978–88). |
| OS 6-inch | *The Ordnance Survey six-inch series maps* first published in the 1830s and 1840s with numerous subsequent editions. It has now been replaced by the OS 1:10,000. |
| OSM | *Ordnance Survey memoirs of Ireland,* ed. Angélique Day and Patrick McWilliams (Belfast 1990– ). |
| OS Name Sheets | *Ordnance Survey name sheets* for the parishes of Co. Antrim. They appear to be transcripts of the *OSNB*s but contain additional information. Originals in Ordnance Survey headquarters, Phoenix Park, Dublin. |
| OS Name Sheets (J O'D) | Spellings of place-names attributed to John O'Donovan in the *OS Name Sheets.* |
| OSNB | Name-books compiled during the progress of the Ordnance Survey in 1834–5 and preserved in the Ordnance Survey, Phoenix Park, Dublin. |
| OSNB Inf. | Informants for the Irish forms of place-names in the *OSNB.* |
| OSRNB | *Ordnance Survey revision name books,* compiled c. 1858. They list under the OS 6-inch sheet number the minor place-names on that sheet and include descriptive remarks and in some cases information on the origin of the place-names. Originals in Ordnance Survey Headquarters, Phoenix Park, Dublin. |
| PNI | *Place-names of Northern Ireland* vols 1–3 (Belfast 1992–3). |
| Post-Sheanchas | *Post-Sheanchas i n-a bhfuil cúigí, dúithchí, conntaethe, & bailte puist na hÉireann,* Seosamh Laoide (Baile Átha Cliath 1905). |
| PRIA | *Proceedings of the Royal Irish Academy* (Dublin 1836– ). Published in three sections since 1902 (section C: archaeology, linguistics and literature). |
| Protest. Householders | Register of Protestant householders in Co. Antrim (1740), PRONI T808/15258. |
| PSAMNI | *Preliminary survey of the ancient monuments of Northen Ireland,* ed. D.A. Chart (Belfast 1940). |
| Reg. Deeds | Original bound MSS volumes in the *Registry of Deeds,* Henrietta St., Dublin (1708–1832). Microfilm copies in PRONI mic. 7. |

| | |
|---|---|
| Reg. Deeds abstracts | *Registry of Deeds, Dublin. Abstracts of wills, 1708–1832*, ed. P. Beryl Eustace and Eilish Ellis, 3 vols (Dublin 1954–84). |
| Reg. Dowdall | "A calendar of the register of Primate George Dowdall, commonly called the *Liber Niger* or 'Black Book'", ed. L.P. Murray, *J Louth AS* vi (1925–8) 90–101, 147–58, 211–28; vii (1929–32) 78–95, 258–75. |
| Reg. Octavian (EA) | *Register of Octavian de Palatio, Primate 1478–1513*, cited in EA passim. |
| Reg. Prene (EA) | *Register of John Prene, Primate 1439–43*, cited in EA passim. |
| Regal Visit. (PROI) | *Regal visitation of Down and Connor*, 1634. Original in PROI (Tenison Groves). Also PRONI T975/1–3. |
| Regal Visit. (Reeves) | *Regal visitation of Down, Connor & Dromore, AD 1633–34*, transcribed by William Reeves, and collated and corrected from originals in the Prerogative Office [now the Record Office] Dublin, PRONI DIO/1/24/2/4. |
| Rent Roll Mass. Est | Rent roll of Lord Massereene's estate, Co. Antrim, 1711–12, PRONI D562 834. |
| Rev. Celt. | *Révue Celtique*, 51 vols (Paris 1870–1934). |
| Samuel Bryson (OSNB) | Irish forms of place-names suggested by Samuel Bryson in the *OSNB* for a small number of parishes in Co. Antrim. |
| Scot. Nat. Dict. | *Scottish National Dictionary*, ed. William Grant (1929–46) & David D. Murison (1946–76), 10 vols (Edinburgh). |
| Sett. O'Neill Ests. (O'Laverty) | Deed of settlement of the O'Neill estates in 1863, cited in O'Laverty's *An historical account of the diocese of Down and Connor ancient and modern* vol. iii, *passim*. |
| Shaw Mason's Par. Sur. | *A statistical account, or parochial survey of Ireland, drawn up from the communications of the clergy.* William Shaw Mason, vol. i (Dublin 1814). |
| Speed's Antrim & Down | A map entitled *Antrym and Downe*, AD 1610, by John Speed. Reproduced in *UJA* ser. 1, vol. i (1853) between pp 123 and 124. |
| Speed's Ireland | *The Kingdome of Irland devided into severall Provinces and then againe devided into Counties. Newly described*, AD 1610, by John Speed. Also published in his atlas *The Theatre of the Empire of Great Britain* (Sudbury & Humble 1612). |
| Speed's Ulster | *The Province Ulster described*, AD 1610, by John Speed. Also published in his atlas *The Theatre of the Empire of Great Britain* (Sudbury & Humble 1612). |

State Connor — "State of the diocese of Connor as per return to the House of Lords, 30 Jan. 1765", PRONI mic. 35 reel 5.

Statist. Sur. Ant. — *Statistical survey of the county of Antrim, with observations on the means of improvement,* by Rev. John Dubourdieu, 2 pts. (Dublin, 1812).

Taylor & Skinner (Rev.) — *Maps of the roads of Ireland, surveyed 1777, corrected down to 1783,* by George Taylor and Andrew Skinner (Dublin, 1783); republished by Irish University Press (Shannon 1969).

Terrier (O'Laverty) — "Terrier or ledger book of Down and Connor, c. 1615", O'Laverty v 318–334.

Terrier (Reeves) — *Terrier or ledger book of Down and Connor, c. 1615,* transcribed by William Reeves, PRONI DIO/1/24/2/3.

Theiner's Vet. Mon. — *Vetera Monumenta Hibernorum et Scotorum,* 1216–1547 (Rome 1864).

Tírechán's Collect. (Bieler) — *Tírechán's Collectanea* (AD 670c), ed. L. Bieler in *The Patrician Texts in the Book of Armagh.* Scriptores Latini Hiberniae, vol. X (Dublin 1979).

Tithe Applot. — *Tithe Applotment Books* for Co. Antrim (1824–38), PRONI, FIN VA.

Topog. Poems — *Topographical poems: by Seaán Mór Ó Dubhagáin and Giolla-na-Naomh Ó hUidhrín,* ed. James Carney (Dublin 1943).

Trav. New Guide Ire. — *The travellers' new guide through Ireland* by Dr Thomas Molyneux (1705), cited in *Buick's Ahoghill,* p. 15n.

Trias Thaum. — *Triadis Thaumaturgae seu divorum Patricii, Columbae et Brigidae . . . acta, tom.* ii, John Colgan (Lovanii 1647).

Trien. Visit. (Boyle) — *Boyle's Triennial visitation of Down, Connor and Dromore, AD 1679,* transcribed by William Reeves, PRONI DIO/1/24/16/1, pp. 34–49.

Trien. Visit. (Bramhall) — *Bramhall's Triennial visitation of Down, Connor and Dromore, AD 1661,* transcribed by William Reeves, PRONI DIO/1/24/16/1, pp 1–16.

Trien. Visit. (Margetson) — Margetson's *Triennial visitation of Down, Connor and Dromore, AD 1664,* transcribed by William Reeves, PRONI DIO/1/24/16/1, pp 19–33.

Trip. Life (Mulchrone) — *Bethu Phatraic: the Tripartite Life of Patrick,* ed. Kathleen Mulchrone, vol. 1 (Dublin 1939).

Trip. Life (Stokes) — *The tripartite life of Saint Patrick, with other documents relating to that Saint,* ed. Whitley Stokes, 2 vols (London 1887).

UJA

*Ulster Journal of Archaeology,* 1st ser., 9 vols (Belfast 1853–62); 2nd ser., 17 vols (1894–1911); 3rd ser. (1938– ).

Ulster & Other Irish Maps

*Ulster and Other Irish Maps,* published by Irish Manuscripts Commission, ed. G.A. Hayes-McCoy (Dublin 1984).

Ulster Map 1570c

*A plat of Ulster,* c. 1570, annotated by Lord Burghley, AD 1590, PRO MPF 90. There is a copy in PRONI T1493/6.

Ulster Visit. (Reeves)

*The state of the diocese of Down and Connor, 1622, as returned by Bishop Robert Echlin to the royal commissioners,* copied from TCD E.3.6. by William Reeves, PRONI D10/1/24/1.

Ultach

*An tUltach: iris oifigiúil Chomhaltas Uladh* (1923– ).

Walks Ballymena

"Walks about Ballymena", two anonymous articles published in the *Ballymena Observer,* Jan. 23, Feb. 6 1858, PRONI mic 35 reel 1.

Ware (Harris)

3 vols. by James Ware on the Bishops, Antiquities and Writers of Ireland in Latin, ed. and translated by Walter Harris (Dublin 1739).

Warr Ire. Hist. (O'Laverty)

*The Warr of Ireland:* the history of the war of Ireland from 1641 till 1653, by an officer in the regiment of Sir John Clotworthy (Dublin 1873), cited in O'Laverty's *Historical account of the diocese of Down and Connor ancient and modern, passim.*

Williamite Forf.

"Persons forfeiting their freehold lands or leases in ye Co. of Antrim by their being of ye late King James his party in ye time of ye late Rebellion and Warr". PRONI, D207/15/30.

ZCP

*Zeitschrift fur Celtische Philologie* 1897–.

# SECONDARY BIBLIOGRAPHY

| | | |
|---|---|---|
| Adams, G.B. | 1954 | "Place-Name phonology", *BUPNS* ser. 1 vol. ii 30–1. |
| Andrews, J.H. | 1974 | "The maps of the escheated counties of Ulster, Ulster,1609–10", *PRIA* vol. lxxiv, sect. C, 133–70. |
| | 1975 | A *paper landscape; the Ordnance Survey in nineteenth-century Ireland* (Oxford). |
| | 1978 | *Irish maps: the Irish heritage series, no.* 18 (Dublin). |
| Arthurs, J.B. | 1955–6 | "The Ulster Place-name Society", *Onoma vi* 80–2. |
| Bell, Robert | 1988 | *The book of Ulster surnames* (Belfast). |
| Binchy, D.A. | 1941 | *Crith Gablach*, Medieval and Modern Irish Series, xi (Dublin). |
| Black, G.F. | 1946 | *The surnames of Scotland* (New York). |
| Byrne, F.J. | 1959 | *The history of the Ulaid to 1201* AD, MA (UCD). |
| | 1973 | *Irish kings and high-kings* (London). |
| Carleton, C.T. | 1991 | *Heads and hearths: The hearth money rolls and poll tax returns for Co. Antrim 1660–69* (Belfast). |
| de hÓir, E. | 1980–1 | "The place-names of Ireland", *BUPNS* ser. 2 vol. 3, 1–7. |
| Ekwall, E. | 1960 | *The concise Oxford dictionary of English place-names (Oxford* 4th edn). |
| Falkiner, C.L. | 1903 | "The counties of Ireland: an historical sketch of their origin, constitution, and gradual delimitation", *PRIA* vol. xxiv, sect. C, 169–94. |
| Fee, T. | 1950 | *The kingdom of Airgialla and its subdivisions,* MA (UCD). |
| Flanagan, D. | 1978(b) | "Common elements in Irish place-names: *Baile*", *BUPNS* ser. 2, vol. 1, 8–13. |
| | 1978(c) | "Seventeenth-century salmon fishing in Co. Down", *BUPNS* ser. 2, vol. 1, 22–26. |
| | 1978(d) | "Transferred population or sept-names: *Ulaidh* (a quo Ulster)", *BUPNS* ser. 2, vol. 1, 40–3. |
| | 1979(a) | "Common elements in Irish place-names: *ceall, cill*", *BUPNS* ser. 2, vol. 2, 1–8. |
| | 1979(f) | "Review of *The meaning of Irish place names* by James O'Connell (Belfast 1978)", *BUPNS* ser. 2, vol. 2, 58–60. |
| | 1979(g) | Addendum to Mac Aodha's "Rian an Bhéarla ar áitainmneacha Thuama Íochtair agus Thuama Uachtair", *BUPNS* ser. 2, vol. 2, 55. |
| | 1980–1(a) | "Common elements in Irish place-names: *dún, ráth, lios*", *BUPNS* ser. 2, vol. 3, 16–29. |
| | 1981–2(b) | "Some guidelines to the use of Joyce's *Irish names of places*, vol. i", *BUPNS* ser. 2, vol. 4, 61–9. |

|  | 1981–2(c) | "A summary guide to the more commonly attested ecclesiastical elements in place-names", *BUPNS* ser. 2, vol. 4, 69–75. |
| Hamilton, J.N. | 1974 | *The Irish of Tory Island* (Belfast). |
| Hamlin, A.E. | 1976 | *The archaeology of early Christianity in the north of Ireland,* PhD (QUB). |
| Hogan, Edmund | 1910 | *Onomasticon Goedelicum locorum et tribuum Hiberniae et Scotiae* (Dublin). |
| Holmer, N.M. | 1940 | *On some relics of the Irish dialect spoken in the Glens of Antrim* (Uppsala). |
|  | 1942 | *The Irish language in Rathlin Island, Co. Antrim,* Todd Lecture Series, xviii (Dublin). |
| Kneen, J.J. | 1925 | *Place-Names of the Isle of Man* (Douglas; reprint 1973). |
| Lawlor, H.C. | 1928 | *Ulster: its archaeology and antiquities* (Belfast). |
| McAleer, Patrick | 1936 | *Townland names of Co. Tyrone with their meanings;* (reprint Portadown & Draperstown 1988). |
| Mac Aodha, B. | 1979 | "Rian an Bhéarla ar áitainmneacha Thuama íochtair agus Thuama Uachtair", *BUPNS* ser. 2, vol. 2, 41–42. |
| McErlean, Thomas | 1983 | "The Irish townland system of landscape organisation" in *Landscape archaeology in Ireland,* ed. Terence Reeves-Smyth and Fred Hamond, 315–39 (Oxford). |
| Mac Giolla Easpaig, D. | 1981 | "Noun-plus-noun compounds in Irish place-names", *Ét. Celt.* xviii, 151–63. |
|  | 1984 | "Logainmneacha na Rosann", *Dongl. Ann.* vol. 36, 48–60. |
|  | 1989–90 | "The place-names of Rathlin Island", *Ainm* iv, 3–89. |
| McKeown, L. | 1937 | "Historical itineraries in Antrim and Down", *JDCHS* viii, 28–38. |
| MacLysaght, Edward | 1985 | *The surnames of Ireland* (Dublin, 4th edn; 1st edn 1957). |
| MacNeill, Eoin | 1932 | "The *Vita Tripartita* of St Patrick", *Ériu* xi 1–41. |
| McNeill, T.E. | 1980 | *Anglo-Norman Ulster* (Edinburgh). |
| Marshall, J. | 1934 | *Lough Neagh in history and legend* (Dungannon). |
| Moody, T.W. | 1939 | *The Londonderry plantation, 1609–41: the city of London and the plantation in Ulster* (Belfast). |
| Mooney, B.J. | 1954(a) | *The parish of Seagoe – its place-names and history:* part 1, the place-names explained (Newry). |
| Morton, Deirdre | 1956–7 | "Tuath-divisions in the baronies of Belfast and Massereene", *BUPNS* ser. 1, vol. iv 38–44; v 6–12. |
| Munn, A.M. | 1925 | *Notes on the place names of the parishes and townlands of the County of Londonderry* (reprint Ballinascreen 1985). |

Ó Baoill, C.  1978  *Contributions to a comparative study of Ulster Irish and Scottish Gaelic* (Belfast).

Ó Ceallaigh, Séamus  1950(b)  "Notes on place-names in Derry and Tyrone," *Celtica* i, 118–40.

Ó Concheanainn, T.  1966  "Ainmneacha éideimhne", *Dinnsean.* iml. ii, uimh. 1 15–19.

Ó Corráin, D. & Maguire, F.  1981  *Gaelic personal names* (Dublin).

Ó Cuív, B.  1984  "Some Irish items relating to the MacDonnells of Antrim", *Celtica* xvi, 139–156.

Ó Donnchadha P.  1950c  *Ainmneacha áiteann i gCondae Mhuigheo*, MA (UCG).

O'Donovan, John  1848  *The tribes and customs of Hy-Many, commonly called O'Kelly's country* (Dublin).
  1849  *Miscellany of the Celtic Society* (Dublin).

Ó Foghludha, R.  1935  *Log-ainmneacha i. dictionary of Irish place-names . . . (Dublin)*.

O'Kane, James  1970  "Placenames of Inniskeel and Kilteevoge. A placename study of two parishes in central Donegal", *ZCP* xxxi, 59–145.

O'Kelly, O.  1985  *The place-names of Co. Kilkenny* (Kilkenny).

Ó Maille, T.S.  1955(b)  "*Muiceanach* mar áitainm", *JRSAI* lxxxv, 88–93.
  1959  "*Bullaun is* ainmneacha gaolmhara", *Galvia* vi, 50–59
  1968  "*Cam* in áitainmneacha", *NMAJ* xi, 64–70.
  1987  "Place-Name elements in -*ar*", *Ainm* ii, 27–36.
  1989–90  "Irish place-names in -*as, -es, -is, -os, -us*", *Ainm* iv, 125–43.

Ó Maolfabhail, Art  1974  "*Grianán* i logainmneacha", *Dinnsean.* iml. vi, uimh. 2, 60–75.
  1987–8  "Baill choirp mar logainmneacha", *Ainm* ii 76–82; iii, 18–26.
  1990  *Logainmneacha na hÉireann, iml. i: Contae Luimnigh* (Baile Átha Cliath).

Ó Muraíle, Nollaig  1985  *Mayo places: their names and origins* (Dublin).
  1989  "Ainmneacha na mbailte fearainn i seanpharóiste Chluain Fiacla – notes on the townland names of the old parish of Clonfeacle", *Dúiche Néill* vol. 4, 32–40.

O'Rahilly, T.F.  1932  *Irish dialects past and present* (Dublin; reprint 1976).
  1946  *Early Irish history and mythology* (Dublin; reprint 1976).

Otway-Ruthven, A.J.  1964  "Parochial development in the rural deanery of Skreen", *JRSAI* xciv, 111–22.

| Petty, William | 1672 | *The political anatomy of Ireland* (1672), reprinted in *Tracts and treatises illustrative of Ireland* ii 72–3 (Dublin 1860–1). |
|---|---|---|
| Power, Patrick | 1932 | *Críchad an chaoilli: being the topography of ancient Fermoy* (Cork). |
| | 1947 | "The bounds and extent of Irish parishes", *Féil. Torna* 218–23. |
| Price, Liam | 1963 | "A note on the use of the word *baile* in place-names", *Celtica* vi, 119–26. |
| Reeves, William | 1861 | "On the townland distribution of Ireland", *PRIA* vii 473–90. |
| | 1903 | "Crannogs or artificial islands in the counties of Antrim and Derry", *UJA* ser. 2 vol. ix, 168–176. |
| Reid, Professor | 1957 | "A note on *cinament*", *BUPNS* ser. 1, vol. v, 12. |
| Room, A. | 1983 | *A concise dictionary of modern place-names in Great Britain and Ireland* (Oxford). |
| Shaw, W. | 1913 | *Cullybackey: the story of an Ulster village* (Edinburgh). |
| Sibbett, R.M. | 1928 | *On the shining Bann – records of an Ulster manor* (Belfast; reprint Ballymena and Draperstown 1991). |
| Sommerfelt, Alf | 1958 | "The English forms of the names of the main provinces of Ireland", *Lochlann* i 223–7. |
| Stewart, G. | 1975 | *Names on the Globe* (New York). |
| Stockman, Gearóid | 1986 | "Giorrú Gutaí Fada Aiceannta i nGaeilge Chúige Uladh", *Féilscríbhinn Thomáis de Bhaldraithe* ed. Seosamh Watson (Dublin). |
| Taylor, Isaac | 1896 | *Names and their histories* (1896), reprinted in the Everyman edition of his *Words and places* (1911). |
| Uí Fhlannagáin, D. | 1969(b) | "*Lann*", *Ultach*, Iúil, 8. |
| | 1970(d) | "*Caiseal* agus *Cathair* sna logainmneacha", *Ultach*, Aibreán, 8. |
| | 1970(k) | "*Bóthar na bhFál, Maigh Lón, an tSeanchill agus Baile na mBráthar*", *Ultach*, Nollaig, 7,22. |
| Wagner, Heinrich | 1979 | "Origins of pagan Irish religion and the study of names", *BUPNS* ser. 2, vol. ii, 24–40. |
| Walsh, P. | 1957 | *The placenames of Westmeath* (Dublin). |
| Woulfe, Patrick | 1923 | *Sloinnte Gaedheal is Gall: Irish names and surnames; collected and edited with explanatory and historical notes* (Dublin). |

# GLOSSARY OF TECHNICAL TERMS

**advowson**   The right of presenting a clergyman to a vacant benefice.

**affricate**   A plosive pronounced in conjunction with a fricative; e.g. the sounds spelt with *(t)ch* or *-dge* in English.

**alveolar**   Pronounced with the tip of the tongue touching the ridge of hard flesh behind the upper teeth; e.g. *t* in the English word *tea*.

**analogy**   The replacement of a form by another in imitation of words of a similar class; e.g. in imitation of *bake – baked, fake – faked, rake – raked* a child or foreigner might create a form *shaked.*

**anglicize**   Make English in form; e.g. in place-names the Irish word *baile* "homestead, townland" is anglicized *bally.*

**annal**   A record of events in chronological order, according to the date of the year.

**annates**   Later known as First Fruits; a tax paid, initially to the Pope, by a clergyman on appointment to a benefice.

**apocope**   The loss of the end of a word.

**aspiration**   (i) The forcing of air through a narrow passage thereby creating a frictional sound; e.g. *gh* in the word *lough* as pronounced in Ireland and Scotland is an aspirated consonant, (ii) the modification of a consonant sound in this way, indicated in Irish writing by putting *h* after the consonant; e.g. *p* aspirated resembles the *ph* sound at the beginning of *phantom;* also called **lenition.**

**assimilation**   The replacing of a sound in one syllable by another to make it similar to a sound in another syllable; e.g. in some dialects of Irish the *r* in the first syllable of the Latin *sermon-* was changed to *n* in imitation of the *n* in the second syllable, giving a form *seanmóin.*

**ballybetagh**   Irish *baile biataigh* "land of a food-provider", native land unit, the holder of which had a duty to maintain his lord and retinue when travelling in the area (*Colton Vis.* 130).

**ballyboe**   Irish *baile bó* "land of a cow", a land unit equivalent to a modern townland, possibly so-named as supplying the yearly rent of one cow (*Colton Vis.* 130).

**barony**   In Ireland an administrative unit midway in size between a county and a civil parish, originally the landholding of a feudal baron (*EA* 62).

**benefice**   An ecclesiastical office to which income is attached.

**bilabial**   Articulated by bringing the two lips together; e.g. the *p* in the English word *pea.*

**Brittonic**   Relating to the branch of Celtic languages which includes Welsh, Cornish and Breton.

**calendar**   A précis of an historical document or documents with its contents arranged according to date.

**carrow**   Irish *ceathru* "a quarter". See **quarter.**

**cartography**   The science of map-making.

**cartouche**   An ornamental frame round the title etc. of a map.

**carucate**   Latin *carucata* "ploughland", a territorial unit, the equivalent of a townland.

**Celtic**   Relating to the (language of the) Irish, Scots, Manx, Welsh, Cornish, Bretons, and Gauls.

**centralized**   Pronounced with the centre of the tongue raised; e.g. the vowel sound at the beginning of *again* or at the end of *the.*

**cess**   Tax.

**cinament**   A territorial unit of lesser size than a **tuogh** (which see). Three derivations have been suggested: (i) from Irish *cine* "a family", (*cineamhain?*) (*EA* 388); (ii) from French *scindement* "cutting up, division" (Morton 1956–7, 39); (iii) from French *(a)ceignement* "enclosure(?)" (Reid 1957, 12).

**civil parish**   An administrative unit based on the medieval parish.

**cluster**   See **consonant cluster.**

**coarb**   Irish *comharba*, originally the heir of an ecclesiastical office, later a high-ranking hereditary tenant of church land under the bishop. The coarb may be in charge of other ecclesiastical tenants called **erenaghs,** which see.

**compound**   A word consisting of two or more verbal elements; e.g. *aircraft, housework.*

**consonant**   (i) An element of the alphabet which is not a vowel, e.g. *c, j, x,* etc., (ii) a speech sound in which the passage of air through the mouth or nose is impeded, e.g. at the lips (*b, p, or m*), at the teeth (*s, z*), etc.

**consonant cluster**   A group of two or more consonants; e.g. *bl* in *blood, ndl* in *handle, lfths* in *twelfths.*

**contraction**   (i) The shortening of a word or words normally by the omission of one or more sounds, (ii) a contracted word; e.g. *good-bye is* a contraction of *God be with you; can not is* contracted to *can't.*

**county**   Feudal land division, equivalent to an English shire, created by the English administration in Ireland as the major subdivision of an Irish province.

**deanery**   Properly called a rural deanery, an ecclesiastical division of people or land administered by a rural dean.

294

**declension**  A group of nouns whose case-endings vary according to a fixed pattern. (There are five declensions in modern Irish).

**delenition**  Sounding or writing a consonant as if it were not aspirated; see **aspiration.**

**dental**  A sound pronounced with the tip of the tongue touching the upper teeth; e.g. *th* in the English *thumb.*

**devoicing**  Removing the sound caused by the resonance of vocal cords; see **voiced.**

**dialect**  A variety of a language in a given area with distinctive vocabulary, pronunciation or grammatical forms.

**digraph**  A group of two letters expressing a single sound; e.g. *ea* in English *team* or *ph* in English *photograph.*

**diocese**  The area or population over which a bishop has ecclesiastical authority.

**diphthong**  A union of two vowel sounds pronounced in one syllable; e.g. *oi* in English *boil.* (Note that a diphthong cannot be sung on a single sustained note without changing the position of the mouth).

**dissimilation**  The replacing of a sound in one syllable by another to make it different from a sound in another syllable e.g. Loughbrickland comes from an original Irish form, *Loch Bricrenn.*

**eclipsis**  The replacement in Irish of one sound by another in initial position as the result of the influence of the previous word; e.g. the *c* of Irish *cór* "choir" (pronounced like English *core)* is eclipsed by *g* in the phrase *i gcór* "in a choir" due to the influence of the preposition *i,* and *gcór* is pronounced like English *gore*; also called **nasalization.**

**elision**  The omission of a sound in pronunciation; e.g. the *d is* elided in the word *handkerchief.*

**emphasis**  See **stress.**

**epenthetic vowel**  A vowel sound inserted within a word; e.g. in Ireland an extra vowel is generally inserted between the *l* and *m* of the word *film.*

**erenagh**  Irish *airchinnech* "steward", hereditary officer in charge of church lands, later a tenant to the bishop *(Colton Vis.* 4–5).

**escheat**  Revert to the feudal overlord, in Ireland usually forfeit to the English crown.

**etymology**  The facts relating to the formation and meaning of a word.

**fiant**  A warrant for the making out of a grant under the royal seal, or (letters) patent.

**fricative**  A speech sound formed by narrowing the passage of air from the mouth so that audible friction is produced; e.g. *gh* in Irish and Scottish *lough.*

**Gaelic**   Relating to the branch of Celtic languages which includes Irish, Scottish Gaelic and Manx.

**glebe**   The house and land (and its revenue) provided for the clergyman of a parish.

**glide**   A sound produced when the organs of speech are moving from the position for one speech sound to the position for another; e.g. in pronouncing the word *deluge* there is a *y*-like glide between the *l* and the *u*.

**gloss**   A word or phrase inserted in a manuscript to explain a part of the text.

**Goedelic = Gaelic**   which see.

**grange**   Anglo-Norman term for farm land providing food or revenue for a feudal lord, frequently a monastery.

**haplology**   The omission of a syllable beside another with a similar sound; e.g. *lib(ra)ry*, *deteri(or)ated*.

**hearth money**   A tax on the number of hearths used by a household.

**impropriator**   The person to whom rectorial tithes of a monastery etc. were granted after the Dissolution.

**inflect**   To vary the form of a word to indicate a different grammatical relationship; e.g. *man* singular, *men* plural.

**inquisition**   A judicial inquiry, here usually into the possessions of an individual at death.

**International Phonetic Alphabet**   The system of phonetic transcription advocated by the International Phonetic Association.

**labial = bilabial** which see.

**lenition**   See **aspiration.**

**lexicon**   The complete word content of a language.

**lowering**   Changing a vowel sound by dropping the tongue slightly in the mouth; e.g. pronouncing *doctor* as *dactor*.

**manor**   Feudal estate (Anglo–Norman and Plantation), smaller than a barony, entitling the landowner to jurisdiction over his tenants at a manor court.

**martyrology**   Irish *féilire,* also translated "calendar", a list of names of saints giving the days on which their feasts are to be celebrated.

**mearing**   A boundary.

**metathesis**   The transposition of sounds in a word; e.g. saying *elascit* instead of *elastic.*

**moiety**   French *moitié,* "the half of", also a part or portion of any size.

**morphology**   The study of the grammatical structure of words.

**nasalization**   See **eclipsis.**

**oblique**   Having a grammatical form other than nominative singular.

**onomasticon**   A list of proper names, usually places.

**orthography**   Normal spelling.

**palatal**   A sound produced with the tongue raised towards the hard palate.

**parish**   A subdivision of a diocese served by a single main church or clergyman.

**patent**   (or letters patent), an official document conferring a right or privilege, frequently here a grant of land.

**patronymic**   A name derived from that of the father.

**phonemic**   Relating to the system of phonetic oppositions in the speech sounds of a language, which make, in English for example, *soap* a different word from *soup,* and *pin* a different word from *bin.*

**phonetic**   Relating to vocal sound.

**phonology**   The study of the sound features of a language.

**plosive**   A sound formed by closing the air passage and then releasing the air flow suddenly, causing an explosive sound; e.g. *p* in English *pipe.*

**ploughland**   Medieval English land unit of about 120 acres, equivalent to a townland.

**prebend**   An endowment, often in land, for the maintenance of a canon or prebendary, a senior churchman who assisted the bishop or had duties in the cathedral.

**precinct**   *Ad hoc* land division (usually a number of townlands) used in Plantation grants.

**prefix**   A verbal element placed at the beginning of a word which modifies the meaning of the word; e.g. *un-* in *unlikely.*

**proportion**   *Ad hoc* land division (usually a number of townlands) used in Plantation grants.

**province**   Irish *cúige* "a fifth": the largest administrative division in Ireland, of which there are now four (Ulster, Leinster, Connaught, Munster) but were once five.

**quarter**   Land unit often a quarter of the ballybetagh, and thus containing three or four townlands, but sometimes referring to a subdivision of a townland. See also **carrow.**

**raising**   Changing a vowel sound by lifting the tongue higher in the mouth; e.g. pronouncing *bag* as *beg*.

**realize**   Pronounce; e.g. *-adh* at the end of verbal nouns in Ulster Irish is realized as English *-oo*.

**rectory**   A parish under the care of a rector supported by its tithes; if the rector cannot reside in the parish he appoints and supports a resident vicar.

**reduction**   (i) Shortening of a vowel sound; e.g. the vowel sound in *board is* reduced in the word *cupboard*, (ii) = **contraction** which see.

**register**   A document providing a chronological record of the transactions of an individual or organization.

**rounded**   Pronounced with pouting lips; e.g. the vowel sounds in *oar* and *ooze*.

**Scots**   A dialect of Anglo-Saxon which developed independently in lowland Scotland from the 11th to the 16th centuries. By the time of the Union of Crowns in 1603 it was markedly different from southern English.

**seize**   To put in legal possession of property, especially land.

**semantic**   Relating to the meaning of words.

**semivowel**   A sound such as *y* or *w* at the beginning of words like *yet, wet*, etc.

**sept**   Subgroup of people, for instance of a tribe or ruling family.

**sessiagh**   Irish *seiseach* "a sixth", usually referring to a subdivision of a townland or similar unit. Apparently three sessiaghs were equivalent to a ballyboe (*Colton Vis.* 130).

**shift of stress**   The transfer of emphasis from one syllable to another; e.g. *Belfast* was originally stressed on the second syllable *fast* but because of shift of stress many people now pronounce it **Bel**fast. See **stress.**

**stem**   (dental, o-, etc.) Classification of nouns based on the form of their endings before the Old Irish period.

**stress**   The degree of force with which a syllable is pronounced. For example, the name Antrim is stressed on the first syllable while Tyrone is stressed on the second.

**subdenomination**   A smaller land division, usually a division of a townland.

**substantive**   A noun.

**suffix**   A verbal element placed at the end of a word which modifies the meaning of the word; e.g. *-less* in *senseless*.

298

**syllable**   A unit of pronunciation containing one vowel sound which may be preceded or followed by a consonant or consonants; e.g. *I*, *my*, *hill*, have one syllable; *outside*, *table*, *ceiling* have two; *sympathy*, *understand*, *telephone* have three, etc.

**syncopation**   The omission of a short unstressed vowel or digraph when a syllable beginning with a vowel is added; e.g. *tiger+ess* becomes *tigress*.

**tate**   A small land unit once used in parts of Ulster, treated as equivalent to a townland, although only half the size.

**termon**   Irish *tearmann*, land belonging to the Church, with privilege of sanctuary (providing safety from arrest for repentant criminals), usually held for the bishop by a coarb as hereditary tenant.

**terrier**   A list of the names of lands held by the Church or other body.

**tithes**   Taxes paid to the Church. Under the native system they were shared between parish clergy and erenagh (as the tenant of the bishop), under the English administration they were payable to the local clergyman of the Established Church.

**topography**   The configuration of a land surface, including its relief and the position of its features.

**toponymy**   Place-names as a subject for study.

**townland**   The common term or English translation for a variety of small local land units; the smallest unit in the 19th-century Irish administrative system.

**transcription**   An indication by written symbols of the precise sound of an utterance.

**tuogh**   Irish *tuath* "tribe, tribal kingdom", a population or territorial unit.

**unrounded**   Articulated with the lips spread or in neutral position; see **rounded**.

**velar**   Articulated with the back of the tongue touching the soft palate; e.g. *c* in *cool*.

**vicarage**   A parish in the charge of a vicar, the deputy either for a rector who received some of the revenue but resided elsewhere, or for a monastery or cathedral or lay impropriator.

**visitation**   An inspection of (church) lands, usually carried out for a bishop (ecclesiastical or episcopal visitation) or for the Crown (regal visitation).

**vocalization**   The changing of a consonant sound into a vowel sound by widening the air passage; akin to the disappearance of *r* in Southern English pronunciation of words like *bird*, *worm*, *car*.

**voiced**   Sounded with resonance of the vocal cords. (A test for voicing can be made by closing the ears with the fingers and uttering a consonant sound. e.g. *ssss*, *zzzz*, *ffff*, *vvvv*. If a buzzing or humming sound is heard the consonant is voiced; if not it is voiceless).

**voiceless**   See **voiced**.

# INDEX TO IRISH FORMS OF PLACE-NAMES
## (with pronunciation guide)

The following guide to the pronunciation of Irish forms suggested in this book is only approximate. Words are to be sounded as though written in English. The following symbols have the values shown:

| | |
|---|---|
| ă | as in *above, coma* |
| ā | as in *father, draught* |
| ċ | as in *lough, Bach* |
| ch | as in *chip, church* |
| ġ | does not occur in English. To approximate this sound try gargling without water, or consider the following: *lock* is to *lough* as *log* is to *loġ*. If you cannot manage this sound just pronounce it like *g* in **go**. |
| gh | as in *lough, Bach*; not as in *foghorn* |
| ſ | as in *five, line* |
| ky | as in *cure, McKeown* |
| ly | at beginning of words as in *brilliant, million* |
| ō | as in *boar, sore* |
| ow | as in *now, plough* |

Stress is indicated by writing the vowel in the stressed syllable in bold, e.g., Armagh, Ballymena, Lurgan.

| Place-Name | Rough Guide | Page |
|---|---|---|
| Baile Mainistreach | ballă manishtragh | 169 |
| Baile Móinteánach | ballă mōnchanagh | 170 |
| Baile Meánach, An | ă ballă managh | 234 |
| Baile Mhac an Tuaisceartaigh | ballă wack ă tooshkarty | 92 |
| Baile Mhic Giolla Rua | ballă vick gillă ruă | 31 |
| Baile Mhic Gairbhith | ballă vick garăvy | 218 |
| Baile na bPollán | ballă nă bullan | 27 |
| Baile na Cille | ballă nă killyă | 11 |
| Baile na Cluaise | ballă nă clooshă | 194 |
| Baile na Creige | ballă nă cregyă | 32 |
| Baile na Cúile | ballă nă koolyă | 93 |
| Baile na Faiche | ballă nă faċyă | 93, 241 |
| Baile na Léana | ballă nă lyeynă | 33 |
| Baile na Lorgan | ballă nă lurăgăn | 30, 91 |
| Baile na Mullán | ballă nă mullan | 94 |
| Baile Trasna, An | ă ballă trasnă | 34 |
| Baile Uachtar Maí | ballă ooaghtăr mwee | 196 |
| Baile Uí Chinnéide | ballee ċinyedjă | 166 |
| Baile Uí Dhónalláin | ballee ġōnăline | 88 |
| Baile Uí Dhuígeannáin | ballee ġeeganine | 89 |
| Baile Uí Fharannáin | ballee aranine | 10 |
| Béal Átha an Droichid | bell ahăn drihidge | 23 |
| Bearnais | barnish | 35 |
| Bhanna, An | ă wannă | 123 |
| Breacach na Muclaí | brackagh na muckly | 241 |
| Breacghort | brackġort | 95 |
| Brocais | brockish | 96 |
| Bruach Duáin | brooagh dooine | 197 |
| Bruach na Molt | brooagh nă molt | 170 |
| Cadaigh | kaddy | 35 |
| Cam | kam | 123 |
| Carn Fhainche | carn anăċyă | 175 |
| Carn Fhearaígh | carn arree | 174 |
| Carn Liáin | carn lyeeine | 97 |
| Carn Liath, An | ă carn lyeeă | 222 |
| Carn Mhig Ráine | carn vig rānyă | 242 |
| Carn Mic Mhuáin | carn vick wooine | 173 |
| Carraigín, An | ă carrigeen | 96 |
| Chabrach, An | ă ċabragh | 221 |
| Choillidh Fhada, An | ă ċălyee adă | 49 |
| Chraobh, An | ă ċreeoo | 100 |
| Chreag Mhór, An | ă ċrag wore | 40 |
| Cill Chon Riala | kill ċon reeălă | 216 |
| Cill Domhnaigh | kill dōnee | 203 |
| Cill Eaglaise | kill aglishă | 138 |
| Clár | clār | 36 |
| Clochar | cloċăr | 223 |

| Place-Name | Rough Guide | Page |
|---|---|---|
| Dún Dá Éan | doon dā ain | 82 |
| Dún Fiann | doon feeăn | 226 |
| Dún Gall | doon gal | 230 |
| Dún Máil | doon māl | 28 |
| Dún Mór, An | ă doon more | 59 |
| Dún na bhFiach | doonă veeagh | 225 |
| Éadan an Bhile | aidăn villă | 150 |
| Éadan Dúcharraige | aidăn dooċarrigă | 61 |
| Eanach Mór | annagh more | 86 |
| Easca Leathan | askă lyahăn | 151 |
| Eochaillidh | oughălyee | 25 |
| Fearann Fliuch | farrăn flyugh | 71 |
| Fhionnchoillteach, An | ăn yinċăltchagh | 245 |
| Fíobha | feewă | 125 |
| Fiodhóg | feeog | 45 |
| Fíonach | feenagh | 202 |
| Fionnachadh | finnaċoo | 203 |
| Forloch | forloċ | 44 |
| Gallach | gallagh | 107 |
| Gall Gorm | gal gorum | 178 |
| Garbhachadh | garooaghoo | 246 |
| Garbhdhoire | garooġirră | 108 |
| Ghallánach, An | ă ġallanagh | 151 |
| Gleann Aodha | glan ee | 180 |
| Gort an Chairn | gort ă ċārn | 46 |
| Gort an Chaorthainn | gort ă ċeerhin | 247 |
| Gort Carnaigh | gort carny | 109 |
| Gort Fada, An | ă gort fada | 247 |
| Gort Gabhail | gort gōil | 248 |
| Grianán, An | ă greenan | 111 |
| Grógán, An | ă graugan | 47 |
| Gruagach | grooăgagh | 212 |
| Léanach | lyeynach | 51 |
| Leath Mhór, An | ă lya wore | 182 |
| Léim an Charria | lyame ă ċarreeă | 183 |
| Liatroim | lyeeătrim | 50 |
| Lios Cinn Eich | lyiss kin eċ | 71 |
| Lios Mhic Bhloscaidh | lyiss vick lusky | 112 |
| Lios Mhuirneacháin | lyiss wurnyaghine | 184 |
| Lios na bhFaoileán | lyiss na weelan | 184 |
| Lios na gCreagán | lyiss nă graggan | 51 |
| Lios na hUinseann | lyiss nă hinshăn | 205 |
| Lios Neamhnach | lyiss nyownagh | 152 |
| Lios Rodáin | lyiss roddine | 253 |
| Lios Tí Ghearáin | lyiss tee yarrine | 252 |
| Loch na gCoraí | lough nă gorree | 207 |
| Lorgain, An | ă lurăgin | 52 |

# PLACE-NAME INDEX

Sheet numbers are given below for the OS 1:50,000 map only where the name occurs on that map. Not all the townlands discussed in this volume appear on the published 1:50,000 map and no sheet number is given for those names. The sheet numbers for the 1:10,000 series and the earlier 6-inch series, which is still important for historical research, are supplied for townlands, although not for other names.

| Place-Name | 1:50,000 | 1:10,000 | 6 inch | Page |
|---|---|---|---|---|
| Tannaghmore | 14 | 80, 95 | 43 | 67 |
| Tavnaghmore | 14 | 80, 81 | 43, 44 | 153 |
| Taylorstown | 14 | 79, 80 | 42, 43 | 140 |
| Teeshan | 8 | 55, 67 | 32 | 210 |
| Terrygowan | 14 | 80 | 43 | 68 |
| Three Islands, the | 14 | | | 76 |
| Tobernaveen | 14 | 81, 96 | 44 | 154 |
| Toome | 14 | 94 | 42, 48 | 122 |
| Toome Barony | | | | 1 |
| Town Parks | | 67 | 32, 37 | 232 |
| Tullaghbeg | | 94 | 48 | 122 |
| Tullaghgarley | 8 | 55 | 27, 31 | 210 |
| Tullaghgarley | 8 | 67 | 37 | 187 |
| Tully | 8 | | | 259 |
| Tullygowan | | 67 | 37 | 188 |
| Tullynahinnion | 8 | 54, 66 | 31 | 256 |
| Tullynatrush | | 95 | 43 | 76 |
| Tullyreagh | 8 | 43 | 27 | 233 |
| Whitehill | 14 | | | 77 |